MODERN PAINTING AND SCULPTURE: 1880 TO THE PRESENT AT THE MUSEUM OF MODERN ART

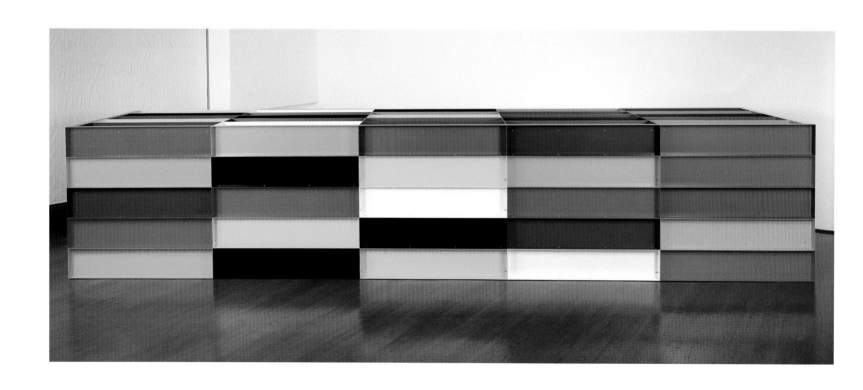

MoDERN ART

PAINTING AND SCULPTURE

1880 TO THE PRESENT AT
THE MUSEUM OF MODERN ART

EDITED BY JOHN ELDERFIELD

THE MUSEUM OF MODERN ART, NEW YORK

This publication is made possible by
the Blanchette Hooker Rockefeller Fund.

Produced by the Department of Publications,
The Museum of Modern Art, New York

Edited by Joanne Greenspun
Designed by Steven Schoenfelder
Production by Marc Sapir
Printed and bound by Dr. Cantz'sche Druckerei,
Osfildern, Germany
Printed on 150 gsm Biberist Allegro

Library of Congress Control Number: 2004111555
ISBN: 0-87070-576-8 (clothbound)
ISBN: 0-87070-577-6 (paperbound)

Published by The Museum of Modern Art, New York
11 West 53 Street, New York, New York 10019-5497
(www.moma.org)

Distributed in the United States and Canada by
D.A.P./Distributed Art Publishers, Inc., New York

Distributed outside the United States and Canada
by Thames & Hudson, Ltd., London

Frontispiece: Donald Judd. Untitled. 1989. Painted
aluminum, 59" x 24' 7½" x 65" (150 x 750 x 165 cm).
Purchase, 2004

Page 62: Paul Signac. *Opus 217. Against the Enamel
of a Background Rhythmic with Beats and Angles,
Tones, and Tints, Portrait of M. Félix Fénéon in 1890*
(detail). 1890. Oil on canvas, 29 x 36½" (73.5 x
92.5 cm). Fractional gift of Mr. and Mrs. David
Rockefeller, 1991

Page 100: Henri Matisse. *The Moroccans.* Late
1915 and fall 1916. Oil on canvas, 71⅜" x 9' 2" (181.3 x
279.4 cm). Gift of Mr. and Mrs. Samuel A. Marx,
1955

Page 190: Paul Klee. *Fire in the Evening* (detail).
1929. Oil on cardboard, 13⅜ x 15¼" (33.8 x 33.3 cm).
Mr. and Mrs. Joachim Jean Aberbach Fund, 1970

Page 296: Wifredo Lam. *The Jungle* (detail). 1943.
Gouache on paper mounted on canvas, 7' 10¼" x
7' 6½" (239.4 x 229.9 cm). Inter-American Fund,
1945

Page 386: James Rosenquist. *F-111* (detail). 1964–65.
Oil on canvas with aluminum (23 sections), 10 x 86'
(304.8 x 2621.3 cm). Gift of Mr. and Mrs. Alex
L. Hillman and Lillie P. Bliss Bequest (both by
exchange), 1996

Page 446: Gerhard Richter. *Meadowland* (detail).
1985. Oil on canvas, 35⅝ x 37½" (90.5 x 94.9 cm).
Blanchette Rockefeller, Betsy Babcock, and Mrs.
Elizabeth Bliss Parkinson Funds, 1985

Printed in Germany

Contents

Preface

On November 8, 2004, The Museum of Modern Art celebrated its seventy-fifth anniversary. At almost the same time, it completed the largest and most comprehensive building program in its history. The conjunction of these two events, though partially coincidental, provides an opportunity to reflect on both the Museum's history and on the direction in which it is going today. Alfred H. Barr, Jr., The Museum of Modern Art's founding Director, spoke of the Museum's collection as being metabolic and self-renewing. While he meant this in terms of the Museum's acquisition processes, the idea of an institution capable of considering and reconsidering itself in response to an ongoing and continuous inquiry about modern art is central to any understanding of the Museum. This publication and the installation of the collection in the new galleries are the result of the most recent phase of reassessment that has looked at the Museum's collection as an evolution strongly dependent on individual judgment and tastes of curators and collectors, not to mention the vagaries of historical opportunities. The works selected for this publication do not offer a simple teleology of movements and counter-movements, but reflect the richness of the collection distinguished by masterworks and lesser-known yet equally pivotal examples of painting and sculpture. In like manner, the anthology of texts presented in this volume, representative of nearly seventy-five years of the museum's literature, reveals that just as its collection is strongly dependent on fluctuating preferences and the contingencies of history, so too is the explication of images and the writing of modern art's history.

Born of a fundamental conviction that the art of our time is as exciting and important as the art of the past, and that the pleasures and lessons of engagement with it should be shared with as large a public as possible, the Museum has functioned as a kind of ongoing experiment. Museums are above all venues of artistic and intellectual inquiry, and this is especially true of The Museum of Modern Art, where several generations of scholarship have shaped and reshaped the way we see and understand the art of our time. This process began with the Museum's very first exhibition in the opening year of 1929, *Cézanne, Gauguin, Seurat, van Gogh*, which sought to identify the roots of modern art in Post-Impressionism. Shows of the 1930s and 1940s examined folk art, African-American art, prehistoric rock paintings, arts of the native peoples of the North and South Americas, and other such traditions with an eye to their relevance to modern art. Installations of the permanent galleries through the 1970s and 1980s endeavored to establish and explicate a history of modern art. Modern art, however, is resistant to simplification and organization, as Barr clearly showed in the interlocking and overlapping lines of his legendary diagrams tracing modernism's sources and routes of development.

In its early years, the Museum was understood to be a laboratory in terms of both its collection (which was meant to grow through acquisitions and to be refined through careful deaccessioning) and its exhibition program, in which each exhibition and each installation of the collection was seen as presenting not a definitive statement but an argument about the history of modern art. In this way the Museum's program can be seen as a series of hypotheses about how modern art can be read at any given moment, subject to review and modification as the art itself changes, and as we gain greater insight into a tradition that is still unfolding. Put differently, The Museum of Modern Art is constantly revising the narrative of its own history, tracing what Marcel Proust called *"le fil des heures, l'ordre des années et des mondes"*—the continuous thread through which selfhood is sewn into the fabric of a lifetime's experience. This is a collective process of interlocking dialogues and narratives played out over a theoretically infinite number of lifetimes. Each thread, each experience, is part of an ever-expanding set of ideas and realities made concrete by the objects that the Museum collects and displays. As each of these narratives is encoded into the pattern of the Museum's history through acquisitions, exhibitions, publications, and programs, it inflects and alters the Museum's intellectual and physical space.

A publication of this scale requires the skill and dedication of many people. I wish to express my particular appreciation for the extraordinary efforts of John Elderfield, The Marie-Josée and Henry Kravis Chief Curator, Department of Painting and Sculpture, who brought this large group of works together and conceived of the publication, which is supported by a generous grant from the Blanchette Hooker Rockefeller Fund.

Glenn D. Lowry
Director, The Museum of Modern Art

Acknowledgments

The preparation of this publication was made possible by members of the Departments of Education, Imaging Services, Painting and Sculpture, and Publications, the office of the General Counsel, and the Museum Archives. In the selection and organization of the plates and texts, I am especially indebted to Sarah Ganz Blythe and Elizabeth Levine Reede; also to Mary Chan, Sharon Dec, Joanne Greenspun, Angela Meredith-Jones, Iris Mickein, and Claudia Schmuckli. While writing the Introduction, I learned from Sarah Ganz Blythe, Jeanne Collins, Michelle Elligott, Joanne Greenspun, and Glenn D. Lowry. In the design and production of this book, I relied on the expertise of Steven Schoenfelder and Marc Sapir. I thank them all.

John Elderfield
The Marie-Josée and Henry Kravis Chief Curator
Department of Painting and Sculpture

1. Installation view of the exhibition *Cézanne, Gauguin, Seurat, van Gogh*,
November 7–December 7, 1929, The Museum of Modern Art, 730 Fifth Avenue,
New York

The Front Door to Understanding

John Elderfield

In 1929, the first published statement of the founding trustees of The Museum of Modern Art asserted that its "ultimate purpose will be to acquire, from time to time, either by gift or by purchase, a collection of the best modern works of art." Should this be consistently done, they claimed, New York "could achieve perhaps the greatest museum of modern art in the world." When these words were written, the Museum occupied a rented loft space, had no endowment, no purchase funds—and no collection. It did, however, have a group of enthusiastic and committed trustees—spearheaded by the Museum's three founders, Lillie P. Bliss, Mrs. John D. (Abby Aldrich) Rockefeller, Jr., and Mrs. Cornelius Sullivan—and had appointed its first Director, a twenty-seven-year-old art historian, Alfred H. Barr, Jr.

Lacking a collection, the Museum began by organizing loan exhibitions, and within its first year produced seven important exhibitions, which were attended by more than two hundred thousand visitors. By early 1931, therefore, Barr was able to write to a colleague in Germany that the Museum had been running with such extraordinary success as an experimental institution that the time had come to start building a collection. Initially, this would be a collection of painting and sculpture. However, Barr proposed to the trustees that, in time, the Museum should become multidepartmental, devoted to all the visual arts of our time: architecture and design, photography, and film, as well as painting and sculpture, drawings, and prints. His model was the Bauhaus, the experimental German art and design school that he had visited in 1927.

One of Barr's two greatest achievements was that he was the first person to conceive of a comprehensive museum of modern visual arts and to bring such a museum into being. His second was that he envisioned the Museum's collection of painting and sculpture as one that should afford a comprehensive overview of modern art composed of the finest works possible, and that he brought such a collection into being. If this no longer seems a novel approach either to collecting or exhibiting the art of our time, it is because Barr's vision of the modern museum is now so widely accepted.

The present publication is devoted to consequences of the second of these achievements, that is, to the Museum's collection of painting and sculpture. It appears on the seventy-fifth anniversary of the Museum's founding, being intended to complement the new installation of the collection in the redesigned Museum by Yoshio Taniguchi. Both the publication and the installation, in offering reviews of modern painting and sculpture, also present a picture of what Barr, together with his colleagues and successors, achieved in forming the Museum's collection in these mediums.

As to Barr's other great achievement, it needs saying here that the multidepartmental Museum evolved steadily but, in some areas, slowly. By 1932, there was a Department of Architecture; by 1935, a Film Library; and by 1940, a Department of Photography. Prints and drawings were collected from the very start, a drawing and eight prints comprising the Museum's very first acquisitions. It was, in fact, a simple matter to collect prints and especially drawings within the context of paintings and sculptures because the artists were the same. For this very reason, however, departments for these mediums came later than all others. By 1949 there was a Print Room, but not until 1966 a Department of Drawings and Prints, which subsequently would divide into a Department of Prints and Illustrated Books and a Department of Drawings, founded in 1969 and 1971, respectively. Since the Museum effectively began as a department of painting and sculpture, which eventually expanded its collecting to include works in other mediums, it is difficult to specify quite when the Department of Painting and Sculpture itself was founded. (I will say something later about its tangled history.) If we mean a department that took particular responsibility for painting and sculpture (with drawings and prints), then an appropriate founding date would be 1943, when Barr was asked to resign as Museum Director and concentrate on research and on work on the collection. However, if we mean an independent department, solely devoted to painting and sculpture, then that did not come to pass until the cession of prints and drawings in 1966.

Barr himself retired the following year, 1967, making his creation both of the multi-departmental museum and of an autonomously comprehensive painting and sculpture collection the great, twin achievements of the first half of the Museum's history. Barr's many groundbreaking exhibitions and publications inspired and were inspired by his work on the Museum's collections; all combine in the notion of a museum that is a laboratory for research and experiment, which still remains his very broadest legacy.

The development and shape of the Museum's painting and sculpture collection is inexorably tied to this principle; it began as, and remains, a collection based on continuing enquiry into the evolving nature of modern art. This being so, an understanding of its development and present shape requires some knowledge of the following subjects. First, we need to learn about the *founding* of the collection, especially how it came to be devoted to international modern art from around 1880 to the present. Second, we need to learn something of what *building* the collection required: what it meant to collect across a continually changing field of modern and contemporary art. Third, the *shaping* of the collection requires explanation, both the means of acquisition and the philosophy that guides collecting on a subject understood to be in progress. These policies were effectively decided in the Barr years, 1929 to 1967. Since then, however, the painting and sculpture collection has been enlarged greatly under the successive direction of William S. Rubin, Kirk Varnedoe, and John Elderfield. Fourth, we need to know what *growing* such an extraordinary collection in the post-Barr years has entailed. Fifth, we need to understand that *showing* the collection has always brought its special challenges, because the public, exhibited collection has always comprised a minority of the works owned by the Museum. How the design and installation of the Museum's painting and sculpture galleries simultaneously have represented the collection and its subject, modern art, is not as straightforward as it may seem. And, sixth, since the

Museum was chartered as an educational institution, it is important to know how the aim of *teaching* visitors about modern art has shaped the layout of its installations.

In the pages of this introduction, I shall take up these subjects in this order because, with the partial exception of the last two subjects, this was how they came to demand the Museum's particular attention. However, they are not separable but are intertwined with the history of the Museum's developing collection; they will do that here, interweaving with a survey of the growth of the collection that is largely based on the works illustrated in this volume.

The events recounted here have been, at times, controversial—sometimes very controversial—such has been the passion that the Museum has instilled among both supporters and detractors. Therefore, it needs saying from the start that this is not an official history, but rather a personal and, at times, opinionated account of the development of the collection and installations of painting and sculpture at the Museum by the person now privileged with the responsibility and authority for their well-being. (For sources consulted in the preparation of this text, see page 506.) Inevitably, Barr's ideas and approaches loom over everything else. This is appropriate, not only because they provided the foundation for what was later possible, but also because they continue to be treated as doctrines and are, thereby, sometimes misunderstood. This account will reveal a more realistic picture of Barr's changing understanding of how the collection should be shaped and installed, which committed the Museum to principles but not to practices, to beliefs but not to habits, to questions but not to solutions.

Thus, new directions for the Museum were encouraged and have come to pass. My aim in the latter part of this essay is to show how Barr's vision was broad enough to allow his successors' visions to flourish, too, in departure from, as well as in concert with, their inheritance. And thus, Barr's notion of an experimental Museum of Modern Art has mirrored its own subject, modern art itself, whose own history has amply demonstrated that it will not thrive if it becomes monotonous or repetitive. Pablo Picasso once told the critic Michel Leiris how he feared that the work of their friend Alberto Giacometti was becoming just that, at which Leiris offered the justification that Giacometti was consumed with the wish "to find a new solution to the problem of figuration." Picasso replied: "In the first place there isn't any solution, there never is a solution, and that's as it should be."

1. Founding

The Museum's founding statement of 1929 spoke of a collecting policy for the new Museum. It was intended to function in relationship to New York's Metropolitan Museum of Art in a way akin to how, in Paris, the Musée Luxembourg then functioned in relationship to the Musée du Louvre, as a sort of waiting room for contemporary art from which works deserving of promotion would move into the senior institution. But the Museum's collection was to have its own historical beginnings, comprising not only a collection of contemporary art by living artists but also a complementary collection of works by pioneers of modern art still too controversial for universal acceptance. Thus, from the very start, a dual mission was stated for the temporal range of the collection.

2. Installation view of the
exhibition *Selections from
the Permanent Collection
of Painting and Sculpture*,
The Museum of Modern
Art, New York, 1993.
At right: Auguste Rodin's
*St. John the Baptist Preach-
ing*; on center wall: Paul
Cézanne's *The Bather*

This mission continues to the present, and is now often described as the collecting of
both modern and contemporary art. However, Barr used the word *modern* not to de-
scribe precontemporary art, but rather an aspect of contemporary art, one that sug-
gested "the progressive, original and challenging rather than the safe and academic
which would naturally be included in the supine neutrality of the term 'contempo-
rary.'" In 1929, the "modern" and the "contemporary" were not easily distinguishable
by chronological means. And we cannot be certain who precisely were the unidentified
pioneers that the founders had in mind. But we do know which artists soon came to and
still continue to open the Museum's collection, and chief among them is Paul Cézanne,
whose great *The Bather* of around 1885, stepping forward to the viewer, long stood
within the entry to the collection (fig. 2), symbolizing the beginning of the advance of
modern art.

"Cézanne est notre maître à tous," Henri Matisse insisted. Barr agreed. The Mu-
seum's first loan exhibition, of November 1929, had been devoted to Cézanne, Paul
Gauguin, Georges-Pierre Seurat, and Vincent van Gogh. The Lillie P. Bliss Collection,
bequeathed to the Museum in 1931 and accessioned in 1934 to form the foundation of
its collection, was dominated by Cézanne: eleven oils and eleven watercolors. Barr's fa-
mous genealogical diagram of the development of "Cubism and Abstract Art," on the
jacket of the Museum's 1936 catalogue of that title, raises the name of Cézanne above
the 1890 starting date of everyone and everything else (fig. 3). As such, it parallels the
chronology of the Museum's collection, which, it was suggested by 1933, should begin
some fifty years prior to then, which eventually was taken to mean prior to the date of
the Museum's founding in 1929. And it also parallels the English critic Roger Fry's
characterization of Cézanne as the "tribal deity" of modern art in his monograph on
the artist, published two years before that, a characterization based on Cézanne's "clas-
sic" Post-Impressionist style created around 1880. Barr had met Fry in London in that

very year, 1927, and unquestionably was influenced by him. The conclusion seems inescapable that 1880 was eventually recognized as an appropriate date for the Modern's collection to begin because it was then that Cézanne founded classic modernism, in Fry's—and Barr's—interpretation.

It is certainly true that the Museum's painting and sculpture collection, and most especially the selection from it installed in the galleries, has long and rightly been taken to embody, in Kirk Varnedoe's words, "a cumulative proposal . . . about the nature of modern art." This is to say, the exhibited collection composes an extended argument about premises, ambitions, and alternatives that were conspicuously in play in the art of the 1880s, but not quite so even in the art of the 1870s; that continued to inform the artistic practice of the now classic, early- and mid-twentieth-century painters and sculptors; and that continue to inform the work of contemporary artists, however obliquely or even unconsciously they do so.

This is not to say, of course, that one stream, path, course, or route spans this century and a quarter. The entwined spaghetti of just forty-five years in Barr's "Cubism and Abstract Art" diagram only gets denser as the years pass. Neither is it to say that the year 1880 marks some definitive break with the past. As modern art gained attention and continued to attract controversy, in the 1930s, a consensus obviously did develop that what Cézanne and the Post-Impressionists had created marked a very profound transition indeed. This led some supporters as well as opponents of modern art to promote the myth that it was something sequestered and apart. For example, the highly sympathetic English critic Herbert Read wrote that the changes that modern art had brought were even more than revolutionary, which implies a turning over, and were actually catastrophic, which implies "an abrupt break with all tradition. . . .The aim of five centuries of European effort is openly abandoned," he said. From a present perspective, such an apocalyptic view seems not just hyperbole but sheer nonsense. From Barr's contemporary prospect it was, too. Indeed, even as he was acknowledging, in the early years of the Museum, Cézanne's revolutionary importance as *prima inter pares* among the ancestors of contemporary painters, he was also sketching a very different opening for the collection.

Barr proposed, in a 1933 "Report on the Permanent Collection" (hereafter: 1933 Report), that the Post-Impressionist ancestors should be preceded by their own nineteenth-century ancestors, from Eugène Delacroix to Hilaire-Germain-Edgar Degas. He pondered going further back to begin with Jacques-Louis David and Francisco Goya. And he even imagined what it would be like to start with *two* "background" collections. The first would be a selection from "older European traditions which seem most significant <u>at present</u>: for instance, a Fayum portrait, a Byzantine panel, Romanesque miniatures," and so the list went on through Giotto and Piero

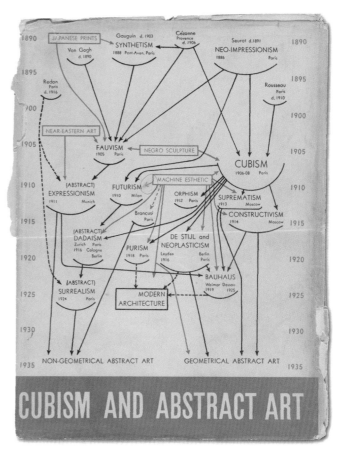

3. Jacket for the exhibition catalogue *Cubism and Abstract Art*, by Alfred H. Barr, Jr. New York: The Museum of Modern Art, 1936

13

della Francesca to Nicolas Poussin and Giovanni Battista Piranesi. The second background collection would be non-European: "Coptic textiles, Scythian bronzes, Japanese prints, Chinese painting, African and pre-Columbian objects."

This interest in European precursors of European modernism and in the influence of non-European traditions—the latter aimed, as Barr wonderfully put it, "to destroy or weaken the prejudice of the uneducated visitor against non-naturalistic kinds of art"—would find expression in the Museum's temporary exhibition program through 1954 but never in the painting and sculpture collection itself. Goya did make it into the print collection in 1964. But "the collection proper," Barr had already realistically acknowledged by 1933, needed to begin with the paintings of the Post-Impressionists, or "paintings less than fifty years old," which moving target would later be specified as a "dividing date" of 1880.

There will be more to say about Barr's 1933 Report, but its ambitiousness is already very evident. It belongs to a period of imagining very grand possibilities even as a collection was beginning to grow that threatened to foreclose them. Given the extraordinary range and quality of the Museum's early modernist collection, it may be inferred that it began as it became. In fact, it began conservatively. The first major work in the collection was Aristide Maillol's bronze, *Île de France* (1910), the first painting, Edward Hopper's *House by the Railroad* (1925). Five years after the Museum opened, the twentieth-century paintings in the collection all dated after 1917 and were generally traditional. In addition to nine of the paintings—by Cézanne, Gauguin, Matisse, Picasso, Odilon Redon, and Seurat—that now remain from the Bliss Bequest, only six works owned by the Museum in 1934 are still regularly exhibited: the Hopper, Constantin Brancusi's *Bird in Space* (1928), Salvador Dali's *The Persistence of Memory* (1931), Otto Dix's *Dr. Mayer-Hermann* (1926), Maillol's *Desire* (1906–08), and Édouard Vuillard's *Interior, Mother and Sister of the Artist* (1893). This is fifteen works out of a collection that then numbered ninety-one paintings and sculptures.

At that date, when the Bliss Bequest formally entered the collection, the Museum had, surprising though this may now seem, a greater late-nineteenth-century painting collection than any other North American museum except the Art Institute of Chicago. But compared to the Société Anonyme collection assembled by Katherine S. Dreier and Marcel Duchamp, the A. E. Gallatin Collection, and the Guggenheim Collection, of which only the Gallatin Collection was then on public view, the Museum's collection lacked representation of any and all of the great pioneering movements of the early twentieth century.

Moreover, it was, with the exception of only a few works by North American artists, an almost entirely European collection. The Museum's founding manifesto of 1929 had spoken of wishing to collect the modern art of especially France and the United States, but also that of England, Germany, Italy, Mexico, and other countries: an interesting national prioritization. In Barr's 1933 Report, the field actually narrows. Its now famous diagrams of the collection "as a torpedo moving through time, its nose the ever advancing present, its tail the ever receding past" (fig. 4), mentions only four national groups: French (School of Paris), Rest of Europe, Mexicans, and Americans. Even more surprisingly, Barr's 1941 revision of the diagram (fig. 5) places the United States and Mexico in the nose cone of the torpedo, driving into the future, with the School of Paris and

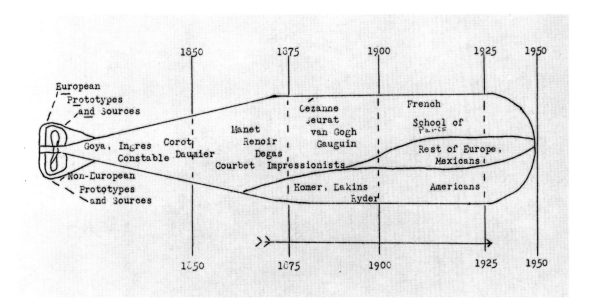

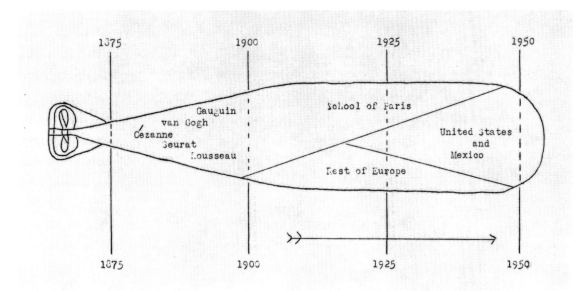

4. Alfred H. Barr, Jr. "Torpedo" diagram of the ideal permanent collection of The Museum of Modern Art, as advanced in 1933. Prepared by Barr for the "Advisory Committee Report on Museum Collections," 1933

5. Alfred H. Barr, Jr. "Torpedo" diagram of the ideal permanent collection of The Museum of Modern Art, as advanced in 1941. Prepared by Barr for the "Advisory Committee Report on Museum Collections," 1941

the Rest of Europe lagging behind. But Barr was diagramming the contemporaneity of the art of the Americas in the collection as compared to early European modernism. In the new, 1941 report on the collection that contained the revised diagram, the sequence of representation by national origin had, it is true, advanced Mexico above England, now dropped from top to bottom place among the minor nations. (Italy had simply disappeared, presumably subsumed in the category "Other," while Russia had newly appeared—above Mexico.) Nonetheless, nineteenth-century France still comprised nearly half of the collection, followed by a strong showing of the School of Paris, then the United States, with the remainder—German, Russian, Mexican, English, and other works—comprising only some six percent of the collection.

Mexican art did have a favored place almost from the start, with special emphasis on work by the three leaders of the Mexican mural movement, Diego Rivera, José Clemente Orozco, and David Alfaro Siqueiros, all of whom spent extended periods in the United States in the early 1930s. One of them, Rivera, became in 1931 the subject of the Museum's second exhibition devoted to a single artist. (The first, that same year, was a Matisse exhibition.) There were important works by these artists in the collection

of thirty-six paintings and one hundred and five works on paper that Mrs. John D. Rockefeller, Jr., donated in 1935. (Her sculpture collection followed in 1939.) And, by the time of Barr's 1941 diagram, and possibly motivating it, the Museum was poised to embark upon an extremely ambitious program of acquiring works by Latin American and Caribbean artists, with the help of the Inter-American Fund, anonymously endowed by Nelson A. Rockefeller, Museum President from 1939 to 1941. The fund was established in 1942, and in a single year, Barr, Edgar Kaufmann, Jr., nominally a design curator, and especially Lincoln Kirstein, appointed as Consultant on Latin-American Art, enlarged the collection from thirty-eight, mostly Mexican works, to almost three hundred works by artists from Argentina, Chile, Colombia, Cuba, Ecuador, Peru, and Uruguay, as well as Mexico. Thus, the number of American countries came to exceed the number of European countries represented in the collection.

Mrs. Rockefeller's collection was an ecumenical one, but it was especially strong in the work of North American artists, from Charles Burchfield and John Marin to Maurice Prendergast and Max Weber. Barr's 1933 Report had recognized that the Museum's American collection was a "problem" because contemporary American art was also collected by The Metropolitan Museum of Art through its exceptional Hearn Fund (which produced the then-huge sum of $25,000 per year) and, exclusively, by the Whitney Museum of American Art. To add to the competition for works would "bring joy to painters and dealers," but was unintelligent and imprudent. But Barr was biased because he did not particularly like new American art. (In 1929, he had sidestepped the problem of selecting the Museum's first exhibition devoted to that subject, "Nineteen Living Americans," by taking the dangerous step of letting the trustees choose.) In any event, he recommended that the Museum should develop an American collection that was "daring and exclusive" but not "representative." In 1938, the Museum's Board of Trustees refined this policy with the general request that the American art that was acquired should, wherever possible, come from artists outside New York City; should be work that seems "American" rather than "shows European influence"; and should be by younger rather than established artists. Thankfully, this well-intentioned but naïve attempt to foster the building of a distinctively national collection came to nothing— and soon, because the times were against it.

As the Museum's President, John Hay Whitney, would write in 1942: "It is natural and proper that American artists should be included in greater numbers than those of any other country. But it is equally important in a period when Hitler has made a lurid fetish of nationalism that no fewer than twenty-four nations other than our own should also be represented in the Museum Collection." In fact—both nationalism and internationalism notwithstanding—the principal emphasis, and legacy, of the second half of the 1930s was to build up the early-twentieth-century European collection. In 1935, Mrs. Rockefeller established the Museum's first purchase fund in the form of a one-thousand-dollar donation for Barr to buy works in Europe during the summer. While seemingly a trifling sum, it netted him four works by Max Ernst, two by Kazimir Malevich, and one each by André Masson, Kurt Schwitters, and Yves Tanguy. Then, in 1938, Mrs. Rockefeller established a fund that soon amounted to more than thirty times that, to be renewed the following year, while Mrs. Simon Guggenheim began making the sequence of donations over three decades of early modern works, to be chosen by Barr

and his colleagues, that Barr himself called magnificent: not only great but great-making in raising the level immeasurably for the future.

With this support, the balance of the collection began decisively to change in favor of the pioneering artists and movements of the twentieth century. Change had begun with multiple purchases from Barr's two great pioneering survey exhibitions, *Cubism and Abstract Art* of 1936 and *Fantastic Art, Dada, Surrealism* of 1936–37. By the end of the decade, a determination had set in to seek out single great works—witness the early, 1939 acquisition of Henri Rousseau's *The Sleeping Gypsy* (1897) as the gift of Mrs. Guggenheim—and to build collections of great works by the most important artists. Thus, by the end of the 1930s, the basis was formed of major collections of works by Joan Miró (including *The Hunter*, 1923–24, and *Person Throwing a Stone at a Bird*, 1926), Picasso (*Les Demoiselles d'Avignon*, 1907; *The Studio*, 1927–28; and *Girl Before a Mirror*, 1932)—Barr's proudest trilogy—and Paul Klee (*Around the Fish*, 1926, and *The Twittering Machine*, 1922), while Piet Mondrian's *Composition in White, Black, and Red* (1936), Giacometti's *The Palace at 4 A.M.* (1932), and Matisse's *Gourds* (1915–16) and *The Blue Window* (1913) adumbrated what would become equally important collections.

Around the Fish, The Blue Window, and other works were purchased, albeit indirectly and after much soul-searching, from the notorious Lucerne auction of Nazi-consigned, officially "degenerate art" of 1939, and thereby saved from certain destruction, Barr persuaded himself. He was as scrupulous as possible about not acquiring from any source works that may have been privately confiscated, or their sales coerced, by Nazis or Nazi sympathizers and then passed into the commercial market. But the availability of many works acquired in the later 1930s unquestionably was influenced by the deteriorating political situation in Europe. Indeed, Barr found himself in the doubly uncomfortable position of turning down bargains, for shortage of funds, from collectors who had fled Germany.

Not that funds were impossible to find. What made this period's acquisitions possible was a munificence prompted by plans for a new Museum building at 11 West Fifty-third Street, designed by Philip L. Goodwin and Edward D. Stone. When it opened, in 1939, on the tenth anniversary of the Museum's founding, it was clear that the painting and sculpture collection was taking the shape it still occupies, a collection of art made internationally since Post-Impressionism, with emphasis on Europe in the earlier years and a broader emphasis later. However, there was one very important piece of unfinished business left over from the founding manifesto of 1929. This was the Luxembourg-Louvre model of the Museum's collection as a temporary holding place for contemporary works of art that might become classics and graduate to The Metropolitan Museum of Art in order to make room for new works to keep The Museum of Modern Art truly modern, meaning contemporary. At the opening banquet for the 1939 building, Paul J. Sachs, Barr's teacher at Harvard and a founding trustee, returned to this theme. He recommended that purchase funds be divided into two: half for one or two works of the highest quality; half for contemporary art, including the work of absolutely unknown artists. As the Museum grows older, he said, there is a danger: "the *danger of timidity*. The Museum must continue to take risks."

2. Building

The Museum had begun to build a collection in 1931 with the policy, described thus by the Museum's first President, A. Conger Goodyear: "The permanent collection will not be unchangeable. It will have somewhat the same permanence that a river has." That same year, the some hundred, mostly Post-Impressionist paintings and drawings that composed the Bliss Collection were first shown at the Museum. The magnificence of this promised bequest only made its conservative weighting of the Museum's collection all the more evident, and its provision that works could be sold to fund more contemporary acquisitions all the more likely to be acted upon. Barr wanted to act. However, Goodyear wanted to continue to emphasize loan exhibitions and either not have a collection at all, or at least "not to be troubled with too many possessions" in order to remain "a living active institution abreast of its time." On the other hand, Mrs. Rockefeller was distressed about how to remain modern (contemporary) while satisfying donors that the works they gave would not be discarded in an objectionable manner. A Luxembourg-Louvre treaty with the Metropolitan seemed to Barr to be a good way of being able to build a collection while satisfying the competing views of trustees—and he truly believed that the collection would remain modern by "metabolically" discarding older works as it acquired newer ones.

However, in 1933, when Barr was endorsing the policy of a collection of works no more than fifty years old, that policy did not compete with his conception of modern art as beginning with the classic Cézanne of the 1880s, nor did it seriously endanger the Bliss Bequest: only five of the twenty-two Cézannes were earlier than 1883; neither were the two paintings by Degas (although most of his works on paper were), nor more than a handful of works by other artists. That year, William Sloane Coffin, the President of the Metropolitan's Board of Trustees, lobbying on behalf of a deal with the Modern, announced that a modern museum could not form a permanent collection without the risk of "becoming permanently congested with examples of the taste of its early friends," and that the extent of a modern collection should be only ten or twenty years. Barr's reaction is unknown—and, thank goodness, the intermuseum discussions stalled shortly afterwards—but we may presume that he would have been horrified. (In 1947, when the Modern-Metropolitan pact finally was being arranged, he bitterly opposed a suggested dividing line of 1910, since it would mean giving up the Post-Impressionists, and lobbied for 1880.) Coffin thought that modern art meant contemporary art, Barr that it included it. Coffin thought that modern (contemporary) art was transient, subject to period taste, Barr that modern (and contemporary) art included, of course, works of transient, period taste, which would be discarded from the Museum's collection as it grew, but also works that exemplified modern canons of excellence that would long continue to retain our interest.

But for how long? In 1933, Barr could retain the Post-Impressionists if the collection had a fifty-year parameter, but not a ten- or twenty-year one. In 1947, it would require a nearly seventy-year collection to do the same job. And so things have continued, until, at the date of this writing, it now requires a one hundred and twenty-five year collection. But the point that Barr had reached in 1947 was not the point at which he had begun. In 1933, his plans for the collection were based on the optimistic premise

that founding, older works of modern art would be so completely assimilated within fifty years of their existence that they no longer would need defense and explanation, and could therefore be promoted upstairs. When the 1933 Report was written, about half the collection was composed of Bliss Bequest works, and was desperately short of twentieth-century masterpieces. Since it had been understood from the start that the collection would have the same permanence as a river, and since the Bliss Bequest explicitly allowed deaccessioning, Barr was keen to act. But it was not until 1939 that he was able to act ambitiously, and then did so very ambitiously, selling a Degas pastel from the Bliss Bequest toward the acquisition of Picasso's *Les Demoiselles d'Avignon.*

Nothing, however, was sold in 1940, and almost half of the collection still comprised French art of the later nineteenth century. Barr was impatient and wrote in 1941 that only one-eighth of what the Museum owned was worthy of an ideal collection; that it had gaps in Futurism, German Expressionism, Fauvism, and Analytical Cubism; and that, in order to fill these gaps, the Museum "should increase in its metabolism, should dispose more rapidly of works which it does not need." It is ironic, then, that the next great acquisition made through Bliss Bequest sales, that very same year, was for a painting made in France in 1889, namely, van Gogh's *The Starry Night.*

We should pause to grasp the implications of this action. Barr, and the Museum, had not repudiated the idea of a temporal collection of art of the past fifty years, yet in 1941 had just bought a painting made fifty-two years earlier. In 1941, Barr asserted that the "future development of the Collection can be financed almost entirely by sales from the existing Collection," and a Luxembourg-Louvre model pact with the Metropolitan remained unfinished business, soon to be revived. But these two factors had now become disconnected. Both sought incrementally to shape the collection. However, the former called for particularized, tactical deaccessioning of early works, in order to refine the early collection as well as to advance the collection into the future, while the latter called for programmatic, strategic deaccessioning of earlier works in order to eliminate the early collection and advance the collection into the future. The former was a policy based on the idea that modern art *included* contemporary art, the latter on the idea that modern art *was* contemporary art.

Whereas the late 1930s had seen aggressive collection building, the early 1940s was, in contrast, a period of discussion about gaps to be filled, masterworks to be sought, and directions to be taken. This was the period of World War II that brought confusion to the Museum, including the Board falling into the hands of aesthetically conservative trustees and Barr's firing as Director of the Museum. It had to be the uncertainty of the time, but far less was said about the impermanence of the collection. Indeed, in 1941, Barr was asserting that the Museum had a unique opportunity and responsibility to build a *comprehensive* collection. Such a collection ideally would need to begin with a Claude Monet or a Camille Pissarro—"an impressionist painting as a point of departure and a clarification of the term 'impressionism'"—then continue with a Pierre-Auguste Renoir and a Degas before Cézanne took up the path of Post-Impressionist modernity and, finally, modern art began. A year later, Barr added that the function of such a collection, in comparison to that of changing exhibitions, was to give "a sense of relative stability and continuity to an institution dedicated to the changing art of our unstable world."

In January 1944, Barr's next report on the collections appeared. In this remarkable document, entitled "The Museum Collections: A Brief Report," he listed seven criteria by which the purposes and value of the collections could be judged, when compared to loan exhibitions. *Quality*: The quality of an exhibited collection should be superior to that of hastily assembled, temporary exhibitions. *Concentration*: It should not just include "anything interesting that comes along," but, rather, what conforms to "the Museum's essential program of the modern visual arts." *Comprehensiveness*: Although necessarily selective in its parts, the exhibited collection as a whole should offer the broadest picture of modern art. *Continuity*: It should comprise a display that, while not necessarily permanent, should offer a continuously present message. *Authority*: It must offer an enduring visible demonstration of what the Museum stands for, its "essential program, its scope, its canons of judgment, taste and value, its statements of principle, its declarations of faith." *Educational Value*: A combination of the foregoing factors will make the Museum's exhibited collection useful to teachers in schools and colleges. *Public Interest*: These will make such a collection hold its own in the public eye.

While it is impossible, of course, to maintain quite the same missionary zeal (and valorization of authority) of sixty years ago, these have been the criteria, broadly speaking, that the Museum's curators have maintained ever since to choose paintings and sculptures for installation in the collection galleries (and that have determined the choice of illustrations in the present publication). The 1944 Report thus marks the beginning of the transition from a very experimental to a potentially authoritative Museum.

Barr concluded by saying: "In a discussion as to whether the collection should be primarily an assemblage of fine paintings or an historical survey, there need be in my opinion no serious conflict . . . because the excellence of the works of art contributes not only to the public's enjoyment but also to the educational effectiveness of the Museum." Understanding art and enjoying art are related. Is the second dependent upon the first? both Proust and Freud wondered. Barr seems to suggest that the efficacy of their relationship depends upon the excellence of the work. Unquestionably, he was interested in the voice spoken by the collection as a whole, taking for granted that the past of modern art never recedes as a subject of puzzlement, but remains difficult for many—including many of the first-time visitors who still comprise the majority of the Museum's audience. And, as it turned out, the ever-advancing present could better be appreciated and understood in the presence than in the absence of the pioneers, however much their early maps had been elaborated or altered by their successors.

Self-evidently, Barr had been refining his understanding of what the modern collection should be. Continuity would be more important than permanence. It would be selective yet comprehensive, and above all it would have the concentration and the authority that followed from the Museum's mandate that the collection represent the broadest, most superior achievements in the modern visual arts. But his report came too late. Three years earlier, his 1941 Report had argued that "a large proportion of the 19th century pictures, particularly the Cézannes . . . should be sold." In 1940, one-third of the works in a strictly equitable, reportorial collection that began in 1880 would have been made in the nineteenth century. But it was understood that the nineteenth-century segment—Barr's inaccurately drawn, narrowly tapering rear of the torpedo— should be smaller. In that year, the nineteenth-century works amounted to fewer than

half of a third of the total, about fourteen percent—forty-four in a collection of six hundred and ten—which does not seem unreasonable. However, they represented almost half the entire financial value of the collection. Given the wartime shortage of acquisition funds, that part of the torpedo was a very attractive target. And in May 1944, four months after Barr's aforementioned report, the Museum did sell nineteenth-century works at auction at the Parke-Bernet Galleries expressly for the purpose of making twentieth-century purchases.

Barr and other members of the staff had objected to this wholesale, public method of deaccessioning, but not against deaccessioning itself, since funds for twentieth-century works were badly needed. And while he complained that the auction was neither a financial nor a public-relations success, he did, that autumn, draw up a "list of important works which we might consider for acquisition," adding: "We now have a good deal of money which is restricted to purchase of works in the 'masterpiece' class." The fourteen works listed, dating from 1904 to 1941, included Picasso's *Girl with a Mandolin (Fanny Tellier)* (1910) and *"Ma Jolie"* (1911–12), Georges Braque's *Man with a Guitar* (1911–12), Marc Chagall's *I and the Village* (1911), and Roger de La Fresnaye's *The Conquest of the Air* (1913), all of which would subsequently enter the collection, four of them by 1947. Other important works were also entering through gift and purchase, among them, in 1942, Max Beckmann's triptych *Departure* (1932–35) and Oskar Schlemmer's *Bauhaus Stairway* (1932). Acquisitions of 1943 and 1944 included recently completed paintings by Matta (*The Vertigo of Eros*, 1944), Mondrian (*Broadway Boogie Woogie*, 1942–43), Robert Motherwell (*Pancho Villa, Dead and Alive*, 1943), and Jackson Pollock (*The She-Wolf*, 1943). And in 1946, the Matisse collection advanced massively with the purchase, through Mrs. Guggenheim's fund, of the *Piano Lesson* (1916). But this great growth spurt in the collection was not likely to deter the party for divestiture; rather, it encouraged it so that such growth might continue.

In fact, keenness to keep adding to the collection—and the bad feeling surrounding the Parke-Bernet auction—renewed interest in the old plans for a Modern-Metropolitan pact, and such a pact was cemented in 1947. That year, Barr was brought back and made Director of Museum Collections. However, his rehabilitation did not include permission to tamper with this agreement. To his very great dismay, it fulfilled the original mandate to which he himself had subscribed: sell off older works to The Metropolitan Museum of Art in order to stay focused on the present. Of the twenty-nine paintings and sculptures that were immediately sold to buy contemporary works, the earliest (excepting two by Edward Hicks) dated to the mid-1860s, Cézanne's *Man in a Blue Cap*, and the latest to 1932, a sculpture by Charles Despiau, among conservative modern sculptures that unsentimentally included the Museum's first sculpture acquisition. But there were twentieth-century works of very real importance, ranging from Matisse's *Gourds* (1915–16) and *Interior with a Violin Case* (1918–19) (both successfully repurchased later) to Picasso's *La Coiffure* (1906) and *Woman in White* (1923) (both not successfully repurchased later). Kirk Varnedoe has detailed the extraordinary events that ensued, which—but for the difficulties of intermuseum cooperation, the negligence of some of the players, internal dissension in the Museum itself, and the dawning at last of good sense—would have reduced the Museum to a fifty-year collection before the agreement was renounced in 1953.

Discussions had already begun in the Museum in 1951 about maintaining a permanent collection of masterworks. They seem to have had four intersecting motivations. First, the early 1950s saw a huge price inflation for both new American art and especially for established European modernism. Was it prudent to be selling classic paintings when their prices were spiraling upward? Second, the pact with the Metropolitan had been based on a Luxembourg-Louvre model of 1929, when the French were deemed the ultimate arbiters of matters cultural. Things had changed. Third, there was concern that donors would give their works directly to the Metropolitan if these works would go there eventually. And fourth, there was concern that the increasing pace of acquisition of postwar contemporary art would utterly transform the Modern as older works were transferred. The final motivation may well have been the deciding one. It appeared to be no more than a question of taste, the new avant-garde proving, as is often the case, difficult to stomach by supporters of the old avant-garde, but that question of taste had its urgent practical consequence.

Within a year of the 1947 Metropolitan agreement, trustees and other supporters of the Museum had been expressing disapproval at proposed acquisitions of new art. Later, in 1951, a member of the Committee on the Museum Collections resigned over the purchase of Giacometti's *The Chariot* (1950), and another did so in 1952 when Mark Rothko's *Number 10* (1950) was acquired as a gift from Philip Johnson, a practice on Johnson's part that became habitual when the Committee wanted to reject an important contemporary work that Barr wanted. Thus, it may be said that a perceived split between modern and contemporary art was one of the reasons that eventually killed the pact with the Metropolitan; that the appearance of new, contemporary art that seemed radically dissimilar to older, modern art made former vanguardists into traditionalists now determined to preserve what they had previously wanted to sell. Barr, of course, wanted it both ways: he now wanted what he understood to be older and newer modern art. And he got it both ways, but only by this historical accident.

Barr's belief that 1880, or thereabouts, marked a convincing starting point for an account of modern art had always, in fact, been irreconcilable with his belief that a collection of modern art could surrender its early, founding works as they were assimilated and succeeded by newer, yet-to-be-assimilated works, and so on. If modern art did mean something different from contemporary art, its most recent manifestation, then those founding works would be needed for as long as modern art existed, precisely because, and to the extent that, those founding works were never completely assimilated but continued, however distantly, to offer an example. Indeed, that would be (and remains) the test of whether modern art did (and does) continue to exist.

Barr obviously had come to this conclusion before the 1947 intermuseum agreement was signed, but he had lost his power base in the early 1940s and was unable to halt the torpedo that he himself had launched. It took the challenge of Abstract Expressionism for the conservative trustees to want to preserve the tradition of modern art by saving the pioneers, and thus annul the possibility of a purely contemporary collection, one that they thought would be a non- (or we might now say, post-) modern collection. It is an inescapable conclusion that Barr was lucky that this happened. It saved him from his historicist notion that the value of works to the collection was temporal, for that view could only be sustained—and only barely—in opposition to his other, overriding view

that there was something called modern art, however difficult it might be to define.

The result for the Museum was that the continuity of modern and contemporary/modern was reaffirmed. Yet, the two had been split apart, and the seams would continue to show. Hence, toward the end of the twentieth century, the ubiquity of reports of how postmodernism had replaced the tradition that began with Cézanne created a similar preservationist initiative. It produced the argument that the Museum should perhaps become the Frick of modern art, less like the Luxembourg in Paris than the Musée du Cluny—or, failing that, should become a two-site museum, with one building for modern and one for contemporary art. Once again, though, sanity prevailed, and the Museum's dual collecting policy, which emerged from the failure of the original Luxembourg-Louvre model, still continues. It requires the refinement of an ever-advancing corpus of classic, acknowledged achievements and the addition of new works, perhaps destined to become acknowledged, classic achievements. In effect, the Museum took upon itself the mission of becoming not only the Luxembourg of modern art but also the Louvre.

3. Shaping

The proceeds from the sales to the Metropolitan Museum did bring, both directly and through freeing-up other funds, a flood of important contemporary works into the collection, notably twelve Abstract Expressionist paintings, among them Arshile Gorky's *Agony* (1947), Franz Kline's *Chief* (1950), and Pollock's *Number 1, 1948* (1948) and *Full Fathom Five* (1947). Additionally, Francis Bacon's *Painting* (1946) became the first work by this artist to enter a museum collection. But there were extraordinary opportunities for classic modernist acquisitions in this postwar period, and these—policies notwithstanding—formed the majority of works acquired.

It was in this postwar period that Barr finally saw the collection approaching the status that he desired for it. In 1940, we remember, fourteen percent of the collection comprised nineteenth-century works. By 1948, that percentage was down to four percent. This was now unquestionably a collection of modern art—in fact, already the greatest such collection in the world. In the years 1947 to 1953 alone, the Picasso collection grew astonishingly with the addition of such exemplary works as *Harlequin* (1915), *Three Musicians* (1921), *Three Women at the Spring* (1921), and *Seated Bather* (1930), and the Matisse collection was fast approaching its stature with the addition of *The Red Studio* (1911) and most of *The Backs* and *Jeannette* series of sculptures, all from Mrs. Guggenheim's funds, the remaining works in the series arriving later. The preparation of a 1949 exhibition of Italian art led to the acquisition of seven major Futurist works, including Umberto Boccioni's *Unique Forms of Continuity in Space* (1913) and *The City Rises* (1910) and Gino Severini's *Dynamic Hieroglyphic of the Bal Tabarin* (1912). These still form the core of the greatest collection of Futurism in any country, even Italy. Simultaneously, the sculpture collection was further enhanced by additions including Brancusi's *Fish* (1930), Giacometti's *Woman with Her Throat Cut* (1932) and *The Chariot* (1950), and Maillol's *The River* (1938–39, 1943). The scale and ambition of these postwar, early modern acquisitions made the danger of losing to the Metropolitan Museum an unrivaled representation of early modern art all the more impossible to consider.

When the 1947 agreement was terminated in 1953, important policy changes ensued. First, it was formally resolved that the Museum should establish a core list of "masterworks" that would comprise a truly permanent collection and would never be traded or sold. "In general," there were to be no works on the list made prior to the mid-nineteenth century. No terminal date was suggested, only that this was to be a collection of "outstanding paintings and sculptures which [the Museum] considers have passed the test of time." But then, the first designated "masterworks," in 1954, were a half-dozen gifts and intended bequests of trustees—from Maillol's *The Mediterranean* (1902–05) to Picasso's *Seated Woman* (1927)—and the works selected for future consideration were in private collections unconnected to the Museum, among them two paintings of 1872 then in the Edward G. Robinson Collection, Cézanne's *The Black Clock* and Jean-Baptiste-Camille Corot's *L'Italienne*. Clearly, the promise of permanency was to be an opportunistic device for attracting gifts. It took until 1956 to propose designating eleven Museum works as masterworks; they covered a forty-year span from van Gogh's *The Starry Night* of 1889 to Picasso's *Night Fishing at Antibes* of 1939. In the following year, Barr could not even remember how many works had been designated: conveniently, perhaps, for he continued to press for a continually fluid collection even while supporting the revised metaphor of an infinitely expanding torpedo moving through time, its nose the ever-advancing present, its tail now tethered to the year 1880.

Nothing came of the "masterworks collection" per se. It was not formally enlarged and, while a few highly desirable works were acquired by the Museum on the condition they would never be sold or traded, these were seen as exceptions to a rule that would be enforced ever more strictly. However, it was symptomatic of a critical refinement of the Museum's original collecting policy. The 1931 policy was maintained—"The permanent collection will not be unchangeable. It will have somewhat the same permanence that a river has"—only now, the source of the river having been defined, its changing patterns will be shaped and refined the better to give it both depth and amplitude and to map its flow through the most important of art-historical territory.

The result was the acquisition policies and procedures that remain today, some as the result of formal trustee mandates, but more often as the result of established practice. They may be summarized as: a highly stringent, historically conscious, but still ecumenical approach to the collecting of older art; and a highly considered, but far more catholic, approach to the collecting of new art.

While Barr was unswerving in his pursuit of quality—once defining his task as "the conscientious, continuous, resolute distinction of quality from mediocrity"—his approach unquestionably was more that of the art historian than of the pure connoisseur, guided by his belief that the collection should serve the educational purpose of providing a balanced historical survey of modern painting and sculpture. Therefore, the important works of lesser as well as greater artists were and are deemed integral to the collection—witness, for example, the continuing presence in the galleries of Vladimir Baranoff-Rossiné's sculpture *Symphony Number 1* (1913)—as are works that are principally important for their influence or reputation. Still, Barr's ecumenicalism was more than matched by his evangelism, which led him to privilege works of critical historical importance in the development of modern art. This position was adopted by his successors, and it is followed in this selection of paintings and sculptures in the present

volume. Thus, as we have seen, major artists have been collected in depth and throughout their careers, and are represented by multiple works. However, in the development of the collection, the innovative moment has mattered most—and therefore the works that define an artistic reputation, movement, or significant change. The Museum's creation of an historical overview has aimed to balance such moments to tell the competing stories of invention and emulation that comprise what we still call modern art.

This is to stress how the collection is, and has always been, a collection not of modernism but of modern art. Barr's historicizing and his passion for diagrams notwithstanding, it would be quite wrong to say that he sought to create a monolithic, sequential logic from historicizing a single development of modern art. To the contrary, he understood that it was a field of competing, sometimes opposed forces and interests that accumulated and vied for critical and art-historical attention—and purchase funds. Modern art was, in fact, rather like The Museum of Modern Art.

Of course, Barr—and therefore his successors—inherited the formalist context of Fry and the Bauhaus, which shaped the institution. And Barr's obsession with genealogy is simultaneous with the so-called neo-Darwinian Modern Synthesis of 1930s and 1940s paleontology, which combined Darwinism and Mendelian genetics to offer the view of a single-evolving human lineage. But it was not and is not realistic to maintain such cloudy idealism in the practical, critical engagement with works of art that speak different modern languages, and within an institution whose ongoing collection cannot be based on a predetermined plan but evolves through advocacy and debate among often very different voices.

Still, an evolving, broad, practical plan did develop. We will remember that in 1944 Barr made a list of fourteen works that he hoped to acquire. It was headed, "Important European Works of Art Recommended for Consideration by the Departmental Committee on Painting and Sculpture." The 1949 list of more than thirty works was called "Gaps in Collection: European Painting 1900–1920." The 1944 list had named specific works. The 1949 list was generic, identifying works simply by artist, date, and style, subject, or medium; for example, "*Matisse*, a fauve painting, 1904–1907," "*Delaunay*, an early cubist painting, 1910–1912," "*Klee*, watercolors, 1912–1920." Since at least 1941, Barr had been talking about the development of the collection as a matter of filling gaps, confirming that he had a picture of what it should become. But only in the late 1940s had a collection in development become a collection whose future course was to involve filling its known gaps with as yet unknown works. Many of the gaps identified in 1949 would soon be filled. The early part of the collection was now to be developed in this systematic manner, and thus the word *lacunae* (literally, "blanks" or "empty parts") entered the vocabulary of the Museum.

Other key words include *accessioning* and *deaccessioning*, both tools of eliminating lacunae. The founding, 1929 statement had spoken of acquiring works by gift or purchase. Since the beginning, both gifts and purchases have been accessioned by the Museum through a committee appointed by the Board of Trustees, and chaired by a trustee. Until 1967, one Committee on the Museum Collections fulfilled that purpose; since then, there has been one committee for each of the six curatorial departments, composed of both trustees and other invited patrons, and with its own budget. The mechanism of acquisition, always the same, is known within the Museum as: curators

propose, committees dispose. That is to say, both gifts and purchases are proposed for acquisition by a curator; the committee debates and then votes on whether or not to accept the proposal. It is effectively a checks-and-balances system in which those who have oversight and fiduciary responsibility for the collection test the advocacy of the curatorial staff. And, since curators present their proposals to their departmental colleagues prior to doing so to a curatorial committee, it is a double such system insofar as individual enthusiasms are thus tested and a curatorial consensus sought. (In the case of deaccessioning, of which more in a moment, a further check is provided: the Board of Trustees must endorse the decision of the committee.)

Still, the collection has not been and is not built according to a uniform consensus. Its development very much reflects individual enthusiasm and advocacy. Therefore, individual artists and schools have come in and out of favor; a new generation of curators finds gaps that their predecessors did not see; the filter of changes in a collecting committee or the persuasiveness of an individual curator may lead to more adventurous or more conservative acquisitions; expediency may require that lesser works be accepted in a gift that includes greater ones. Fluctuations of taste have, therefore, continually rippled the surface of the painting and sculpture collection, sometimes, it now seems, pulling it off course—for example, in the enthusiasm for Pavel Tchelitchew in the late 1930s and early 1940s and the lack of enthusiasm for Pollock in the late 1940s and early 1950s. Taking a longer view, though, it is now clear that a course had been set by midcentury that the collection would comprise an historical account of modern art founded in the diverse revolutions of the late-nineteenth and early-twentieth centuries and developed by representation of innovative moments, large and small, that are extensions and revisions of those beginnings.

Barr's last decade and a half at the Museum—from 1953, when the agreement with the Metropolitan was terminated, until 1967, when he retired—was when this course, having been set, was advanced to the point that most of the difficult work was effectively done.

Between 1953 and 1958, the collection was increased by important bequests, solicited gifts, and purchases made strategically around them. Chief among the bequests was that of Katherine S. Dreier in 1953, which included Duchamp's *To Be Looked At* (1918) and *Three Standard Stoppages* (1913–14), eight Klees, and no fewer than nineteen works by Schwitters. Among gifts, Rousseau's *The Dream* (1910) was donated in 1954, a gift of Nelson A. Rockefeller, and Matisse's *The Moroccans* (1915–16) and *Goldfish and Sculpture* (1912) were donated in 1955, by Mr. and Mrs. Samuel A. Marx and Mr. and Mrs. John Hay Whitney, respectively. Also in 1955, Auguste Rodin's *Monument to Balzac* (1898) was donated by friends of the dealer Curt Valentin and complemented by the purchase of *St. John the Baptist Preaching* (1878–80). This pattern was repeated the following year when five Picassos were received as gifts and five more were purchased, many of them sculptures. In these years, the range of acquisitions was large: from two Vasily Kandinsky mural compositions to three works by Jasper Johns, and from a Monet *Water Lilies* mural (c. 1920) to Larry Rivers's *Washington Crossing the Delaware* (1953).

The first of these last two works, along with a smaller Monet and a Cândido Portinari mural, was destroyed and the second, along with Boccioni's *The City Rises* (1910), was damaged in a fire that occurred during reconstruction of the second floor of the

Museum in 1958. The Museum reopened less than six months later and, with a huge swell of loyal, sympathetic support, did so with an exhibition of works recently given and newly promised by nine important collectors: William A. M. Burden, Mr. and Mrs. William B. Jaffe, William S. Paley, Mrs. John D. Rockefeller 3rd, Nelson A. Rockefeller, Mr. and Mrs. Herbert M. Rothschild, Mrs. Louise R. Smith, James Thrall Soby, and the Honorable and Mrs. John Hay Whitney. It would be the gradual accession of the early modern masterpieces from these collections that filled the important gaps, strengthening the collection often where it was weakest. In the meantime, the ever-reliable fund of Mrs. Simon Guggenheim made possible the 1959 acquisition of a Monet triptych, *Reflections of Clouds on the Water-Lily Pond* (c. 1920), to replace the one lost to the fire. (By 1967, her total contributions to purchases of paintings and sculptures had exceeded the then extraordinary sum of one million dollars.)

The Soby gift of sixty-nine works in 1961 was the first of those aforementioned to enter the Museum. Single-handedly, it established a great Giorgio de Chirico collection of eight metaphysical paintings. Through Soby's friendship with Kay Sage, wife of the Surrealist painter Yves Tanguy, she left to the Museum in 1963 its then largest purchase fund bequeathed for painting and sculpture: in excess of one hundred thousand dollars. That year, the collection grew to over two thousand works.

Among them was Matisse's *Dance (I)* (1909), donated by Nelson A. Rockefeller in 1963, to be followed in 1964 by life-interest gifts of major, difficult Matisses—*Woman on a High Stool* (1914), *Goldfish and Palette* (1914), and *Still Life after Jan Davidsz. de Heem's "La Desserte"* (1915)—from what had become the Schoenborn-Marx Collection, which made the Matisse holdings equal in importance to those of Picasso. By then, the contemporary side of the collection had acquired Abstract Expressionist works, by Philip Guston, Adolph Gottlieb, Hans Hofmann, and Motherwell, and had moved on to the next generation, acquiring works by John Chamberlain, Helen Frankenthaler, Grace Hartigan, Morris Louis, Claes Oldenburg, and Andy Warhol.

During Barr's final few years at the Museum, additions to that list would include works by Kline, Willem de Kooning, Barnett Newman, Pollock, Rothko, David Smith, and Clyfford Still, in the former category, and in the latter by Larry Bell, Ronald Bladen, Jim Dine, Dan Flavin, R. B. Kitaj, Yves Klein, Roy Lichtenstein, Robert Morris, Louise Nevelson, Robert Rauschenberg, Bridget Riley, James Rosenquist, Frank Stella, Mark di Suvero, and Tom Wesselmann. A significant number of these came among a group of fifty promised gifts made by Philip Johnson in 1967. Others—notably, important Abstract Expressionist and Pop works—were among a gift of one hundred and three works made that same year by Sidney Janis. The Janis gift also included early modern works, among them Boccioni's *Dynamism of a Soccer Player* (1913), Dalí's *Illumined Pleasures* (1929), Mondrian's *Composition with Color Planes, V* (1917), Picasso's *Painter and Model* (1928), and six works by Jean Dubuffet, five by Schwitters, and four by Jean Arp. And some other such works were acquired, notably Picasso's *Studio with Plaster Head* (1925) in 1964 and René Magritte's *The Menaced Assassin* (1926) in 1966.

However, as Barr's health began to fail and younger curators had a larger voice, the tide unquestionably turned to emphasis on the acquisition of contemporary art. As William Rubin, who became Barr's successor, would observe in 1984, the efforts of the early years to successfully create "a remarkably wide and deep synoptic collection"

meant that, while the Department of Painting and Sculpture continues "to fill lacunae in the historical collection and to increase its depth where this seems necessary, . . . the overwhelming majority of its acquisitions are of contemporary work." The tide had turned in this direction before Barr retired.

Barr was once described as "the most powerful tastemaker in American art today and probably in the world"; to this he replied that he was a "reluctant" tastemaker, for he did not believe that it was a museum's primary task to discover the new, but to move at a discreet distance behind developing art, not trying to create movements or reputations but putting things together as their contours begin to clarify. These principles continue to be followed today, as are Barr's refreshingly straightforward and realistic criteria for the acquisition of recent art: that mistakes of commission are more easily remedied than mistakes of omission. He is reputed to have said that if one out of eight (sometimes one out of ten) acquisitions stood the test of time he would be satisfied, but it is hard to believe that he allowed that to be an excuse for lack of discrimination. Rubin did say that, while the Museum can necessarily represent only a handful of the many thousand artists now working, it does seek to give "a sense of the quality and range of current activity. To this extent, its purchases of contemporary art must be considered somewhat 'reportorial'; it is not expected that every work—indeed, that the majority of them—will figure in the collection fifty years hence."

This takes us from the subject of accessioning to that of *deaccessioning*. For, as Barr observed, the Museum's commitment to acquiring the work of living artists "must lead inevitably to an accumulation of works which, while essential for the representation of today's work, is bound to be unwieldy once it becomes a review of yesterday. Elimination of works of art in the light of experience from extended holdings will therefore always be an integral part of the Museum's policy and procedure." We will remember how William Sloane Coffin, of The Metropolitan Museum of Art, had warned in 1933 against a modern museum retaining its early acquired works lest it become congested with the taste of its early friends. In 1945, trustee James Thrall Soby had argued, to the contrary, of a curatorial responsibility "in making sure that personal changes in taste do not lead to eliminations [from the collection] which will . . . break the continuity of a public collection which should *illustrate* changes in taste within reasonable limits, rather than be reconstituted entirely according to these changes." This is very wise counsel, partly because it leaves open the question of what limits are reasonable and what are not. That question can only have a circumstantial answer. Besides, while the history of taste and the history of art are intertwined, they are not identical, and it is certainly reasonable to insist that the collection should illustrate the latter before and even at the expense of the former.

Indeed, as we have learned, the Museum has preferred to have the adjective *modern* in its name, rather than "the supine neutrality of the term 'contemporary,'" precisely because it has aimed to tell not the history of the taste in art of our time but the history of the art of our time, understood to be the history of "the progressive, original and challenging." It has, of course, occasionally stumbled on this path, mistaking change for progression, novelty for originality, and surprise for challenge. Hence, one of the important roles of deaccessioning, as a means of correcting lapses of historical understanding.

The original purpose of deaccessioning at the Museum was to surrender unneeded late-nineteenth-century paintings for twentieth-century paintings. In this way, works from the Bliss Bequest were sold to acquire such works as *Les Demoiselles d'Avignon* (1907), *The Starry Night* (1889), and *"Ma Jolie"* (1911–12), paintings so celebrated that their artists need hardly be named—but also works by then contemporary artists whose names can hardly be remembered. And what are we to make of the fact that, of the thirty or so works sold out of that bequest, about half of these historical works could now still be considered plausible candidates for showing in the collection galleries, while of the ninety or so works acquired by all the sales, about half of those then contemporary works would not now be so considered?

What was made of it was an unwritten policy of general historical compatibility between a deaccessioned work and the work acquired with the proceeds. It has never been thought appropriate to sell or exchange the work of a living artist, other than with the artist's permission and for the purpose of upgrading his or her representation. But additionally, it became understood that early modern paintings—indeed, works more than thirty years old—should no longer be sold to acquire contemporary paintings, and the role of deaccessioning, therefore, is now that of incremental refinement of the ever-increasing historical collection. Over the entire history of the Museum, some three hundred and seventy works by about one hundred and eighty artists, which were infrequently on view and less critical to the historical survey afforded by the collection, have been sold or exchanged for this purpose. This represents roughly ten percent of the collection, which now numbers about three thousand five hundred works.

4. Growing

When Rubin assumed directorship of the Department of Painting and Sculpture in 1973, after a confused six-year interregnum that followed Barr's retirement, the collection numbered some two thousand five hundred works. In 1930, when Barr had unsuccessfully proposed to the trustees that a room be provided for showing the collection, it comprised only thirteen works. This offers a very crude gauge of the scope of what Barr had achieved; his tenure saw roughly twice the number of acquisitions per year than in the years that have followed. However, the works hitherto mentioned provide a far more meaningful testimony to the magnitude of his achievement. They left his successors with a different task: not of founding, building, and shaping a collection, but of growing the collection that he and his colleagues had formed. The present generation of curators, Rubin wrote in 1984, has the advantage both of the achievements of earlier curators and of the perspective afforded by time, "which enables them to make some necessary changes in the editing, adjustment, refinement, and equilibration of the collection." Growing the collection meant editing, adjusting, and refining it, as well as adding to it. However, equilibration, given the nature of the subject, proved to be somewhat elusive. In consequence, the task of Barr's successors could not be, and has not been, a matter of slavishly following historical precedents, but rather of seeking to advance their purposes.

Rubin properly spoke of earlier curators. Although Barr's role in building the Museum Collection was of the first importance, he was by no means alone in his work but

benefited from the help and support of many colleagues. Chief among them, perhaps, was Dorothy C. Miller, a curator from 1935 to 1969, whose interest was in contemporary painting and sculpture. But there were others. When Barr was asked to resign as Museum Director in 1943, it was owing to his failings as an administrator. Since the majority of the Museum's programs were in the field of painting and sculpture, he could hardly be allowed to maintain administrative direction of these programs. Therefore, James Thrall Soby, a collector and trustee, was appointed the Museum's first Director of Painting and Sculpture, to be followed in 1945 by James Johnson Sweeney, in 1948 by Andrew Carnduff Ritchie, and in 1958 by (jointly) Peter Selz and William C. Seitz. All these staff members played important curatorial roles under Barr's direction. And equally important was René d'Harnoncourt, Director of the Museum from 1949 to 1968, who encouraged and facilitated Barr's programmatic direction of the painting and sculpture collection.

In 1967, Barr retired from the Museum. The same year, Soby left the Chairmanship of the Committee on the Museum Collections, and the committee itself was dissolved, to be divided into separate units, one for each curatorial department. In 1968, d'Harnoncourt also retired, and Miller retired the year after. With these staff changes, The Museum of Modern Art reached its fortieth anniversary in a period of major transition.

Barr, as first Director of the Museum and then of the Museum's Collections, had ultimate responsibility for all of its collections. After his retirement and the division of the Committee on the Museum Collections, the Department of Painting and Sculpture came into its own as a distinct, separate unit. Thus began the second, still continuing period of collecting and exhibiting painting and sculpture at The Museum of Modern Art, which has three principal stewardships. After Barr's retirement in 1967, there was a somewhat confused transitional period. Bates Lowry became Director of the Department of Painting and Sculpture as well as Museum Director, serving from 1967 until 1969. Then William S. Lieberman, formerly Director of Drawings and Prints, was Director of Painting and Sculpture from 1969 to 1971. At last, after a two-year hiatus, Rubin, who had been, ambiguously, Chief Curator of the Department since 1969, was appointed Director of the Department in 1973 and served until 1988. Kirk Varnedoe followed him from 1988 to 2001, during which period his title was changed from Director of the Department of Painting and Sculpture to Chief Curator. Finally, in 2003, after an interregnum of Kynaston McShine as Acting Chief Curator, John Elderfield was appointed to the Chief Curator's position. In this post-Barr period, the following have held the title of curator in the department and, therefore, have also contributed to the growth of the collection: Betsy Jones, McShine, Carolyn Lanchner, Elderfield, Alicia Legg, Linda Shearer, Robert Storr, Anne Umland, Gary Garrels, Joachim Pissarro, and Ann Temkin.

This section of the introduction shall conclude with an account of the growth of the collection over these thirty or so years. Since this growth involved few of the debates of principle that occurred earlier, the account can be an abbreviated one. Before embarking upon it, however, a few words are in order about what can and should be said about this recent period.

First, it is difficult at present to anticipate any greater division in the Museum's history than that between a Museum with and without Barr's presence. But a division as

great is imaginable. As noted at the end of the second section of this essay, the Museum's staff and trustees considered, not so many years ago, the possibility of creating a two-site Museum that would effectively have separated modern and contemporary art. That would have marked as great a division in the Museum's history. The argument for a two-site Museum was that modern and contemporary art were indeed separate entities, the tradition of modern art having ended in the later years of the twentieth century. That argument was rejected. However, it is entirely feasible that, sometime in the future, a retrospective view on those years, or more likely on subsequent ones, might produce a consensus that the historical period of modern art has indeed ended. Then, a division in the Museum's history even greater than that between the Barr and post-Barr years would need to occur. In the meantime, however, we live with the terms of Barr's legacy.

Second, the post-Barr Museum, while maintaining the early-established principles, nonetheless has taken and continues to take directions that Barr could hardly have predicted—and has done so precisely to maintain that most important of the principles that Barr bequeathed to the Museum: to continue to be a laboratory for research and experiment in the collection and presentation of modern art. Ironically, the entirely proper esteem in which Barr and his legacy are held, both within the Museum and among its supporters, has sometimes led to a forgetting of that most important of his bequests, remembering only the means by which he himself realized it. And, more frequently than one might expect, Barr's means of research and experiment have themselves been forgotten, a view of his legacy being built not on his achievement but on how it subsequently was interpreted. This is especially true of the display of the collection, which, as we shall see, was only established on a permanent basis three years before Barr's retirement.

Third, given that the Museum's history divides naturally into the Barr and the post-Barr years, the latter are the more difficult for anyone to recount because we are still living in them. Moreover, while someone who now has responsibility for the painting and sculpture collection is uniquely qualified to recount his version of these years, he will be offering an account of Rubin's, Varnedoe's, and his own work, that is to say, their differing interpretations of Barr's legacy, in a way that cannot be dispassionately historical. It can pretend to be so, by reporting and not commenting. Yet, however delicate the task, some commentary is needed to point out how Barr's ideas and practices have evolved and changed; to underscore the new directions that the Museum has taken; and to distinguish between the directions taken by his successors.

Fourth, to speak simply of Barr and his successors offers a convenient structure for a summarizing essay like this one, but it does disguise the way in which the painting and sculpture collection and its displays have been shaped by more voices than that. For example, the Museum's collection of contemporary painting and sculpture has owed as much to the curators in the department as to the chief curator; as much to Miller and others as to Barr, to McShine and others as to Rubin, to Storr and others as to Varnedoe. Similarly, the Directors who succeeded Barr have had a major impact on the growth of its most prominent curatorial department. Notably, d'Harnoncourt's brilliantly innovative displays influenced Barr's; the unswerving prioritization of the Department of Painting and Sculpture during the twenty-one-year directorship of Richard E. Oldenburg, the longest in the Museum's history, made possible the breadth of Rubin's activities; and

Glenn D. Lowry's recent interdisciplinary initiatives and commitment to contemporary art have already been deeply influential. And we should keep in mind the fact that the changing membership of the Committee on Painting and Sculpture is an important variable for an understanding of the program of acquisitions. In addition, there are forces external to the Museum that have influenced the development of painting and sculpture programs. A properly nuanced history remains to be written, so what follows is simplified as well as abbreviated.

A first simplification is to take Rubin at his word when he speaks of "editing, adjustment, refinement, and equilibration of the collection," for this statement infers that Rubin saw his task as not simply growing but perfecting the collection. His extraordinary history of acquisitions tells of an art historian-teacher-collector, which is what he was before joining the Museum, wishing to create for the Museum the most perfect teaching collection of modern art in the world: complete, finely calibrated, and composed of the finest obtainable examples. This led him not only to seek acquisitions very vigorously in classic modernist art, most especially in his own primary areas of art-historical specialization, Picasso, Surrealism, and Abstract Expressionism, but also to press insistently for the reportorial representation of areas of contemporary art in which he had an academic but not a passionate interest.

Of course, the higher the standards (and Rubin's standards were high), the more difficult to create a perfectly equilibrated collection; not all gaps could be filled at the level of the greatest works in the collection, and what comprised equilibrium must necessarily be changed by the appearance of new art altering the existing order of the old. Rubin, however, had lengthy experience as a collector as well as a scholar, and brought the skills as well as his own taste to advance the collection with a forbiddingly certain hand.

Prior to being appointed Director of the Department, Rubin had been instrumental in securing the Janis Bequest, mentioned earlier, but also began to strengthen very significantly the Museum's representation of Abstract Expressionism. Thus, twelve works by Pollock entered the collection during his tenure, among them *One: Number 31, 1950*, *Echo: Number 25, 1951*, and *Easter and the Totem* (1953); seven by Ad Reinhardt; six by Motherwell and Rothko; five by Gorky, Gottlieb, and Newman, including the latter's *Vir Heroicus Sublimis* (1950–51); and others beside. Many of these were gifts by the artists or their estates. The result was to make the Museum's Abstract Expressionist collection, and most especially its representation of Pollock, unequaled anywhere and on a par with its collections of Matisse, Picasso, de Chirico, and other early modern artists.

Important acquisitions were also made in the work of artists of the next generation. In 1969, Ellsworth Kelly's *Colors for a Large Wall* (1951), Cy Twombly's *The Italians* (1961), and Carl Andre's *144 Lead Square* (1969) entered the collection, to be followed by nine large works by Stella, paintings by Americans Romare Bearden, Richard Diebenkorn, Frankenthaler, Al Held, Louis, Agnes Martin, Kenneth Noland, Robert Ryman, and others, and works by Europeans, including Anselm Kiefer and Sigmar Polke. In sculpture, groups of works were added by Donald Judd, Morris, and Sol LeWitt, and key pieces by Anthony Caro, Eva Hesse, Richard Serra, and Tony Smith. Furthermore, as Philip Johnson's promised gifts of the 1970s came to the Museum, the collection's representation of contemporary art, especially of Pop art, was further enhanced, notably by Johns's *Flag* (1954–55), Lichtenstein's *Drowning Girl* (1963) and

Girl with Ball (1961), and Rauschenberg's *First Landing Jump* (1961). Many of the contemporary works were added owing to the initiative of curators in the Department of Painting and Sculpture, most importantly McShine.

Unsurprisingly, the Picasso and Cubist collections were enhanced during Rubin's tenure. At his urging, in 1971 Picasso donated to the Museum his first constructed sculpture, *Guitar*, of 1912–13. The same year William S. Paley gave the artist's *The Architect's Table* (1912), and the Museum purchased his *The Charnel House* (1945)—the so-called sequel to *Guernica* that had been on loan to the Museum since 1939. (It was returned to Spain in 1981 in accordance with the artist's wishes.) The long-promised Nelson A. Rockefeller Bequest, which entered the collection in 1979, included the classic early Cubist painting by Picasso, *Girl with a Mandolin (Fanny Tellier)* (1910), and his *papier collé* work *Student with Pipe* (1913), complemented by the great *papiers collés* by Braque, *Still Life with Tenora* (1913), and Juan Gris, *Guitar and Glasses* (1914). Immediately following, Picasso's *Bather with Beach Ball* (1932) was made a partial and promised gift of Jo Carole and Ronald S. Lauder. Altogether, twenty-six Picassos entered the collection during Rubin's tenure.

Among Surrealist works were fifteen Mirós, the most important being Nelson A. Rockefeller's 1976 gift of Miró's *"Hirondelle Amour"* (1933–34) and the 1972 purchase of *The Birth of the World* (1925). These complemented the Mirós in the 1958–61 Soby Bequest, works from which, notably *Self-Portrait, 1* (1937–38) and *Still Life with Old Shoe* (1937), were still entering the collection in 1979, and were enhanced by gifts from the artist in 1972, to make this collection on a par with the other great monographic holdings of the Museum. The holdings of de Chirico, Alexander Calder, Giacometti, and Klee were similarly enhanced. The addition of twelve works by Dubuffet elevated that collection to major status, while eight new Matisses, among them *View of Notre Dame* (1914) and the cutouts *The Swimming Pool* (1952–53) and *Memory of Oceania* (1952–53), reinforced its already unmatched status. Among the gap-filling elsewhere in the early modern collection, either planned or the result of gift or bequest, the most critical works included: Balthus's *The Street* (1933), from the Soby Bequest; Boccioni's three *States of Mind* canvases (1911), the gift of Nelson A. Rockefeller; Symbolist works by Edvard Munch and Gustav Klimt, *The Storm* (1893) and *Hope, II* (1907–08), the latter the gift of Mr. and Mrs. Ronald S. Lauder; Dada reliefs by Arp and Schwitters, *Enak's Tears* (1917) and *Revolving* (1919); and (by exchange with the Guggenheim Museum) the final two panels to complete Kandinsky's ensemble of four paintings created for Edwin R. Campbell's New York apartment in 1914.

Rubin also strengthened the Museum's representation of Russian Constructivism with Gustav Klucis's Maquette for *"Radio-Announcer"* (1922) and Aleksandr Rodchenko's *Spatial Construction no. 12* (c. 1920). In 1983, through the mediation of Elderfield, then Director of the Department of Drawings, the Riklis/McCrory Corporation gift of 249 works, both classic and contemporary, of geometric abstract art, including works by Theo van Doesburg, El Lissitzky, László Moholy-Nagy, Lyubov Popova, Ivan Puni, and Friedrich Vordemberge-Gildewart, not only bolstered the existing representation of celebrated artists in this field but also added to the collection for the first time many paintings and sculptures by less familiar artists.

In addition to such large gifts or bequests, and continuing deaccessioning, even from

33

the Bliss Bequest, the growth of the collection in these years owed enormously to the generosity of individual donors. Especially, in addition to those mentioned, were the Louis and Bessie Adler Foundation, Anne and Sid Bass, Mr. and Mrs. Armand Bartos, Mr. and Mrs. Gordon Bunshaft, the Gilman Foundation, Agnes Gund, the Lauder Foundation, Mr. and Mrs. Pierre Matisse, Mr. and Mrs. David Rockefeller, Mrs. John D. Rockefeller 3rd, Anna Marie and Robert F. Shapiro, and Mr. and Mrs. Joseph Slifka. Significantly, a majority of these donors have been members of the Committee on Painting and Sculpture.

This was the situation that Varnedoe inherited when he assumed direction of the Department of Painting and Sculpture in 1988. Since then, most of these same patrons have continued to remain active, while others have become more active or joined then, including Leon and Debra Black, Donald L. Bryant, Jr., Douglas S. Cramer, Mimi and Peter Haas, Marie-Josée and Henry Kravis, Emily Fisher Landau, Peter Norton, Michael and Judy Ovitz, Emily Rauh Pulitzer, Marcia Riklis, Jerry I. Speyer, Emily and Jerry Spiegel, David Tieger, and others mentioned below.

In addition to benefiting from the generosity of the committee, Varnedoe also oversaw the arrival of long-promised bequests. Of these, three dated back to promises made after the 1958 fire: Mrs. John Hay Whitney's, which included van Gogh's *The Olive Trees* (1889), the companion to *The Starry Night*; William S. Paley's, which included Picasso's *Boy Leading a Horse* (1905–06), Matisse's *Woman with a Veil* (1927), and important works by Cézanne; and Louise Reinhardt Smith's, which included Picasso's great *Bather* (1908–09) and Matisse's *Still Life with Aubergines* (1911). Additionally, the bequest of another early supporter added Pierre Bonnard's *The Bathroom* (1932) and other works to earlier gifts of the Schoenborn-Marx Collection to make it one of the Museum's greatest donations. Newly arrived bequests of Mary Sisler brought Brancusi's *Endless Column* (1918), Stuart Davis's *Odol* (1924), and other works, while the Nina and Gordon Bunshaft Bequest added to the representation of Dubuffet, Frankenthaler, Fernand Léger, Miró, and other artists, and the 2000 gift from the Ian Woodner Family Collection provided no fewer than twenty-four paintings by Redon.

To these immediate additions were added a major new promise for the future from Mr. and Mrs. David Rockefeller, including Cézanne's famous *Still Life with Fruit Dish* (1879–80) and *Boy in a Red Vest* (1888–90), Picasso's *The Reservoir, Horta de Ebro* (1909), Paul Signac's great portrait of Félix Fénéon, *Opus 217* (1890), and important Fauve paintings by Braque, André Derain, Raoul Dufy, and Matisse.

This cornucopia notwithstanding, Varnedoe did seek to close remaining significant gaps in the early modern collection, first with a van Gogh, *Portrait of Joseph Roulin* (1889), later with a major Surrealist sculpture by Dali, *Retrospective Bust of a Woman* (1933), acquired with the help, again, of the Bliss Bequest, and, working with Elderfield, a critical Matisse of the teens, *The Yellow Curtain* (1915), a partial gift of Jo Carole and Ronald S. Lauder, and a late Braque studio painting, *Studio V* (1949–50), acquired through the Bliss Bequest.

Like Rubin, Varnedoe had come to the Museum after teaching the history of art, and similarly was very conscious of continuing Barr's task of making the collection an historically representative one. However, he sought most especially to fill important gaps in the representation of periods that had become historical by the 1980s and that Rubin

had not consciously addressed in detail, as well as of contemporary art, in which quests he was joined by curators McShine, Lanchner, Shearer, and Storr. In practice, this meant, first, that Varnedoe sought to advance the Museum's collection of works by post-Abstract Expressionist artists to the level of its holdings of earlier artists, and with the aim of giving to some of these artists a canonical status equivalent to that of their most vaunted predecessors. And it meant, second, that he adopted and enlarged the forgivingly reportorial stance toward very contemporary art that Rubin, and before him Barr, had held.

In the first category of acquisitions were Leo Castelli's gift in Barr's honor of Rauschenberg's *Bed* (1955) and the purchase of this artist's *Factum II* (1957) and *Untitled (Asheville Citizen)* (c. 1952); the gift by, again, Philip Johnson, of Warhol's *Orange Car Crash Fourteen Times* (1963) and the purchase of the artist's thirty-two *Campbell Soup Cans* (1962); and the gift and bequest of Musa Guston of a full representation of her husband's influential late work. There were also additions of individual key works: a slab painting by Hofmann, *Cathedral* (1959), and recent paintings by Johns, *Between the Clock and the Bed* (1981) and Untitled (1992–95), all gifts of Agnes Gund; an important Marcel Broodthaers, *White Cabinet and White Table* (1965), a promised gift of Ronald S. Lauder; Minimalist sculptures, among them Judd's *Untitled (Stack)* (1967), a partial gift of Joseph Helman, Walter de Maria's *Cage II* (1965), the gift of Agnes Gund and Lily Auchincloss, and Tony Smith's *Die* (1962), a gift of the artist's widow; large paintings by Twombly, Untitled (1970), yet another acquisition made possible by the Bliss Bequest, and *The Four Seasons* (1993–94), a gift of the artist. Groups of works were added in hitherto unrepresented areas—later Abstract Expressionist paintings by de Kooning and Joan Mitchell; English Pop paintings by Richard Hamilton—while large groups of works were added to the already rich representation of Kelly and Warhol with the aim of making them equal to other large monographic clusters in the collection. Among more contemporary works, higher than average additions to the representation of Chuck Close, Ryman, Ed Ruscha, and Elizabeth Murray appeared to have a similar aim.

In this area, the UBS PaineWebber gifts and promised gifts of 1992, initially made possible by the generosity of Donald B. Marron, together with the 1996 donation of the Werner and Elaine Dannheisser Collection, provided an international mix of 1980s painting, late Conceptual and post-Minimal art that fortuitously improved the Museum's post-1960 representation in a decisive way, with works by Richard Artschwager, Matthew Barney, Vija Celmins, Robert Gober, Felix Gonzalez-Torres, Jeff Koons, Brice Marden, Annette Messager, Bruce Nauman, and Polke, among others. To add to these, there were conscious attempts to improve the contemporary European representation. This brought to the collection *arte povera* sculptures by Giovanni Anselmo, Jannis Kounellis, Mario Merz, Panamarenko, and Pino Pascali; new British sculptures by Tony Cragg, Bill Woodrow, and others; works by German artists, among them Georg Baselitz, Joseph Beuys, Jörg Immendorf, Martin Kippenberger, and Polke. Among very contemporary works, the approach to acquisition was extremely ecumenical. Brought to the collection were works by artists as different as Alighiero e Boetti, David Hammons, Jim Nutt, Chris Ofili, Charles Ray, Doris Salcedo, and Luc Tuymans.

Finally, two groups of work began to achieve new prominence in the collection. First was media and installation work, by artists ranging from Gary Hill to William Kentridge

and Pipilotti Rist, often acquired in concert with the Department of Film and Media. Second was a very large work deemed to be of great importance, acquired even if it could not be exhibited continuously. This included paintings from Rosenquist's *F–111* (1964–65) to Kelly's *Sculpture for a Large Wall* (1957) and Gerhard Richter's *October 18, 1977* cycle (1988). But, self-evidently, most such works were sculptures and installation works. Among these have been Chris Burden's *Medusa's Head* (1989–92); Cai Guo-Qiang's *Borrowing Your Enemy's Arrows* (1998); Ilya Kabakov's *The Man Who Flew into His Picture* (1981–88); and three monumental sculptures each by Serra and Rachel Whiteread. Many key members of the Committee on Painting and Sculpture made these purchases possible.

Thus, Varnedoe was attracted to large, ambitious works, and to a collection of postwar and late-twentieth-century art that could be perceived to be as heroic as anything in classical modernism. In that respect, he was Rubin's true successor, only he differed from Rubin in his enthusiastic embrace of art that was subversive of classical modernism, especially that infected by popular culture. The similarities and differences between their two approaches to acquisitions were mirrored in installations, as we shall see in the final, sixth section of this essay.

In mid-2003, Elderfield became Chief Curator of the Department of Painting and Sculpture. Prior to this publication going to press a year later, some important additions had been made to the historical collection. Among these were, in chronological order, de Chirico's *The Serenity of the Scholar* (1914) and Severini's *Visual Synthesis of the Idea: "War"* (1914), both the bequest of Sylvia Slifka; two historically important sculptures, *Dada Head* (1920) by Sophie Taeuber-Arp, and the plaster *Pregnant Woman* (1950) by Picasso; the first sculpture in the collection by Jesús Rafael Soto, Untitled (1959–60); and important proto- and early Minimalist sculptures by LeWitt of 1963, the gift of Marie-Josée Kravis, and of 1964. In addition, Varnedoe had long hoped to acquire arguably the most emotive composition by Johns, the work on paper entitled *Diver* (1962–63); Elderfield was finally able to acquire it, in Varnedoe's honor, thanks to the support of Lowry, as a joint acquisition with the Department of Drawings. Also acquired were a large sculptural fragment, *Bingo*, of 1974, by Gordon Matta-Clark; Bacon's *Triptych* (1991), the artist's last completed work and the first later Bacon to enter the collection, acquired through the initiative of McShine, now Chief Curator at Large, and Dieter Roth's *Solo Scenes* of 1997–98. Among contemporary works, additions have included Kelly's *White Relief over White* (2003), the gift of Kathy and Richard S. Fuld, Jr.; and works by Peter Doig, Mona Hatoum, Sherrie Levine, Juan Muñoz, and Elizabeth Peyton. Finally, through the munificence of Patricia Phelps de Cisneros, nine critical works by Latin American artists were added. These include the first works to enter the painting and sculpture collection by Lygia Clark (*Sundial* and *Poetic Shelter*, both 1960), Gyula Kosice (*Modile Articulated Sculpture*, 1948), Hélio Oiticica (*Neoconcrete Relief*, 1960, and *Box Bolide 12, 'archeologic,'* 1964–65), and Armando Reverón (*Woman of the River*, 1939). Finally, two very recent works were added as this volume went to press—Jasper Johns's *Bush Baby* of 2003 and Sol LeWitt's *Bands in Four Directions* of 2004—together with a major, late polychrome sculpture by Donald Judd, Untitled, of 1989.

It would be inappropriate to swell this account with a manifesto on the present direc-

tion of the department, but a few observations are in order. There is inevitably a large quotient of the spontaneous in acquiring unique works of art, especially important works, which require swift action when they become available. Nonetheless, planning is possible: both the review of Museum holdings to make generic wish lists and the targeting of known, potentially available works. As we have seen, Barr did both things formally, in collaboration with his curators, committees, and trustees. This has become the practice once again. In consequence, while gap-filling continues, for gaps do continue to exist, it is now usually of very specific works indeed. The gaps that exist are, roughly speaking, of five kinds, of which the first four can be summarized very quickly.

First are gaps that have resulted from the context in which the Museum was founded and developed, notably weaknesses in the representation of art made in the United States in the teens through 1930s, which was always the traditional province of the Whitney Museum of Art. Unless truly exceptional works become available, these gaps probably should be accepted. Second are gaps in important works that, owing to their size, simply do not lend themselves to, or even permit, presentation in a museum. Since this is a problem more of exhibiting than of collecting, I shall address this in the next section. Third are the gaps that still remain in truly important, well-developed parts of the collection. These should be filled, if the works are available, obtainable, and of capital importance—and, as even the foregoing list of just one-year's acquisitions shows, this often continues to be possible. And fourth are gaps that have appeared and will appear as newly created works of art reveal to us the importance of aspects of the past of which we have been ignorant. This is why one can never hope for a final equilibration of the collection; on the identity of these gaps we will wait for revelation.

Fifth, and most pressing or problematical, are gaps that remain because parts of the collection were not developed as they might have been. Certain movements, for example, to which both paintings and works on paper were important, were first represented through the latter, in order to fill the gap quickly and less expensively. And some movements—the Die Brücke group, among them—still have not gained full representation in the former. Added to this, Barr's interest in German art was more in Dada and Constructivism than in Expressionism and *Neue Sachlichkeit*; therefore, they are underrepresented. However, the founding of the Neue Galerie for modern German and Austrian art in New York, by the current Chairman of the Museum's Board of Trustees, Ronald S. Lauder, has helped to alleviate that problem.

In a related vein, we saw earlier how Latin American art was avidly collected by the Museum in the 1940s. Collecting has continued, but unsystematically and largely in the field of contemporary art. Now, thanks largely to the generosity of Patricia Phelps de Cisneros, a program has been created to review and fill major gaps in the collection. To this end, the Museum established an adjunct curatorship in this field, a position first filled by Paulo Herkenhoff from Brazil, who worked with Varnedoe, and then by Luis Enrique Pérez Oramas from Venezuela, who has worked with Elderfield and Garrels, with the aim of planning both acquisitions and programs that can, at once, advance the representation of art from Latin America and assist its understanding in the international context that the Museum provides.

We also saw how Rubin sought deliberately to build and shape, from promising but eclectic beginnings, a great Abstract Expressionist collection, and how Varnedoe did

something similar with post-Abstract Expressionist art. Even so, there still are areas of historical expression that unquestionably need attention, ranging from postwar European art to Minimal and post-Minimal art in the United States. Ongoing reviews of the collection, by historical area, now seek to identify both needed works and weaker works that might be replaced or simply surrendered. Moreover, while works of art will continue to be acquired for reportorial reasons, now a very clear priority is given to works that demand to be exhibited, recognizing that it is by its curiosities that a museum attracts interest but by its monuments admiration.

While difficult to attain, this prioritization holds for the acquisition by purchase of works of contemporary art. What demands exhibition now may not do so fifty years hence. Still, Barr's rule that sins of omission were worse than sins of commission only seems to be encouraging of an unbridled covetousness; his own example speaks more loudly of the virtue of fortitude in waiting at least a while for the right picture. But of pride he was remarkably lacking, being very willing to make an impassioned mistake. Moreover, he oversaw not only painting and sculpture but the entirety of the Museum's collections, and such a cross-disciplinary overview ended with his retirement and the creation of separate acquisition committees for the six curatorial departments. Before then, the change from simply collecting works in different mediums to having curatorial departments devoted to separate mediums had guaranteed their institutional support but also began to institutionalize their separation. However, the critical separation of their acquisition procedures after Barr's retirement in 1967 increased departmental autonomy at the very moment that, first, the leadership of the Museum became administrative rather than programmatic, and second, and more critically, the blurring of boundaries between mediums increased in contemporary art. This is to say, the institutional separation of mediums within the Museum in the late-1960s happened to increase proportionally to their very porosity in new art.

This departmental isolationism largely abated with changes in the direction of the curatorial departments, which produced the current set of Chief Curators, and especially with the change in direction of the Museum in 1995, when the current Director, Glenn Lowry, was appointed. Since then, departmental collaboration on acquisitions, including the acquisition of interdisciplinary works, has made significant advances. This is not to suggest that medium-specificity has ended, only that how medium-specificity has to be described may now, on occasion, straddle departmental boundaries, for many recent contemporary acquisitions are not easily assigned to one individual department.

It would be too strong to say that what is new about contemporary art is that it breaks down the viability of distinct departmental collections, requiring everything to be acquired and displayed in an interdisciplinary context. For it has always been helpful to acquire—and, on occasion, to see together—contemporaneous works in different mediums, especially those by the same artist. There have been earlier periods, or movements, of modern art when the interconnectedness of works in different mediums has been especially prominent. And the Museum's still more reportorial approach to contemporary art than to earlier art is encouraging of its collection and display in a way that reveals its variety. What is new, however, is the extent to which works of an ambition earlier associated largely with painting and sculpture are now created in other mediums. When the Museum was founded, Barr understood that the history of pro-

gressive modern art could not be told except by a multimedium museum, but took it for granted that the history was driven by artists working in painting and sculpture. It still is, but also by artists working in other and in interdisciplinary mediums, and it is this that requires a greater curatorial collaboration than hitherto. Now, interdepartmental committees for media work and a Fund for the Twenty-first Century that, respectively, recommend acquisitions to curatorial departments and offer gifts to the six curatorial committees have helped to foster not, of course, a *musée sans frontières*—properly so— but far greater flexibility and cooperation among its *conseil des douanes.*

5. **Showing**

The development of the collection has always been intimately bound up with the quest for spaces adequate for showing it. In 1930, when the new Museum occupied six rooms totaling less than 5,000 square feet for galleries, library, and offices at 730 Fifth Avenue, Barr made his first effort to dedicate one of the rooms to show works acquired for the collection, which then meant five paintings and eight sculptures; the trustees vetoed the proposal. In 1932, the Museum moved to a rented town house at 11 West Fifty-third Street, which afforded five floors for a total of around 9,000 square feet. The following spring, the twelve paintings and ten sculptures in the collection were exhibited for a month on the third floor, while a selection from the Bliss Bequest, not yet acquisitioned, appeared on the second floor. That same year, Barr argued that a "Provisional Museum Collection" of selections from the collection enhanced by key loans should be on view each year for the summer and at least two winter months; "otherwise the 'Museum of Modern Art' may as well change its name to 'Exhibition Gallery.'" Such a display was presented in November 1934 and summer 1935, and in 1936 the trustees approved a resolution that "the Collection shall be exhibited, in whole or in part, to the public in galleries designated for the purpose." In 1937, however, selections from the collection were exhibited only in the summer and one month in the winter.

The new building that opened in 1939 had about three times as much space as the old building—some 20,000 square feet on three floors—plus a sculpture garden designed by John McAndrew. Even so, the collection was on view for a total of only eighteen weeks during the first two years of operation. In 1941, Barr complained to the Museum's Advisory Committee and, from spring 1942 to spring 1944, one floor was devoted to the collection. But thereafter only fifty paintings were on view. Was it then, perhaps, that Barr formed his rule to himself that, all things being equal, he would acquire vertical rather than horizontal paintings since they took up less space? In any event, the internal debates about the future of the collection that followed Barr's 1944 Report, discussed earlier, were proving so difficult to advance that it became necessary to mount a private installation for the benefit of the trustees, half in the Museum, half in a nearby warehouse. As a result, June 1945 saw the opening of a seven-month exhibition of 355 works (about a third of the collection) on two floors of the Museum. It was a striking public success, causing Stephen C. Clark, the Chairman of the Board, to boast: "Without much question the Museum possesses the outstanding collection of contemporary art in the world, although due to lack of space only part of it can be shown and much of it remains in storage."

Barr seized the advantage by, typically, compiling statistics for the trustees. In December 1946, there were on view only fifteen percent of the 702 paintings in the collection; fifty percent of the 155 sculptures; only eleven out of 278 drawings; and hardly anything else. "Lack of space," he concluded, "has proved a more serious handicap to the Museum's collections than lack of funds." But nothing much changed until the intermuseum agreement with the Metropolitan had come and gone and the new "masterworks" policy had been announced. Then, in 1954, on the occasion of the Museum's twenty-fifth anniversary, 495 paintings and sculptures from the collection occupied all three floors of the Museum and the new Abby Aldrich Rockefeller Sculpture Garden designed by Philip Johnson. Five years later, the thirtieth anniversary opened a fund-raising drive for expanded space that spoke of "The Museum's Invisible Collections" and was accompanied by an exhibition entitled *Toward the "New" Museum of Modern Art,* with works displayed in a densely crowded, Salon hang. "Some visitors sympathetically disapproved," Barr observed; "others unexpectedly liked the rich, traditional effect of 'skying.'"

The result of that fund-raising was the enlarged, 1964 building, in which the painting and sculpture collection was allotted 19,000 square feet on the second and third floors, together with the 35,000 square foot sculpture garden, to be used also for temporary exhibitions of sculpture and, occasionally, of architecture and design. Smaller dedicated spaces were also provided for drawings and prints, architecture and design, photography, and temporary exhibitions. Thus, on the Museum's thirty-fifth anniversary, the corner finally turned from a Museum that was, effectively, an exhibition gallery, which on occasion showed its collection, to a museum of modern art, which permanently devotes its largest amount of space to display of its collection.

Henceforward, with those very rare exceptions when the collection galleries have been turned over to a large, temporary exhibition, this conception has been maintained. Twice more the galleries have been expanded. The fifty-fifth anniversary expansion of 1984, designed by Cesar Pelli, enlarged the total gallery space to 85,000 square feet, of which 57,000 square feet was devoted to the collection, some 36,000 square feet to painting and sculpture. Now, on the seventy-fifth anniversary of the Museum, Yoshio Taniguchi's 2004 building provides some 125,000 square feet of gallery space, of which around 100,000 square feet is devoted to the collection, some 55,000 square feet primarily to painting and sculpture, including the Contemporary Gallery of around 15,000 square feet, in which selected works from other mediums will also be shown.

So much for the acquisition and expansion of space; the more interesting question is how that space has been used. In reviewing this subject, four elements require consideration. These form two pairs: the broad aims of the collection installation and the means of selecting what to show; and the overall architecture of the galleries and the particular methods of installation. All four are mutually interdependent. However, until the collection had developed a sufficient identity, questions relating to aims and selection were largely unanswerable in practice. This is also to say that practices relating to the means of display were tested and codified before those related to the contents of display, with intriguing consequences.

To begin with, although, as we have just seen, the fledgling collection was not exhibited in the Museum's original galleries at 730 Fifth Avenue, the design of those

galleries for temporary exhibitions (fig. 1) came to influence the design of the spaces in which the collection would be exhibited. The galleries were cut out of an open, loftlike space by means of partition walls covered with a light, beige-colored fabric, which Barr referred to as monk's cloth, articulated, bottom and top, by very minimal baseboards and moldings from which the paintings were hung on wires. The paintings, whose period frames both objectified and valorized them in this spartan setting, were hung in one, openly spaced line at, or just below, eye level, and all available surfaces were used, even the occasional door and gaps between windows, while corners were chamfered on occasion for yet additional space. Fighting with the pictures was the unavoidable architecture of the building: bulky ceiling beams, prominent air grilles, awkwardly placed lighting. Galleries of this design differed very drastically from the traditional, crowded, multilayered Salon hanging of most museums of premodern art and from the more asymmetrically dynamic, but equally crowded hanging of famous exhibitions of avant-garde art, from the New York Armory Show of 1913 to the Berlin Dada Fair of 1920.

However, single-line hangings were by no means a novelty in 1929, being perhaps an inevitable outcome of museums assuming an educational purpose, a path begun with the opening of the Louvre in 1793. The Louvre is to be counted the first modern museum precisely because it assumed such a purpose, both growing from and replacing the older notion of assemblages of artworks and curiosities in palaces with proselytization of the Napoleonic ideologies of progress and expansion. Their museological translation meant an historical account of painting and sculpture, from the Renaissance to Napoleonic classicism, and an aggressive, international acquisitions policy: Napoleon, a contemporary observed, was "devoured by anticipatory lust for the best things in every country," which may make him the first modern curator. This international art history, disseminated across the Empire and eventually leading to hangings arranged by national schools in their chronological sequence, would influence and be influenced by the development of *Kunstgeschichte*, the Germanic tradition of an historical rather than connoisseurial study of art. With the reinforcement of this scholarly, systematic, and deterministic preoccupation with genealogy, there emerged, by the end of the nineteenth century, the practice of hanging pictures in lines, the better to tell the historical story.

It is only fitting, then, that Barr came across this in Germany, his principal source being the reinstallation of the Niedersächsisches Landesmuseum, Hannover, undertaken by the museum's Director, Alexander Dorner, after 1922. There, Dorner had devised a sequence of rooms for art from the Renaissance to the present, the layout of which was intended to evoke the spirit of the particular period to which it belonged. It was from Dorner's gallery for early modern paintings (fig. 6) that Barr borrowed the design of the galleries at 730 Fifth Avenue.

But there was a far more innovative space at the Landesmuseum, El Lissitzky's *Abstract Cabinet* (1927–28), with walls lined with metal slats that shimmered with the movement of the viewer; sliding panels to reveal or conceal works of art; and architecturally prominent pedestals and revolving showcases (fig. 7). Barr called it "probably the most famous single room of twentieth-century art in the world." Despite his enthusiasm, there are no indications that he thought of adapting this far more innovative approach to the design of his galleries. Of course, the conservatism of his trustees would have

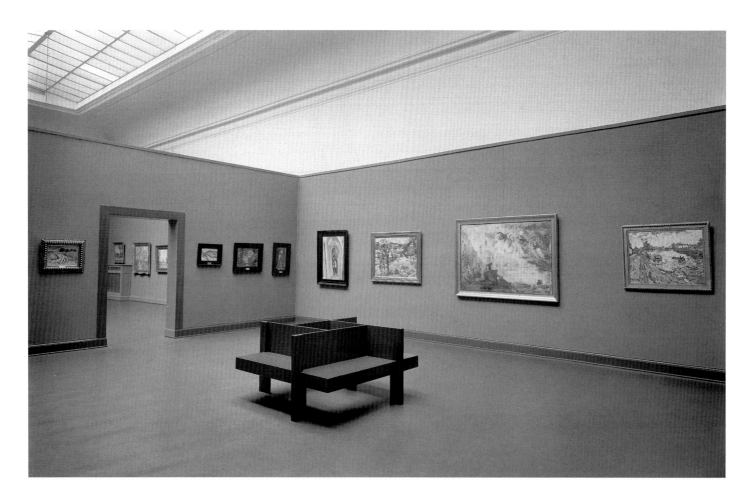

6. "Gallery 44," after Alexander Dorner's reorganization of the Niedersächsisches Landesmuseum, Hannover, c. 1920s

made this a battle very unlikely to be won, but even in the more secure periods of his tenure, he never attempted to engage it. When he had the opportunity to display the collection, he preferred to stay with variants of the approach derived from Dorner's early modern gallery. However, the concept of the *Abstract Cabinet* had an enduring influence on the design of temporary exhibitions, initially on that of architecture and design (fig. 8), but eventually on those of other mediums, even occasionally of painting and sculpture. In Barr's view, the exhibited collection was "the authoritative indication of what the Museum stands for." With this as its base, he said, the temporary exhibitions the Museum organizes can be "adventurous (and adventitious) sorties" into less-charted areas. It would seem that he believed this of the design as well as of the content of these two forms of display.

When, in 1932, the Museum moved into the town house at 11 West Fifty-third Street, the design for temporary exhibitions adopted at 730 Fifth Avenue was developed and refined (figs. 9, 10). The Beaux-Arts details were subdued, wherever practicable, by partitions, false walls, dark curtains, and bases, but elaborate moldings, pilasters, and banisters remained. They and the elements of camouflage, especially the curtains, were sometimes skillfully used to counterpoint the spare display walls that now lined the building. Again, these were covered with beige "monk's cloth," but hanging pictures by wires from a picture rail was now replaced by invisible hanging. And Barr, who had been a novice to installation, began to experiment. In October 1934, he wrote to a friend: "Hanging pictures is very difficult, I find, and takes a lot of practice. . . . I feel that I am just entering the second stage of hanging when I can experiment with asymmetry. Heretofore I followed perfectly conventional methods, alternating light and dark,

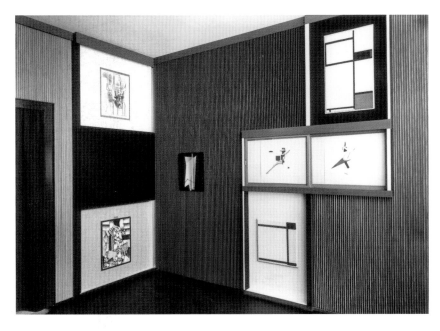

7. El Lissitzky, *Abstract Cabinet*, Hannover, 1927–28

8. Installation view of the exhibition *Machine Art*, The Museum of Modern Art, New York, March 5– April 29, 1934

vertical and horizontal." From this it is evident that Barr was not usually hanging works in a rigidly chronological order but was composing walls. And, while his installations did become more adventurous, they were never allowed to overwhelm his desire for their authoritativeness, and in fact, he continued regularly to install according to the size, orientation, and visual weight of adjacent pictures (fig. 11).

One distinctive innovation of the town-house installation was its lighting by means of individual, pentagonal-shaped fixtures suspended from the ceiling on short posts and banks of these fixtures shielded by long metal baffles. In the 1939 building, the fixtures were refined and the baffles slimmed down. This form of lighting would remain, loved and hated, until 2001, when the Museum closed to embark on its new building. In 1939, it was accompanied by small, ceiling-mounted spots and flush-mounted lay-lights in areas for sculpture. Gone, of course, were the Beaux-Arts details; the baseboards were trimmer and the pedestals cleaner. But the use of curtains continued, and the occasional dark-painted wall, even the obliquely angled and curved wall, served to inflect

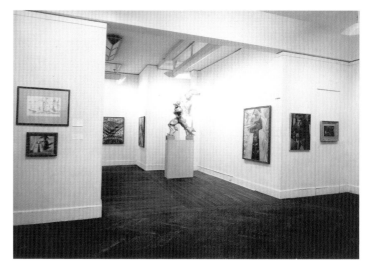

9. Entrance to the exhibition *Vincent van Gogh*, November 4, 1935–January 5, 1936. The Museum of Modern Art, New York

10. Installation view of the exhibition *Cubism and Abstract Art*, March 3–April 19, 1936. The Museum of Modern Art, New York

the simple, custom-made interior in a way analogous to that of the contingent details of the previous interiors. Since the collection was not continuously displayed, but shown in exhibitions from the collection, it is difficult—indeed, risky—to generalize about its authoritative shape. A plan for the 1939 opening collection exhibition, *Art in Our Time* (fig. 12), suggests something as dynamic and varied as the layout of contemporaneous loan exhibitions. However, installation photographs (fig. 13) show something more calm and contemplative.

The 1939 building occupied the site of the town house at 11 West Fifty-third Street and three adjacent lots. Its galleries, which could have been of any buildable size, are of town-house-like dimensions, thereby recalling both the previous galleries and, through them, their original domestic spaces. A politically minded commentator, Christoph Grunenberg, observed: "These calm, contained spaces (often said to have the 'intimacy' of a private home, a reminder that many works in the museum previously belonged to

11. Installation view of the exhibition *Fantastic Art, Dada, Surrealism*, December 7, 1936–January 17, 1937. The Museum of Modern Art, New York

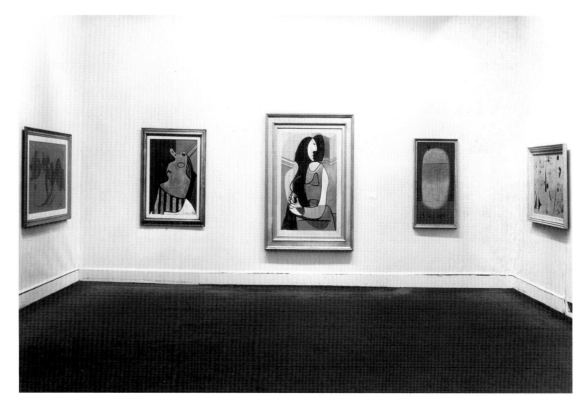

wealthy collectors) provide relief from the bustling metropolis outside and, more broadly, from the material world of production and consumption." In a similar vein, Mary Anne Staniszewski has suggested that the installations in these spaces—placing paintings on neutral-colored walls just below eye level in relatively widely spaced intervals—enhanced the sense of autonomy of both individual viewer and individual work in one-to-one relationships that isolated their encounter from the historical and social contexts in which the work was created and was now being viewed. More stridently, Carol Duncan and Alan Wallach have suggested that, while to some extent all museums decontextualize and

sacralize objects, the Museum's spare galleries especially create the impression that their contents belong "to the universal and timeless realm of spirit." They would have done so even more had a 1941 plan of Barr's for laying out the collection been realized. It was modeled on a cathedral, with the collection occupying twenty-nine chapel-like bays, each twenty-four-feet square, around navelike public space.

However, the Museum, its critics claimed, only "*appears* to be a refuge from a materialist society," and, more fundamentally, seeks not to make of the viewer a disinterested observer but rather, as Walter Benjamin had argued, to rehearse the viewer in the role

12. Philip L. Goodwin and Edward D. Stone. Second-floor plan for the 1939 exhibition *Art in Our Time*, The Museum of Modern Art, New York

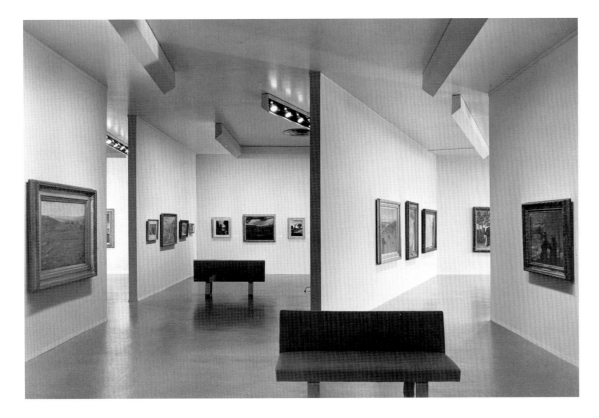

13. Installation view of the upper-floor galleries of the exhibition *Art in Our Time*, May 10–September 30, 1939, The Museum of Modern Art

of a consumer of commodities and, therefore, reconcile him with the outside world.

This sort of critique of the Museum's installations began to emerge long after the period under discussion, in the late 1960s and early 1970s, and, as Grunenberg noticed, comprises a reaction, born in the cultural and political radicalism of that period, against the institutional authority the Museum had then achieved and, therefore, "can be seen as political or even ideological in the assumptions on which it is based." The fact that it emerged after 1964, when the Museum's collection began to be continuously and fixedly shown, is also significant. Ideological it is when the critique attaches more to the literature of blame than of understanding. For it is then less likely to acknowledge that inherited conventions like universalization, atemporalization, and individualization, which are themselves parts of the historical and social context of the modern viewer and the modern work of art, neither prescribe nor supply solutions to how to install paintings, but rather are the media within which the means to these solutions are worked out. Neither do they acknowledge how works of art so installed might, can, and will have both an authentic and an inauthentic function for their viewers.

Besides, visitors to the Museum have never been invited simply to contemplate individual, isolated, sacralized works of art; they have been "also subjected," in Grunenberg's somewhat overstated words, "to a compulsory course in the history of modern art." Modern museums, we have learned, are distinguished by their emphasis on presenting art in such a way as to afford an historical education. What, if anything, distinguishes the painting and sculpture collection of The Museum of Modern Art has been Barr's determination that the collection be developed so that it could afford a synoptic overview of the entire development of progressive art since Cézanne. Along with this came the hope that dedicated, permanent space would be provided sufficient for such an overview, selected from all the paintings and sculptures that the Museum owned. It required that the display of these selected works would create, in their juxtapositions, groupings, and sequences, a highly focused narrative without words but made from many and different artistic voices that describe the complex and contradictory ways in which modern art has developed across the decades.

In such an educational installation, says Nicholas Serota, the arrangement of works "illustrates" a story. Curatorial interpretation, which arranges works in sequences and relationships that could not have existed in the minds of their makers, is stressed over experience. But not arranging them, we just heard, also decontextualizes the works; moreover, it stresses not simply "experience" but commodification. If isolating works in a "neutral" setting decontextualizes and commodifies them, then juxtaposing and sequencing works in such a setting decontextualizes them to risk subsuming them to pedagogy. But, surely, this is not simply a question of how close to each other the pictures are hung. If understanding art and enjoying art are inseparable, a contrast of interpretation and experience is, therefore, a false dichotomy.

6. Teaching

We take it for granted now that there is no such thing as pure, unmediated experience; every experience comes with its own interpretations, which are renewed, adjusted, or even rejected in the duration of the experience. Installing works of art in galleries, Barr

assumed, meant placing them in such a way that the interpretive experience would be renewed in a manner that aided their historical understanding. How the works were sequenced would be the means of that understanding; how insistently they were sequenced would determine its level of emphasis within the interpretive experience. In 1964, after thirty-five years at the Museum and three years before he would retire, Barr finally got to create that installation.

Of all the disciplines that study our cultural patrimony, only the study of visual art announces itself as an historical study: art *history*. "Standardly," as Richard Wollheim put it, "we do not call the objective study of an art the history of that art. We call it criticism." He adds that the idea that the visual arts uniquely require historical study is something that actually requires historical explanation. Part of that explanation—for modern art history, certainly—is the history of and the history told by The Museum of Modern Art. (A larger part, of course, is the foundation of the modern study of art as a positivistic pursuit.) Barr's approach was a positivistic one, yet it also reveals that the historical and the critical are not so easily separated.

The philosophy of installation that Barr established for the Museum frequently has been described as a strictly chronological arrangement. In fact, it has never been strictly and sometimes has been only leniently chronological. Barr established the model of an historical installation. A chronological installation is the museological equivalent of a medieval annal, where everything is arranged in precise date order, and it has the same unarranged, unranked, unedited objectivity. Therefore, Barr's historical arrangement of works, mainly by stylistic groupings, was subjective in the fact of being so arranged. A strictly chronological installation may claim that it simply records the "objective reality." (It would, however, be a pointless claim.) An historical installation, however, cannot possibly make that claim if "history" is the subjective interpretation of "chronology." More than that: insofar as an historical installation records a subjective interpretation, it is a specialized sort of "thematic" installation, one organized according to historical themes. The familiarity of historical installations merely disguises the fact that they too comprise sets of juxtapositions put together to elucidate subjective interpretations of the objective reality of the works of art.

As a plan of the second floor of Barr's galleries makes clear (fig. 14), his approach was twofold: to install by stylistic chapters, each usually corresponding to a single room, which sometimes meant a room devoted to one artist; then to string together these chapter rooms in roughly chronological sequences. Thus, each gallery would offer a cogent unity, and the total display would present the chronological unfolding of a succession of different styles.

Barr generally followed the two-part style history he had created in 1936 by presenting sequential, opposed exhibitions devoted to "Cubism and Abstract Art" and "Fantastic Art, Dada, Surrealism." Hence, the principal narrative of the second-floor galleries led to the subjects of the first exhibition, while the third-floor galleries (fig. 15) opened with the subjects of the second, even though they chronologically preceded much that was on the nominally earlier floor below. Additionally, while most of the stylistic chapter rooms contained works of one movement and, therefore, time-period, some did not. In the latter rooms, works of similar stylistic goals were grouped regardless of variations in their dates. And dedicated galleries, placed on the perimeter of the

47

14, 15. Second- and third-floor information plans, The Museum of Modern Art, New York, 1967

sequences on the two floors, were provided not only for drawings and prints, photography, and architecture and design—by 1966 collected by independent departments—but also for sculpture, not similarly collected. This arrangement did acknowledge modern sculpture's own history, but it separated it from the principal history of style being told by what were, in effect, picture galleries.

Consequently, with rare exceptions, unquestionably produced by architectural constraints, the historical path of Barr's picture galleries was lineally prescribed; the viewer could make detours into galleries for other mediums but not into picture galleries other than in the set path. (Most pointedly, and probably dangerously, a mandated fire-exit opening between galleries five and nine on the second floor was disguised by a curtain, lest a viewer should accidentally stray from "Matisse" into "Cubism to 1914" rather than enter the "School of Paris" gallery.) Moreover, the thresholds between the galleries were often staggered, so that upon entering a gallery there would frequently be a painting in front of you, which emphasized the flow of history between and across the stylistic chapter rooms. Rubin, who expanded this effect, referred to it as being like a fan of playing cards held in the hand. It was created at the expense of being able to anticipate the spatial relationship of adjacent galleries. Together, these architectural

constraints initiated the labyrinth, or beads-on-a chain, model of installation.

An interesting precedent for Barr's (and then Rubin's) conception of history, as manifested in the arrangement of the galleries, is that of the hugely popular and influential *The Story of Art* by E. H. Gombrich, first published in 1958. Although Gombrich did not devote much space in his book to modern art, he created a style history on the same metaphorical model as Barr's and concluded his book with the stirring message: "It is we who must see to it that the thread of tradition does not break and that there remain opportunities for the artist to add to the precious string of pearls that is our heirloom from the past." Gombrich speaks of the whole string of pearls as our heirloom from the past, but it is also the action of stringing one pearl (one illustration, picture, gallery) after the next that replicates how an heirloom is handed on from one generation to the next. This affirmation of an unbroken continuity tells us that the historical narrative is grounded in an *ahistorical* conception of works of art, specifically a modern ahistorical conception that stresses the importance of origins. Of course, the next gallery must be unlike the previous one, but it must also be enough like it to fit on the chain. Hence, what motivated the selection of the contents of the first gallery—Cézanne and the Post-Impressionists—was the contents that would occupy the succeeding galleries, and vice versa. If the Museum's original desire to acquire "the best modern works of art" compares to Gombrich making a historical string from what he thinks to be pearls, then this will mean leaving out what look like wooden beads if they do not contribute to telling the story. Or it will mean putting them in galleries not firmly tied to the chain, ones that are discretionary, not mandatory, for the viewer to enter.

An object lesson is afforded by the most northwestern room (at lower left in the plan) on the second floor: an isolated cul-de-sac behind the women's toilets. In Barr's installation, it was occupied by "Realists and Romantics, 1920–1940," and the toilets were entered off "Special Exhibitions" to the east. In 1978–79 plans of the galleries (figs. 16, 17), reflecting Rubin's changes, "Special Exhibitions" has become "School of Paris" and the entrance to the toilets has moved to the south, leading off a larger cul-de-sac gallery divided between "Americans" and "Latin Americans and Primitives." Directly above, on the third floor, space is surrendered to prevent the men's toilets opening directly into "American and European Art, c. 1950–1960."

This lapse aside, Rubin's revision of Barr's gallery layout did improve upon it. The small, town-house-size rooms were enlarged, and Barr's sometimes muddily connecting sequences—for example, "Matisse" to "School of Paris" to, optionally, "German and Austrian," to "U.S.A" to "Cubism to 1914."—were eliminated, in this case, along with the offending curtain. This meant the removal of some chapter rooms—the old sequences comprised thirty-six galleries; the new one, thirty—and, therefore, the combination of previously separated subjects, for example, "Turn-of-the Century, Fantasy, and Early Expressionism." At times, this required that the two sides of a room, left and right as you passed through it, had different subjects; at others, that strategically placed alcoves and setbacks be constructed to help to isolate and thus insulate those works that did not belong so comfortably with their neighbors. But the result was much clearer, cleaner, and historically more cogent. The two-part story that Barr had adumbrated in his 1936 exhibitions substantially remained more than forty years later, only now in a much more efficiently told form.

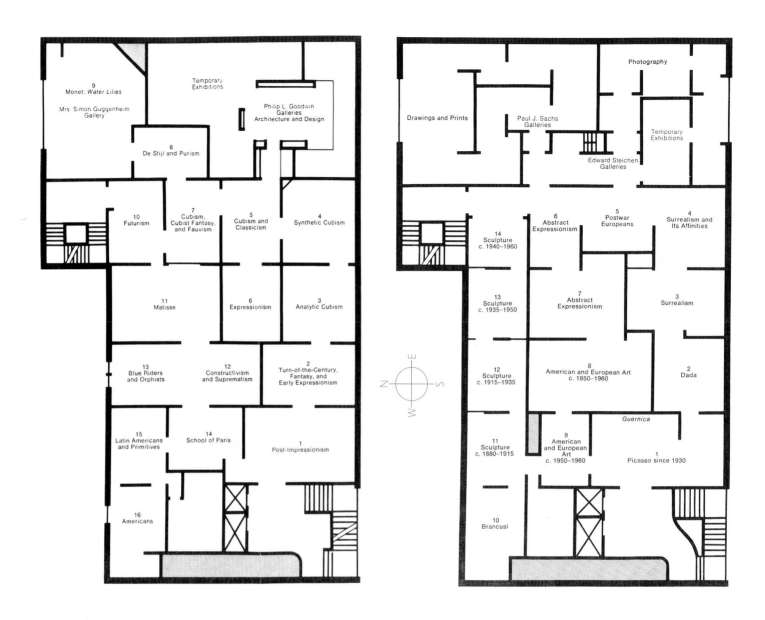

The floor plan labels (left plan):

9 Monet: Water Lilies
Mrs. Simon Guggenheim Gallery
Temporary Exhibitions
Philip L. Goodwin Galleries Architecture and Design
8 De Stijl and Purism
10 Futurism
7 Cubism, Cubist Fantasy, and Fauvism
5 Cubism and Classicism
4 Synthetic Cubism
11 Matisse
6 Expressionism
3 Analytic Cubism
13 Blue Riders and Orphists
12 Constructivism and Suprematism
2 Turn-of-the-Century, Fantasy, and Early Expressionism
15 Latin Americans and Primitives
14 School of Paris
1 Post-Impressionism
16 Americans

(right plan):

Photography
Drawings and Prints
Paul J. Sachs Galleries
Temporary Exhibitions
Edward Steichen Galleries
14 Sculpture c. 1940–1960
6 Abstract Expressionism
5 Postwar Europeans
4 Surrealism and Its Affinities
13 Sculpture c. 1935–1950
7 Abstract Expressionism
3 Surrealism
12 Sculpture c. 1915–1935
8 American and European Art c. 1950–1960
2 Dada
Guernica
11 Sculpture c. 1880–1915
9 American and European Art c. 1950–1960
1 Picasso since 1930
10 Brancusi

16, 17. Second- and third-floor information plans, The Museum of Modern Art, New York, 1978–79

When Rubin laid out and installed the much-increased space for the painting and sculpture galleries in the Museum's 1984 expansion, designed by Cesar Pelli, the same story was further clarified because even further extended, but also, for that same reason, made more labyrinthine (figs. 18, 19). It would have been challenge enough to lay out galleries in the building's long east-west floorplates, created by a western addition that roughly doubled the old space. What both increased the challenge and all but mandated the solution was the further narrowing of the floorplates by a Garden Hall that ran along most of the building's north side, replacing the northern string of galleries (the sculpture galleries and those beneath them) in the old, 1939 building, and extending to occupy half of the new western space. Without the space of those galleries in the 1939 building, the options were either to retain a single circuit, west to east and back again, around the two remaining, back-to-back sets of small galleries, or to enlarge those galleries and effectively give up a circuit that would return to join up with the new galleries to the west. But that second option would disrupt the historical narrative as well as reduce hanging space, so it was not then an option.

The galleries immediately to the west, which extended the circuit, could be larger (not all were) because newly built, but it was impossible to exit from them until the end

of that floor's circuit was reached, back in the Garden Hall. Later, Varnedoe would have an opening cut through the center spine of the sequence, opposite its entrance, but this was insufficient to ameliorate the sense almost of entrapment, of navigating a maze of usually small spaces with hardly an option to change course and hardly a sense of where precisely in the building you were. Placing the entrances to galleries for other departmental collections off the Garden Hall made them more accessible than previously, when they were found, or often not found, halfway around the picture-gallery circuit. But the new arrangement did separate the collections. Conversely, sculpture was now no longer separated from painting, but it was difficult to show it in free space in small galleries with paintings on all their walls.

As time passed and the Museum's audience grew, the galleries seemed no longer intimate but claustrophobic. As a new building began to be planned in the 1990s, their deficiencies seemed intolerable. However, when the galleries opened in 1984, the effect of an extraordinary collection laid out in a fuller, more careful manner than ever before was simply exhilarating.

Rubin's installation emphasized the separate, internal orders of the two, now much more extended, sequences that unfolded on the second floor. Galleries devoted to the founding Post-Impressionists led, first, to the "rationalist" strain of Cubism and abstract art. Then, after the bridging interlude of Matisse—suggesting that his art belonged to both orders, as it did in the Museum's specialized holdings—viewers moved to a more "instinctive" strain, exemplified by both Expressionism and Dada and Surrealism. The third floor picked up the story in postwar Paris before taking it to Abstract Expressionist in New York, after which it was principally a North American sequence.

Rubin's ambition of affirming the continuity of the historical narrative meant that he exaggerated the appearance of likeness of the galleries, provided by their uniform architecture, by uniform gray carpeting, and, most controversially, by reframing the exhibited collection in simple, dark strip-frames, most of which exposed the edges of the canvas. Many welcomed the simplification; a lot of the earlier frames had, in fact, been over-ornate dealers' frames. But others worried at the anachronism and the homogenization of so contemporary an approach. The earliest and most recent parts of the collection were bracketed off: the nineteenth-century galleries that opened the second floor, the more subtly by the frames in these galleries being given a discreet gold surface; the galleries for art since 1960, in the 1939 building and west wing on the third floor, more noticeably by the exposed wooden floors instead of carpeting. Some visitors thought that the latter device was meant to suggest that contemporary art was different in kind from preceding modern art. It was intended to suggest a "gallery" rather than "museum" space and, hence, that the installation of these spaces would rotate in principle, whereas that of earlier ones would only do so to accommodate outgoing loans and new acquisitions.

Some forms of contemporary art were not included because they were not collected. As Rubin wrote in 1984: "That contemporary art has become, to a certain extent, a public art should no more lead us to want to put Earthworks in the Museum garden than we would want the mosaics of San Vitale or the Stanze of Raphael to be transferred into a museum." This observation remains basically true. The Museum of Modern Art was founded in the tradition of museums conceived as depositories of easel paintings

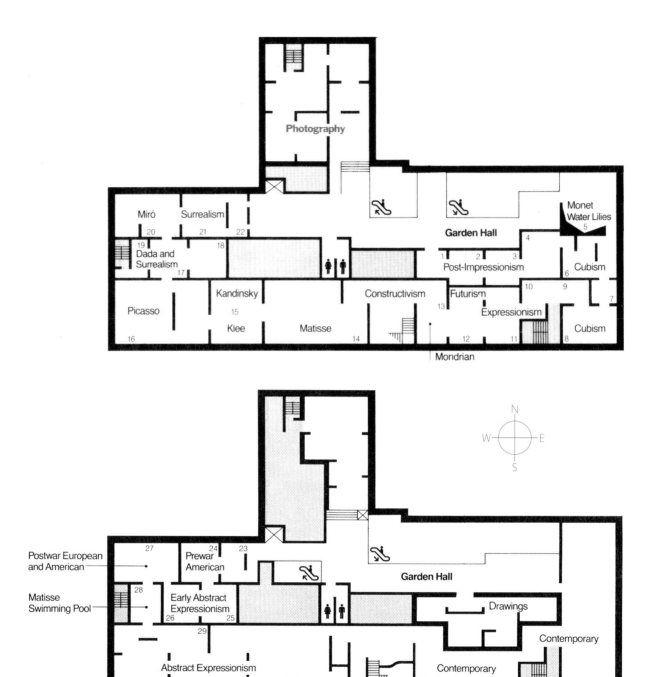

18, 19. Second- and third-floor information plans, The Museum of Modern Art, New York, 1986

and related works of a similar size, and, prior to its recent 2004 expansion, chose not to move from its midtown Manhattan site to one where larger works might be more easily and frequently shown. Although, as we have learned, Varnedoe acquired very large works, believing that they deserved to be in the collection while knowing that they could not permanently, or even regularly, be on exhibition, it is unclear whether he consciously wished to overturn Barr's view that only the exhibited collection offers "a permanent visible demonstration of what the Museum stands for." In any event, for the vast majority of the Museum's public, including artists, Barr's dictum must stand. Therefore, the Museum cannot afford continuously to displace large numbers of other works in order to dedicate a disproportionate amount of gallery space to works of art conceived at a scale that is indifferent, even antagonistic to its own. But neither can it retreat into becoming a picture gallery if the tendency of contemporary art is not in

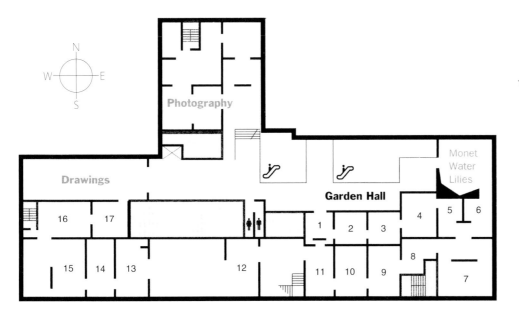

1–3 Post-Impressionism
4 Fauvism, Early Picasso
5 Cubism
6 German Expressionism
7 Futurism, Kandinsky, Chagall
8 de Chirico
9 Collage and Dada, Picasso, Duchamp
10 Mondrian
11 Russian Constructivism
12 Matisse
13 Brancusi, Léger, Duchamp, Picasso 1920s
14 Klee, Schwitters
15 Surrealism: Miró, Arp, Ernst, Picasso 1920s and 1930s
16 Surrealism: Dalí, Magritte
17 Beckmann, Orozco

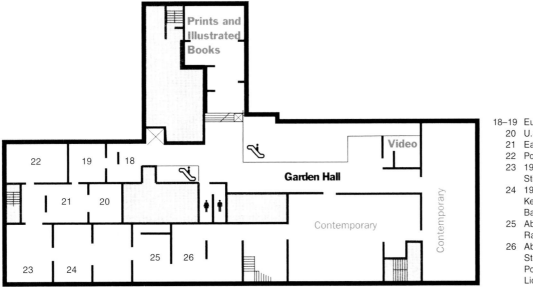

18–19 Europe and U.S. 1940s
20 U.S. 1920–1945
21 Early Abstract Expressionism
22 Pollock
23 1950s: Newman, Reinhardt, Still
24 1950s: Motherwell, Rothko, Kelly, Kline, de Kooning, Bacon
25 Abstract c. 1960s: Johns, Rauschenberg, Twombly
26 Abstract c. 1960s: Fontana, Stella, Martin
Pop: Warhol, Oldenburg, Lichtenstein

that direction. The Museum, as a public institution, has a responsibility to make available to the public the works that it owns. And, as a museum of record, it has a responsibility to represent important innovations in painting, sculpture, and other visual arts.

Recognizing that responsibility, Varnedoe surrendered some galleries in the historical collection so that the drawings galleries could move from the third to the second floor, opening space for some large contemporary works to be shown, in rotation, in the tall-ceilinged, third-floor galleries. Still, even accepting the loss of space for the historical collection, this did not address the possible requirement of permanent gallery space for oversized works. This remains an unsolved problem for the future.

Varnedoe also, in 1996, finally modified the installation of the historical collection by stylistic groupings to introduce a more insistently chronological order (figs. 20, 21). For example, Cubism and Expressionism of 1910–13 were put side by side, and works of

20, 21. Second- and third-floor information plans, The Museum of Modern Art, New York, 1996

53

the teens by Duchamp and de Chirico as well as Picasso and Boccioni were placed in immediate juxtaposition. Varnedoe conceded: "This method of display has sacrificed some of the clarity of each style's internal logic—breaking up Cubist works of 1910 and 1921, for example, to be shown in widely separate rooms—in order to emphasize the argumentative and multifaceted nature of early modern art, and to make viewers more aware of the multiple alternatives co-existing (and competing) with each other in any given year."

"It goes without saying," Wollheim wrote, "that knowing what comes after what is the raw material of historical understanding: it is not historical understanding itself." The more chronological the hanging, the greater the risk, he adds, that historical understanding gets replaced by contextual understanding and the true nature of influence is obscured. It may intuitively seem to be right to believe that only sequencing works that are chronologically close will produce the materials of historical understanding, and it probably is the best bet. But the linked processes of emulation and invention that together compose an historical connection often are indifferent to temporal sequence. Conversely, like works of art, even if assembled in such a sequence, may turn out to be only linked ahistorically by the accidental association of form, subject, theme, or even style.

I say "even style" because stylistic identity is an *ex post facto* construction. Which artists we count as Fauves or Cubists is highly subjective; to display an associated sequence of works that seem to be stylistically Fauvist or Cubist may be utterly ahistorical. However, the proposition that a late, Post-Impressionist style that came to be known as Fauvism was preceded by, and required, the work of Cézanne, Seurat, Gauguin, and van Gogh, and preceded, and required, both Expressionism and Cubism is historical. A display of Fauvism as a style that wishes to place it historically must somehow honor that sequence. Varnedoe's association of works of the teens by Duchamp, de Chirico, Picasso, and Boccioni is also historical, if more unexpectedly so, in revealing different paths taken beyond Cubism. But alternative historical accounts may reasonably be offered of that historical moment. What Varnedoe's installation began to do, with its more insistently chronological order, was not simply to break down the older-style history, but also its putative completeness and fullness.

The dangers with which the older-style history had flirted, sometimes indeed dangerously, were four: its representation of a dualistic structure that allowed works of art to be divided into camps where either rationality or instinct held sway; its implication that the narrative made from these materials was found in them rather than put there by narrative techniques; its valorization of works of art by allowing them to be seen as possessed of the coherence that they collectively are enrolled to describe, making them seem less real than ideal; and its overemphatic narrative drive, of which subject in fiction Hayden White has written: "Here reality wears a face of such regularity, order, and coherence that it leaves no room for human agency, presenting an aspect of such wholeness and completeness that it intimidates rather than invites to imaginative identification."

Varnedoe admitted contingency, and with it fallible human nature, into the history. In doing so, in fact, he withdrew somewhat from telling a history to offering a chronicle, in White's distinction, by accumulating in sequence the record of what happened at the same time; by allowing the record to seem to tell its own story of "multiple al-

ternatives co-existing (and competing) with each other in any given year"; and by promising closure but not providing it. (Unsurprisingly, he organized an exhibition sequence entitled *Open Ends*.) Still, the strict architectural sequencing of the galleries that linked each "kernel" of simultaneous options to the one before and after it effected a sense of natural causality from one moment of dispute to the next, which could lead to the interpretation that the development of modern art has been a continuous internecine warfare.

"Modern art is modern because it is critical," wrote Octavio Paz, describing a consensus that did not mean that it is always *necessarily* combative. But I think Varnedoe enjoyed it when it was. It is fair to say, I offer, that he was not so much opposed to a causal narrative as to one that was not based on the uncertain outcome of debate and argument; the causality of the contingent. Matthew Armstrong has suggested that "while Rubin's presentation could be likened to a long epic saga, Varnedoe's [resembles] . . . an elaborate picaresque the very plot of which continues to be questioned, lampooned, interrupted and recast." This is itself picaresque, which is also to say, postmodernist; but, unquestionably, the empirical narrative did seem to be even mimetic as compared to Rubin's affirmatively historical one, to adopt a distinction in such literary narratives proposed by Robert Scholes and Robert Kellog.

This fundamental alteration of the painting and sculpture installation made it seem contingent, too. "In order to qualify as 'historical,'" White has written, "an event must be susceptible to at least two narrations of its occurrence. Unless at least two versions of the same set of events can be imagined, there is no reason for the historian to take upon himself the authority of giving the true account of what really happened." Now that an alternative history had been told, it became clear that the installation was telling a *version* of history. Varnedoe did not set out to destroy what Staniszewski imprecisely calls the Museum's "staging of institutional invisibility," the pretence that its installations were somehow natural, not constructed—imprecisely, because it required the unseeing participation of the Museum's audience. Moreover, fitting his installation in Rubin's mono-vectorial gallery layout did disguise its multi-vectorial message, and most of the audience saw a modification, not an alternative, to the Museum's familiar history.

The Museum's *Artists' Choice* series of exhibitions from the collection, not to mention external events, from artists' interventional critiques of museum installations to a growing fashion for displays that frankly (or narcissistically) revealed an often didactic curatorial purpose, made it impossible to pretend that any installation was not crafted. Yet, it was not until the Museum's end-of-century exhibitions—experimental displays from the collection that were intended to open, and close, options for the forthcoming new building—that it very prominently showed its own curatorial hand. The response, an equal mixture of pleasure and dismay among its audience, reprised that of Barr's showing his curatorial hand in his *Toward the "New" Museum of Modern Art* exhibition forty years earlier.

This brings us to the new, 2004 Museum building by Yoshio Taniguchi, and the present installation of the painting and sculpture collection. In the development of the program for this building, the four following, important realities about the Museum and its collections were finally acknowledged. First, all previous expansions had been incremental additions to an existing building—and, consequently, an existing concept of

installation—whereas what was now needed was a new concept of installation for a newly conceived building. This meant erasing old interiors as well as building new ones, and shaping them from the installations they were to receive. And, by the same count, the installation they were to receive was no longer to be thought of as an incremental addition to the previous installations, as all previous new installations had been additions to Barr's original, 1964 installation. By a happy coincidence, then, on the fortieth anniversary of Barr's installation, a truly new one could be created from scratch.

Second, the Museum began by privileging contemporary art, because its collection was contemporary in 1929. Therefore, it seemed only proper to renew that commitment, especially since the Museum's contemporary collection had become all but invisible in recent years. Hence, a large, high-ceilinged space of some 15,000 square feet for contemporary art on the second floor becomes the first gallery to be seen by visitors entering the Museum, while the historical collection descends to it from the fifth and then fourth floors (the third floor being a mezzanine containing galleries for architecture and design).

Third, the Museum has only thought it desirable to show in the historical painting and sculpture galleries a selection from the collection, chosen to offer a synoptic overview of the history of modern art. As a result, even its most valued works have never all been on view at one time. The collection has grown primarily because it covers an ever-longer period. Therefore, more space will always be desirable; yet, the addition of space, even beyond the point of viewer exhaustion, will never satisfy that growth. And fourth, the collection needs, as much if not more than additional space, better space. The painting and sculpture galleries had become unduly hermetic, prescriptive, and progressive in their linear, spinal arrangement—the viewer needed sanction to slow down—while the small size of individual galleries no longer served the requirements of an intimate address to the works of art.

From these requirements, the fifth- and fourth-floor galleries were shaped. This process began with a two-part model: first, to maintain a relatively "fixed" core display of the great masterworks that visitors to the Museum reasonably expect to see, to provide a synoptic overview of the development of modern art since 1880; second, to allow for more frequent re-installation of selected, "variable" galleries in that sequence to provide opportunities to see changing arrangements of other paintings and sculptures—and, at times and in places, of works in all mediums—that complement and inflect the more fixed display. This model was developed with the aim of extending Barr's idea of the Museum as a laboratory for the understanding of art by affording, for the visitor, multiple pathways through the exhibited collection and, therefore, the experience of multiple narratives of modern art, some of which would be complicated by the introduction of works in mediums other than painting and sculpture.

The desire to do this was developed in the abstract, before the available space and configuration of the galleries for painting and sculpture were known, and before it was clear what level of integration of important works of art from all departments was compatible with each department's wish to tell the history of its own mediums in its own galleries. The concept is now being tested in the first installation of these galleries, and will continue to be tested in future installations. Already, it seems clear that the boundaries of the bipolar fixed and variable system benefit from becoming fluid. Not

only do limitations of space argue for this; even more so does the recognition that a synoptic overview cannot be composed from a parade of masterworks alone, frozen in permanence, and that it would be unfortunate to create, either programmatically or architecturally, a sense of hierarchies of greater and lesser works. That had doomed the old masterworks policy half a century earlier. Still, opportunities have been sought to create alternative readings of subjects, to delve into them in greater depth, and to introduce unfamiliar subjects into the display.

The result has been this: both the fifth and fourth floors are divided into subject galleries, reminiscent of Barr's chapter rooms, except that their subjects are not exclusively stylistic (figs. 22, 23). Sometimes they are, either generally or specifically—Mondrian and abstract art, Futurism—but they are always descriptive of specific historical periods, the longest being the twenty-year span of the opening, prelude gallery devoted to Cézanne and the Post-Impressionists and Fauves, and the shortest being the five-year span of the gallery devoted to a strict definition of Pop art, with most of them covering five to ten years. Each gallery is conceived autonomously, the test of its success being whether it could exist alone. And the architecture of pure, rectangular spaces, without alcoves or setbacks, aids the sense of self-sufficiency. The absence of staggered thresholds does that, too, affording anticipation of adjacent spaces without flowing into them. Thus, the relationship of adjacent galleries is juxtapositional rather than continuous, the aim being to unfold the collection not as one whole, causal development, but as an accumulation of kernels of often different and opposing innovations or propositions that are tied to particular periods of time.

Effectively, my colleagues and I have sought to embed the mimetic approach adumbrated by Varnedoe within an historical account, both to drive it and to check it. This aim is aided by the fact that the galleries, while affording a principal route, are not arranged in a single, prescribed sequence. This allows at times for temporally coincident kernels to be placed side by side; provides, in one instance, five possible, equally plausible routes from a single gallery; and, halfway through each floor, allows access by stairway to the other route. And, most importantly, the installation of every subject gallery is amenable to change—more easily in some cases than others—to offer reinterpretations of its subject, a gallery effectively being conceived as a proposition about a proposition. It is anticipated that the subjects of some of the galleries will indeed be fully variable. These will change from time to time within their historical period. For example, a gallery devoted to Futurism may subsequently be devoted to other developments from Cubism, a gallery devoted to Pollock may be devoted to Newman or Rothko, or sculpture of the 1950s—or Abstract Expressionist drawings—for the aim is to include more works in other mediums. Or they will offer thematic selections of materials that afford the surprise of juxtaposition with the subjects of their neighboring galleries. In the end, though, Barr's old aim remains: the exhibited collection must offer a continuously present, visible demonstration of what the Museum stands for. "An experience of all possible things is not a possible experience," Kant warned. The exhibited collection offers the experience only possible in The Museum of Modern Art.

Not every museum collection devoted to the same period should be organized in the same way. Since the Museum's painting and sculpture collection remains unique in its ability to afford a synoptic historical overview of modern art since 1880, it has a

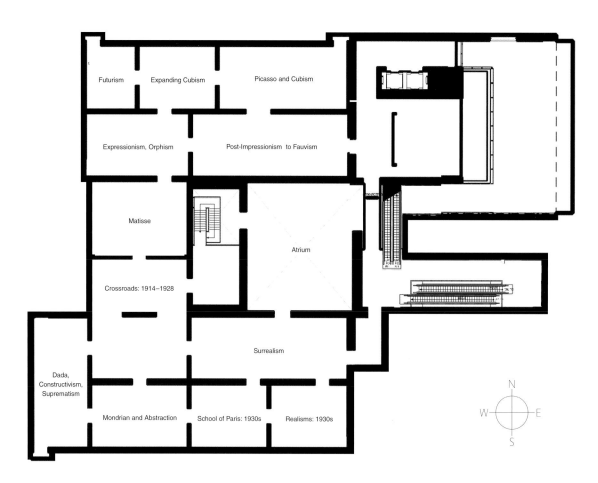

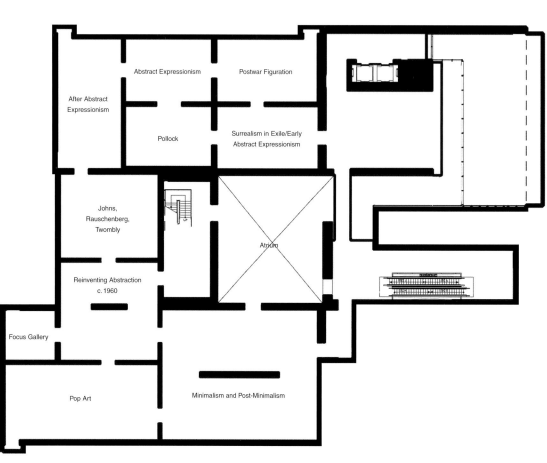

22, 23. Fifth- and fourth-floor Painting and Sculpture Galleries, The Museum of Modern Art, New York, 2004

responsibility to do just that. But it has an equal responsibility to do so by revealing the continually disputed idea of what it means to make modern art, the styles and movement functioning as the arguments and counter-arguments. Therefore, the component parts of that history, which finally means the individual works of art, cannot be subjugated to the whole. We will want to learn from them in what Barr described as "an art history without words." But we will want to delight in them as well as think about them—which does not mean staging institutional invisibility, but does require a curatorial punctiliousness that eases their way to the viewer without drawing undue attention to the contrivance of installation.

Ungovernable things can happen in front of great works of art because they are transformational objects that occupy our thoughts as we occupy them with ours. To be successful, an installation must admit to this sympathetic, mutual colonization in which imaginative visual enquiry may become comfortable with the unfamiliar and familiar with the uncomfortable. This publication surrounds its some three hundred works with the words that the Museum's curators, past and present, have written about them to aid their appreciation. But it is worth remembering what Barr wrote in 1934, in the introduction to *Modern Works of Art: Fifth Anniversary Exhibition*. He stressed how the most profound experiential moments are fundamentally wordless occasions: "Words about art may help to explain techniques, remove prejudices, clarify relationships, suggest sequences and attack habitual resentments through the back door of the intelligence. But the front door to understanding is through experience of the work of art itself."

Texts and Plates

The sequence of six sections of plates that follows presents more than three hundred works from the painting and sculpture collection, all of which are likely to be found, at one time or another, in the new galleries of The Museum of Modern Art. Like the installation in the galleries, it offers, more than simply a group of masterworks, a synoptic overview of modern art since around 1880. The first three sections, containing works dating from about 1880 to 1940, correspond to the Museum's fifth-floor galleries; the next two sections, with works from around 1940 to 1975, to the fourth-floor galleries; and the final section, with works made since about 1975, to the second-floor galleries, where works unrepresented here, because in mediums other than painting and sculpture, may also be found. Of course, turning the pages of a book to look at images in a single sequence is very different from the experience of real works of art in multiple, spatial sequences in galleries; therefore, the groupings of works and of artists have sometimes been changed here for the sake of the coherence of this publication.

Each section of plates is introduced, after a short prefatory note, by texts on selected works, artists, and artistic movements represented in it. Rather than writing or commissioning yet new texts on frequently much-discussed works of art, we felt that it would be far more useful to reprint materials from the archives and publications of The Museum of Modern Art that provide a history of its responses to these works as they were collected and exhibited. The authors of these texts include curators and conservators of the Museum, ranging from Alfred H. Barr, Jr., writing in the first Museum publication of 1929, to current members of the Museum's staff, writing hitherto unpublished statements in support of their acquisitions. And it also includes those outside the Museum who have written for its publications—distinguished critics and art historians and, interestingly, artists. The resulting double anthology of texts and illustrations is intended to offer a unique overview of how modern art was greeted and interpreted, as well as collected and exhibited, at The Museum of Modern Art.

Titles of publications are often given in abbreviated form in the texts. Full citations appear in the Selected Bibliography (pages 516–20). Notes to the Texts are on pages 506–15. The texts appear exactly as published and have not been amended to conform to a consistent style of punctuation or capitalization. Titles of artworks mentioned in these texts sometimes differ from those in the captions, which are based on the most current research.

Since many of the texts derive from catalogues of Museum exhibitions, whose own sequence reflects the history of interest in the artists and works described, it seemed useful to offer a Chronology (pages 521–32), which presents in parallel: a selection of the Museum's major exhibitions of painting and sculpture and the sequence of its acquisition of the works in this publication.

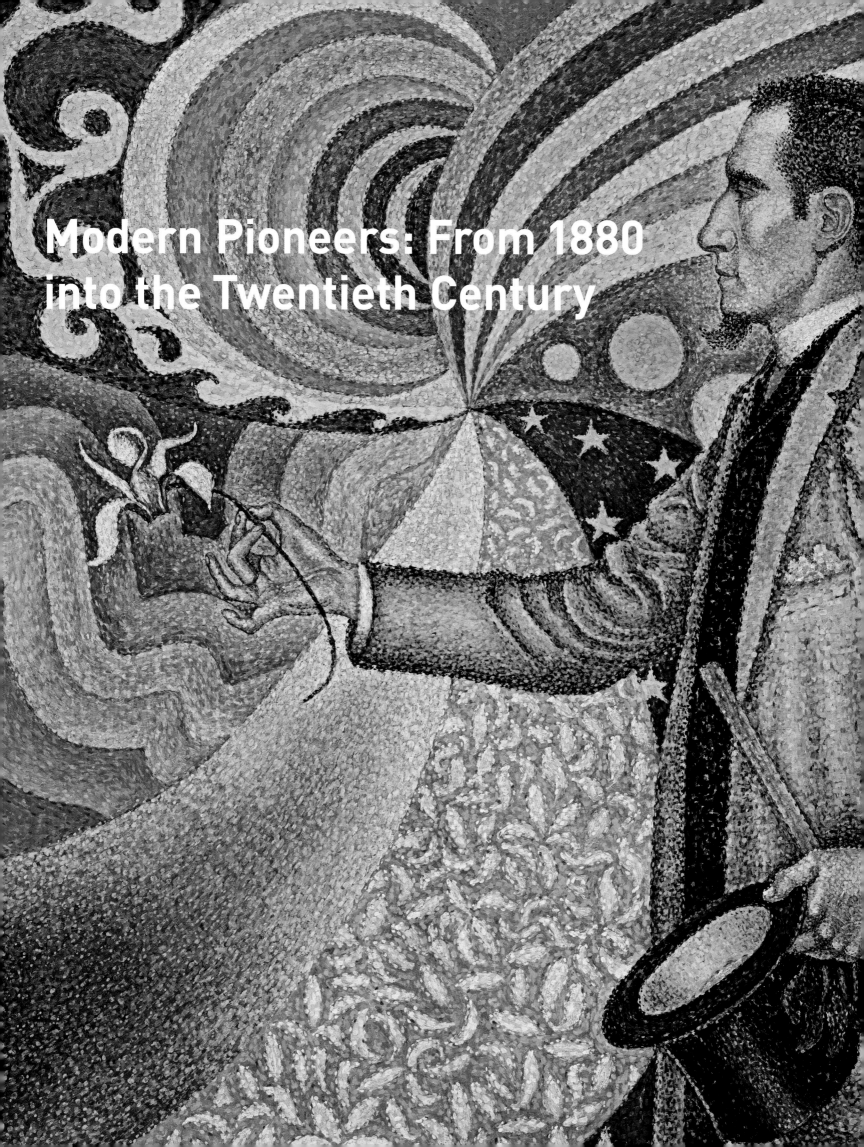

Modern Pioneers: From 1880 into the Twentieth Century

In the catalogue of the Museum's first loan exhibition, *Cézanne, Gauguin, Seurat, van Gogh*, of 1929, Alfred H. Barr, Jr., wrote that these four artists "were especially honored as pioneers who founded new traditions and, more important perhaps, rediscovered old ones." As the Museum's collection began to grow, it was paintings by these artists in particular that were sought after to open its account of the development of modern art. Eventually, Paul Cézanne's great *The Bather* of c. 1885 (page 94) would become the very first painting that viewers saw. The stride of this self-absorbed figure might be thought to symbolize the giant step forward they themselves were about to make into the complex and sometimes difficult pathways of modern art.

Barr's 1929 catalogue essay, an extract from which opens the anthology of texts that follows, describes the old and new traditions that each of the four artists rediscovered and founded. Cézanne rediscovered the structural tradition of artists from Giotto to Nicolas Poussin and founded a new tradition that led to Cubism. Paul Gauguin relearned the simplifications and coloristic intensity of Primitive artists, and opened the way to Fauvism and, beyond, to coloristic abstraction. Georges-Pierre Seurat's pointillist technique also had implications for Fauvism, yet his remaking of Neoclassicism was encouraging to the Cubists. And Vincent van Gogh's artistic roots in the Northern Romantic tradition provided the foundations of German Expressionism. What they had in common was that they went beyond their Impressionist beginnings and, in so doing, altered irrevocably the means and purposes of art's representation of the visible world; their heritage was profound change in the social conditions of the production and reception of visual art that would be played out by subsequent, modern artists.

In Barr's and the Museum's history of modern art, the work of other important late-nineteenth-century artists has been seen, and therefore installed, in relationship to the four principal pioneers. Thus, Gauguin and van Gogh are related to the Symbolist painters James Ensor, Edvard Munch, and Odilon Redon and the self-taught Henri Rousseau. These artists are thought to have further advanced the imagination of emotionally charged or fantastic scenarios that would continue to surface in later modernism. The sculptors Auguste Rodin and Medardo Rosso appear in this context more for their vivid proto-Expressionism and radical handling of materials, twentieth-century qualities, than for their nineteenth-century, quotidian realism. Likewise, both the late work of Hilaire-Germain-Edgar Degas and the later, early work of Édouard Vuillard frequently find a place in the Museum's first gallery for pioneering the discovery of drama and tension within intimate scenes of bourgeois daily life. Looking both backward and forward, the Impressionist Claude Monet, art-historically earlier than any of the other pioneers, is most famously represented in the collection by his *Reflections of Clouds on the Water-Lily Pond* of around 1920 (pages 88–89), a late Symbolist work that, when acquired in the late 1950s, was seen as prefiguring the art of the American Abstract Expressionists.

Modern Pioneers

Alfred H. Barr, Jr., *The Museum of Modern Art: First Loan Exhibition, New York, November 1929: Cézanne, Gauguin, Seurat, van Gogh*, **1929**, pages 11, 12, 14, 15, 16, 20, 21, 22, 23, 24, 26, 27

By the painters of the first quarter of the 20th century, four men of previous generations were especially honored as pioneers who founded new traditions and, more important perhaps, rediscovered old ones.

They are [Paul] Cézanne and [Georges-Pierre] Seurat, [Paul] Gauguin and [Vincent] van Gogh.

Cézanne and Gauguin died about 1905, Seurat and van Gogh about 1890, almost forty years ago. Yet so revolutionary are certain aspects of their work that it is still subject to misunderstanding and, for a recalcitrant few, battleground of controversy.

All four had one element in common—Impressionism as a point of departure, as a background from which their individual attitudes emerged. Since late medieval times painters had been stimulated and seduced by various problems in the "realistic" imitations of nature. Anatomy, the appearance, structure, and movement of the human body, making painted forms round by sculpturesque modeling in light and shade, giving the illusion of space by perspective, each of these scientific problems was solved by groups of research specialists. The impressionists . . . were specialists in the problem of outdoor lighting and, like that of their predecessors in science, their art was unbalanced, eccentric in relation to the great "central" tradition of European painting. For in their eager effort to represent the shimmer of sunlight they lost interest in definite convincing forms, in arrangement and composition, as well as in all dramatic and psychological values. . . .

During the early eighties Cézanne, Seurat and Gauguin and a little later van Gogh, worked in the Impressionist manner. But before 1890 all four had come out of the Impressionist blind-alley, though by very different paths. Cézanne and Seurat gradually modified Impressionism but Gauguin and van Gogh rebelled against it far more suddenly and overtly. It is not surprising therefore that their heresies, more conspicuous and more easily understood, should have become powerful influences considerably before the subtle and profound discoveries of Cézanne and Seurat. . . .

Subject matter, "human interest," was of considerable importance to Gauguin. Whoever looks at his work as mere decoration or experiment in "form" sadly misconstrues the intention of the painter. . . .

[August] Strindberg wrote of Gauguin: "Who then is he? He is Gauguin the wild man . . . the titan who, jealous of his creator, knocks together a little creation of his own at odd moments; a child who destroys his toys to make new ones of the fragments; a man who challenges ordinary opinion, who prefers to paint the sky red instead of blue." But Gauguin wrote of himself: "I have escaped from the false and have entered into Nature confident that tomorrow will be as free and as lovely as today. Peace wells up within me."

As early as 1890 Gauguin gained an important place among the progressive younger painters of the period. . . . [Maurice] Denis writes: "Gauguin freed us from all the restraints which the idea of copying nature had placed upon us. For instance, if it was permissible to use vermilion in painting a tree which seemed reddish . . . why not stress even to the point of deformation the curve of a beautiful shoulder or conventionalize the symmetry of a bough unmoved by breath of air? Now we understood everything in the Louvre, the Primitives, Rubens, Veronese."

This is of the greatest importance, for it is one of the earliest deliberate statements of an attitude which has dominated painting during the last thirty years. . . .

Vincent van Gogh had neither the intelligence nor the hardihood of his friend Gauguin. He was passionately single-minded, a fanatic whether in love, religion, or art. His pathetically tragic life is too well known to need recounting. "To what end can I be put? What purpose can I serve? There is some power within me but I know not what it is.". . .

Under the burning sun of Provence he at last discovered himself. For six months during the summer of '88 he worked continuously with the most violent energy. He painted in bold unbroken patches of scarlet, startling greens and yellow. His brush swirled and leapt in staccato rhythms as if he found joy in the very action of his hand and wrist. . . . He sees with such intolerable intensity that painting alone can give him release from his torment. Van Gogh the evangelist is transmuted into van Gogh the artist, the seer, the mystic, apprehending,

making visible the inner life of things. . . .

From 1880 till his death in 1906 Cézanne saw his path lying clear before him. It was a synthesis of his baroque and Impressionist decades. Twice he defined his program: "We must make of Impressionism something solid like the art of the museums." And, again: "What we must do is to paint [Nicolas] Poussin over again from nature." In these pregnant sentences he insists both upon the importance of tradition and the validity of contemporary discovery. . . .

With the exception of his early work and the sporadic *baignades* and *bacchanales* which appear during the '80's and '90's, Cézanne was purely a realist, that is, he depended entirely upon the look of things which he made no conscious effort to alter. But he looked not once as might, ideally, an Impressionist but a thousand times. . . .

Such was Cézanne's dependence upon the stimulation given him by the object—whether human, landscape, or the convenient apple. "One cannot be too scrupulous or too sincere or too submissive to nature; but one should be master of one's model and certainly of one's manner of expression.". . .

What did Cézanne really see in nature? Let him answer: "An optical sensation is produced in our eyes which makes us classify [grade] by light—half tones and quarter tones—each plane represented by a sensation of color." He gives us here the key to the technical understanding of his later work. Each plane of light in nature is represented on his canvas by a plane of color. If we examine a landscape, or a still life, we find the paint broken up into a series of small planes, each one of which, especially in the landscapes, is made up of several subtly graded parallel strokes and hatchings. By this technique which Cézanne developed only after twenty years of painting he "realized" what he modestly called his "petite sensation.". . .

While we study a Cézanne we can feel . . . [color] planes shifting forward and back, taking their appointed distances until after a time the painted world into which we are drawn becomes almost more actual than the real world. The grandeur of a Poussin is perceived, is read, remains as it were at arm's length. But a great Cézanne is immanent; it grows around one and includes one. The result is at times almost as hypnotic as listening to great music in which strength and order are overwhelmingly made real. . . .

Seurat's theory of art rested upon a very simple and purely formal aesthetic. He believed that the art of painting depended upon the relations between tones (lights and darks), colors, and lines, and on the harmony of these three elements. . . . He asserted that color in painting should consist only of "red and its complementary green, orange and blue, yellow and violet." He then proceeded to apply these six primary colors systematically in little round dots of equal size, thereby eliminating, theoretically at least, all trace of the personal "touch." He even painted the frames in such a way that their colors were complementary to the adjacent colors in the picture. . . .

Seurat was the inventor of a method, the constructor of a system without parallel in the history of art for its logical completeness. What other man, artist or layman, came so near realizing the 19th century illusion of possible perfection through science? But Seurat, the artist, was greater than Seurat, the scientist. In his work, from the least drawing to the most elaborate composition, great intelligence is complemented by consummate sensibility. . . .

Gauguin whose burning color and exotic sentiment conceal somber power; van Gogh the master—and victim—of spontaneous artistic combustion; Cézanne arriving by infinitely patient trial and error at conclusions which have changed the direction of the history of art; Seurat who proves that great art can proceed from cool exquisite calculation; here are four painters!

Paul Signac

Opus 217. Against the Enamel of a Background Rhythmic with Beats and Angles, Tones, and Tints, Portrait of M. Félix Fénéon in 1890. 1890
Illustrated on page 81

Kirk Varnedoe, *Masterpieces from the David and Peggy Rockefeller Collection: Manet to Picasso*, **1994**, page 38

In the hands of [Georges-Pierre] Seurat, the myriad dots of pointillist painting had proved especially well-attuned to conjuring the tint of sunsets, the half-light of gas lamps, and afternoon shadows. Yet here Seurat's younger cohort Paul Signac deploys pointillism in the service of a giddy carnival of colors and a boldly flattened pinwheeling pattern; and sets in its midst, sternly reserved and decorous, a caricaturally sharp profile of the art critic Félix Fénéon, one of the prime supporters of Seurat's and Signac's Neo-Impressionism.

Fénéon (whose resemblance to the archetypal Yankee, "Uncle Sam," is here played up) shared with Signac the belief that a new aesthetics could be based on hidden mathematical laws of relationship between the hues and vectors of visual experience and the viewer's emotional response. As a believer in the doctrines of anarchism, he felt these universal laws would serve the broad projects of educating the working classes and promoting new orders of social harmony. Accordingly, the wheel of color and pattern behind his

figure was intended in part to demonstrate the ideas of Charles Henry, one of the prime theorists of the new "scientific" aesthetics. The precise meanings of the demonstration and of the various symbols—the lily in Fénéon's hand or the stars behind him—are often debated. What is unmistakably clear, in any event, is that the elaborately titled picture has the coded references, not just of esoteric theory, but of an elaborately staged in-joke. Conceived in a spirit of subversive conspiracy by its author and its subject, the portrait was designed from the outset to be both shocking and mystifying. It suggests a lost moment in the early modern era when it could be imagined that art might reconcile science, beauty, and social reform, and all in high spirits.

Signac

Opus 217. Against the Enamel of a Background Rhythmic with Beats and Angles, Tones, and Tints, Portrait of M. Félix Fénéon in 1890
Illustrated on page 81

Jodi Hauptman, in *Masterpieces from the David and Peggy Rockefeller Collection: Manet to Picasso*, **1994**, page 77

The subject of this portrait, Félix Fénéon (1861–1944), began a distinguished career as a partisan of contemporary art and literature by contributing brief reviews in a concise and evocative style to several of the short-lived periodicals devoted to the arts that proliferated in Paris in the 1880s. At that time he held a clerical post in the Ministry of War, a position he subsequently lost as a result of an ardent and lifelong commitment to anarchism. . . . Accused of setting off a bomb in 1894, he was imprisoned for several months that year but not actually convicted. Although never proven, it is generally accepted that Fénéon did indeed fabricate a small bomb, detonating it at the luxurious restaurant in the Foyot Hotel in the Latin Quarter.[1] Upon his acquittal, Fénéon became involved with the most important avant-garde periodical of the time, *La Revue blanche*, and was instrumental in publishing there the work of the major Symbolist writers as well as sponsoring on the magazine's premises exhibitions of young artists. . . .

Contemporary viewers, many of whom knew both artist and subject, were startled and disconcerted when this painting was first exhibited at the Salon des Indépendants in the spring of 1891. Camille Pissarro wrote to his son Lucien of this "bizarre portrait of Fénéon, standing, holding a lily, against a background of interlacing ribbons of color which are neither decorative nor comprehensible in terms of feeling, and do not even

give the work decorative beauty."[2] Reviewing the exhibition, the critic Gustave Geffroy dryly commented, "My taste for explication stops short in front of the painting labeled 'Sur l'émail . . . portrait de M. Félix Fénéon en 1890'";[3] and the Belgian poet Emile Verhaeren wrote: "This cold and dry portrait can hardly please us as much as the landscapes by the same painter."[4]

One critic, perhaps alerted by Signac or Fénéon, displayed greater insight into the meaning of the work. Arsène Alexandre noted: "M. Signac, who is very fervent and bold, has portrayed a model against a synthetic background of curves and associated tones, in which one must see, not the simple caprice of a colorist, but an experimental demonstration of the theories on color and line which will soon be published in a work by the artist in collaboration with M. Charles Henry."[5] The painting is, in fact, a pictorial illustration of current aesthetic ideas that had preoccupied both artist and subject and, in its programmatic character, it reflects both Neo-Impressionist theory and Symbolist thought.

Georges-Pierre Seurat

Evening, Honfleur. 1886
Port-en-Bessin, Entrance to the Harbor. 1888
Illustrated on page 82

Daniel Catton Rich, *Seurat: Paintings and Drawings*, **1958**, pages 15–16, 19, 20

Neo-impressionism might be defined as the light that failed. Its chief claim—based on certain laws of physics—was greater luminosity; actually the "division" of colors through dots and tiny strokes produced greys and neutrals that extinguished the very brilliance its artists desired. . . . The neo-impressionists, though acknowledging the contribution of the impressionists, found their predecessors careless and romantic. They disliked their fluid, dissolving vision, demanding a return to form and structure. They found pseudo-scientific formulas to justify their experiments, though like the impressionists, they employed the same subjects, landscapes and scenes of daily life. The new movement did accomplish one reform; carefully employed, its method created an effect of depth no impressionist could rival. This return to the third dimension from the impressionists' fleeting web of color and light was one of Seurat's chief contributions. . . .

While Seurat spent on the average of a year on each of his more ambitious compositions, which one by one seem to demonstrate the application of his theories, he objected to having them called pictures with a thesis. And almost every summer he left Paris to go to the coast of Brittany or Normandy "to wash," as he said "the stu-

dio light" from his eyes and "to transcribe most exactly the vivid outdoor clarity in all its nuances." During his lifetime Seurat's landscapes were often admired by those who refused to accept the daring stylizations of his larger canvases. They are deceptively simple and seem, at first glance, to be close to the impressionists in theme and effects of atmosphere. But upon further acquaintance they appear as original as his major works. Seurat often emphasized a wide, broad frontal plane; in some of his first landscapes this was made by a meadow beyond which, carefully simplified into geometric patterns, appear houses, roofs and a band of trees. He employed much the same plan for a number of his seascapes, where the sand or shore serves as a base and where in a series of horizontal planes, distant piers, ships or horizon again and again reinforce a mood of calm detachment. . . .

Seurat felt, to judge from reports by his contemporaries as well as from his own brief utterances, that he was applying with the invincible logic of the scientist, a series of optical principles to the making of works of art. Such consistency was part of his temperament; one must remember that he was rigidly trained in the strict, academic schools of the day, and when he discovered the laws of contemporary physics respecting color and light, he adopted them eagerly, substituting for the old worn out rules of picture-making the new rules of science. To the nineteenth century mind, science opened a door upon imagination and the creative future. Its promises were immense and many of the best artists of the century were vastly stimulated by the new vision of this expanding universe. In Seurat we have one of the first examples of the artist-scientist which was to become—in our century—a well-defined type. Seizing upon certain concepts of natural science, he is driven to continuous, unending experiment in the course of which he "explains" or rationalizes his point of view. Seurat, indeed, seemed to derive a certain aesthetic delight from the very practice of art *as* science.

Vincent van Gogh

The Olive Trees. 1889
The Starry Night. 1889
Illustrated on page 83

John Rewald, *Post-Impressionism: From van Gogh to Gauguin*, **1978**, pages 312, 321–22

In [a] letter the painter reported: "I did a landscape with olive trees and also a new study of a starry sky. Although I have not seen the last canvases painted by either [Paul] Gauguin or [Émile] Bernard, I am fairly convinced that these two studies which I just mentioned are done in a similar spirit [to theirs]. When you will have had these two studies before your eyes for a certain time, as well as the one of ivy, then I may be able to give you a better idea than through words of the things that Gauguin, Bernard and I have sometimes discussed and that preoccupied us. This is not a return to the romantic or to religious ideas, no. Nevertheless, while deriving from [Eugène] Delacroix more than might appear, in color and through a draftsmanship that is more intentional than the exactness of *trompe-l'oeil*, one can express a rustic nature that is purer than the suburbs, the taverns of Paris. . . ."[1]

[Van Gogh's] *Starry Night*, with its sleeping houses, its fiery cypresses surging into a deep blue sky animated by whirlpools of yellow stars and the radiations of an orange moon, is a deliberate attempt to represent a vision of incredible urgency, to liberate himself from overpowering emotions rather than to study lovingly the peaceful aspects of nature round him. The same tendency and the same use of heavy outlines appear in several other paintings done at that time, particularly a landscape with silver-green olive trees in a rolling field with a range of undulating blue mountains in the background, over which hovers a solid white cloud. In a letter to his brother [Theo], van Gogh tried to explain what he had wanted to achieve: "The olive trees with the white cloud and the mountains behind, as well as the rise of the moon and the night effect, are exaggerations from the point of view of the general arrangement; the outlines are accentuated as in some of the old woodcuts." And he went on to say: "Where these lines are tight and purposeful, there begins the picture, even if it is exaggerated. This is a little bit what Bernard and Gauguin feel. They do not care at all about the exact form of a tree, but they do insist that one should be able to say whether its form is round or square—and, by God, they are right, exasperated as they are by the photographic and silly perfection of some painters. They won't ask for the exact color of mountains, but they will say: 'Damn it, those mountains, were they blue? Well then, make them blue and don't tell me that it was a blue a little bit like this or a little bit like that. They were blue, weren't they? Good—make them blue and that's all!'"[2]

Vincent van Gogh

Portrait of Joseph Roulin. 1889
Illustrated on page 84

Kirk Varnedoe, *Van Gogh's Postman: The Portraits of Joseph Roulin*, **2001**, pages 1–5

Roulin was not a door-to-door letter carrier, but an official in charge of sorting mail at the Arles railway station. His rank bolstered his pride in the blue uniform, ornamented with gold buttons and braid, that he seems to have worn night and day. He probably met van Gogh

soon after the artist arrived (they lived on the same street), and he was among the first to consent to pose when van Gogh decided to paint an array of picturesque local figures. In various letters, the artist sized up his subject as "a man more interesting than most," and noted his distinguishing characteristics: a short-nosed physiognomy, reminiscent of Socrates; the flushed coloration of a heavy drinker; and vehemently populist politics.

The letters attest that van Gogh's first portrait of Roulin, done in the early days of August, was the seated half-length image—with erect torso, sprawled arms, and huge, gothically crimped hands—now in the Boston Museum of Fine Arts. But, concerned by the awkwardness with which his sitter posed, the artist almost immediately began another head-and-shoulders picture (now in The Detroit Institute of Arts), and worked on both simultaneously. Still getting to know Roulin, he may have thought of these pictures as capturing a type more than probing an individual. He spoke of treating the postman in the manner of [Honoré] Daumier, the renowned master of caricature, and boasted of having done the head-and-shoulders image on the fly, in a single session.

During these initial sittings, Roulin's wife gave birth to their third child. It was an event that had the postman glowing with pride and that doubtless increased the estimation in which van Gogh—perpetual loner, tormented by his sterile alienation from love—held him as a figure of virile energy. In November, van Gogh pursued a concerted series of portraits of the whole Roulin family, including the two sons, aged eleven and sixteen. It was in this context that he made his third oil portrait of the father, now in the Kunstmuseum Winterthur. The slightly stiff alertness of the initial encounter in August was replaced by a tilted head and a more distant, possibly melancholy, expression. The forms of this painting are bounded in softly heavy outlines, with the features and beard rendered more summarily, and its yellow ground may reflect experimentation with the decorative strategies favored by van Gogh's fellow painter Paul Gauguin—who by then had come from Brittany to live and work with him in Arles.

These two artists had sharply different temperaments and ideas about art, and Gauguin's sojourn produced a friction that culminated, notoriously, in an emotional explosion in late December, during which van Gogh severed his own ear. Following that incident of derangement, it was Roulin who took the artist home, then saw him into the hospital, looked after his affairs during recuperation, and shepherded his efforts to return to normal life. Never were the postman and the painter closer, nor van Gogh more in debt to their friendship, than during these weeks. But the artist's let-

ters give no indication of any new posing before January 21st, when Roulin left Arles for a better-paying post in Marseilles. Since the two men saw each other only intermittently thereafter, scholars have speculated that the remaining portraits may not have been painted from life but from earlier pictures and from memory. These last portraits are now in the Barnes Foundation, the Kröller-Müller Museum, and The Museum of Modern Art. Their dating and sequence are still debated. Nearly identical in scale and in their head-and-shoulders format, they share a hieratically frontal, mug-shot pose, a roiling beard, and (in varying degrees of graphic intensity) a backdrop of a wallpaper-like floral pattern, parallel with other portraits van Gogh conceived that January. The Museum of Modern Art's picture is the most intensely stylized of these works. In it, Roulin's beard takes on a cascading turbulence like that of van Gogh's characteristic cypress trees, and the whorling floral backdrop seems akin to the sky of *The Starry Night* [see page 83]. The artist's deepened feeling for this compassionate friend and protector, expressed through a newly aggressive commitment to the abstracted means of patterned linear energy and heightened color, yielded an imposing, elevated icon of Roulin's persona, sharply transformed from the more garrulous, naturalistic characterizations of the previous summer.

Paul Gauguin
Portrait of Jacob Meyer de Haan. 1889
Illustrated on page 85

John Elderfield, *The Modern Drawing: 100 Works on Paper from The Museum of Modern Art*, **1983**, page 24

[This painting] was made in the Breton village of Le Pouldu, probably at Mlle Marie Henry's inn, where Gauguin and his friends (among them [Jacob] Meyer de Haan) covered virtually all of the dining room with painted decorations—including even the cupboard doors, where [this work] was originally located. . . .

Hovering over the work is Gauguin's preoccupation with a lost paradise and the Satanic temptation to lust that forfeited it; also with a redeeming spiritual order within nature, and with the artist as seer who illuminates it. Meyer de Haan (although in fact a deformed dwarf) appears cunning and devilish. Before him are [Thomas] Carlyle's *Sartor Resartus* and [John] Milton's *Paradise Lost*. The former has as its hero an angelic-demonic split personality; it refers to the ambivalence of appearance—which, like clothing, simultaneously reveals and conceals naked reality. The latter begins by

telling "Of Man's first disobedience and the fruit/ Of that forbidden tree . . ." Beside these books we see such fruit, linked by color to de Haan; opposite them, a lamp, formally analogous to the apples but coloristically and symbolically contrary.

A part of the context is Gauguin's ambivalence about women, which saw them alternatively as sexual objects and symbols of pure love. In the latter category came his friend Émile Bernard's sister, Madeleine, to whom he wrote about the temptations of the flesh. . . . [In the former category] came presumably his mistress, the maid of the inn, and certainly Mlle Henry, the plump innkeeper, whom Gauguin jealously pursued, losing her however to de Haan . . . The painting of de Haan as a lustful devil matched one of Gauguin, ironically portrayed as Milton's fallen angel, on the other cupboard door.

Just at this time, Gauguin sent to Madeleine Bernard, as a pledge of "fraternity," a modeled pot showing himself as a grotesque savage with his thumb in his mouth. It was based on a self-portrait in a Le Pouldu carving which grasps despairingly at a plump (possibly pregnant) "sexual" woman (Mlle Henry?), saying to her: *Soyez amoureuses et vous serez heureuses.* Was it, perhaps, an act of wish-fulfilling transference, or guilt, that fused this image with that of the actual seducer . . . making it . . . an autobiographical companion to the self-portrayal as Satan? The question cannot be answered, for it asks about the unknowable. The demonstrable is silent and refuses to tell.

Paul Gauguin
The Seed of the Areoi. 1892
Illustrated on page 85

William Rubin, *The William S. Paley Collection*, **1992**, pages 50, 53, 55

The painter's title [*Te aa no aerois*], which means the seed . . . of the Areoi—a Polynesian secret society that had disappeared long before Gauguin's stay in Tahiti—refers directly to the principal poetic symbol in the picture, the flowering seed that the young girl holds in her hand.[1] This motif stands for the procreative potential of the girl herself, less in her real-life role as Tehura, the painter's thirteen-year-old native mistress, than in the form Gauguin has imaginatively envisioned her: as Vaïraümati, the mythic earth-mother of the Areoi sect. . . .[2]

In his writings and statements, Gauguin led one to believe that he learned about . . . Maori legends directly from Tehura, thus implying that he was painting these subjects in the context of a living tradition.[3]

But with one or two aged exceptions, to whom Gauguin did not have access, the last of the "storytellers" who knew these legends had died generations before Gauguin's trip to the Society Islands, and the old religions had long since been displaced by Christianity.[4] In fact, Gauguin discovered the myth not through personal contacts but in an early travel book he had borrowed, Jacques-Antoine Moerenhout's *Voyages aux îles du Grand Océan*—a text replete with mistaken accounts and anthropological errors. . . .

By painting Tehura as Vaïraümati, Gauguin implies that the way of life of the Tahitians of his day was still part of a continuous cultural cycle though, in fact, it had been profoundly altered by the advent of colonialism. He clung to this idea because his willfully anachronistic vision of Tahitian society provided him an ideal alternative model against which to set the supposedly debased European culture that he abhorred. Describing himself often as a *sauvage*, and asserting that he could not find happiness except in a "state of nature" (which he wanted to believe could still be found in Polynesia), his casting of Tehura as the mother-goddess of the Maori people placed him by extension, as her real-life paramour, in the role of the creator-god Oro. This poetic parallelism between the artist and a deity was not new to Gauguin's psychology; during his Brittany period, he had painted a self-portrait which posited a parallel between himself and the crucified Christ.[5] The reference there was to the artist as sufferer; here the allusion would be to his role as a creator. . . .

In *The Seed of the Areoi*, the resonance of complementaries (purple against yellow) in the background, and neighboring tones (red, yellow, and brown) in the foreground, forms an exquisite color chord, but of a kind that nevertheless struck the turn-of-the-century public as shocking. Perhaps to "rationalize" his work and thus make it more acceptable, the artist liked to claim he discovered his palette in the Tahitian landscape: ". . . the landscape with its bright, burning colors dazzled and blinded me . . . [I]t was so simple to paint things as I saw them, to put on my canvas a red and a blue without any of the calculation [of his earlier work]."[6] But even at their brightest, the visual realities of the Polynesian village and landscape are far from the palette we see in Gauguin's paintings, and his suggestion that his color was merely—or even primarily—a transposition of what he *saw* ironically denies us the full measure of his genius.

Henri Rousseau

The Sleeping Gypsy. 1897

Illustrated on page 86

Henri Rousseau

The Dream. 1910

Illustrated on page 87

Michel Hoog, *Henri Rousseau*, **1985**, pages 140–41

"The feline, though ferocious, is loathe to leap upon its prey, who, overcome by fatigue, lies in a deep sleep."—[Henri] Rousseau (inscription on the frame)

"A wandering Negress, a mandolin player, lies with her jars beside her (a vase with drinking water) overcome by fatigue in a deep sleep. A lion chances to pass by, picks up her scent yet does not devour her. There is a moonlight effect, very poetic. The scene is set in a completely arid desert. The gypsy is dressed in oriental costume" (Rousseau's letter to the Mayor of Laval, July 10, 1898, offering to sell him the picture).

The Sleeping Gypsy is undoubtedly the most *invented* and also the most fascinating of Rousseau's large pictures. Particularly striking is its formal perfection, the rigor in the disposition of masses, the precision of its contours, the almost miraculous placement, in which every line, every surface, and every accent finds its rhyme within the composition itself. The workmanship is careful, almost overpolished, in the manner of the academic painters. Rousseau plays delicately with light on the lion's body and on the lute, which is quite faithfully depicted, probably after an illustrative engraving in an encyclopedia. Rousseau has vaguely sketched in the features of a face in the moon. . . .

Should we regard this picture as one of Rousseau's dreams and the gypsy as a projection of Rousseau himself, the ignored artist-musician? As for the lion, we must bear in mind that in his Jungle paintings Rousseau very seldom attributed cruelty to the lion and often endowed it with the stereotyped appearance of protective King of the Beasts. . . . After the Mayor of Laval's refusal to purchase *The Sleeping Gypsy* at Rousseau's urging, the picture disappeared until 1923. It was then found by Louis Vauxcelles . . . and entrusted to the dealer D. H. Kahnweiler. There it was seen by Serge Férat, Robert Delaunay, Wilhelm Uhde, Jacques Doucet, [Constantin] Brancusi, and [Pablo] Picasso. The latter brought it to the attention of Henri Pierre Roché,[1] who alerted the American collector John Quinn, for whom he was purchasing works of art in France. The picture was sent to America. Oddly enough, it was later said that Picasso had expressed doubts as to the authenticity of *The Sleeping Gypsy* and that he had even claimed to have painted it himself.[2] Since the affair had caused talk in Parisian art circles, it is possible that Picasso, harassed with questions, took this course in order to rid himself of pests.

Daniel Catton Rich, *Henri Rousseau*, **1942**, pages 69, 73

[Rousseau's] works possess a vitality which goes beyond decoration. Each has its special mood. . . . [His] use of form and color, symbolically, explains part of the fascination of his last great work, *The Dream*, painted in 1910 and exhibited in that year at the Independents [Salon des Indépendants]. . . .

His awakened amorous spirit found sublimation, perhaps, in *The Dream*, to which he attached a poem:

Yadwigha in a lovely dream,
Having most sweetly gone to sleep,
Heard the snake-charmer blow his flute,
Breathing his meditation deep.
While on the streams and verdant trees
Gleam the reflections of the moon,
And savage serpents lend their ears
To the gay measures of the tune.

(Translated by Bertha Ten Eyck James)

There is a tradition that in his youth Rousseau had been enamored of a Polish woman named Yadwigha. . . .

His last great effort is a creative résumé of his entire career. In *The Dream* he . . . set the figure of Yadwigha on a red sofa in the midst of a jungle. This mixture of incongruous elements surprised even his friends and caused a sensation in the Independents. To a critic, André Dupont, who wrote for an explanation, Rousseau replied: "The sleeping woman on the sofa dreams that she is transported into the forest, hearing the music of the snake-charmer. This explains why the sofa is in the picture." But though the motif was thus cleared up for the literal, Rousseau was so much the artist that to André Salmon he confided: "The sofa is there only because of its glowing, red color."

The Dream is a summation of all those qualities which make Rousseau inimitable. Its organization of spaces and complex tones (an artist counted over fifty variations of green alone) is equaled by its sentiment. The plane of reality (the figure on the sofa) is inventively joined to the plane of the dream (the jungle). In it appears, in heightened form, every symbol of the last ten years of Rousseau's life, redesigned and related with a free intensity. The nude figure surrounded by enormous lilies is one of Rousseau's most perfect realizations, while the leopards peering from the jungle leaves are full of his expressive mystery.

"Tell me, M. Rousseau," [Ambroise] Vollard asked him,

"how did you get so much air to circulate among those trees and the moonlight to look so real?"

"By observing nature, M. Vollard," replied the painter, true to his ideal to the last.

As he prepared the picture for exhibition, Rousseau expressed himself as pleased. To [Guillaume] Apollinaire he wrote: "I have just sent off my big picture; everyone likes it. I hope that you are going to employ your literary talents to avenge me for all the insults and injuries I have received" (letter of March 11, 1910). These words, spoken at the end of his life, are one of the few indications we have of how much Rousseau had suffered from being misunderstood.

On September 4, 1910, he died at a hospital in Paris at the age of sixty-six. His friends were out of the city and only seven people attended his funeral, among them Paul Signac, President of the Independents. A year later a tombstone was set up by Robert Delaunay, Apollinaire and M. Quéval, his landlord. And in 1913 [Constantin] Brancusi and the painter [Manuel] Ortiz de Zarate engraved on the stone the epitaph that Apollinaire had written:

Hear us, kindly Rousseau.
We greet you,
Delaunay, his wife, Monsieur Quéval and I.
Let our baggage through the Customs to the sky,
We bring you canvas, brush and paint of ours,
During eternal leisure, radiant
As you once drew my portrait you shall paint
The face of stars.

(Translated by Bertha Ten Eyck James)

Claude Monet

Reflections of Clouds on the
Water-Lily Pond. c. 1920
Illustrated on pages 88–89

William C. Seitz, *Claude Monet: Seasons and Moments*, **1960**, pages 38, 40, 43, 45–46, 50, 52

In 1890, after the purchase of the farmhouse in which [Monet] lived at Giverny, he acquired a tract of flood land that lay across the road and the one-track railroad from his front gateway. On it grew some poplars, and a tiny branch of the Epte River provided a natural boundary. Excavation was immediately begun to result, after several enlargements of the plan, in a 100 by 300 foot pond through which the flow of water from the river was controlled by a sluice at either end. Curvilinear and organic in shape, it narrowed at the western end to pass beneath a Japanese footbridge. Willows, bamboo, lilies, iris, rose arbors, benches, and on one shore curving steps leading to the water were added, providing a luxuriant setting for the spectacle of cloud reflections and water lilies floating on the pond's surface. Except for a single gate, the water garden was fenced with wire upon which rambling roses were entwined; sealed off from the outside world it formed an encircling whole, a work of art with nature as its medium, conceived not as a painting subject, but as a retreat for delectation and meditation. . . .

In the open water Monet's gardeners were kept busy pruning groups of lily pads into circular units. Searching among them his eyes found arrangements that gradually began to exclude the shore entirely. By 1905 a new relationship of space and flatness had evolved. Its patterns are open, curvilinear, and expanding, and of a random naturalness; yet the clusters were nevertheless held in mutual attraction by a geometry as nebulous as that of the clouds whose reflections passed over the pond's surface. It is surprising how little "aesthetic distance" separates these images from photographic actuality; yet in their isolation from other things, and because of the mood they elicit, they seem, like pure thought or meditation, abstract.

It is an ironic reminder of the artist's predicament that Monet found as much anguish in struggling to represent his garden as he did satisfaction in contemplating it. . . .

The conception of an ovoid salon decorated with water landscapes probably entered Monet's mind (if he had not thought of it earlier) at this time. During the eighties he had experimented with enlarging landscapes to mural size, and combining small panels in a decorative scheme; but the enlargements lost their impressionist immediacy and the combinations lacked unity. In the water garden, however, he had already created a motif for which such a room would be the ideal equivalent. It was apparent, moreover, that the individual canvases of water lilies, though carefully composed and therefore satisfying in themselves, were also fragments that begged to be brought together in an encompassing whole. Reviewing the 1909 exhibition in the *Gazette des Beaux-Arts*, the critic Claude Roger-Marx included an "imaginary" conversation in which Monet spoke thus: "I have been tempted to employ this theme of *Nymphéas* in the decoration of a salon: carried along the walls, its unity, unfolding all the panels, would have given the illusion of an endless whole, of water without horizon or bank; nerves tense from work would be relaxed there . . . and to him who lived there, that room would have offered the refuge of a peaceable meditation in the center of a flowing aquarium."[1] . . .

[In 1918], when Monet was visited by the art dealers Georges Bernheim and René Gimpel (who had heard gossip about an "immense and mysterious decoration on which the artist worked") they saw assembled in the new studio "a strange artistic spectacle: a dozen canvases

placed in a circle on the floor, one beside the other, all about two meters [78¾"] wide and one meter twenty [47¼"] high; a panorama made up of water and lilies, of light and sky. In that infinitude, water and sky have neither beginning nor end. We seem to be present at one of the first hours in the birth of the world. It is mysterious, poetic, delightfully unreal; the sensation is strange; it is a discomfort and a pleasure to see oneself surrounded by water on all sides."[2] There were about thirty of these panels in all. . . .

The universe that Monet discovered in the suspended quiet of his water garden, and recreated in his last canvases, reawakens dulled sensibilities by cutting perception loose from habitual clues to position, depth, and extent. It is a world new to art, ultimately spherical in its allusions, within which the opposites of above and below, close and distant, transparent and opaque, occupied and empty are conflated. Nevertheless—notably in The Museum of Modern Art's breathtaking triptych[3]—equilibrium is maintained by an indeterminate horizontal; a shadowy equator before which the surrounding globe of sky, seen in the iridescent clouds that curve downward in an inverted image, becomes one with the water to form a common atmosphere. The pond's surface is only barely adumbrated by the unfinished constellations of lily pads that, like flights of birds, punctuate the expanding space.

In the darkness below, the life-rhythm that Monet worshipped is all but stilled. It is the tangibility of the work of art that keeps it alive—the saturated, shuttling color tones, the scraped and scumbled flatness of the canvas surface, the nervous tangles that will not retreat into illusion, and the few furtive stabs of white, yellow, pink, or lilac that we recognize as blossoms.

To Monet these final landscapes of water, like those of the Norman beaches, the Seine, or the open sea, were records of perceived reality, neither abstract nor symbolistic; but to him, from the beginning, nature had always appeared mysterious, infinite, and unpredictable as well as visible and lawful. He was concerned with "unknown" as well as apparent realities. "Your error," he once said to [Georges] Clemenceau, "is to wish to reduce the world to your measure, whereas, by enlarging your knowledge of things, you will find your knowledge of self enlarged."[4]

Edvard Munch
The Storm. 1893
Illustrated on page 90

John Elderfield, *The Masterworks of Edvard Munch,* **1979**, pages 7–8, 11

When Munch wrote the now famous statement in his Saint-Cloud diary of 1889—"no more interiors should be painted, no people reading and women knitting; they should be living people who breathe, feel, suffer, and love"—he was expressing a concern with emotional, meaningful, and antinaturalistic themes that was shared by very many members of his artistic generation. Like [Paul] Gauguin, [James] Ensor, and [Ferdinand] Hodler, moreover, he sought to realize these themes in intrinsically emotional, meaningful, and antinaturalistic subjects. The obvious contrast here is with [Vincent] van Gogh, who shunned subjects of this kind and for whom, therefore, there was no division between "people reading and women knitting" and "living people who breathe, feel, suffer, and love." When we compare Munch's art to van Gogh's, we see that the Norwegian required emotional characters to express emotional moods, and that the characters of his art are important not as individuals, but only as vehicles for the moods that they express. How successful they do their task seems largely to depend on whether they capture or merely personify these moods, whether what we see is more than just "a translation of abstract notions into a picture language, which is itself nothing but an abstraction from objects of the senses."

This is [Samuel Taylor] Coleridge's definition of allegory, to which he opposed symbolism's "translucence" of the specific in the individual and the general in the specific. Is this, then, to say that an art like Munch's succeeds to the extent it is symbolic rather than allegorical? Such a definition would seem to provide for the exact alignment of the personal and the general that characterizes Munch at his best. Even at his best, however, Munch is allegorical in the sense of channeling and directing the power of his art to convey a didactic content. Even at those greatest moments when his art presents itself at its most archetypal and mythic, the myths and archetypes it contains are employed rhetorically rather than being simply embodied in the work, which is therefore in one way or another "literary" and moralizing in character. There is always some sense of distance between personal emotion, symbolic code, and pictorial structure because there is always a certain allegorical quotient in Munch's art. Again the comparison with van Gogh is suggested. Munch's very dependence upon intrinsically "important" themes meant that he was denied the absolute fusion of form, symbol, and subjective emotion available to van Gogh and bound instead to seek what Robert Goldwater called (using Holdler's terminology) a state of "parallelism" between them. It is a sign, however, of the greatness of Munch's best work, particularly of his paintings and prints of the 1890s, that the "parallelism" of the elements is so exact and so closely drawn as to defy their separation.

To look at his great pictures of the nineties is to realize that Munch has harnessed within his oeuvre, and

often within individual works, two major symbolical themes of nineteenth-century art, each of which was coming to a climax when Munch was finding himself as an artist and each of which had acute personal significance for him. The source of power in his work seems indeed to reside in the way in which traumatic personal experiences allowed Munch to pass on the accumulated force of these themes and to tie them together. One was the theme of conflict between man and modern urban life; the other the theme of sexual conflict. To call one social and therefore public and the other psychological and therefore private is to avoid the fact that the social manifests itself psychologically and the psychological socially, but let these terms stand for the moment. . . .

The disjunctive character of Munch's art sets the pattern for modern Expressionism, which is likewise torn between stillness and rigidity on the one hand and vitality and chaos on the other, and between suppressed emotion and the brittle, easily shattered form in which it is encased. It also belongs, more generally, with modern Existentialist art in representing a fallen and fatalistic world of disconnected fragments resistant to being ordered—except that no sense of irony, and none therefore of resignation, attaches to this situation in Munch's case. Unprotected by irony, Munch's art takes refuge in subjectivity and in empathy. Isolated but never detached—and denied therefore the role either of reporter or of pure inventor—Munch cast himself as a kind of medium. Experiences invading the body would be transformed into a symbolic code that tells of both private emotion and public feeling. "If only one could be the body through which today's thoughts and feelings flow," he wrote in 1892, "that's what an author ought to be. A feeling of solidarity with one's generation, but yet standing apart. To succumb as a person yet survive as an individual entity, this is the ideal."

Munch
The Storm
Illustrated on page 90

Arne Eggum, *The Masterworks of Edvard Munch*, **1979**, page 24

The motif [of *The Storm*] is taken from Åsgårdstand with the Kiøsterud building in the background, well known from many of Munch's pictures. . . . The motif was inspired by the experience of a strong storm there. The storm is, however, depicted more as a psychic than a physical reality. The nervous, sophisticated brushstrokes, the somber colors, and the agitated nature are brought into harmony, rendering the impression of

anxiety and turbulent psychological conflicts. *The Storm* is also a reflection of Munch's interest in the landscapes of Arnold Böcklin. . . . [T]he illuminated windows function as an important pictorial element. The eye is drawn toward them; in a strange way, they radiate psychic life. Munch emphasized controlling the effects rendered by the illuminated windows. He has scraped out the paint around the yellow areas to achieve the maximum effect. It is as though the house becomes a living organism with yellow eyes, creating contact with the surroundings. In front of the house, a group of women stands huddled together, all with their hands up against their heads like the foreground figure in the painting *The Scream*. Isolated from the group, closer to the center, stands a lonely woman, also with her hands against her head. Like the foreground figure in *The Scream*, she represents anxiety and violent spiritual conflicts. The mood and charged atmosphere indicate that the object of the anxiety is an erotic urge. In the summer months Åsgårdstand was visited by a great number of women, since most of the summer guests consisted of families whose men worked during the week in Christiania. By now, Munch had formulated an aesthetic which dictated that in his most important motifs, he should represent pictures of recollection as well as the artist's psychological reactions to them. He also made a small woodcut of this motif.

Odilon Redon
Green Death. c. 1905
Illustrated on page 91

John Rewald, *Odilon Redon. Gustave Moreau. Rodolphe Bresdin*, **1962**, page 40

Redon's subjects were only simple incidents in the general arrangement of colors and forms. No doubt his horror of empty, white surfaces continued to prompt him to start each pastel by scrawling chalk colors on his sheet to "bring it to life" and to invoke inspiration. It seemed immaterial whether a subtle expanse of clouds was enhanced by a cavalcade of horses and transformed into a representation of Phaeton, whether some mysterious cliffs and swelling waves were complemented by small figures which turned the scene into Perseus delivering Andromeda, or whether almost abstract forms floating on a neutral background were adorned with vague floral ornaments and thus became purely invented animals of the sea. All that mattered was that colors, space, design, texture, composition were organized according to the dictate of Redon's creative will.

That this will continued to obey his inspiration relieved the artist of the necessity of using color realistically; on

the contrary, it induced him to the greatest freedom, of which he took full advantage. No wonder then that André Masson has called Redon "perhaps the first really free colorist," crediting him with the demonstration of "the endless possibilities of lyrical chromatics." According to Masson, Redon invented "color as metamorphosis," and used his "tight-rope hues to the limits of the possible."[1] Indeed, the figures and the faces, the aquatic fauna and the butterflies, but above all the unending succession of fabulous blossoms which Redon brought into existence make no pretense at representing natural truth. They are, more often than not, prolongations of dreams, happy dreams vying with the splendors of the rainbow.

In the late nineties, Redon took up his brushes again, not to put them down anymore. He now used both pastel and oils to explore the realm of color. In his oil paintings he found new attraction in surface texture, from thin washes to heavy impasto, often combining them on the same canvas.

In the same way in which his first lithographs had been transpositions of earlier drawings, some of his paintings were translations of subjects previously treated in lithographs. The ironic Death, whose image continued to haunt the artist, reappeared, surging through intense tonalities.

James Ensor

Masks Confronting Death. 1888
Illustrated on page 91

Libby Tannenbaum, *James Ensor*, **1951**, pages 47–48, 52–54, 80–81

Ensor's name has become almost synonymous with masks. So completely were they finally to usurp his interest in the human figure itself that in his later years when the painter approached portraiture, his figures are conceived as a reanimation of the masks on a mechanical rather than an organic level in that the figures become puppets.

The source of the masks was the carnival which was most elaborately celebrated in Ostend [Belgium], where the natives have little work during the long dull winter season. . . . The mask was . . . dissociated from the carnival to become an abstraction of the frightening and the terrible. . . . Like all moralists, Ensor sought the allegory, and with society failing to provide any significant pattern which might measure and describe the world, he was thrown back upon his own experience. And here he was particularly fortunate in this deeply personal and at the same time traditional world of the masks which were sold in the family souvenir shop.

This world of masks heralds the beginning of the expressionist movement: within it, Ensor is at complete liberty to distort for effect. And yet, intensification and exaggeration of expression being implicit in the very convention of the mask, he avoids the expressionists' need to justify their right to distort. Ensor is able to move swiftly in a direction which was opened to the artists of France and Germany only after a long and arduous tentative period of theorizing. Here in Ostend, he found in the carnival mask the vivid concentration of meaning for which [Paul] Gauguin was to search in Tahiti and the next generation in African art. The cruelties and absurdities of his personal milieu he was able to project on an abstracted and universal plane which makes him the first of the artists of the *Weltangst* which characterizes so much of late nineteenth- and twentieth-century expression. It is this isolated creation of an art out of the personal and the local that has made Ensor one of the baffling originals. It is his genius for recognizing the elements out of which a new art must be molded that marks his significance as artist-innovator. . . .

Ensor was never himself a socialist. He was too distrustful of the resources of mankind in any positive direction. Outside his art, James Ensor's life is actually a singular personal record of lack of event rather than event. The only alternative to a life whose very premises dismayed him was the death which would assuredly come to him whether he willed it or not. If he was born into a withering souvenir shop in Ostend, there he would remain, a torn lace curtain across the shop window when he died almost a century later—but the masks, the sea shells, the hatreds and the jokes of the shop transmuted by genius.[1]

Hilaire-Germain-Edgar Degas

At the Milliner's. c. 1882
Illustrated on page 92

John Elderfield, *The Modern Drawing: 100 Works on Paper from The Museum of Modern Art*, **1983**, page 16

This wonderful, virtuoso pastel by Degas seems traditional in its subordination of color to tonal shading. The coherence of the work is not, principally, a function of color, or hue, itself, but of the tonal armature that, running through the work (even across the most vivid contrasts) like a connecting tissue, mutes down to subtly modulated variations between black and dark green or between brown and ocher the areas of color that define the subject. This said, however, color does not read simply as an attribute of modeled form. Not only are few

areas of the pastel in fact fully modeled, but shifts of tonality, or value, read also and coincidentally as shifts of color, so that the composition of the work is given as a bold and flattened patterning of strongly contrasting color values. Color achieves its effectiveness not through purification, not through escape from tonality. It is not by expelling but by exaggerating and by balancing the tonal components of color that Degas makes it effective in a new way.

By drastically narrowing the range of tones visible in any single color area, Degas (like [Édouard] Manet before him) flattens each area to the surface. Since color is a property of surfaces, he thereby draws attention to the coloredness of these areas; even the darkest of them reads as colored. By counterposing such areas, however, he retrieves his work from the airlessness that can stultify an allover flattened surface. The contrasts of value give and take space across the spread of the surface, being assisted in this by the oblique viewpoint of the drawing, which pries the subject from frontality, allowing air to circulate among the forms. But the surface is insisted on: by the cropped-out nature of the composition, which draws attention to its edges, flattening whatever is near to them; by the central focus of interest, that empty, floating, and flattened bonnet, which advances to the surface even as the customer is waiting to try it on (she is, in fact, the American painter Mary Cassatt); and by the connecting fibrous substance of the pastel medium itself.

Pastel assumed new importance for drawing toward the end of the nineteenth century as part of a new preoccupation with color. Here it clings tangibly to the surface like accumulated dust, carrying within its very particles the delicately tonal color from which the work is constructed. Its inherent fragility is entirely appropriate to the fleeting and fugitive moment that it shows.

Édouard Vuillard
Interior, Mother and Sister of the Artist. 1893
Illustrated on page 93

Andrew Carnduff Ritchie, *Édouard Vuillard*, **1954**, pages 7, 10, 12, 13

Édouard Vuillard was a strangely complex personality.... His origins were petty bourgeois and, despite his later associations with a somewhat fashionable set in Parisian society, he remained in all essentials a petty bourgeois to his death. He was a retiring, silent, even timid little man, given only occasionally to bursts of anger. He suffered from a kind of melancholy or ennui, which he endured patiently. He was a great reader on art and was devoted to the poetry of [Stéphane] Mal-

larmé; he read Paul Valéry, Jean Giraudoux and all of [Charles] Baudelaire[1]....

About 1890 Vuillard reached a crisis in his early career. In this year [Pierre] Bonnard occupied a small studio at 28 rue Pigalle, and Vuillard joined him there together with Maurice Denis and [Aurélien-François] Lugné-Poë. He apparently could no longer deny the almost religious fervor of his friends. The symbolist movement, with which the Nabis were in sympathy, was then at its height. Mallarmé in poetry and [Paul] Gauguin in painting were two of its leaders. In some ways a latter-day revival of the romantic movement of the first half of the nineteenth century, it sought to counter the documentary realism of the naturalist movement in letters, typified by the novels of [Émile] Zola, and the literal translation of visual sensations by the impressionist painters. At the same time it fought the neo-classic verse techniques of the academic poets, the so-called Parnassians, and the mechanical "finish" of academic painters like [William] Bouguereau and [Jean-Léon] Gérôme. Led by [Paul] Sérusier, who has been called St. Paul to Gauguin's Christ, the Nabis derived their first inspiration from the latter's school of Pont Aven. Émile Bernard, the admirer of [Paul] Cézanne, was with Gauguin there and he, more than anyone in the Pont Aven circle, provided the theoretical basis for most of the master's anti-impressionist theories....

Vuillard's reaction to these symbolist theories, which were also called synthetist and neo-traditionist, is to be seen in his paintings of 1890–92.... [H]e took from the synthetist credo only its technical formulations on color and drawing and, unlike all the other Nabis with the exception of his friend Bonnard, avoided the anecdotal, peasant subjects inspired by Gauguin or the Pre-Raphaelite-like primitivism of Maurice Denis' religious pictures.

Like Bonnard he chose to stick to the world he knew intimately, in his case his home and his mother's workroom or, if he went outdoors, the familiar parade of people in the parks and gardens of Paris. This choice of subject matter has, in fact, a closer relation to the impressionists than to the symbolists....

Vuillard may well have been influenced by this impressionist approach to reality, but he added another dimension to his perception of it.... Vuillard's eye and temperament found a different meaning in the common things about him. Having explored to his complete satisfaction the extreme possibilities of the redness of red, the greenness of green, the blueness of blue, and having "assembled" his colors in a striking variety of orders, retaining to the full the flatness of his panel or canvas, he proceeded to explore as early as 1893, in what one feels is a Mallarméan spirit, the mysterious possibilities

of an infinite gradation of color hues to extract thereby the subtlest overtones, the essential perfume of intimate objects and activities in and about his home.

Paul Cézanne
L'Estaque. 1879–83
Illustrated on page 97

William Rubin, *The William S. Paley Collection*, **1992**, pages 28, 31

In selecting his motif for this painting, Cézanne set his easel on a hillock which gave a view of the rooftops of the town on the left and the bay of L'Estaque in the distance. The great stone cliffs which rise abruptly on the right of the canvas suggest that Cézanne's location was just above the house he had rented in 1882. In May of that year the artist wrote to his friend Émile Zola in Paris that he had taken a house situated up from the level of the railroad station "at the foot of the hill where behind me there are pines and the cliffs begin."[1]

Unlike most of the landscapes Cézanne painted from high vantage points, which are primarily vistas that open onto unenclosed and often vast spaces, the artist chose here to emphasize compression and tautness both in the closure that marks his composition and in the limited morphological range he gives his angular "constructive" brushstrokes. The large pine and the rooftops at the left, and the startlingly angular ascent of the stone cliffs on the right, serve to drive the eye back constantly to the space of the center foreground rather than inviting it to browse through the depth of the pictorial field. Two roughly diagonal lines of pictorial force formed by the cliff on the right and the pines and rooftops on the left come together to suggest a pyramid balancing on its apex—a typically Cézannian inversion of Old Master compositional principles. . . .

The Impressionists had conceived the canvas as something of a counterpart to the retina, whose screen of rods and cones reacted to the myriad *petites sensations* of colored light focused on it by the eye's lens. In recapturing for painting something of the pictorial architecture the Impressionists had excised from it, Cézanne nevertheless made use of the Impressionists' own optical building blocks, "becoming classical again through nature," as he put it, "that is to say, *by way of sensations.*"[2] But Cézanne's particular transformation of their formula depended on rejecting the Impressionist notion that in the mosaic of retinal sensations which make up the visual field, each tessera, so to say, was of equal value. Rejecting [Claude] Monet's and [Auguste] Renoir's art as too exclusively dependent on the passive eye, Cézanne gave the mind equal emphasis, so as to

guarantee "the logic of organized sensations."[3] In practice, this meant selecting out and elaborating upon those *petites sensations* that lent themselves to the artist's bent for construction.

Paul Cézanne
Boy in a Red Vest. 1888–90
Illustrated on page 95

Kirk Varnedoe, *Masterpieces from The David and Peggy Rockefeller Collection: Manet to Picasso*, **1994**, page 30

This painting, which once belonged to Cézanne's friend Claude Monet, is one of four showing the same subject in slightly varying poses. The young Italian who posed was, unusually for Cézanne, a professional model; but nothing is known that would convincingly explain the meaning of the costume or shed light on the particular conjunction of grandly draped setting and relatively casual posture. Here, as in the great Cézanne *Bather* (c. 1885) already in the Museum's collection [see page 94], an undramatized confrontation with an apparently stock studio subject results in a painting of deep fascination and beauty. Slightly hunched, inert, and passively inexpressive in terms of conventional cues, the sitter still seems endowed with a complex inner life. The device of the dark drape gives the light sleeves great volumetric presence, allowing them to set off the note of clear red in the protruding vest; similarly, the dark shadow in the drape sets off the boy's profile. Yet the life of the work lies not so much in the major elements of the composition—such as the large interlocking reverse sweeps of that drapery, which move in nascent pinwheel fashion around the bent body of the youth—as in smaller moments: the subtle parallelisms and rhymes of large and small contours; the specific physiognomy of minor moments such as the folds in the shirt or the notching angles of the vest and sleeves; and the constant, unpredictable dialogue of sharply drawn and gently constructed passages of painting.

Cézanne
Boy in a Red Vest
Illustrated on page 95

Jodi Hauptman, in *Masterpieces from The David and Peggy Rockefeller Collection: Manet to Picasso*, **1994**, p. 73

Although it has not been possible to verify [Lionello] Venturi's assertion that the boy is dressed as "a peasant

of the Roman Campagna," his costume may have had more than coloristic appeal for Cézanne. The youth with unusually long hair—a style long out of fashion— and wearing a red vest may have evoked in the aging Cézanne memories associated with both poetry and youthful rebellion. At the premiere of Victor Hugo's controversial play *Hernani* in 1830, the long-haired young poet Théophile Gautier had appeared in a red waistcoat, leading a band of youthful followers to acclaim the author before a hostile audience. Following this famous episode in the history of the Romantic movement, the term *un gilet rouge* (a red vest) became an epithet identifying one who defied bourgeois convention and appears often in nineteenth-century French literature. Accounts of Cézanne's own romantic temperament in his youth lend credibility to Ambroise Vollard's report that he had adopted this symbol of solidarity with rebellious youth during his early years in Paris: "An old painter who had known Cézanne at that epoch [1860s; possibly Jean-Baptiste Antoine Guillemet] said of him, 'Yes, I remember him well! He wore a red waistcoat and always had enough in his pocket to buy dinner for a comrade.'"[1]

Paul Cézanne

Still Life with Apples. 1895–98
Illustrated on page 96

William Rubin, *Cézanne: The Late Work*, **1977**, pages 188–89, 191

At the heart of Cézanne's disquiet—or at least that aspect of it which is most readily located in his work— was his anxiety over "realization," his doubt about his ability to complete the individual picture, and more broadly, to realize his aims in his work as a whole. The unfinished state of many of Cézanne's paintings, particularly those of his later years, bears witness to this anxiety. [Pablo] Picasso's exploration of a new definition of "finish"—in part forced upon him by his own problems of realization—became for him an opening into Cézanne's oeuvre and an aspect of a special bond between the two painters. This syndrome did not come into play for [Georges] Braque, in whose appreciation of Cézanne's integrity—in the literal as well as metaphorical sense—was an important factor.[1] It is therefore not by accident that the nominally unfinished Cézannes should inflect the history of Cubism specifically through Picasso's work—at just the time (1909) when Picasso's interest in Cézanne had deepened.[2] . . .

We must approach the question of finish in Cézanne keeping in mind the fact that few if any artists are entirely conscious of their enterprise, and therefore of the manner in which the changing directions in their art may transcend the frames of reference imposed by their moment in time. There is no question, of course, that many of the works that Cézanne left partially unpainted simply went wrong. But the evidence of my eyes in respect to such paintings as The Museum of Modern Art's *Still Life with Apples*, to take a convenient example, leads me to the opinion that there are also many nominally unfinished paintings from the last years of Cézanne's life on which the artist simply stopped working when the structure had arrived at the point where a further mark upon the surface might have taken more away than it could add.

While Cézanne himself, consistent with his conservative attitudes in general, appears to have judged these canvases from the point of view of received notions of finish, I would suggest that he had intuited, quite without being able to interpret or define, a new and autonomous concept of finish—one that in its essentially twentieth-century character differed even from the non-finito of Impressionism. The Impressionists had only partially disengaged the question of finish from a standard outside the picture (i.e., nature), locating it primarily in style—the even flicker of light and the allover molecular texture that we demand of an Impressionist picture.[3] Cézanne, it seems to me, proposed in *all* his mature painting—though not in his philosophy—a more self-contained idea of finish, in which the integrity of the composition alone is the determining standard. . . .

In *Still Life with Apples*, Cézanne ceased work at a point when much of the surface was still unfinished as defined by any traditional meaning of the word. The range of handling in this image passes from the highly developed modeling of the most prominent fruit through the rudimentary modeling exemplified by the apple at the apex of the group at the left, to the fragmentary contouring and toning in the curtain, to the underpainting of the background and much of the tablecloth, and finally to the significant areas of surface that are entirely unpainted. The "incompleteness" does not, to my eye, detract from the picture. On the contrary, the gamut of unfinishedness forms a hierarchy of its own that is integral to the structure of the work.

Paul Cézanne

Turning Road at Montgeroult. 1898
Illustrated on page 97

Angela C. Lange, in *Masterworks from The Museum of Modern Art, New York, 1900–1955*, **2001**, page 43

Turning Road at Montgeroult, painted in the summer of 1898, is one of the last landscapes Cézanne painted in the north of France. In 1899 he returned south, to his native town of Aix-en-Provence, and remained there until his death. The picture is also among the most fully resolved and complete Cézanne landscapes of the 1890s, and has been regarded by scholars as a prime example of the innovations in color, brushwork, and pictorial space that made Cézanne so important for Pablo Picasso and Georges Braque in their development of early Cubism, a decade later. The art historian Meyer Schapiro said of this painting: "It is an undistinguished subject, without a dominant point of interest, yet it is picturesque for modern eyes. . . . A scene like this one was fascinating to the artist as a problem of arrangement—how to extract an order from the maze of bulky forms. It is one aspect of the proto-Cubist in Cézanne."

The view looks upward, with a lifted horizon that crowds the area of sky to the very top and center of the vertically framed view. A relatively loosely brushed mass of foliage covers the bottom third of the scene, obscuring all but a hint of the climbing road until its sharp bend appears on the right, almost halfway up. At that point, indeterminate, generalized leafy areas suddenly give way to assertive masonry volume, as the wall along the road thrusts diagonally into the picture like the flying buttress of a cathedral, ramming into the sunlit vertical plane of the central house. At the level of that house, the picture is structured from the upper left across nearly to the right edge with an interlocked series of architectural facets, a folded play of partial rectangles, parallelograms, and triangles that evoke the simple masses and irregular order of a provincial hillside village. Especially given the opposition between the cool greens and blues of the lower foliage and the hotter earth tones of the buildings, the picture tends to invert near and far, giving the feeling of a powerfully angular relief suspended (or pinioned by the buttressing road) above a more recessive, falling foreground. As much as the overall structuring of the picture in terms of blocks of color and consistent, modular brushstrokes, it was this sense of tectonic volume conveyed without conventional modeling or perspective—and even without, apparently, regard for gravity—that seemed to open up new possibilities for younger artists like Picasso and Braque.

Auguste Rodin

St. John the Baptist Preaching. 1878–80
Illustrated on page 99

Albert E. Elsen, *Rodin*, **1963**, pages 9, 10, 11

The memorable sentences of the poet, Rainer Maria Rilke, who served for a time as Rodin's secretary and remained one of his most loyal friends and admirers, stand apart with lithic durability from the glutinous sentimentality and inflated chauvinism that characterize much of the literature on the sculptor and his art. In Rilke's penetrating essay, written in 1913, one finds many statements unsurpassed in the depth and lucidity of their insight. He saw Rodin as the seeker after "the grace of the great things," although "his art was not built upon a great idea, but . . . upon a craft," in which "the fundamental element was the surface . . . which was the subject matter of his art." "He was a worker whose only desire was to penetrate with all his forces into the humble and difficult significance of his tools. Therein lay a certain renunciation of Life, but in just this renunciation lay his triumph, for Life entered into his work.". . . And finally, "With his own development Rodin has given an impetus to all the arts in this confused age."

By the excellence of his own art, Rodin was able to persuade a previously apathetic society what sculpture could and should be. When he found it necessary to rethink sculpture down to "the hollow and the mound," he forced artists, critics and the public to take stock of their own definitions and beliefs about art. Since Rodin, this inventory and self-searching has continued and now seems limitless. When we search for the origins of modern sculpture, it is to Rodin's art that we must inevitably go. Every sculptor who came to maturity before 1914 was affected by him and had to take a stand for or against his sculpture. His was an art that could not be ignored. . . .

Rodin was the Moses of modern sculpture, leading it out of the wilderness of the nineteenth-century Salons and academic studios. Like the biblical Moses, he lived only long enough to look on the Promised Land. Not his death, however, but his steadfast adherence to naturalism and certain of its traditions prevented Rodin from entering into the new territories that were being surveyed and colonized by younger sculptors of the twentieth century.

Auguste Rodin

Monument to Balzac. 1898

Illustrated on page 98

Albert E. Elsen, *Rodin*, 1963, pages 89, 93, 101

In 1891, when Rodin received from the Société des Gens de Lettres the commission for a sculpture of [Honoré de] Balzac to be placed in front of the Palais Royal, he had little idea how prophetic his remark to his patrons would be: "I should like to do something out of the ordinary."[1] . . .

The artist himself regarded this as his most important and daring work, "the sum of my whole life, result of a whole lifetime of effort, the mainspring of my esthetic theory. From the day of its conception, I was a changed man."[2] Yet, in 1898, although supported by many friendly writers and critics against what seemed the entire public, a predominantly hostile press, and his patrons themselves, Rodin on at least one occasion confided that perhaps he should have dropped the project three years earlier. In another instance, his correspondence reveals that he considered the adverse reception of the sculpture a bitter defeat. At other times, he consoled himself that the *Balzac* could be appreciated only by connoisseurs. The ambivalence of the artist's own reaction is all the more fascinating because, even though he generally seems to have regarded this as his masterpiece, he never attempted to carry his ideas in the *Balzac* further in other large-scale works. . . .

In the firm belief that the geographical area in which a man was born would reveal similar ethnic types, and that physical environment could influence character, Rodin beginning in 1891 made lengthy trips into Balzac's home territory around Tours. He made actual clay sketches of Tourangeaux [natives of Tours] whose resemblance to the dead man struck him. Balzac's old tailor was commissioned to make a suit of clothes to the measurement that he had kept throughout the years. In Paris, Rodin encountered a factory worker who seemed to possess the author's features, which he then transposed into wax and clay studies. Over forty studies in wax, clay, plaster and bronze have survived, but they have so far resisted complete dating or the establishment of a firm chronology.[3] These studies, however, indicate the triple nature of Rodin's problem. First was the task of recreating the head—the likeness that would mirror the spirit. Second, the body had to be built and the amount of stress to accord it be decided. Third, should the figure be clothed, and if so, how?

At the outset, the artist indicated that obtaining a resemblance was not his major problem: "I think of his intense labor, of the difficulty of his life, of his incessant battles and of his great courage. I would express all

that."[4] Statements such as this suggest that Rodin may have identified himself with Balzac, so that the projected portrait was in some sense a double one. As the enormity of his objective unfolded in his imagination, Rodin's studies increased, but so did his inactivity, due to demands upon his health and creative powers. Deadlines were continually protracted. His despair deepened as it alternated with moments of enthusiasm.[5] . . .

The side views of the *Balzac* enforce its sexuality. Rodin has transformed the embattled writer into a godlike visionary who belongs on a pedestal aloof from the crowd. His head has become a fountainhead of creative power, and by a kind of Freudian upward displacement it continues the sexual emphasis of the earlier headless nude study. What more fitting tribute to Balzac's potency as a creator from the sculptor most obsessed with the life force!

Medardo Rosso

The Bookmaker. 1894

Illustrated on page 99

Robert Goldwater, *What Is Modern Sculpture?*, 1969, pages 30, 33

Impressionist painters were interested in capturing the momentary. They rendered it through the informal poses of their figures and composition of their canvases, and especially through effects of color and light that tended to dissolve solid form. There thus can be no exact equivalent in sculpture.

Among the impressionist painters only [Edgar] Degas [and Auguste Renoir in his old age] did any sculpture. Degas's subjects were those of his paintings: horses, dancers, and women in the routine postures of their everyday lives. . . .

Rosso's intentions were . . . closely allied to those of the impressionist painters. In *The Bookmaker* the impreciseness of surface detail is an acknowledgment of an intervening atmosphere that diffuses the tangible form. The figure's slant suggests movement, the shifting, broad planes of light and dark, the impermanence of vision. Using his preferred medium of wax, Rosso has minimized the hard and tactile qualities of sculpture in favor of momentary appearance. To do this he has had to fix the position of the evanescent forms; *The Bookmaker* must be viewed from the front only, and lit only in a certain way, to reveal what is seen at a particular moment in a particular environment.

Modern Pioneers

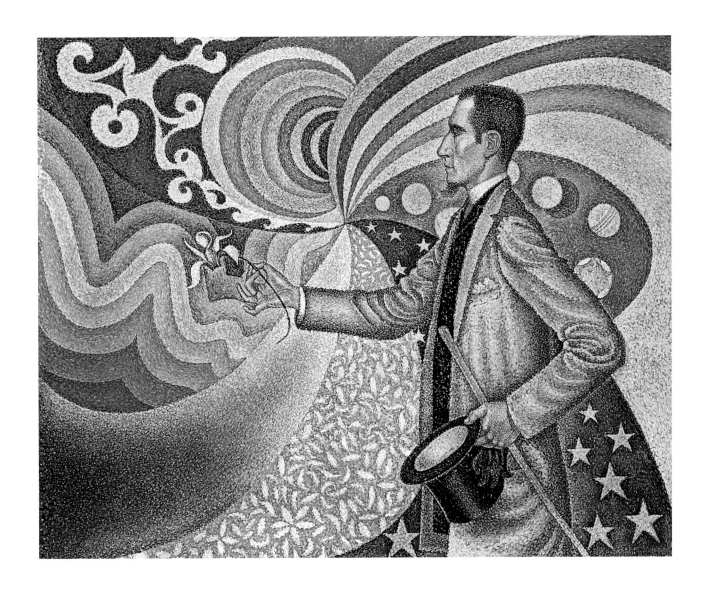

Georges-Pierre Seurat | (FRENCH, 1859–1891)
EVENING, HONFLEUR. 1886
OIL ON CANVAS, 25¾ x 32" (65.4 x 81.1 CM)
GIFT OF MRS. DAVID M. LEVY, 1957

Georges-Pierre Seurat
PORT-EN-BESSIN, ENTRANCE TO THE HARBOR. 1888
OIL ON CANVAS, 21¾ x 25⅛" (54.9 x 65.1 CM)
LILLIE P. BLISS COLLECTION, 1934

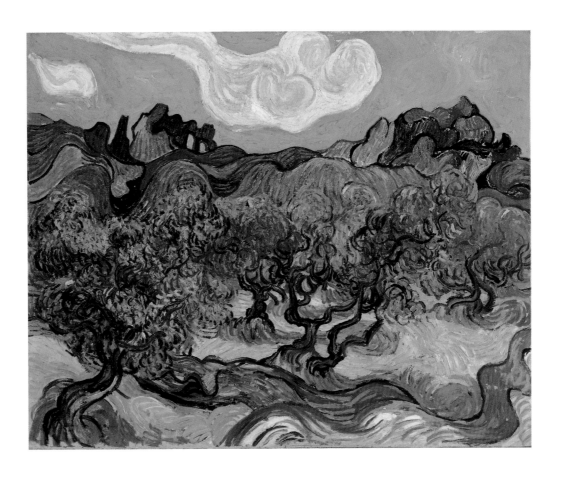

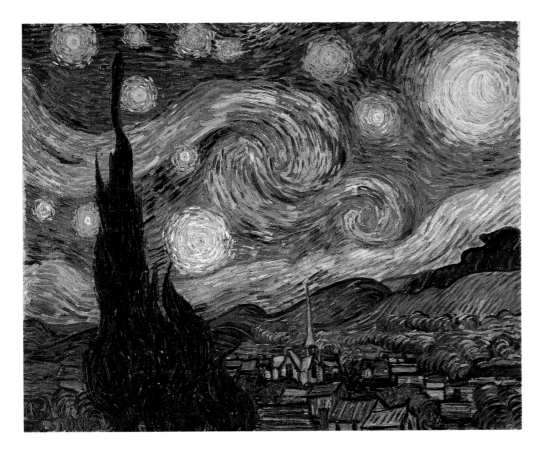

Vincent van Gogh | (DUTCH, 1853–1890)
THE OLIVE TREES. June–July 1889
OIL ON CANVAS, 28⅛ x 36" (72.6 x 91.4 CM)
MRS. JOHN HAY WHITNEY BEQUEST, 1998

Vincent van Gogh
THE STARRY NIGHT. June 1889
OIL ON CANVAS, 29 x 36¼" (73.7 x 92.1 CM)
ACQUIRED THROUGH THE LILLIE P. BLISS BEQUEST, 1941

83

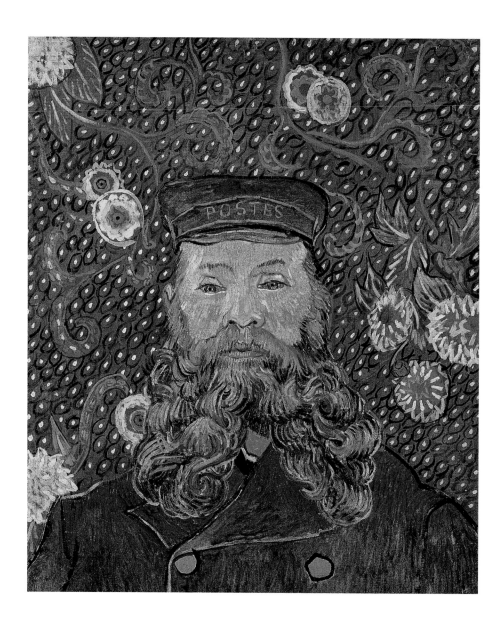

Vincent van Gogh | (DUTCH, 1853–1890)
PORTRAIT OF JOSEPH ROULIN. Early 1889
OIL ON CANVAS, 25⅜ x 21¾" (64.4 x 55.2 CM)
GIFT OF MR. AND MRS. WILLIAM A. M. BURDEN, MR. AND MRS. PAUL ROSENBERG, NELSON A.
ROCKEFELLER, MR. AND MRS. ARMAND P. BARTOS, THE SIDNEY AND HARRIET JANIS COLLECTION,
MR. AND MRS. WERNER E. JOSTEN, AND LOULA D. LASKER BEQUEST (ALL BY EXCHANGE), 1989

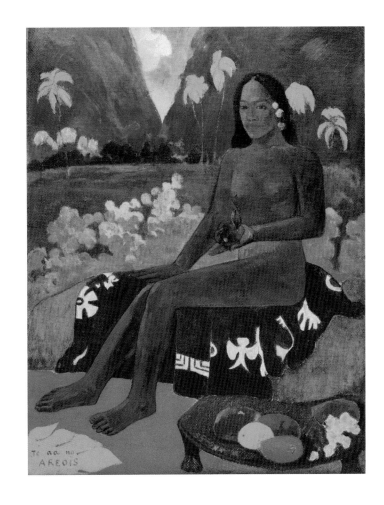

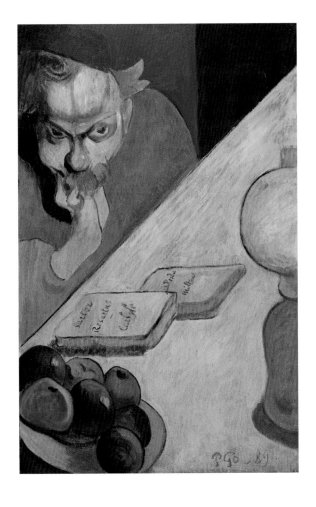

Paul Gauguin | (FRENCH, 1848–1903)
PORTRAIT OF JACOB MEYER DE HAAN. 1889
OIL ON WOOD, 31⅛ x 20½" (79.6 x 51.7 CM)
FRACTIONAL GIFT OF MR. AND MRS. DAVID ROCKEFELLER, 1958

Paul Gauguin
THE SEED OF THE AREOI. 1892
OIL ON BURLAP, 36¼ x 28⅜" (92.1 x 72.1 CM)
THE WILLIAM S. PALEY COLLECTION

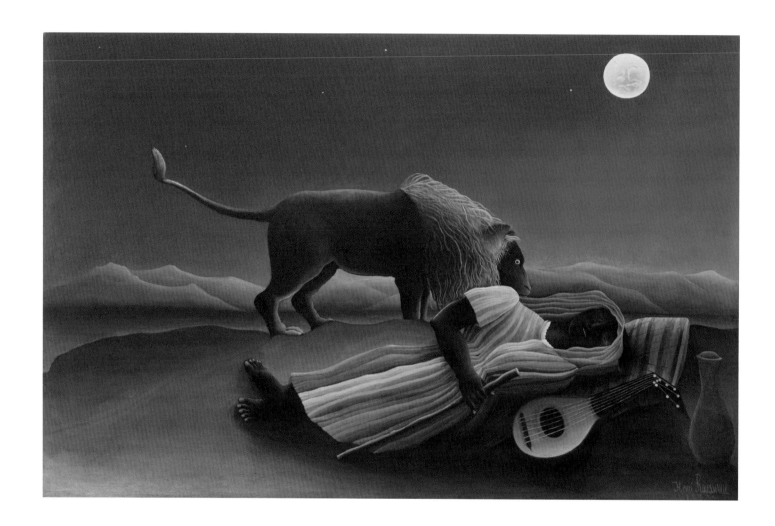

Henri Rousseau | (FRENCH, 1844–1910)
THE SLEEPING GYPSY. 1897
OIL ON CANVAS, 51" x 6' 7" (129.5 x 200.7 CM)
GIFT OF MRS. SIMON GUGGENHEIM, 1939

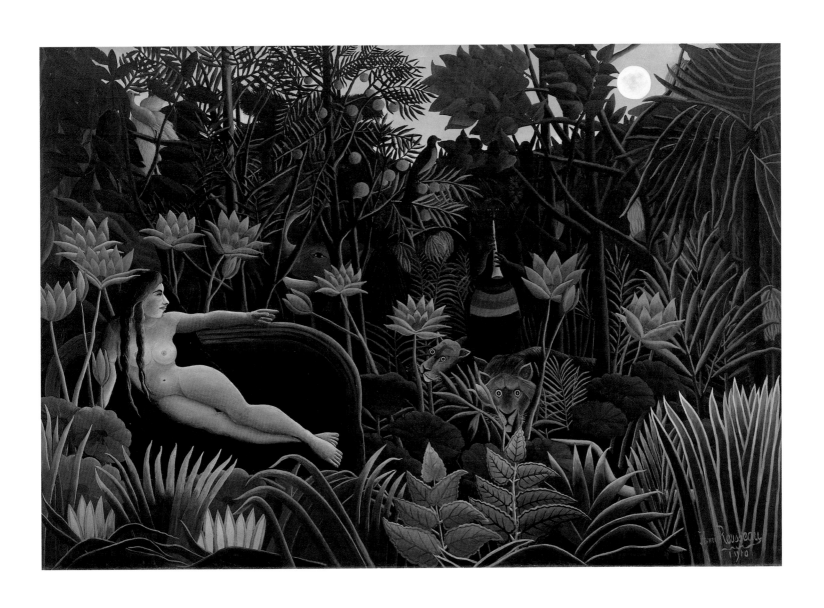

Henri Rousseau
THE DREAM, 1910
OIL ON CANVAS, 6' 8½" x 9' 9½" (204.5 x 298.5 CM)
GIFT OF NELSON A. ROCKEFELLER, 1954

Claude Monet | (FRENCH, 1840–1926)
REFLECTIONS OF CLOUDS ON THE WATER-LILY POND. c. 1920
OIL ON CANVAS, THREE SECTIONS, EACH 6' 6" x 14' (200 x 425 CM)
MRS. SIMON GUGGENHEIM FUND, 1959

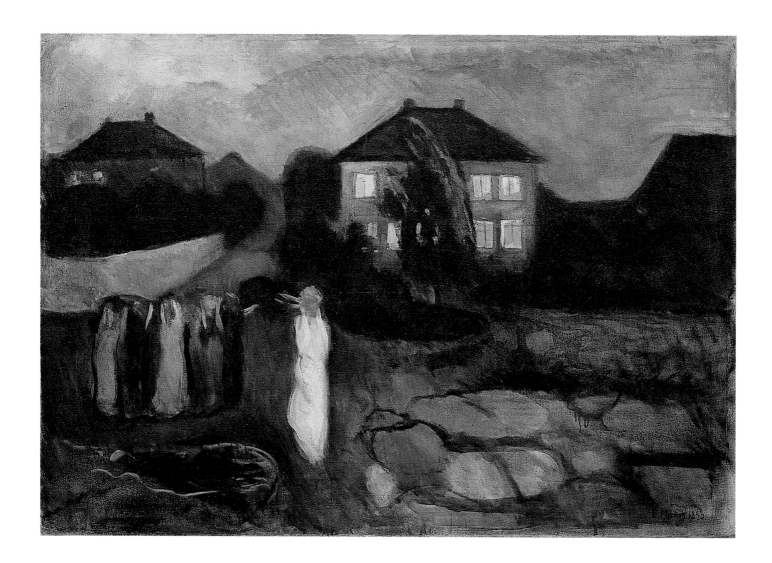

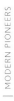
Edvard Munch | (NORWEGIAN, 1863–1944)
THE STORM 1893
OIL ON CANVAS, 36⅛ x 51½" (91.8 x 130.8 CM)
GIFT OF MR. AND MRS. H. IRGENS LARSEN AND ACQUIRED THROUGH
THE LILLIE P. BLISS AND ABBY ALDRICH ROCKEFELLER FUNDS, 1974

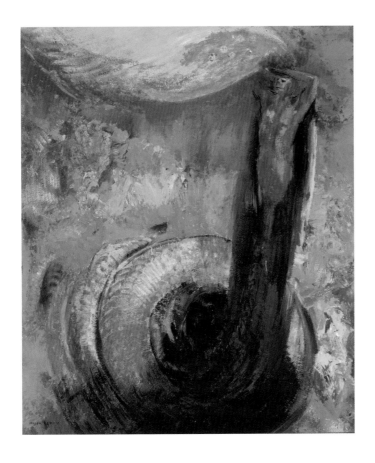

Odilon Redon | (FRENCH, 1840–1916)
GREEN DEATH. c. 1905
OIL ON CANVAS, 21⅝ x 18¼" (54.9 x 46.3 CM)
LOUISE REINHARDT SMITH BEQUEST, 1995

James Ensor | (BELGIAN, 1860–1949)
MASKS CONFRONTING DEATH. 1888
OIL ON CANVAS, 32 x 39½" (81.3 x 100.3 CM)
MRS. SIMON GUGGENHEIM FUND, 1951

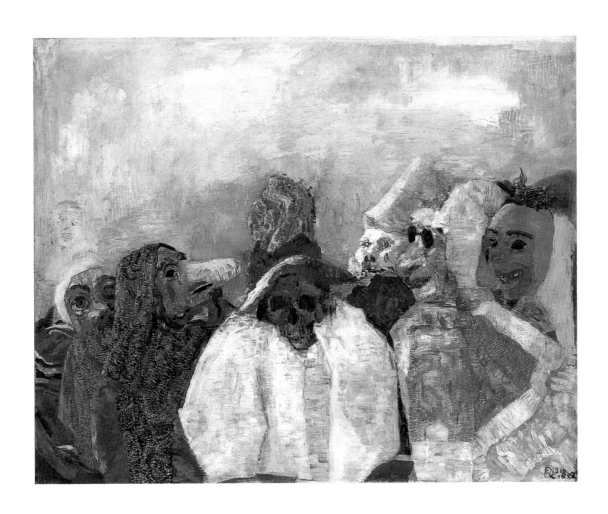

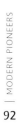

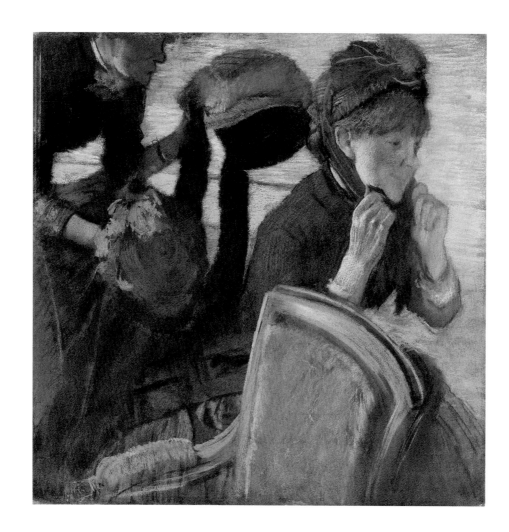

Hilaire-Germain-Edgar Degas | (FRENCH, 1834–1917)
AT THE MILLINER'S. (c. 1882)
PASTEL ON PAPER, 27¼ x 27¾" (70.2 x 70.5 CM)
GIFT OF MRS. DAVID M. LEVY, 1957

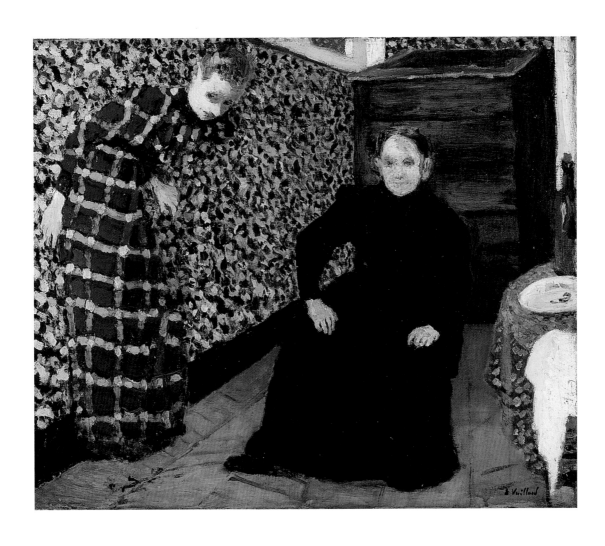

Édouard Vuillard | (FRENCH, 1868–1940)
INTERIOR, MOTHER AND SISTER OF THE ARTIST. 1893
OIL ON CANVAS, 18¼ x 22½" (46.3 x 56.5 CM)
GIFT OF MRS. SAIDIE A. MAY, 1934

93

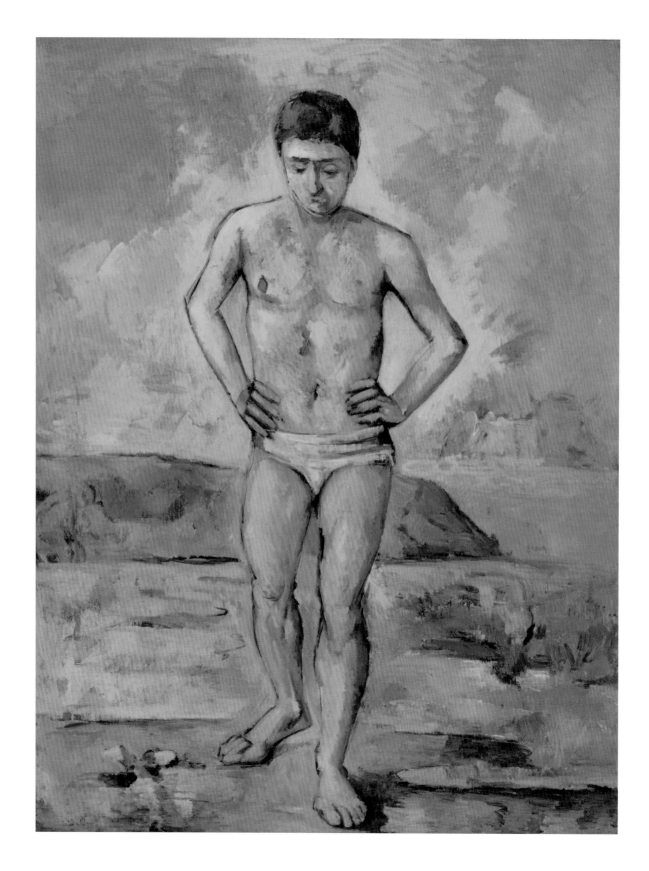

Paul Cézanne | (FRENCH, 1839–1906)
THE BATHER. c. 1885
OIL ON CANVAS, 50 x 38⅛" (127 x 96.8 CM)
LILLIE P. BLISS COLLECTION, 1934

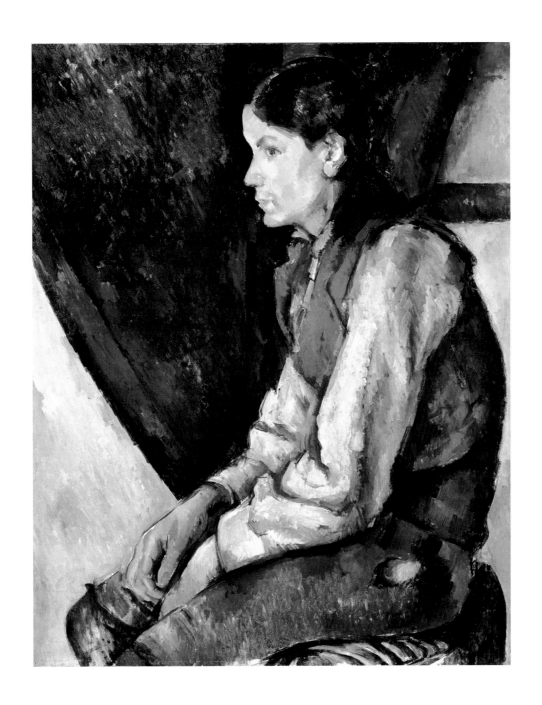

Paul Cézanne
BOY IN A RED VEST, 1888–90
OIL ON CANVAS, 32 x 25⅝" (81.2 x 65 CM)
FRACTIONAL GIFT OF MR. AND MRS. DAVID
ROCKEFELLER (THE DONORS RETAINING A
LIFE INTEREST IN THE REMAINDER), 1955

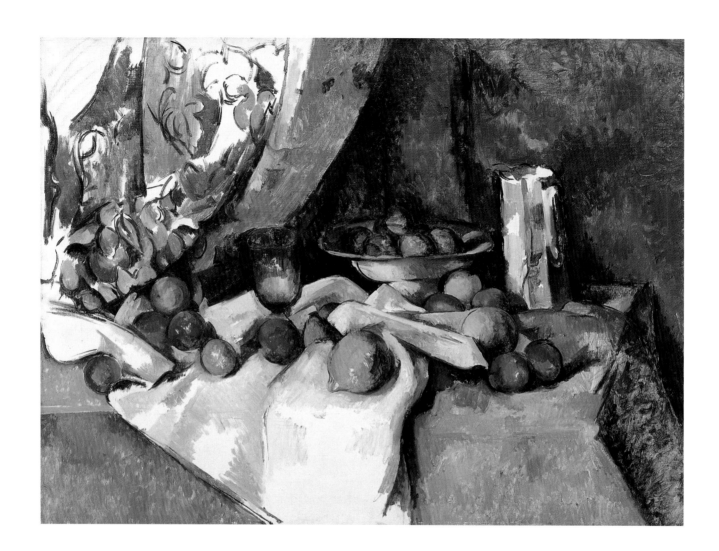

Paul Cézanne | (FRENCH, 1839–1906)
STILL LIFE WITH APPLES. 1895–98
OIL ON CANVAS, 27 x 36½" (68.6 x 92.7 CM)
LILLIE P. BLISS COLLECTION, 1934

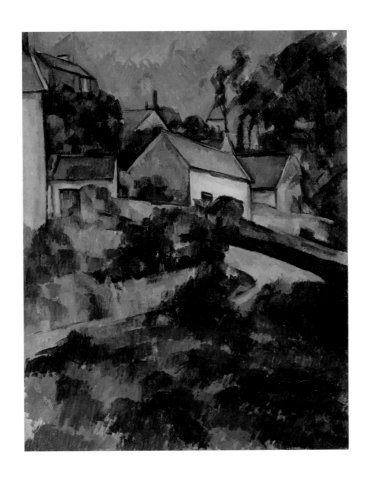

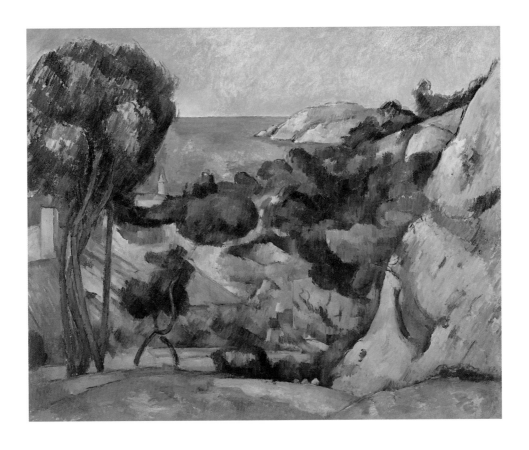

Paul Cézanne
TURNING ROAD AT MONTGEROULT. 1898
OIL ON CANVAS, 32 x 25⅞" (81.3 x 65.7 CM)
MRS. JOHN HAY WHITNEY BEQUEST, 1998

Paul Cézanne
L'ESTAQUE. 1879–83
OIL ON CANVAS, 31½ x 39" (80.3 x 99.4 CM)
THE WILLIAM S. PALEY COLLECTION, 1959

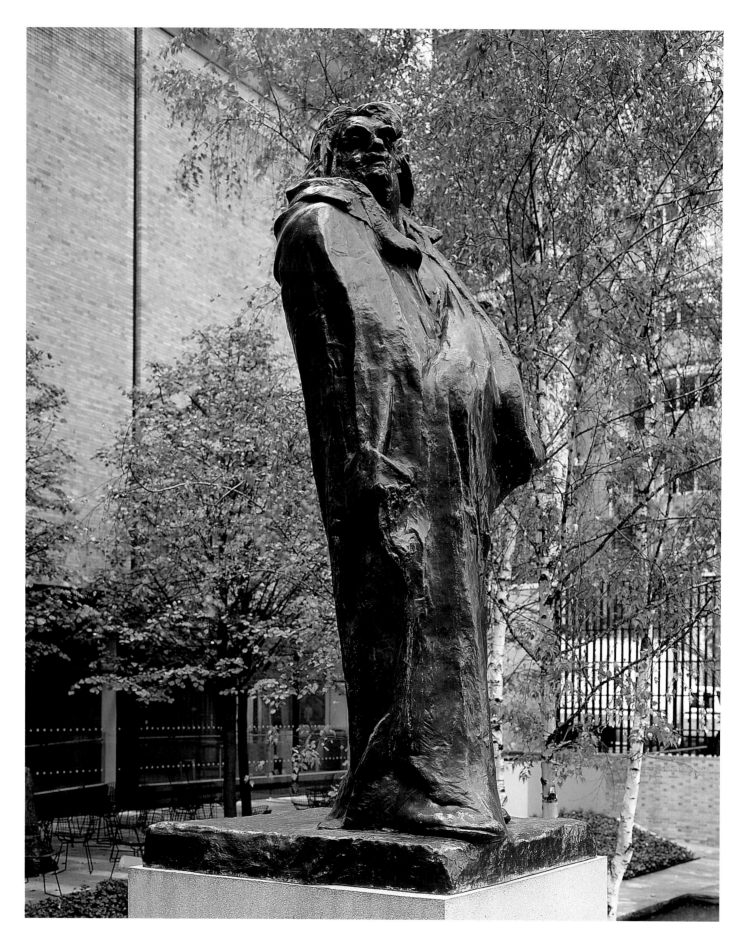

Auguste Rodin | (FRENCH, 1840–1917)
MONUMENT TO BALZAC. 1898 (cast 1954)
BRONZE, 9' 3" x 48¼" x 41" (282 x 122.5 x 104.2 CM)
PRESENTED IN MEMORY OF CURT VALENTIN BY HIS FRIENDS, 1955

Medardo Rosso | (ITALIAN, 1858–1928)
THE BOOKMAKER. 1894
WAX OVER PLASTER, 17½ x 13 x 14" (44.3 x 33 x 35.5 CM)
ACQUIRED THROUGH THE LILLIE P. BLISS BEQUEST, 1959

Auguste Rodin
ST. JOHN THE BAPTIST PREACHING. 1878–80
BRONZE, 6' 6¼" (200.1 CM) HIGH, 37 x 22½" (94 x 57.2 CM) AT BASE
MRS. SIMON GUGGENHEIM FUND, 1955

Matisse, Picasso, Modernism:
Art in Europe through World War I

In the years 1905–07, Henri Matisse, André Derain, Georges Braque, and other progressive artists in Paris came to be known as *les fauves*—the "wild beasts"—for what then seemed to be a violent manner of painting in dots, dashes, and swirls of unnaturally bright color. Subsequently, Fauvism has been celebrated as the first twentieth-century art movement. However, Fauvism was as much a final explosion of late Impressionism or Post-Impressionism, melding the lessons of its four pioneering modernists, Paul Cézanne, Paul Gauguin, Georges-Pierre Seurat, and Vincent van Gogh, as it was the beginning of something new. For this very reason, and not despite it, the Fauvist synthesis was quickly disseminated, and influenced, infiltrated, or validated different forms of coloristically expressive near abstraction. Artists as different as Robert Delaunay, František Kupka, and Marc Chagall in Paris, the Expressionists Ernst Ludwig Kirchner, Karl Schmidt-Rottluff, and Emil Nolde in Germany, and Vasily Kandinsky in Russia were enabled by the example of Fauvism and often specifically by the example of Matisse. Even the late, Austrian Symbolists, Gustav Klimt, Egon Schiele, and Oskar Kokoschka, were not untouched by the liberations of color and drawing that achieved such notoriety in Paris. Thus, not Fauvism itself but this post-Fauvist diaspora may be said to comprise the first movement, and first international style in modern art of the twentieth century.

In the early years of the Museum, its director, Alfred H. Barr, Jr., hoped to establish its international reputation by organizing exhibitions dedicated to the work of Matisse and Pablo Picasso. (They would be held in 1931 and 1939, respectively.) But if Barr treated Matisse solely as an individual genius, he also treated Picasso as the founder of a lineage. His 1936 exhibition *Cubism and Abstract Art* thus laid out a genealogy of early modernism that led from Picasso's Cubism to "geometrical" abstract art. Effectively, Barr's history—and the many that followed—turned on the key 1907–08 period, when the Fauves, Braque and Derain, shifted their affiliation from Matisse to Picasso, and when Matisse scathingly described a painting by Braque as composed "of small cubes." From that moment, the path of Cubism and abstract art was opened.

Here, Picasso is seen with his Cubist colleague, Braque, and adjacent to their followers, both near and distant, including Vladimir Baranoff-Rossiné, Jacob Epstein, Roger de La Fresnaye, Juan Gris, Henri Laurens, Fernand Léger, Jacques Lipchitz, and Amedeo Modigliani, and some, like Delaunay and Kupka, who also learned from Fauvism. Next will be found works by the Futurists Giacomo Balla, Umberto Boccioni, Carlo Carrà, and Gino Severini, the most immediate successors of the Cubists. But then, rather than moving on to later geometric abstraction, both this section and the installation itself turn to a display of Matisse's art, for its own address to Cubism, then opens onto a display that reveals both the diversity and the interconnectedness of abstractionist currents in the period around World War I. Matisse's own wartime production is not, in fact, unrelated to the melancholic fantasy art of Giorgio de Chirico, often associated with Surrealism. Here, both are seen to belong to a large post-Cubist world of art that also includes, among others, works by Picasso and Léger, the "Purism" of the painter-architect Le Corbusier, the paintings, influenced by popular culture, of the Americans Stuart Davis, Gerald Murphy, and Patrick Henry Bruce, and the reductive sculpture of Constantin Brancusi. From these crosscurrents will develop the varied directions of modern art in the third major phase of that art as represented in the Museum's painting and sculpture collection.

Fauvism, Symbolism, Expressionism

Aristide Maillol
The Mediterranean. 1902–05
Illustrated on page 138

Andrew Carnduff Ritchie, *Sculpture of the Twentieth Century*, **1952**, page 19

[Auguste] Rodin's forms have a volcanic materiality made all the more substantial when they come closest to bursting their corporeal bonds and exploding into surrounding space. Maillol's, by a process of abstraction, become dematerialized, however massive by symbolic implication they are intended to appear. "Form," he said, "pleases me and I create it; but, for me, it is only the means of expressing the idea. It is ideas that I seek. I pursue form in order to attain that which is without form. I try to say what is impalpable, intangible."... His overriding idea, I presume, from his lifelong preoccupation with the female nude was the womanness of woman, the earth-mother of the peasant, folk memory. In his *Mediterranean*, one of his earliest sculptures but perhaps his most typical, the majesty of Maillol's idea can be appreciated and, at the same time, by comparing this figure with its prototype, Michelangelo's *Night*, one can see how much he has sacrificed of formal and spatial variety and intensity. Perhaps this idealization and therefore abstraction of form in Maillol explains why his sculpture early gained wide popular approval. For one person who looked at his work as sculpture, thousands saw in it a type which inevitably came to be known as the Maillol woman.

Nevertheless, it must be admitted that to the forward-looking generation of sculptors immediately following Rodin, Maillol appeared as a healthy revolutionary come to deliver them from what they considered to be the excessive literary gesturings of the older master. His influence has been felt directly or at a distance by many artists, however much they may differ in personality and in their other sources of stylistic inspiration.

Wilhelm Lehmbruck
Kneeling Woman. 1911
Illustrated on page 139

Jere Abbott, *Wilhelm Lehmbruck and Aristide Maillol: Sculpture*, **1930**, page 6

Lehmbruck's departure from realism in physical form suggests at once his preoccupation with the spiritual.

The Gothic craftsmen of the north, impressed with the importance of spiritual preparation for the world to come, felt in the repression of the physical a simple indication of religious fervor. [El] Greco in Spain terminates a long line of artists who recognized the aesthetic value of this means—this strange attenuation, in subjectively influencing those who stood pondering their painting. The departure then from a physical reality fixes at once more attention to compositional arrangement as such. For this reason, partly, there is less of [Aristide] Maillol's physical dynamic quality in Lehmbruck's work and more of "design." The structural feeling alters. It is less influenced by classical tradition. It becomes more structurally suggestive of a form rather than appearing in the reality of the form itself. There is, accordingly, in Lehmbruck's sculpture more of the quality of an action relative to a mental state—a moving tenseness born of the man himself, for the nervous tensity of a life that ended in tragedy goes into Lehmbruck's work.

Lehmbruck is little interested in the physical—the fine movement of a swinging stride or the downward circle of an arm. The physical for him is a resultant of the mental. Action may be the frenzy of despair—repose, the indication of a weary soul or again it may hinge more abstractly upon pure design, but there must always be for him in his sculpture something which commands, "think!"—not *of* it but *with* it. Something which evades us but holds us, a strange rapport between a thing lifeless, yet *knowing*, and ourselves.

John Elderfield, *The "Wild Beasts": Fauvism and Its Affinities*, **1976**, pages 13, 14, 15, 16

Genuinely new art is always challenging, sometimes even shocking to those not prepared for it. In 1905, the paintings of [Henri] Matisse, [André] Derain, [Maurice] Vlaminck, and their friends seemed shocking to conservative museum-goers; hence the eventual popularity of the term *les fauves*, or "wild beasts," by which these artists became known. But shock and surprise quickly disappear. To look again at these exquisitely decorative paintings is to realize that the term *Fauvism* tells us hardly anything at all about the ambitions or concepts that inform Fauvist art. "Wild beasts" seems the most unlikely of descriptions for these artists. The title Fauvism is in fact a misleading one for the movement to be discussed here.

Matisse and his friends were first called *fauves* when they exhibited together at the Paris Salon d'Automne of 1905. The artists themselves did not use the name. "Matisse tells me that he still has no idea what 'fauvism' means," reported Georges Duthuit later.[1] The Fauvist movement, it could be said, was the result of public and critical reactions to the artists' work. It began when their work first provoked widespread public interest, in the autumn of 1905, and lasted until approximately the autumn of 1907, when critics realized that the group was disintegrating. Critical recognition, however, inevitably lags behind artistic innovation. The Fauvist style (or better, styles) slightly preceded the Fauvist movement: the first true Fauve paintings were exhibited at the Salon des Indépendants in the spring of 1905; the last important Fauvist Salon was the Indépendants two years later. The Fauvist group, in contrast, preceded both the movement and the style, since it had begun to emerge even before 1900. . . . When compared with Post-Impressionist painting, the color and brushwork of the Fauves possess a directness and individual clarity that even now can seem, if not raw, then declamatory, and of astonishing directness and purity. "This is the starting point of Fauvism," Matisse said later, "the courage to return to the purity of means."[2] His talk of a return is significant. Fauvism was not only—and not immediately—a simplification of painting, though that is what it became. It was initially an attempt to recreate, in an age dominated by Symbolist and literary aesthetics, a kind of painting with the same directness and anti-theoretical orientation that the art of the Impressionists had possessed, but one created in cognizance of the heightened color juxtapositions and emotive understanding of painting that were the heritage of Post-Impressionism. In this sense, Fauvism was a synthetic movement, seeking to use and to encompass the methods of the immediate past. . . .

Fauvism was not a self-sufficient and relatively autonomous movement in the way most modern movements have been. Although it existed by virtue of friendships and professional contacts, it had no announced theories or intentions as did, say, Futurism. Nor had it a single common style that can be plotted rationally, as is the case with Cubism. Its perimeters, therefore, necessarily seem vague. In consequence, both exhibitions and studies devoted to the movement sometimes treat it with alarming latitude. For example, it has been considered but an aspect of the broad Expressionist impulse that affected early twentieth-century art,[3] or part of a new art of color that extended far beyond the boundaries of the Fauve group.[4] Indeed, Fauvism was not alone in certain of its general ambitions; it was, nevertheless, a unique artistic movement that requires definition as such. Where there is genuine difficulty is in establishing its relationship to the contemporary Parisian avant-garde, and in deciding whether friendship alone, or stylistic similarity alone, suffices to denote Fauve membership. . . .

The history of Fauvism is largely the history of this essentially private artist's [Matisse's] single sustained period of cooperation with the Parisian avant-garde, albeit for a very short period. Within this period, we see an emphasis upon the autonomy of color almost entirely new in Western art, a concern with directness of expression that countenanced mixed techniques and formal dislocations for the sake of personal feeling, and a truly youthful bravado that in its search for the vital and the new discovered the power of the primitive. We also see a rendering of external reality that found pleasurable stimulus in the "vacation culture"[5] subject matter of the Impressionists, but that pushed it at times either to the verge of a vernacular urban realism or toward a more ideal celebration of the *bonheur de vivre*. Finally, and perhaps most basic of all, is a belief in both individual and pictorial autonomy, which found a remarkable balance between the concern for purely visual sensation and for personal and internal emotion, and in so doing rediscovered a tradition of high decorative art that has provoked some of the most sublime as well as expressive paintings of this century.

André Derain
Charing Cross Bridge. 1905–06
Illustrated on page 140

Kirk Varnedoe, *Masterpieces from The David and Peggy Rockefeller Collection: Manet to Picasso*, **1994**, page 50

Claude Monet's 1904 exhibition of paintings of London was well-received by the Parisian public; and Derain's dealer, apparently thinking to mine further the same vein, sent him across the Channel to bring home vistas of the English capital. But where Monet's views—including one of this bridge—are typically moody and fog-shrouded even when the sun is high, Derain's more youthful outlook yielded a consistent sense of exuberance, evident even in this sunset theme. Not since William Turner painted *The Burning of the Houses of Lords and Commons* (1835) had the Thames been similarly set ablaze in paint.

The Museum already owns a Derain *London Bridge* from this same period, but it is far more structured and busy, with the traffic-filled bridge plunging inward toward a crowded embankment over a river alive with barges and boats. [This] *Charing Cross Bridge*, with only its thin band of silhouetted architecture dividing the sweep of the sky from the shimmering river, is far more abstract. It is one of the most explosive of all Derain's views of London, and indeed one of the most opulently freewheeling of all Fauve vistas. The loose, planar array of color suggests the spreading washes of a giant watercolor, and the picture seems as yet innocent of the influence of [Paul] Cézanne that would soon begin to inflect Derain's and [Henri] Matisse's canvases with a more regular structure of stroke and composition.

Derain
Charing Cross Bridge
Illustrated on page 140

Jodi Hauptman, in *Masterpieces from The David and Peggy Rockefeller Collection: Manet to Picasso*, **1994**, pages 85–86

This painting of a brilliant sunset over London shows Charing Cross Bridge in the middle ground, with puffs of blue smoke indicating the passage of trains over the bridge, and the silhouettes of the Big Ben clock tower and the buildings of Westminster beyond. The view is apparently seen from mid-river and somewhat above the water—perhaps from the walkway on Waterloo Bridge.

The dealer Ambroise Vollard, who had begun to buy Derain's work in February 1905, recalled that it was his suggestion that the artist go to London to paint a series of views.[1] This was confirmed by Derain himself, who late in life wrote that Vollard "sent me in the hope of renewing completely at that date the expression which Claude Monet had so strikingly achieved which had made a very strong impression in Paris in the preceding years."[2] . . . Derain's London work has been described as both an emulation and rebuttal of the very successful and popular paintings by Monet.[3] Derain painted at least thirty views of London, chiefly of the bridges and monuments along the Thames.

Georges Braque
Landscape at La Ciotat. 1907
Illustrated on page 140

William Rubin, *Cézanne: The Late Work*, **1977**, pages 157, 158, 159

The late spring and summer of 1907 saw most of the Fauve painters in the Midi—[André] Derain at Cassis and Braque together with [Otto] Friesz at nearby La Ciotat. Braque visited frequently with Derain and kept up with the latter's new work. . . .

Braque was increasingly emphasizing the Cézannian component (already evident in his pictures of L'Estaque from the fall of 1906) within what remained a Fauve style. This Cézannism has caused Braque's Fauve pictures to be unfavorably compared with those of [Henri] Matisse and Derain. But the dismissal of Braque as a "minor Fauve"[1] automatically contributes to a misunderstanding of his subsequent development, as it posits a more radical change in the value of his work than was in fact the case. The sheer quality of Braque's . . . *Landscape at La Ciotat* raises him far above the level of the minor Fauves. . . . And though [it is] less flat and bright than paintings by the two remaining masters of the movement, such Braques should no more be interpreted as failed Matisses or Derains than the Cézannes of 1872–75 should be seen as failed Impressionist pictures.

What distinguishes these Braques is the presence of a kind of concealed modeling accomplished by lining up unexpected decorative hues according to their values—an extension, based on substitution, of Cézanne's modeling through color. Braque's tendency to align his own gamut of Fauve colors—founded on secondary and tertiary hues, frequently pastel—in value relationships that imply sculptural relief, an interest utterly alien to the more purely decorative concerns of Matisse and Derain in 1905–06, was no failing on his part, but an anticipation of his own Cubist future. As was the case with Cézanne's conservative version of Impressionism in the

early 1870s, Braque was simply loath to give up the particular plasticity of modeled forms—with its attendant emotional and ethical implications. That *gravitas* and sobriety, secured by the illusion of relief, which links the beginnings of the Renaissance and modern traditions in the persons of Giotto and Cézanne, accorded well with Braque's personality (as his subsequent history in Cubism bore out). Hence, Braque's conservative Fauvism must be understood as a deliberate and personal variant of the style—a "withholding of complete assent, and a restoration of that connecting tonal tissue that Matisse had abruptly terminated."[2]

This "restoration" is the basic measure of Braque's commitment to Cézanne, whose painting he had seen as early as 1902 and who was a factor in his development as early as 1904. But by the summer of 1907, Braque's Cézannism had become more than a question of implied modeling. In *Landscape at La Ciotat*, for example, he adapts from Cézanne the entire configuration of his picture, a configuration that he would subsequently make paradigmatic for Cubism. Braque takes Cézanne's high horizon, a perspective that lays out the picture more in height than in depth, and treats it in such a way that the forms seem to spill downward and outward toward the spectator from the hill at the top. In addition, Braque extensively uses his own rude adaptation of Cézanne's "constructive stroke" and, like the master of Aix, outlines his forms in Prussian blue. While profoundly Cézannesque, *Landscape at La Ciotat* nevertheless also contains, in the decorativism of the foliage, vestiges of an interest in [Paul] Gauguin,[3] whose art had earlier been at the center of Fauvism.

Henri Matisse

Interior with a Young Girl (Girl Reading). 1905–06
Illustrated on page 141

John Elderfield, *Matisse in the Collection of The Museum of Modern Art*, **1978**, pages 44, 46

Girl Reading shows Matisse's daughter Marguerite in the family's Paris apartment at 19 Quai Saint-Michel in the winter of 1905–06. . . .

Matisse's ability to work all but simultaneously in different and virtually opposite styles is hardly ever more evident than in 1906. In 1906 it is partly to be attributed to his uncertainty in a period of transition, but not entirely so. It is evidence of a basic duality in his art between analytic and synthetic, between nature and imagination. On the one hand, the directness of his response to the observed world was crucial and precious to him. On the other, the very immediacy of the effects he

created was often disturbing, and he wanted something more: something more condensed, detached, and controlled. And yet that too was not without its dangers. A synthetic statement could also be an "ephemeral and momentary" one: "When the synthesis is immediate, it is premature, without substance . . . "[1]

Matisse's simultaneous pursuit of different manners of painting is also evidence of the same kind of stylistic self-consciousness that allowed him to mix different techniques of painting in a single work, as he does in this one. The mixed-technique style of Fauvism, of which this is a supreme example, expresses the radical nature of Matisse's art as much as does its liberated color. . . .

Girl Reading is a paradigm of the mixed-technique Fauvist style, with its juxtaposed lines, spots, and patches of color, larger areas of brushed and scumbled paint, and liberal areas of blank canvas that both separate colors and function (in the foreground) as colored areas themselves. Not only does the bare canvas surface serve color by providing breathing space between contrasting hues; it is as much a part of the materials of painting as what is placed upon it. Art encompasses the painted and unpainted alike. And more than that: the surface itself is the final arbiter of pictorial coherence. The paint is clearly on top of the surface, is always responsive to it, and never visually penetrates it. Matisse accepts, as he must, the sharp tonal contrasts that some of the contrasts of hue provide, but since the painting is full of contrasts, the eye can never linger long enough with one of them to find its way behind the picture plane and stay there.

Oskar Kokoschka

Hans Tietze and Erica Tietze-Conrat. 1909
Illustrated on page 142

Oskar Kokoschka, Letter to Dorothy Miller, curator at The Museum of Modern Art, **1953**

Portrait of Dr. Hans Tietze and his wife—done 1909 in Vienna. First time exhibited when the Museum acquired it. Exceptional circumstance worthwhile to be mentioned is that it was meant as symbol of the married life of the two sitters and as such commissioned. Of certain technical interest may be that my technique at that early period was the only one to render the vision of people being alive, due to the effect of a inner light, resulting technically from layers of thinly painted colour and fundamentally from a creative approach, which in stressing the sense of vision, as the act of seeing, is diametrically opposed to all fashionable theories on art asserting the human being to be seen as a kind of nature morte.

I know this double-portrait to be one of the best examples of my early work if not of the whole period, how many works of artists in the last 50 years can compete with the unheard of mystery of this painting, being still an instrument of transmission of LIFE that had been lived through by the two sitters and will be excitingly life long after all of us shall be gone westwards.

I certainly approve of it having been restored to the original size!

Concluding, I am to felicitate myself that, at least, two examples of my pre-wars painting had been preserved in your museum through all the political changes and catastrophies of mankind. My warmest congratulations also to your able directors for acquiring these works of an artist who was not and never will be [in] fashion.

Kokoschka
Hans Tietze and Erica Tietze-Conrat
Illustrated on page 142

Werner Haftmann, *German Art of the Twentieth Century*, **1957**, pages 78–80

Desire for knowledge was in the modern spirit. It was directed immediately toward man and his inner being. Through [Edvard] Munch and [August] Strindberg it had already been made clear, artistically, that man does not exist on a narrow plane that is free of doubts. This intuitive probing of the inner world of man through art was now powerfully confirmed by the science of psychoanalysis founded by [Sigmund] Freud in Vienna. And out of the milieu of the Vienna Jugendstil came the painter, Oskar Kokoschka (born 1886), who had an incomparable capacity for uncovering images beneath the sensitive skin of natural appearances. . . .

His early pictures, of the period 1908–09, are immediately recognizable representations of still lifes and portraits. But the visual reality of objects and faces within these works really represents the psychological state of the painter, and this is achieved by a hallucinatory manipulation of the painter's objects. His portraits are sketches of human faces made half in a trance, and they disclose more about the painter and his humanity than they do about the model. For this reason all the models resemble each other in their spiritual condition. The eye of the painter looking at a man suddenly conceives something phantasmal in him, a play of gesture, some piece of mimicry caught on the wing, which takes the place of the subject, and which the artist relentlessly isolates and penetrates. This response of the painter stands in direct relationship to himself alone. His painting is, to be sure, a visual impression, but there

is behind this, submerged, an element of second-sight, another aspect of the artist's reality—it is a revelation of himself. Kokoschka attempts to illustrate this vision with the means at the disposal of painting. This is objectively expressed in the portraits by means of grimace and gesture, and hence the emphasis on the head as the scene of mimicry and of the hand as the scene of gesture. The means themselves are an Impressionism made ecstatic; the graphic elements become nervous and hectic, and the color feverish and phantasmagoric. The goal of the picture is the most expressive possible illustration of a vision that has been torn out of the feelings, and in impression even though, as may happen, the organic body of the picture itself is in shreds. The painters of the Brücke, those of the Blaue Reiter, and [Emil] Nolde all sought to transform a visual experience into painting. Kokoschka came from the other side of reality, from a world that objectified dream and vision. It was his genius to show the visionary possibilities of German Expressionism.

Gustav Klimt
Hope, II. 1907–08
Illustrated on page 143

Kirk Varnedoe, *Vienna 1900: Art, Architecture & Design*, **1986**, pages 149–50, 155, 158–59

At the turn of the century, Klimt embodied both authority and rebellion. Born in 1862 as a goldsmith's son, he became a professional decorative artist in his teens, and in one instance executor for the designs of the "prince" of Viennese art in the Ringstrasse era, Hans Makart. After Makart's death Klimt, regarded as his "heir," became a favored painter for the ceilings of the later Ringstrasse buildings.[1] As an honored young professional, Klimt thus commanded special respect, in the 1890s, from forward-looking artists' clubs like the Siebener (the Seven) of Joseph Hoffmann and Koloman Moser.[2] But as an aging prodigy who had spent too many hours on scaffolds satisfying institutional tastes (and who had been passed over for a professorship in history painting), he was ripe to be converted to their idea that modern art had something better to offer.[3] In two major instances in the later 1890s—the paintings commissioned from him for the ceiling of the University of Vienna's Great Hall, and the formation of the Secession—Klimt decided to leave the path of his "correct" career, and cast his lot with youth and change. This *exemplum virtutis*, in combination with his fraternal artisan's spirit, gave him a certain secular sainthood, enhanced by the "martyrdom" he suffered at the hands of critics. His beard, sandals, and studio smock en-

hanced this image of piety, so piquantly incongruous with his reputation as a womanizer and with the hothouse sensuality of his work. Klimt was part Francis of Assisi, part Rasputin. . . .

A frustration with what were seen as the limitations of easel painting [similarly] goaded other ambitious European painters around 1900, longing for art to take on transcendent themes in grander forms. It remains an open question whether the very goal they pursued, of an art public in scale and ambition yet determinedly individual in inspiration and style, was itself feasible; but it seems clear that where many tried—[Edvard] Munch, [Paul] Gauguin, and [Paul] Signac among them—few succeeded in the way they had hoped. Klimt was nonetheless drawn, not just by the hazard of commissions but independently, to the notion that by wedding itself to architecture in a new way, his painting could aspire to the status of great mural art of the past, and he could work in the nobler atmosphere of philosophy. . . .[4]

This kind of confusion and ornamental richness does not embellish the content of Klimt's art, it *is* the content. For Klimt the maintaining of irresolution—between figure and ground, flatness and depth, object and image—was a key way to heighten the experience of art.[5] It evoked the privileged state of a dreamlike floating in which fantasy liquefies the world, tinting and bending it to its own desires. (It is in this strategy that Klimt's paintings have affinities with psychedelic imagery of the 1960s.) The most extreme statements of this willed decorative disorientation lie in the "golden" phase of Klimt's work, from 1906 to 1909. In those works, metallic lead appliqués and embossed designs determined a collage-like surface life, assertively independent of figural content. They also drew on a repertoire of ancient and exotic decorative motifs to assemble a vocabulary of *Ur*-forms of geometry and biology—spirals, rectangles, lozenges, triangles, etc.—intended to evoke primal associations of male and female, mind and nature.[6]

These are the same combined goals—an anti-illusionist play directly on the viewer's sensorium, and an abstract formal language attuned to universal expression—that led other European artists in these same years to decisive certainties of sharp reduction and synthesis. In Klimt they gave rise to elaboration and ambiguity. While others looked to sources in archaic and exotic art for a new economy of volume and line, Klimt saw in the same sources the heightened splendor of complexity—not only the blunt empiricism of a head by Giotto, but that head and its flat golden halo together; not only the woodcut simplicity of Hokusai's form, but that simplification overprinted with multi-patterned kimono forms; not the white purity of Greek art at Segesta, but the rich ornament of the recent Mycenaean finds. For him, the exotic, archaic, and primitive arts bore evidence of a primal human love of proteiform brilliance—the doubled intensity of earthy observation joined with fertile abstract invention and lust for materials. This was the common ground that, from nomadic metalwork to Byzantine mosaics, shaped a tradition of spiritually charged art he sought to recover.

Emil Nolde

Christ and the Children. 1910
Illustrated on page 144

Peter Selz, *Emil Nolde*, **1963**, pages 9, 19–20

Taciturn and morose by nature, and highly introverted, Nolde felt most at home among the peasants of his native soil. He shared a great many of their fears, superstitions and prejudices, but with his unique artistic gifts he was able to lend these notions a mystical and often demonic aspect. He visualized himself as a missionary whose privileged duty it was to create a vital, intense art of the North. Standing somewhat apart from the main stream of the art of his time, he remained essentially a regionalist, but a regionalist of genius.

In his several autobiographical volumes and in his published and unpublished letters, Nolde appears as a misanthrope: one who suffered greatly from perpetual loneliness, who was constantly aware of his inability to take part in the normal human community, yet who longed desperately for signs of friendship or at least of acceptance. From early adolescence he shunned other people; he seems frequently to have experienced deep religious feelings and mystic identifications with Christ's Passion. His attitude of melancholy mysticism remained with him throughout his long lifetime.

Nolde's copious writings are clumsy in syntax and phrased in a naïve vocabulary, which is only partly due to his own strange language, characteristic of the European border peasantry that is never fully at home in the culture of any language. His persistent anti-intellectualism of course merely contributed to this awkwardness of expression. . . .

In his etchings, woodcuts and lithographs he had first made some fantastic figure compositions of considerable dramatic force. During his entire life he felt a deep personal, almost visionary concern with religion, regarding himself as almost a mystic evangelist. In the summer of 1909, while he was living alone in Ruttebüll in northwestern Schleswig close to his birthplace, he fell severely ill. During this time he experienced a sudden, urgent need for religious self-expression through

paintings. "I followed an irresistible desire to represent profound spirituality, religion and tenderness, without much intention, knowledge or deliberation,"[1] he recalls in his autobiography. . . .

Nolde's biblical paintings frequently combine a pronounced sensual excitement with his unquestionably sincere religious passions: religion seems, after all, to have been for him a matter of primitive passion, and often he frankly expressed inhibited sexual drives. On the other hand, a rather simple personal color symbolism is the key to the tender *Christ Among the Children*, formerly in Hamburg's Kunsthalle. Here the tender figure of the Saviour, draped in a blue mantle, looms up protectively as an overpowering diagonal form, separating the bright children—all aglow in red and yellow—from the dark purple disciples, rebuking those who brought the children, dubious and astonished at Christ's concern for them.

Ernst Ludwig Kirchner
Street, Dresden. 1908
Illustrated on page 144

John Russell, *The Meanings of Modern Art*, **1981**, pages 79, 80, 82, 83–84, 86

When he was 20 years old, [Kirchner] was appalled by what then passed for "modern German painting." "The content of those pictures, and their execution, were as depressing as the public's total lack of interest," he wrote later. "Inside the gallery there were those pale, lifeless daubs. Outside, there was the flood of life itself, with its color, its sunshine, its sadness. . . . Why didn't those worthy gentlemen paint real life? Because it moves, that's why. They neither see it nor understand it. And then I thought—why shouldn't I try? And so I did." . . .

It was in Dresden that Kirchner and his friends Erich Heckel and Karl Schmidt-Rottluff invented, between 1905 and 1911, a new kind of German art. Dresden before 1914 was not at all provincial in the sense that Oslo was provincial in [Edvard] Munch's early days. It had a first-rate theater and a first-rate opera house, a waterfront on the Elbe which was one of the most beautiful sights in Europe, and Old Master collections which were worth crossing the world to see. . . .

Kirchner and his friends took a long time to find what we now call "the Brücke style." . . . Kirchner saw the Brücke group as *Neudeutsche:* "new Germans." "German creativity is fundamentally different from Latin creativity," he wrote. "The Latin takes his forms from the object as it exists in nature. The German creates his form from fantasy, from an inner vision peculiar

to himself. The forms of visible nature serve him as symbols only . . . and he seeks beauty not in appearance but in something beyond."

By "symbol," here, Kirchner did not mean the delicate vibration which [Stéphane] Mallarmé had had in mind. He meant something robust, forthright, provocative. His idea of a symbol was something that said "Live more naturally! It's a mistake not to." Living more naturally meant breaking with the current notion of fine art and relying, for example, on the antithesis of the woodcut, the primeval clash of plain black against plain white, as against the curdled sauces of German Impressionism. It meant using color contrasts that looked both caustic and gaudy when set against the super-civilized procedures of [Henri] Matisse. The human beings in Brücke paintings often looked as if they had been carved out of wood with a blunt knife; and when the Brücke portrayed big-city life it was rarely without a hint of underlying menace. . . .

Kirchner had been a compulsive draftsman from childhood onward; and when he came to paint his big Dresden street scene, he had no difficulty in finding a graphic equivalent for the quirks of character and deportment which he had been studying for the greater part of his life. He had never drawn "from the model," in the academic sense; what he drew, he had lived. The Dresden *Street* is, on one level, almost dandified in its use of the continually varied hat shapes, back and forth across the upper half of the canvas. Kirchner is no less ingenious in his animation of the shallower space on the right-hand side of the picture; how subtly does he suggest that these are people possessed by the city! Yet the picture is neither decorative nor polemical; the drawing sees to that. Each person is an individual, an identifiable Dresdener hurrying to keep up. If we ask "To keep up with *what?*"—history has an answer.

Vasily Kandinsky
Picture with an Archer. 1909
Illustrated on page 145

Magdalena Dabrowski, in *Masterworks from The Louise Reinhardt Smith Collection*, **1995**, page 24

Described by Alfred Barr as "lyrical, musical, dramatic" when first exhibited at the Museum in 1958, this painting is remarkable for its large size, innovative style, and vibrant color. The composition, executed in 1909 in Murnau (near Munich) after Kandinsky had been living in that region for over a decade, relies on the principle—learned from Fauvism—of abandoning traditional spatial conventions in favor of juxtaposing areas of color disassociated from the precise definition of form. A cer-

tain sense of depth is conveyed by the vigorous expressionist brushwork that creates a rich surface in relief. The specific narrative role of the figurative motifs depicted is of secondary importance to the intense color scheme; together they establish a powerfully dramatic effect and an ominous mood that invites the viewer to interpret the mysterious subject matter. Despite the painting's descriptive title, its visual impact alternates between an almost purely pictorial construction, in which the landscape and figures are absorbed into the sumptuous mass of explosive color that describes an outdoor scene of a rider on horseback, and a narrative scene.

The rider was Kandinsky's favored subject in the pre–World War I years, and this work is one in an important sequence, beginning with the 1903 painting *Blue Rider* (private collection, Zurich), continuing with several depictions of apocalyptic riders, and culminating in the cover image of the *Blaue Reiter Almanac* (a compendium of essays on art edited by Kandinsky and Franz Marc in 1912). Here, the archer turns uncharacteristically backward, aiming his bow at an unknown pursuer while galloping through a semi-abstract landscape.

Awe-inspiring in its grandeur, the landscape is punctuated by several figurative motifs: a fragment of a Russian town with onion-domed towers, a group of people in Russian dress, and a strangely shaped tree. The picture's large scale is emphasized by an enormous vertical shape, like a bizarre tree trunk or a monolithic rock . . . that looms grandly over the composition. This form's imposing stability contrasts sharply with the dynamism of the archer and creates tension among the compositional elements while unifying them into a harmonious, mysterious whole.

These figurative motifs express Kandinsky's nostalgia for his native Russia and relate the painting to his works of the early 1900s, especially his "colored drawings." They also stylistically, and to a degree conceptually, point to Kandinsky's most important works of the following years, . . . which repeat these figurative motifs, spatial definitions, and rich, exuberant color.

Vasily Kandinsky
Panels for Edwin R. Campbell. 1914
Illustrated on pages 146, 147

Werner Haftmann, *German Art of the Twentieth Century*, **1957**, pages 67, 70

In the course of a profound, spiritual assimilation of the ideas growing out of the Jugendstil, [Vincent] van Gogh, the Neo-Impressionists, and the Fauves [Kandinsky] succeeded in evolving the abstract picture. His aim was now no longer to reproduce objects in painting, but to make painting itself the object; the new pictorial structure was marked by an inner resonance which moves sensibility in the same way as do representational pictures and the creations of nature. This event took place in 1910, and from that date Kandinsky abandoned objective titles as well, choosing such designations as "Abstraction," "Improvisation," and "Composition."

"Composition" always denoted some analogy to music. In the early abstractions of 1910–11 one could even find a relationship to [Richard] Wagner's great operatic compositions. Just as Wagner's music is saturated with sensuous and symbolic allusions and evokes images of large scenery and figurative analogies in the listener's mind, so the waves of color in these first incunabula of abstract painting conjure up a whole inventory of material associations: symbols of walking forms, horsemen jumping, sturdy Russian churches, dramatic or bucolic scenic backgrounds. If the eye follows the epic course of the sonorous colors, it is continually confronted by these individual figurative symbols, leitmotifs, as it were, of a dramatic composition for the stage: movements of mystical color which seek to make a dramatic state of the soul visible, but do not yet sufficiently trust their independence from representation to be able to entirely abandon objective reference. Such naturalistic and sentimental residues still muddy the overall formal organization. This fact emerges most clearly in the spatial organization which still has a naturalistic character, as of a corridor, in the perspective gradations from foreground to background. But the painting changes as early as 1911. The scheme of lines that determines the form is woven into the tempestuous colored background in a free arabesque. And now, too, the attempt to produce illusions of space disappear. The picture seems to soar away from terrestrial perspective, with its simple arrangement of foreground, middle ground, background, into a cosmic perspective in which this clear recession is replaced by and merges into a more complicated space. 1912–13 is the period in which Kandinsky vigorously came to terms with the pictorial organization of the young Frenchmen. In his paintings of 1913 we see illusionistic space give way to a shallow pictorial depth which does not observe traditional perspective, a system of stepwise layers of space and interpenetrating planes. The comparison with Cubism is obvious, but in that comparison we recognize the way in which Kandinsky gives this relatively rational system, with its calculated architecture, a very broad tension in a highly expressive way by irrationally puncturing and opening up space. Kinetic forms of motion bring a space-time element into the painting. In this way the orchestration of a new kind of picture is created, embracing both the rational and the irrational, the finite and

the infinite, the static and the dynamic; the unbridled force of the Northern European-Eastern world of expression has erupted in an Orphic song. If one had to choose a stylistic designation for this art, it could only be called Abstract Expressionism.

Kandinsky
Panels for Edwin R. Campbell
Illustrated on pages 146, 147

Magdalena Dabrowski, in *MoMA: The Magazine of The Museum of Modern Art*, **1999**, pages 2–3, 5

In 1889, upon entering a peasant hut during a trip to the Vologda region of Northern Siberia, Vasily Kandinsky experienced an aesthetic and emotional revelation. According to his memoirs, the entire interior was an environment of images and colors complemented by polychromed carved furnishings. Kandinsky felt he had entered a picture. In a variety of works created over the next five decades, he tried to capture and re-create that feeling. The suite of four paintings by Kandinsky in the collection of The Museum of Modern Art, executed in 1914 . . . are one such attempt. They may also be thought of as a *Gesamtkunstwerk*, or total artistic environment, a concept popular at the end of the nineteenth century, in which art and architecture harmonize to create a completely unified whole. The intention was to envelop the spectator on all sides with the pictorial space.

By the end of November 1913, Kandinsky had already painted his first abstract compositions. Although Kandinsky was not widely famous, his work gained exposure in America in a key presentation of modern art, the 1913 International Exhibition of Modern Art, known as the Armory Show. Among the collectors who had embraced the cause of European modernism and begun acquiring examples of the most advanced art was a Chicago lawyer, Arthur Jerome Eddy (1859–1920). Eddy shared his admiration for Kandinsky's work with his friend Edwin R. Campbell (1874–1929), a doctor who had abandoned medicine and become the founder of the Chevrolet Motor Company. In May 1914 Kandinsky received from Campbell a commission to create four paintings for the foyer of his apartment at 635 Park Avenue in New York. The commission, the only one Kandinsky received in his career, came via Eddy, who on May 21, 1914, wrote to Kandinsky: "I have persuaded a friend here in New York to buy some of your work. He is taking the pictures entirely upon my urging him to do so and therefore I am very anxious they shall please him and his wife when they are in his home. He wants four paintings for the four walls of a reception hall. There are four panels in the walls and the paintings will each fill a panel." The letter, preserved in the archives of The Museum of Modern Art, specifies dimensions for the works, clarifying that they were to be of the same height but of different widths (appropriate to the dimensions of the specific walls). Even the compositional content was suggested by Eddy, who indicated that one of the paintings in his collection, *Landscape with Red Spots II* (1913), would be a suitable model for the Campbell works. "It is so brilliant in color that it makes a beautiful wall decoration," he wrote. "Now I think my friend would like four pictures painted in the same mood, strong brilliant pictures." The commission was to be executed very quickly, so that it would arrive in New York by September 1914.

Completed as requested, the suite did not reach New York until early 1916 due to the outbreak of World War I. The panels were presumably installed in Campbell's foyer in the fall of 1916. We do not, however, have any evidence to that effect other than Eddy's description as to how they would have been framed and installed. Campbell divorced and moved out of the apartment in 1921 and died in 1929. The works disappeared entirely from view during the 1920s and 1930s, and were separated into two pairs. The first pair, *Number 199* and *Number 201*, resurfaced in 1940 in Florida and were acquired by the Guggenheim Museum in 1941. The second pair, *Number 198* and *Number 200*, appeared in 1953 in an auction in upstate New York as "Modern Abstract Paintings" and were purchased by The Museum of Modern Art in 1954.

Identified by art historian Kenneth C. Lindsay as the suite commissioned by Campbell, the paintings were finally reunited, by exchange, in 1983. (Lindsay also proposed that the panels represent the four seasons, characteristics of which are conveyed by the color schemes and moods of the paintings; we have no evidence, however, that Kandinsky thought of the works in these terms.) Following their reunification the works were systematically restored through surface cleaning and varnish removal . . . and were thus brought to their original, harmonious relationship.

Picasso and Cubism

Pablo Picasso

Boy Leading a Horse. 1905–06
Illustrated on page 148

William Rubin, *Picasso in the Collection of The Museum of Modern Art*, **1972**, page 34

Late in 1905, Picasso began some studies of figures and horses, which at first reflected the ambience of the circus. Soon, however, the varied motifs combined in the artist's imagination to form an image that evoked a more remote world, pastoral and antique in spirit. The large work Picasso had in mind, *The Watering Place*, was never realized, though a gouache study for it exists.[1] The monumental and superbly assured *Boy Leading a Horse* is a full-scale rendering of one of its central groups.

The classical, more sculptural turn that Picasso's art took late in 1905 was probably influenced by [Paul] Cézanne, thirty-one of whose paintings had been exhibited in the Salon d'Automne of 1904 and ten more at that of 1905. The monumentality of the boy, whose determined stride possesses the earth, the elimination of anecdote, and the multiaccented, overlapping contouring all speak of the master of Aix.[2]

But Picasso had also been looking at Greek art in the Louvre, and under this influence he showed himself increasingly responsive to the kind of revelatory gesture that is the genius of classical sculpture. In the *Study for Boy Leading a Horse* in the Baltimore Museum of Art the youth directs the animal by placing his hand on its neck; but in later studies and in the final painting Picasso chose a gesture whose sheer authority—there are no reins—seems to compel the horse to follow. This "laureate gesture," as it has been called, draws attention by analogy to the power of the artist's hand.[3] Sculptures of idealized, striding male nudes were given as prizes to the winners of the ancient Olympics; that Picasso intended to allude to such laureates can be shown by tracing this very model back through *Girl on Horseback, and Boy* to *Boy with a Pipe*, where his head is wreathed in flowers.

Picasso's interest in classicism at this time was probably stimulated by the view of Jean Moréas, a leader in the neoclassical literary movement that developed out of, but finally reacted against, Symbolism. Moréas was a regular, along with [Guillaume] Apollinaire and [André] Salmon, at the soirées that Picasso attended Tuesday evenings at the Closerie des Lilas. The painter's search for an antique image—as distinguished from his contemporary restatement of ancient themes such as the sleeper watched—may also have been stimulated by the painting of [Pierre] Puvis de Chavannes,[4] whose work was featured along with that of Cézanne in the Salon d'Automne of 1904. But in *Boy Leading a Horse* we see that Picasso's classical vision is imbued with a natural *areté* unvitiated by the nostalgia of Puvis' "rosewater Hellenism."[5]

In *Boy Leading a Horse* Picasso makes no concession to charm. The shift of emphasis from the sentimental to the plastic is heralded by a mutation of the Rose tonality into one of terra cotta and gray, which accords well with the sculpturelike character of the boy and horse. The pair is isolated in a kind of nonenvironment, which has been purged not only of anecdotal detail but of all cues to perspective space. The rear leg of the horse dissolves into the back plane of the picture, and the background is brought up close to the surface by the magnificent scumbling on the upper regions of the canvas.

William Rubin, *Picasso and Braque: Pioneering Cubism*, **1989**, pages 15, 16, 26, 27

The pioneering of Cubism by [Pablo] Picasso and [Georges] Braque is the most passionate adventure in our century's art. . . . Not since Rembrandt's has any painting so captured the elusive shading of human consciousness, the complex anatomy of thought, the paradoxical character of knowledge. . . .

From 1910 through 1912 especially, the incremental advances in each artist's work, and the network of linkages between them, provide what may be the clearest revelation we have had of the nature of pictorial thought. This twentieth-century embodiment of Leonardo's definition of painting as *cosa mentale* was Cubism's most important bequest to subsequent generations, and the work of Duchamp is no less indebted to it than is that of [Piet] Mondrian.[1]

The fact that Cubism unfolded essentially through a dialogue between two artists extending over six years makes it a phenomenon unprecedented, to my knowledge, in the history of art. Not surprisingly, much that has been said about the Cubism of Picasso and Braque turns on the comparative quality of their respective work. To the extent such argument overlooks the more readily quantifiable differences in their styles and

methods, however, it seems to me something of a canard. Not that I regard the two artists as equals. Braque is one of the great modern painters, but we must go back to the most prodigious Renaissance masters for the like of Picasso. We have come to expect more from Picasso, and in the Cubist period, under the pressure of the dialogue with Braque, we get it consistently. But the point is that what we get from Braque is not less of the same, but something different. . . . Their [Picasso and Braque's] differences, in temperament, mind, and pictorial gift, contributed to a shared vision of painting that found them both at their best when they were closest to one another—a vision which neither, I am convinced, could have realized alone. . . .

The friendship of Picasso and Braque may have been a classic instance of an attraction of opposites, but the nascent language they increasingly held in common served equally well their contrasting needs. For Picasso, whose facility was demonic, and whose poorest work shows him merely coasting on it, Cubism was a kind of deliverance. It obliged him consistently to forgo the refuge of virtuosity for an art which, at least in 1908–09, any reasonably trained novice could execute—if he knew where to put the marks. . . . Thereafter, and undeviatingly until World War I, Picasso accepted as axiomatic the Cézannian commitment to conception—that is to say, invention—as the heart of painting, to the exclusion of everything related to execution. Talent was out, along with anything else that could mask or obscure the pictorial idea.

Cubism also sentenced Picasso to an emphatic focusing-down insofar as its essentially iconic nature forced him to work against the grain of one of his greatest strengths, and pleasures—that of pictorial storytelling. The Cubist years are unique in Picasso's career in being virtually devoid of overt narrative imagery. . . .

If Cubism forced Picasso severely to narrow the range of his subjects, it nevertheless fostered a compensatory profundity in his explorations of them. The banal yet very personal objects that are the motifs of his and Braque's Cubism constituted a studio world that gradually incorporated an iconography drawn from the more gregarious milieu of the café. The artists cultivated a profound affection for these objects, all of which were to be touched and used as well as seen; Picasso, for example, thought it "monstrous" that women should paint pipes "when they don't smoke them."[2] In their patient scrutiny of these articles, endlessly disassembled and reconceived, the two artists sought a rendering at once more economical and synoptic than sight. And this involved them in deliberations more protracted than any in which either painter would later engage. Their quest ended by making the very process of image-formation virtually the subject of their pictures, placing their enterprise at a far remove from that of other vanguard artists. . . .

The importance Braque attributes to the picture field, as against Picasso's stress on the physiognomic of particular forms, is also expressed in the priority he gives the spatial continuum. Picasso starts with the objects that inhabit this continuum. Braque, as he himself said, was "unable to introduce the object until I had created the space for it."[3] Braque's insistence on dissolving distinctions between figure and ground, a characteristic of his Cubism throughout, follows from this position, and also partly explains why his pictures are wont to be more painterly (malerisch) than Picasso's, in which the brushwork tends to produce harder, more sculptural surfaces. The radical fragmentation of objects that took place in 1910 allowed Braque further to subsume their contours in a synthesizing light and space, and he led the way in establishing the new kind of all-over painterliness that displaced the essentially sculptural illusionism of 1908–09 Cubism. The culmination of this pictorialism was the luminous space of the two artists' 1911 Céret pictures, which also marked the moment of highest coincidence between the Cubist language and Braque's individual painterly gift. While Picasso also exploited the new fusion of figure and ground to great advantage in his work of 1910–11, his real interest in the fragmentation of objects lay in the opportunity it gave for pushing their physiognomic into a world of new signs.

It is precisely in the invention of signs that the power of Picasso's imagination makes itself most manifest in Cubism. In morphological terms, Braque's art is essentially, if inventively, reductive.[4] He seeks a sign that is easily assimilated to the fabric of the picture—hence at once not overly distinguished in its individual profile, while maximally conditioned in its size, shape, and placement by the framing edge and the implicit grid structure derived from it. The signs Braque invents, such as the panels of simulated woodgraining he introduced in the winter of 1911–12, tend to be generated by the surface qualities rather than the shapes of his motifs. Picasso's signs are derived from the physiognomic of objects, and he often presses their individuation in imaginative ways until they appear, at least by the end of 1912, almost arbitrary. Although Braque invented papier collé, Picasso's ability to carry further its sign possibilities resulted in a more variegated and colorful exploitation of the medium. Synthetic Cubism was to open upon a different constellation of possibilities than the Analytic Cubism of the preceding years. And the Braque who was a full partner in the high Analytic Cubism of 1908–11, and played a crucially inventive role in the transition of 1912, was less able than Picasso to develop within the non-illusionistic sign language of the Synthetic mode of 1913.

Pablo Picasso

Les Demoiselles d'Avignon. 1907

Illustrated on page 149

William Rubin, *Les Demoiselles d'Avignon*, Studies in Modern Art 3, **1994**, pages 13–14, 17, 18–19, 103, 104, 105

Les Demoiselles d'Avignon created an historical fault-line that makes even the most radical of Fauve paintings look today like the modernism of the late nineteenth century. But the courage and perseverance of Picasso's undertaking cannot be measured by reference to pictorial values alone. Doubtless a competitiveness with [Henri] Matisse and [André] Derain acted as a spur for Picasso, encouraging him to go beyond even their first post-Fauve innovations in a "masterpiece" that would both summarize and surpass his earlier work.[1] And certainly it took considerable nerve for him to push his picture so far that those very colleagues saw it less as a triumph of artistic daring than as a preposterous and incomprehensible failure.[2] . . . Yet the courage of which I speak, which was the motor force that drove the almost six-month-long metamorphosis of the *Demoiselles*,[3] was less a matter of aesthetic endeavor than of relentless self-confrontation—and was in this sense comparable to [Sigmund] Freud's solitary self-analysis.

Insofar as Picasso's aims in the *Demoiselles* were artistic, one almost demeans them by invoking the goal of surpassing Matisse's and Derain's daring. For as work on the picture progressed, Picasso's ambition became nothing less than the recovery of the magical function that first led humankind to make images: the power to change life. Picasso understood instinctively that the Western tradition had been losing contact with that primordial, talismanic aim of image-making—indeed, had lost it altogether in the nineteenth-century definitions of art shared by his painter-father, the schools he attended, and the Salons that insured prevailing values. But for Picasso, it was less the nature and conventions of art than those of life—and most important, of his own life—that were at stake.[4]

In the winter of 1906–07, when Picasso began his studies for the *Demoiselles*, vanguard painting was clearly at a crossroads. The inherited Impressionist/Symbolist phase of modernism was coming to an end, and solutions that could seriously redirect the enterprise of painting were not yet visible.[5] But the primary impulse for the terrifying night journey of the soul that Picasso undertook in the *Demoiselles* was a crisis of a personal, psychological order. It became an artistic one, insofar as Picasso needed to forge new tools adequate to excavate the deeper strata of his mind. This exploration induced the astonishing variety of styles that we see in the *Demoiselles* and in the many hundreds of drawings and paintings associated with it[6]—quantity of preparatory work unique not only in Picasso's career, but without parallel, for a single picture, in the entire history of art. . . .

Picasso studiously avoided giving titles to his works. And *Les Demoiselles d'Avignon*—"How that name annoys me!" the artist exclaimed—is not among the rare exceptions. Nevertheless, Picasso seems to have acquiesced early on—though possibly not until World War I—to the more pointed "Le Bordel d'Avignon" and to "Les Filles d'Avignon" as studio "handles" for the picture. He is quoted by [Daniel-Henry] Kahnweiler, perhaps mistakenly, as saying in 1933 that the picture "was called 'Le Bordel d'Avignon' at the beginning."[7] The earliest publication of the painting, Gelett Burgess's 1910 article "The Wild Men of Paris," contained no title for it; its reproduction was captioned simply "Study by Picasso." Burgess briefly recalled the studio contents at the time of his 1908 visits to Picasso, and it is probable that his references to both "sub-African caricatures, figures with eyes askew, with contorted legs" and "ultramarine ogresses" were inspired by the right-hand figures of the *Demoiselles*.[8] . . .

The earliest published reference to "Avignon" in connection with Picasso's picture dates from 1916, when the work was publicly shown for the first time in an exhibition called the Salon d'Antin in Paris . . . organized by [André] Salmon.[9] Given the private manner in which Picasso always treated the *Demoiselles* . . . it is difficult to imagine that Salmon would not have discussed the delicate issue of the picture's title with Picasso well before the exhibition. In publicly baptizing the picture known by Picasso's intimates as "Le Bordel philosophique"—and perhaps as "Le Bordel d'Avignon" or "Les Filles d'Avignon"—with the name *Les Demoiselles d'Avignon*, Salmon "confirmed" the locale of its scene while deftly sidestepping scandal by dropping "brothel" and substituting "maidens" for "girls."[10] In 1916, Picasso seems himself to have used "Les Filles d'Avignon" with the Danish painter Axel Salto, who saw the picture in Picasso's studio not long before the Salon d'Antin.[11] Although Picasso presumably approved Salmon's title in 1916, if only grudgingly, he later regretted it. Salmon's finessing of brothel whores into anodyne maidens probably accounts for Picasso's having been "annoyed" by the title in 1933.[12] Salmon's formulation clearly blunted the most understandable clue to the social transgression of the picture, and as such was alien to Picasso's raw and uncompromising sexual directness.

Recorded references to the *Demoiselles* by Picasso himself are few, and begin, at the earliest, only in the

113

1930s. They redirect emphasis from "demoiselles" to "filles," and explain, somewhat contradictorily, the presence of the word "Avignon." "You know very well that its name was 'The Brothel of Avignon' in the beginning," Picasso told Kahnweiler in the conversation cited above. "You know why? Avignon has always been for me a very familiar name, connected to my life. I was living around the corner from Avignon Street. It is there that I bought my paper, my watercolor supplies. And, as you know, Max's [Max Jacob's] grandmother was from Avignon. We joked about the painting. One of the women was Max's grandmother. One was Fernande, another was Marie Laurencin, all of them in a brothel in Avignon."[13] In a letter to Alfred H. Barr, Jr., in 1939, Kahnweiler added that Max Jacob had "told Picasso that a certain brothel at Avignon was a most splendid place, with women, curtains, flowers, fruits. So Picasso and his friends spoke about the picture as being 'this place of carnal pleasure.'"[14] . . .

In the years after 1907, Picasso's position as regards the relation of tribal art to the *Demoiselles* was, to say the least, variable and contradictory. His comments to Florent Fels shortly after World War I suggested that he was already fed up with the constant association of his work of 1907–08 with "art nègre."[15] But his denials that a rapport existed between the *Demoiselles* and tribal art began only during, or just before, World War II . . .

Against this, however, must be set a considerable amount of evidence to the contrary, some of it from the artist himself. Four major witnesses of the period of the *Demoiselles* . . . specifically refer to Picasso's contacts at that time with "art nègre" (which term referred to Oceanic as well as African Art). Moreover, Picasso himself recounted to [André] Malraux in 1937 that *Les Demoiselles d'Avignon* "must have come to me that very day" (the day of his visit to the Trocadéro [museum]).[16] . . .

It is precisely because Picasso was looking for new solutions to the direct communication of deepening fears touching his own humanity . . . that he seized upon tribal art at that particular moment as a source of inspiration. . . . To the extent, therefore, that at least two of the demoiselles were influenced by ideas about tribal art prompted by Picasso's Trocadéro visit, their images open outward toward the collective implications of masking . . . Insofar, however, as those visages were in fact arrived at by Picasso's search for plastic correlatives in exorcising his private psychological demons, they constitute . . . a form of visual abreaction, and lead us inward to the other, Freudian sense of masking, in which emotions too painful to confront directly . . . are dealt with by substituting "cover" images.

Pablo Picasso

Girl with a Mandolin (Fanny Tellier). 1910
Illustrated on page 150

Kirk Varnedoe, *Picasso: Masterworks from The Museum of Modern Art,* **1997**, page 58

During the summer of 1910, Picasso pushed his Cubist stylizations toward a point of near-total abstraction, dissolving solid forms into an open, linear armature of shifting planes. This picture, which was studied (exceptionally) from a posing model, seems by contrast to present an evident dialogue between a shallow architecture of featureless slabs and more traditionally modeled volumes. Scholars have differed as to whether this indicates a transitional work done in the spring, or a work of the autumn in which Picasso began to pull back from the brink of abstraction. Picasso's testimony that Fanny Tellier, the model for this painting, quit prematurely—apparently in protest over the slow progress of the many sessions—adds a further element of doubt. How much further might the painter have elaborated passages like the neck and face, which seem uncharacteristically plain and whole amidst the general fragmentation of forms? The motif of the woman with a musical instrument, set against what appears to be a studio backdrop of canvases stacked against each other, likely derives from similar scenes painted by the nineteenth-century artist J.-B.-C. Corot, which Picasso could have seen in an exhibition in fall 1909. Picasso was drawn to these images of a female model contemplating a work of art in the studio setting, and variations on the theme would recur throughout his career. Corot's atmospherics have been overturned here, though in favor of a Cubist insistence on a gridlike organizing lattice that governs the geometricized facets of both the body and its surroundings. Later works would go much further with the formal puns and analogies that could link mandolins, violins, and guitars to the female body; such stringed instruments would become central, recurring emblems of Cubism. Their presence, here and elsewhere, underlines the strange paradox by which such a radically transforming revolution in art could be realized in terms of the traditional themes and intimate atmosphere of the studio portrait and still life—an explosive cataclysm of representation set forth, in tender chiaroscuro, with the contemplative air of chamber music.

Pablo Picasso

"Ma Jolie." 1911–12
Illustrated on page 151

William Rubin, *Picasso in the Collection of
The Museum of Modern Art*, **1972**, pages 68, 70

[This picture dates] from the period spanning summer 1910 and spring 1912, during which Picasso and [Georges] Braque, with whom he was then working closely, developed the mode we may call high Analytic Cubism. Such paintings are difficult to read, for while they are articulated with planes, lines, shading, space and other vestiges of the language of illusionistic representation, these constituents have been largely abstracted from their former descriptive functions. Thus disengaged, they are reordered to the expressive purposes of the pictorial configurations as autonomous entities.

This impalpable, virtually abstract illusionism is a function of Cubism's metamorphosis from a sculptural into a painterly art. Sculptural relief of measurable intervals has here given way to flat, shaded planes—often more transparent than opaque—which hover in an indeterminate, atmospheric space shimmering with squarish, almost neo-impressionist brushstrokes.[1] That this seems finally a shallow rather than a deep space may be because we know it to be the painterly detritus of earlier Cubism's solid relief.

The light in early Cubist paintings did not function in accordance with physical laws; yet it continued to allude to the external world. By contrast, the light in these high Analytic Cubist pictures is an internal one, seeming almost to emanate from objects that have been pried apart. Accordingly, the term "analytic" must here be understood more than ever in a poetic rather than scientific sense, for this mysterious inner light is ultimately a metaphor for human consciousness. The Rembrandtesque way in which the spectral forms emerge and submerge within the brownish monochromy and the searching, meditative spirit of the compositions contribute to making these paintings among the most profoundly metaphysical in the Western tradition.

The degree of abstraction in these images is about as great as it will be in Picasso's work, which is to say that while the pictures approach nonfiguration, they maintain some ties, however tenuous or elliptical, with external reality. Even without the advantage of its subtitle—*Woman with a Zither or Guitar*[2]—we would probably identify the suggestions of a figure in *"Ma Jolie."* The sitter's head, though devoid of physiognomic detail, can be made out at the top center of the composition; her left arm is bent at the elbow—perhaps resting on the arm of a chair whose passementerie tassels are visible just below—and her hand probably holds the bottom of a guitar whose vertical strings are visible in the center. Together with the wine glass at the left and the treble clef and musical staff at the bottom of the picture, all this suggests an ambience of informal music-making. . . .

Partly to draw attention by contrast to its luminous space, and thus reconfirm this highly abstract art as one of illusion, Picasso followed Braque in placing large trompe-l'oeil printed or stenciled letters on the surfaces of many pictures of this period.[3] . . .

"Cubism," as Picasso observed, "is an art dealing primarily with forms." But its subjects, he added, "must be a source of interest."[4] Lettering plays a crucial role in communicating these, and its often witty references to external reality relieve the pictures' formal asceticism. The words *"Ma Jolie,"* for example, are from the refrain line of a popular song of 1911,[5] but they were also a pet name of Picasso's new companion Marcelle Humbert ("Eva"), about whom he wrote to his dealer [Daniel-Henry] Kahnweiler that he loved her very much and would write it on his pictures.[6] Placed at the bottom center of the picture like a mock title,[7] these easily legible words form a whimsical contrast with the nearly indecipherable image of the "pretty one" to whom they appear to refer.[8]

Pablo Picasso

Guitar. 1912–13
Illustrated on page 152

William Rubin, *Picasso in the Collection of
The Museum of Modern Art*, **1972**, page 74

In the Cubism of 1909, the "skins" of objects were never penetrated, however much they were abstracted or reordered. . . . High Analytical Cubism, on the other hand, provided a model for an illusionistic art of seemingly transparent as well as opaque planes superimposed so as to suggest that the eye could see into and through objects. The type of open-work construction-sculpture that Picasso initiated with *Guitar* (executed toward the beginning of 1912, or perhaps at the end of the previous year)[1] built on this "see-through" arrangement, but necessarily in terms of larger, opaque planes (of a type that would increasingly characterize his paintings in 1912).

In inventing this three-dimensional counterpart for the uncurved planes and frontal arrangements of Cubist paintings of 1911–12, Picasso so radically altered the nature and direction of sculpture that he provided a point of departure for a veritable second history of the medium.[2] Sculpture, which had remained from before the time of the Egyptians and Greeks up to that of [Constantin] Brancusi and [Jean] Arp essentially an art

of carved and modeled solids, became predominantly one of hollow constructions made from planes and lines. Moreover, the configurations of these sculptures at once demanded and made possible the use of new materials and techniques.

The pictorial origin of Picasso's constructions is confirmed by the fact that *Guitar*, and most of the sculptures that succeeded it in the years 1912–16, were not conceived in the round, but as reliefs, which permitted the recapitulation of the paintings' planar overlappings in an actual shallow space. Musical instruments were preferred motifs precisely because, viewed frontally, they are structured in a high Cubist manner, their major planes flat and parallel to one another. Like the objects in the paintings, the body of the sheet-metal guitar is cut open and its components dislocated so as to provide simultaneous views of its different levels. As a result, however, of the metal's opacity, the transparencies illusioned in the paintings could only be implied. . . .

Guitar shows Picasso well along the road to [a] "rehabilitation" of objects which characterized the paintings of 1912. Most of its planes are readily identified with parts of the instrument. The back of the guitar's body is partially visible to the left. The neck of the instrument is represented only by its rear plane, a vertical half cylinder, as if the flat front plane of the fingerboard (implied by the wire strings) had become transparent.

The front of the guitar's body is radically cut away, leaving only a cylinder that represents the hole in the sounding board. This is the most remarkable formal constituent of the work. Viewed from an angle, the "hole" is paradoxically the only positive and integral form in the central void of the composition; viewed frontally, only the rim of the cylinder is visible, so it functions like a line drawing of a circle.

Pablo Picasso
Guitar. 1913
Illustrated on page 152

Deborah Wilk, in *Modernstarts*, **1999**, pages 309, 310

The guitar was a popular subject for avant-garde artists at the beginning of the twentieth century. In the early modernist art of the Cubists, the guitar, commonly found in the café and the artist's studio, bespoke a bohemian life. For Pablo Picasso and Juan Gris, the instrument evoked the Spanish culture of their homeland, where the guitar is thought to have originated. In addition to communicating place, the Spanish flamenco and classical guitar were both extremely popular in the late-nineteenth and early-twentieth centuries.

Stringed instruments also belong to the fine-art tradition of still life and genre painting, where they frequently have amorous connotations. Picasso's guitars are no exception. He acknowledged that the curvaceous form of the guitar was associated with the female body, an idea then current in art and literary circles.

In the language of Cubism, the guitar provided a potent and playful subject for visual punning: how much of its fragmented form could represent the whole instrument? A curved silhouette becomes shorthand for the body of the guitar. A circle and parallel lines can read as sound hole and strings. Ironically, the part of the guitar that is a void often becomes the most solid and recognizable part. . . .

In *Guitar*, a collage of 1913, Picasso introduced wallpaper, a mass-produced object, in an attempt to disrupt traditional methods of representing the observable world and to insert a material deemed unacceptable in art. Visual and verbal puns abound. Floral wallpaper cut in the shape of a guitar reappears in rectilinear form, perhaps to indicate a table or wall, and has the visual effect of flattening the space. A rectilinear swath of box-patterned wallpaper, in this context, stands for the guitar's neck and fretwork, while a circle of newsprint represents the sound hole. Picasso includes the front page of the Barcelona newspaper *El Diluvio*, which is truncated to read "Diluv," a sly pun on the Musée du Louvre in Paris, where modern art was not exhibited. The front page also contains an advertisement for an oculist, a possible reference to disparaging critics who joked that the disintegrating objects of Cubism were the result of poor vision.

Georges Braque
Still Life with Tenora. 1913
Illustrated on page 153

Henry R. Hope, *Georges Braque*, **1949**, pages 58, 59, 60, 62, 64

Both [Pablo] Picasso and Braque felt dissatisfied with the possibilities of the oil medium and the limitations it imposed. For three or four years they had rejected nearly all color and had been producing paintings of almost monochromatic effect. . . . At some time during the year [1913] he [Braque] introduced bits of green or gray marbleized surfaces into some of his pictures and also rectangular strips painted in imitation of wood grain.

A great deal has been written about the sources of these devices in his commercial painting apprenticeship. However, he had been painting for twelve years before they appeared in his work. It is significant that none of them appears in his paintings of the *fauve* or Cézanne periods. The new attitude toward painting

which was then developing out of cubist theories and experiments gave Braque this opportunity to draw upon his past experience. First it had been the *trompe l'oeil* nail, then the block lettering, and now marbleizing and wood graining. In retrospect, this sequence appears to be logical and perhaps inevitable. Nevertheless, it was a happy chance that the otherwise unrelated phenomena of house-painting conventions and a new theory of representing volumes in space were to join as formative elements in Braque's painting of these years. It brought about a new and rich phase in the maturing of his own style and led directly to some of his great post-war paintings.

Who made the first collage? This is a question which will never find a satisfactory answer unless it is stated in the same evolutionary terms. For it was in this atmosphere of cubist theory and under the same impulses that the first papier collés or collages were made. Picasso, whose extraordinary talent and passion make him as much a draftsman as a painter, and as much a sculptor as a draftsman, had many times experimented with sculpture. At that moment he had been experimenting with painted metal and possibly other materials. Braque in the meantime had been making paper sculpture, folding it into shapes like certain geometric details in his paintings. None of these has survived but we can guess what they looked like from the fact that Picasso in a letter of that date addressed Braque as "*Mon vieux Vilbure*," referring to Wilbur Wright. These paper sculptures seem to have suggested possible adaptations to painting which led to the making of the first collage.

As Braque remembers it, this was at Sorgues in September of 1912. Picasso had already returned to Paris. He and Marcelle [Humbert] stayed on at the *Villa Bel Air*. His eye was attracted by some wallpaper at an Avignon shop, printed to resemble the close grain of quartered oak. He bought some, took it to the studio and began experimenting with it. . . .

In many of the first collages the drawn details are in black and white, in short, they are drawings with pasted paper, but others combine strips of newspaper and various other papers. Later many of Braque's collages are composed on large rectangular boards or canvases which have been sized and painted flat white . . . If some of Braque's oil paintings of 1910 and 1911 bear a close resemblance to the work of Picasso, the collages have qualities particularly his own . . . The most successful by Braque achieve a sense of elegance and serenity . . . The musical instruments and wine glasses have a kind of cardboard reality like playing cards; these thin, delicate shapes appear to hover over the surface in a boundless white space.

Braque
Still Life with Tenora
Illustrated on page 153

Robert Rosenblum, in *Modern Art and Popular Culture: Readings in High & Low*, **1990**, pages 126, 127

The mysterious woodwind that turns up again and again on Cubist tabletops and that has been consistently misidentified as a clarinet (despite the obvious dissimilarity of its mouthpiece)[1] is, in fact, a folkloric instrument from Catalonia, a *tenora*, which Picasso had heard in performance in the Pyrenees and which both he and Braque often included in their still lifes as what must have been an ethnic memento of Spanish culture, comparable to their many allusions to the bullfight and other Spanish motifs. And here, too, the choice not of a clarinet, for which Mozart himself had written concert and chamber music, but of a crude woodwind from a lower cultural stratum was characteristic of the constant fluctuation in Cubist art between high-brow cultural traditions and grass-roots reality, whether in the heart of Paris or in the remoteness of the Pyrenees. Any survey of the musical references in Picasso and Braque's work indicates the double-track allusions to both the music of the concert hall . . . and that of popular café-concerts, whose songs and dances find their titles, refrains, and even scores fragmented throughout the writings and pastings in Cubist art.[2]

Juan Gris
Guitar and Glasses. 1914
The Sideboard. 1917
Illustrated on page 154

William S. Lieberman, *Twentieth-Century Art from the Nelson Aldrich Rockefeller Collection*, **1969**, pages 13–14

Juan Gris was the most representational, and perhaps the most lucid, of the cubist painters. In his own words, he had "witnessed the birth of cubism, adopted it shortly afterwards and exhibited for the first time at the Salon des Indépendants in 1912." In the summer of 1914, when he was twenty-seven, Gris fled wartime Paris. For personal reasons, he could not return to Spain, and he settled instead near the border at Collioure, a small fishing village on the Mediterranean. When he returned to Paris in November, he brought with him six paintings, and three collages—one of which is the *Guitar, Bottle, and Glass* in the Rockefeller collection. . . . Gris's *Guitar, Bottle, and Glass* is an oval still life contained within a rectangle, this time a vertical

one. Its intermingled combinations of pasted papers, paint, and drawing are exquisitely resolved and are very characteristic of Gris. The checkered pattern is also typical of his art. The contrasts of gray and black, green and brown, are warm and subdued. The multiple views of the glass illustrate perfectly the cubists' preoccupation with the presentation of several aspects of the same object at the same time. The guitar also serves as table, with a leg breaking through the oval.

Gris spent most of 1917 in Paris. Although by this time the cubists had abandoned collage, his austere and soaring *Sideboard* owes much to its inventions. Cubism was never wholly abstract, and Gris himself best described his aims in a letter to his friend, the dealer Daniel-Henry Kahnweiler:

"I would like to continue the tradition of painting with plastic means while bringing to it a new aesthetic based on the intellect. I think one can quite well take over [Jean-Baptiste-Siméon] Chardin's means without taking over either the appearance of his pictures or his conception of reality. Those who believe in abstract painting seem to me like weavers who think they can produce a material with threads running in one direction only and nothing to hold them together. When you have no plastic intention how can you control and make sense of your representational liberties? And when you are not concerned with reality how can you control and make sense of your plastic liberties? . . . I have also managed to rid my painting of a too brutal and descriptive reality. It has, so to speak, become more poetic. I hope that ultimately I shall be able to express very precisely, and by means of pure intellectual elements, an imaginary reality. This really amounts to a sort of painting which is inaccurate but precise, just the opposite of bad painting which is accurate but not precise."

Amedeo Modigliani
Head. 1915?
Illustrated on page 156

Alan G. Wilkinson, in *"Primitivism" in 20th Century Art: Affinity of the Tribal and the Modern*, **1984**, pages 417, 418, 419

Both as a painter and a sculptor, Modigliani was essentially a portraitist. The subject of twenty-three of his twenty-five surviving carvings is the human head. It is in these sculptures and numerous related drawings, rather than in his paintings, that we find Modigliani's subtle assimilation of African tribal art. . . . [T]here can be no doubt that African art was one of the major influences in the formation of the distinctive, highly personal style of Modigliani's elongated stone heads. . . .

The sculpture of Modigliani and that of his mentor [Constantin] Brancusi do not share the close stylistic affinities that often occur in the work of artists living and working in close proximity: . . . Brancusi's early stone carvings certainly influenced Modigliani, but more important was the "moral" example of the Rumanian, a sculptor who retained his individuality and remained fiercely independent of current movements of the avant-garde in Paris. Modigliani, in his dedication to working exclusively in stone, single-mindedly followed Brancusi's dictum "Direct carving is the true path toward sculpture,"[1] whereas Brancusi himself, by 1913–14, was sculpting in various materials—stone, wood, plaster, and had a number of his works cast in bronze. But it must be remembered that when the two artists met in 1909, almost all Brancusi's sculptures of the previous two years were carved in stone or marble. Modigliani, like Brancusi, . . . turned to direct carving and tribal sources as a way of escaping the overpowering influence of [Auguste] Rodin. [Jacques] Lipchitz has recorded of his friend, "Modigliani, like some others at the time, was very taken with the notion that sculpture was sick, that it had become very sick with Rodin and his influence. There was too much modeling in clay, too much 'mud.' The only way to save sculpture was to begin carving again, directly in stone. We had many very heated discussions about this . . . but Modigliani could not be budged."[2] In 1909 Modigliani could not have found a sculptor more dedicated to direct carving than Brancusi. In addition, Brancusi's interest in tribal art undoubtedly offered Modigliani an alternative to the Greco-Roman Renaissance tradition. . . .

Modigliani's stone heads made a considerable impact on a number of artists who visited his studio. Years later, Lipchitz recalled his visit in 1912 to the studio and made the important observation that the stone heads were intended to be seen together, and as a group produced a unique effect: "I see him as if it were today, stooping over those heads, explaining to me that he had conceived all of them as an ensemble. It seems to me that these heads were exhibited later the same year in the Salon d'Automne, arranged in step-wise fashion, like tubes of an organ, to produce the special music he wanted."[3]

Jacques Lipchitz
Man with a Guitar. 1915
Illustrated on page 156

Henry R. Hope, *The Sculpture of Jacques Lipchitz*, **1954**, pages 10, 11

In the grim atmosphere of war-time Paris, Lipchitz went to work with a devotion and frugality that is reflected in

the austerity of the new style. . . . The first new sculpture was a thin statuette in clay, a human figure with all details eliminated, organic shapes transformed to geometric, and volume reduced to a thin shaft. Soon this abstract image appeared in wood—flat boards, cut out and fitted together like prefabricated toys. . . .

Then his vision enriched these thin forms, by transferring them to stone, where they at once acquired weight, solidity and a clean, geometric rhythm. He preferred to hire a stone cutter for all but the finishing touches, but with his meager resources this was difficult. In 1916 a contract with Léonce Rosenberg, providing extra payment for labor and material, gave him what he needed. Thus liberated, he created a series of tall, thin shafts of great beauty. One of these, the *Man with a Guitar*, made a sensation when first exhibited because of the hole cut through the center. . . .

At this time his friendship with Juan Gris had brought Lipchitz into the inner circle of cubism. Like Gris, and some of the poets, he delved into occult science, looking—in vain—for a deeper meaning in cubism. He also read in metaphysics and philosophy and had many talks with Gris, whose searching intellect always added zest to their conversations. Quite possibly these widening intellectual interests were beginning to divert Lipchitz from his intense preoccupation with cubism and to prepare the way for new subject matter in his sculpture—although the change did not become visible in his work for several years.

The interchange of ideas and images with others in the circle gave some of his work the collective quality of the movement. Occasionally his gouaches and polychromed reliefs, done mostly in 1918, resembled the work of the painters ("that's the closest you ever came to Picasso," Gris once remarked to his infuriated friend).

Jacob Epstein
The Rock Drill. 1913–14
Illustrated on page 157

K. G. Pontus Hultén, *The Machine as Seen at the End of the Mechanical Age*, **1968**, page 65

"It was in the experimental pre-war days of 1913 that I was fired to do the rock drill, and my ardour for machinery (short-lived) expended itself upon the purchase of an actual drill, second-hand, and upon this I made and mounted a machine-like robot, visored, menacing, and carrying within itself its progeny, protectively ensconced. Here is the armed, sinister figure of to-day and to-morrow. No humanity, only the terrible Frankenstein's monster we have made ourselves into . . .

"Later I lost my interest in machinery and discarded

the drill. I cast in metal only the upper part of the figure."[1]

After thus describing *The Rock Drill* in his *Autobiography* some forty years later, Epstein goes on to add that: "I had thought of attaching pneumatic power to my rock drill, and setting it in motion, thus completing every potentiality of form and movement in one single work," but he abandoned this idea, deciding that it would provide "a kind of excitement . . . far removed from the nature of the aesthetic experience and satisfaction that sculpture should give."

The confusion in Epstein's thinking about *The Rock Drill* is typical of the ambivalent attitude toward machinery held then and later by many people who, for lack of a clear commitment, have been unable to define their opinions or positions toward it. As Richard Buckle has pointed out, Epstein's concept of a masked man drilling rock "held for him the fascination of a heroic, demonic, even sexual image,"[2] its phallic character is especially evident in some of the preparatory drawings. At the same time, as the passage from his *Autobiography* makes clear, Epstein also felt a kind of abhorrence and fear of the figure, which he termed "menacing," "sinister," "terrible," and devoid of all humanity.

When the plaster model was exhibited in London in March, 1915, it was mounted on an actual rock drill that formed a tripod-like base. It seems almost too symbolic that Epstein ultimately took this away, thereby depriving the sculpture of most of its original meaning. His fear of the machine turned out to be too strong. Unable to resolve this undefined emotional crisis, his art and ideas thereafter lost some of their original revolutionary energy and in general took a more traditional turn.

Fernand Léger
Contrast of Forms. 1913
Illustrated on page 159

Beth Handler, in *Fernand Léger*, **1998**, pages 154–55

In his lecture of May 1913, as well as in another lecture given a year later, Léger argued that art must acknowledge its time not through the naturalistic representation of contemporary subject matter ("visual realism") but by transforming that subject matter through explicitly pictorial devices—a "realism of conception."[1] In "the modern picture . . . ," Léger argued, "the painter . . . uses a subject in the service of purely plastic means . . . the contemporary painter . . . must not become an imitator of the new visual objectivity, but be a sensibility completely subject to the new state of things."[2] The way to capture the contrasts of the modern environment was through "pictorial contrasts."[3] In *Contrast of Forms*, then, colors, lines, and forms interact to create a

completely nonobjective statement—Léger's first, and the first to emerge from Cubist initiatives. This interaction results in a mass of geometric shapes organized around a vertical central axis. The shapes are mostly dependent on line for definition; nonetheless, their colors—red, blue, orange, green, yellow, white, black—assert their independence by floating within lines' boundaries, or at times existing completely outside of them. Line too is both dependent and independent, relying on color for subtly three-dimensional articulation while at times remaining distinct from that articulation. Patches of unpainted canvas enhance the painting's flatness and declare its status as object.

This art of what Léger called "dynamic divisionism"[4] was founded on formal contrasts among basic pictorial elements, but it also related to the "modern mentality" and was, the artist explained, "bound up with the visual aspect of external things,"[5] with "present-day life, more fragmented and faster moving than life in previous eras."[6] He stressed that art must have "an affinity with its own time,"[7] an affinity that, paradoxically, would allow it to "lay claim to pure classicism, that is, to a lasting quality independent of the period of its creation."[8] In fact, despite its abstraction, *Contrast of Forms* has a latent representational quality, fusing the human figure and its fragmented environment. The ascending segments of tubular forms on the left and right seem to allude to arms, and the more circular forms in the center, abutted by the chain of rectangles, to a torso. Read in this way, these elements assume a forceful mechanical presence that appears to move dramatically forward from the canvas.

Fernand Léger

Propellers. 1918
Illustrated on page 159

George L. K. Morris, in *The Museum of Modern Art Bulletin*, **1935**, pages 2, 3, 5

The very unfamiliarity with which a work of Léger will assert itself from other paintings of the Paris School provides a key to its comprehension; for Léger is, of all the contemporary painters, the one most truly modern. . . . Léger has derived but little from either past civilizations or his contemporaries; he cannot even, like [J.-B.-C.] Corot and [Georges] Braque, be snugly fitted into the French tradition. His aesthetic contributions always stand quite naked and apart, and when he does have intercourse with the past it is completely transparent, without being absorbed, in any eclectic sense, by his creative system.

Of the few contacts that Léger must concede, his relation to the Cubist group has been the one most erroneously expanded. Indeed, since critics need must peg each artist on to a specific branch or stem, he is often put forward as a Cubist painter,—sometimes as a leader in the movement. Actually, Léger was never a Cubist at all. . . .

As a way of painting, Cubism was from the first misunderstood; it is popularly regarded as the dividing of an object into cubes. In reality it has very little to do with cubes; it has to do with *planes*,—not the color-planes of [Paul] Cézanne, but planes that tilt according to the tonal transition. The Cubists proceeded to break the object more and more for added movement, sensing the violence with which the eye will swing into the rhythm fixed by the direction of breakage. Cézanne could only break his object through glances (he himself has said that he could not paint without a model). Likewise the Cubists, though less eye-conscious than Cézanne, never completely turned their glance from Nature. Their paintings—although free from direct visual resemblance to that which they represent—have always a connection with reality, in fact are usually portraits or landscapes. And, most unexpectedly of all, the misty spectre of Impressionism glides throughout the Cubist pictures, shedding high-lights, cast-shadows, and blurred transitions in its path. The measured lift of shifting planes tilted in illimitable variation,— it is from this that the finest Cubist paintings derive their imperial complexity and repose.

There is nothing comparable to this spaciousness in Léger, who had thrown Impressionist tendencies overboard at the start, who had never put aside his cold though garish colors. His forms are always clear and sharp, and the conception of the object has remained as mental as a Coptic fresco. It is the object that removes him farthest from the Cubists, and it is the object for its own sake that has become the *grande passion* of Léger's artistic consciousness; he has reduced his art of late to an ever-tightening rendition of objects; he will recount how in this mechanical age a painting must stand comparison with the other things sold in the cities; he has sought to paint them all—pipes, disks, parts of the machines—with such freshness and precision that they can compete with the modern craftsman's products. Human beings and fragments of foliage intrude throughout the pictures, and from no love of Nature Léger paints them, but merely as other perfectly functioning mechanisms that he meets upon the streets.

František Kupka
Mme Kupka among Verticals. 1910–11
Illustrated on page 160

Virginia Spate, in *Modern Masters: Manet to Matisse,* **1975**, page 146

The Czech artist Kupka was the first painter in Paris systematically to explore the possibilities of abstraction. This portrait of his wife was begun about 1909 (when he was experimenting with Fauvist color), but was left unfinished until 1911, when he painted the vibrant planes which almost overwhelm the face. . . .

Kupka . . . intended a [deep] significance in the juxtaposition of the abstract and the figurative. He believed in the unity of the human spirit with the spiritual forces animating the cosmos. He found confirmation of this belief both in the fact that white light is composed of prismatic color and in the contemporary scientific discovery that matter is composed of energy, which may have determined him to replace the body with a tissue of vibrating prismatic colors. Kupka was also probably influenced by the spiritualist belief that every individual possesses an "aura" which indicates personality and which is perceptible to those endowed with spiritual "sight." He may have believed that his awareness of his wife's spiritual being dictated his shimmering immaterial colors. In this sense, the painting is a colored radiance, a literal illustration of a spiritualist belief. More importantly, it helped Kupka escape from illustration, for as he improvised the strokes of color, he became absorbed in the way that they formed coherent structures. He came to realize that such abstract structures contain their own meaning.

Kupka arrived at abstract art through the processes of painting rather than through theory, and thus achieved a profound understanding of the experience that is embodied in such art. He maintained that a work of art cannot communicate a specific idea, since the artist's idea is transformed by the creative process and by the spectator's response, but that it could awaken the spectator's consciousness of his own being by absorbing him in its unique physical reality. Although Kupka did not succeed in awakening such consciousness in this painting—the head draws attention to the existence of a specific person in such a way that one cannot appreciate the abstract forms—his awareness of why he was unsuccessful caused him to move to more firmly structured abstract paintings.

Robert Delaunay
Simultaneous Contrasts: Sun and Moon. 1913
Illustrated on page 160

John Elderfield, *European Master Paintings from Swiss Collections,* **1976**, page 102

Delaunay . . . was inspired not by the solidity but the flux in modern life: "Sky over the cities, balloons, towers, airplanes. All the poetry of modern life: that is my art."[1] . . .

The disk form had first appeared in Delaunay's painting as early as 1906, possibly as a result of his exposure to [André] Derain's London paintings of 1905 which used prominent spectral suns;[2] but this form began to be used consistently only with his Sun and Moon series of 1913. . . .

Color contrasts, Delaunay said, were the "constructional elements of pure expression."[3] He had begun as a Neo-Impressionist painter and read the color theories of M.E. Chevreul, from whom he derived his own theory of "simultaneous contrasts."[4] Whereas the strokes and blocks of pure color in Neo-Impressionist paintings fused together in the spectator's eye and created, therefore, "binary" contrasts, "simultaneous" contrasts retained the separate identities of colors as they interacted simultaneously upon the eye. In their interaction, the effect of movement was engendered. The static presentation of the outside world created by Neo-Impressionism was thus replaced by a display of moving colored light.

Marc Chagall
I and the Village. 1911
Illustrated on page 161

Marc Chagall, in *The Museum of Modern Art Bulletin,* **1946**, pages 32–34

"Already during the other war [World War I] I remember wondering about painting. I was still very young and did not picture art as a profession or a job. It did not seem to me that pictures were destined solely for decorative or domestic purposes. I remember saying to myself 'Art is in some way a mission—and don't be afraid of this old word. What ever may have been achieved by the technical and realistic revolution in painting, it has merely scratched the surface. Neither so-called "real-color" or "conventional color" truly color the object. It is not what we describe as perspective that gives depth. Neither shadow nor light illumine the subject and the third dimension of the cubists does not yet allow a vision of the subject from all sides.'

"This in short was the sentiment which seized me in

Paris in 1910. But if you talk this way in a technical, realistic period of art, you are accused of descending into literature. Was I, myself, not trying to get away from 'literature,' from symbolism in art?

"It was precisely 'literature' that I saw not only in the great compositions of the old 'romantics,' but also in the simple still-lifes of the impressionists and cubists, since 'literature' in painting to my way of looking at it is all that can be explained. It seemed to me that by 'killing' a still life or a landscape in some way—not only in deforming their surfaces—it would be possible to give them new life.

"And just as I was accused of descending into 'literature,' before the war of 1914, today people call me a painter of fairy tales and fantasies. Actually my first aim is to construct my paintings architecturally—exactly like the impressionists and cubists have done in their own fashions and by using the same formal means. The impressionists filled their canvases with patches of light and shadow; the cubists filled theirs with cubes, triangles, and curves. I try to fill my canvases in some way with objects and figures treated as forms—forms resounding like noises—forms of passion—designed to add a new dimension which neither the geometry of the cubists, nor the patches of the impressionists can achieve.

"I am against the terms 'fantasy' and 'symbolism.' Our whole inner world is reality perhaps even more real than the world of appearances. If we call everything that appears illogical 'fantasy,' 'fairy-tales,' etc., we really admit that we do not understand nature. Impressionism and cubism are comparatively easy to understand because they present but a single aspect of an object to our consideration: simple contrasts of light and shadow. But a single aspect of an object is inadequate to the summing up of the complete subject-matter of a picture. Every object has diverse aspects. I am not against cubism: I have admired the great cubists and I have profited from cubism."

Chagall
I and the Village
Illustrated on page 161

James Johnson Sweeney, *Marc Chagall*, **1946**, pages 7, 15

When Chagall first arrived in Paris in 1910, cubism held the center of the stage. French art was still dominated by the materialist outlook of the 19th century. Fifty years earlier naturalism and realism had opened the way to impressionism. Impressionism's analyses of light on objects had led to cubism's analyses of the objects themselves. Little by little the manner of representing an object had come to have a greater interest than the subject—the physical character of the painting more importance than its power to awake associational responses in the observer. Chagall arrived from the East with a ripe color gift, a fresh, unashamed response to sentiment, a feeling for simple poetry and a sense of humor. He brought with him a notion of painting quite foreign to that esteemed at the time in Paris. His first recognition there came not from painters, but from poets such as Blaise Cendrars and Guillaume Apollinaire. To him the cubists' conception seemed "earthbound." He felt it was "necessary to change nature not only materially and from the outside, but also from within, ideologically, without fear of what is known as 'literature.'" . . .

[In] *I and the Village* . . . cubism's respect for the plane of canvas is . . . clearly illustrated. . . . And this picture offers an ideal exemplification of Chagall's statement: "I fill up the empty space in my canvas as the structure of my picture requires with a body or an object according to my humor." The composite strikes one first, then the details: first the large profiles, then smaller reminders of life in Vitebsk: the milkmaid, the farmer and his companion and the neighborhood church. Chagall, like the expressionists, uses color and line to underscore emotion, but also makes the details serve as emotional comments, footnotes or glosses.

Futurism

Joshua C. Taylor, *Futurism*, **1961**, pages 9, 10, 11, 17

With cries of "Burn the museums!" "Drain the canals of Venice!" and "Let's kill the moonlight!" the Futurist movement burst upon the consciousness of an astonished public in the years 1909–1910. For the first time artists breached the wall erected between conventional taste and new ideas in art by carrying their battle directly to the public with the noise and tactics of a political campaign. Taking their cue from the anarchists with whom as youths they were in sympathy, the self-styled Futurists published shocking manifestoes negating all past values, even art itself. Fighting their way towards a new liberty against apathy, nostalgia, and sen-

timentality, they became for a very wide public the symbol of all that was new, terrifying, and seemingly ridiculous in contemporary art. . . .

That so violently launched a movement should come out of Italy is not altogether surprising, for in no other country did the youth feel so completely subjugated to the past, deprived of a world of its own. The complacent Italian public was content with guarding a tradition and obstinately refused to notice new events in art and literature, at home or elsewhere.[1]

As for the term Futurism, there is no mystery about its origin, nor was it a word thrust by chance upon the artists as were "Impressionism," "Fauvism," and "Cubism." It was coined in the autumn of 1908 by the bilingual Italian poet, editor, and promoter of art, Filippo Tommaso Marinetti, to give ideological coherence to the advanced tendencies in poetry he was furthering in the controversial periodical, *Poesia*. . . .

In February 1909, Carlo Carrà, Umberto Boccioni, and Luigi Russolo, met with Marinetti . . . and proposed that painters also be included in the movement. With Marinetti's enthusiastic support the three young artists drew up a manifesto of their own. . . . On the manifesto's "official" publication dated 11 February 1910, appeared . . . the name of Giacomo Balla, . . . teacher of both Severini and Boccioni. These five, Balla, Boccioni, Carrà, Russolo, and Severini, became "the Futurist painters." . . .

Because the Futurist painters early adapted to their own use some of the formal language of Cubism, their painting has often been considered a kind of speeded up version of that classically oriented movement. In spite of the obvious testimony of Futurist writing and, more significantly, the painting itself, critics have persisted in seeing Futurism as an analytical procedure like early Cubism, differing only in its aim to represent motion, a goal better realized in moving pictures. . . .

Motion for the Futurist painter was not an objective fact to be analyzed, but simply a modern means for embodying a strong personal expression. As different as their procedures were, the Futurists came closer in their aims to the *Brücke* or, better, to [Vasily] Kandinsky and the *Blaue Reiter*, than to the Cubists. And in their iconoclasm and concern for the vagaries of the mind, they had not a little in common with Dada and the Surrealists. . . .

"Dynamism" was a magical word for the Futurists. It signified the difference between life and death, between participation in an evolving, expanding universe and withdrawal into an eddy of personal isolation. They looked upon the world with the same eager expectation as the Transcendentalists, but the world they saw was not the quieting realm of tree and sky; it was the world of modern science that triumphed over nature, promising always something new in its rapid development towards an undetermined end. Dynamism was at its heart. Theirs was a transcendentalism founded on a whole new universe. "We are the primitives of a new, completely transformed, sensibility," they boasted. The new sensibility accorded emotional value to a mechanized world. . . .

Futurism was not a style but an impulse, an impulse that was translated into poetry, the visual arts, music, and eventually into politics. "Futurism is only the praise, or if you prefer, the exaltation of originality and of personality," Marinetti declared to an interviewer in 1911; "the rest is only argument, trumpeting, and blows of the fist."[2] The nature of the Futurist impulse in politics, it might be added, should not influence the assessment of its achievement in art.

Umberto Boccioni

States of Mind I: The Farewells. 1911
States of Mind II: Those Who Go. 1911
States of Mind III: Those Who Stay. 1911
Illustrated on pages 162, 163

K. G. Pontus Hultén, *The Machine as Seen at the End of the Mechanical Age*, **1968**, pages 60–61, 62

Boccioni was probably the most contemplative as well as the most gifted of the Futurists. Realizing how complex would be the interference of machines in people's emotional lives, he could not content himself with the over-enthusiasm displayed by some of his colleagues for the mechanical world.

In a lecture delivered at the Circolo Internazionale Artistico in Rome in May, 1911, Boccioni developed the idea of "the painting of states of mind." Before going to Paris with Carlo Carrà in the autumn of 1911 to see the most recent trends in art and prepare for the Futurist exhibition that was to take place the following winter, he had already exemplified his aims in a first version of *States of Mind*. He described these paintings to Guillaume Apollinaire: "one expressing departure, the other arrival. . . . To mark the difference in feeling I have not used in my painting of arrival a single line from the painting of departure."[1]

Boccioni's early sketches and first canvases of *States of Mind* were still somewhat under the influence of Edvard Munch. Highly charged with symbolism, they were filled with expressive lines that tellingly convey a sense of nostalgia and anxiety. After his encounter with the Cubists in Paris, he reorganized the composition of the three paintings, *Those Who Stay, The Farewells*, and *Those Who Go*, to give them a more precise spatial clarity . . .

Boccioni makes us realize that goodbyes in a railway station are not the same as those said at a stage-coach.

In a station, the departures are more final—not because trains go faster and farther than stage-coaches, but because those who enter into a train become part of a system, while those who stay behind are outside that system. Those who leave become a group, although a minute earlier they may have been unknown to one another. In *The Farewells*, Boccioni shows how drastically the locomotive has split people into two groups. His representation of the locomotive itself is the strongest and most beautiful of all such images of the period. The numbers "6943" that rise out of its side become a clear and simple mathematical symbol of the machine's own strength and individuality. . . .

Boccioni's admiration for the train was probably tempered by his emotions concerning his first journey to Paris. On the one hand, he was leaving behind in Milan his mother, to whom he was extremely attached. On the other hand, he knew that he was about to be confronted with the Cubists and their works and realized that this would drastically change his own style of painting, and perhaps also his outlook on life. But though his formal vocabulary was indeed modified, his basic aim of expressing emotions remained unchanged. In the Paris exhibition catalogue, for whose preface he was chiefly responsible, he wrote:

"One may remark, also, in our pictures spots, lines, zones of colour which do not correspond to any reality, but which, in accordance with a law of our interior mathematics, musically prepare and enhance the emotion of the spectator.

"We thus create a sort of emotive ambience, seeking by intuition the sympathies and the links which exist between the exterior (concrete) scene and the interior (abstract) emotion. Those lines, those spots, those zones of colour, apparently illogical and meaningless, are the mysterious keys to our pictures."[2]

Umberto Boccioni
Development of a Bottle in Space. 1912
Illustrated on page 164

Kirk Varnedoe, *Masterworks from The Museum of Modern Art, New York, 1900–1955*, **2001**, page 22

Boccioni's "Technical Manifesto of Futurist Sculpture" of 1912 called for a sculpture that would "give life to objects, making their extension in space palpable, systematic, and plastic," and one which would abolish completely the limits imposed by definite lines in what he called "closed sculpture." This theoretical statement preceded Boccioni's actual practice of sculpture, which began a short time later. None of Boccioni's sculptures was cast in his lifetime. Three-quarters of them, acci-

dentally destroyed in 1917 after a posthumous exhibition in Milan, are known only through photographs. Fragments of several works, including *Development of a Bottle in Space* and *Unique Forms of Continuity in Space* [see page 164], were collected and carefully reconstructed by Filippo Tommaso Marinetti and other friends of the artist.

Most of Boccioni's lost sculptures were large three-dimensional assemblages, which daringly joined art materials such as plaster with objects from the everyday world in much the same way Pablo Picasso and Georges Braque used scraps of paper in their *papier collés*. In its materials as well as in its scale, Boccioni's bronze *Development of a Bottle in Space* is thus more traditional than most of his sculptural work. Boccioni has presented us with the inner cylinder of a bottle which unfurls and spirals into the space around it. Its roundness expands with a centrifugal momentum, engulfing the forms of the tabletop still life around it. The spiraling bottle's highlights and shadows create counter-rhythms that produce a sensation of extreme volatility. The work also reveals the artist's concern for conjuring the rapid transience of light, the interpenetrating of masses, and projections of the edges from half-concealed forms. Observed from any angle the sculpture conveys a sense of motion.

Until Picasso's constructions of 1912–14, it was highly unusual to take a still life as a motif for sculpture. But in his violent reaction against traditional sculpture, Boccioni asserted that "there is more truth in the intersection of the planes of a book with the corners of a table . . . than in all the twisting of the muscles in all the breasts and thighs of the heroes and Venuses which inspired the idiotic sculpture of our time."

Development of a Bottle in Space is certainly indebted to Cubist paintings in its initial approach . . . But it goes beyond any earlier Cubist sculpture in the way it opens up forms and fuses itself with space. Moreover, its physical dynamism and the whirling interrelation of its forms are completely at variance with the quiet atmosphere and cerebral conundrums that characterized Cubist painting at this time.

Umberto Boccioni
Unique Forms of Continuity in Space. 1913
Illustrated on page 164

Sarah Ganz, *Body Language*, **1999**, page 69

With Umberto Boccioni's *Unique Forms of Continuity in Space* of 1913 body and environment interpenetrate. The figure steps forth, its center of gravity thrust forward, while contours of flesh are shaped by and dissolve into the air through which the body moves. Boccioni called for a sculpture of environment in his "Technical

Manifesto of Futurist Painting" of 1910, stating that "the gesture which we would reproduce on canvas shall no longer be a fixed *moment* in universal dynamism. It shall be the dynamic sensation itself. . . . We therefore cast aside and proclaim the absolute and complete abolition of definite lines and closed sculpture. We break open the figure and enclose it in environment."[1] The confluence of metal, flesh, and air presents a figure at once ensconced in fluttering flames and weighted down by the heavy blocks on which it stands as well as the apparent effort required to penetrate the space through which it moves.

The voice of [Henri] Bergson permeates Boccioni's ideas and those of the Futurist manifestos; the application of philosophical inquiry to the body particularly attracted the Italian artist . . . *Unique Forms of Continuity in Space* seems to materialize Bergson's claims for the body as the vehicle through which space and environment are perceived: "Consider the movement of an object in space. My perception of the motion will vary with point of view . . . but when I speak of an absolute movement, I am attributing to the moving object an inner life and so to speak, states of mind."[2] The glistening bronze figure suggests progress through time and space; its undulating contours . . . intimate mobility and duration beyond the represented moment. Although the figure was born of aspirations toward modernity and dynamism, its armless, sexless appearance is evocative of antiquity, including the winged *Victory of Samothrace*.

Gino Severini

Dynamic Hieroglyphic of the Bal Tabarin.
1912
Illustrated on page 166

Joshua C. Taylor, *Futurism*, **1961**, pages 66, 69

By combining the suggestion of abstract forms with identifiable parts, Severini invites us to experience, almost kinesthetically, the exhilarating action of the dancer. He has relinquished his interest in things as seen to concentrate on the action of pictorial forms themselves. A line or a sequence of color becomes an experience of motion which is then given particular meaning by the identifiable subject. Some months later, acknowledging his greater dependence on the forms themselves, Severini wrote, "It has been my aim while remaining within the domain of the plastic, to realize . . . forms which partake more and more of the abstract." It was his hope that, freed from the limitations of mass and time, painting "by means of abstract forms will give the pictorial rhythm of an ideal world."[1]

The most complex work in this transparent, rhythmic style is the large *Dynamic Hieroglyphic of the Bal Tabarin*, painted in Italy during the summer of 1912. The description of "dynamic hieroglyph" accords with Severini's idea that the painting is first of all a synthesis of abstract rhythmic forms that attach themselves to other experiences through some means of association. Painted in the small town of Pienza, far from the gay Parisian night life it depicts, the painting's swirling rhythms enclose vividly remembered bits of the far-off scene. A monocle flashes, the stiff frills of a red petticoat flash saucily from under the purple skirts, and bows, curls, and decorations become entangled in the general movement. Words stand out—the irregular POLKA and the smooth VALSE—to bring music to mind, and above the hubbub of conversation rise the words MICHETON and BOWLING. It is the synthesis in one complex and dynamic form—the "dynamic hieroglyph"—of a wide range of remembered experiences.

Gino Severini

Visual Synthesis of the Idea: "War." 1914
Illustrated on page 167

K. G. Pontus Hultén, *The Machine as Seen at the End of the Mechanical Age*, **1968**, page 63

"We wish to glorify war—the only health giver of the world," [Filippo Tommaso] Marinetti proclaimed in his Manifesto of 1909. In line with their enthusiasm as political activists, immediately on the outbreak of the First World War in August, 1914, the Futurists began intensive propaganda and demonstrations calling for Italian participation.

War was one of several related paintings of 1914–1915 that Gino Severini included in his one-man show, "First Futurist Exhibition of Plastic Art of the War," held at the Galerie Boutet de Monvel in Paris, January 15–February 1, 1916. In a concurrent article, Severini described his pictorial intentions:

"I believe . . . that a modern work of plastic art should not only express the idea of an object and its extension (*continuité*) but also a kind of plastic ideograph or synthesis of general ideas. . . . For example I have tried to express the idea: *War*, by a plastic composition made up of these realities, Cannon, factory, flag, mobilization order, airplane, anchor.

"According to our concept of ideational realism, no more or less naturalistic description of a battle field or carnage could give us the synthesis of the idea: *War*, better than these objects which are its living symbol."[1]

The symbols alluding to the army, the navy, and the air force, and the inscription EFFORT MAXIMUM in large capitals, parade the outward signs of heroism still to come.

Matisse

John Elderfield, *Henri Matisse: Masterworks from The Museum of Modern Art*, **1996**, page 146

On March 31, 1909, [Sergei] Shchukin wrote to Matisse from Moscow confirming the commission of two large decorative panels, *Dance* and *Music* (now in the Hermitage Museum). Shchukin had just returned from Paris, where he had seen the first version of *Dance*, which Matisse had painted very quickly in March 1909, in the hope of obtaining this important commission.

Matisse's conception of the subject of *Dance* is an ancient one, going back to Greek red-figure vases, but his immediate source was the ring of six dancers in the background of his arcadian composition of 1905–06, *Le bonheur de vivre*. Underdrawing visible beneath the paint in the lower left section of the present painting shows that Matisse began it with six figures before reducing it to five. We are given to suppose that the dance takes place on the top of a hill, but Matisse insisted: "When I put down green, that doesn't signify grass; when I put down blue, that doesn't mean sky. . . . All my colors sing together, like a chord in music." It was the expressive, not the depictive attributes of the colors that were important to him.

The depicted subject did have important contemporaneous associations. In 1909, Sergei Diaghilev arrived in Paris, and Isadora Duncan danced there—for the Symbolist generation, dance was the art in which form and meaning were organically combined. Matisse uses this subject to shape the form of the painting. Dancers and painting cohere simultaneously in the form of the dance. Yet his great painting is a landmark for additional reasons. Its extreme flatness, totally nonillusionistic space, and highly abstracted and schematic means of representation open the surface and expand it to the experience of color in a way virtually unknown in Western painting since Byzantine art.

John Elderfield, *Matisse in the Collection of The Museum of Modern Art*, **1978**, pages 86–87, 88, 89

A visitor to Matisse's studio at Issy in June 1912 described what the interior shown in *The Red Studio* was really like. The studio was set to one side of the large walled garden that surrounded the Matisse house, "among trees, leading up to which were beds of flaming flowers. The studio, a good-sized square structure, was painted white, within and without, and had immense windows (both in the roof and at the side), thus giving a sense of out-of-doors and great heat. A large and simple workroom it was, its walls and easels covered with large, brilliant, and extraordinary canvases. . . . My main recollection is of a glare of light, stifling heat, principally caused by the immense glass windows, open doors, showing glimpses of flowers beyond, as brilliant and bright-hued as the walls within . . . "[1]

In *The Red Studio*, Matisse has avoided showing any sign of the out-of-doors. What seems to be part of a window appears at the extreme left. If that is what it is, it may not have looked out onto the garden, as a studio plan shows.[2] We are looking at an enclosed interior: at a corner of the studio and about twenty-three feet of one of the walls.[3] The wall of course is not white, as it was in fact, but like the floor and all the furniture is red. "You are looking for the red wall," Matisse observed to another visitor, who came to the studio shortly after the painting was completed; "this wall does not exist at all! As you can see here, I have painted the same pieces of furniture against a wall of the studio of a pure blue-gray color. These are the sketches, the studies if you wish; as pictures they did not satisfy me. When I had found the color red, I put these studies in a corner, and they remain there. Where I got the color red—to be sure, I do not know that. . . .[4] I find that all these things, flowers, furniture, the chest of drawers, only become what they are to me when I see them together with the color red. Why such is the case I do not know . . ." It is entirely possible that Matisse "found the color red" in the interior shadows of the room. It could well have been produced optically when he entered the dazzling white interior after looking at the green of his garden, for he was particularly responsive to perceptual color substitutions of this kind, though inclined to justify

them as emotive responses to his subjects[5]—which of course they became, regardless of what sparked them in the first place.

Wherever he found it, the mat red that invades the surface of *The Red Studio* is what largely contributes to its being "perhaps the flattest easel painting done anywhere up to that time."[6] It is Matisse's boldest attack to date on traditional three-dimensional illusionism. The virtually unreproducible Venetian red modified by the blue-gray underpainting establishes the frontality of the whole surface. It joins background to foreground, top to bottom, and side to side in one frontal plane. The division of floor and wall is mostly hidden and the angle of the corner not shown. The rectilinear architecture of the room itself is used to reinforce the painting's flatness and rectilinearity, as are the paintings and all the flattened-out objects shown. There are no depicted volumes at all. . . .

The works of art in *The Red Studio* represent a temporal succession of single views on a scarcely varying subject, showing therefore, in the [Henri] Bergsonian sense, the "duration" of the pastoral ideal in the way the past is carried into and constitutes the present.[7] We see in the separate images the growth of that ideal, just as the separate but similar circular leaves on the stem of ivy growing from the pot in the foreground show us the different manifestations of that form of growth. The circularity of these leaves carries the eye to the round face of the clock. Although the paintings on the wall seem at first to be haphazard in their arrangement, they are in fact clustered around this clock without hands, thus enforcing the metaphor of past and present suspended in one timeless state. They are, moreover, fixed and preserved in the red ground, almost as if in illustration of Bergson's discussion of how separate temporal incidents stand out from the flux of time which bonds them together.

Henri Matisse
Goldfish and Sculpture. 1912
Illustrated on page 170

John Golding, *Matisse Picasso*, **2002**, pages 80, 81

The sculpture at the bottom right is the terracotta version of [Matisse's] own *Reclining Figure I (Aurora)* (1907), a work that meant much to him. He makes repeated use of it to furnish his still lifes and interiors. Here she is both a stand-in work of art and a surrogate human presence. She appears to float forwards from the edge of the table on which she is placed and is metaphorically crowned by flowers (nasturtiums). Plants and flowers were essential elements of Matisse's environments. . . .

But it is the goldfish that are the key to the significance of this Matisse painting, and temporarily they were to become an emblem of Matisse's philosophy of life. Here they make an early appearance in his art and over the next few years they reappear frequently. They can perhaps best be seen as an extension of Matisse's immersion in the world of Islam. Goldfish, long known in the Far East as symbols of luxury and contemplation, had been introduced into Europe in the seventeenth century.[1] *Goldfish and Sculpture* was executed in the studio at Issy-les-Moulineaux after a two month sojourn in Tangier; and Morocco, in a sense, had been annexed to the East because of its religion. Goldfish appear in the paintings of Matisse's second working visit to the country, from October 1912 to February 1913. In a key work, *The Moroccan Café*, painted either in Tangier or soon after his return to Issy in the spring of 1913, the two Arabs that occupy the foreground squat and recline on the ground, lost in reverie before a bowl containing goldfish and a small vase of flowers placed next to it.

Matisse's own goldfish were kept in a large cylindrical laboratory jar. Fascinated as Matisse was by transparency, he insisted that the water must be kept crystal clear, a task assigned to his children.[2] For Matisse the brilliantly coloured fish contained in and gliding through colourless substance were clearly a source of wonder and fascination. Despite the physical presence of the fish they simultaneously act as patches of dazzling, disembodied colour. Matisse's friend, the painter Jean Puy, was to compare Matisse himself to a goldfish gazing out on the world.[3] In 1930 in Tahiti Matisse was spellbound for long hours looking down into the glass bottom of a small converted boat. Transparency he associated with light. He was to say: "For a long time now I've been conscious of expressing myself through light or in light, which seems to me like a crystal within which something is taking place."[4]

Henri Matisse
The Blue Window. 1913
Illustrated on page 172

John Elderfield, *Matisse in the Collection of The Museum of Modern Art*, **1978**, pp. 90, 92

The Blue Window was painted in the Matisses' bedroom of their house at Issy-les-Moulineaux, before a window looking out over the garden with its willow-pattern-like trees[1] and huge spherical bushes to the studio in the background,[2] over which hovers a large oval halo of a cloud not too dissimilar to those that floated over the beach of Saint-Tropez in *Luxe, calme, et volupté*. On the table or shelf in front of the window[3] we see a still life

of domestic objects: the cast of an antique head,[4] a vase of flowers set on a circular mat, a small decorated jar, a yellow-ocher dish containing a blue brooch, and what is probably a square mirror with a red frame. On the window ledge behind the mirror is a lamp, which had possibly been in Matisse's possession since his student days,[5] and seemingly fastened to the wall at the left is a green Chinese vase.[6] The painting is, as Alfred Barr has written, "all verticals and horizontals, as structural as a scaffolding, against which are hung the free forms of the still life and landscape. Each object is as isolated and simply rendered as the objects on the table of a medieval Last Supper."[7]

And yet, as Barr points out, the isolation of the objects "is subject to whimsical magic,"[8] which brings them together in unexpected and illogical ways, thus joining the space of the room to that of the garden outside. When asked why he was attracted to the motif of the window, Matisse replied: " . . . for me space is one unity from the horizon right to the interior of my workroom . . . the wall with the window does not create two different worlds."[9] All of his paintings of windows establish the contiguity of the outside space of nature and the man-made space of the interior, thus asserting the harmony of the natural and the artificial. . . . In *The Blue Window*, inside and outside interpenetrate and join in a single blue plane.

Much of this effect is due to oddities in juxtaposition and to formal analogies. The vase of flowers is elided into the foliage of the garden, while the circular mat on which it stands is echoed in the shapes of bushes and in the white cloud directly above. The mullion of the window seems to be growing out of the top of the plaster cast, and so resembles the trunk of the tree sprouting from the lamp (which itself appears to be standing on the mirror) that we may be excused for thinking that the mullion is a tree too. The triangular shape of the statue echoes the ocher triangle of Matisse's studio, joining art and the place where art is made, telescoping space between these two points. The whole set of ovals and circles inside and outside the window so clearly share a common order of being that inside and outside are given as one. Added to this, the ubiquitous blue, modulated with green and white and ranging from cobalt to ultramarine, fills and inflates most of the forms, causing them to swell out, as if full of the blue atmosphere that surrounds them and from which they are inseparable.[10] The pervading blueness of the picture unifies and flattens space, yet gives to space such a feeling of substance and density as to allow the objects that inhabit it a certain solidity too. . . .

Although purchased by one of Matisse's German patrons, Karl Osthaus, the painting was apparently first intended for the designer Jacques Doucet, who rejected it, finding it "too advanced for him," Matisse recalled.[11] No specific documentation of this commission has come to light, nor anything to prove the suggestion sometimes made that it was to be the first element of a decorative ensemble.[12] There is indeed considerable confusion as to when *The Blue Window* was made. It is sometimes dated to 1912, but more often, per Barr's lead, to late 1911, although on one occasion Matisse himself dated it to 1913.[13] It certainly follows the use of a monochrome field established in *The Red Studio* of October 1911 [see page 169]. . . . In some respects it recalls the *Harmony in Red* of 1908 with its somewhat similar tree forms—but now the geometric replaces the arabesque, making *The Blue Window* a harbinger of the newly architectonic feeling that entered Matisse's art in 1913.

Henri Matisse
View of Notre Dame. 1914
Illustrated on page 170

Anne Baldassari, *Matisse Picasso*, **2002**, pages 125, 126

From his studio window at 19 quai Saint-Michel, Matisse, from the onset of the century, was able to choose for motif the cathedral of Notre-Dame.[1] When he began *View of Notre-Dame* in 1914 Matisse was watching the irresistible explosion of springtime in Paris, and would once again, in his own manner, go out "to the motif.". . . Matisse decides *in situ*, in a major and unprecedented stylistic change, to adapt a principle alien to his own pictorial idiom. When he says "A rapid translation of the landscape can only give a moment of its life duration. By insisting on its character, I prefer to risk losing some of its charm and gain more stability,"[2] his statement had much in common with [Pablo] Picasso, who declared: "In my case painting is a sum of destructions."[3] In this respect both artists rise up in opposition to the Impressionist option as set out by [Stéphane] Mallarmé: "I seek only to reflect on the lasting and clear mirror of painting that which lives perpetually, and yet dies at each instant, that which exists only in the will of the idea, and yet which constitutes the sole, authentic and certain advantage of nature: the Aspect."[4] This immanent presence to the world can be considered to constitute the lost paradise of modern painting to which Matisse, before breaking free by the "mechanics of painting,"[5] once again submits himself by painting a naturalistic painting with luminous and airy accents. "What happiness to be an Impressionist. This is the painter in the sheer innocence of painting," as Picasso describes his native state.[6]

In *View of Notre-Dame*, the landscape is exactly framed by the rectangle of the window. Matisse has

given the work the physical dimensions of the window, not only enclosing its frame and shutter within the painting, but also projecting the chequered pattern of its panes upon it.[7] The painting has thus quite literally made the point of view its object.[8] We are not viewing the simple coinciding of interior and exterior landscapes, but a homothetic relation between painting and the frame or stretcher of vision. The structural graph superimposing the triangular geometries composed by the window frame and the lines of force of the landscape are marked up in black on monochrome blue.[9] Painted in large, free brushstrokes, this blue lets the ground that has been left unpainted show through. As a pictorial palimpsest, the half-erased lines reweave the naturalistic version of the motif, and the square shape of the cathedral appears superimposed like a section drawing on the previous perspective view of the building. This underlying presence of the original image results in the final painting being abruptly projected forward, turning it into a surface phenomenon.

The functioning of the painting on two levels calls up the dialectic of planes in Picasso's *papiers collés*, playing on the disparity of codes and meanings. By superimposing naturalistic and synthetic notations, Matisse achieves a visual back and forth movement similar to Picasso's reworking of figure/ground and surface/depth relations. Matisse also gave predominance to voids over filled spaces in composition, which marked with the *papiers collés* a clear affirmation of the physical base, its format and materiality, as the primary prerequisite of vision. Besides the primacy of the surface and the void and the superimposition of levels of representation, *View of Notre-Dame* also borrows from Picasso's Cubism the oblique line at the heart of the painting. . . .

From different directions, Matisse and Picasso set down the same claim: nature must henceforth be set at a distance and the painting is the place for this distancing.[10] The Impressionist artist identifying with the world by effusion with it and through the loss of self, gives way to the modern painter, solitary, cut off from nature, absorbed, in competition with reality, in a self-referential elaboration of signs.

Henri Matisse

The Moroccans. 1915–16
Illustrated on page 174

Alfred H. Barr, **Jr.**, *Matisse: His Art and His Public*, **1951**, page 173

The Moroccans was composed from memories of the winters of 1912 and 1913 spent in Tangier. The picture is divided into three sections, separate both as regards composition and subject matter: at the upper left one sees a terrace or balcony with a pot of large blue flowers at the corner, a small mosque beyond, and, above, the lattice of a pergola; below, on a pavement, is a pile of four yellow melons with their great green leaves; and at the right are half a dozen Moroccans, one of them seated in the foreground with his back turned, the others, extremely abstract in design, are reclining or crouching with burnouses drawn over their heads. These three groups might be described as compositions of architecture, still life and figures. They are like three movements within a symphony—with well-marked intermissions—or perhaps three choirs of instruments within the orchestra itself.

The three major groupings in the composition of *The Moroccans* are . . . isolated . . . and . . . ordered around an empty center and against a background which is two-thirds black with a left-hand third in color—though as Matisse remarked . . . he was using black as a "color of light" not darkness. The black in *The Moroccans* in fact does seem as brilliant as the lavender. . . . Linear perspective is almost eliminated, the artist having silhouetted the objects in tiers as in an Egyptian relief. He does however diminish the more remote forms, thereby implying distance without sacrificing the clarity and immediacy of the images.

The six colors, blue, plaster white, green, violet pink, black and ochre, are carefully balanced, interlocked and distributed. The two most positive of them, the green and the violet pink, are not only complementaries but are disposed on opposite sides of the canvas in vertical and horizontal areas. . . .

The analogies and ambiguities which enrich the composition of *The Moroccans* are ingenious. The four great round flowers in the architecture section echo the four melons in the still-life section. Yet these melons are so like the turban of the seated Moroccan in the figure section that the whole pile of melons with their leaves has sometimes been interpreted as Moroccans bowing their foreheads to the ground in prayer. At the same time, to complete the circle, some of the figures are so abstractly constructed as to suggest analogies with the architecture section.

Thus Matisse, in one of his greatest paintings, sets up a polyphony of both formal and representational analogues.

Henri Matisse

Piano Lesson. 1916

Illustrated on page 171

Alfred H. Barr, Jr., *Matisse: His Art and His Public,* **1951**, page 174

The very large *Piano Lesson* was painted by Matisse in the living room of his villa at Issy. The artist's son Pierre sits barricaded behind the Pleyel. Looking down on him from the wall above, as if in surveillance, is a greatly elongated version of a painting of 1914, the *Woman on a High Stool.* At the left the big window with open casements looks on the garden, with its triangle of green foliage. In the lower left-hand corner stands the artist's bronze *Decorative Figure* of 1906.

Unfortunately Matisse cannot remember whether the *Piano Lesson* was painted before or after the equally large but very different version of a similar subject, the *Music Lesson.* Pierre Matisse is however quite sure that this is the earlier of the two and was painted in the fall of 1916, reversing Matisse's usual procedure of working from realistic to abstract. . . .

Few compositions by Matisse have been more rigorously simplified and geometrized than the *Piano Lesson.* The pervasive grey background may well have been suggested by the grey *Woman on a High Stool* and, just as in the *Blue Window* [see page 172], the monochrome of walls and floor is here carried even out of doors in a single great plane broken by carefully selected and isolated incidents. . . .

The composition is centrifugal with the center passive and almost empty. The vertical green wedge of the garden at the upper left balances the complementary pink of the horizontal piano top, lower right; and the dull blue painted female figure, clothed and Gothicly rigid in the upper right-hand corner, wittily complements the dull brown sculptured female figure, nude and relaxed, at the lower left. These figures, human and geometrical, are framed or linked by a scaffolding of blue and black bars. The painting is full of other subtle analogies and entertaining polarities. Besides the two intricately contrasted female figures, the big triangle of green, as it echoes and expands the small foreground triangle of the metronome, may be noted; and also the play between the black arabesques of music rack and window grill. The sharp converging points of green, black, pink and grey provide a valuable moment of excitement in an otherwise disciplined calm, just as the vigorously pyramidal metronome disturbs the general flatness of the rest of the picture.

There are some cubist vestiges in the *Piano Lesson* but no cubist ever surpassed the beautiful divisions, the grave and tranquil elegance of this big picture. Nor did Matisse himself.

Henri Matisse

Memory of Oceania. 1952–53

Illustrated on page 175

Lawrence Gowing, *Henri Matisse: 64 Paintings,* **1966**, page 21

When Matisse began working in cut paper he had written of drawing with scissors: "Cutting to the quick of color reminds me of the sculptor's direct carving."[1] The association was significant; he was cutting into a primal substance, the basic chromatic substance of painting, which he had extracted from impressionism and preserved intact, as if alive. The sharp edge he cut defined figure and ground, both at once, as in a carved relief. With each stroke the cutting revealed the character both of the material, the pristine substance of color, and also of an image, a subject. Whether there was an evident motif or none, there was the sense of a subject that transcended it, the radiance and movement of an ideal southern milieu. Sometimes the theme was more mobile and flowing than anything he had painted for many years; the movement was like a dance. In the greatest of the *papiers découpés,* the soaring *Souvenir of Oceania,* 1953, and the radiating spiral of *The Snail,* 1953, the rhythm resides simply in the action and interaction of colors. The movement springs out of a progression that begins, characteristically, with emerald. It expands in every direction, moving in great lazy leaps out to the extremes of violet and orange-red. An ideal world was completely realized and the achievement, more than any other, discovered a new reality for painting.

Late in his life, a writer tried to persuade [Matisse] to pronounce against the non-figurative tendencies of young painters. He answered: "It is always when I am in direct accord with my sensations of nature that I feel I have the right to depart from them, the better to render what I feel. Experience has always proved me right. . . . For me nature is always present. As in love, all depends on what the artist unconsciously projects on everything he sees. It is the quality of that projection, rather than the presence of a living person, that gives an artist's vision its life."[2]

Henri Matisse

The Back (I). 1908–09
The Back (II). 1913
The Back (III). 1916
The Back (IV). 1931
Illustrated on pages 176, 177

John Elderfield, *Henri Matisse: Masterworks from The Museum of Modern Art,* **1996**, pages 54, 58, 60

Matisse's four imposing life-size reliefs, the Back sculptures, were made at widely spaced intervals over a period of more than twenty years, from 1908–09 to c. 1931. They are by far his largest sculptures and, being reliefs, are closer to Matisse's paintings than his fully three-dimensional sculptures. Thus they alone in his sculptural *oeuvre* share with his many grand paintings the look of ambitious, monumental, and public art.

Although they are usually now presented together as a series, where we can judge the remarkable transformation the image undergoes, they were never visible as such in the artist's lifetime. Although they do give the appearance of being conscious public masterpieces, only *Back I* was regularly exhibited by the artist, who late in life did not even remember how many reliefs he had made, and had apparently forgotten entirely about *Back II*, which was only discovered after his death.

The four reliefs were conceived, in fact, in the context of major painting projects, which defined the usefulness of the sculptures to the artist. *Back I* was made in 1908–09, when Matisse was producing such ambitious figure compositions as *Bathers with a Turtle* and the first, Museum of Modern Art version, of *Dance* [see page 168]. *Back II*, of 1913, and *Back III*, of 1916, were made contemporaneously with *Bathers by a River*. And *Back IV*, of c. 1931, dates to the period of Matisse's work on a mural on the theme of *Dance* for the Barnes Foundation. The sculptures cannot exactly be considered studies for these paintings, though. Rather, they clarified for Matisse his conception of the figure on a scale equivalent to that of the paintings he was preparing, and helped him to order his feelings about the figure when conceived at such a scale.

Back I was accompanied by a group of pen-and-ink drawings of a female model posed facing the wood-paneled wall of Matisse's studio. But the absence of feet in the sculpture shows that the artist was thinking of a bather standing in a shallow pool. His 1909 painting *Bather* shows a similar figure, wading into the picture surface just as the figure in *Back I* appears to meld into the relief plane. Matisse forms an arabesque from the figure that winds through it from the relaxed right leg up to the bent left arm. Between these extremities, the line cuts deep into the spine, threatening dissection of the image into two parts, each an assembly of bulbous volumes.

Four years later, in *Back II*, part of the spinal crevice has been filled in, yet the cuts that remain have been deepened and extended. Matisse told his students to "feel a center line in the direction of the general movement of the body and build about that." He thus straightens the spine, aligns it with the inner contour of the left leg, and forms branches that divide up the blocked-in parcels of mass that surround it. . . .

With *Back III*, of 1916, an even more astonishing transformation occurs. The full extent of the spine has returned, but now in relief, utterly straightened, and attached to the head so that it reads as a fall of long hair. . . . The figure presents a series of bold, broad vertical zones of light and dark tonalities that fracture it into parts and yet recompose it in their repetitive rhythms. The vestigial sense of an arabesque in the preceding relief is replaced by the parallel uprights of trunklike legs, limp but weighty right arm, adjacent flattened area of back, and long fall of hair which functions as the fulcrum around which the other forms are balanced.

Although *Back IV*, made some fifteen years later, completes the process of simplification, it is no longer the product of explorative modeling, of a vigorous attack on the figure. It builds on those things, but its purity and utter tranquility are of an entirely different and far more distanced order.

This final relief comprises three simple vertical zones, much enlarged from before in relation to the ground, to whose rectangular shape they are locked by the newly prominent negative areas of the relief. The interaction of figure and ground is therefore much more a matter of design than it was in the previous states. Indeed, the nearly symmetrical harmony of the work, the homogeneous nature of the surface, and the fluidity of the contours, which creates one uninterrupted flow from top to bottom, all speak of Matisse's willingness to surrender the expressiveness of individual parts to that of the designed surface as a whole. . . . This sculpture remained in Matisse's studio to the end of his life, where its reductive purity, the outcome of a development going back to his earliest decorative paintings, was totally in harmony with his last decorative works, the large-scale cutouts, for whose simplified, separated forms this work prepared.

Crosscurrents

Constantin Brancusi
Mlle Pogany. Version 1, 1913
Illustrated on page 179

Alfred H. Barr, Jr., New Acquisitions, **1953**

Over a year ago [c. 1952] the Museum received a letter from a lady in Camberwell, Australia. She wrote that almost forty years ago, before the first World War, Brancusi had made her portrait in Paris. The bronze might be for sale if a museum were interested. This Museum was very much interested, for the letter was signed Margit Pogany. After long negotiations the purchase was made, and three weeks ago the bust arrived in New York after its long voyage.

Miss Pogany has written how Brancusi came to do her portrait. In 1911 while she was an art student in Paris she came to know the sculptor. Two years later she asked him to do her portrait. She sat several times for him, but at each sitting after completing what she thought was an excellent likeness he would throw the clay back into the bin.

Early in 1912 when she left Paris the bust had not yet been begun, but finally in 1913 it was completed. Brancusi gave her the choice of a marble or bronze. She chose the latter.

Later, in 1919–20, Brancusi made several variants in polished bronze and in marble of a second version of the *Mlle Pogany*, somewhat more abstract and elaborate, especially in the treatment of the hair. These are far better known than this original bronze which may, in fact, never have been publicly exhibited before.

Constantin Brancusi
Endless Column. Version 1, 1918
Illustrated on page 179

Francis M. Naumann, *The Mary and William Sisler Collection*, **1984**, pages 50, 53, 54, 55

Throughout his life, Brancusi was reluctant to consider his individual sculptures as wholly independent creative efforts, but rather preferred to regard his finished works as simply intermediary stages in the realization of a given theme. Just a few months before his death in March 1957, however, he told a reporter that he thought the *Endless Column* was one of his most resolved and definitive works, a sculpture in which he had approached perfection.[1] . . .

As other major themes in Brancusi's work evolved through years of experimentation and refinement, the formal and iconographic program of the *Endless Column* developed through a series of methodical changes, both in the final configuration and physical presentation of the work. . . .

The only version of the column from this period to survive intact is the example preserved [here]. Brancusi's method for sculpting this work was in all likelihood the same as for the making of later columns, documented in several photographs of the artist at work in his studio. After having determined the precise size of each rhomboid element, he marked their equally spaced increments along the outer surface of an old oak beam. With a large crosscut saw he then carefully scored these divisions along the surface of the beam, cutting into the wood up to, but not beyond, the points where each rhomboid tapered to its narrowest width. Finally, straddling the beam from one side, Brancusi then removed the unwanted wood with a series of accurate and determined strokes, administered by the broad blade of a large, crescent-shaped ax. The resultant rhomboidal modules are approximately twenty inches in height, ten inches in width, and taper to just about five inches at their narrowest point, producing a ratio of 4:2:1, or, when read conversely, 1:2:4. The simplicity of these proportions was clearly intentional, and is perfectly in keeping with the simplicity of the column's vertical and bilateral symmetry. "Simplicity is not an end in art," Brancusi wrote, "but one arrives at simplicity in spite of oneself, in approaching the real sense of things."[2]

But the "real sense" of what "thing," we might ask, was Brancusi hoping to approach in making these columns? If we can rely on Brancusi's own statements about his work, then one of his most persistent goals was to reveal the essence of the material from which a sculpture was made. "The sculptor must allow himself to be led by the material," Brancusi later told a friend, "the material will tell him what he should do."[3] That Brancusi consistently selected wood as his medium for these early columns is significant, since he maintained that the integrity of a given material must be preserved in the final sculpture. "Wood," he told a reporter in the early 1920s, "is already and under all circumstances inherently sculptural. One must not destroy it, one must not give to it an objective resemblance to something

that nature has made in another material. Wood has its own forms, its individual character, its natural expression; to want to transform its qualities is to nullify it and to render it sterile."[4] It is likely, therefore, that the geometric clarity, overall symmetry, verticality, and repetitive elements in the column's design were meant to allude to these same qualities in wood, both in its natural state as a tree and when hewn into a long, rectangular beam.

The artist provided a date of 1918 for the carving of this column, and there is no reason to question it.[5] But did Brancusi initially conceive of this work as a fully independent sculptural form, or was he still envisioning the column simply as an elaborate base for another sculpture? Evidence suggests that for some years after its making Brancusi continued to treat even the 1918 version of the column as a base. . . .

There was no longer a need for such a pedestal, however, in Brancusi's first realization of the column on a monumental scale . . . Moreover, by this time Brancusi must no longer have envisioned the column merely as a support for another sculpture; the sheer height and repetitive geometry would have made the concept of infinite expandability an inseparable feature of the design. For Brancusi such an interpretation of the sculpture would naturally have tended to enhance these same characteristics in the earlier columns, qualities that were already an integral, though perhaps less obvious feature of their design.

Brancusi

Endless Column. Version 1
Illustrated on page 179

James Thrall Soby (mid-1960s?), in *The Museum of Modern Art at Mid-Century: Continuity and Change,* Studies in Modern Art 5, **1995**, pages 203–04

One of his [Brancusi's] most famous projects [is] the *Endless Column.* The tallest of these columns is in metal and stands ninety-eight feet high in the Rumanian town of Tîrgu Jiu, near Brancusi's birthplace.[1] But even the smallest of the "endless columns" is a tour de force of ingenious balance which an engineer like Buckminster Fuller might well envy. They look as though they might topple over and they never do; they are as strong and immovable as the version Brancusi once carved from a live poplar on the estate of a friend. They are rooted not only in a non-existent earth but in a profound philosophical conviction which nothing can sway. "You see," Brancusi said by way of explanation, "even the Pyramids end somewhere in a point. My columns need not end anywhere but can go on and

on."[2] [The] strongest impression I had on my last visit to this studio was the incredibly subtle variety Brancusi was able to give his few preferred subjects—the egg, the bird, the fish, the human head. I realized that this variety had little to do with the basic material he used, whether marble, polished bronze or wood. It was managed by nearly invisible shifts in emphasis on a given form, by changes in scale which many could see but also by alterations of contour and balance which even an expert would find hard to trace or define. I came to the conclusion in the end that Brancusi was one of the last of the true mystics, a fact which his worldliness and rough humor did their best to conceal. More than any artist I've ever known he had an inner life immune to penetration by the outer world. But he is alive in his sculpture to a degree beyond the reach of aesthetic awareness.

Constantin Brancusi

Bird in Space. 1928
Illustrated on page 180

Helen M. Franc, *An Invitation to See: 150 Works from The Museum of Modern Art,* **1992**, page 51

In . . . *Bird in Space* the form has become simplified to a high degree, consonant with Brancusi's dictum: "Simplicity is not an end in art, but we arrive at simplicity in spite of ourselves as we approach the real sense of things." He sought not merely to portray a bird but to capture "the essence of flight," and the underlying theme, as in [Kazimir] Malevich's Suprematist airplane, was the conquest of space. But whereas Malevich exalted the idea of liberation through flight into space by a machine, represented by geometrical shapes, Brancusi embodied similar concepts in a living organism, a bird, streamlined but subtly asymmetrical in its outlines. The highly polished surface of *Bird in Space* disguises the density of its bronze material; its luminosity catches the light, and changing reflections intensify the effect of upward motion as the observer moves around it. . . .

This *Bird in Space* is set upon a two-part stone pedestal—the upper element a cylinder, the lower one a cruciform block. An old photograph, however, shows that it originally rested upon a base of paired truncated pyramids, one inverted above the other— an indented form suggested by the serrations of African wood sculpture, which influenced many of his works. Over the years he elaborated this form in several versions of the *Endless Column* [see page 179].

The stone cylinder and cross-shaped block that now serve as pedestal for this *Bird in Space* contrast with the sculpture they support in several significant respects: a composite versus a unitary form; the matte surface of

stone versus the high glitter of polished metal; man-made, geometrical shapes versus organic, subtly inflected contours; and the heavy mass of the stone base, bound by gravity to the earth, versus the bird's implied weightlessness as it soars freely into space.

Constantin Brancusi
Fish. 1930
Illustrated on page 181

Scott Burton, *Artist's Choice: Burton on Brancusi*, **1989**, n.p.

The Museum of Modern Art's *Fish* base is a choice one. Istrati and [Natalia] Dumitresco have provided us with its background: "In the studio on Impasse Ronsin, the blue-gray marble *Fish* was atop a big slab of plaster. When *Fish* was sent to The Museum of Modern Art in New York, the sculptor designed smaller bases for it. Alexandre Israti carved these in 1948 in accordance with the new measurements. The sculpture lost none of its presence." In some sense it is foolhardy to separate the *Fish* from its base even temporarily, given the thematic relation that the two elements may have: it has been suggested that the stone circle over which the fish floats may be a representation of a pool, lake, or ocean. But the base alone surely holds its own as sculpture.

Giorgio de Chirico
The Song of Love. 1914
Illustrated on page 183

William S. Rubin, *Dada, Surrealism, and Their Heritage*, **1968**, page 80

De Chirico's undermining of the rational classical world was expressed iconographically through enigmatic combinations of objects, usually autobiographical and often sexual in content. The association of the head of the *Apollo Belvedere*, a surgeon's glove, a ball, and a steam locomotive in the exquisitely colored *Song of Love* has the simplicity and poignancy of Lautréamont's famous image. We feel that these objects have been retrieved from the edge of memory. Some of them recall de Chirico's childhood in Greece and the world of his engineer father. In *The Philosopher's Conquest*, the juxtaposition of cannon, balls, and artichokes evokes a veiled eroticism that is more usually expressed in de Chirico's paintings by the towers and arcades of his dream architecture.

De Chirico was the first to translate Lautréamont's poetic paradigm into painting; [Marcel] Duchamp's im-ages on glass and compound Readymades came later. While the Surrealists—[René] Magritte excepted—were to use the principles as a springboard for hybrid fantasies and fantastical metamorphoses, de Chirico rarely altered or abstracted the objects he represented. As in dreams, the approach to reality was selective, but the prosaism of dream imagery was maintained. "Yet even if the exterior aspect of the object is respected," [André] Breton observed, "it is evident that this object is no longer cherished for itself, but solely as a function of the signal that it releases . . . [de Chirico] retains only such exterior aspects of reality as propose enigmas or permit the disengagement of omens and tend toward the creation of a purely divinatory art."[1]

Giorgio de Chirico
The Evil Genius of a King. 1914–15
Illustrated on page 183

James Thrall Soby, *Giorgio de Chirico*, **1955**, pages 98, 100

De Chirico did not fully develop the mannequin theme until 1915. Meanwhile he had begun a series of three still lifes whose objects are especially cryptic. The series includes *The Sailors' Barracks, The General's Illness* and *The Evil Genius of a King*. All three of these pictures are related in compositional formula to the *Still Life: Turin, Spring* and *The Fête Day* in that their foreground areas rise steeply, forming a sort of ramp or platform high above the background street level with architecture. These paintings, instead of enticing the observer to enter an illusory, over-all picture space, as in the earlier series of Italian squares, force him to climb to a dizzy vantage point above the ground.

All three paintings in the series under discussion include a standing, vertical board, like that in *The Song of Love* but swung sideways, which divides their compositions asymmetrically; their still-life vocabulary is, as noted, unusually fantastic. If certain objects in them may be identified with some degree of certainty, others seem thoroughly "unreal." The ball, tube and shuttlecock or paper hat in *The General's Illness*; the epaulet, egg, ball, baton, pipe and checkerboard of *The Sailor's Barracks*; the party favors, ball and flower of *The Evil Genius of a King*—these are objects such as de Chirico might have seen on his solitary walks through Paris. But other still-life forms seem to have little basis in tangible reality. In both cases the objects are depicted with extreme precision and for a definite reason. Just as the cubists at this time were affixing sand, bits of string and other commonplace materials to their canvases in order to affirm an essential contact with reality, so de Chirico was

eager to propose his fantasies in the most convincing possible manner. But above all he wished the poetry of his art to consist in unexpected juxtapositions taking place in an unlikely locale. He must have conceived of the artist's function as that of documenting metaphysical shifts in the continuity of everyday, settled reality. [Guillaume] Apollinaire's respect for the element of "surprise" in painting again comes to mind.

Le Corbusier

Still Life. 1920
Illustrated on page 184

Alfred H. Barr, Jr., *Cubism and Abstract Art*, **1936**, pages 163, 166

Purism was . . . a reform movement, technological in atmosphere, self-consciously modern, aware of social problems and embracing eventually not merely painting but architecture and the practical arts within its scope. It differed in making "reactionary" use of recognizable objects in painting. . . .

Le Corbusier's *Still Life* of 1920 is characteristic of the machine esthetic in its faultlessly precise drawing, its smooth color and the way the contours of the forms fit together. The forms themselves are not very abstract and often resemble the silhouettes of ordinary objects. This is a deliberate choice, for it was part of the Purist program to use as motives the shapes of familiar objects which would be recognizable to all Europeans of all classes. The elimination of depth, the free use of overlapping transparent planes, the arbitrary color and the atmosphere of *nature-mortisme* make Purist painting a methodical kind of Cubism. In its elaborate, systematic theories of color and line it suggests Neo-Impressionism and [Georges-Pierre] Seurat was in fact much admired by the Purists.

Purist paintings were designed architectonically so that they were appropriate decorations for the new architecture which Le Corbusier was just developing. Furthermore they were exercises in color which Le Corbusier was to use so subtly in his architecture: light blues, pinks and dark browns in contrast to the insistent primary blue, red, and yellow of *de Stijl*; and finally they gave him practice in that sensitive adjustment of subtle curves to straight lines which was to distinguish the planning of his later architecture and furniture from that of the orthodox *Stijl* and Bauhaus designers who rarely departed from the straight line and right angle. This is not to say that Le Corbusier's architecture is an outgrowth of his Purist painting: they were, rather, interdependent developments united by the same esthetic and the same immaculate taste.

Fernand Léger

Three Women. 1921
Illustrated on page 185

Robert Storr, *Modern Art despite Modernism*, **2000**, page 54

Rather than losing his faith in modernity during the war, Léger reconfirmed it and retooled his work in preparation for developing a schematic but robust naturalism. Like his Cubist confederates, Léger stuck to traditional formats—figure studies, interiors, still lifes, and landscapes—and like them, he injected his forms with a classical rigor. Vibrant, good-natured, and vaguely droll, Léger's neoclassicism, however, exhibits very little antiquity and a lot of industrial streamlining. His renditions of the postwar *éternel féminin* are ample, impassive, and unapologetically vulgar. As distinct from the languorous reclining nudes of [Henri] Matisse or the Sabine women of [Pablo] Picasso, the bumpy odalisques in Léger's *Three Women* resemble three Rubensian graces stylishly coiffed, poured into shiny, tubular, steel corsets or body stockings, and posed in an Art Deco apartment. They are big, big city women who thoroughly enjoy their swank surroundings.

They may also be working-class women accustoming themselves to an undreamed of luxury, for, more so than any of the Cubists, Léger was a man of the Left. When he spoke of "discovering the people of France" among the laborers and artisans in his regiment, Léger was not indulging in chauvinism, as so many artists of the interwar years were to do, but rather announcing his eagerness to cast his lot with that of his wartime comrades-in-arms and his peacetime comrades in the streets.

Pablo Picasso

Three Musicians. 1921
Illustrated on page 186

Kirk Varnedoe, *Picasso: Masterworks from The Museum of Modern Art*, **1997**, page 80

In 1921, Picasso summered in the château town of Fontainebleau near Paris. Painting in a rented garage, he dedicated himself to several large canvases, including two versions of this composition (the other is now in the Philadelphia Museum of Art). They were the most imposing works Picasso had conceived in the style of Synthetic Cubism—a style that, in the aftermath of World War I, had come to seem rather outmoded. It was instead the neoclassicism the artist had initiated in the later 1910s (and used in alternating parallel with

Synthetic Cubist stylizations) that was being increasingly celebrated, for its timely revivification of noble French and Mediterranean traditions. Indeed, many writers have seen *Three Musicians* as a summation of, and grand farewell to, a passing epoch in Picasso's art. But there may be other reasons, too, for the monumental somberness conveyed by the painting's dominantly dark palette and spectral light, and by the uncommonly grave, iconic address of this three-man band. Noting that the mingling of commedia dell'arte figures with a religious personage evokes a masked ball or carnival occasion, Theodore Reff has argued that Picasso here situated his own favorite avatar, the harlequin, as the guitar player between two poets who were comrades of his youth: on the left, a bulky Pierrot would represent Guillaume Apollinaire, who had died in 1917, and on the right, a more diminutive masked man in monk's garb would evoke Max Jacob, whose close friendship with Picasso had crumbled years before, and who had in fact entered a Benedictine monastery in the spring of 1921. The Philadelphia version of this nostalgic "reunion," or wake for the artist's bohemian youth, is more brightly upbeat. Here, with a more austere interlocking of broad, zigzagging planes and piquant details (such as the tiny hands), and with the addition of a dark dog beneath, the trio seems to play its jazzlike harmonies in a more muted key. The whimsical freedoms and decorative jauntiness of earlier Synthetic Cubist works persist, but the total air is one of haunting solemnity.

Pablo Picasso

The Studio. 1927–28
Illustrated on page 187

William Lieberman, *Modern Masters: Manet to Matisse*, **1975**, page 244

Although curved contours characterize many of his works of the late 1920s, Picasso passed to opposite and completely linear extremes in *The Studio.* This large and precisely calculated composition of rectangles and straight lines seems at first glance to be an abstract picture. It is not.

We see an artist at work, a theme frequent in Picasso's art. In a room stands the painter, palette and brush in either hand. At the right is his subject—a table, again dressed by a red tablecloth, on which rest a *compotier* with a single fruit and, on a base, a white plaster head. The eyes and mouth of the sculpture are placed vertically, as are those of the artist himself. The sharp, aggressive angles which outline the figure, cloth, bowl, and bust are stabilized by the strict rectangles of the mirror and picture frame on the wall and, at left

and right, the larger easel and door. In addition, Picasso emphasizes the rectangular format of the picture by a black line and, parallel to it, a thin strip of frame painted white. The still life on the table is comparable to that in the earlier studio of 1925. Here, however, it is realized completely without modeling or detail and with a flatness of paint as well as of design.

Straight lines, dislocated dots of eyes, thumb hole, and table-leg tips recall drawings by Picasso in 1926 which were engraved as woodcuts and added to his illustrations to [Honoré] Balzac's *Le Chef-d'Oeuvre Inconnu* etched the following year. The spare and linear discipline of the delineation also relates the painting to a specific sculpture of the same period, notably Picasso's monument to his deceased and beloved friend, the poet Guillaume Apollinaire. The maquette for the monument was constructed in light iron rods.

Stuart Davis

Lucky Strike. 1921
Illustrated on page 188

John Russell, *The Meanings of Modern Art*, **1981**, page 303

Just about the only artist who used specifically and unmistakably American subject matter without falling into an isolationist aesthetic was Stuart Davis, who loved France and French art and yet never reneged on his wiry, sinewy, plainspoken nature. He cut the descriptive element in painting to essentials that could be reduced no further; and then he put them together again in ways that owed much to French mentors but were also quintessentially American in their throwaway wit. It was Davis, as much as anyone, who deprovincialized American painting. This was acknowledged already in 1931 by Arshile Gorky, then 26 years old, when he paid tribute to Davis as "this man, this American, this pioneer, this modest painter, who never disarranges his age, who works to perfect his motives, who renders—clear, more definite, more and more decided—new forms and new objects." The phrase that matters here is that Davis "never disarranges his age"; the art and the age were one, in his work, and a painting like his *Lucky Strike* of 1921 has about it not only an after-echo of Fernand Léger but a specifically American form of plain statement.

Patrick Henry Bruce

Painting. c. 1929–30
Illustrated on page 189

William C. Agee, *Patrick Henry Bruce*, **1979**, pages 2, 28, 30, 37

Although Bruce's work first became more widely known through the exhibition "Synchromism and Color Principles in American Painting, 1910-1930," . . . he never allied himself with any school, even unofficially. On the contrary, he broke with one teacher after another, ultimately renouncing [Robert] Delaunay as well, to go his own way in search of a personal and unique style that is an original contribution to Cubism as well as to color abstraction. In his final search for the "absolute," Bruce came to reject much that he was taught and practically everything he saw, preferring to spend his time studying the Old Masters at the Louvre rather than talking at the cafés of Montparnasse that he frequented during his youth. A demanding artist to begin with, he became ever more demanding both of himself and of others. . . .

In 1933 Bruce destroyed all but twenty-one of [his geometric still lifes] [1] . . . We do not know how many he had actually painted by 1933 although he had exhibited thirty-four between 1919 and 1930. They are neither signed nor dated, and the sequence and chronology . . . [are] based on stylistic analysis and on a few documents and eyewitness accounts. . . .

We still tend, reflexively and simplistically, to associate gometry with the cold, the impersonal, and the unfeeling. It is a measure of the richness—as well as the complexity and ambiguity—of Bruce's work that his geometric paintings appeal to the senses, evoking old artifacts that Bruce deeply loved; gathered from many countries and cultures, each has its own set of historical and personal connotations and references. They are objects that represent the intimacy and pleasures of his private world. . . .

In [this painting] . . . the shapes stand on their own, each conceived as a fully modeled entity. Here it should be noted that the bulk and separate space accorded each object always distinguishes Bruce's paintings from the more flattened and schematic shapes in the still lifes of [Amédée] Ozenfant, Le Corbusier, and [Fernand] Léger. In earlier paintings Bruce had employed a wide range of pearlescent, almost pastel hues, but in the late vertical bar paintings and the last two pictures, Bruce returned to richer and more simplified color, consisting of the primaries and a few of their variants. The primaries in the last painting form the dominant chord and are heightened and contrasted by the deep black of the table, by creamy whites, and the gray of the cylinder; they are also set off by the light greens of the vertical planes at front and rear, as well as by the subtle gradation of the several zones of red toward the pink of the glass. The yellow straw strikes a binding and resounding note that is almost sublime. In the late pictures Bruce never graduated or contrasted hues within a given area, and values were kept at an equally high but modulated pitch. His touch became lighter, surfaces were kept more even, and he achieved a full, though not heavy, paint texture. It was in this painting that Bruce found the richness and balance that he took for his model for the paintings that he continued to work on steadily until he left for America in 1936.

Gerald Murphy

Wasp and Pear. 1927
Illustrated on page 189

William Rubin, *The Paintings of Gerald Murphy*, **1974**, page 42

Murphy considered *Wasp and Pear* "probably the best" of his pictures, and in some respects it is. . . . [T]he insect and fruit have more freely invented arabesqued silhouettes, for which the background acts rather as a foil. The progression through a shallow space from the rear planes where the insect's comb is located to the bulging surface of the pear in the center of the field is more consistent and more controlled than in previous works, and indicates a surer grasp of Cubism.

The notebook entry for *Wasp and Pear* reads:

Picture: hornet (colossal) on a pear (marks on
skin, leaf veins, etc.)
(*battening* on the fruit, clenched . . .

This is Murphy's only convincing rendering of an organic, living thing. . . . Murphy had always been a careful observer of nature—"Have you ever seen the lining of a potato bug's wings?" he wrote Sara during their courtship[1]—and he "never forgot the large technically drawn and colored charts" of fruits, animals, and insects which he had encountered by chance during his wartime training.[2] But despite the precision of his drawing and the accuracy of the textbook-like microscopic enlargement of the wasp's leg,[3] Murphy had no Audobonesque scientific concern in this image. His emphasis is on inventive patterning, as in the head and transparent wing of the wasp, and to that end he was perfectly content to omit the insect's rear wings.

Fauvism, Symbolism, Expressionism

Aristide Maillol | (FRENCH, 1861–1944)
THE MEDITERRANEAN. 1902–05 (cast c. 1951–53)
BRONZE, 41 x 45 x 29¾" (104.1 x 114.3 x 75.6 CM)
GIFT OF STEPHEN C. CLARK, 1953

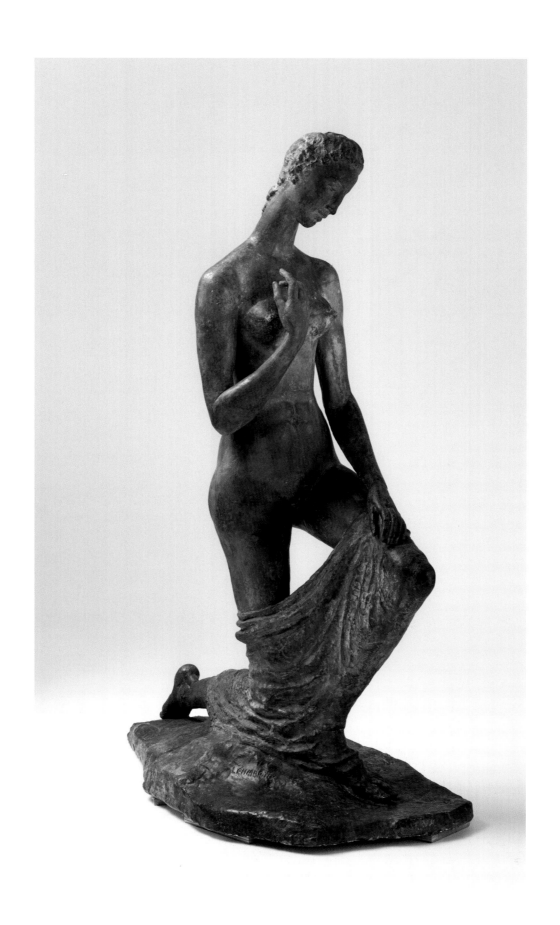

Wilhelm Lehmbruck | (GERMAN, 1881–1919)
KNEELING WOMAN 1911
CAST STONE, 69½ x 56 x 27" (176.5 x 142.2 x 68.6 CM)
ABBY ALDRICH ROCKEFELLER FUND, 1938

139

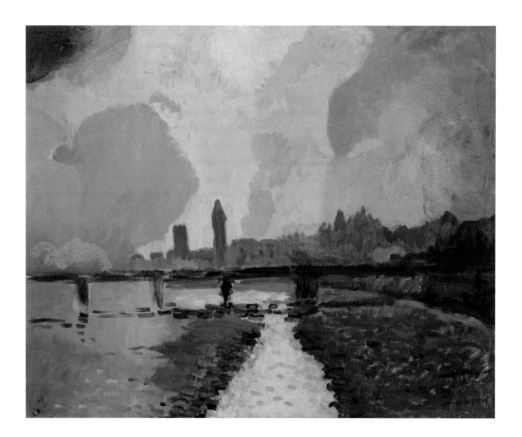

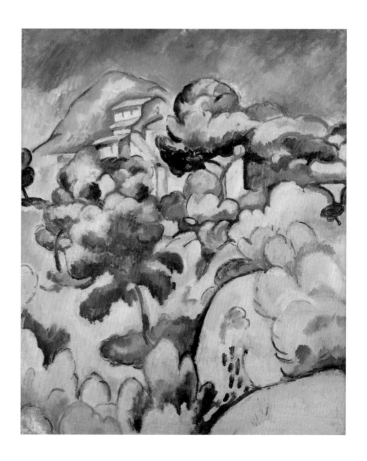

André Derain | (FRENCH, 1880–1954)
CHARING CROSS BRIDGE. 1905–06
OIL ON CANVAS, 32⅛ x 39⅝" (81.7 x 100.7 CM)
FRACTIONAL GIFT OF MR. AND MRS. DAVID ROCKEFELLER, 1992

Georges Braque | (FRENCH, 1882–1963)
LANDSCAPE AT LA CIOTAT. Summer 1907
OIL ON CANVAS, 28¼ x 23⅜" (71.7 x 59.4 CM)
ACQUIRED THROUGH THE KATHERINE S. DREIER AND
ADELE R. LEVY BEQUESTS, 1975

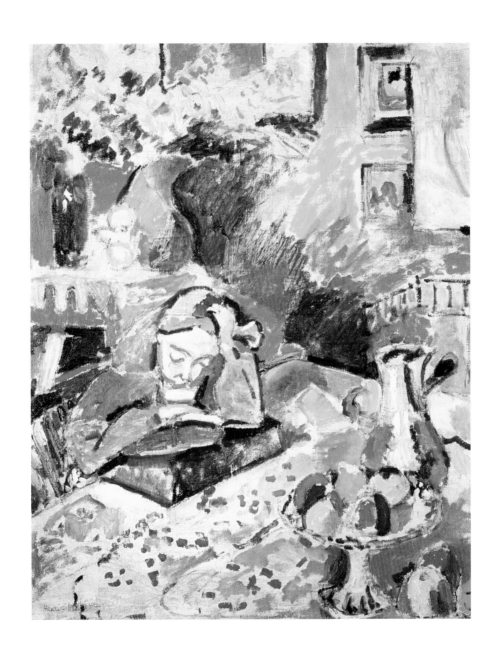

Henri Matisse | (FRENCH, 1869–1954)
INTERIOR WITH A YOUNG GIRL (GIRL READING). 1905–06
OIL ON CANVAS, 28⅞ x 23½" (72.7 x 59.7 CM)
FRACTIONAL GIFT OF MR. AND MRS. DAVID ROCKEFELLER, 1991

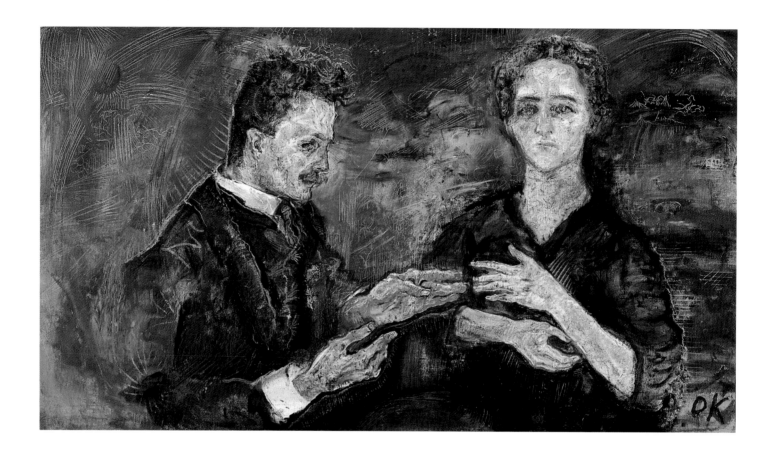

Oskar Kokoschka | (AUSTRIAN, 1886–1980)
HANS TIETZE AND ERICA TIETZE-CONRAT. 1909
OIL ON CANVAS, 30⅛ x 53¼" (76.5 x 136.2 CM)
ABBY ALDRICH ROCKEFELLER FUND, 1939

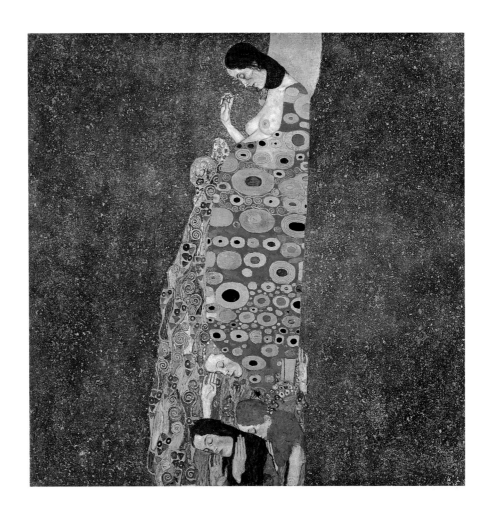

Gustav Klimt | (AUSTRIAN, 1862–1918)
HOPE, II. 1907–08
OIL, GOLD, AND PLATINUM ON CANVAS,
43½ x 43½" (110.5 x 110.5 CM)
MR. AND MRS. RONALD S. LAUDER AND HELEN
ACHESON FUNDS, AND SERGE SABARSKY, 1978

Egon Schiele | (AUSTRIAN, 1890–1918)
PORTRAIT OF GERTI SCHIELE. 1909
OIL, SILVER, GOLD-BRONZE PAINT, AND PENCIL
ON CANVAS, 55 x 55¼" (139.5 x 140.5 CM)
PURCHASE AND PARTIAL GIFT OF THE LAUDER
FAMILY, 1982

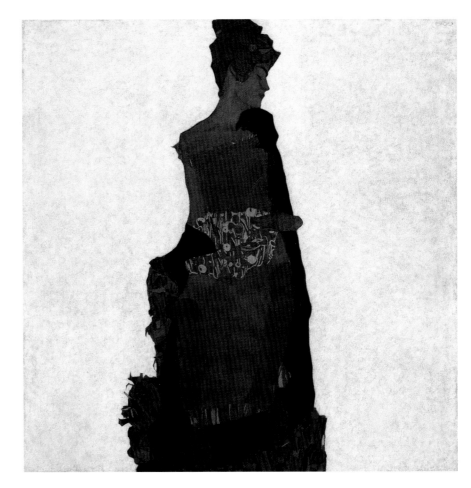

143

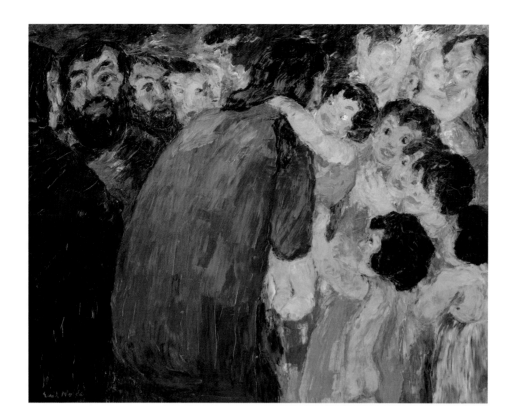

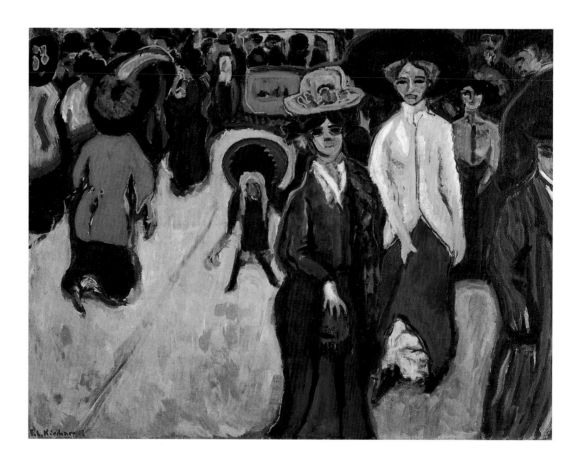

Emil Nolde | (GERMAN, 1867–1956)
CHRIST AND THE CHILDREN, 1910
OIL ON CANVAS, 34⅛ x 41⅞" (86.8 x 106.4 CM)
GIFT OF DR. W. R. VALENTINER, 1955

Ernst Ludwig Kirchner | (GERMAN, 1880–1938)
STREET, DRESDEN, 1908 (dated on painting 1907)
OIL ON CANVAS, 59¼" x 6' 6⅞" (150.5 x 200.4 CM)
PURCHASE, 1951

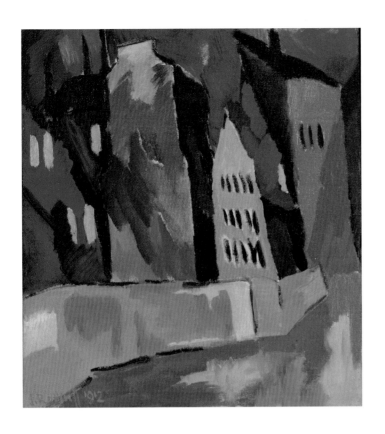

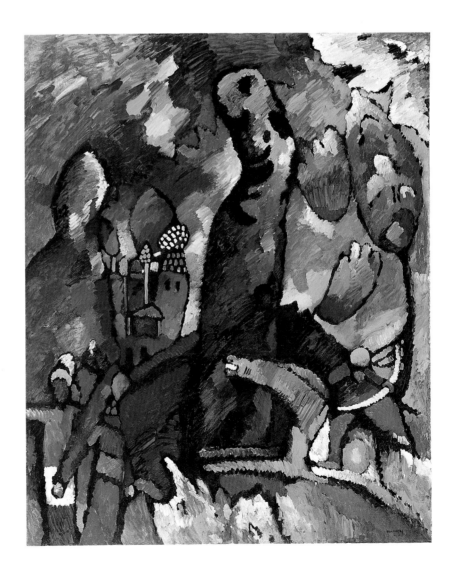

Karl Schmidt-Rottluff | (GERMAN, 1884–1976)
HOUSES AT NIGHT. 1912
OIL ON CANVAS, 37⅝ x 34½" (95.6 x 87.4 CM)
GIFT OF MR. AND MRS. WALTER BAREISS, 1957

Vasily Kandinsky | (FRENCH, BORN RUSSIA.
1866–1944)
PICTURE WITH AN ARCHER. 1909
OIL ON CANVAS, 68⅞ x 57⅛" (175 x 144.6 CM)
GIFT AND BEQUEST OF LOUISE REINHARDT SMITH, 1959

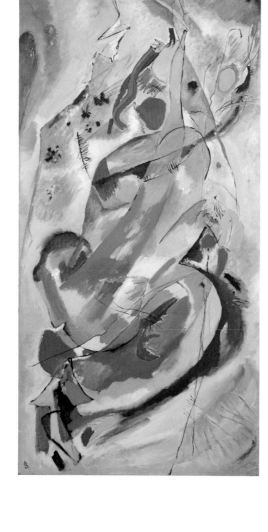

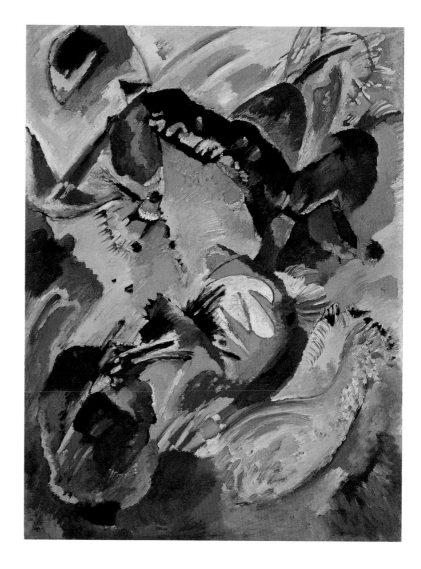

Vasily Kandinsky | (FRENCH, BORN RUSSIA, 1866–1944)
PANEL FOR EDWIN R. CAMPBELL NO. 1. 1914
OIL ON CANVAS, 64 x 31½" (162.5 x 80 CM)
MRS. SIMON GUGGENHEIM FUND, 1954

Vasily Kandinsky
PANEL FOR EDWIN R. CAMPBELL NO. 2. 1914
OIL ON CANVAS, 64⅛ x 48⅜" (162.6 x 122.7 CM)
NELSON A. ROCKEFELLER FUND (BY EXCHANGE), 1983

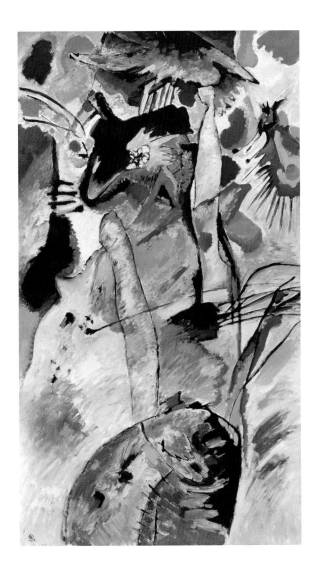

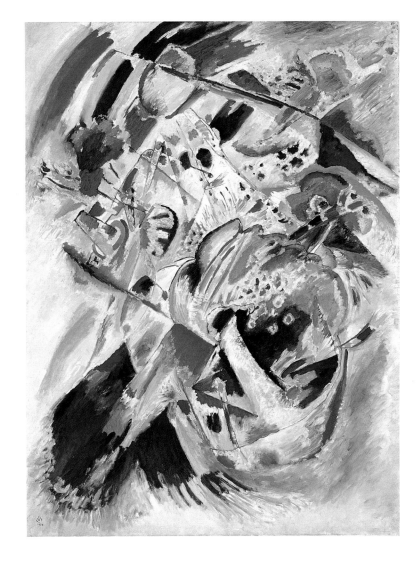

Vasily Kandinsky
PANEL FOR EDWIN R. CAMPBELL NO. 3. 1914
OIL ON CANVAS, 64 x 36¼" (162.5 x 92.1 CM)
MRS. SIMON GUGGENHEIM FUND, 1954

Vasily Kandinsky
PANEL FOR EDWIN R. CAMPBELL NO. 4. 1914
OIL ON CANVAS, 64¼ x 48¼" (163 x 122.5 CM)
NELSON A. ROCKEFELLER FUND (BY EXCHANGE), 1983

147

Picasso and Cubism

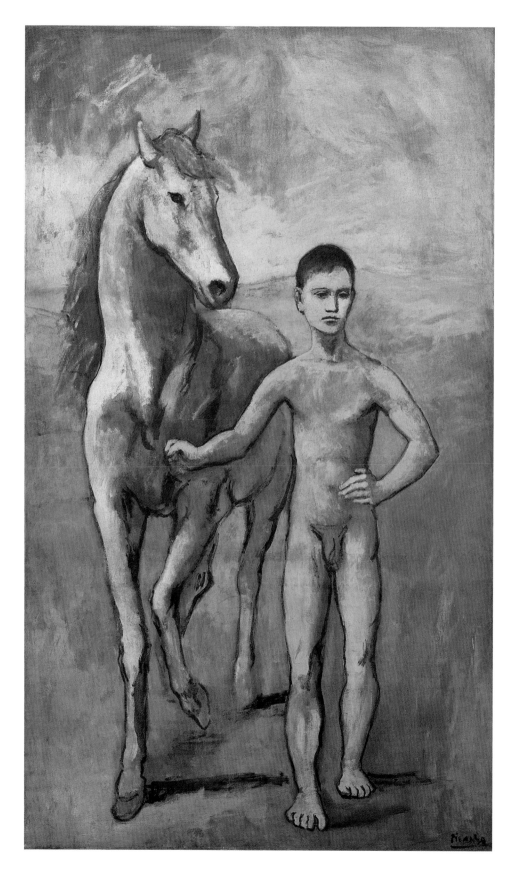

Pablo Picasso | (SPANISH, 1881–1973)
BOY LEADING A HORSE. 1905–06
OIL ON CANVAS, 7' 2⅞" x 51¼" (220.6 x 131.2 CM)
THE WILLIAM S. PALEY COLLECTION, 1964

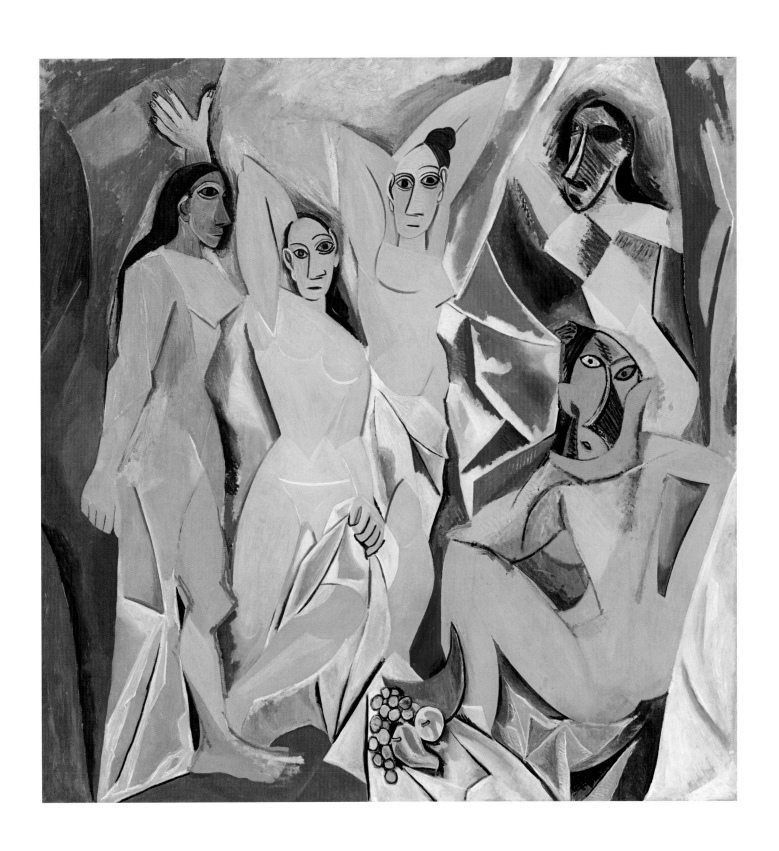

Pablo Picasso
LES DEMOISELLES D'AVIGNON. June–July 1907
OIL ON CANVAS, 8' x 7' 8" (243.9 x 233.7 CM)
ACQUIRED THROUGH THE LILLIE P. BLISS BEQUEST, 1939

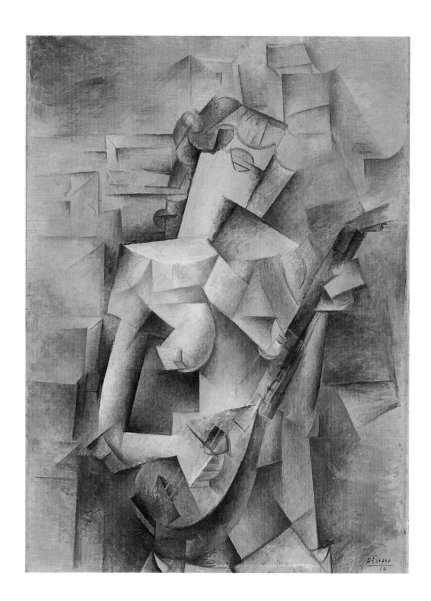

Pablo Picasso | (SPANISH, 1881–1973)
GIRL WITH A MANDOLIN (FANNY TELLIER). Late spring 1910
OIL ON CANVAS, 39½ x 29" (100.3 x 73.6 CM)
NELSON A. ROCKEFELLER BEQUEST, 1979

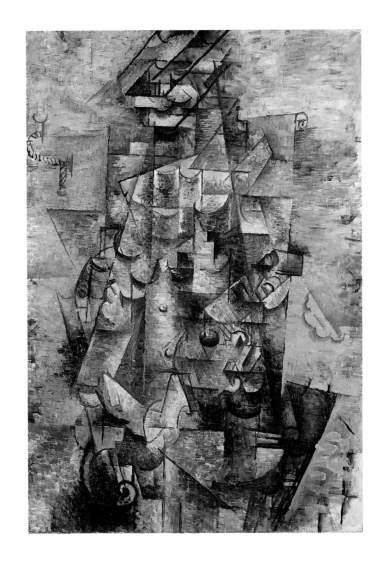

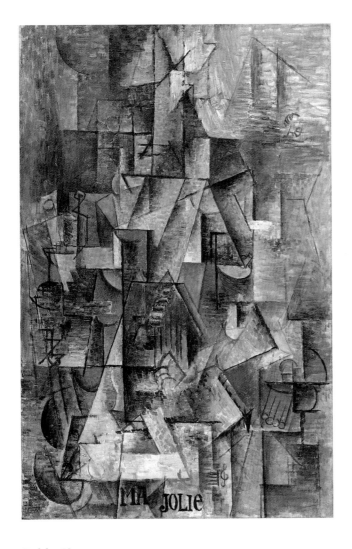

Pablo Picasso
"MA JOLIE." Winter 1911–12
OIL ON CANVAS, 39⅜ x 25¾" (100 x 64.5 CM)
ACQUIRED THROUGH THE LILLIE P. BLISS BEQUEST, 1945

Georges Braque | (FRENCH, 1882–1963)
MAN WITH A GUITAR. Summer 1911–early 1912
OIL ON CANVAS, 45¾ x 31⅞" (116.2 x 80.9 CM)
ACQUIRED THROUGH THE LILLIE P. BLISS BEQUEST, 1945

151

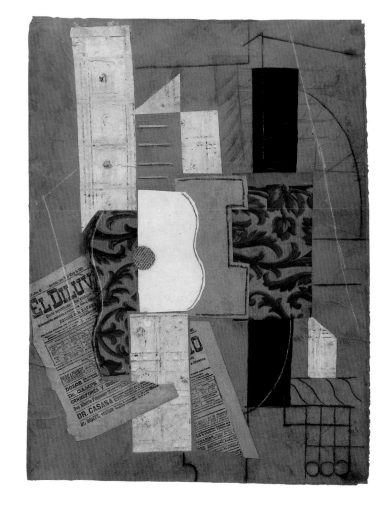

Pablo Picasso | (SPANISH, 1881–1973)
GUITAR. Winter 1912–13
SHEET METAL AND WIRE, 30½ x 13¼ x 7⅝" (77.5 x 35 x 19.3 CM)
GIFT OF THE ARTIST, 1971

Pablo Picasso
GUITAR. (after March 31, 1913)
PASTED PAPER, CHARCOAL, INK, AND CHALK ON BLUE PAPER,
MOUNTED ON RAGBOARD, 26⅛ x 19½" (66.4 x 49.6 CM)
NELSON A. ROCKEFELLER BEQUEST, 1979

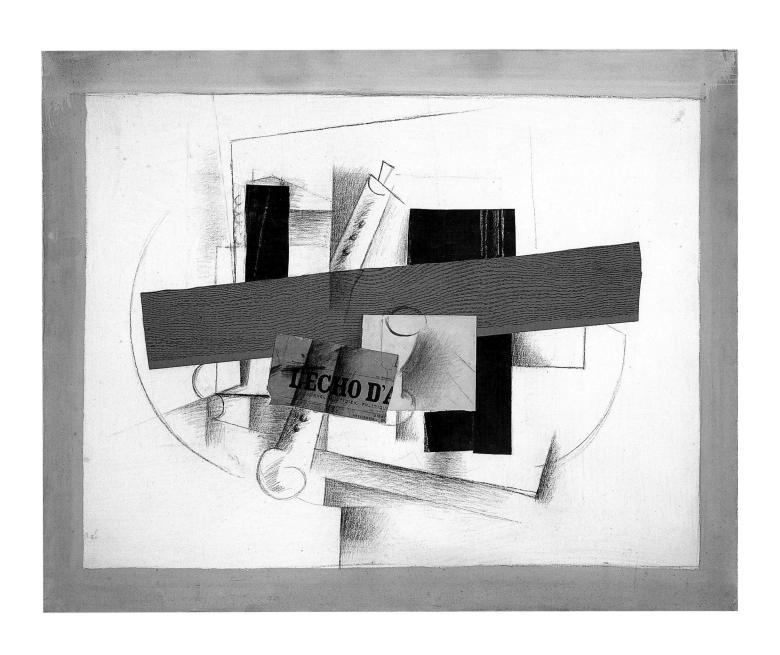

Georges Braque | (FRENCH, 1882–1963)
STILL LIFE WITH TENORA. (Summer or fall 1913)
PASTED PAPER, OIL, CHARCOAL, CHALK, AND PENCIL ON
CANVAS, 37½ x 47⅛" (95.2 x 120.3 CM)
NELSON A. ROCKEFELLER BEQUEST, 1979

153

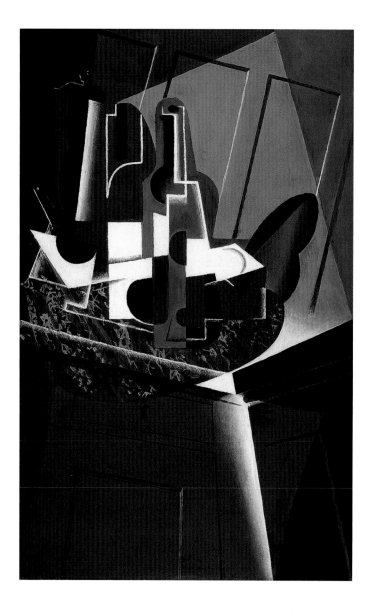

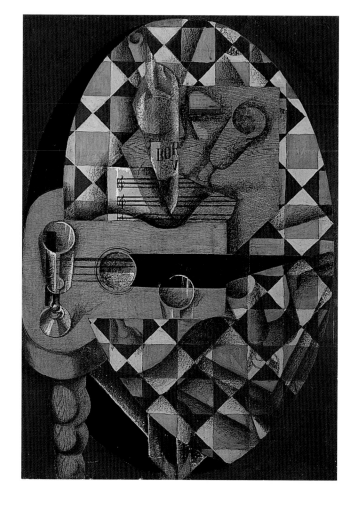

Juan Gris | (SPANISH, 1887–1927)
THE SIDEBOARD. 1917
OIL ON PLYWOOD, 45⅞ x 28¾" (116.2 x 73.1 CM)
NELSON A. ROCKEFELLER BEQUEST, 1979

Juan Gris
GUITAR AND GLASSES. 1914
PASTED PAPERS, GOUACHE, AND CRAYON
ON CANVAS, 36¼ x 25½" (91.5 x 64.6 CM)
NELSON A. ROCKEFELLER BEQUEST, 1979

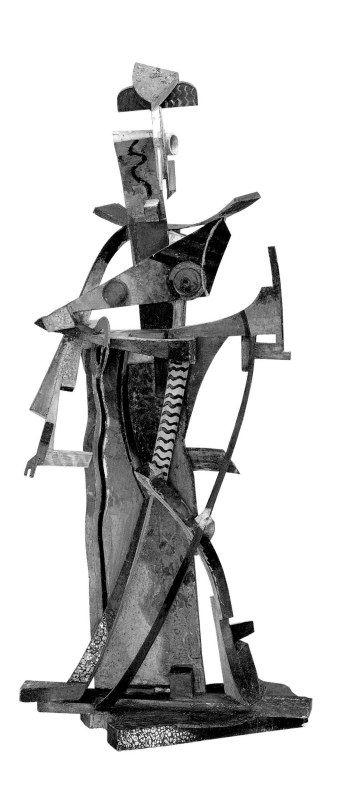

Henri Laurens | (FRENCH, 1885–1954)
HEAD OF A WOMAN. 1915
PAINTED WOOD CONSTRUCTION, 20 x 18¼" (50.8 x 46.3 CM)
VAN GOGH PURCHASE FUND, 1937

Vladimir Baranoff-Rossiné | (RUSSIAN, 1888–1942)
SYMPHONY NUMBER 1. 1913
POLYCHROME WOOD, CARDBOARD, AND CRUSHED EGGSHELLS,
63¼ x 28½ x 25" (161.1 x 72.2 x 63.4 CM)
KATIA GRANOFF FUND, 1972

155

Amedeo Modigliani | (ITALIAN, 1884–1920)
HEAD. 1915?
LIMESTONE, 22⅛ x 5 x 14¾" (56.5 x 12.7 x 37.4 CM)
GIFT OF ABBY ALDRICH ROCKEFELLER IN MEMORY OF
MRS. CORNELIUS J. SULLIVAN, 1939

Jacques Lipchitz | (AMERICAN, BORN
LITHUANIA. 1891–1973)
MAN WITH A GUITAR. 1915
LIMESTONE, 38¼ x 10½ x 7¾" (97.2 x 26.7 x 19.5 CM)
MRS. SIMON GUGGENHEIM FUND (BY EXCHANGE), 1951

Jacob Epstein | (BRITISH, 1880–1959)
THE ROCK DRILL. 1913–14 (cast 1962)
BRONZE, 28 x 26" (71 x 66 CM) ON WOOD BASE
MRS. SIMON GUGGENHEIM FUND, 1962

157

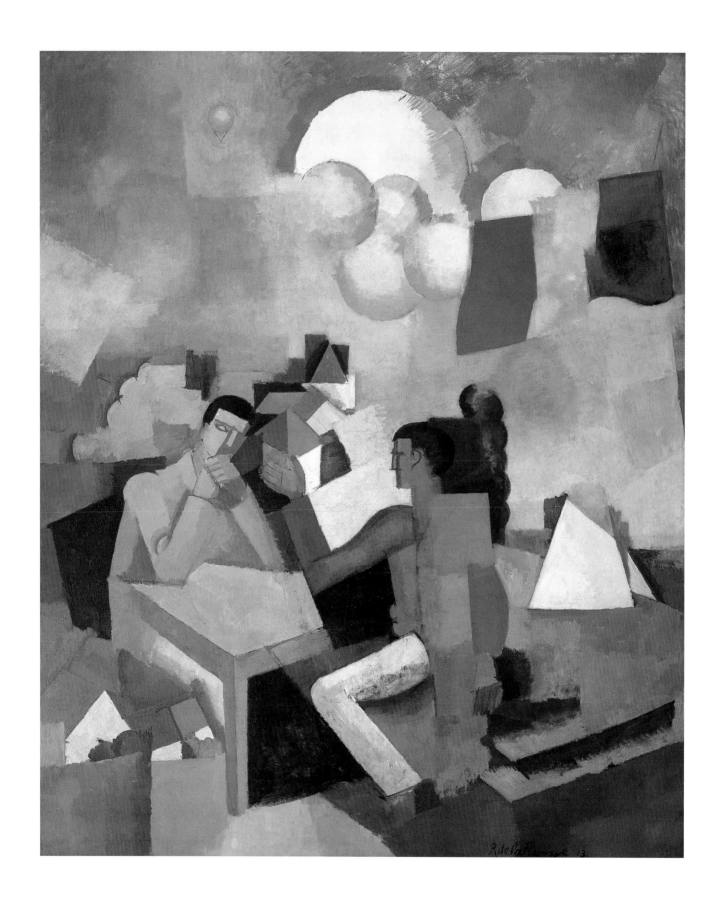

Roger de La Fresnaye | (FRENCH, 1885–1925)
THE CONQUEST OF THE AIR, 1913
OIL ON CANVAS, 7' 8¼" x 6' 5" (235.9 x 195.6 CM)
MRS. SIMON GUGGENHEIM FUND, 1947

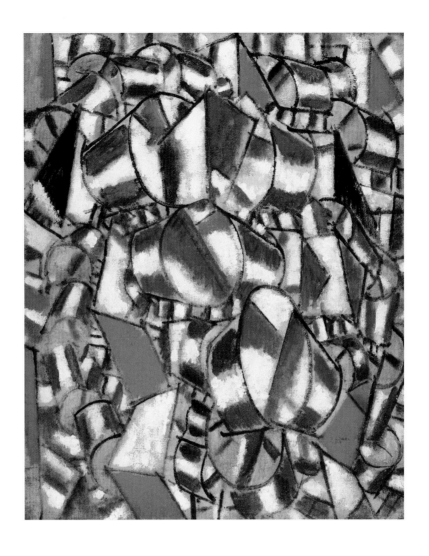

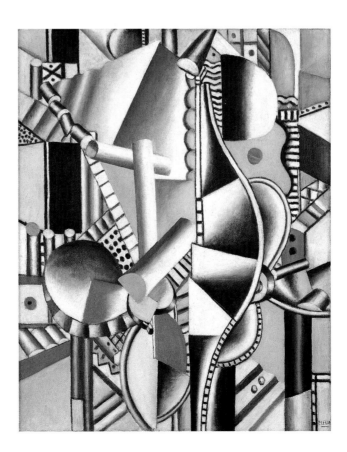

Fernand Léger | (FRENCH, 1881–1955)
CONTRAST OF FORMS. 1913
OIL ON CANVAS, 39½ x 32" (100.3 x 81.1 CM)
THE PHILIP L. GOODWIN COLLECTION, 1958

Fernand Léger
PROPELLERS. 1918
OIL ON CANVAS, 31⅞ x 25¾" (80.9 x 65.4 CM)
KATHERINE S. DREIER BEQUEST, 1953

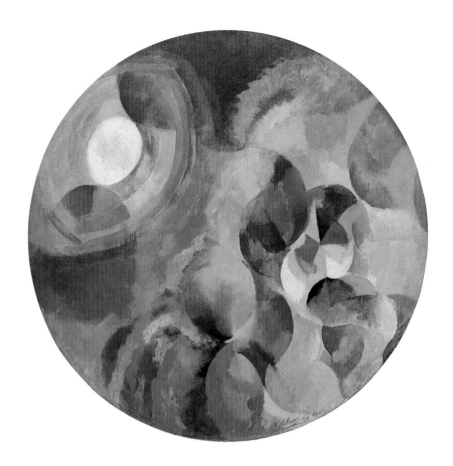

Robert Delaunay | (FRENCH, 1885–1941)
SIMULTANEOUS CONTRASTS: SUN AND MOON.
1913 (dated on painting 1912)
OIL ON CANVAS, 53" (134.5 CM) IN DIAMETER
MRS. SIMON GUGGENHEIM FUND, 1954

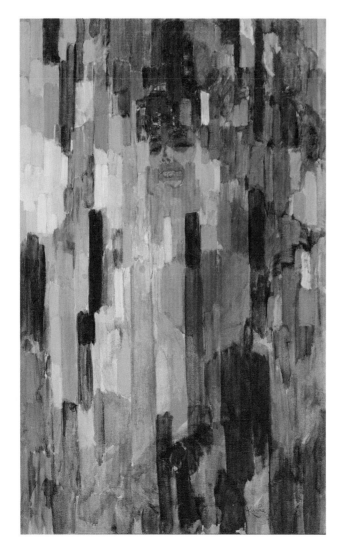

František Kupka | (CZECH, 1871–1957)
MME KUPKA AMONG VERTICALS. 1910–11
OIL ON CANVAS, 53⅜ x 33⅛" (135.5 x 85.3 CM)
HILLMAN PERIODICALS FUND, 1956

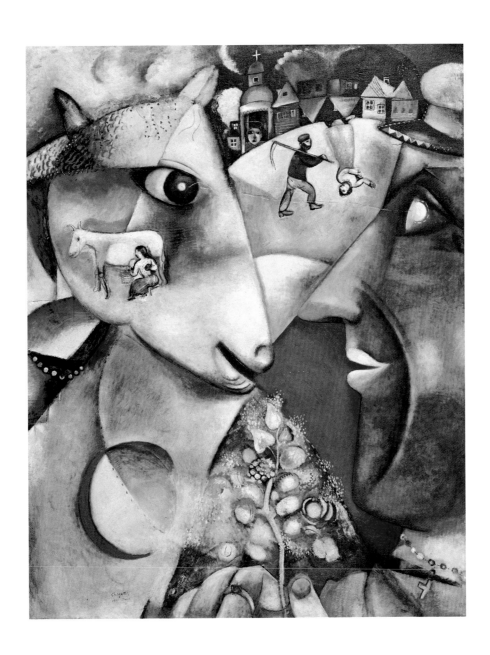

Marc Chagall | (FRENCH, BORN BELARUS. 1887–1985)
I AND THE VILLAGE. 1911
OIL ON CANVAS, 6' 3⅝" x 59⅝" (192.1 x 151.4 CM)
MRS. SIMON GUGGENHEIM FUND, 1945

Futurism

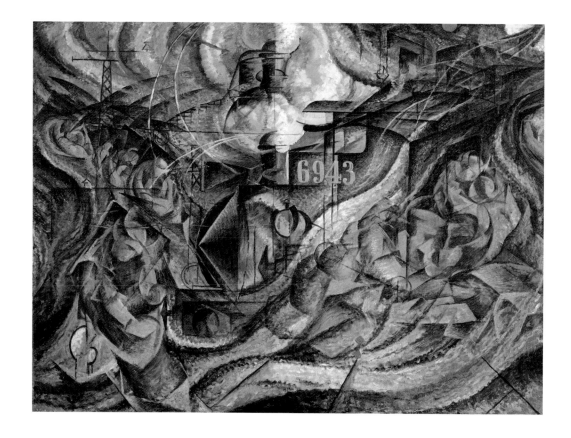

Umberto Boccioni | (ITALIAN, 1882–1916)
STATES OF MIND I: THE FAREWELLS. 1911
OIL ON CANVAS, 27⅛ x 37⅞" (70.5 x 96.2 CM)
GIFT OF NELSON A. ROCKEFELLER, 1979

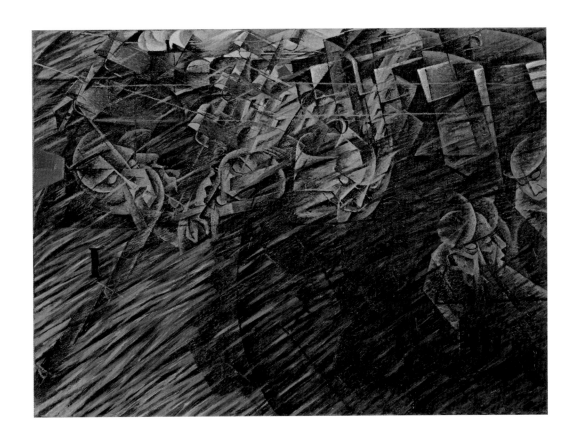

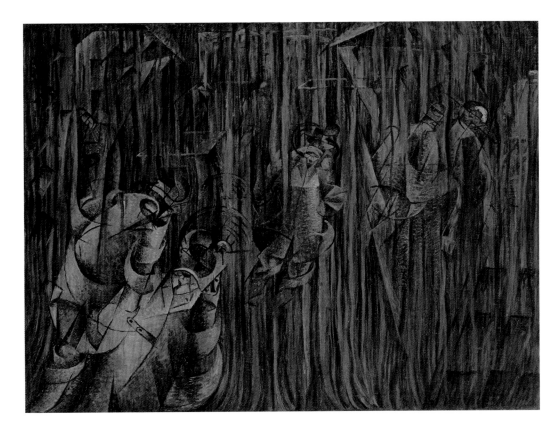

Umberto Boccioni
STATES OF MIND II: THOSE WHO GO. 1911
OIL ON CANVAS, 27⅞ x 37¾" (70.8 x 95.9 CM)
GIFT OF NELSON A. ROCKEFELLER, 1979

Umberto Boccioni
STATES OF MIND III: THOSE WHO STAY. 1911
OIL ON CANVAS, 27⅞ x 37¾" (70.8 x 95.9 CM)
GIFT OF NELSON A. ROCKEFELLER, 1979

163

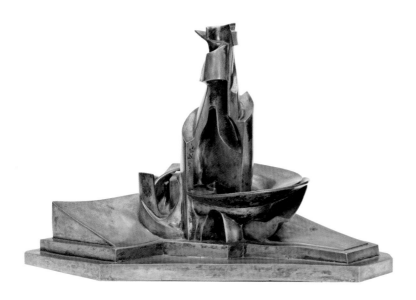

Umberto Boccioni | (ITALIAN, 1882–1916)
DEVELOPMENT OF A BOTTLE IN SPACE. 1912 (cast 1931)
SILVERED BRONZE, 15 x 23¾ x 12⅞" (38.1 x 60.3 x 32.7 CM)
ARISTIDE MAILLOL FUND, 1948

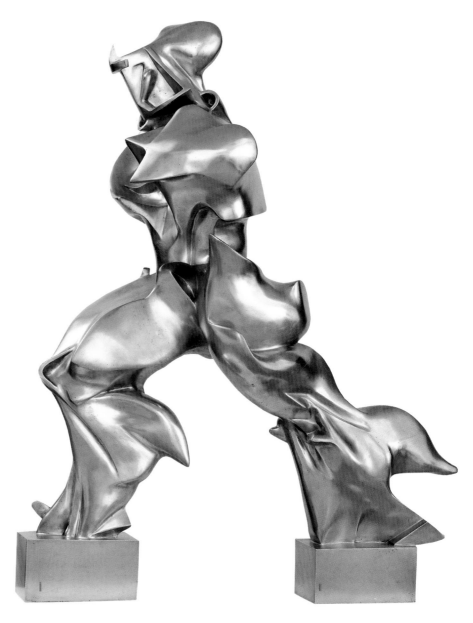

Umberto Boccioni
UNIQUE FORMS OF CONTINUITY IN SPACE. 1913 (cast 1931)
BRONZE, 43⅞ x 34⅞ x 15¾" (111.2 x 88.5 x 40 CM)
ACQUIRED THROUGH THE LILLIE P. BLISS BEQUEST, 1948

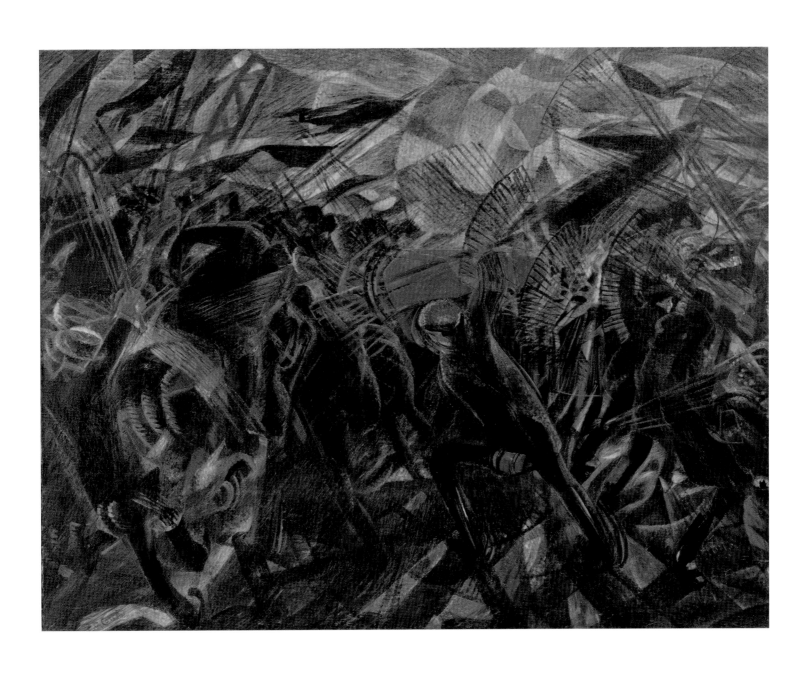

Carlo Carrà | (ITALIAN, 1881–1966)
FUNERAL OF THE ANARCHIST GALLI. 1910–11
OIL ON CANVAS, 6' 6½" x 8' 6" (198.7 x 259.1 CM)
ACQUIRED THROUGH THE LILLIE P. BLISS BEQUEST, 1948

165

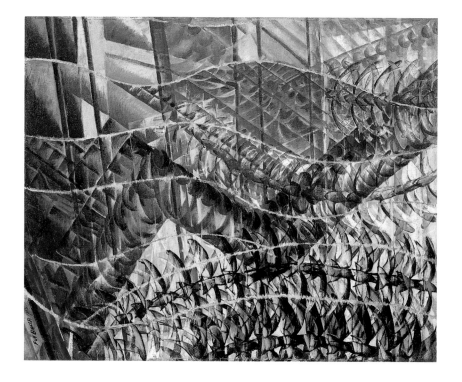

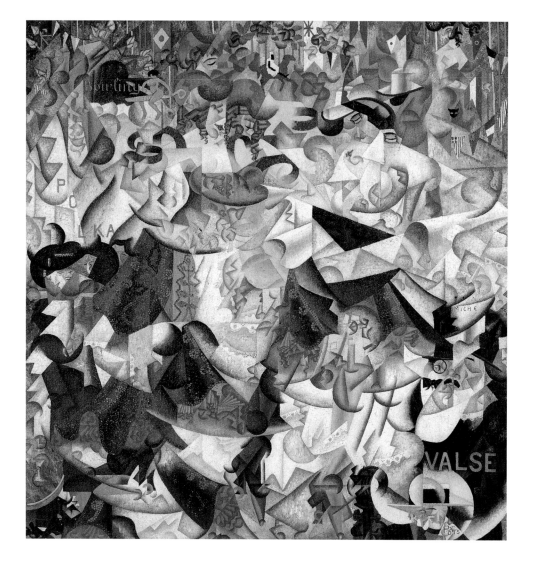

Giacomo Balla | (ITALIAN, 1871–1958)
SWIFTS: PATHS OF MOVEMENT + DYNAMIC
SEQUENCES. 1913
OIL ON CANVAS, 38⅛ x 47¼" (96.8 x 120 CM)
PURCHASE, 1949

Gino Severini | (ITALIAN, 1883–1966)
DYNAMIC HIEROGLYPHIC OF THE BAL
TABARIN. 1912
OIL ON CANVAS WITH SEQUINS, 63⅜ x 61½"
(161.6 x 156.2 CM)
ACQUIRED THROUGH THE LILLIE P. BLISS
BEQUEST, 1949

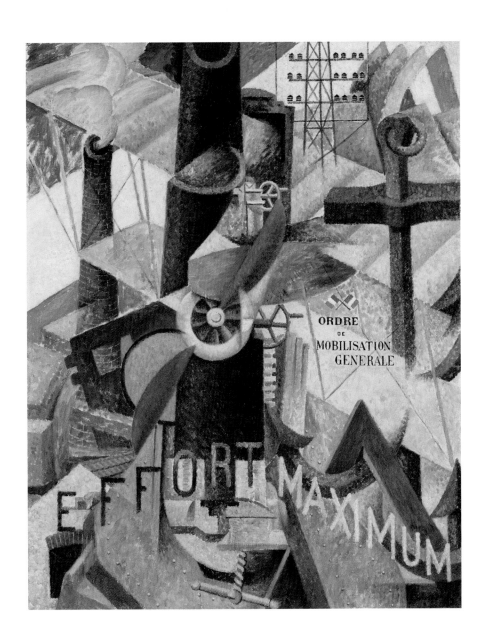

Gino Severini
VISUAL SYNTHESIS OF THE IDEA: "WAR." 1914
OIL ON CANVAS, 36½ x 28¼" (92.7 x 73 CM)
BEQUEST OF SYLVIA SLIFKA, 2004

Matisse

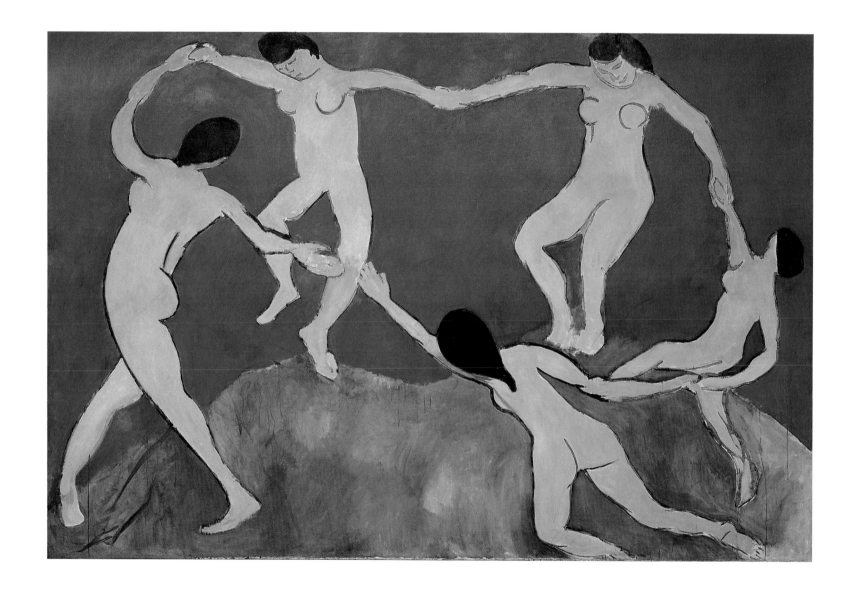

Henri Matisse | (FRENCH, 1869–1954)
DANCE (I). Early 1909
OIL ON CANVAS, 8' 6½" x 12' 9½" (259.7 x 390.1 CM)
GIFT OF NELSON A. ROCKEFELLER IN HONOR OF ALFRED H. BARR, JR., 1963

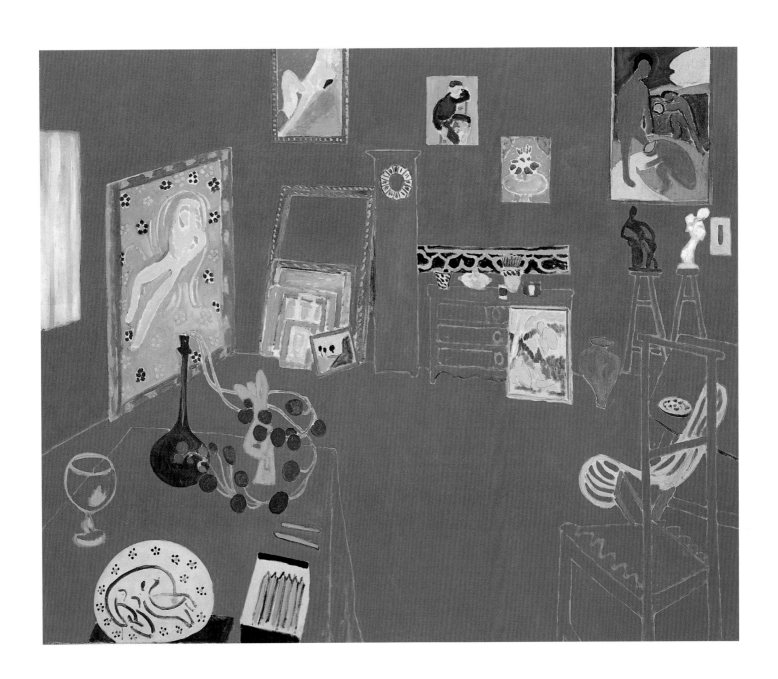

Henri Matisse
THE RED STUDIO. Fall 1911
OIL ON CANVAS, 71¼" x 7' 2¼" (181 x 219.1 CM)
MRS. SIMON GUGGENHEIM FUND, 1949

169

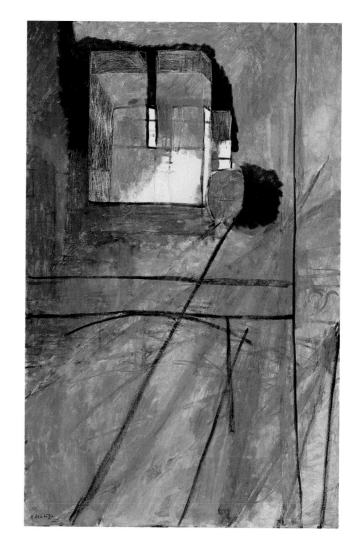

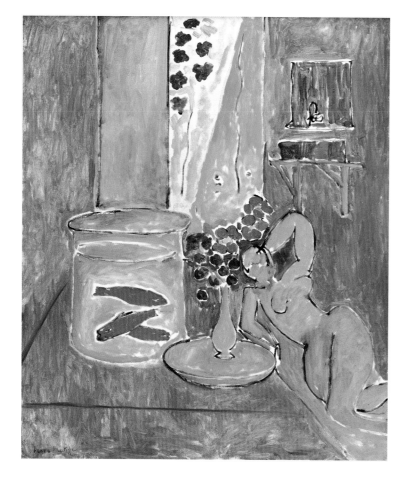

Henri Matisse | (FRENCH, 1869–1954)
GOLDFISH AND SCULPTURE. Spring–summer 1912
OIL ON CANVAS, 46 x 39⅝" (116.2 x 100.5 CM)
GIFT OF MR. AND MRS. JOHN HAY WHITNEY, 1955

Henri Matisse
VIEW OF NOTRE DAME. Spring 1914
OIL ON CANVAS, 58 x 37⅛" (147.3 x 94.3 CM)
ACQUIRED THROUGH THE LILLIE P. BLISS BEQUEST, AND THE HENRY
ITTLESON, A. CONGER GOODYEAR, MR. AND MRS. ROBERT SINCLAIR
FUNDS, AND THE ANNA ERICKSON LEVENE BEQUEST GIVEN IN MEMORY
OF HER HUSBAND, DR. PHOEBUS AARON THEODOR LEVENE, 1975

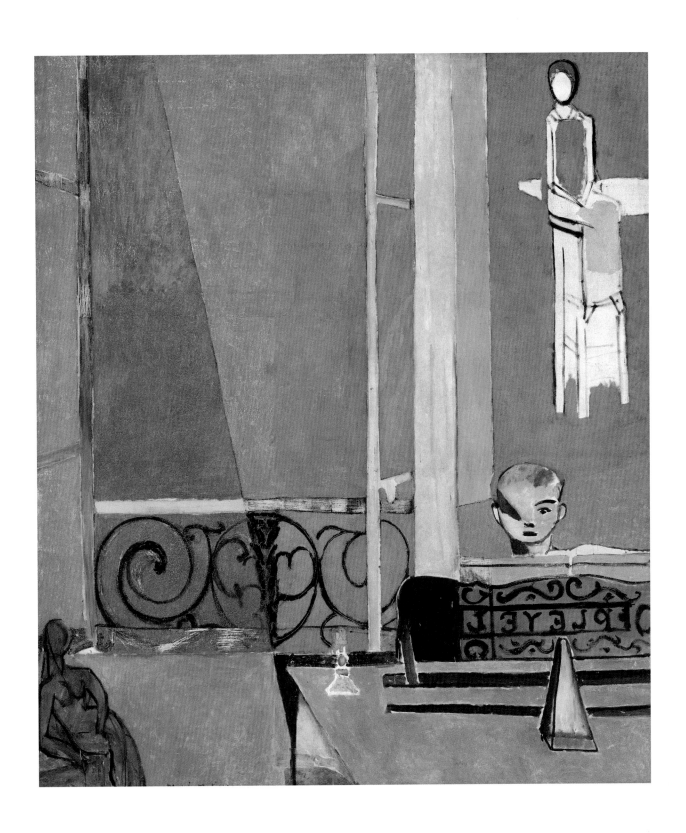

Henri Matisse
PIANO LESSON. Late summer 1916
OIL ON CANVAS, 8' ½" x 6' 11⅜" (245.1 x 212.7 CM)
MRS. SIMON GUGGENHEIM FUND, 1946

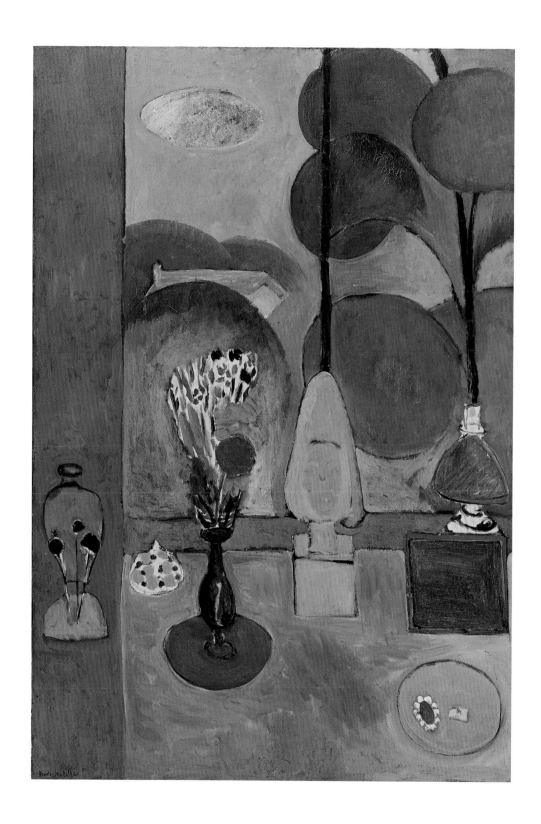

Henri Matisse | (FRENCH, 1869–1954)
THE BLUE WINDOW. Summer 1913
OIL ON CANVAS, 51½ x 35¼" (130.8 x 90.5 CM)
ABBY ALDRICH ROCKEFELLER FUND, 1939

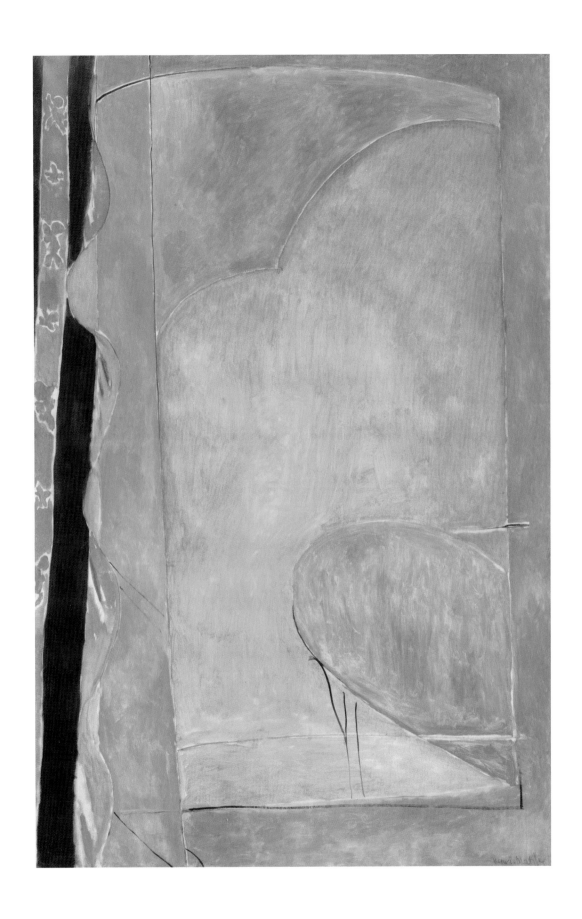

Henri Matisse
THE YELLOW CURTAIN. 1915
OIL ON CANVAS, 57½ x 38¼" (146 x 97 CM)
GIFT OF JO CAROLE AND RONALD S. LAUDER, NELSON A.
ROCKEFELLER BEQUEST, GIFT OF MR. AND MRS. WILLIAM H.
WEINTRAUB, AND MARY SISLER BEQUEST (ALL BY EXCHANGE), 1997

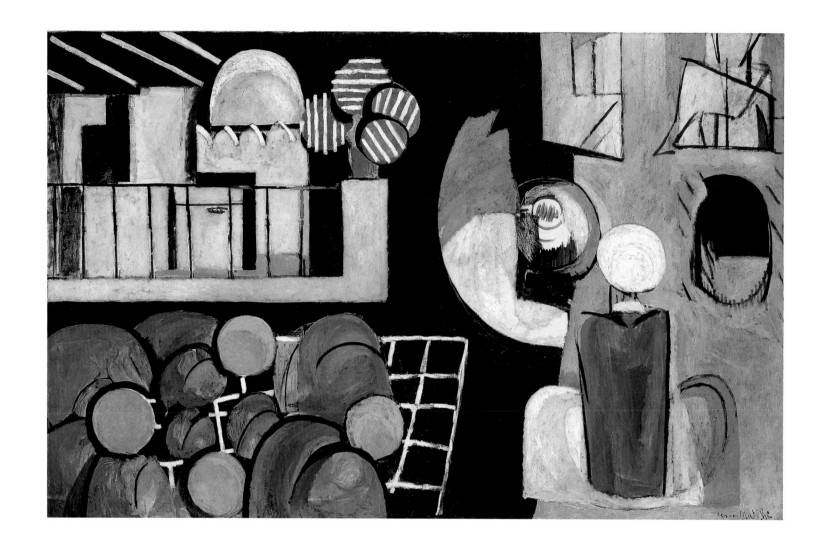

Henri Matisse | (FRENCH, 1869–1954)
THE MOROCCANS. Late 1915 and fall 1916
OIL ON CANVAS, 71⅜" x 9'2" (181.3 x 279.4 CM)
GIFT OF MR. AND MRS. SAMUEL A. MARX, 1955

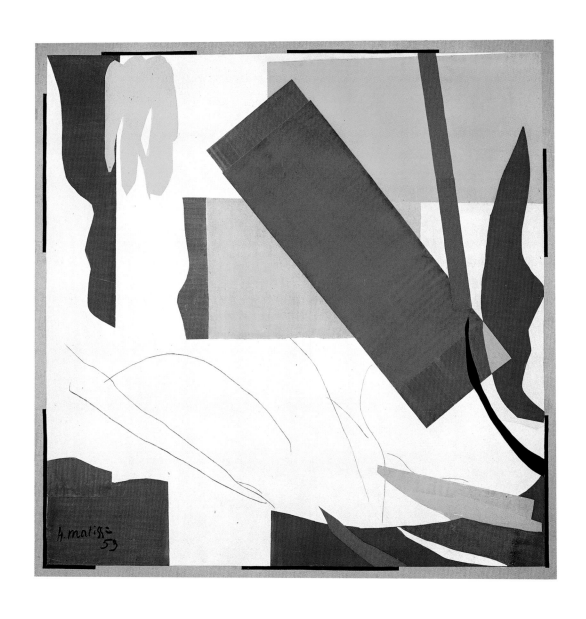

Henri Matisse
MEMORY OF OCEANIA. Summer 1952–early 1953
GOUACHE ON PAPER, CUT AND PASTED, AND CHARCOAL ON
PAPER MOUNTED ON CANVAS, 9' 4" x 9' 4⅞" (284.4 x 286.4 CM)
MRS. SIMON GUGGENHEIM FUND, 1968

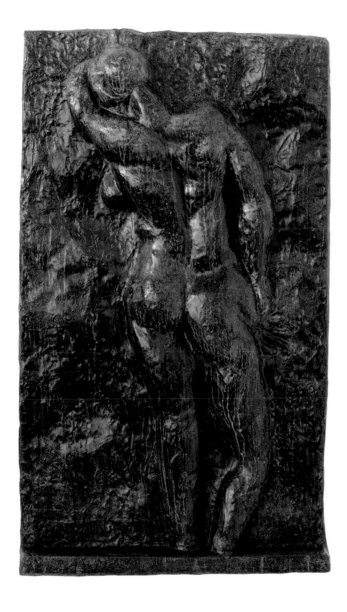

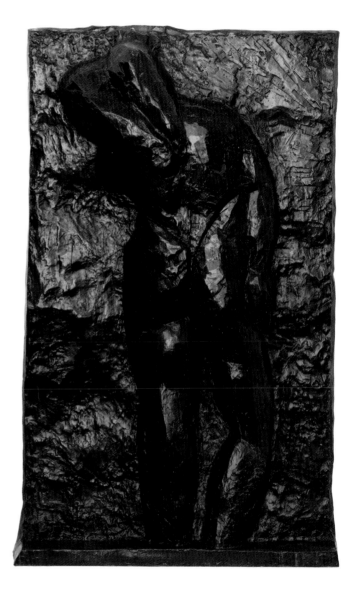

Henri Matisse | (FRENCH, 1869–1954)
THE BACK (I). Spring 1908–late 1909
BRONZE, 6' 2⅜" x 44½" x 6½" (188.9 x 113 x 16.5 CM)
MRS. SIMON GUGGENHEIM FUND, 1952

Henri Matisse
THE BACK (II). Spring–early fall 1913
BRONZE, 6' 2¼" x 47¼" x 6" (188.5 x 121 x 15.2 CM)
MRS. SIMON GUGGENHEIM FUND, 1956

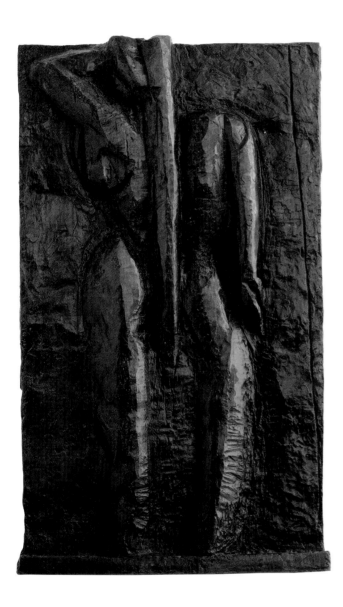

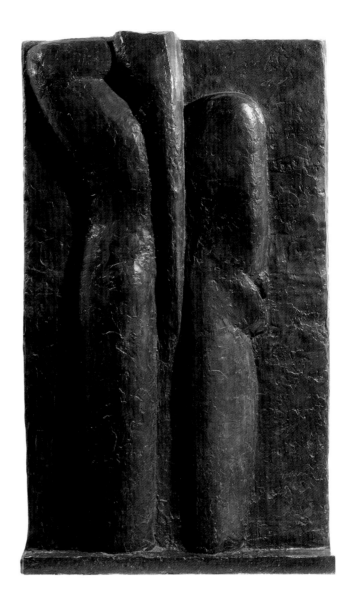

Henri Matisse
THE BACK (III). Spring–summer 1916
BRONZE, 6' 2½" x 44" x 6" (189.2 x 112.4 x 15.2 CM)
MRS. SIMON GUGGENHEIM FUND, 1952

Henri Matisse
THE BACK (IV). c. 1931
BRONZE, 6' 2" x 44⅞" x 6" (188 x 112.4 x 15.2 CM)
MRS. SIMON GUGGENHEIM FUND, 1952

Crosscurrents

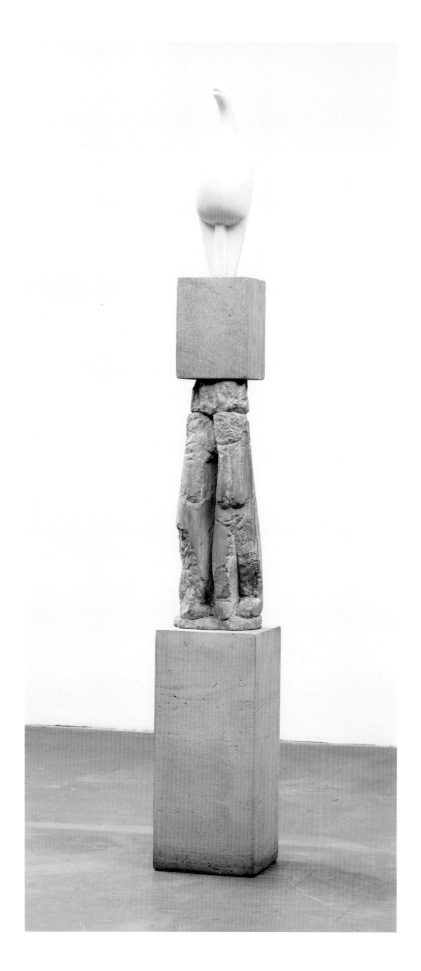

Constantin Brancusi | (FRENCH, BORN
ROMANIA. 1876–1957)
MAIASTRA [MAGIC BIRD]. 1910–12
WHITE MARBLE 22" (55.9 CM) HIGH, ON THREE-PART
LIMESTONE PEDESTAL 70" (177.8 CM) HIGH, OF WHICH
THE MIDDLE SECTION IS THE DOUBLE CARYATID
KATHERINE S. DREIER BEQUEST, 1953

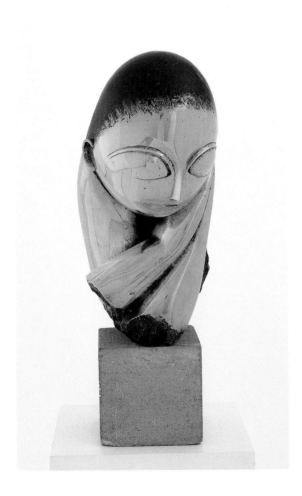

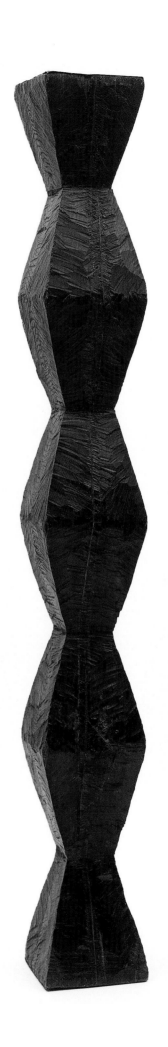

Constantin Brancusi
MLLE POGANY. VERSION I, 1913 (after a marble of 1912)
BRONZE WITH BLACK PATINA, 17¼ x 8½ x 12½" (43.8 x 21.5 x 31.7 CM),
ON LIMESTONE BASE, 5¼ x 6⅛ x 7⅜" (14.6 x 15.6 x 18.7 CM)
ACQUIRED THROUGH THE LILLIE P. BLISS BEQUEST, 1953

Constantin Brancusi
ENDLESS COLUMN. VERSION I, 1918
OAK, 6' 8" x 9⅞" x 9⅝" (203.2 x 25.1 x 24.5 CM)
GIFT OF MARY SISLER, 1983

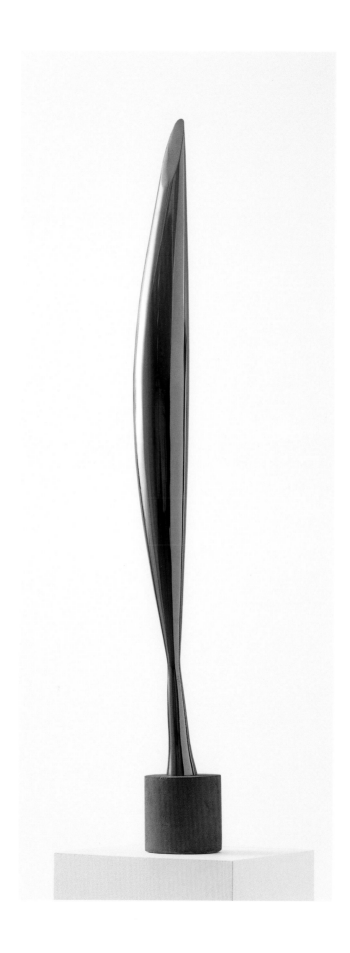

Constantin Brancusi | (FRENCH, BORN ROMANIA. 1876–1957)
BIRD IN SPACE. 1928
BRONZE, 54 x 8½ x 6½" (137.2 x 21.6 x 16.5 CM)
GIVEN ANONYMOUSLY, 1934

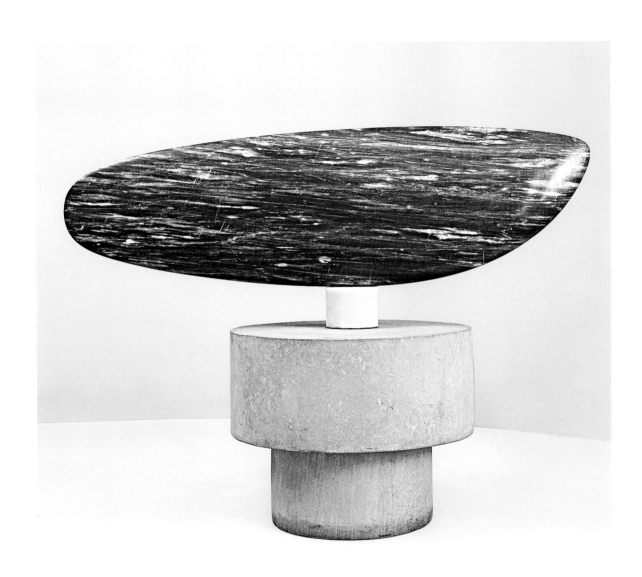

Constantin Brancusi
FISH. 1930
BLUE-GRAY MARBLE, 21 x 71 x 5½" (53.3 x 180.3 x 14 CM),
ON THREE-PART PEDESTAL OF MARBLE 5⅛" (13 CM) HIGH,
AND TWO LIMESTONE CYLINDERS 13" (33 CM) HIGH AND 11"
(27.9 CM) HIGH x 32⅛" (81.5 CM) DIAMETER AT WIDEST POINT
ACQUIRED THROUGH THE LILLIE P. BLISS BEQUEST, 1949

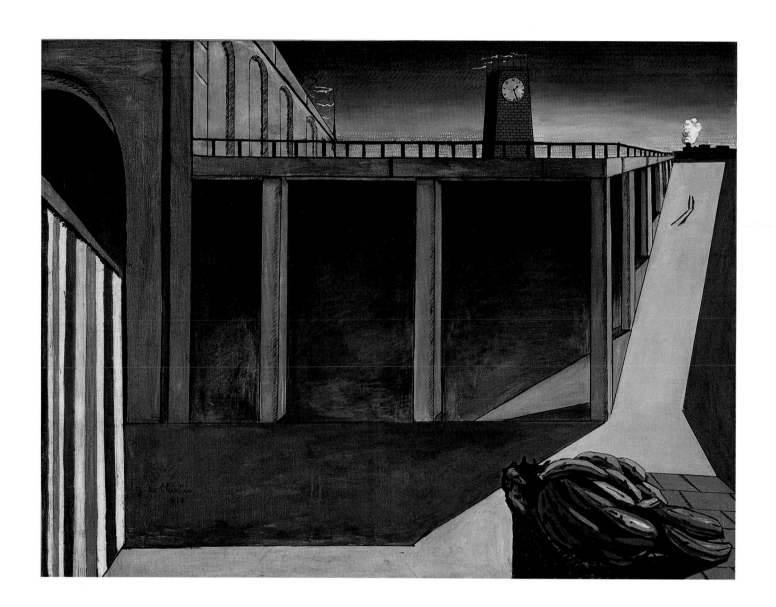

Giorgio de Chirico (ITALIAN, BORN GREECE. 1888–1978)
GARE MONTPARNASSE (THE MELANCHOLY OF DEPARTURE). Early 1914
OIL ON CANVAS, 55⅛" x 6'⅛" (140 x 184.5 CM)
GIFT OF JAMES THRALL SOBY, 1969

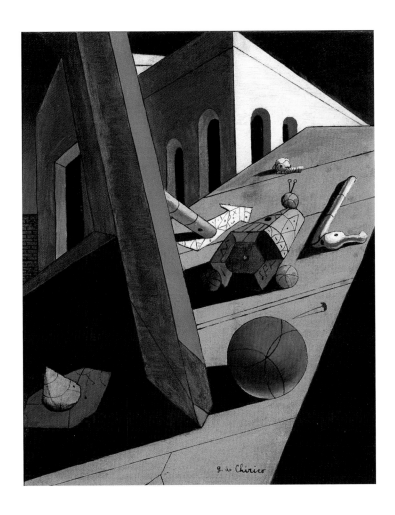

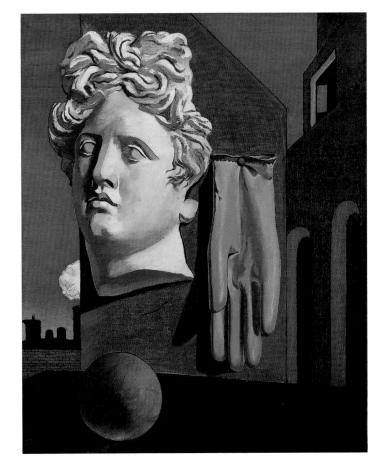

Giorgio de Chirico
THE EVIL GENIUS OF A KING. 1914–15
OIL ON CANVAS, 24 x 19⅝" (61 x 50.2 CM)
PURCHASE, 1936

Giorgio de Chirico
THE SONG OF LOVE. June–July 1914
OIL ON CANVAS, 28¾ x 23⅜" (73 x 59.1 CM)
NELSON A. ROCKEFELLER BEQUEST, 1979

183

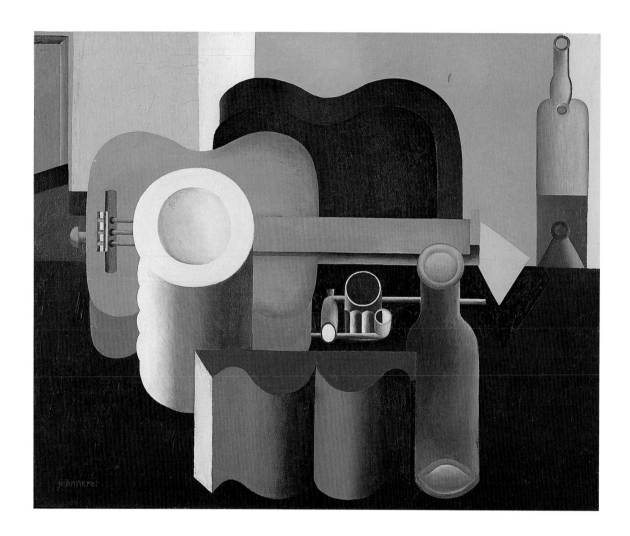

Le Corbusier
(FRENCH, BORN SWITZERLAND. 1887–1965)
STILL LIFE. 1920
OIL ON CANVAS, 31⅞ x 39¼" (80.9 x 99.7 CM)
VAN GOGH PURCHASE FUND, 1937

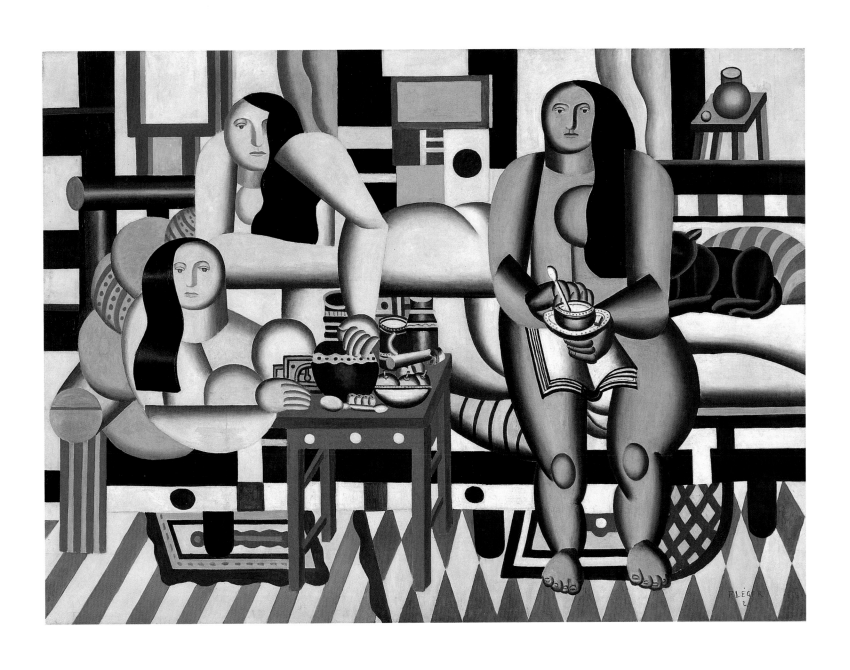

Fernand Léger | (FRENCH, 1881–1955)
THREE WOMEN. 1921
OIL ON CANVAS, 6' 1¼" x 8' 3" (183.5 x 251.5 CM)
MRS. SIMON GUGGENHEIM FUND, 1942

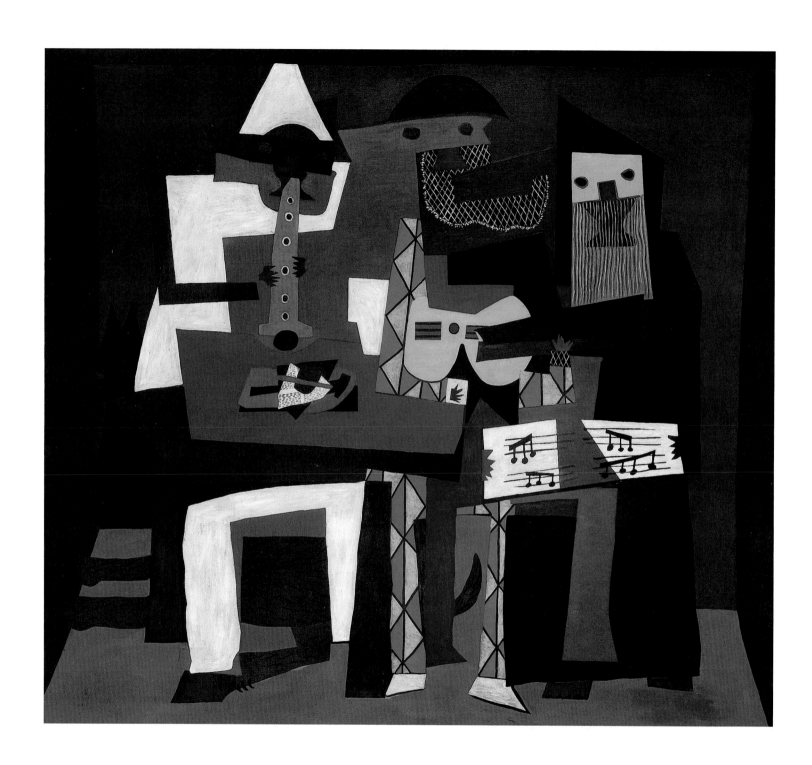

Pablo Picasso | (SPANISH, 1881–1973)
THREE MUSICIANS Summer 1921
OIL ON CANVAS, 6' 7" x 7' 3¾" (200.7 x 222.9 CM)
MRS. SIMON GUGGENHEIM FUND, 1949

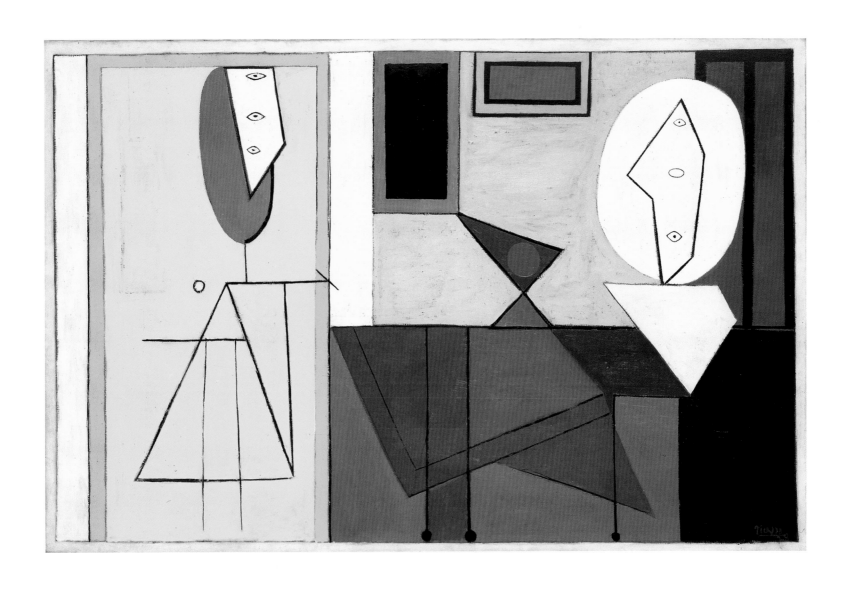

Pablo Picasso
THE STUDIO. Winter 1927–28
OIL ON CANVAS, 59" x 7' 7" (149.9 x 231.2 CM)
GIFT OF WALTER P. CHRYSLER, JR., 1935

187

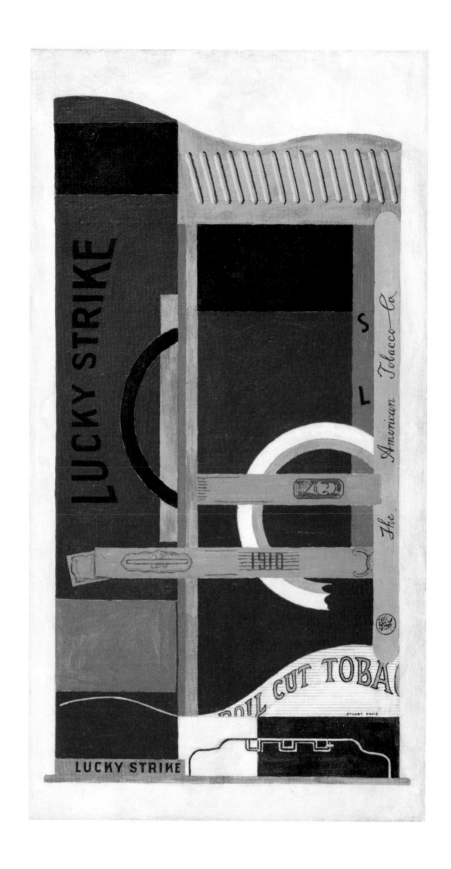

Stuart Davis | (AMERICAN, 1892–1964)
LUCKY STRIKE. 1921
OIL ON CANVAS, 33¼ x 18" (84.5 x 45.7 CM)
GIFT OF THE AMERICAN TOBACCO COMPANY, INC., 1951

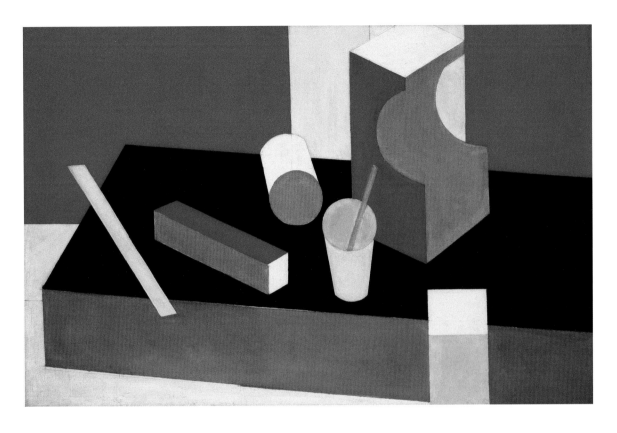

Patrick Henry Bruce | (AMERICAN, 1881–1936)
PAINTING. c.1929–30
OIL ON CANVAS, 23¾ x 36⅞" (60.3 x 92.4 CM)
G. DAVID THOMPSON, MRS. HERBERT M. DREYFUS, HARRY J.
RUDICK, WILLI BAUMEISTER, EDWARD JAMES, AND MR. AND
MRS. GERALD MURPHY FUNDS, 1978

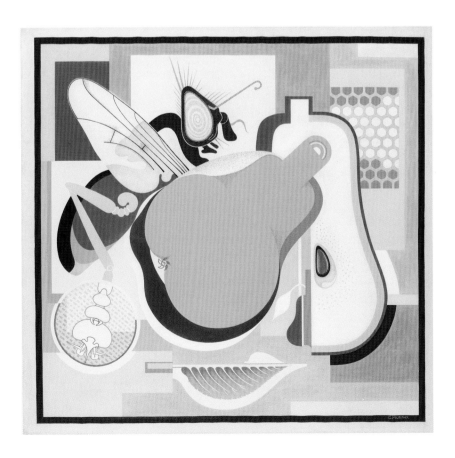

Gerald Murphy | (AMERICAN, 1888–1964)
WASP AND PEAR. 1927
OIL ON CANVAS, 36¼ x 38 ⅝" (93.3 x 97.9 CM)
GIFT OF ARCHIBALD MACLEISH, 1964

Age of "isms": Modernisms between the two World Wars

The historical overview offered by the Museum's painting and sculpture collection reveals a continually disputed idea of what it means to make modern art, the styles and movements functioning as the arguments and counter-arguments. This is never more evident than in the proliferation of "isms" in the period between the two World Wars.

Dada was born in Zurich in 1916 by artists seeking refuge from the war, among them Jean Arp and Sophie Taeuber, and subsequently spread across Europe, attracting artists as diverse as George Grosz in Berlin and Kurt Schwitters in Hannover, and finding affinity with earlier, like activity in New York and Paris, most prominently by Marcel Duchamp. The childlike name evokes Dada's skepticism toward conventional artistic norms, and a desire to reshape from scratch the premises behind the production of art, which led to interest in simplified languages of both organic and machine-made forms, in chance, assemblage, and deliberate provocation.

In Paris in 1924, Dada transformed into Surrealism, which shared its anti-rational interests only to turn them into preoccupation with dreams, memories, and the unconscious. However, most of the Surrealists did not have Dada backgrounds or affiliations. Conversely, Dada elided into the international, post-Cubist, abstract geometric art of the 1920s, and these two currents did interact: for example, the Dadaist Schwitters collaborated with the Constructivist El Lissitzky. For this reason, here and in the present installation, Dadaism is placed adjacent to Suprematism and Constructivism and then to de Stijl, with Surrealism appearing later.

The anti-materialist, Suprematist abstraction of the Russian Kazimir Malevich is seen with different manifestations of the Constructivism that succeeded it: from the abstract-representational sculpture of Naum Gabo to the pure abstract art of Aleksandr Rodchenko, and architecturally inspired work by Lissitzky. Then the greatest abstract painter of this period, Piet Mondrian, is presented alongside his colleagues in the Dutch utopian movement de Stijl ("the Style") and with the Uruguayan Joaquin Torres-Garcia. (In the installation, a changing roster of abstract artists will accompany Mondrian.)

Broadly speaking, abstraction and Surrealism polarized European art of the later 1920s and 1930s, the social utopianism of the former counterpointing the psychological utopianism of the latter. If abstraction may model a perfected universe, Surrealism will probe for full access to the subconscious mind. Hence, the hallucinatory illusionism of painters like Salvador Dali and the mysterious, atavistic objects of Meret Oppenheim. However, the poetic sign language of Joan Miró and André Masson does link Surrealism to abstraction. Conversely, illusionistic Surrealist artists are associated with the recurring realist reaction to and within modernism that first appeared after World War I.

Some artists of this reaction, like Aristide Maillol and Pierre Bonnard, were not new to realist representation, having their roots in early modernism. But most were either of the abstractionist or Surrealist pole or tended toward it, while belonging to neither. The coolness and clarity of the Germans—George Grosz and Otto Dix of the *Neue Sachlichkeit* (New Objectivity) movement and the Bauhaus artist, Oskar Schlemmer—together with the Americans Georgia O'Keeffe and Charles Sheeler, associate them with the abstractionists. And the Americans Edward Hopper and Jacob Lawrence learned from them, in different, more oblique ways. Picasso was, of course, associated with the Surrealists; Balthus too; and the Mexicans, José Clemente Orozco, David Alfaro Siqueiros, and Frida Kahlo looked at them. Only Max Beckmann stood apart.

Dada

Marcel Duchamp

The Passage from Virgin to Bride. 1912
Illustrated on page 230

Lawrence D. Steefel, Jr., in *Marcel Duchamp*, **1973**, pages 70, 73

Marcel Duchamp's interest in the machine and the mechanistic is best understood as a consequence of his pursuit of a poetic of impersonality in which there will be a positive separation for the artist between "the man who suffers and the mind that creates."[1] Seeking to distance himself from his own fantasies, Duchamp sought a means of converting pathos into pleasure and emotion into thought. His mechanism of conversion was a strange one, but essentially it consisted of inventing a "displacement game" that would project conflicts and distill excitements into surrogate objects and constructs without whose existence his mental equilibrium might not have been sustained. Using personalized though expressively impersonal conventions . . . Duchamp disciplined the artistic products of his excited fantasy by a progressive mechanization of their aesthetic valence. By using the machine as an increasingly distinct and rigid counter against the turbulent vastness of unchanneled association and unfiltered dream, Duchamp created an art of nonsense that "hygienically" freed his mind from all those capsizing factors which had previously haunted him as a Laforguian "sad young man."[2] . . .

Leading us, the viewers, back toward the condition from which Duchamp had originally worked himself out, images like *Nude Descending a Staircase, The Passage from the Virgin to the Bride*, and Readymades like the *Bicycle Wheel* [page 232], *With Hidden Noise*, or *In Advance of the Broken Arm* frustrate our good intentions and insult our common sense. Framed as they are by a superficially logical set of titles to be correlated with what ought to, but does not, make sense, Duchamp's visual puzzles lead us to expect that with sufficient effort and technical intelligence we can integrate his problems by sheer persistency of task. If we can only transcend his inconsistencies by extrapolating his consistencies, or so we fondly think, we can master the situation and find ourselves at rest. For most if not all viewers, however, this is a deceptive and irrational hope, for the ultimate heuristic thrust of Duchamp's

dissembling work is to lead us continually to a brink of consummatory expectation only to "short circuit" our cognitive grasp."[3] . . .

In the mechanomorphic period which follows Duchamp's first introjection of mechanical and machinelike "substances" into the "body" of his art, we find a significant intensification of formal concentration matched by a growing sense of distance between our emotional reactions to the forms and to what the imagery is presumably "about." To a crucial extent, for the viewer who becomes involved with Duchamp's imagery of 1912, which mechanizes the body more strictly as it becomes more visceral and abstract, the problem of what the machine means to Duchamp becomes of less immediate interest than the problem of coping with the perceptual and conceptual paradoxes of "seeing" the art. Duchamp's "perplexes" of the year 1912 are pervaded by mechanization and machine forms (mostly armored turret forms and thrashing rotor mechanisms in *The King and Queen Surrounded by Swift Nudes*, anatomized filaments and robotoids in *The Passage from the Virgin to the Bride*, and cruciblelike distillery apparatus in the *Bride*). It is the labyrinthine elaboration of these mechanisms, more than their "actions," that compels our attention and dazzles our minds.[4] Closer in potential affect to the language labyrinths of Jean-Pierre Brisset, with their elaboration of animal cries into human language, than to any other non-Duchampian verbal or pictorial form,[5] Duchamp's "putting to the question" of parental authority (*The King and Queen*), the loss of virginity (*The Passage*) and the matrix (literally "womb") of desire (the *Bride*) combines an aggressive and regressive obsession with the complexity of primal energies and relationships and a ruthless distancing of interest about these most intimate affairs.[6]

Francis Picabia

I See Again in Memory My Dear Udnie. 1914
Illustrated on page 231

John Tancock, in *Marcel Duchamp*, **1973**, page 161

With Picabia, . . . the erotic atmosphere of [Marcel Duchamp's] paintings is what made the most lasting

impression. There was no trace of this liberating element in two of his most successful "Cubist" paintings of 1912, *Dances at the Spring* and *Procession, Seville*. By 1912, however, with paintings such as *Udnie (Young American Girl)* and *Edtaonisl (Ecclesiastical)*, the formal language had been greatly expanded in keeping with the more personal nature of the theme—Picabia's voyage to the United States aboard the same ship as the dancer Mlle Napierkowska and a Dominican priest who was fascinated by her. Finally in *I See Again in Memory My Dear Udnie*, c. 1914, the erotic implications of the two previous paintings became fully explicit. Reliving in memory the series of events on board ship, Picabia relied even more heavily on the Duchamp of 1912. His reverie on the "star-dancer" is expressed in sequences of forms that range from the geometrical to the biomorphic, from the totally abstract to the almost specific (in forms that resemble electrical appliances). Yet, when compared to its major source, the display of passion in the painting is much more public, altogether less hermetic, than the transformation taking place within Duchamp's *Bride*. Picabia's bolder, more flamboyant forms enact events on an erotic plane, but as spectacle rather than as mysterious event.

Marcel Duchamp

Bicycle Wheel. 1913 (original)
Illustrated on page 232

Joseph Kosuth, in *Contemporary Art in Context*, **1990**, page 47

Duchamp is difficult to talk about because his work is so rich in its complexity. For me, it changed the way artists see their activity: we no longer believe, simply, in certain institutionalized forms of authority in art.

There is a brief to be made as an artist against certain forms, because those forms constitute fixed meanings. Readymades that are naturalized as the language of art are not seen, in fact, as ready-made. Any artist who goes to art school, who is given a canvas and paint, realizes that you didn't invent those mediums. It's given to you, and that's a Readymade. But because our conception of art acknowledges the authority of that form, it's considered a naturally given one.

Institutions of art . . . are another framing device. One of my favorite stories . . . happened some years ago, when Duchamp died. They [The Museum of Modern Art] put together a small installation of some Duchamps from the collection. One was a Rotorelief:[1] it was set on a pedestal and next to it was a text by Mr. William Rubin which discussed why this was a masterpiece of the twentieth century, declared that it smashed

forever the boundaries between painting and sculpture, it was not a painting, it was not a sculpture, and went on like that in a very interesting and intelligent way. On the pedestal was a big sign that said "Please do not touch the sculpture."

In one way, this reflects a problem of any museum that serves the public, but it points to something fundamental. Basically, art is making meaning. In a sense, it's philosophy made concrete, in a period in which one can no longer believe in speculative philosophy, which has become an academic activity. Art alone answers certain questions and deals with certain issues in the world. It clarifies and makes visible how our consciousness is formed in mass culture, and takes mass culture and uses it in a way that reveals the whole internal mechanism of culture. That is a very important human role of art in a period when we don't have the spiritual satisfaction that a traditional religion can give us and the kind of cultural perks that come from homogeneous culture in which, as you get older, life is more meaningful and death is meaningful. Science as a religion deprives us of that, and so, as we continue, we are finding art is more and more valuable to people.

Marcel Duchamp

Network of Stoppages. 1914
Illustrated on page 233

Marcel Duchamp, in *The Museum of Modern Art Bulletin*, **1946**, pages 19, 20, 21

"The great trouble with art in this country [America] at present, and apparently in France also, is that there is no spirit of revolt—no new ideas appearing among the younger artists. They are following along the paths beaten out by their predecessors, trying to do better what their predecessors have already done. In art there is no such thing as perfection. And a creative lull occurs always when artists of a period are satisfied to pick up a predecessor's work where he dropped it and attempt to continue what he was doing. When on the other hand you pick up something from an earlier period and adapt it to your own work an approach can be creative. The result is not new; but it is new insomuch as it is a different approach.

"Art is produced by a succession of individuals expressing themselves; it is not a question of progress. Progress is merely an enormous pretension on our part. There was no progress for example in J.-B.-C. Corot over Phidias. And 'abstract or naturalistic' is merely a fashionable form of talking—today. It is no problem: an abstract painting may not look at all 'abstract' in 50 years. . . .

"The basis of my own work during the years just

193

before coming to America in 1915 was a desire to break up forms—to 'decompose' them much along the lines the cubists had done. But I wanted to go further—much further—in fact in quite another direction altogether. This was what resulted in *Nude Descending a Staircase*, and eventually led to my large glass, *La Mariée mise à nu par ses célibataires, même.* . . .

"The reduction of a head in movement to a bare line seemed to me defensible. A form passing through space would traverse a line; and as the form moved the line it traversed would be replaced by another line—and another and another. Therefore I felt justified in reducing a figure in movement to a line rather than to a skeleton. Reduce, reduce, reduce was my thought;—but at the same time my aim was turning inward, rather than toward externals. And later, following this view, I came to feel an artist might use anything—a dot, a line, the most conventional or unconventional symbol—to say what he wanted to say. The *Nude* in this way was a direct step to The Large Glass, *La Mariée mise à nu par ses célibataires, même.* And in the *King and Queen* painted shortly after the *Nude* there are no human forms or indications of anatomy. But in it one can see where the forms are placed; and for all this reduction I would never call it an 'abstract' painting. . . .

"Futurism was an impressionism of the mechanical world. It was strictly a continuation of the Impressionist movement. I was not interested in that. I wanted to get away from the physical aspect of painting. I was much more interested in recreating ideas in painting. For me the title was very important. I was interested in making painting serve my purposes, and in getting away from the physicality of painting. For me [Gustave] Courbet had introduced the physical emphasis in the XIX century. I was interested in ideas—not merely in visual products. I wanted to put painting once again at the service of the mind. And my painting was, of course, at once regarded as 'intellectual' 'literary' painting. It was true I was endeavoring to establish myself as far as possible from 'pleasing' and 'attractive' physical paintings. That extreme was seen as literary. *My King and Queen* was a chess king and queen. . . .

"Dada was an extreme protest against the physical side of painting. It was a metaphysical attitude. It was intimately and consciously involved with 'literature.' It was a sort of nihilism to which I am still very sympathetic. It was a way to get out of a state of mind—to avoid being influenced by one's immediate environment, or by the past: to get away from clichés—to get free. The 'blank' force of dada was very salutary. It told you 'don't forget you are not quite so "blank" as you think you are.' Usually a painter confesses he has his landmarks. He goes from landmark to landmark. Actually he is a slave to landmarks—even to contemporary ones.

"Dada was very serviceable as a purgative. And I think I was thoroughly conscious of this at the time and of a desire to effect a purgation in myself. I recall certain conversations with [Francis] Picabia along these lines. He had more intelligence than most of our contemporaries. The rest were either for or against [Paul] Cézanne. There was no thought of anything beyond the physical side of painting. No notion of freedom was taught. No philosophical outlook was introduced. The cubists, of course, were inventing a lot at the time. They had enough on their hands at the time not to be worried about a philosophical outlook; and cubism gave me many ideas for decomposing forms. But I thought of art on a broader scale. There were discussions at the time of the fourth dimension and of non-Euclidean geometry. But most views of it were amateurish. [Jean] Metzinger was particularly attracted. And for all our misunderstandings through these new ideas we were helped to get away from the conventional way of speaking—from our café and studio platitudes."

Man Ray

The Rope Dancer Accompanies Herself with Her Shadows. 1916
Illustrated on page 235

John Tancock, in *Marcel Duchamp*, **1973**, pages 161, 162

Man Ray, . . . until he met [Marcel] Duchamp in 1915, had contented himself with the traditional media and had painted in a style that was considerably influenced by Cubism. He became extremely close to Duchamp and was readier than any of his contemporaries to put Duchamp's principles into practice. "I want something where the eye and hand count for nothing," Duchamp had said to Walter Pach in 1914.[1] Pach could not accept the total rejection of painterly faculties, but Man Ray, who had been trained as an architectural draftsman, understood exactly what Duchamp meant. Anxious to free himself from painting and its "aesthetic implications,"[2] he turned immediately to collage (a technique that enabled him to achieve striking effects without the apparent intrusion of the artist's hand) and, in one major painting, *The Rope Dancer Accompanies Herself with Her Shadows*, to pseudo-collage.[3]

May Ray's objects clearly owed a great deal to Duchamp's Readymades, especially the more complicated examples, yet in their inventiveness and abundance they reveal the entirely different bent of his character. . . .

For Duchamp, the significance of Readymades lay in the fact that their number was severely limited, although once chosen they could be duplicated. Man Ray,

on the other hand, saw no reason to be so sparing with his talents and regarded his object as yet another way of making a point.

Jean Arp
Enak's Tears (Terrestrial Forms). 1917
Illustrated on page 236

William S. Rubin, Dada, Surrealism, and Their Heritage, **1968**, pages 39, 40, 41

Though many Dadaist and Surrealist artists were practicing poets, Arp is one of the very few whose poetry stands in both quality and quantity as an important contribution in its own right. The involvement of the painters of these movements with poetry produced a variety of rapports between the two arts, some of which endowed their *peinture-poésie* with new and unexpected dimensions, but others of which tended to vitiate their painting through a dilution of aesthetic modes. Arp's collages, reliefs, and sculpture share with his poetry an iconography . . . a gentle whimsy, and a feeling of naturalness, but nowhere is their plasticity compromised.

For three years prior to the emergence of his personal style in the winter of 1915/1916, Arp had worked within the discipline of Cubism. Then in collages, and in machine-sawn reliefs such as the *Portrait of Tzara* of 1916 and *Enak's Tears* of 1917, the prevailing rectilinear structures of the Cubist work dissolved under the pressure of a new curvilinear, "organic" morphology.

This biomorphism had its roots in Art Nouveau, although there it was primarily linear in style and botanical in its associations. Arp established it in terms of closed flat forms that were endowed with anthropomorphic allusions as well. . . .

In the face of Analytic Cubism's searching but ultimately assured equilibrium and stasis, Arp's reliefs unwind in an improvisational, meandering manner that implies growth and change. Here is no longer the sober, classical scaffolding of the external world of architecture. The forms of the *Portrait of Tzara* and *Enak's Tears*, while describing nothing specifically, multiply associations to physiological and botanical processes, to sexuality, and through their very ambiguity, to humor.

Although biomorphism initiated a new vocabulary of forms, it did not in itself constitute a style in the sense that Impressionism or Cubism did; nor did it generate any new comprehensive principle of design or distribution of the total surface, or of the illusion of space, in pictures. Rather it provided constituent shapes for paintings in a variety of styles. When more than one or two such shapes are used by the "abstract" Surrealists we almost always find them disposed in relation to one another and to the frame in a Cubist manner. Thus, while we may speak of the form-language or morphology of Arp, [André] Masson, and [Joan] Miró as anti-Cubist, this does not apply to the over-all structure of their compositions, since on that level these painters cling to organizational principles assimilated from the Cubism that all of them had practiced earlier.

Sophie Taeuber-Arp
Dada Head. 1920
Illustrated on page 237

Anne Umland, report on purchase, Department of Painting and Sculpture, **2003**

Sophie Taeuber-Arp was born in Davos, Switzerland, in 1889. . . . Her first significant works were realized within the heady milieu of Zurich Dada. She was a key participant in the Dadaists activities with her companion Hans Arp. . . .

It was during Taeuber-Arp's Zurich periods that she created her famous *Dada Heads*, forms of turned wood resembling the dummies of haberdashers and hairdressers, which she painted with highly stylized angular and curvilinear patterns. Taeuber-Arp called these works "portraits," though they show none of the interest in naturalistic, physical resemblance usually associated with the genre. Instead, their simple, elegantly severe shapes and colorful geometric designs combine to create mask-like faces, which evoke the ornamentation on Oceanic and Northwest Coast Indian artifacts. Incisively witty, Taeuber-Arp's *Dada Heads* are quintessential Dada objects, polychromed sculptures that might double as hat stands, described by Hugo Weber as a "feminine nuance of the Dada game: nonsense with a utilitarian purpose."[1]

Taeuber-Arp's *Dada Heads* are exceedingly rare. Only four are believed to be extant . . . Thus the *Dada Head* acquired by this Museum is in all senses an exceptional, and exceptionally rare, object. It fills a major lacuna within the Museum's representation of Taeuber-Arp's achievement, which is currently limited in [the] Painting and Sculpture [Department] to two works from the 1930s; it enriches the picture the Museum can present of Zurich Dada's particular contributions; and it adds an important new dimension to the Museum's collection of Dada and Surrealist objects.

George Grosz

"The Convict": Monteur John Heartfield after Franz Jung's Attempt to Get Him Up on His Feet. 1920
Illustrated on page 238

Kristin Makholm, in *MoMA: The Magazine of The Museum of Modern Art*, **1997**, pages 19, 21, 22

The name Hannah Höch is probably not the first to come to mind when considering the antics of Berlin Dada. . . . Yet it is [she], whom Hans Richter dubbed the "good girl" of Berlin Dada, who took the characteristic Dada medium of photomontage to its most provocative and challenging heights. With photographs from mass-market periodicals, Höch's photomontages display the chaos and combustion of Berlin's visual culture from a particularly female perspective. . . .

By cutting out photographs and words from mass-market magazines and pamphlets and reassembling them into fractured new compositions, Höch and the other Dada artists reconfigured the images of daily life into abstracted works reminiscent of the hectic pace of modern urban life. They downplayed their roles as individual creators by calling these works "montages," which suggests the impersonal act of a technician or a graphic designer who merely assembles and mounts pre-existing images. With photomontage they could call into question the very ways that society viewed itself. . . .

Among the most provocative and disturbing photomontages are those collectively entitled "From an Ethnographic Museum," which Höch created between 1925 and 1930. With photographs of female body parts attached to those of so-called primitive sculptures, Höch combines the familiar with the unusual, the Self with the Other, in a powerful indictment of the display and fetishization of the human body within a modern consumer culture.

In *Indian Dancer* of 1930, for example, Höch displays a publicity still of the actress Marie Falconetti as Joan of Arc in Carl Theodor Dreyer's 1928 film *The Passion of Joan of Arc.* A wooden dance mask from Cameroon covers the actress's mouth and eye, freezing the painful grimace of the martyr into something akin to the seductive glances of a magazine pinup girl. Joan's crown of straw has been replaced by cutout silhouettes of silverware, changing the symbol of her martyrdom into one of domestic servitude. With the title *Indian Dancer* Höch compares the light, transparent veils of an oriental dancer with the ossified features of the wooden mask, freezing the dancer's sensuous performance into a crude parody of the shackles and stereotypes that marked the modern-day media representation of women.

John Elderfield, *The Modern Drawing: 100 Works on Paper from The Museum of Modern Art*, **1983**, page 128

The sly, pugnacious character with the machine heart does not much resemble the artist's friend and Dada co-conspirator Helmut Herzfelde, alias John Heartfield. Toughness and belligerence have been added. If the result evokes a convict, imprisoned in his cell, with a broken water-jug beside him, then that, surely, was how Grosz conceived the antiauthoritarian Berlin Dadaist.

The blue smock suggests prison garb; also, however, the outfit of a mechanic. Heartfield was known as "Monteur-Dada," for his concentration on photomontage—which term (wrote Raoul Hausmann) "translates our aversion at playing artists . . . thinking of ourselves as engineers, we intended to assemble, construct [*montieren*] our works." Berlin was the most aggressive of Dada centers . . . When Dada began in Zurich, it opposed machinery and civilization, as associable with the First World War and the materialism that had produced it, and proposed instead—most notably in [Jean] Arp's work—an instinctive and primitive escape from its times. Outside that neutral oasis, however, such an approach seemed far too passive. In hungry, war-weary Berlin, it seemed simply "metaphysical," and there Dada engaged with its times. Hence the importance of photomontage, and of the caricature-based documentary realism that frames it here. Dada was to replace art by documentation, and thus provide a more authentic record of the world than a picture of a narrative could. . . .

But, of course, there is no such thing as inchoate experience; neither can anything that is crafted be simply "an expression of the times." It was all a Dadaist fiction: a way of giving factual shape to the alogical world of instinct that lay at the heart of the Dada imagination. Dada in Berlin, no less than in Zurich, opposed the technological with the instinctive. . . . In Berlin, it produced photomontage and documentary realism. For what was required were forms that could give to something unseeable the appearance of something real that had actually been documented, thus to subvert mechanically the modern machinist world and discover within it a primitive internal world as "real" as the world outside. And when, as here, the space of this world needs to be shown, the irrational perspective of [Giorgio] de Chirico is used to define it. But whereas the effect of de

Chirico's art is of traditional techniques used for modern purposes, that of Grosz's is exactly the opposite. Modern techniques are employed for traditional purposes, namely didactic and ideological ones. Modernism is used but not engaged. "Doubt became our life," wrote [Richard] Huelsenbeck of Dada in Berlin. "Doubt and outrage." It was a kind of doubt so fundamental as to suspect even the language in which it was spoken.

Max Ernst

The Hat Makes the Man. 1920
Illustrated on page 239

John Elderfield, *The Modern Drawing: 100 Works on Paper from The Museum of Modern Art*, **1983**, page 130

"One rainy day in 1919," Ernst wrote, "my excited gaze was provoked by the pages of a printed catalog. The advertisements illustrated objects relating to anthropological, microscopical, psychological, mineralogical, and paleontological research. Here I discovered the elements of a figuration so remote that its very absurdity provoked in me a sudden intensification of my faculties of sight . . . " All that was necessary, he realized, was subtly to modify and rearrange these images. "These changes, no more than docile reproductions of *what was visible within me*, recorded a faithful and fixed image of my hallucination. They transformed the banal pages of advertisement into dramas that revealed my most secret desires."

Like Man Ray's use of machine images as a way of musing on the loss of instinctive sexuality, or [George] Grosz's giving his friend a machine heart, Ernst's use of mechanical illustrations to tell of autobiographical fantasies and hallucinations reveals that characteristic Dada duality in which modern and instinctive worlds collide. Inscribed on this image of anthropomorphic eroticism is the legend: "Seed-covered stacked-up man, seedless waterformer, ('edelformer'), well-fitting nervous system also tightly fitted nerves! (The hat makes the man, style is the tailor.)". . . Ernst, that most iconographically inventive—and literary—of the Dadaists, erects from the subject of hats a phallic fantastic construction in combined human and plant-life form. He had been a student of psychology before the First World War, and had indeed read [Sigmund] Freud. But if we see in his work the obsessive self-regard of a Freudian age, we also, I think, see that when he inspected his fantasies, he found them drolly humorous. At least, that is the impression provided by this massive set of perambulating phalli, satirically sexual mutations of [Giorgio] de Chirico's cold mannequins, transparently blundering about their little stage.

Kurt Schwitters

Revolving. 1919
Illustrated on page 240

Peter Reed, Modern*starts*, **1999**, pages 333, 336

Kurt Schwitters's relief assemblage of discarded materials, *Revolving*, is an appropriate segue from . . . images of "concrete poetry," which included [a] Dada poster Schwitters designed with Theo van Doesburg. The expressive power of his visual poetic experiments coincided with his revolutionary pictures of fragments of stuff laid on a painted canvas. Like collage, unconventional materials were now put on an equal footing with paint; as in his poetry, which juxtaposed words in new contexts for expressive effect, so was Schwitters equally liberated in his manipulation of materials, colors, and forms. Both a painting and a construction, *Revolving* suggests the inner workings of a machine with turning gears. The precision of the circles and diagonal connecting rods (made of metal, cord, wire, and leather) serves no apparent purpose. It is not an optimistic piece, but is infused with the melancholy of making a new world (and new art forms) from the remains of German culture following the Great War. Schwitters explained that "everything had broken down . . . new things had to be made from fragments." The revolving circles, the detritus of some machine, takes on more universal meanings with its implications of worlds revolving in space.[1]

Despite the atmospheric qualities of Schwitters's painterly canvas, we are also aware of the assemblage as relief. Objects are literally nailed onto the picture, reinforcing its "thinglike" status as a relief painting that hangs on the wall. When abstraction approaches a condition of flatness by the suspension of illusionistic depth, the result is an emphasis on the vertical plane and hence a wall or screenlike quality.

Kurt Schwitters

Merz Picture 32A (The Cherry Picture). 1921
Illustrated on page 241

John Elderfield, *Kurt Schwitters*, **1985**, pages 68–69

Schwitters started to make [a group of both painted and unpainted constructions] around 1922. These . . . are clearly so different in character from the assemblages that they deserve separate discussion. The latest works he made that properly belong with the assemblages are a small group of pictures of 1920 and 1921 which break entirely with the concentric or diagonal forms . . . in favor of grid format.[1] Some are not especially successful, but *Das Kirschbild (The Cherry Picture)* of 1921—

the finest of this group—is one of Schwitters' most inspired pictures. (Its title puns on "Kurtchen," Schwitters' pet name.) It uses some high-relief and bulky objects but is dominated by rectangular-shaped pieces of carefully graded relief and size which line up with, and to some extent duplicate, the proportions of the picture edges. The pieces all appear to have breathing-space in the form of darker and more irregularly shaped fragments behind them. In consequence, the picture stays open in feeling, its planes seeming to reach for each other across the illusion of an expansive but taut space. The materials seem to control and to direct the flow of the pictorial space; they exist as materials and are used as materials, and not as if they were something else. The very natural and intuitive freedom yet sense of ordered containment manifested in this wonderful picture is like that of the small collages of this period.

Paul Klee

Actor's Mask. 1924
Illustrated on page 243

Alfred H. Barr, Jr., *Paul Klee*, 1941, pages 5, 6

Much has been written . . . about Klee's art. Indeed few living painters have been the object of so much speculation. For a work by Klee is scarcely subject to methods of criticism which follow ordinary formulae. His pictures cannot be judged as representations of the ordinary visual world. Usually, too, they cannot be judged merely as formal compositions, though some of them are entirely acceptable to the esthetic purist.

Their appeal is primarily to the sentiment, to the subjective imagination. They have been compared, for this reason, to the drawings of young children at an age when they draw spontaneously from intuitive impulse rather than from observation. They have been compared to the fantastic and often truly marvelous drawing of the insane who live in a world of the mind far removed from circumstantial reality. Klee's work sometimes suggests the painting and ornament of primitive peoples such as: palaeolithic bone carvings, Eskimo drawings and Bushman paintings, the pictographs of the American Indian. Drawings made subconsciously or absentmindedly or while under hypnosis occasionally suggest Klee's devices. In fact, Klee had himself at times made "automatic" drawings with some success. The child, the primitive man, the lunatic, the subconscious mind, all these artistic sources (so recently appreciated by civilized taste) offer valuable analogies to Klee's method.

But there are in Klee's work qualities other than the naïve, the artless, and the spontaneous. Frequently the caricaturist which he might have been emerges in drawings which smile slyly at human pretentiousness. Often he seduces the interest by the sheer intricacy and ingenuity of his inventions. At times he charms by his gaiety or makes the flesh creep by creating a spectre fresh from a nightmare.

Of course he has been accused of being a "literary" painter. For the person who still insists upon regarding painting as decorative, or surface texture, or pure, formal composition the accusation is just. But Klee defies the purist and insists as do [Giorgio de] Chirico and [Pablo] Picasso upon the right of the painter to excite the imagination and to consider dreams as well as still life material for their art.

Klee is a master of line which seems negligent but is unusually expressive. . . .

Klee made a study of masks in theatrical and ethnographic museums, and experimented with their power to startle and bind the imagination. *Actor's Mask* reminds one of Melanesian ceremonial masks in its startling, hypnotic effect. . . .

Klee has used a variety of media, all of them handled with remarkable skill and inventiveness. He combines watercolor and ink, oil and gouache, using diverse surfaces including paper, canvas, linen, burlap, silk, tin and compoboard. Like the Cubists and Surrealists he has made many experiments with textures.

Nothing is more astonishing to the student of Klee than his extraordinary variety. Not even Picasso approaches him in sheer inventiveness. In quality of imagination also he can hold his own with Picasso; but Picasso of course is incomparably more powerful. Picasso's pictures often roar or stamp or pound; Klee's whisper a soliloquy—lyric, intimate, incalculably sensitive.

Klee

Actor's Mask
Illustrated on page 243

Lucy Lippard, in *Three Generations of Twentieth-Century Art*, 1972, page 38

The actor's mask was one of the earliest themes in Klee's phenomenally rich iconography, going back to his drawings and Comedian etchings of 1903–1904 and reflecting the influence of James Ensor, an important one for Klee in his early years. The theme is an outgrowth of Klee's love for the theater (together with music, perhaps the most constant of his interests), which led him to study in theatrical and ethnographical museums, and later to make puppets. The *Actor's Mask*, painted in 1924, reflects this study of primitive cultures through its strong resemblance to certain Melanesian

masks, a resemblance that is even clearer in some later works of Klee. The impassive frontal stare characteristic of all Klee's figures and heads, both animal and human, is in itself a reflection of an ancient mask aesthetic. There is an extremely close connection between man and animal in his work, a connection that at times amounts to a confusion of the two, such as one finds in primitive cultures and in children's tales. Here, the eyes resemble the hypnotic gaze of a cat.

As the critic Andrew Forge has noted, "Unlike the early etchings, which are drawings of imaginary faces and masks, in the *Actor's Mask*, mask and face are one. The strata-like formation out of which the features grow is ancient. It is as though time had slowly pressed out the eyes, the mouth. Pressure seems to bear across the face in the parallel red lines."[1] Thus the striated patterning of the face is suggestive both of tattooing and of geological strata, giving the face a primordial appearance. Such striations were later to be specifically identified with landscape in the series of images that Klee produced following his trip to Egypt in the winter of 1928/29.

Paul Klee
Fire in the Evening. 1929
Illustrated on page 242

Angela C. Lange, in *Masterworks from The Museum of Modern Art, New York, 1900–1955*, **2001**, page 70

Klee has no single, easily definable "style," nor anything like a conventional, linear development as an artist. He often worked in several different manners, with contrasting degrees of abstraction, simultaneously. "Nothing is more astonishing to the student of Klee than his extraordinary variety," Alfred H. Barr, Jr., wrote in 1930. The diversity that Barr saw in Klee's artistic vocabulary reflected the variety of his creative associations with and affinities for movements as diverse as the Munich expressionist group *Der Blaue Reiter*, the Parisian Surrealists, and the Bauhaus in Dessau, the pedagogic center of a new unity among the fine and applied arts. . . .

Fire at Evening seems a pure exercise in abstract, musical poetry of hue and interval, as geometrically regular and unpredictable as a patched textile. It may have its origins, though, in a 1928 trip to Egypt that left Klee with strong visual impressions of, among other things, the stratifications of cliffs that cut through the Nile and the fertile valley plain. Klee's choice of palette, his use of warm brown and cool pinkish and blue tones, as well as the bright red square just to the right of the center of the canvas, conjure without ever merely describing some of the experience of landscape at day's end evoked by his choice of title. But these suggestive connotations have nothing to do with illustration, even by indirection, and never compromise the rigorous abstraction of the work. Writing of paintings like this one, Barr insisted: "They have nothing to do with Cubism for they are pure inventions rather than abstractions of things seen. . . . Here are forms which live and breathe with convincing actuality though their like has never been seen."

Suprematism and Constructivism

Kazimir Malevich
Woman with Pails: Dynamic Arrangement.
1912–13
Illustrated on page 244

John Russell, *The Meanings of Modern Art*, **1981**, page 241

Unlike so many of his colleagues he [Malevich] had never been to Western Europe; but from the magazines, and from studying the great French pictures which were freely available to him in the collections of [Sergei] Shchukin and [Ivan] Morozov in Moscow, he knew more than most Frenchmen about what had lately happened in Paris. But when he came to paint the Russian peasant we see what might be called the pawmark of the Russian bear—the heavy, stamping, pounding rhythms that come through so memorably in the Russian dance in *Petrouchka*, which [Igor] Stravinsky had composed in 1911. Such paintings have a double inspiration: on the one hand, the French Post-Impressionists' use of pure flat color and simplified drawing, on the other, the emphatic plain statement of the Russian *lubok*, or popular print.

Malevich's peasant subjects of 1911–12 should, in fact, be related to something that turned up all over the civilized world before 1914—the wish to reinvigorate painting by reference to primitive or demotic modes of expression. Malevich knew a great deal about older European art, but he agreed with the dissident group of painters in St. Petersburg who had said in 1905 that no art of general communication could be fashioned from what they called "a sauce of history." If primeval energies were to hand, they should be tapped; if popular imagery, popular songs, popular forms of narrative were valid for the whole community in ways denied to more sophisticated forms of statement, then they too should be annexed for art.

Kazimir Malevich

Reservist of the First Division. 1914
Illustrated on page 245

Magdalena Dabrowski, in *Essays on Assemblage*, Studies in Modern Art 2, **1992**, pages 13, 16–17, 18, 19

Representation, Malevich felt, remained tied to the art of the past and to a merely imitative rather than a truly creative art. As he pointed out in 1915, in *From Cubism and Futurism to Suprematism:* "Only with the disappearance of a habit of mind which sees in pictures little corners of nature, madonnas and shameless Venuses shall we witness a work of pure, living art."[1] He amplified this, saying, "Things have disappeared like smoke; to gain the new artistic culture, art approaches creation as an end in itself and domination over the forms of nature,"[2] and emphatically stressed that "it is absurd to force *our* age into the old forms of time past."[3] He believed that in order to realize the true beauty of modern life, artists needed to invent a new formal language, entirely independent of traditional forms—a language that had to be non-objective, self-referential, and pure, in order to express the philosophical and spiritual concerns of the modern age and the new man. Within this way of thinking, the perception of the internal relationships among the material elements of the composition assumed fundamental importance. The relationships among form, color, and line had to be reconceived in an innovative way because these pure relations conveyed something of the dynamism of another realm. Such relationships—the elements that energized the surface, the interplay of proportions among compositional parts, the tensions brought about by their placement, color, and weight, their juxtaposition or superimposition— were the subjects of Malevich's investigations. From these investigations came the style he called Suprema-

tism, which eliminated all references to the world of visible reality, leaving only the purely pictorial elements.

That extremely radical step advanced from the achievements of Cubism and Futurism. Principal among these, and facilitating his search for the new formal elements of a modern visual language, was collage. Because it could make use of materials taken directly from the ordinary world, collage made it possible to synthesize two kinds of space: the pictorial and the real. As such, it mediated between reality and illusion. . . .

In *Warrior of the First Division*, the collaged elements are scattered around the focal point of a blue square. The form of the square plays a prominent role in the composition, being a symbol of a man's head, with the strictly figurative areas limited to a fragment of the back of the warrior's head, his ear, and his mustache, along the left and lower edges of the square. The collage components, placed seemingly at random throughout the composition, include words and letters clipped from newspapers, along with a postage stamp and a thermometer. These items, and particularly the thermometer, create a sense of extension forward into the viewer's space. . . .

What became important in *Warrior of the First Division* were two features: first, the extension into real space through elements applied to the surface, such as the cut-and-pasted papers and the thermometer; and second, the insistence on the paramount meaning of the surface itself, as an active element of the composition in its own right. Malevich strongly emphasized this point in *From Cubism and Futurism to Suprematism*, saying: "Any painting surface is more alive than any face from which a pair of eyes and a grin jut out. A face painted in a picture gives a pitiful parody of life, and this allusion is only a reminder of the living. But a surface lives: it has been born."[4] It is this concentration on the role of the surface plane in conveying meaning, and in originating new spatial relations, that makes *Warrior of the First Division* a milestone in the evolution of Suprematist concepts of space.

Kazimir Malevich

Suprematist Composition: Airplane Flying. 1915
Illustrated on page 246

Helen M. Franc, *An Invitation to See: 150 Works from The Museum of Modern Art*, **1992**, page 50

[Malevich] called his art Suprematism to signify "the supremacy of pure feeling or perception in the pictorial arts." He explained its premises, saying: "The artist can be a creator only when the forms in his picture have

nothing in common with nature . . . Forms must be given life and the right to individual existence." The Suprematist compositions of Malevich and his followers were the first purely geometrical abstractions. He did not use the term "abstract" for such works, however, but called them "non-objective," to indicate their complete liberation from representation; and he proclaimed Suprematism to be "the new realism in painting."

Like [Naum] Gabo, Malevich opposed [Vladimir] Tatlin's anti-aesthetic, utilitarian approach to art. His goals were visionary and utopian, emphasizing an art of feelings and emotions. He was interested in aerial photography, and in both his theoretical writings and his paintings, such as this one, he identified flight with man's "great yearning for space, . . . to break free from the globe of the earth." "It was nothing other than a yearning for speed . . . for flight . . . which, seeking an outward shape, brought about the birth of the airplane," he declared. The blank background was essential for the realization of his concept: "The blue color of the sky has been defeated by the Suprematist system, has been broken through, and entered white, as the true real conception of infinity, and therefore limited from the color background of the sky," he wrote. "I have torn through the blue lampshade of color limitation, and come out into the white; after me, comrade aviators sail into the chasm—I have set up semaphores of Suprematism. . . . Sail forth! the white, free chasm, infinity, is before us."

With no horizon line to orient the viewer, in this Suprematist composition the geometrical elements that represent the airplane float freely in space. There is no clearly defined "up" or "down," for the canvas is allowed to rotate. Photographs taken at various times and places during Malevich's lifetime show it installed so that the diagonal thrust of the composition proceeds from lower right to upper left, as here, and at other times it goes in the opposite direction, from lower left to upper right.

Kazimir Malevich

Suprematist Composition: White on White. 1918
Illustrated on page 247

Press release, The Museum of Modern Art, **1942**

Some of the earliest abstract art ever produced will be shown in a group of eleven compositions by the first great master of geometrical abstract painting, the Russian Kasimir Malevich, who in 1913 began to base his art (which he called Suprematism) upon the square and the circle. Several of the Malevich compositions were brought to the United States in 1935 by Alfred H. Barr, Jr., Director of the Museum of Modern Art. He had found them in a German cellar hidden from the Hitlerian

wrath against all modern art. Mr. Barr bought them and, to get them safely out of Germany, wrapped several of the canvases around his umbrella, hid drawings in magazines, and thus was able to take them out of the country unnoticed. Also exhibited will be works by Alexander Rodchenko, who was probably the first to call his paintings Non-objectivist. . . .

Mr. Barr made the following statement in regard to the exhibition: "Russian abstract art done both before and after the revolutions of 1917 is richly represented by the work of seven masters, including [Mikhail] Larionov the Rayonist, Malevich, the Suprematist, and Rodchenko, probably the first to take the name Non-objectivist. Malevich's seven paintings, four drawings and five analytical charts form probably the only exhibited collection of the work of this important pioneer who is no longer honored in his own country.". . .

NOTE: Chief among Malevich's followers was Alexander Rodchenko, who in 1915 broke away from his master and founded the "Non-objectivist" group. At the famous Tenth State Exhibition in Moscow in 1919, works by both Malevich and Rodchenko were prominently exhibited. Rodchenko found out before the opening that Malevich was going to submit the composition *White on White* (a white square on a white canvas), and in a spirit of rivalry he painted and submitted his *Black on Black* [see page 250]. . . .

The battered condition of both paintings is evidence of their refugee wanderings. For in the years following the 1919 Exhibition, abstract art fell gradually into official disfavor in Moscow. No longer encouraged to paint Non-Objectivist canvases, Rodchenko was persuaded that he would be more useful to society in typography and photography, in which he was still active when last heard from before the outbreak of war. His paintings lay unseen, uncared for, and forgotten for many years before coming to this country. On his part, Malevich retired to Leningrad and later sent his paintings to a still hospitable Germany where an exhibition of his work was held about 1927. But with the advent of Hitler, his paintings again went into hiding until Mr. Barr rescued them seven years ago.

Malevich

Suprematist Composition: White on White
Illustrated on page 247

Ellsworth Kelly, *Artist's Choice: Fragmentation and the Single Form*, **1990**, n.p.

By 1915 Malevich was isolating a single black or red square against a white ground, and three years later he painted a white square on white. Recently I realized

how closely related the Malevich squares on white are to early Russian icons. Most icons have large borders, a built-in "frame" that is sometimes in slight relief around the icon itself. In his black and red square paintings, Malevich, in effect, blocked out and completely abstracted the specific religious content within the squared border-frames, making color his content. In the icons, holy figures are often found standing or sitting on a platform that is tilted in isometric perspective, assuming a diamond shape like that in Malevich's *White on White* of 1918. The similarities of Malevich's Suprematist paintings to the traditional icons of his Russian culture are structural, formal, and even metaphysical in that there is a shared commitment to picturing transcendental realities.

Naum Gabo
Head of a Woman. c. 1917–20
Illustrated on page 248

Andrew Carnduff Ritchie, *Sculpture of the Twentieth Century*, **1952**, page 28

The futurists' glorification of technology was first echoed in Russia during and immediately after the first World War by so-called constructivist sculptors like [Vladimir] Tatlin, [Aleksandr] Rodchenko, Gabo and [Antoine] Pevsner. Later, constructivist ideas spread throughout Europe. Optimistic acceptance of scientific and technological progress marks all the early constructivist experiments. Inspired by the promise of the social revolution in Russia, by a somewhat sentimental socialism as with the Bauhaus's [László] Moholy-Nagy and his students, by the more prosaic orderliness of the Stijl group in Holland or by the somewhat Romantic outlook of England's Ben Nicholson, Barbara Hepworth and other members of Unit One in the thirties, the end-result, with local variations, is much the same. By the avoidance of all reference to living forms, by an absolute dependence upon an abstract geometrical manipulation of spatial rhythms, by excluding any explicit expression of his personal emotions, the constructivist considered that the universal appeal of his work to all classes of mankind would be insured. It is a noble platonic aim, but so far this ideal objective has not been completely realized.

Constructivism and parallel movements in painting such as suprematism and de Stijl are the extreme abstract off-shoots of cubism. Their concern is not with living or organic phenomena but with space—space elevated to a mathematical or mystical element dominating all other instruments of sensation. Gabo and Pevsner did not reach this rarefied position all at once. Both in their early years made constructions along cubist

lines . . . However, by the use of translucent celluloid (opaque though it may have grown with the passing of time) the intention of the sculptor to enclose space by the most immaterial appearing substance possible, in short, to sculpt with space as the medium, is obvious. . . . Gabo . . . prefers translucent materials like glass or plastic combined at times with a harp-like gut stringing. What he gains thereby in lightness and airiness he loses, alas, in permanence and stability.

Lyubov Popova
Painterly Architectonic. 1917
Illustrated on page 249

MoMA Highlights, **2004**, page 84

In *Painterly Architectonic*, one of a series of works by this title, Popova arranges areas of white, red, black, gray, and pink to suggest straight-edged planes laid one on top of the other over a white ground, like differently shaped papers in a collage. The space is not completely flat, however, for the rounded lower rim of the gray plane implies that this surface is arching upward against the red triangle. This pressure finds matches in the shapes and placements of the planes, which shun both right angles and vertical or horizontal lines, so that the picture becomes a taut net of slants and diagonals. The composition's orderly spatial recession is energized by these dynamic vectors, along which the viewer's gaze alternately slides and lifts.

Influenced by her long visits to Europe before World War I, Popova helped to introduce the Cubist and Futurist ideas of France and Italy into Russian art. But, no matter how abstract European Cubism and Futurism became, they never completely abandoned recognizable imagery, whereas Popova developed an entirely nonrepresentational idiom based on layered planes of color. The catalyst in this transition was Kazimir Malevich's Suprematism, an art of austere geometric shapes. But where Suprematism was infused with the desire for a spiritual or cosmic space, Popova's concerns were purely pictorial.

Aleksandr Rodchenko
Non-Objective Painting no. 80 (Black on Black). 1918
Illustrated on page 250

Magdalena Dabrowski, *Aleksandr Rodchenko*, **1998**, pages 23, 24, 28, 30

From his early years as an artist, Rodchenko was interested in more than merely formal artistic explorations;

he was preoccupied with the idea of an art of the future. This became particularly important after his move to Moscow [in 1913] and his entry into the circle of the avant-garde. As he writes in his memoirs, he felt far less close to the aesthetes of the World of Art group, with their bourgeois tastes, than to artists who were neglected by the collectors and attacked in the newspapers, artists such as [Kazimir] Malevich, [Vladimir] Tatlin, [Vladimir] Mayakovsky, and Velimir Khlebnikov, artists whose work subverted the established aesthetic canons, tastes, and values—artists like him.[1] "We were for the new world," he wrote, "the world of industry, technology and science. We were for the new man; we felt him but did not imagine him clearly. . . . We created a new understanding of beauty, and enlarged the concept of art. And at that time such battle—I believe—was not a mistake."[2] This battle had barely begun by October of 1917, when the artists' "leftist" ideas were joined to the ideals of the Revolution. . . .

Further research into such physical attributes of painting, and into the dynamic relationships among those attributes, appears in Rodchenko's "Black on Black" series, in all of which the artist investigates mutations of the same structural problem: how to organize interlocking circular and parabolic or elliptical elements, colored in a close range of blacks, in the most economical way, yet at the same time in the most expressive one. He also explores the inherent potentials of *faktura* in this series. The differing textures of individual elements; the interplay of these textures, and of the forms to which they are applied; the play of light on them—all these result in transformations of the surfaces and expressive qualities of Rodchenko's paintings. Differences in texture, for example, set some forms in greater relief, while others seem to act as the stronger forms' "shadows," or even to dissolve into the background. The content of the paintings becomes the dynamic interaction of basic geometric forms in closely valued hues against a uniformly colored pictorial surface. The works bear no relation to any traditional mimetic or narrative values, and their highly reductive pictorial vocabulary manifests the ultimate radicalism of Rodchenko's innovations.

These experiments further show Rodchenko's interest in discovering new pictorial options through both technical transformations of the painting's surface and the creation of dynamic spatial effects by solely pictorial means. In the process he examines the properties of color, in its absolute as well as its relative values—that is, both the fundamental characteristics of a color and those of its different shades. Aleksandr Lavrent'ev has suggested that Rodchenko's "Black on Black" paintings represent his response to Malevich's famous *Black Square*, which had been prominently displayed in the *0:10* exhibition back in 1915 and had been much dis-

cussed since then by the avant-garde.[3] As Malevich began the non-objective phase in painting, so Rodchenko responded to the dialectic of non-objectivity.[4] In fact, however, Rodchenko was responding not only to the iconic image and meaning of *Black Square* but also to Malevich's quintessential statement on the absolute in art, which he attempted to achieve in his most reductivist work, *White on White* of 1918 [see page 247]. The "Black on Black" works counter Malevich's icon of spirituality with symbols of nothingness. . . .

In the black paintings, then, black is divested of its function as color and becomes subsumed into the element that engenders new meaning—the *faktura* or surface treatment, the material substance identified with the parameters of the picture plane.

In addition, a crucial new aspect comes to the fore, namely the concept of professionalism of execution. Objective elements displace subjective judgment as criteria of the work's artistic value; in fact they become vital components in the viewer's process of evaluation. The physicality of the painting as an object, and the physicality of the execution, become the new criteria in the appreciation of the work of art. Material itself—in this case paint—and the method of its application influence the perception of the object. This unprecedented approach to the painting as an object in itself marks a major development in Rodchenko's art, and indeed a crucial innovation in the history of the avant-garde. It also represented their utopian conception of the aesthetic needs of the new mass viewer.

Aleksandr Rodchenko
Spatial Construction no. 12. c. 1920
Illustrated on page 251

Magdalena Dabrowski, *Aleksandr Rodchenko*, **1998**, pages 37, 38, 40

Rodchenko's investigations into line as a structural "material" coincided with his membership in a group known by the acronym Zhivskul'ptarkh, or "Collective of painterly, sculptural, and architectural synthesis." This association, founded in November 1919, included artists working in all three of the aesthetic domains listed in its name,[1] and it stimulated Rodchenko's interest in architecture and architectural design. The first projects he executed for the group were the designs for newspaper kiosks, their structures looking back to the drawings and paintings of 1918 that were built up of numerous overlapping planes. . . .

As architecture, the structures Rodchenko imagines . . . are "futuristic" and inventive. . . . They have a linear quality that acted as a catalyst for the emergence of the

artist's "Linearism" system and for his interest in three-dimensional structures in real space. These works would find their three-dimensional counterparts in Rodchenko's experimental freestanding structures of 1921, built of identically sized wooden parts assembled into complex geometrical forms. The structures were based on a systemic principle not dissimilar from that applied in the "Black on Black" *faktura* paintings: a basic element (the wooden part), of a given length and size, served as a recombinant module in generating diverse geometric configurations and acting in space as line acts on the picture surface.

The use of straight lines . . . however, did not fully address the issue of the dynamics of form. For that, Rodchenko eventually began to experiment with combinations of straight and circular lines, creating in 1920 a series of drawings and paintings based on this principle. To make these linear constructions . . . he used mechanical devices (a compass and a ruler), deploying objective, reductivist means to produce a series of studies of the spatial relationships among forms based on the line and the circle. As in earlier linear works on black grounds, the organization of the elements derives from the manipulation of mechanical devices. This essentially eliminates the notion of style. Although decisions as to the placement and number of the mechanically drawn forms still remain with the artist to make, all other subjective elements are absent.

The works become stereometric studies. Interacting tensely and dynamically, lines and circles intersect to produce composite forms that seem to imply volume and defy the laws of gravity, hanging suspended in unstructured abstract spaces. The logical conclusion of these works, then, was the extension of such forms into real space. This Rodchenko achieved in a new series of geometric, kinetic spatial constructions suspended from the ceiling. . . .

Conceptually simple but visually and structurally complex, these constructions, of which only one survives—*Spatial Construction no. 12*—transposed Rodchenko's two-dimensional linear drawings into the third dimension. A drawing from the artist's notebook shows sketches for all of the works in the series. All six were geometric shapes: an oval, a circle, a triangle, a square, a hexagon, and an octagon. Rodchenko executed them in thin sheets of plywood, composing each of them as a series of forms inscribed one within the other, identical in shape but graduating downward in size, and cut out in intervals of about half an inch. Their surfaces were thinly painted silver, to reflect light. When flat, each of them made a two-dimensional form . . . They could, however, be opened up into space by fanning the layers apart. (The geometric shapes within each geometric shape all rotated along the same axis.) Thus real space became an integral part of the constructed form.

Gustav Klucis
Maquette for *"Radio-Announcer."* 1922
Illustrated on page 251

Press release, The Museum of Modern Art, 1980

Radio-Announcer, a 1922 construction-sculpture by the painter, sculptor, and designer Gustav Klutsis [sic], is a maquette for one of his "radio announcers" or "screen-tribune-radio-kiosks" developed in 1922 for the Fifth Anniversary of the Russian Revolution and the Fourth Congress of the Comintern. These Constructivist propaganda kiosks were designed to be placed at main intersections for the radio transmission of Lenin's speech of 1922. Formally the work embodies all of the principal characteristics of constructivist work in three-dimensions. It is a composite of geometric panels, "architectural" supports, and gaily painted loudspeakers assembled by means of tension cables—which hold the composition together by reciprocal tension. This piece is not only one of the best examples of Klutsis's work, but also one of the rare original constructions surviving from this period. The first such three-dimensional work to enter the Collection, it is an important addition to the Museum's holdings of Russian avant-garde paintings and works on paper.

Klucis
Maquette for *"Radio-Announcer"*
Illustrated on page 251

Alice Aycock, in *Contemporary Art in Context*, **1990**, pages 53, 54

On the evening of August 4, 1914, a month and a half after the assassination [of Archduke Ferdinand of Austria] at Sarajevo, and on the eve of the German invasion of Belgium, Sir Edward Gray was looking out the windows of the British Foreign Office. He turned to a friend and said, "The lamps are going out all over Europe. We shall not see them lit again in our lifetime."

By now I've worn out his remark in thinking about it. That one short conversation came at the beginning of the war but at the end of everything else. In order to really savor that scene in the London twilight, one has to know all the things that came before : [Albert] Michelson- [and E. W.] Morley and the constancy of the speed of light; [Albert] Einstein and his clock paradox; Max Planck and his quanta; [Pablo] Picasso and his *Demoiselles d'Avignon*; and poof! the stability of the Newtonian world is gone. . . .

[T]he Constructivist artists, of whom Gustav Klutsis [sic] is an example, were responding to all of those

things—to Einstein, to Planck, to Picasso, and also to the fact that World War I had sort of wiped the slate clean. I think that what they invented, and certainly not only them but Picasso and the Futurists, was basically the paradigm of the twentieth century. It was a schema that did away with the Renaissance—and when you read them you can see that they have just thrown away the Renaissance, they have thrown away harmony, balance, locating things at a point in time, humanism, the figure, all of these things that were valued. What they've substituted is distortion, fragmentation, things that had no relationship to or fragmented the human body, disequilibrium, a kind of schema which they felt dealt with how we were going to perceive the world in the twentieth century. . . .

They were correct that the world could no longer be seen from a single point of view, located, static in time, but that one had to take in a vast amount of information and that there was a kind of fragmentation and dislocation and disequilibrium when we perceive the world. I think that this paradigm that they invented is one which no one thus far has been able to topple over. . . .

The way I see it is that a group of people, who were elite and who were privy to a great deal of information, invented a new way of composing a world. They thought that this new composition would have mass appeal and that everyone would understand it. They thought that they could go out, as Klutsis did, and build constructions that would work in the world, that would be utilitarian, and that the new culture, the new people, would understand. And of course the new people didn't understand. They said, Give me Social Realism, give me something I can understand.

I think the motivation was to combine this elitist act with all the new technology and the new icons of the day, and to make a kind of art that really did deal with the culture of the day and was at the same time a radical formulation. I think that they succeeded, except, as always, they were before their time.

El Lissitzky

Proun 19D. 1922?
Illustrated on page 252

John Elderfield, *The Modern Drawing: 100 Works on Paper from The Museum of Modern Art*, **1983**, page 138

A "new man" creating a new art for a new world without frontiers was the image that Lissitzky projected as he traveled around Europe in the 1920s, welcomed by the international Constructivist avant-garde as an ambassador-at-large for the new Soviet culture. The image

he projected was that to which Constructivist artists of the 1920s aspired. Theirs was not a Constructivist art in the original Russian sense, for by 1922 . . . the whole range of abstract and constructional styles that had developed during and just after the First World War had escaped their national boundaries to create a newly ecumenical alliance, though one whose factions retained their original names. Common to them all—from de Stijl to Lissitzky's own "Proun"—was a notion of art as composed of "elements," viewed as expressive of both modern and universal order from which, in theory, any fabricated object could be made. Lissitzky was an extraordinarily versatile artist, who worked in nearly a dozen fields from painting and printmaking to architectural design. "Proun" was an acronym for "Project for the Affirmation of the New (in Art)," and he described its intention as to create an "interchange station" between painting and architecture. The travel metaphor is appropriate to Lissitzky. Modernity and movement together were central to his art (as indeed they were to his period).

Proun compositions were modern because they embodied the economy of means, clarity of form, and precision of relationships characteristic of the machine. "Machine fetishism" was opposed, but the order of technology was admired: indeed (*pace* the Dadaists), its economical processes were analogous to those of nature itself. Anything that specifically connoted nature, however, was avoided, including sensuous color. The restrained color scheme of Lissitzky's work analogized industrial materials: copper, iron, aluminum, and so on. . . . The presentation, then, is coolly modern. . . .

Lissitzky is often described as a "bridge" between [Vladimir] Tatlin's Constructivism and [Kazimir] Malevich's Suprematism. It is an attractive metaphor, punning as it does on his own Proun railroad-station idea—and Lissitzky was indeed a synthesist. But he was very much more. Not only was he a great avant-gardist . . . but also an original artist, whose insight into his time was embedded in his practice of his art, which thereby escapes contemporary suggestion for an entirely classical stasis, even as it tells us how he thought the contemporary should be changed.

László Moholy-Nagy

Q 1 Suprematistic. 1923
Illustrated on page 253

John Russell, *The Meanings of Modern Art*, **1981**, pages 247, 248

Moholy-Nagy was a one-man compendium of the postwar pacific International. He had shared a studio with

Kurt Schwitters, he had attended the Constructivist Conference which had been called by [Theo] van Doesburg in Weimar in 1922, he knew [El] Lissitzky, he was familiar with the achievement of [Kazimir] Malevich. . . .

It may, in fact, be Moholy-Nagy in the end who most thoroughly validates the Bauhaus' reputation for modernity. By the second half of the 1920s people were already remarking on the fact that the school was dominated by people whose careers had begun before 1914, and that the arts-and-crafts element in the Bauhaus had always augured oddly for an institution which prided itself on being up-to-date. With Moholy-Nagy, no such complaints were possible. He, if anyone, was alert to all the possibilities of his time. (In 1922 he had painted a picture by telephone, giving orders so exact that they could be carried out by any skilled executant.) In his books *The New Vision: From Material to Architecture* and *Vision in Motion* an attentive reader will find a running fire of ideas and injunctions as to how best to bring about the reintegration of art and society.

Moholy-Nagy said in 1922 that "the art of our century, its mirror and its voice, is Constructivism." In this he followed Lissitzky, [Naum] Gabo and [Vladimir] Tatlin, all of whom were convinced that new materials called for a new art, and a new art which would above all be dynamic and kinetic in its allegiances; a clean break was to be made with the static apartness of older art, and with its traditional stance on wall or floor.

Mondrian and de Stijl

Piet Mondrian

Composition in Oval with Color Planes I. 1914
Illustrated on page 254

James Johnson Sweeney, Mondrian, **1948**, pages 10, 13

Mondrian's fundamental aim in art was to transcend the particular to express the universal. He was the great uncompromising classicist of the early 20th century. Romantic art deals with the particular; for Mondrian the particular was a trammel, a fetter. He felt that naturalistic forms in painting were limited forms by the very definition of their specific references: "the particularities of form and natural color evoke subjective states of feeling which obscure pure reality." For Mondrian reality was that essential quality we find in nature, not its surface appearances. The appearances of natural things were constantly changing, but this living quality, this inner reality of nature, was constant—universal. In his opinion a truly universal art should provide through its own medium an equivalent for this inner reality, or living quality, rather than merely a reflection of surface features. In other words, he wanted a cleaner universal basis of expression than naturalistic representation could give him—a purer base for the universal expression of the classicist than any painter before him had achieved. This is what he meant by his frequently repeated insistence that we must "destroy the *particular* form." This is why he pursued the tangent of the arc, described by the Cubist movement, toward a further simplification of elements, instead of returning with it to a relative naturalism after its first severe disciplinary phase had served its end.

Cubism was not the solution. But besides pointing a step in the direction of destroying the particular form it also clarified Mondrian's basic problem for him. Through Cubism he came to realize that he might achieve an equivalent for the living quality or inner reality of nature through an interplay of contrasting pictorial elements and through the tension of their relationships. He saw that in a picture the only dependable source of energy for such an interplay of forces lay in a persistent, equilibrated contrast between an invariable element and a group of variables. He found that for him the only constant relation in painting was the right angle. Variety he saw most universally expressed through contrasting simple forms and primary colors, never naturalistically limited. And on these bare premises all the work of Mondrian's last twenty-five years was based.

Piet Mondrian

Tableau I: Lozenge with Four Lines and Gray. 1926
Illustrated on page 256

Angela C. Lange, in Masterworks from the The Museum of Modern Art, New York, 1900–1955, **2001**, page 134

With the end of World War I in November 1918, Mondrian left the Netherlands for the last time, and re-

turned to Paris in late June 1919. He took with him a newly acquired independence. He was no longer as evidently reliant as he had been on the architecture of Parisian Cubism, and one mark of this new autonomy was his adoption in 1918 of a diamond or (as he called it) "lozenge" format. Within the strictly reduced terms of horizontal and vertical lines Mondrian had charted for his art, the question of the diagonal was bound to be a fraught issue. Indeed, Mondrian and his early collaborator Theo van Doesburg eventually parted company in part because Mondrian could not accept van Doesburg's heresy of interjecting diagonal lines into the previously pure rectilinearity of Neo-Plasticism. But by rotating the canvas ninety degrees, Mondrian had been able to incorporate some of the dynamic instability of the diagonal axis, without violating the pure grid of his compositions. Writers have noticed that the format has a precedent in earlier Dutch art, in the diamond-shaped heraldic plaques often seen hanging on piers in seventeenth-century paintings of church interiors.

While the lozenge form introduced a new element of complexity into his art, it came at a time when Mondrian was otherwise fiercely paring his work down to bare essentials, including either only primary colors, or . . . only gray to relieve the absolutes of black and white. Accordingly, *Painting, I* is a work of high austerity, but is not at all simple or easy to grasp. . . . The insistent squareness of the picture format, and the aggressive symmetry of the diamond, emphasize the asymmetries and imbalances of the "cropping" of the implied, nearly-square rectangle, made from lines of varying weight. Evocations of concealment (three unseen intersections), and of implied extension (lines that continue unchecked, as at upper left), pull us out of the composition, while the strongly centralized composition draws us inward toward the unmarked midpoint of the long and tall axes of the canvas's shape.

Piet Mondrian

Composition in White, Black, and Red. 1936
Illustrated on page 257

Alfred H. Barr, Jr., *What is Modern Painting?* **1943**, page 27

Piet Mondrian is Dutch by birth and he loves cleanliness and fine workmanship. He likes cities with their rectangular patterns of streets, buildings, windows. The *Composition in White, Black and Red,* which seems so simple, took months to paint; for each rectangle is a different size, each black line a different thickness, and the whole is put together and adjusted to a hair's breadth with the conscience and precision of an expert engi-

neer—though with this fundamental difference: that the engineer works for practical results, Mondrian for artistic results—which in his case might be called the image of perfection.

Yet Mondrian's pictures almost in spite of themselves have achieved practical results to an amazing extent. They have affected the design of modern architecture, posters, printing layout, decoration, linoleum and many other things in our ordinary everyday lives. (Mondrian, by the way, is not a cold intellectual; though he is over seventy he loves swing music; his latest abstract painting is called *Broadway Boogie Woogie* [see page 258] and lives up to its title.)

Piet Mondrian

Broadway Boogie Woogie. 1942–43
Illustrated on page 258

Piet Mondrian, in *The Museum of Modern Art Bulletin,* **1946**, pages 35, 36

The first aim in a painting should be universal expression. What is needed in a picture to realize this is an equivalence of vertical and horizontal expressions . . .

The second aim should be concrete, universal expression. In my work of 1919 and 1920 (where the surface of the canvas was covered by adjoining rectangles) there was an equivalence of horizontal and vertical expression. Thus the whole was more universal than those in which verticals predominated. But this expression was vague. The verticals and horizontals cancelled each other, the result was confused, the structure was lost.

In my paintings after 1922 I feel that I approached the concrete structure I regard as necessary. And in my latest pictures such as *Broadway Boogie Woogie* and *Victory Boogie Woogie* the structure and means of expression are both concrete and in mutual equivalence . . .

It is important to discern two sorts of equilibrium in art: 1. static balance; 2. dynamic equilibrium. And it is understandable that some advocate equilibrium, others oppose it.

The great struggle for artists is the annihilation of static equilibrium in their paintings through continuous oppositions (contrasts) among the means of expression. It is always natural for human beings to seek static balance. This balance of course is necessary to existence in time. But vitality in the continual succession of time always destroys this balance. Abstract art is a concrete expression of such a vitality.

Many appreciate in my former work just what I did not want to express, but which was produced by an incapacity to express what I wanted to express—dynamic movement in equilibrium. But a continuous struggle for

this statement brought me nearer. This is what I am attempting in *Victory Boogie Woogie*. . . .

To move the picture into our surroundings and give it real existence, has been my ideal since I came to abstract painting. I think that the logical outgrowth of painting is the use of pure color and straight lines in rectangular opposition; and I feel that painting can become much more real, much less subjective, much more objective, when its possibilities are realized in architecture in such a way that the painter's capabilities are joined with constructive ones. But then the constructions would become very expensive; they would require a pretty long time for execution. I have studied the problem and practiced the approach with removable color and non-color planes in several of my studios in Europe, just as I have done here in New York.

Mondrian

Broadway Boogie Woogie
Illustrated on page 258

Beatrice Kernan, *MoMA: The Magazine of The Museum of Modern Art*, **1995**, pages 7, 9, 11

In early September 1938, the sixty-six-year-old Mondrian wrote from Paris . . . to a young American admirer: "You know I have always wanted to come live in New York, but I haven't dared risk it. Until now, I could work peacefully in Paris . . . I would like to come to New York and rent a room, a studio would be too expensive."[1] Within weeks, growing political agitation in Europe following the signing of the Munich Pact prompted Mondrian to accept an immediate offer of safe haven from artist colleagues in London. This refuge, however, proved short-lived: in the fall of 1940, German bombs descended, shattering the windows of his small Hampstead studio. With both his life and his life's work imperiled, Mondrian at last fixed his resolve to immigrate to America. . . .

Mondrian's abstract art found resonance in the most modern of metropolises. His utopianism celebrated the image New York presented him, an image of teeming diversity harmonized in a vibrant, coherent whole. He delighted in the city's angular regularity—its soaring verticals and unyielding grids, its glistening modular fenestration and nocturnal geometries of light. In New York at mid-century the most resolute modern abstractionist found a spiritual home. . . .

Mondrian seems to have responded instinctively to the vitality and congeniality he found in New York. Long a devotee of American jazz, he took fresh inspiration in the syncopated beat and improvisational aesthetic of jazz's most recent incarnation, boogie-woogie.

He was introduced to the boogie-woogie music of pianists Albert Ammons, Pete Johnson, and Meade Lux Lewis on his first evening in New York by Harry Holtzman. Holtzman, who had sponsored Mondrian's immigration, remembered the artist's enthusiastic and spontaneous exclamation: "Enormous, enormous."[2] . . .

The culminating achievement of Mondrian's New York period, *Broadway Boogie Woogie* (1942–43), was the product of ten months' labor. Here, the colored lines of *New York City I* are transformed into pulsating paths of repeated primaries: chromatic chord progressions and percussive notes held in harmony by the familiar stabilizing grid. Severity of style surrenders to sublimely restrained ebullience in a work that pays homage, explicitly in title and implicitly in pictorial equivalence, to the brilliant night spectacle of Manhattan and the staccato, improvisatory rhythms of jazz. (The painting was acquired by The Museum of Modern Art shortly after its completion.)

Theo van Doesburg

Rhythm of a Russian Dance. 1918
Illustrated on page 259

Helen M. Franc, *An Invitation to See: 150 Works from The Museum of Modern Art*, **1992**, page 64

A few years after [Kazimir] Malevich started from scratch to create a "pure" art from simple geometrical forms, a group of artists in the Netherlands achieved total abstraction by working in the opposite direction. They began with naturalistic forms and, by analyzing their essential elements, gradually reduced—or abstracted—them to compositions constructed entirely of rectilinear shapes.

Rhythm of a Russian Dance is the culmination of a detailed analysis that van Doesburg carried out through a sequence of seven preceding studies. He moved progressively from his first naturalistic sketch of a dancer to the final painting, which is composed of flat bars arranged at right angles to one another in such a way that their shapes, and the spatial intervals between them, are an abstract transcription of the rhythmic, staccato dance movements.

Van Doesburg was the organizer and principal theorist of a group of painters and architects, whom he brought together in 1917 under the name of de Stijl ("the Style"). Their aesthetic principles restricted the artists' means to the basic minimum of the straight line and right angle (symbols of man's intellectual dominance over the diffuse, capricious forms of nature) and to the three primary colors red, yellow, and blue, together with the neutrals black, gray, and white. They regarded the painting thus created as the new, universal

art of the future and named it Neo-Plasticism. It was described as "*abstract-real* because it stands between the absolute-abstract and the natural, or concrete-real. It is not as abstract as thought-abstraction, and not as real as tangible reality. It is aesthetically living plastic representation: the visual expression in which each opposite is transformed into the other."

Joaquin Torres-García

Construction in White and Black. 1938
Illustrated on page 261

Florencia Bazzano Nelson, in *Latin American Artists of the Twentieth Century*, **1993**, pages 72, 75, 76

What Torres-García called Constructive Universalism rested on two principles: the universalist notion that an artistic tradition has existed since remote times that expresses essential truths through geometrically determined archetypes, and the classical idea that the work of art is a ground where opposing cosmic forces can be combined harmoniously. On these principles Torres-García elaborated a monumental but coherent metaphysical and aesthetic system. His beliefs were so firm and his message so timely that his avant-garde Americanist project influenced several generations of artists. . . .

The symbolic quality of Torres-García's Constructive Universalism is one of its most notable features. The use of symbols became an essential aspect of his system,

and it is the most important point of difference between his work and that of other Constructivists. His symbols are self-referential graphic ideas that do not represent anything but themselves because the idea is completely identified with the form.[1] Torres-García's symbols are, by his own reckoning, comparable to Platonic forms because they are "*materializations of the universal spirit*,"[2] which, having the magical virtue of translating spiritual states, awake analogous emotions in the soul[3] and "make the spirit present."[4] He also believed that his symbols expressed the vast world of the unconscious, a conviction that indicates the often overlooked connection of his work with Surrealism.[5] . . .

Surrealism also affected Torres-García's relationship with adherents of other Constructivist movements.[6] Torres-García could only agree partially with their aim of consolidating "a common front against 'the tyranny of the individual' in art" because he still deemed the unconscious necessary in the "constructive" process.[7] Torres-García also disagreed with their opposition to all art of the past, a stance proposed by Naum Gabo and Antoine Pevsner in the "Realistic Manifesto" of 1920, and with their emphasis on logical reasoning based on scientific facts, and their call for standardization and utilitarianism.[8] Thus, Constructive Universalism differed greatly from its European counterparts because Torres-García defined and understood constructivism not only in terms of the avant-garde but also as continuing a tradition of universal art that privileged metaphysical concerns above all others.

Realisms

Alfred H. Barr, **Jr.**, *Modern German Painting and Sculpture*, **1931**, pages 7, 12, 13

To appreciate German art it is necessary to realize that much of it is very different from either French or American art. Most German artists are romantic, they seem to be less interested in form and style as ends in themselves and more in feeling, in emotional values and even in moral, religious, social and philosophical considerations. German art is as a rule not pure art. . . .

Max Beckmann emerged from the vigorous impressionism of the first Berlin Secession, passed through the war period with a violent, contorted manner suggestive of German primitives, into his present style which for strength, vitality and breadth of feeling is unequalled in Germany. Whether the genuine great-

ness of his personality will be realized in his paintings so that he will take his place among the half dozen foremost modern artists is a question which the next few years should answer.

Since the War expressionism has been followed by various reactions even in the work of leaders in the movement. . . . Beckmann's work has become happier in spirit and more disciplined in form. But there are also at least three distinguishable movements on the part of younger artists in the repudiation of expressionism. One of these . . . has taken the form of abstract composition of more or less geometrical shapes. Another and very wide-spread movement concerns itself with emphatic and frequently exact realistic painting of the objective world. It has been called *die Neue Sachlichkeit*—the New Objectivity. . . .

The phrase "New Objectivity" was invented by Dr. G. F. Hartlaub, Director of the Mannheim Kunsthalle, to designate artists who were turning both from expressionism and from abstract design to concentrate upon the objective, material world.... In Germany, three men who are chosen to represent the New Objectivity ... have each of them experienced the discipline of abstract composition and the license of expressionism. George Grosz's most important work is in drawing and watercolor by which he has made himself a scourge to all that is comfortable and vulgar in contemporary Germany. Otto Dix, less brilliant than Grosz, but stronger, paints with a strident at times almost bizarre realism.... In the work of these men may be found resemblances to 15th century painters such as [Carlo] Crivelli or [Pietro] Perugino, to choose a pair of opposites, or, in the north to the greatest of German painters, [Albrecht] Dürer, [Hans] Holbein, or [Matthias] Grünewald.... The New Objectivity is no longer new and like expressionism is taking its place in the past. The future of German painting is difficult to discern. No movement at present is dominant in Germany any more than it is in Paris or America.

Oskar Schlemmer

Bauhaus Stairway. 1932
Illustrated on page 262

Jodi Hauptman, in *MoMA: The Magazine of The Museum of Modern Art*, **1996**, page 21

Traveling in the spring of 1933 in Germany, Alfred Barr, the first director of MoMA, and his wife, Marga, visited an exhibition of Oskar Schlemmer's work at Stuttgart's Kunstverein. Schlemmer had studied painting but he was also a sculptor, choreographer, and costume designer; he made his mark as the founder of the Department of Theater and Ballet at the Bauhaus. Established in Dessau by Walter Gropius, the Bauhaus was the most important school for the study of architecture and design during the 1920s.

Returning to Schlemmer's exhibition two weeks after his first visit, Barr found that all of the paintings had been removed from public view and that Schlemmer had been charged with "art bolshevism." Describing the effect of politics on culture in Germany, Barr wrote that while the Nazi government "took no direct steps to close the exhibition . . . the decisive attack was made in the local Nazi paper and in the light of events in other German cities there can be little doubt but that the officials of the Kunstverein . . . were moved to protect themselves more than the pictures."[1]

Looking again at the paintings in their hiding place,

Barr was determined to acquire Schlemmer's 1932 painting *Bauhaus Stairway* for the Museum's collection. Painted from memory by the artist three years after leaving the Bauhaus, the work, with its gridded structure and its accurate rendition of the building's space, celebrates the principles of design promulgated by the school. It also calls to mind the spirit of optimism felt by Bauhaus teachers and students, especially in the figure *en pointe* who seems to lift off the ground. But given the context in which it was created and the climate in which it was seen by Barr, the painting can take on a far darker reading: with their blank faces, the ephemeral figures point, nostalgically, to an unrecoverable time.

Recounting later what transpired in Stuttgart, Barr wrote, "Since the museum had no money I cabled Philip Johnson to ask him if he would buy the picture for eventual gift to the museum."[2] He did, and *Bauhaus Stairway* entered the Museum's collection in 1942. For both Barr and Johnson, the picture "had a certain sentimental association" since both men "were very much interested in the Bauhaus and its history."[3] But Barr also took great pleasure in the successful rescue of the work: "I had got [Johnson] to buy it," Barr wrote, "partly to spite the Nazis just after they had closed [Schlemmer's] Stuttgart exhibition."[4]

Otto Dix

Dr. Mayer-Hermann. 1926
Illustrated on page 263

Robert Storr, *Modern Art despite Modernism*, **2000**, page 59

The portrait *Dr. Mayer-Hermann* provides a four-square image of a portly physician in which each detail of his medical equipment is described with the same emotionally detached precision used for the features of his impassive face. The painting is manifestly the creation of an artist with a camera eye, but the hand that records what the eye sees has been to school with Albrecht Altdorfer, Lucas Cranach, Albrecht Dürer, Hans Baldung Grien, and Wolf Huber. The clinical calm of this portrait differs strikingly from the chaotic ferocity of much of the rest of Dix's work; his ghastly depictions of the trenches, his lurid scenes of poverty, sex crimes, and cabaret life, and his angry caricatures of the war wounded begging on the streets of Berlin show Dix's fury at its bluest flame.

Images of the latter kind suggest another reason why "realism" seemed a necessity for artists wishing to document or react to what they had seen during the war. While it is true that some merely sought security in the old artistic ways and others hoped to rebuild what had

been destroyed by patching fragments of modernism together with bits of salvaged tradition, those who wanted to depict a damaged world had to address a basic formal problem: for those damages to be visible some semblance of a pictorial whole needed to exist. A tear in the flesh of an already dismembered image was simply a graphic detail. A gash in a recognizably rendered face, on the other hand, registered the violence done. In short, bullets and bayonets had "abstracted" the body in ways that grotesquely mimicked Cubist dismantling of the figure; any confusion between the two threatened to become an intolerable, aesthetic parody of actual suffering.

Max Beckmann
Departure. 1932; 1933–35
Illustrated on pages 264, 265

Peter Selz, *Max Beckmann*, **1964**, pages 55, 56, 58

Beckmann began his great triptych, *Departure*, in May 1932 while he was still in Frankfurt, took the half-finished panels to Berlin with him, and finished the triptych there on December 31, 1933.[1] Although completed during the first year of the Nazi rule of terror, *Departure* is far more universal than the "symbolic portrayal of the artist's departure from his homeland and the reasons for it," in which he "symbolized the cruelty of the Nazi torturer on the left-hand side and the madness and despair of the era on the right. . . . To avoid trouble with the Nazis, Beckmann hid the picture in an attic and affixed the cryptic label *Scenes from Shakespeare's Tempest*."[2] Such explanations are of little help in deciphering the triptych. Not only was *Departure* completed in 1933, long before Beckmann left his homeland in 1937, but its concept is a great deal broader. He himself pointed out that it "bears no tendentious meaning." And surely his reference to the *Tempest* was no whim or mere ruse: He has, in fact, re-created the world of Caliban and Prospero. . . .

Lilly von Schnitzler, Beckmann's friend and patron, remembers explanatory remarks he made in February 1937 in Berlin about the triptych: "On the right wing you can see yourself trying to find your way in the darkness, lighting the hall and staircase with a miserable lamp, dragging along tied to you as part of yourself, the corpse of your memories, of your wrongs and failures, the murder everyone commits at some time of his life—you can never free yourself of your past, you have to carry the corpse while Life plays the drum."[3] . . . A newspaper lies next to the bound woman's globe on which the word *Zeit* is legible. This surely indicates that the triptych alludes to its time. Although beginning his famous speech in London in 1938 by asserting that he

had never been politically active in any way, Beckmann was deeply troubled about the events of his time and *Departure* reflects—among other things—on the cruelty of the time. . . .

The darkness, the crowded space, the general oppressiveness and horror of the side panels is in utter contrast to the bright, open, colorful luminosity of the center panel. . . . Here, in the broad midday light, floating in their barge on the luminous blue sea are figures whose scale is larger, as their pace is slower. On the left, standing erect and holding a large fish between outstretched arms, is the large masked personage, "Gliding wrapt in a brown mantle, hooded/I do not know whether a man or a woman."[4] . . .

In the center of the boat the woman . . . holds a child. Her frontal stance and detached look endow her with the appearance of universality. Beckmann, who, like many of his great contemporaries—[James] Joyce, [T. S.] Eliot, [Thomas] Mann, [Pablo] Picasso come to mind—often quotes from the past, has given the woman here a classical appearance—including the almond-shaped eyes and the Phrygian cap—of fifth-century Greece. And if the woman recalls classical antiquity, the fisher-king reminds us of the culture of the Middle Ages. With his three-pointed crown and angular profile he evokes the image of the saints and kings on the portals of Reims and Bamberg and in the choir of Naumburg.

The infant, who may represent the hope embodied in youth, is in the very center of the whole three-panel composition. Next to the mother and child is the largely hidden male figure who has been interpreted variously, as a Joseph accompanying the central Madonna and Child;[5] as Charon steering the boat to an unknown port;[6] or possibly a veiled self-portrait.[7] The fisher-king, pulling in a full net and gazing across the sea into the distant space, lifts his right hand in a magnificent gesture that rejects the despair of the side panels and at the same time points ahead into an unknown future.

Pablo Picasso
Bather with Beach Ball. 1932
Illustrated on page 266

Robert Rosenblum, in *Picasso and Portraiture: Representation and Transformation*, **1996**, pages 360, 361

In *Bather with Beach Ball* of August 30, 1932 as in other paintings of that great vintage year, the corporeal presence of Marie-Thérèse [Walter] now dominates the world, swollen into a ballooning giantess, an unexpected preview of the pneumatic cartoon characters

that float on high in Macy's annual Thanksgiving Day parade. . . . But unlike most images prompted by Marie-Thérèse in 1932, this one, at first comically clumsy in its airborne athletics, quickly becomes grotesquely ugly, as if the demon Olga [Picasso's first wife] may have once more possessed her rival's placid spirit.

At first, we recognize many of the attributes of the teen-ager who, summering at Dinard, was actually photographed in a bathing suit, beach ball in hand. There is the smooth flow of her seedpod hair, the spheroid anatomy, and even the color code of yellow and violet on her skintight bathing suit. But another kind of being, more predatory than seductive, appears to inhabit her spirit and body, transforming her into a humanoid kin of a rubbery, gray squid. Jet-propelled across the blue sky, her bulbous head, with its two round, staring, lidless eyes and its vertical air vent, both mouth and vagina, mindlessly hunts its prey, the hair streaking behind like waterborne tentacles. The prey, of course, is presumably nothing but a beach ball, but it will never be caught. Rendered in two dimensions, as opposed to the creature's emphatically modeled three, it also becomes the most remote astral body, which its pursuer stupidly grasps at with tumescent, fingerless hands, as demanding and as ignorant as a child reaching for the moon. A voracious creature, perhaps the specter of Olga, has momentarily invaded this seaside romp on what the diminutive tricolor, which shuttles us dizzily from near to far, round to flat, tiny to huge, proclaims as French territory. And as usual, Picasso is secretly present.

Pablo Picasso
Girl Before a Mirror. 1932
Illustrated on page 267

Robert Rosenblum, in *MoMA: The Magazine of The Museum of Modern Art,* **1996**, pages 7, 8

It is before a magical mirror that Marie-Thérèse [Walter] [Picasso's companion in the late 1920s and early 1930s] stands in her most famous transformation, painted on March 14 [1932]. *Girl Before a Mirror* embraces . . . a multitude of symbols . . . which endlessly enriches the traditional motif of feminine vanity before a looking glass. . . .

Marie-Thérèse's head is . . . a marvel of compression, merging, for instance, one of the most pervasive cultural myths about women inherited from the later nineteenth century, the polarity between the virgin and the whore, archetypes that haunted Picasso from his earliest years, when he could alternate between Madonna-like mothers and female creatures of sexual depravity.

So it is that the profile view of the head extends to an enclosing contour of white radiance that bleaches the stripe pattern to an ethereal pallor and suggests the chastity of both halo and veil. The half-hidden frontal view, however, becomes a cosmetic mask of sexual lure: the half-mouth lipsticked, the cheek rouged, the skin brazenly gilded. Such a duality, of course, echoes in countless other directions, including the evocative imagery of the sun and moon's cycles around the earth. In this context of astronomical rhythms, it is not surprising that the theme of the girl before a mirror has even been described as "a girl before her mirror image counting the days when her period is due to find out whether or not she could be pregnant, thus becoming connected with the moon and the sun and concerned with giving life and facing death."[1] This intense physiognomic contrast gives visual form to the ever more popularized Freudian concept of clashing but coexisting aspects of the human mind, a tug between the conscious and the subconscious, the overt and the repressed.

Such invisible worlds, imagined by Freud and Jung, plumbed far into a dark, instinctual level that for Picasso, as for the culture into which he was born in the late nineteenth century, seemed far more potent in the female of the species, the procreative goddess who is foretold in this image of a young girl embracing and peering into a destiny that would wed her to the cycles of nature. . . .

If the contemplative girl, in the ripeness of puberty, still appears constrained and virginal in the angular corseting of her swelling body, the uterine image in the mirror releases such repressions, even warping the uncomfortably acute color-pyramid upon which she must support her tensely watchful head. Moreover, the promise of sexual union and procreation revealed in Picasso's familiar genital puns (such as the visual rhyming of upright arm and breasts with erect phallus and testicles)[2] is fulfilled in the mirror, where one breast, part fruit and part ovum, seems fertilized by a black spot, generating a coiling green shoot. And if a life cycle is beginning, it is also ending, for the mirror image is haunted by the specter of death. In fact, Picasso's mirror image almost literally illustrates the English phrase "from womb to tomb": before our eyes, the tough enclosure of burgeoning life, with fetal head and developing internal organs, becomes a mummy's shrouded coffin, with an Egyptoid spirit head painted upon it. And, as always Picasso is observing and guarding his female possession. As Jung had recognized in the same year, Picasso's alter ego might well be identified with Harlequin. Here, in fact, as so often before in his work, the diamond harlequin pattern, now of the wallpaper, can become a coded symbol of the artist's own presence, a heraldic field that proclaims her territory and that, when reaching, at the

left, the body of his now mythical beloved, burns with the national colors of Spain, red and yellow.

Pierre Bonnard

The Bathroom. 1932
Illustrated on page 268

Sarah Whitfield, in *Bonnard*, **1998**, pages 23, 24

The way in which Bonnard is never tempted by a precise physical description that might distract from the unity of the whole can . . . be seen as tying in with his respect for the rules of classical art. The faces of the nudes, particularly those of the later years, are erased or blurred, even made invisible, their features scumbled over with a thick residue, rather like the accumulation of mineral deposits that encrust the surface of old marble. . . . And it seems to be broadly true that, although the features of Marthe [Bonnard's wife] are recognisable in many of the domestic scenes in which she figures, they are more often than not effaced or concealed when she is portrayed as a nude. The unity of the composition is further reinforced by what Bonnard called the "aesthetic of movement and gesture."[1] The nude acts as a support, a pole on which the composition rests, and Bonnard is extremely careful not to let her line or form conflict with the simple geometry of the interior. As he said, "there has to be a stop mechanism, something to lean on."[2] . . .

Take *The Bathroom* of 1932. The setting is the bathroom at Le Bosquet, a setting that is by now extremely familiar. The nude is familiar too, but neutralised into a smooth sculptural form. She is seen against a sheet of yellow-gold striped through with purples and red, a passage of glowing heat which is picked up in the soft brightness of the pink pubis. Between those two warm areas is the cool marble white of the nude's right breast reflecting off the scalding whiteness of the stool. The passage between the bath and the nude is a closely plotted course through the abstract patterns made by the heavily grouted bathroom tiles, the horizontal slats of the blind, and the grid created by the lozenge pattern of the linoleum floor. . . . The eye is encouraged to pass over the painting's surface from left to right, as though following the light as it moves across the porcelain coolness of the bath and the damp blue tiles to the warmth of the nude's skin and the burnished coat of the dog. The measured pace of the colour here, and the way each mark is knitted into the structure of the composition, give the painting its weighty stillness. The clock, its hands pointing at five in the afternoon, quietly signals an arrest of time.

Aristide Maillol

The River. 1938–39
Illustrated on page 268

Alfred H. Barr, **Jr.**, *Masters of Modern Art*, **1954**, p. 45

Its daring instability of pose combined with its dynamic torsion make *The River* unique in Maillol's sculpture. Maillol's characteristic figures such as *The Mediterranean* [see page 138] are calm, reposeful, static. Even when they represent muscular strain, there is little movement; the action is self-contained. Maillol was aware of his avoidance of movement, and remarked upon it as late as 1937. Nevertheless, within a year or so afterwards he had conceived *The River*, a work of astonishing, almost reckless movement such as had not appeared in his work since his canvases of women tumbling in the waves done long before in the 1890s while he was still a painter.

Begun before the war, probably late in 1938 or early 1939, *The River* was originally commissioned as a monument to the famous writer and pacifist Henri Barbusse—a project which was abandoned when the war started.

In composing *The River*, Maillol began with various elements of an earlier figure, *The Mountain*, which he had completed in 1937. Much of the work on the plaster model was carried out, following Maillol's instructions, by the sculptor [Robert] Couturier, his friend and disciple. The figure, an entirely new conception, was apparently finished late in 1943 when Maillol gave final approval to the work a few months before his death at the age of eighty-two.

The River is probably Maillol's last completed work, a final magnificent flowering of bold invention and creative energy on the part of a man who was, in his generation, the world's greatest sculptor.

Balthus

The Street. 1933
Illustrated on page 269

James Thrall Soby (mid-1960s?) in *The Museum of Modern Art at Mid-Century: Continuity and Change*, Studies in Modern Art 5, **1995**, pages 213, 214, 215

The picture, called *The Street*, was the first large-scale work of Balthus' career and is an imaginative transcription of a scene on the short rue Bourbon-le-Château in Paris' VI arrondissement. Balthus had painted the picture in 1933 and it had been shown in his first one-man exhibition at Pierre Loeb's Paris gallery the following year. I had seen *The Street* in that show and had never been able to get it out of my mind. A little more than

two years later I was again in Loeb's gallery and, to my astonishment, the painting had not yet been sold. I bought it at once, with a vast sigh of relief, having brooded about it almost constantly since 1934.

The fact that *The Street* was almost 6¼ by 8 feet in size may have discouraged some possible purchasers. But the chief difficulty . . . was that the painting's left section included a passage which even the French, usually calm about such matters, found hard to take. The passage shows a young girl being seized by the crotch by a strange . . . young man who has come up behind her, his face taut with easily decipherable excitement. Since the French had been frightened off by this passage, I began to worry about getting the picture through U. S. Customs. But Hartford was then a Port of Entry and I had brought so many modern paintings through Customs there that the officers regarded me as eccentric rather than libidinous, and they let the Balthus through without any fuss of any kind. Indeed, one of these men told me, bless his heart, that this was the first picture I'd sent from Europe which he really liked! . . .

As the years went by I worried more and more about whether our Museum [The Museum of Modern Art] would be able to exhibit *The Street* when it was finally turned over to that institution at my death. . . . In 1956, Balthus was having a one-man show in Paris[1] and he wrote to ask me whether I'd lend *The Street*. I replied that I would, of course. I added, not as a condition but as a plea, that I was concerned about the picture ever being shown to a large audience in its then-current state. I told Balthus in all frankness that several restorers had offered to "improve" the lurid passage but that I wouldn't let anyone touch the canvas except Balthus himself. I thought this hint would mean the end of a friendship very dear to me. But to my astonishment Balthus replied that he would like to repaint the offending passage. "When I was young I wanted to shock," he wrote. "Now it bores me."[2]

I heard nothing more from Balthus for months after *The Street* had arrived in Paris for his exhibition, and I assumed he'd had a change of heart about making any changes in the composition. But late in the summer of the same year . . . I stopped off to spend a few days with Balthus . . . I grew steadily more nervous about what condition *The Street* would be in and thought in my gloomier hours that Balthus had probably painted it out entirely. He must have sensed how apprehensive I was, since he dragged the big picture into the living room at once. The Mongolian boy's hand had been moved very slightly to a less committed position on the young girl's body, though his eyes were tense with the same fever. I think *The Street* is safe now anywhere from Puritanical rage; I've always thought it one of the very great pictures produced by a member of Balthus' generation.

Georgia O'Keeffe

Lake George Window. 1929
Illustrated on page 270

Helen M. Franc, *An Invitation to See: 150 Works from The Museum of Modern Art*, **1992**, page 123

Like [Giacomo] Balla, O'Keeffe has taken a single motif from perceived reality and, by isolating it from its surroundings, intensified its visual and emotional impact. At first sight, her *Lake George Window* seems far closer to photography than his *Street Light;* and it is tempting to push the analogy to camera work, in view of the fact that O'Keeffe's art was first exhibited in 1916 at the famous avant-garde "291" gallery directed by the master photographer Alfred Stieglitz, whom she subsequently married. On closer inspection, however, what seems paramount in this painting is the rigid selectivity of O'-Keeffe's approach, which is highly stylized, deleting any details that might mar the immaculate precision of the forms and the surface of the canvas. By contrast, a photograph of the same Lake George farmhouse by Stieglitz is more complex in composition and is taken at an angle, with a raking light to accentuate the textures of the clapboards.

O'Keeffe presents the structure in a strictly frontal, symmetrical view and drastically reduces its three-dimensionality. Commenting on this painting, Lloyd Goodrich has said: "Though entirely realistic, its severe simplification, stark rectangular forms and austere color harmony, and the fine relations of all elements, give it the quality of a handsome abstract design."

Charles Sheeler

American Landscape. 1930
Illustrated on page 271

William Carlos Williams, in *Charles Sheeler: Paintings, Drawings, Photographs*, **1939**, pages 6, 7, 9

I think Sheeler is particularly valuable because of the bewildering directness of his vision, without blur, through the fantastic overlay with which our lives so vastly are concerned, "the real," as we say, contrasted with the artist's "fabrications."

This is the traditional thin soup and cold room of the artist, to inhabit some chance "reality" whose every dish and spoon he knows as he knows the language that was taught him as a child. Meanwhile, a citizen of the arts, he must keep his eye without fault upon those things he values, to which officials constantly refuse to give the proper names.

The difficulty is to know the valuable from the impost and to paint that only. . . . It is the measurable dis-

proportion between what a man sees and knows that gives the artist his opportunity. He is the watcher and surveyor of that world where the past is always occurring contemporaneously and the present always dead needing a miracle of resuscitation to revive it. . . .

Any picture worth hanging is of this world—under our noses often—which amazes us, into which we can walk upon real grass. It's no "fabrication," we realize that at once, but what we have always sought against that shrunken pulp (from which everyone is running faster nowadays than ever) called, monstrously, "the real."

Charles Sheeler gives us such a world, of elements we can believe in, things for our associations long familiar or which we have always thought familiar. . . .

Sheeler had especially not to be afraid to use the photographic camera in making up a picture. It could perform a function unduplicatable by other means. Sheeler took it that by its powers his subject should be intensified, carved out, illuminated—for anyone (I don't know that he said this to himself) whose eyes might be blurred by the general fog that he might, if he cared to, see again. . . .

A picture at its best is pure exchange, men flow in and out of it, it doesn't matter how. I think Sheeler at his best is that, a way of painting powerfully articulate. But after all, so is all good painting.

Sheeler

American Landscape
Illustrated on page 271

Alfred H. Barr, Jr., *What is Modern Painting?*, **1956**, pages 14, 15

Factories used to be thought ugly and utilitarian until such artists as Charles Sheeler revealed their beauty. Sheeler, who is one of the greatest American photographers, took a series of superb photographs of the Ford plant at River Rouge before he painted *American Landscape*. This picture is like a good photograph in its sharp-edged precision. But it goes beyond a photograph because, as Sheeler says, it is not an image recorded instantaneously and mechanically on a film, but a composite image, simplified, with certain details left out, certain adjustments made, until the effect is of a serene, almost classic perfection which photographs rarely give.

Edward Hopper

House by the Railroad. 1925
Gas. 1940
Illustrated on page 272

Charles Burchfield, in *Edward Hopper*, **1933**, page 16

Hopper's viewpoint is essentially classic; he presents his subjects without sentiment, or propaganda, or theatrics. He is the pure painter, interested in his material for its own sake, and in the exploitation of his idea of form, color, and space division. In spite of his restraint, however, he achieves such a complete verity that you can read into his interpretations of houses and conceptions of New York life any human implications you wish; and in his landscapes there is an old primeval Earth feeling that bespeaks a strong emotion felt, even if held in abeyance. Mr. Duncan Phillips once called attention to Hopper's power of achieving intensity without distortion—and there is in truth a strong emotional, almost dramatic quality about his work that is not always present in the classic outlook. Some have read an ironic bias in some of his paintings; but I believe this is caused by the coincidence of his coming to the fore at a time when, in our literature, the American small towns and cities were being lampooned so viciously; so that almost any straightforward and honest presentation of the American scene was thought of necessity to be satirical. But Hopper does not insist upon what the beholder shall feel. It is this unbiased and dispassionate outlook, with its complete freedom from sentimental interest or contemporary foible, that will give his work the chance of being remembered beyond our time.

Edward Hopper is an American—nowhere but in America could such an art have come into being. But its underlying classical nature prevents its being merely local or national in its appeal. It is my conviction, anyhow, that the bridge to international appreciation is the national bias, providing, of course, it is subconscious. An artist to gain a world audience must belong to his own peculiar time and place; the self-conscious internationalists, no less than the self-conscious nationalist, generally achieve nothing but sterility. But more than being American, Hopper is—just Hopper, thoroughly and completely himself. His art seems to have had few antecedents and, like most truly individual expressions, will probably have no descendants. Search as you will, you will find in his mature art no flounderings, or deviations, no experimenting in this or that method of working. Such bold individualism in American art of the present or, at least, of the immediate past, is almost unique, and is perhaps one explanation of Hopper's rise to fame. In him we have regained that sturdy American

independence which Thomas Eakins gave us, but which for a time was lost.

Hopper

House by the Railroad
Gas
Illustrated on page 272

James Thrall Soby, *Contemporary Painters*, **1948**, pages 36, 37, 39

What is almost always conveyed, what holds our attention in the best of Hopper's works, is the exceptionally clear and devout communication between the painter and his subjects. His language of seeming understatement has a backlash to it. It is not eloquent, but it is memorable, and his art has some of the dramatic force of evidence blurted in a courtroom, in an atmosphere of long circumlocution. He must be deeply stirred or he does not attempt to record his reaction. He works slowly, with infinite care, and sometimes goes through extended periods of inactivity between paintings. And perhaps the struggle his technique costs him accounts for the penetrating quality of his painting. For if the surfaces of his pictures are usually bland and unspectacular, their under-structure is exceptionally firm and sensitive. One has only to look at his recent handling of stone masonry to realize how sure his control of pigment can be. He gives New York's granite something of marble's inner illumination, and cuts its joinings with a sculptor's sense of form. . . .

If Hopper describes light with rare skill, he also records the density of air like the most delicate of barometers. A subtle gradation of atmospheric values is common to many of his finest works. In *Gas*, for example, the air seems to thin out as the eye moves from the bright area of the service station toward the thick woods across the road, light and the breeze waning together. The extremes of his atmospheric control are to be found in his depiction of absolute calm and the medium wind, and it is typical of his restraint that he should reject [Winslow] Homer's northeasters as too plainly dramatic. But he can bring the summer air to a dead halt—a far more difficult task than might be supposed—and he handles the wind with knowledgeable stagecraft. . . .

When the artist paints rooms rather than facades, a comparable lull in activity is usually evoked, and we may take his words on one of John Sloan's New York interiors as an indication that a romantic mood is consciously sought. Sloan's picture, Hopper declared, "renders remarkably the quality of a brooding and silent interior in this vast city of ours." Hopper's depic-

tion of interiors is, however, more piercing in emotion than Sloan's and less often concerned with local color's cheerful familiarity. . . .

Hopper is not a man for whom drawing or color is an unrelenting necessity. He works only when accumulated or sudden experience has inspired him with something to say. But his strength lies in the fact that he is so inartistic in the European sense of the term: no formalism, no seeking for graciousness, no painterly references; but self-invented realism, warm, convinced, romantic in overtone through its very bluntness of statement. If his expression cannot be compared in scope or power to that of leading Europeans, it is emphatically his own and American. Who abroad does what he does? Who there or here does it so well?

Jacob Lawrence

Four works from The Migration Series. 1940–41
Illustrated on page 273

Jacob Lawrence, *The Great Migration*, **1992**, n.p.

This is the story of an exodus of African-Americans who left their homes and farms in the South around the time of World War I and traveled to northern industrial cities in search of better lives. It was a momentous journey. Their movement resulted in one of the biggest population shifts in the history of the United States, and the migration is still going on for many people today.

The great migration is a part of my life. I grew up knowing about people on the move from the time I could understand what words meant. There was always talk in my house of other families arriving from the South. My family was part of the first big wave of migration, which occurred between the years 1916 and 1919. . . .

I arrived in New York City's Harlem community in 1930, when I was thirteen years of age. . . . After school I went to an arts-and-crafts program at the Utopia Children's House, which my mother enrolled me in to keep me busy while she was at work. I decided then that I wanted to be an artist. . . .

Eventually, teachers, friends, even actors on the street corners helped me to understand how my own experiences fit into a much larger story—the history of African-Americans in this country. It seemed almost inevitable that I would tell this story in my art. I spent many hours at the Schomburg Library in Harlem reading books about the great migration, and I took notes. Soon my research gave me the images I needed to tell the story of the great migration. Many of the images were new for me—along with my street scenes, I would now need to paint rural landscapes, images of violence,

and interiors, like the inside of a schoolroom.

I started the Migration series in 1940, when I was twenty-two years old, and finished it one year later. I can still remember all the panels spread out in my studio on tables made from boards and sawhorses. My wife, Gwen, helped me to prepare the surfaces. I painted the panels all at once, color by color, so they share the same palette. I had made some preparatory sketches that provided me with general outlines, but I worked out the details of the pictures as I painted them. There are sixty panels in the series, and since I wanted them to tell a story, I gave each one a number and painted it directly onto its frame.

To me, migration means movement. While I was painting, I thought about trains and people walking to the stations. I thought about field hands leaving their farms to become factory workers, and about the families that sometimes got left behind. The choices made were hard ones, so I wanted to show what made the people get on those northbound trains. I also wanted to show just what it cost to ride them. Uprooting yourself from one way of life to make your way in another involves conflict and struggle. But out of the struggle comes a kind of power, and even beauty. I tried to convey this in the rhythm of the pictures, and in the repetition of certain images.

Diego Rivera

Agrarian Leader Zapata. 1931
Illustrated on page 274

Waldo Rasmussen, *Latin American Artists of the Twentieth Century: A Selection from the Exhibition*, **1993**, pages 19, 21

By the mid-1920s in Mexico, and throughout the Americas in succeeding years, art became infused with more explicit politics. Profoundly affected by the Mexican and Russian revolutions, and later the international economic depression and the rising threat of fascism, artists like Rivera, José Clemente Orozco, and David Alfaro Siqueiros began creating monumental murals on public buildings in Mexico. Rejecting the abstract language of the modernist avant-garde, they adopted realist styles to make clear political statements and saw the primary function of art as the ideological education of the masses.

Rivera had studied the tradition of fresco painting in Italy and on his return to Mexico in 1921 became interested in the pre-Columbian murals of his own country. His *Agrarian Leader Zapata*, painted for his 1931 exhibition at The Museum of Modern Art, New York, demonstrates his mastery of both fresco technique and didactic subject matter. In the picture, the hero and his peasant followers descend from the hills, armed with the tools of their labor, trampling a landowner. [Emiliano] Zapata holds the reins of the legendary white horse of Hernán Cortés, the Spanish conqueror, turning a symbol of colonial oppression into a symbol for the forces of the Revolution. The grandeur of Rivera's composition and the idealized but still recognizably indigenous features, at once gentle and fierce, of Zapata and his peasant army contrast with Orozco's depiction of a similar theme.

José Clemente Orozco

Dive Bomber and Tank. 1940
Illustrated on page 275

Alfred H. Barr, Jr., *What is Modern Painting?*, **1956**, page 8

Orozco's mural *Dive Bomber and Tank* was painted two months after Dunkirk. His mind, like ours, was full of the shock of the mechanical warfare which had just crushed western Europe. But instead of picturing an actual incident with technically accurate details he makes us feel the essential horror of modern war—the human being mangled in the crunch and grind of grappling monsters "that tear each other in their slime." We can see suggestions of the bomber's tail and wings, of tank treads and armor plate and human legs dangling from the jaws of shattered wreckage. Beneath emerge three great sightless masks weighted with chains which hang from pierced lips or eyes. These ancient symbols of dramatic agony and doom are fused with the shapes of modern destruction to give the scene a sense of timeless human tragedy.

David Alfaro Siqueiros

Collective Suicide. 1936
Illustrated on page 276

Robert Storr, *Modern Art despite Modernism*, **2000**, page 64

The youngest of the leading Mexican muralists, Siqueiros was the closest to being a modernist of the three, but the heightened dynamism of his work has an undeniably baroque dimension. Undulating yet lacquer hard, his forms are muscular, aggressive, and rhetorical. Unlike [Diego] Rivera and [José Clemente] Orozco, Siqueiros was fascinated by new technologies and their potential application to the problems of painting. From the Soviet filmmaker Sergei Eisenstein, he learned the

use of exaggerated photographic angles and cinematic effects for the development of his space-exploding compositions. From the agitprop Dadaist [John] Heartfield, he borrowed techniques of montage. Simultaneously, Siqueiros's research into new pigments and mediums released him from the constraints of traditional oil on canvas and fresco. Yet at the root of his studio innovations, militant theorizing, and painterly melodrama was a strangely tradition-bound sensibility. Like [Mario] Sironi but far more daring in his response to and competitive appropriation of avant-garde ideas, Siqueiros painted brooding pictures in which—as is common in the work of that ominous period between the two world wars—light cuts into and carves darkness, but cannot fully penetrate or dispel it.

Frida Kahlo

Self-Portrait with Cropped Hair. 1940
Illustrated on page 277

Robert Storr, *Modern Art despite Modernism*, **2000**, pages 64–65

In her life, as distinct from her art, Frida Kahlo lacked reserve of any kind. "A ribbon wrapped around a bomb," [André] Breton described her pictures.[1] Art-historically speaking, the bomb did not explode until almost a quarter of a century after her death in 1954. No one could have predicted this; thirty years ago, even in Mexico precious little had been published on Kahlo save a small pamphlet on her house and studio, the Casa Azul, which had yet to become the pilgrimage spot it now is. In the 1970s, feminist criticism and scholarship, the questioning of formalist dogma (in which feminism played so large a part), and the "rediscovery" of Central and Latin America by North Americans, who had spent the 1950s and 1960s enthralled by their new cultural power, all contributed to the reappraisal of Kahlo. However, the cult status she now enjoys tends to obscure the basis, and limits, of her achievement. Anything but naive—her paintings are without exception carefully constructed and methodically rendered—Kahlo is nevertheless largely responsible for her reputation as an artist governed by emotion. Unlike that of her husband, [Diego] Rivera, Kahlo's traditionalism was less a matter of rejuvenating an old approach to art-making than of continuing an ongoing one while turning it inside out. Thus in her almost exclusive devotion to self-portraiture, she derived her fixed formal vocabulary and corresponding iconic intensity from the idolatry of Mexican folk art and colonial Spanish religious art. *Self-Portrait with Cropped Hair* is a challenge to Kahlo's unfaithful mate, whose rejection of the androgynously dressed and coiffed Kahlo is voiced in the inscription above her head —"Look, if I loved you it was for your hair. Now that you don't have hair, I don't love you." In addition, this small oil is an especially striking example of Kahlo's work because it brings together the spareness of *retablo* painting with the combination of text and pictorial vignette found in José Guadalupe Posada's broadsides, or *corridos*, in which polemical or vernacular lyrics are illuminated by graphic images.

Surrealism —————————

William S. Rubin, *Dada, Surrealism, and Their Heritage*, **1968**, pages 63, 64

The word "surrealism" had been used first by [Guillaume] Apollinaire in 1917 in a context that coupled avant-garde art with technological progress;[1] his neologism possessed none of the psychological implications that the word would later take on. . . . "Up to a certain point," [André] Breton wrote in November 1922, "one knows what my friends and I mean by Surrealism. This word, which is not our invention and which we could have abandoned to the most vague critical vocabulary, is used by us in a precise sense. By it, we mean to designate a certain psychic automatism that corresponds rather closely to the state of dreaming, a state that is today extremely difficult to delimit."[2]

By autumn of 1924, Breton had assumed exclusive rights to the magic word and in the Surrealist manifesto published then he gave it formal definition:

SURREALISM. noun, masculine. Pure psychic automatism, by which one intends to express verbally, in writing or by any other method, the real functioning of the mind. Dictation by thought, in the absence of any control exercised by reason, and beyond any aesthetic or moral preoccupation.

ENCYCL. *Philos.* Surrealism is based on the belief in the superior reality of certain forms of association

heretofore neglected, in the omnipotence of dreams, in the undirected play of thought. . . .[3]

As Surrealist painting emerged in its heroic period—between the first (1924) and the second (1929) manifestoes—it bipolarized stylistically in accord with the two Freudian essentials of its definition. Automatism (the draftsmanly counterpart of verbal free association) led to the "abstract"[4] Surrealism of [Joan] Miró and [André] Masson, who worked improvisationally with primarily biomorphic shapes in a shallow, Cubist-derived space. The "fixing" of dream-inspired images influenced the more academic illusionism of [René] Magritte, [Yves] Tanguy, and [Salvador] Dali. We tend to think of Miró and Masson primarily as painters (*peintres*), in the sense that the modernist tradition has defined painting; we think of the latter artists more as image-makers (*imagiers*). The styles of all Surrealist painters are situated on the continuum defined by these two poles. That of Max Ernst—the "compleat Surrealist"—oscillated between them. Both kinds of painting were done virtually throughout the history of the movement, though the automatist-"abstract" vein dominated the pioneer years and the period of World War II. In between, oneiric illusionism held sway.

The common denominator of all this painting was a commitment to subjects of a visionary, poetic, and hence, metaphoric order, thus the collective appellation, *peinture-poésie*, or poetic painting, as opposed to *peinture-pure*, or *peinture-peinture*, by which advanced abstraction was sometimes known in France. Surrealists never made nonfigurative pictures. No matter how abstract certain works by Miró, Masson, or [Jean] Arp might appear, they always allude, however elliptically, to a subject. The Cubists and Fauvists selected motifs in the real world but worked *away* from them. The Surrealists eschewed perceptual starting points and worked *toward* an interior image, whether this was conjured improvisationally through automatism or recorded illusionistically from the screen of the mind's eye.

Max Ernst

Two Children Are Threatened by a Nightingale. 1924
Illustrated on page 278

John Russell, *The Meanings of Modern Art*, **1981**, page 206

It was Max Ernst, in 1924, who best fulfilled the Surrealists' mandate. Ernst did it above all in the construction called *Two Children Are Threatened by a Nightingale*, which starts from one of those instincts of irrational panic which we suppress in our waking lives.

Only in dreams can a diminutive songbird scare the daylights out of us; only in dreams can the button of an alarm bell swell to the size of a beach ball and yet remain just out of our reach. *Two Children* incorporates elements from traditional European painting: perspectives that give an illusion of depth, a subtly atmospheric sky, formalized poses that come straight from the Old Masters, a distant architecture of dome and tower and triumphal arch. But it also breaks out of the frame, in literal terms: the alarm or doorbell, the swinging gate on its hinge and the blind-walled house are three-dimensional constructions, physical objects in the real world. We are both in, and out of, painting; in, and out of, art; in, and out of, a world subject to rational interpretation. Where traditional painting subdues disbelief by presenting us with a world unified on its own terms, Max Ernst in the *Two Children* breaks the contract over and over again. We have reason to disbelieve the plight of his two children. Implausible in itself, it is set out in terms which eddy between those of fine art and those of the toyshop. Nothing "makes sense" in the picture. Yet the total experience is undeniably meaningful; Ernst has re-created a sensation painfully familiar to us from our dreams but never before quite recaptured in art—that of total disorientation in a world where nothing keeps to its expected scale or fulfills its expected function.

Yves Tanguy

Mama, Papa Is Wounded! 1927
Illustrated on page 279

William S. Rubin, *Dada, Surrealism, and Their Heritage*, **1968**, pages 101–02

Yves Tanguy was the only autodidact among the illusionist Surrealists. Unlike [René] Magritte and [Salvador] Dali who, after art school training, experimented with various forms of Cubism, Tanguy went from the whimsical primitivism of such paintings as *Fantômas* to the tightly painted academic illusionism of his mature style without ever passing through modernist painting. His characteristic manner crystallized in 1927, and from then until his death in 1955 it underwent no change except for a tightening in execution after 1930, and a gradual intensification of color.

This consistency of style paralleled the persistence of his vision, a "mindscape" resembling desert wasteland or ocean floor which remained with him for life. In the [works of the late 1920s] this world is sparsely populated with forms that are a conversion of [Jean] Arp's flat biomorphic patterns into three-dimensional illusions a few years before Arp himself was to realize his own personal form-language as sculpture in the round. . . .The

proliferation and enlargement of [the] biomorphs, which are characteristic of Tanguy's paintings of the thirties, led in the following decade to structures affecting an architectural grandeur. . . .

The poetry of Tanguy's mature imagery differs from that of the other illusionist Surrealists, and even from that of most of the "abstract" painters in the group; it is less specifically literary. Though on occasion his forms are anthropomorphic . . . they are never particularized with features or anatomical details. Nor can his forms ever be identified as recognizable objects, as can the shapes of [Joan] Miró and [André] Masson, to say nothing of those of Magritte and Dali. If Tanguy's style is realistic, his visual poetry is abstract.

conscious, speak exactly the secret and symbolical language of the subconscious, which is to say that surrealist images are perfectly understood by that which is deepest in the spectator and make exactly the immediate poetic effect for which they are destined, even when the spectator consciously protests and believes that he has experienced no emotion whatsoever. To know just what effect a surrealist image has produced it would be necessary to subject the spectator to a long analysis, it would be necessary to know his dreams and all the modifications experienced by his psychic life after viewing a surrealist image. For on the conscious level he is always ready to defend himself against this kind of imagery by the well-known method of suppression."

Salvador Dali

Illumined Pleasures. 1929
Illustrated on page 281

Salvador Dali

The Persistence of Memory. 1931
Illustrated on page 280

Press release, The Museum of Modern Art, **1934**

Mr. Dali [in a lecture at The Museum of Modern Art on January 11, 1934] said in part: "I find it perfectly natural when my friends and the general public pretend not to understand the meaning of my pictures. How would you expect anybody to understand the significance of my pictures when I myself, who have made them, I myself regret to say do not understand them either. I must admit that I am the first to be surprised and often terrified by the extravagant images that I see appear with fatality on my canvas. In truth I am but the automaton which registers, without judgment and with all possible exactitude, the dictates of my subconscious, my dreams, the hypnological images and visions, my paranoiac hallucinations, and, in short, all those manifestations, concrete and irrational, of that sensational and obscure world discovered by Freud, which I don't for a moment doubt is one of the most important discoveries of our epoch, reaching to the most profound and most vital roots of the human spirit. The fact that I myself at the moment of painting my pictures know nothing of their meaning is not to say that the images in question are without sense. On the contrary their meaning is so profound, systematic, and complex, that they require an absolutely scientific interpretation. In short, the only way to reduce a surrealist picture to current terms would be to submit it to the most rigorous psychoanalysis. But such understanding of the picture is only scientifically accessible, and not in the least necessary for the public. On the contrary, the public must draw all its pleasure from the unlimited sources of mystery, enigma, and anguish that such images always offer the spectator, for they are addressed actually to each spectator's own sub-

MoMA Highlights, **2004**, page 154

The Persistence of Memory is aptly named, for the scene is indelibly memorable. Hard objects become inexplicably limp in this bleak and infinite dreamscape, while metal attracts ants like rotting flesh. Mastering what he called "the usual paralyzing tricks of eye-fooling," Dali painted with what he called "the most imperialist fury of precision," but only, he said, "to systematize confusion and thus to help discredit completely the world of reality." It is the classical Surrealist ambition, yet some literal reality is included too: the distant golden cliffs are the coast of Catalonia, Dali's home.

Those limp watches are as soft as overripe cheese—indeed "the camembert of time," in Dali's phrase. Here time must lose all meaning. Permanence goes with it: ants, a common theme in Dali's work, represent decay, particularly when they attack a gold watch, and become grotesquely organic. The monstrous fleshy creature draped across the painting's center is at once alien and familiar: an approximation of Dali's own face in profile, its long eyelashes seem disturbingly insectlike or even sexual, as does what may or may not be a tongue oozing from its nose like a fat snail.

The year before this picture was painted, Dali formulated his "paranoiac-critical method," cultivating self-induced psychotic hallucinations in order to create art. "The difference between a madman and me," he said, "is that I am not mad."

René Magritte

The Lovers. 1928
Illustrated on page 282

William S. Rubin, *Dada, Surrealism, and Their Heritage*, **1968**, pages 91, 93

The first year of Surrealist painting following the publication of the manifesto [in 1924] had witnessed the total dominance of the automatism so emphasized in its text. But late in 1925 the Belgian painter René Magritte, under the influence of [Giorgio] de Chirico, renewed "dream image" illusionism. . . .

The style Magritte established in 1925 remained essentially the same to the end of his life. [1] He sought an almost total prosaism in the things he represented. . . . In his greater closeness to de Chirico, Magritte distinguishes himself from the other Surrealists by the technical devices—*frottage*—and aesthetic formulation—biomorphism—he eschews. [2] In an attempt to create a purely poetic image, he sought to by-pass modernist painting, though the handsomeness and economy of his compositions recall his apprenticeship as an abstractionist. The originality of his images—though not the measure of their pictorial quality—lies in the secret affinities between dissociated objects revealed by means of Lautréamont's poetic principle.

The paintings produced during the first three years of Magritte's maturity were dark in mood and in color. The . . . frustrating isolation of *The Lovers* [is] more intense than the impersonality, irony, and dead-pan humor his later painting allowed. Overwhelmingly black and brown, [it is] devoid of the decorative qualities introduced by 1929 in *On the Threshold of Liberty* and emphasized in recent paintings such as *Arch of Triumph*, the background of which suggests Magritte's assimilation of the decorative "all-over" configurations familiar in abstract painting after World War II.

René Magritte

The False Mirror. 1928
Illustrated on page 283

Helen M. Franc, *An Invitation to See: 150 Works from The Museum of Modern Art*, **1992**, page 95

Magritte was strongly influenced by [Giorgio] de Chirico and, like him, sought to reveal the hidden affinities linking objects that are normally dissociated. His pictures present a challenge to the "real" world by turning everyday logic topsy-turvy, substituting a different kind of order, which our unconscious mind recognizes as having a rationale of its own.

In *The False Mirror*, equivalences are established between the eye and the cloud-filled sky that forms its iris, the pupil being the black disk that floats like a sun in the center. Isolated from any anatomical reference to a depicted face, the huge eye not only fills the entire height and breadth of the canvas but also seems to extend beyond the picture's edge at left and right. The image owes much of its compelling effect to this inflated scale and to the meticulous finish with which it is painted, recalling works by the Flemish old masters of Magritte's native Belgium. In his adherence to illusionistic technique, Magritte anticipated the "hand-painted dream photographs" of his fellow Surrealist [Salvador] Dali.

In contradistinction to [Odilon] Redon, Magritte always insisted that his art could not be equated with symbolism, for this would imply a supremacy of the invisible over the visible. "My paintings have no reducible meaning: they *are* a meaning," he declared.

The title of this picture was given to it by Paul Nougé, a writer who was a member of the Surrealist group that Magritte helped to found in Brussels shortly before his sojourn in the environs of Paris, where *The False Mirror* was painted. Magritte's visualization of the mind's eye has become a kind of modern icon, frequently copied or adapted, as in the CBS trademark.

Joan Miró

The Hunter (Catalan Landscape). 1923–24
Illustrated on page 284

William S. Rubin, *Miró in the Collection of The Museum of Modern Art*, **1973**, pages 20, 23, 24

The Hunter, also known as *Catalan Landscape*, [1] is Miró's first painting realized wholly within the profile of his personal style, the first free of the manifest influences of Cubism and Fauvism. Its gracile drawing, which links the entire surface in its filigree tracery, is of a tenuousness that remains unsurpassed in his work. And its imagery witnesses the introduction of many signs and symbols that were to become familiar in the landscape of *miromonde*. . . .

The landscape of *The Hunter* is dominated by a beige circle that stands for the trunk of a large carob tree; this tree sprouts but a single leaf that stands, in turn, for all its foliage. The leaf is an example of indicating a set by a single extract; the circle no doubt derives from a memory-image "selection" of roundness as the trunk's most essential attribute. The perspective of the horizontal cross section of the trunk, exactly at right angles to that of most other constituents of the picture, is consistent within the standard "inconsistencies" characteristic of memory images.

Also seeming to grow out of the tree is a giant eye whose pupil is exactly on the horizon line, as if the scene were laid out in perspective according to that eye's position[2]—a situation that identifies it with the eye of the painter himself. Indeed, the extraordinary adventures and metamorphoses of the disembodied eye, as it traverses so many of Miró's pictures of the twenties, reinforce its identification with the artist's persona—a not unknown symbolism,[3] and one which would certainly occur to a painter whose very name means "he saw." Autonomous eyes, eyes growing out of landscape elements, and supplemental eyes growing out of animals were familiar to Miró from Romanesque art and from the paintings of Hieronymus Bosch.[4] Closer to Surrealism were the mysterious disembodied eyes to be found in the work of [Odilon] Redon[5] and—in the years just prior to *The Hunter*—of Max Ernst.[6] But while the giant eye in *The Hunter* may be read as growing out of the tree—and this has been its standard interpretation—it may also be read as situated at "infinity" on the distant horizon (this would explain why it is only partially visible through the carob tree); indeed, Miró himself does not necessarily identify the eye in this picture with the carob tree.[7]

Joan Miró

The Birth of the World. 1925
Illustrated on page 285

William S. Rubin, *Miró in the Collection of The Museum of Modern Art*, **1973**, pages 30, 32, 33

Late in 1924 Miró developed a new manner of painting, which in the originality of its means and effects remained unrivaled until the work of Jackson Pollock more than two decades later. This spontaneously executed, manifestly post-Cubist type of picture dominated Miró's output in 1925 and continued to play an important role—alternating with images in a painstaking, precise style—until the end of the twenties. Indeed, the new manner and the "automatic" techniques by which it was effected have, with modifications, remained basic to Miró's arsenal ever since. *The Birth of the World*, executed in Montroig in the summer of 1925, is his masterpiece in this style.

The new method, which involved loose brushing, spilling and blotting thinned-out paint in tandem with cursive, automatic drawing, not surprisingly led Miró to a larger average format. But even among his new large canvases, *The Birth of the World* (slightly over eight by six feet) was exceptional in size—which intensified the effect of its unexpected style. An extraordinary challenge to the conception of easel painting that obtained at that time, *The Birth of the World* was to enjoy an underground reputation among a handful of the artists and critics who saw it in the studio in 1925–26. However, the response of most viewers—even of those interested in Miró's work—was negative, and until after World War II this was the prevailing attitude toward all of Miró's paintings in this style. René Gaffé, the pioneer Belgian collector who purchased *The Birth of the World* the year following its execution,[1] spoke of the reactions of his collector and critic acquaintances: "It goes without saying that they took Miró for a madman, a hoaxer, or both. But they took me for an even greater fool for having bought the picture. The informed opinion of the day was that I had been taken."[2]

Gaffé developed an extremely protective stance toward *The Birth of the World*, never allowing it to leave his home until its first brief public exhibition in Brussels over thirty years after it was painted;[3] it would not be shown again until The Museum of Modern Art's "Dada, Surrealism, and Their Heritage" [exhibition] in 1968 and has never been publicly exhibited in Paris.

The "underground" reputation of *The Birth of the World* was certainly among the considerations that led André Breton in the middle-fifties to liken it to [Pablo] Picasso's *Demoiselles d'Avignon* [see page 149], itself not publicly exhibited or reproduced until many years after its execution; but when Breton called *The Birth of the World* "the *Demoiselles d'Avignon* of the '*informel*,'"[4] he had primarily in mind the picture's radical character, large size, and, above all, the fact that it had anticipated the type of post–World War II painting known as *l'informel* in France (the counterpart of Abstract Expressionism in America). And earlier, in 1928, when Breton had written that it was "by such pure psychic automatism that Miró may pass for the most Surrealist of us all,"[5] he was thinking of Miró's improvisational, loosely brushed paintings of 1925–28 as a group, "but above all," he has pointed out, "of *The Birth of the World*."[6]. . .

Miró has spoken of this picture "as a sort of genesis," and although the title, *The Birth of the World*, was invented by either Breton or Paul Eluard, as the artist recalls, it was very much in what Miró considered the spirit of the picture. As a genesis, it is the first of a long series of visionary Surrealist works which deal metaphorically with the act of artistic creation through an image of the creation of a universe.

Joan Miró

"Hirondelle Amour." 1933–34
Illustrated on page 286

William S. Rubin, *Miró in the Collection of
The Museum of Modern Art*, **1973**, page 64

Hirondelle/Amour ("Swallow/Love") is one of four
paintings of 1934 that were occasioned by a commission
for a group of tapestry cartoons.[1] In executing these pic-
tures, however, Miró made no concession to the tech-
niques of the weaver and conceived them entirely as
paintings in their own right. The painting is the prod-
uct of a more spontaneous procedure than had been
used the previous year for the large paintings based on
collages. The drawing, though less "automatic" than in
certain 1925–26 paintings, not only recaptures the spon-
taneity of that era, but exhibits greater exuberance and
rhythmic continuity—and this within an overall con-
text of more commanding pictorial authority. The
forms seem to spill from Miró's brush as it figure-skates
its way across the blue ground which we read as sky.
Most of the illusionist space of the 1933 paintings has
disappeared. No longer isolated in static suspension but
galvanized by continuous rhythms, the now slightly
shaded design elements are locked into the picture
plane in reciprocal relation to the blue ground, so that
the configuration binds the entire surface.

Miró's hand seems to reenact the ecstasy of flight.
Among the figures that tumble from it as it glides across
the canvas is a swallow; without lifting the brush dipped
in the black of his contour lines, he writes the word *hi-
rondelle*. Just below, in a free association to his sensations
of joy, freedom, and simple celebrity, he writes *amour*.
Functioning as decorative linear passages as well as po-
etic allusions, these words recall the graphism of Miró's
"picture-poems" of the twenties,[2] except that here the
words are not set in syntactical arrangements but func-
tion rather as simple exclamations.

It is impossible to identify most of the shapes in
Hirondelle/Amour as specific motifs. At the bottom, to
be sure, there is the suggestion of a human head juxta-
posed helter-skelter with stylized signs that in Miró's
other paintings often stand for breasts and for hair. And
at the top—swooping, hovering, darting—is unques-
tionably a flock of birds. In between, however, seeming
to rise from the constraints of gravity and aspiring to
the weightlessness and freedom of flight, are forms
which suggest human limbs that alternately issue into
hands or feet—or metamorphose into birds. It was
probably with regard to pictures such as *Hiron-
delle/Amour* that [Alberto] Giacometti, one of Miró's
closest friends at the time it was painted, was later to

say, "For me, Miró was synonymous with freedom—
something more aerial, more liberated, lighter than
anything I had ever seen before."[3]

Joan Miró

Still Life with Old Shoe. 1937
Illustrated on page 287

James Thrall Soby, *Joan Miró*, **1959**, pages 80, 83,
86–87

Among his friends Miró is known for his almost total
lack of interest in political matters. At the same time,
he cannot have failed to have been outraged by the
atrocities of General Franco's Fascist and Nazi allies.
Moreover, it is no exaggeration to say that the Spanish
Civil War stirred the artists and writers of Europe (and
America) as they had not been stirred by a foreign issue
since the Greek War of Independence, when men as
different in temperament as [Lord] Byron and [Eu-
gène] Delacroix were impelled to protest. At any rate, in
1937 Miró, perhaps as a deliberate foil to [Pablo] Pi-
casso's magnificent *Guernica*, produced a work unique
in his career as an easel painter: the *Still Life with Old
Shoe*, a tragic and forceful summary of his emotions
about the war.

Pierre Loeb, at that time Miró's Paris dealer, has said
that the artist set up on a table on the second floor of
Loeb's gallery on the rue des Beaux-Arts an actual still
life consisting of an apple[1] pierced by tines, a gin bottle
with paper wrapping, a loaf of bread, and an old shoe,
and painted it all of every day for a month. (Afterwards
Miró took the picture back to his new studio on the rue
Blanqui to finish; it is dated on the back January
24–May 29, 1937.) For the melancholy protest Miró
wished to make against Spain's poverty and suffering, a
return to the realism of his early career must have
seemed necessary. The colors are dark and lurid. In the
sky a poltergeist-like shadow floats in from the left, the
bottle casts a heavy shadow and ominous black clouds
fill the upper right section. The apple is savagely im-
paled by the fork, the loaf of bread's carved end be-
comes a skull, and even the gin bottle with its
grimacing letters, G I, seems menaced by the upheld,
ragged ends of its own wrapping. The more gentle col-
ors of the old shoe do nothing to obviate its vitality as a
symbol of need; the calluses and wrinkles of long wear
are effectively defined, and one senses the weariness of
the foot it once encased.

To create so memorable a polemic work of art in
terms of still life is a very considerable achievement, not
unworthy of its allegorical companion piece, Picasso's

223

Guernica. It remains to be said, however, that the picture seemed to some of Miró's more abstract-minded champions a betrayal of his innate gifts. The Surrealists, on the other hand, and indeed many of those admirers of the artist who are not disturbed by humanistic or psychological content, have praised the image enthusiastically. For quite apart from its subject matter, the picture is beautifully composed and its captivating fluidity of tone repays our closest scrutiny. Miró himself is justifiably proud of this painting. Some years ago he told the writer that it foretold a direction he would like to follow more and more often as a gesture of protest against the decorative tendencies of much abstract art he saw around him. There is no evidence that he has done so on an easel scale. Perhaps only the horrors of war in his beloved Spain could have prompted him to paint this unique and haunting picture.

André Masson
Battle of Fishes. 1926
Illustrated on page 288

William S. Rubin, *André Masson*, **1976**, pages 15, 16, 21, 22, 25, 26

The often hybrid subjects of Masson's pictures of the middle twenties suggest a constant state of generation, eclosion, and metamorphosis. Horses become celestial signs . . . while architecture dissolves into humanoid forms; the limbs and extremities of human figures issue into birds or fish, their organs become flowers or fruit. A sense of pervasive movement, and sometimes even violence, emerges from these transformations. . . . The pictures teem with elements that seem to be growing and changing. But this *élan vital* is in constant confrontation with processes and symbols of dissolution and destruction—an alternation that produced the poetic and the visual rhythms of the pictures, their characteristic "pneuma.". . .

The new forms which forced their way into the Cubist structures of the 1924 Massons represented on both the plastic and poetic level a transposition into painting of *trouvailles* of his automatic drawings. These drawings . . . come as close as anything Surrealism produced to the dictionary definition of the term as given in the first manifesto (which some of them antedate).[1] Masson had no particular subject matter in mind as he began these drawings; the hand wandered freely, producing a web of markings out of which subject elements were subsequently, in effect, "provoked.". . .

The automatic drawings provided, then, a reservoir of both forms and subjects for Masson's paintings of 1924–25. The paintings, however, were necessarily executed in a measured, unautomatic way. This lag seems increasingly to have bothered Masson in 1926, and he cast about for a way in which the process of painting could be made to accommodate linear automatism and thus profit from the freshness and directness of the drawings. The problem lay in "drawing" with a brush: constant reloading broke the continuity of the line as well as the sequence of psychic impulses, while the drag of the brush hindered its speed and its consistency . . . [Vasily] Kandinsky had faced this problem in the more rapidly improvised of his pictures of 1912–14; he solved it by drawing on the canvas with pen and pencil. [Jackson] Pollock would confront it over two decades later. . . .

Masson's solution to this problem . . . involved drawing directly from the tube and pouring a liquid medium (often spreading it with the hand). In the sand paintings of 1926–27,[2] Masson first poured glue in patches and lines over the surface of his canvas, using his fingers to spread it here and there in a sort of automatic drawing. The sand which he subsequently sprinkled over the entire surface remained on the gluey areas and fell away from the rest when the stretcher was tilted. . . . The apparently random spillings and patches formed by the glue and sand constituted a suggestive ground that conditioned the second phase of the configuration—the inscription of automatic drawing. The drawing might be accomplished by spilling a very liquid medium of the sand . . . or by drawing directly with the tube. . . . In instances where the canvas was primed, as in *Battle of Fishes*, linear detailing might be added with charcoal or pencil. . . .

Battle of Fishes is the most individually rich illustration of the universe that is evoked collectively by the sand paintings. Only a small part of its surface is covered with sand. . . . This provides the environment for a group of sharklike creatures that devour one another. The configuration preserves all the randomness of its automatic beginnings, not only in the sand passages, but in the contouring and rubbing of pencil and charcoal inscribed around them. Yet it is finally no less ordered—if differently and less immediately perceived as such—than the oil paintings of 1924–25. This purely artistic order, which is arrived at in the later stages of the work, served psychologically for Masson as a symbolic counterthrust to the disruptive elements of his personality, whose unconscious and instinctual drives are the subjects of the pictures.

Matta

The Vertigo of Eros. 1944
Illustrated on page 289

Alberto Giacometti

The Palace at 4 A.M. 1932
Illustrated on page 290

William S. Rubin, *Matta*, **1957**, pages 4, 6

The title, *The Vertigo of Eros (Le Vertige d'Éros)*, a pun on the phrase "*Le Vert-Tige des Roses*" (The Green Stem of the Roses), relates to a passage in which [Sigmund] Freud located all consciousness as falling between Eros and the death wish—the life force and its antithesis. Afloat in a mystical light which emanates from the deepest recesses of space, an inscrutable morphology of shapes suggesting liquid, fire, roots and sexual parts stimulates an awareness of inner consciousness such as we trap occasionally in revery and dreams. Yet this imagery is wholly opposed to [Salvador] Dali's "hand-painted dream photographs" or [René] Magritte's dreamlike mutations and confrontations of objects in external reality. The components of everything we "see" in a dream, whatever their juxtaposition or distortion, are present in waking life. The flames and giraffes of Dali's noted enigma are in themselves visually commonplace. But Matta's language transcends this ultimately prosaic level of imagery. His invented shapes constitute a new morphology that reaches back behind the level of dream activity to the central and latent source of life, forming an iconography of consciousness before it has been hatched into the recognizable coordinates of everyday experience.

Light rather than color is the unifying factor in *The Vertigo of Eros*. It is light that suggests its unfathomable spaces, represses or exposes its symbols. By 1944 the colorful mountains, flames and congealed elements of the "inscapes" have dissolved into an *a priori* continuum of light in which float a galaxy of smaller and more tenuously linked forms. Simultaneously astral and genital egg shapes are foci or energy centers, articulating a vision in which light forms a common denominator like that divined by Eliphas Levi, a mystic for whose speculations Matta felt a deep affinity. In his *History of Magic* Levi writes: "There exists a mixed agent, natural and divine, corporeal and spiritual, a universal plastic mediator, a common receptacle of the vibrations of movements and the images of form. . . . this universal agent of the works of nature is *astral light*."

Christian Klemm, *Alberto Giacometti*, **2001**, page 100

The most magical Surrealist object made by Giacometti is *The Palace at 4 A.M.*, which was bought by Alfred H. Barr, Jr., for The Museum of Modern Art in 1936, only four years after its execution. A viewing of the *Palace* raises the question: Is this still an object, a thing? Almost an immaterial drawing in space, the *Palace* barely steps across the threshold between the imagination and external space. In a short text for *Minotaure* Giacometti described his working method by drawing on the example of the *Palace*, the idea of which gradually took on its final, succinct form in the late summer of 1932. He said that the work appeared in its finished form before his inner eye and that it was then quickly realized.[1] It was only in the finished sculpture that he found—albeit altered—images, impressions, and experiences that had deeply affected him, a working method typical of the Surrealists. According to the artist the *Palace* reflects a past time when he and a woman attempted obsessively to build a palace out of matchsticks, which always collapsed at the slightest movement. Giacometti attributes the spinal column to the woman; the standing figure to the left he identified as his mother as she appeared to him as a child; and the artist saw himself in the object in the unfinished or ruined tower. Everything seems noncorporeal, transparent, individual, and at the same time general: the timeless temple facade with three doors and the hieratically unapproachable, self-contained figure of the mother, opposite her Giacometti's lover at the mercy of time and thus of death, and the fragile glass walkway that links the two spheres and crosses over the symbol of masculinity, itself half eye, half sexual organ, ambiguously rising or falling.

The piece seems like the model of a stage with a constellation of figures from a psychodrama. It has only one main viewing angle and, as [Reinhold] Hohl has remarked, bears a relationship to [Arnold] Böcklin's visionary painting *Isle of the Dead*.[2] By contrast the sign-like reduction points forward to a diagram that Giacometti later used in his most complex autobiographical text, "Le Rêve, le sphinx et la mort de T." (The Dream, the Sphinx and the Death of T.) of 1946, as a way of demonstrating the tangled simultaneity of events in our memories.[3] Here events do not come to Giacometti chronologically but are linked by themes and all at once: perception and cognition are actuated in a web of spatial interconnections. That accounts for the thematic and formal plenitude of Giacometti's work

and will prove the impetus for a specific, phenomenological approach in his postwar output.

Hans Bellmer

The Machine-Gunneress in a State of Grace. 1937
Illustrated on page 291

K. G. Pontus Hultén, *The Machine as Seen at the End of the Mechanical Age*, **1968**, page 160

Many Surrealists of the 'thirties accepted without question the misconceptions about technology incorporated in the theories of machine-aesthetics formulated by such men as Le Corbusier, and ardently embraced by [Fernand] Léger. The qualities of functionalism, standardization, and utility which these theorists attributed to the machine and singled out for praise were, however, rejected in an equally uncritical, emotional way by the Surrealists.

The Surrealists were, nevertheless, strongly attracted by the erotic overtones of machines and their movements. Hans Bellmer, a Berlin artist who in the early 'twenties had been associated with [George] Grosz and [John] Heartfield, began constructing his puppet-like figures in 1933, inspired by the doll Olympia in a Max Reinhardt production of *The Tales of Hoffman.* Photographs of Bellmer's doll, a female mannequin that had ball joints which allowed it to be dismantled and reassembled in various erotic positions, were seen by the Paris Surrealists and reproduced in their review *Minotaure* in 1934. The *Machine-Gunneress* [was] done after Bellmer had visited Paris in 1936 and joined the Surrealists . . .

Besides reflecting the Surrealists' general skepticism toward the machine, this particularly aggressive version of Bellmer's doll alludes to the threat of the heavy war machine that was building up at the time.

Alberto Giacometti

Woman with Her Throat Cut. 1932
Illustrated on page 291

Peter Selz, *Alberto Giacometti*, **1965**, pages 8, 9, 10, 11

"To render what the eye really sees is impossible" [said Giacometti] . . . Everyone before him in the whole history of art, he continued, had always represented the figure as it is; his task now was to break down tradition and come to grips with the optical phenomenon of reality. . . .

Like other artists of his generation he is engaged more in the adventure than concerned with the result.

Each work is a step for him, a study for new work, for the task of achieving the impossible: to render reality truly as it appears to the eye and yet to make a sculpture or a painting which, somehow, can find its place in the history of art. . . . His frank erotic symbolism, the near-abstraction of his work, his exploitation of the dream and reliance on the unconscious, brought him into close contact with the Surrealists, and for a brief time he took part in their exhibitions and wrote for their publications. But whereas they seemed satisfied once they had found a certain style and imagery, Giacometti continued to experiment, discovering new forms and symbols, such as the frightening *Hand Caught by a Finger*, a fiendish system of gears which, if they did function, would grind the hand to bits. The violent and destructive aspects of his imagination and an obsession with sexual murder is revealed most clearly in the *Woman with Her Throat Cut*, a nightmarish image, part woman, part animal, part machine. In the *Invisible Object*, on the other hand, his frightened self and his perpetual fear of the void find a mysterious climax. Simultaneously with work of this Surrealist nature, Giacometti also explored the solidity of objects, making his remarkable *Cubist Head*, which once again shows his fascination with man's glance.

Joan Miró

Object. 1936
Illustrated on page 292

William S. Rubin, *Miró in the Collection of The Museum of Modern Art*, **1973**, pages 70, 71

This object is distinguished from Miró's other constructions, earlier and later, by its more thoroughgoing literary character, which placed it more directly in the spirit of the Surrealist objects that proliferated in avant-garde circles during the 1930s. Elsewhere, Miró tended to shape or paint over the *objets trouvés* he used; here all the components save the wooden cylinder (cut by a carpenter according to the artist's specifications) were used as found.

The Surrealist object was essentially a three-dimensional collage of found articles chosen for their metaphoric potential rather than for their purely visual, that is plastic, value. Its literary character opened the possibility of its fabrication—or, better, its confection—to poets, critics, and others who stood, professionally speaking, outside or on the margins of the plastic arts. This partially explains the tremendous vogue that reached a climax in the famous "Exposition Surréaliste d'Objets" held in Paris at the Charles Ratton Gallery in May 1936. The flurry of activity leading to that exhibi-

tion seems to have inspired Miró to create this very uncharacteristic work in Barcelona during the spring of the year. . . .

Miró's 1936 object may be read—and Miró concurs with this interpretation—as a kind of poetic fantasy, a chain of associations literally springing from the head of the man whose hat forms the base of the construction. Thus, the red plastic fish that swims around the brim of the latter and the map[1] that projects from it suggest the vast expanses of the mind's universe. The isolation of a lady's gartered leg, her foot in an elegant high-heeled shoe, focuses interest on a very particular region of the subject's thoughts. This fetishistically isolated leg is actually movable, as it hangs from a string. . . .

In this object, Miró was working a terrain that was not properly his own. Though a poetic painter, he is not a literary artist of the type that can entirely put aside plastic concerns. Indeed, to the extent that the wooden core of his work was carefully designed, Miró did not even try to put them aside. Moreover, sculpture does not separate itself as clearly as does painting from the world of objects. Almost any three-dimensional form can be *seen as sculpture*, if not necessarily as good sculpture. The determination is largely based on the observer's expectations or mental set. . . . However much Miró may have tried to minimize his aesthetic consciousness in putting together the Museum [of Modern Art's] object, it is precisely the presence of his formative hand that makes this work enduring, that keeps it interesting after many cleverer and more *outré* objects by his Surrealist friends have begun to pall.

Alexander Calder
Gibraltar. 1936
Illustrated on page 292

Alexander Calder, in *The Museum of Modern Art Bulletin*, **1951**, page 8

My entrance into the field of abstract art came about as the result of a visit to the studio of Piet Mondrian in Paris in 1930.

I was particularly impressed by some rectangles of color he had tacked on his wall in a pattern after his nature.

I told him I would like to make them oscillate—he objected. I went home and tried to paint abstractly—but in two weeks I was back again among plastic materials.

I think that at that time and practically ever since, the underlying sense of form in my work has been the system of the Universe, or part thereof. For that is a rather large model to work from.

What I mean is that the idea of detached bodies floating in space, of different sizes and densities, perhaps of different colors and temperatures, and surrounded and interlarded with wisps of gaseous condition, and some at rest, while others move to peculiar manners, seems to me the ideal source of form.

I would have them deployed, some nearer together and some at immense distances.

And great disparity among all the qualities of these bodies, and their motions as well.

A very exciting moment for me was at the planetarium—when the machine was run fast for the purpose of explaining its operation: a planet moved along a straight line, then suddenly made a complete loop of 360° off to one side, and then went off in a straight line in its original direction.

I have chiefly limited myself to the use of black and white as being the most disparate colors. Red is the color most opposed to both of these—and then, finally, the other primaries. The secondary colors and intermediate shades serve only to confuse and muddle the distinctness and clarity.

When I have used spheres and discs, I have intended that they should represent more than what they just are. More or less as the earth is a sphere, but also has some miles of gas about it, volcanoes upon it, and the moon making circles around it, and as the sun is a sphere—but also is a source of intense heat, the effect of which is felt at great distances. A ball of wood or a disc of metal is rather a dull object without this sense of something emanating from it.

When I use two circles of wire intersecting at right angles, this to me is a sphere—and when I use two or more sheets of metal cut into shapes and mounted at angles to each other, I feel that there is a solid form, perhaps concave, perhaps convex, filling in the dihedral angles between them. I do not have a definite idea of what this would be like, I merely sense it and occupy myself with the shapes one actually sees.

Then there is the idea of an object floating—not supported—the use of a very long thread, or a long arm in cantilever as a means of support seems to best approximate this freedom from the earth.

Thus what I produce is not precisely what I have in mind—but a sort of sketch, a man-made approximation.

That others grasp what I have in mind seems unessential, at least as long as they have something else in theirs.

Calder

Gibraltar

Illustrated on page 292

Alfred H. Barr, Jr., *Masters of Modern Art,* **1954,** page 146

Early in 1932, just before they were first exhibited, Calder asked Marcel Duchamp what he should call his new moving constructions.[1] Duchamp immediately answered "mobiles." A year earlier, Jean Arp had named Calder's first static construction "stabiles." The nomenclature of Calder's art could scarcely have had more distinguished sponsors, though [Piet] Mondrian was a greater inspiration to Calder, and [Joan] Miró had greater influence upon his art.

Marcel Jean

Specter of the Gardenia. 1936

Illustrated on page 293

Marcel Jean, text sent to the Museum during *The Art of Assemblage* exhibition, **1961**

In *The Specter of the Gardenia,* an "image-object": the zip fastener . . . is introduced as a plastic translation of another current expression: . . . "eyes flashing like lightning." Thus the plaster head, covered with a black wool sheath where, in place of eyes, two brilliant metal zippers seem to cast a piercing look, at the same time may convey the idea of a stormy sky illuminated by flashes of lightning; while small bits of plaster gleam here and there on the darkened face like specks of fire in a black cloud.

The zippers can be opened or closed like real eyes and their circular holes can take, like pupils, various positions which will change the expression of the face. Tiny photographs have been inserted behind the zippers, their images being not bigger than the reflections which can be observed in the crystalline of real eyes: one of these photographs shows a star, the other the minute face of a woman.

The "collar" is another equivalent: the segment of film around the neck appears as a black replica of the white celluloid collars which were in use at the beginning of the century, as cheaper substitutes for linen ones. The image of Dora Maar shows upon this piece of film: [Pablo] Picasso's one time friend gave me this clipping of a short scene featuring herself, to replace the one that was lost after she photographed my object in 1936.

Partly because of this film collar, the object took at first the title of an old movie reel called *Le Secret du Gardénia* ("The Gardenia's secret") discovered in a shop at the "Flea market" in Paris where the head's red velvet plinth was also bought. When the object was shown at the Surrealist Object exhibition, Galerie Charles Ratton, Paris 1936, the title became, through a misprint in the catalogue: *Le Spectre du Gardénia,* thus giving emphasis, unintentionally, to the idea of a dark projection, shadow or "negative" of some white thing such as a gardenia flower is. And then, it may be added, the specks of white plaster on the brow and cheeks of the head, might appear as freckles in negative. . . .

In the whole, the dramatic, phantom-like aura which seems to me to be hovering around this object was probably present from the start. The head's shape was obtained by remodeling one of those plaster casts which are on sale in some artists' materials shops; the cast found most suitable for the purpose happened to be the one reproducing the well-known bust, by [Jean-Antoine] Houdon, of King Louis XV's mistress, Madame Dubarry; and I remembered afterwards that this lady's gardenia-like existence ended on the guillotine, during the stormy days of the French Revolution.

Joseph Cornell

Untitled (Bébé Marie). Early 1940s

Illustrated on page 293

Kynaston McShine, in *The Art of Assemblage,* **1961,** pages 68, 70

Joseph Cornell's serene and exquisite boxes are journeys into an enchanted universe that also has the reality of this world. The evocative and mysterious poetry arising from this severely balanced work is that of the marvelous, of paradox and enigma, of questions without answers and answers without questions. The boxes are not collections of fetishes, but treasuries. They contain the hermetic secrets of a silent and discreet Magus, disguised as a game full of delightful humor and playful irony. They are autonomous allegories providing a discovery of the past, present and future; an endless complex of ideas and associations.

It is no coincidence that Cornell has selected astrological charts and astronomical maps for many of his boxes, for the sun, the moon, and the planets which govern objects and men also reveal the knowledge of the universe. Sole master of this domain, he defies all laws or tradition. His hieratic talismans are like the highly treasured possessions of a child—anything: a Haitian postage stamp, a clay pipe, a compass, even the Night.

Despite an aura of renunciation and isolation, the magic of these boxes is not Faustian or "black," but nat-

ural and filled with love. Cornell's work stands as a crystalline refuge from a world of frustrated hopes and increasing complexity, from an impersonal world that has forgotten the magic and mystery of poetry. Lost illusions are sheltered along with pristine innocence and the pure naïveté of childhood. . . .

His poetry of recollection and desire transcends eccentric nostalgia or excessive romanticism. Realizing what is present we are also aware of the infinity of what is absent. The emptiness of some boxes, some with uncoiled clock springs, perches which some rare bird has deserted, glass neatly fractured by a bullet, or the sands of the sea and of Time, becomes a grave and desperate warning. Cornell's assertion of purity and of paradox is basic and human. His art is as enduring as it is ephemeral, as sophisticated and imaginative as it is innocent and simple, as universal and real as it is mysterious and personal, as wise and serious as it is witty and ironic.

It is easy to fall under the spell of such a magician and seer.

Meret Oppenheim
Object. 1936
Illustrated on page 295

Jenny Holzer, in *Contemporary Art in Context*, **1990**, pages 55, 56

[This is] an everyday object but it's also an otherworldly thing. It could come from another civilization—maybe it did—and I think it's fair to say that this is a mundane object rendered sublime, absurdly sublime.

One reason I have continued to . . . enjoy it is because it was made by a woman. . . . I suppose, too, it was just handy to know that this piece was made relatively early in modern art, and was made successfully. As a woman artist, it does give you courage to go on to see that someone else has pulled it off before.

Another thing I like about this is the fact that it's very concise. . . . The scale, I think, in this case helps it. It's a nonart material: basic fur and teacup. . . . I think that women tend to be drawn to nonart materials . . . because women often deal with what I would call real-world subject matter—things that happen in the world—and so nonart materials are appropriate for these kinds of concerns. It's a generalization to say that all women work that way, but I think it's enough of a trend that it's interesting to note it. Still, Oppenheim is not as well known as she should be, I suspect. I think she got confined to the lower tier because of her sex.

The piece is sinister. It seems like a cup that could fight back. I suppose fur implies teeth, and so the cup could bite you. I also like that it's repulsive. That's always a good quality in art. I won't even say one reason for its repulsiveness, but I was thinking that when you're eating, there is nothing more disgusting than when you get a hair in your mouth. This is really an in-depth study in repulsion. . . . I like that the fur would be a way to muffle sound. It's like she killed off the chit-chat part of the tea ceremony. I like also that it would be insulated by the fur—the thermos effect.

I think that [confounding expectations] is a rich vein for artists to work in. . . . But I think it's also fine to make things that are genuinely shocking and that are about serious subjects. And I think if you use contradiction in the form or in the language itself, or in the placement of the work, that this is conducive to dealing with hard subjects and making good art. . . .

This is a latter-day projection onto the object, but I think this could be an early example of Conceptual art because . . . the thing can live in your mind once you've seen it. Although it is wonderful to see, you can carry it in your mind without actually looking at it. It's also a nice piece of art because you can make it yourself at home. That goes back to the nonart materials. . . .

Finally, what I like about this object is its quality of aggressiveness. . . . It certainly would throw a wrench into things if you brought this cup to afternoon tea; it wouldn't be the polite ceremony that tea parties are supposed to be. . . . I think that this piece tells you that life is not what it seems.

Dada

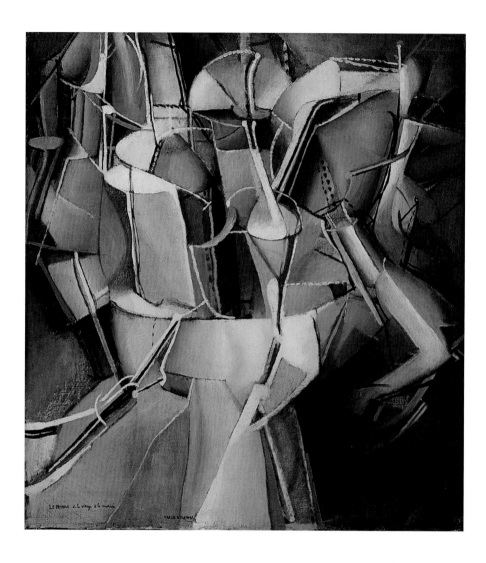

Marcel Duchamp | (AMERICAN, BORN FRANCE. 1887–1968)
THE PASSAGE FROM VIRGIN TO BRIDE. July–August 1912
OIL ON CANVAS, 23⅝ x 21¼" (59.4 x 54 CM)
PURCHASE, 1945

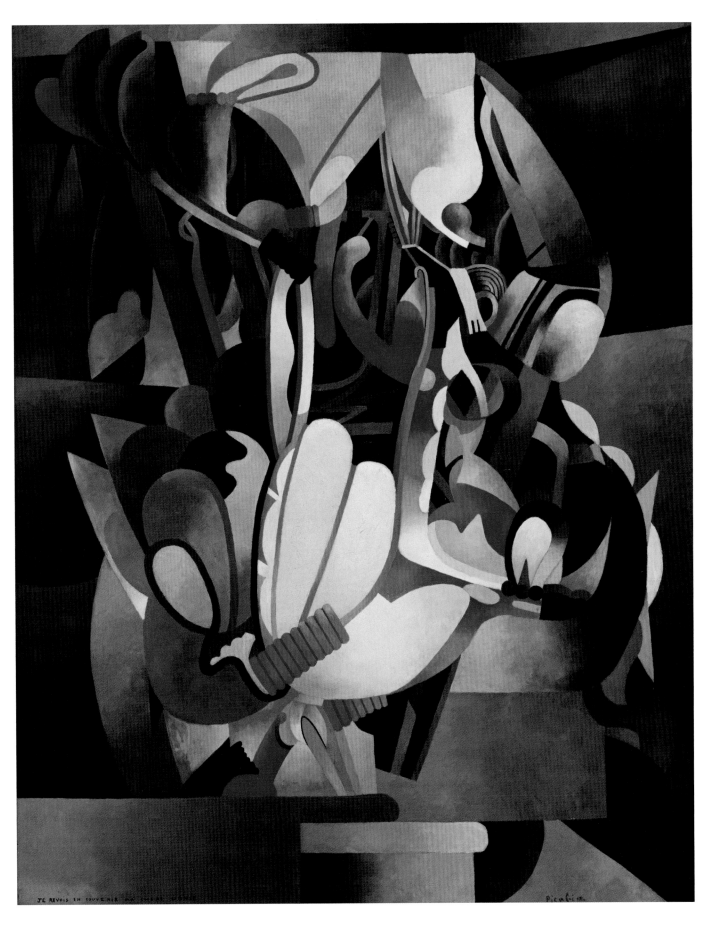

Francis Picabia | (FRENCH, 1879–1953)
I SEE AGAIN IN MEMORY MY DEAR UDNIE.
1914, possibly begun 1913
OIL ON CANVAS, 8′ 2½″ × 6′ 6¼″ (250.2 x 198.8 CM)
HILLMAN PERIODICALS FUND, 1954

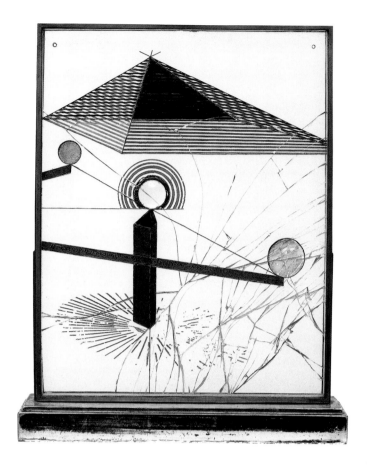

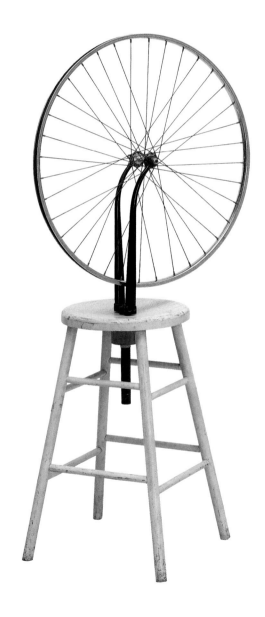

Marcel Duchamp | (AMERICAN, BORN FRANCE. 1887–1968)
TO BE LOOKED AT (FROM THE OTHER SIDE OF THE GLASS) WITH
ONE EYE, CLOSE TO, FOR ALMOST AN HOUR. 1918
OIL PAINT, SILVER LEAF, LEAD WIRE, AND MAGNIFYING LENS ON GLASS
(CRACKED), 19½ x 15⅞" (49.5 x 39.7 CM) MOUNTED BETWEEN TWO PANES OF
GLASS IN A STANDING METAL FRAME, 20⅛ x 16¼ x 1½" (51 x 41.2 x 3.7 CM)
ON PAINTED WOOD BASE, 1⅞ x 17⅞ x 4½" (4.8 x 45.3 x 11.4 CM), OVERALL
HEIGHT 22" (55.8 CM)
KATHERINE S. DREIER BEQUEST, 1953

Marcel Duchamp
BICYCLE WHEEL. 1951 (third version, after lost original of 1913)
METAL WHEEL MOUNTED ON PAINTED WOODEN STOOL, 50½ x 25½ x 16⅛" (128.3 x 63.8 x 42 CM)
THE SIDNEY AND HARRIET JANIS COLLECTION, 1967

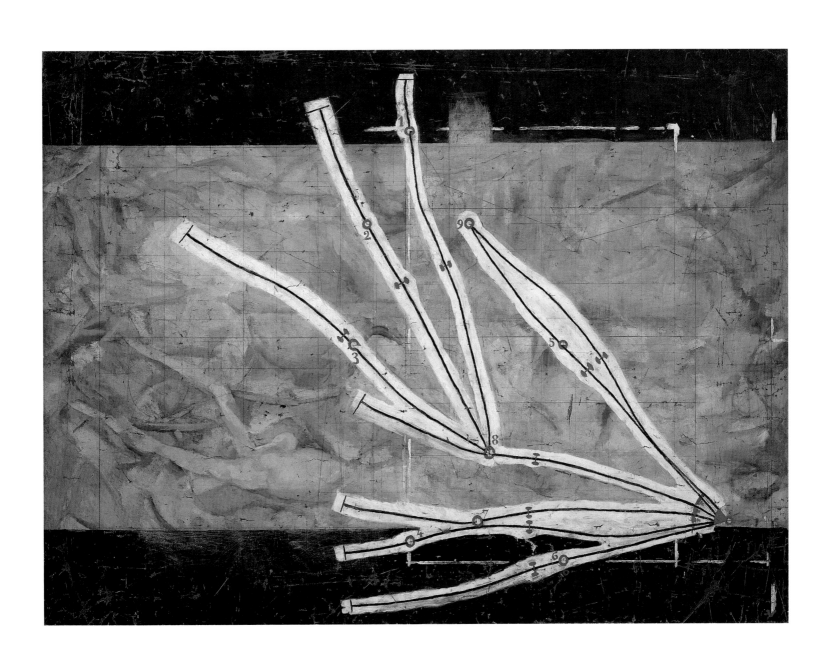

Marcel Duchamp
NETWORK OF STOPPAGES, 1914
OIL AND PENCIL ON CANVAS, 58⅝" x 6' 5¼" (148.9 x 197.7 CM)
ABBY ALDRICH ROCKEFELLER FUND AND GIFT OF MRS. WILLIAM SISLER, 1970

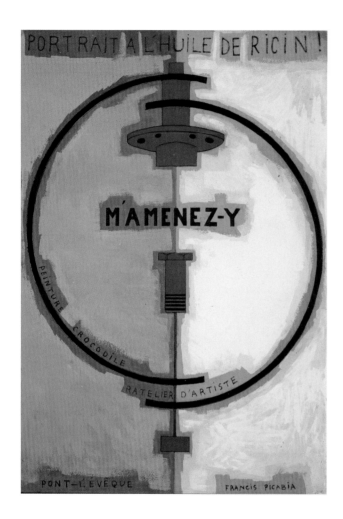

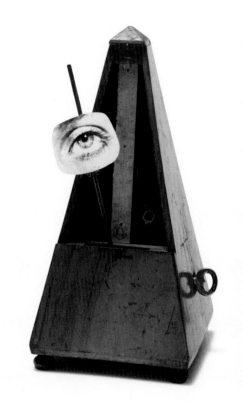

Francis Picabia | (FRENCH, 1879–1953)
TAKE ME THERE. 1919–20
OIL ON CARDBOARD, 50¾ x 35⅞" (129.2 x 89.8 CM)
HELENA RUBINSTEIN FUND, 1968

234

Man Ray
(AMERICAN, 1890–1976)
INDESTRUCTIBLE OBJECT (OR OBJECT TO BE DESTROYED).
1964 (replica of 1923 original)
METRONOME WITH CUTOUT PHOTOGRAPH OF EYE ON PENDULUM, 8⅞ x
4⅜ x 4⅝" (22.5 x 11 x 11.6 CM)
JAMES THRALL SOBY FUND, 1966

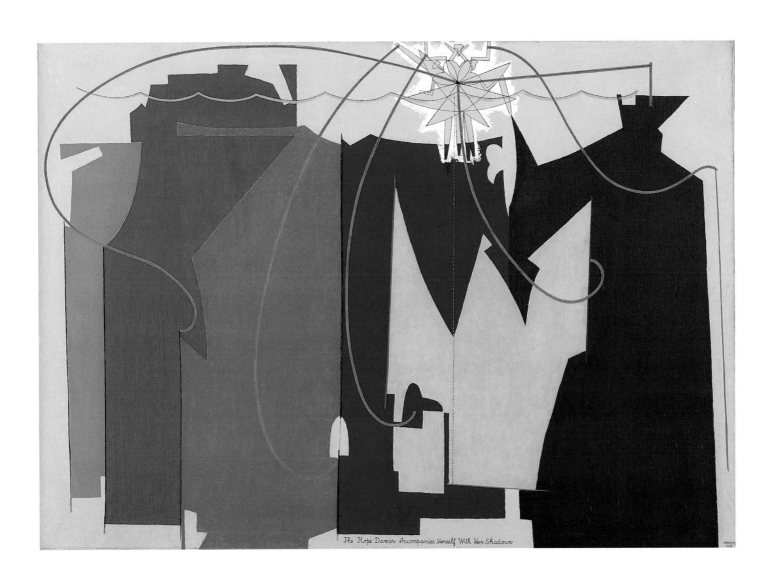

Man Ray
THE ROPE DANCER ACCOMPANIES HERSELF WITH HER SHADOWS. 1916
OIL ON CANVAS, 52" x 6' 1⅛" (132.1 x 186.4 CM)
GIFT OF G. DAVID THOMPSON, 1954

235

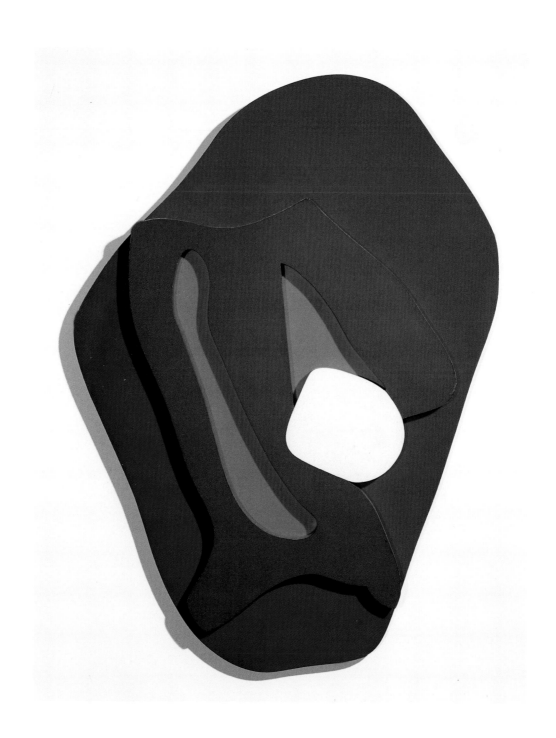

Jean (originally, Hans) Arp | (FRENCH, BORN
GERMANY [ALSACE], 1886–1966)
ENAK'S TEARS (TERRESTRIAL FORMS), 1917
PAINTED WOOD, 34 x 23¼ x 2⅜" (86.2 x 58.5 x 6 CM)
BENJAMIN SCHARPS AND DAVID SCHARPS FUND AND PURCHASE, 1979

Sophie Taeuber-Arp | (SWISS, 1889–1943)
DADA HEAD. 1920
PAINTED WOOD WITH GLASS BEADS ON WIRE, 9¼" HIGH (23.5 CM)
MRS. JOHN HAY WHITNEY BEQUEST (BY EXCHANGE) AND
COMMITTEE ON PAINTING AND SCULPTURE FUNDS, 2003

Hannah Höch | (GERMAN, 1889–1978)
INDIAN DANCER: FROM AN ETHNOGRAPHIC MUSEUM. 1930
CUT-AND-PASTED PRINTED PAPERS AND METALLIC FOIL ON PAPER,
10¼ x 8⅞" (25.7 x 22.4 CM)
FRANCES KEECH FUND, 1964

George Grosz | (AMERICAN, 1893–1959)
"THE CONVICT": MONTEUR JOHN HEARTFIELD AFTER FRANZ
JUNG'S ATTEMPT TO GET HIM UP ON HIS FEET. (1920)
WATERCOLOR, PENCIL, CUT-AND-PASTED POSTCARDS, AND HALFTONE
RELIEF ON PAPER, 16½ x 12" (41.9 x 30.5 CM)
GIFT OF A. CONGER GOODYEAR, 1951

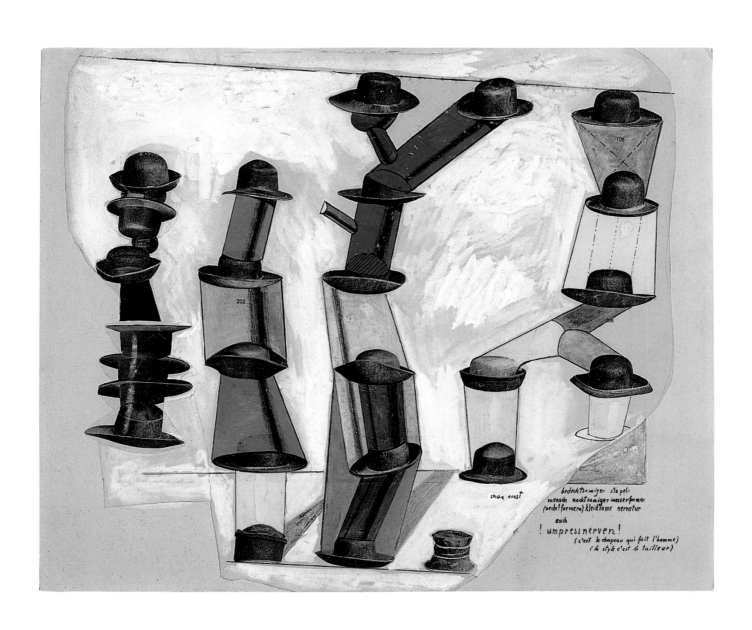

Max Ernst | (FRENCH, BORN GERMANY. 1891–1976)
THE HAT MAKES THE MAN. (1920)
GOUACHE AND PENCIL ON CUT-AND-PASTED PRINTED PAPERS ON
BOARD WITH INK INSCRIPTIONS, 14 x 18" (35.6 x 45.7 CM)
PURCHASE, 1935

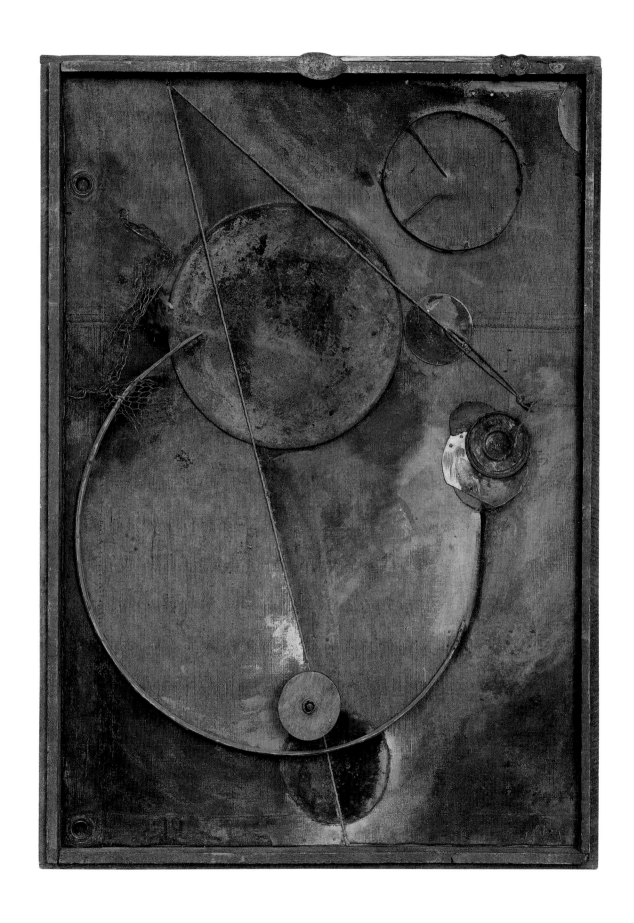

Kurt Schwitters | (BRITISH, BORN GERMANY. 1887–1948)
REVOLVING. 1919
WOOD, METAL, CORD, CARDBOARD, WOOL, WIRE, LEATHER, AND OIL
ON CANVAS, 48⅛ x 35" (122.7 x 88.7 CM)
ADVISORY COMMITTEE FUND, 1968

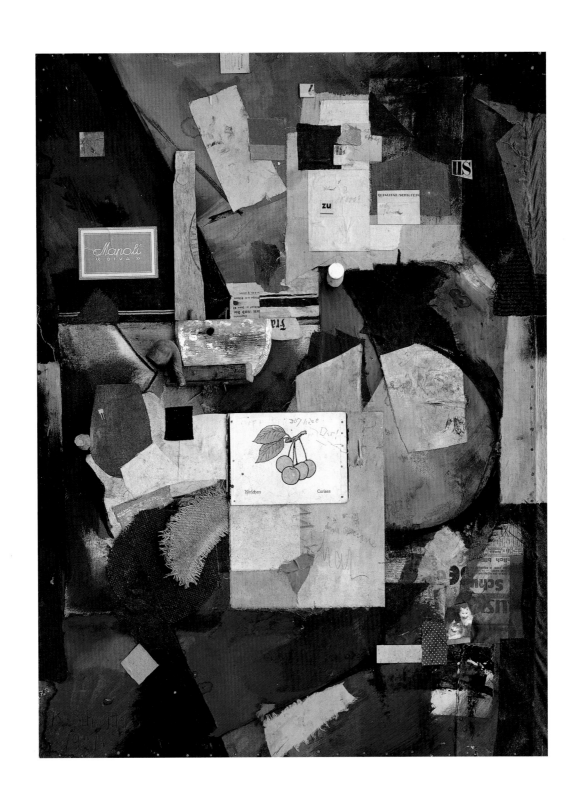

Kurt Schwitters
MERZ PICTURE 32A (THE CHERRY PICTURE). 1921
CUT-AND-PASTED COLORED AND PRINTED PAPERS, CLOTH,
WOOD, METAL, CORK, OIL, AND PENCIL AND INK ON CARD-
BOARD, 36⅛ x 27¼" (91.8 x 70.5 CM)
MR. AND MRS. A. ATWATER KENT, JR. FUND, 1954

241

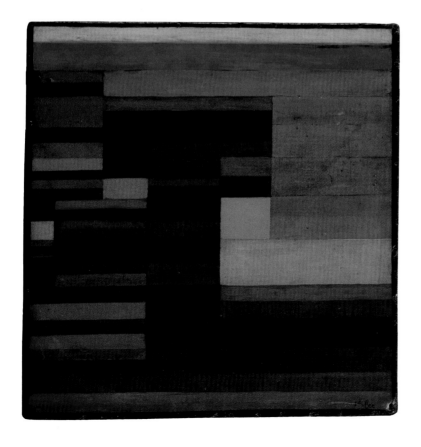

Paul Klee | (GERMAN, BORN SWITZERLAND. 1879–1940)
VOCAL FABRIC OF THE SINGER ROSA SILBER. 1922
WATERCOLOR AND PLASTER ON MUSLIN, MOUNTED ON CARDBOARD,
24⅛ x 20½" (62.3 x 52.1 CM)
GIFT OF MR. AND MRS. STANLEY B. RESOR, 1955

Paul Klee
FIRE IN THE EVENING. 1929
OIL ON CARDBOARD, 13⅜ x 13¼" (33.8 x 33.3 CM)
MR. AND MRS. JOACHIM JEAN ABERBACH FUND, 1970

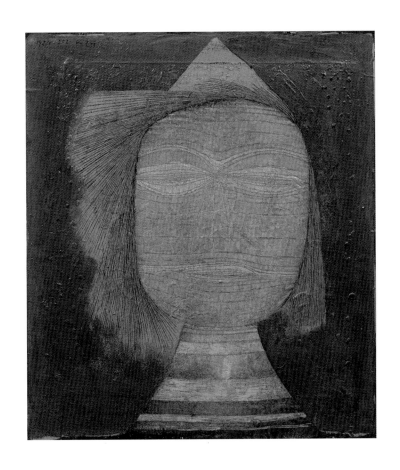

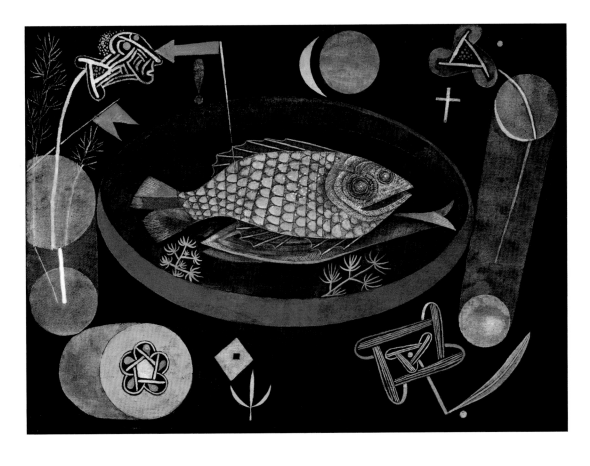

Paul Klee
ACTOR'S MASK. 1924
OIL ON CANVAS, MOUNTED ON BOARD, 14½ x 13⅛" (36.7 x 33.8 CM)
THE SIDNEY AND HARRIET JANIS COLLECTION, 1967

Paul Klee
AROUND THE FISH. 1926
OIL ON CANVAS, 18⅜ x 25⅛" (46.7 x 63.8 CM)
ABBY ALDRICH ROCKEFELLER FUND, 1939

243

Suprematism and Constructivism

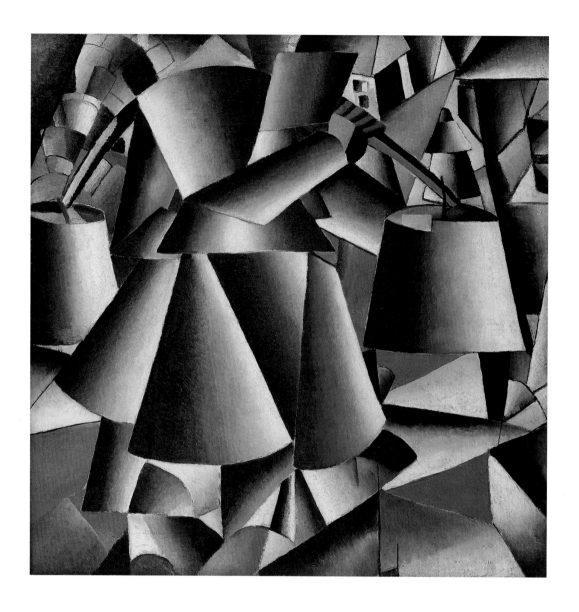

Kazimir Malevich | (RUSSIAN, BORN UKRAINE. 1878–1935)
WOMAN WITH PAILS: DYNAMIC ARRANGEMENT. 1912–13 (dated on verso 1912)
OIL ON CANVAS, 31⅛ x 31½" (80.3 x 80.3 CM)
1935 ACQUISITION CONFIRMED IN 1999 BY AGREEMENT WITH THE ESTATE OF KAZIMIR MALEVICH
AND MADE POSSIBLE WITH FUNDS FROM THE MRS. JOHN HAY WHITNEY BEQUEST (BY EXCHANGE)

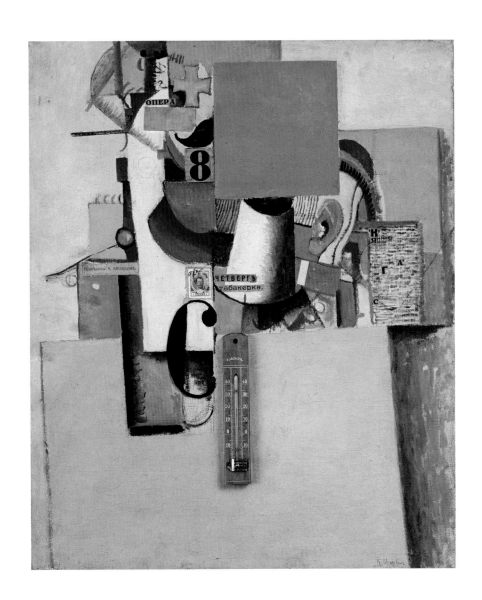

Kazimir Malevich
RESERVIST OF THE FIRST DIVISION. Fall–winter 1914
OIL ON CANVAS WITH COLLAGE OF PRINTED PAPER, POSTAGE
STAMP, AND THERMOMETER, 21⅛ x 17⅛" (53.7 x 44.8 CM)
1935 ACQUISITION CONFIRMED IN 1999 BY AGREEMENT WITH THE
ESTATE OF KAZIMIR MALEVICH AND MADE POSSIBLE WITH FUNDS
FROM THE MRS. JOHN HAY WHITNEY BEQUEST (BY EXCHANGE)

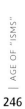
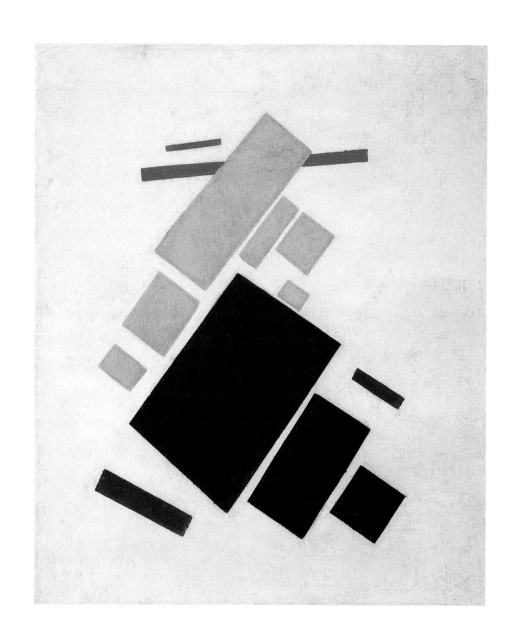

Kazimir Malevich | (RUSSIAN, BORN UKRAINE. 1878–1935)
SUPREMATIST COMPOSITION: AIRPLANE FLYING. 1915 (dated on
reverse 1914)
OIL ON CANVAS, 22⅞ x 19" (58.1 x 48.3 CM)
1935 ACQUISITION CONFIRMED IN 1999 BY AGREEMENT WITH THE ESTATE OF
KAZIMIR MALEVICH AND MADE POSSIBLE WITH FUNDS FROM THE MRS. JOHN
HAY WHITNEY BEQUEST (BY EXCHANGE)

Kazimir Malevich
SUPREMATIST COMPOSITION: WHITE ON WHITE. 1918
OIL ON CANVAS, 31¼ x 31¼" (79.4 x 79.4 CM)
1935 ACQUISITION CONFIRMED IN 1999 BY AGREEMENT WITH THE
ESTATE OF KAZIMIR MALEVICH AND MADE POSSIBLE WITH FUNDS
FROM THE MRS. JOHN HAY WHITNEY BEQUEST (BY EXCHANGE)

247

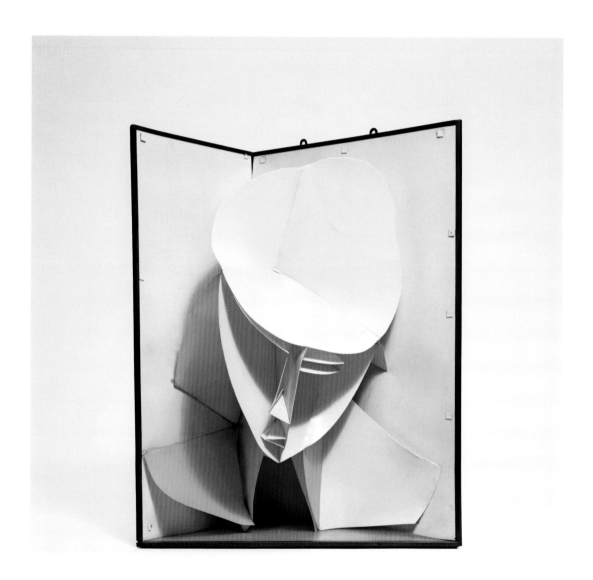

Naum Gabo | (AMERICAN, BORN RUSSIA. 1890–1977)
HEAD OF A WOMAN. c. 1917–20 (after a work of 1916)
CELLULOID AND METAL, 24⅛ x 19¼ x 14" (62.2 x 48.9 x 35.4 CM)
PURCHASE, 1938

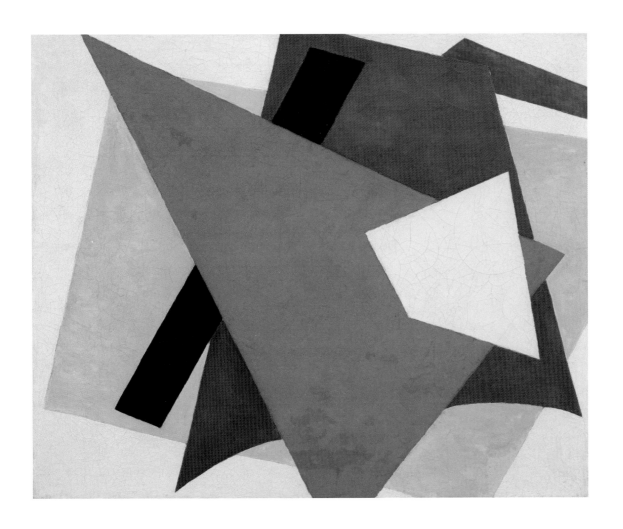

Lyubov Popova | (RUSSIAN, 1889–1924)
PAINTERLY ARCHITECTONIC. 1917
OIL ON CANVAS, 31½ x 38⅜" (80 x 98 CM)
PHILIP JOHNSON FUND, 1958

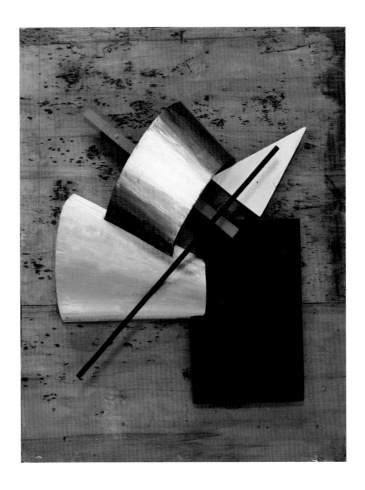

Ivan Puni | (RUSSIAN, BORN FINLAND. 1892–1956)
SUPREMATIST RELIEF-SCULPTURE. 1920s (reconstruction of 1915 original)
PAINTED WOOD, METAL, AND CARDBOARD, MOUNTED ON WOODEN PANEL,
20 x 15½ x 3" (50.8 x 39.3 x 7.6 CM)
THE RIKLIS COLLECTION OF MCCRORY CORPORATION, 1985

249

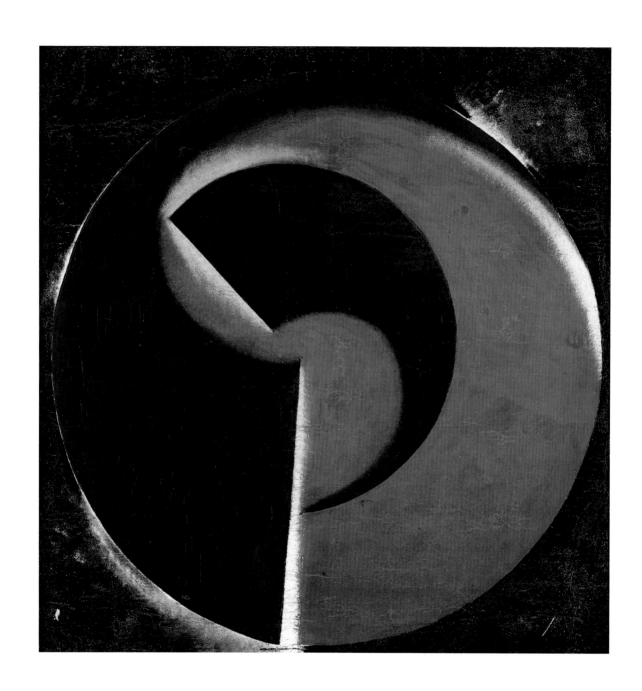

Aleksandr Rodchenko | (RUSSIAN, 1891–1956)
NON-OBJECTIVE PAINTING NO. 80 (BLACK ON BLACK). 1918
OIL ON CANVAS, 32¼ x 31¼" (81.9 x 79.4 CM)
GIFT OF THE ARTIST, THROUGH JAY LEYDA, 1936

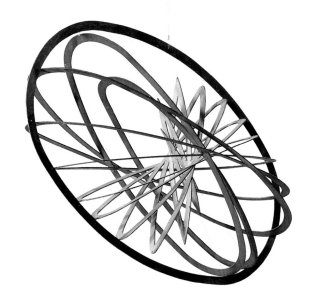

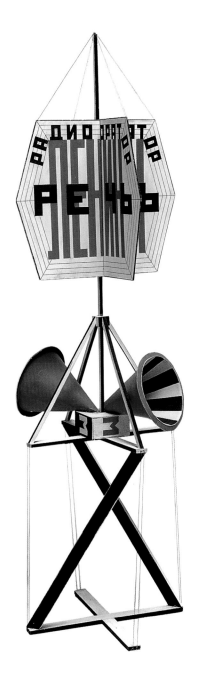

Aleksandr Rodchenko
SPATIAL CONSTRUCTION NO. 12. c. 1920
PLYWOOD, OPEN CONSTRUCTION PARTIALLY PAINTED
WITH ALUMINUM PAINT, AND WIRE, 24 x 33 x 18½"
(61 x 83.7 x 47 CM)
ACQUISITION MADE POSSIBLE THROUGH THE EXTRA-
ORDINARY EFFORTS OF GEORGE AND ZINAIDA COSTAKIS,
AND THROUGH THE NATE B. AND FRANCES SPINGOLD,
MATTHEW H. AND ERNA FUTTER, AND ENID A. HAUPT
FUNDS, 1986

Gustav Klucis | (LATVIAN, 1895–1944)
MAQUETTE FOR "RADIO-ANNOUNCER." 1922
CONSTRUCTION OF PAINTED CARDBOARD, PAPER,
WOOD, THREAD, AND METAL BRADS, 45¾ x 14½ x
14½" (106.1 x 36.8 x 36.8 CM)
SIDNEY AND HARRIET JANIS COLLECTION FUND, 1979

251

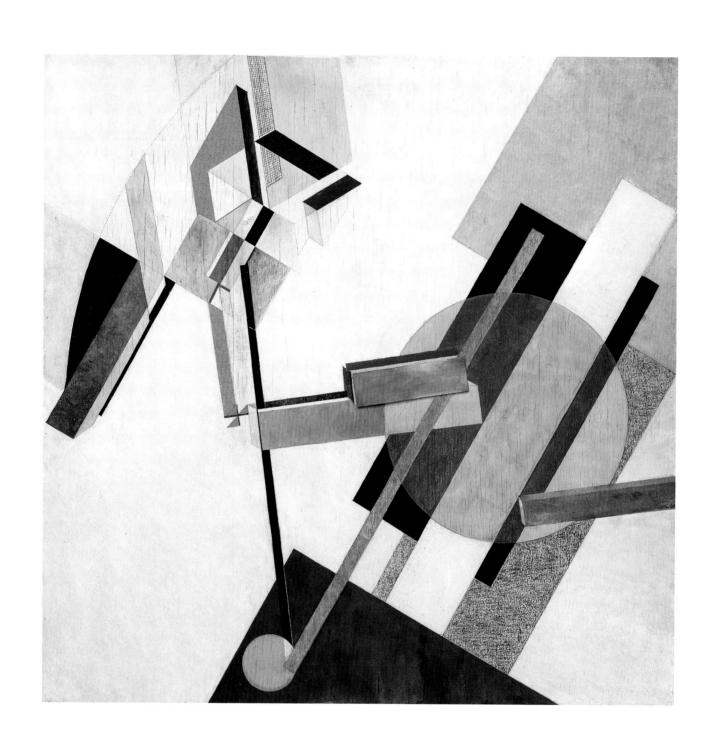

El Lissitzky | (RUSSIAN, 1890–1941)
PROUN 19D. 1922?
GESSO, OIL, COLLAGE OF CUT PAPER, CARDBOARD, AND
SILVER PAPER ON PLYWOOD, 38⅛ x 38¼" (97.5 x 97.2 CM)
KATHERINE S. DREIER BEQUEST, 1953

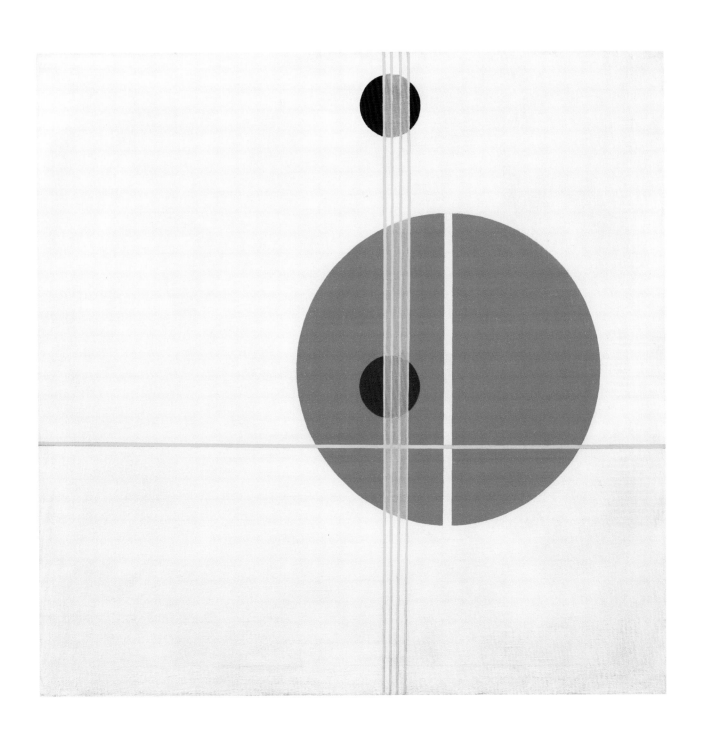

László Moholy-Nagy | (AMERICAN, BORN HUNGARY. 1895–1946)
Q 1 SUPREMATISTIC. 1923
OIL ON CANVAS, 37½ x 37½" (95.2 x 95.2 CM)
THE RIKLIS COLLECTION OF MCCRORY CORPORATION, 1985

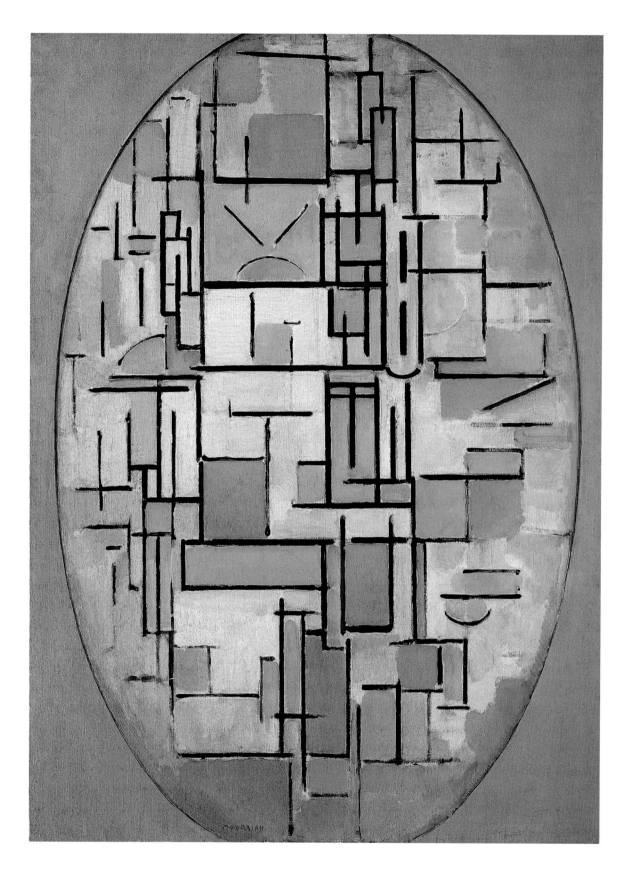

Piet Mondrian | (DUTCH, 1872–1944)
COMPOSITION IN OVAL WITH COLOR PLANES 1. 1914
OIL ON CANVAS, 42⅜ x 31" (107.6 x 78.8 CM)
PURCHASE, 1950

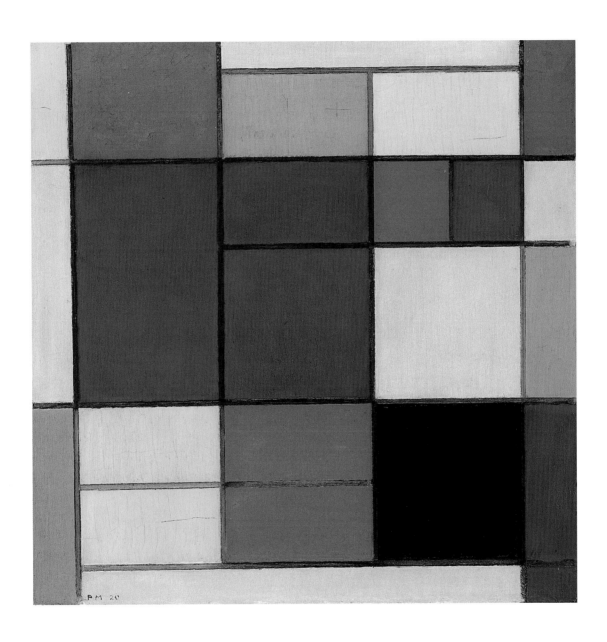

Piet Mondrian
COMPOSITION C. 1920
OIL ON CANVAS, 23¾ x 24" (60.3 x 61 CM)
ACQUIRED THROUGH THE LILLIE P. BLISS BEQUEST, 1948

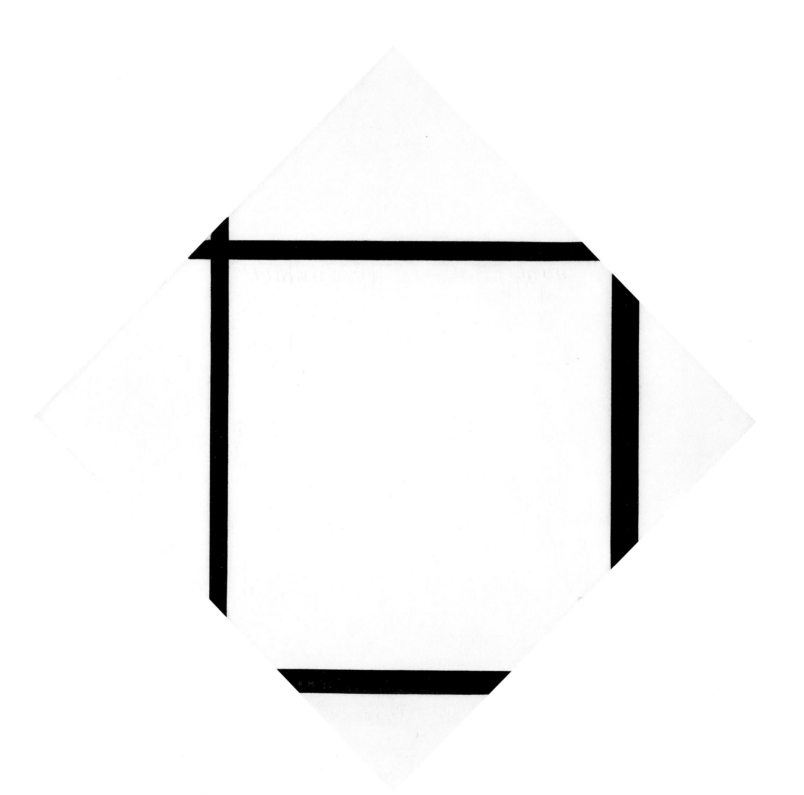

Piet Mondrian | (DUTCH, 1872–1944)
TABLEAU I: LOZENGE WITH FOUR LINES AND GRAY. 1926
OIL ON CANVAS, 44¼ x 44" (113.7 x 111.8 CM) DIAGONAL MEASUREMENTS
KATHERINE S. DREIER BEQUEST, 1953

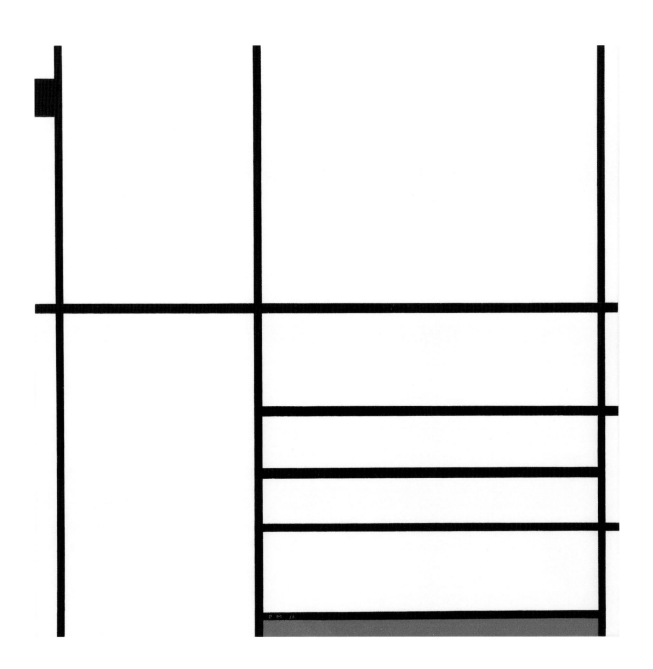

Piet Mondrian
COMPOSITION IN WHITE, BLACK, AND RED. 1936
OIL ON CANVAS, 40¼ x 41" (102.2 x 104.1 CM)
GIFT OF THE ADVISORY COMMITTEE, 1937

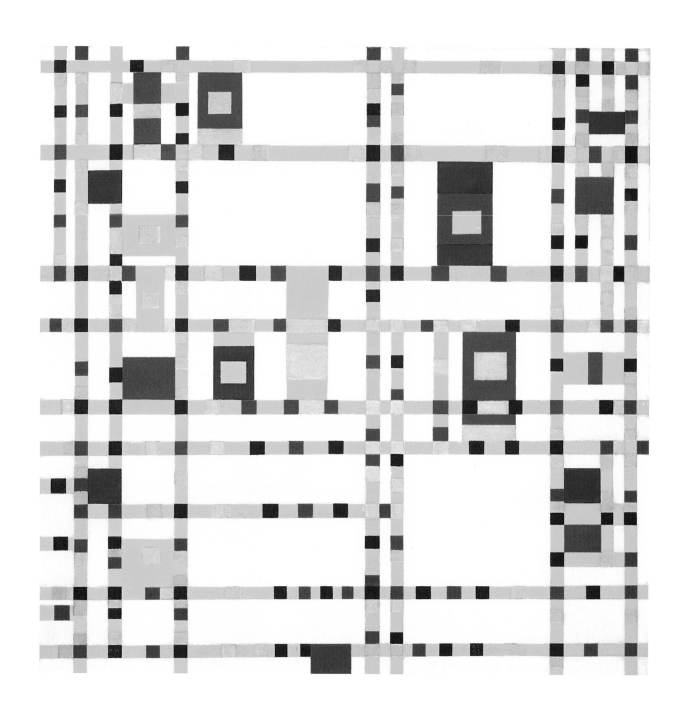

Piet Mondrian | (DUTCH, 1872–1944)
BROADWAY BOOGIE WOOGIE. 1942–43
OIL ON CANVAS, 50 x 50" (127 x 127 CM)
GIVEN ANONYMOUSLY, 1943

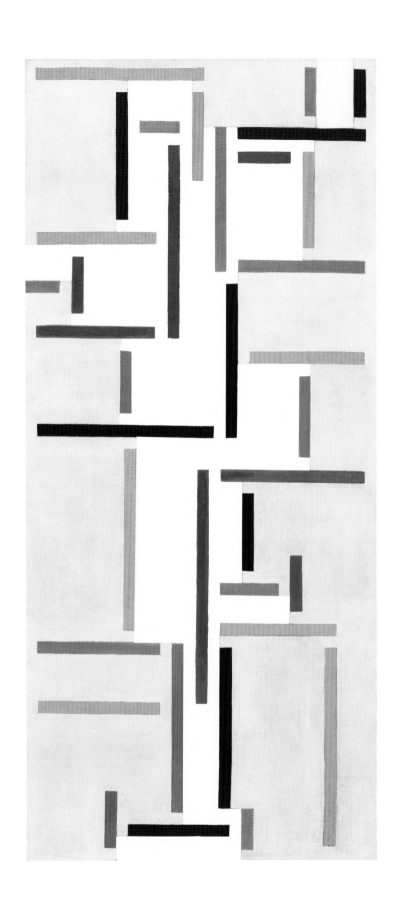

Theo van Doesburg | (DUTCH, 1883–1931)
RHYTHM OF A RUSSIAN DANCE. June 1918
OIL ON CANVAS, 53½ x 24¼" (135.9 x 61.6 CM)
ACQUIRED THROUGH THE LILLIE P. BLISS BEQUEST, 1946

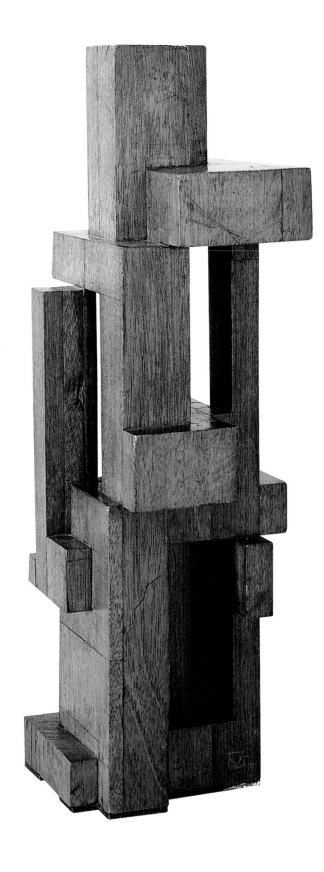

Georges Vantongerloo | (BELGIAN, 1886–1965)
CONSTRUCTION OF VOLUME RELATIONS. 1921
MAHOGANY, 16⅛ x 5⅝ x 5¼" (41 x 14.4 x 14.5 CM)
GIFT OF SILVIA PIZITZ, 1953

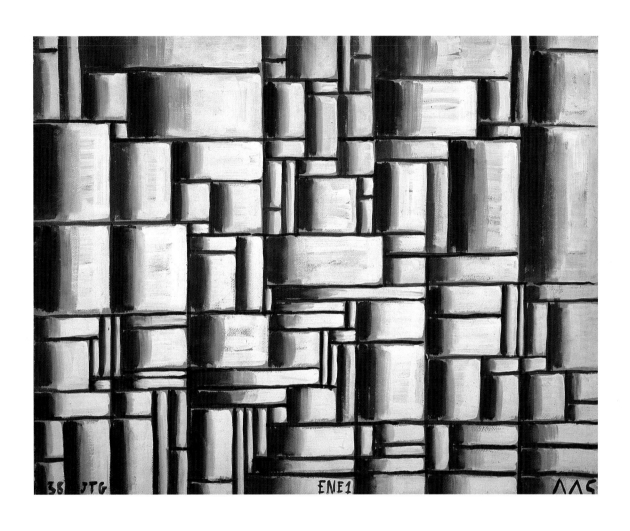

Joaquín Torres-García | (URUGUAYAN, 1874–1949)
CONSTRUCTION IN WHITE AND BLACK. 1938
OIL ON PAPER MOUNTED ON WOOD, 31¼ x 40⅛" (80.7 x 102 CM)
FRACTIONAL AND PROMISED GIFT OF PATRICIA PHELPS DE CISNEROS
IN HONOR OF DAVID ROCKEFELLER, 2004

261

Realisms

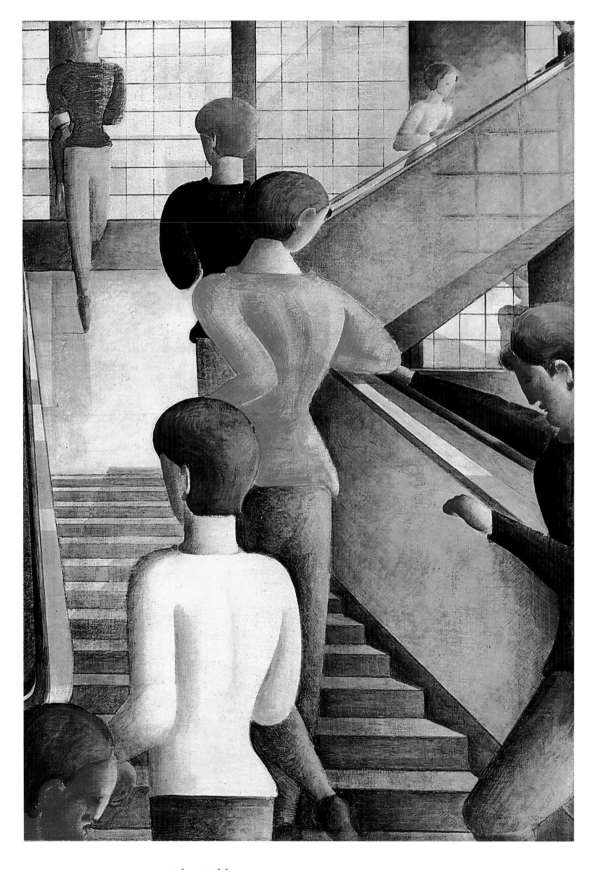

Oskar Schlemmer | (GERMAN, 1888–1943)
BAUHAUS STAIRWAY. 1932
OIL ON CANVAS, 63⅞ x 45" (162.3 x 114.3 CM)
GIFT OF PHILIP JOHNSON, 1942

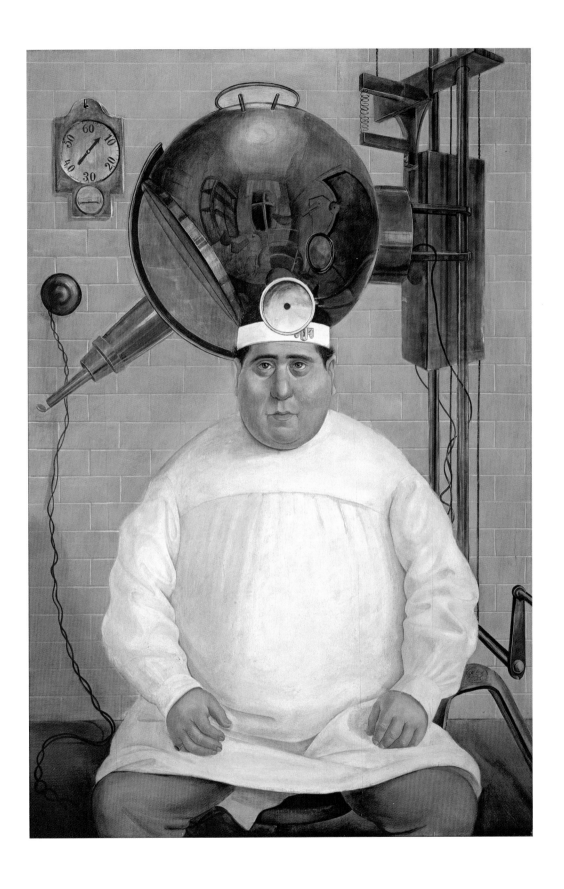

Otto Dix | (GERMAN, 1891–1969)
DR. MAYER-HERMANN, 1926
OIL AND TEMPERA ON WOOD, 58⅞ x 39" (149.2 x 99.1 CM)
GIFT OF PHILIP JOHNSON, 1932

263

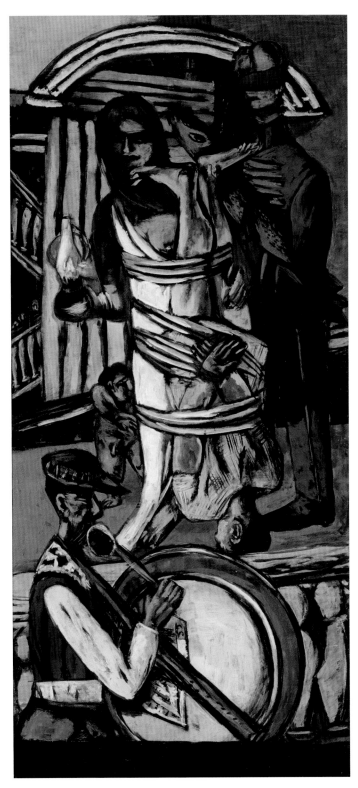

Max Beckmann | (GERMAN, 1884–1950)
DEPARTURE. 1932, 1933–35
OIL ON CANVAS, SIDE PANELS 7' 1/4" x 39 1/4" (215.3 x 99.7 CM),
CENTER PANEL 7' 1/4" x 45 1/4" (215.3 x 115.2 CM)
GIVEN ANONYMOUSLY (BY EXCHANGE), 1942

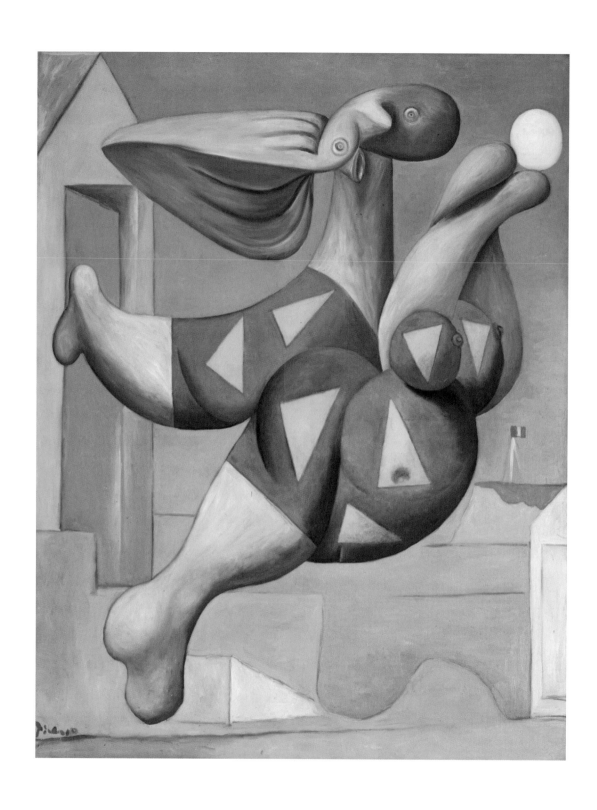

Pablo Picasso | (SPANISH, 1881–1973)
BATHER WITH BEACH BALL. August 1932
OIL ON CANVAS, 57⅛ x 45⅛" (146.2 x 114.6 CM)
PARTIAL GIFT OF AN ANONYMOUS DONOR AND PROMISED
GIFT OF JO CAROLE AND RONALD S. LAUDER, 1980

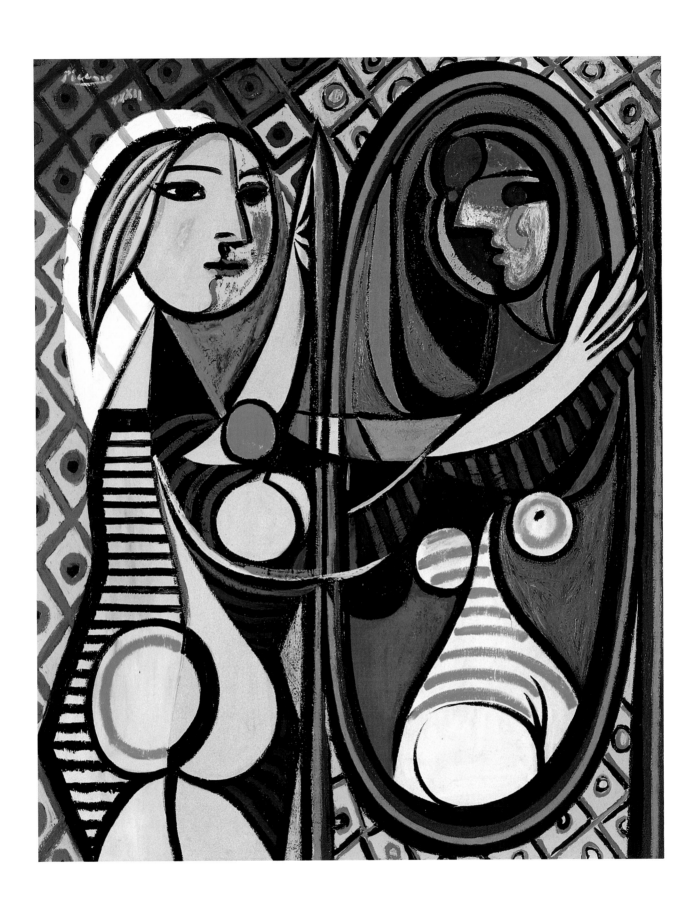

Pablo Picasso
GIRL BEFORE A MIRROR. March 1932
OIL ON CANVAS, 64 x 51¼" (162.3 x 130.2 CM)
GIFT OF MRS. SIMON GUGGENHEIM, 1938

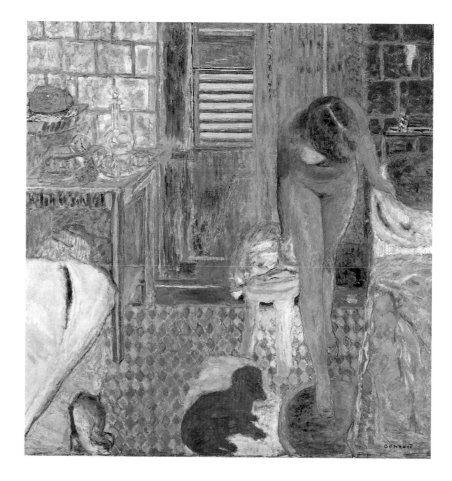

Pierre Bonnard | (FRENCH, 1867–1947)
THE BATHROOM. 1932
OIL ON CANVAS, 47½" x 46½" (121 x 118.2 CM)
FLORENE MAY SCHOENBORN BEQUEST, 1996

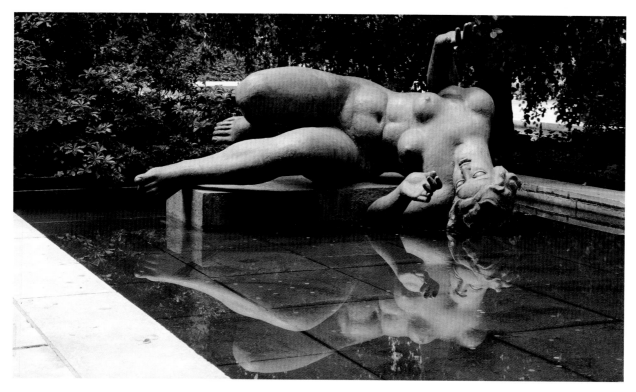

Aristide Maillol | (FRENCH, 1861–1944)
THE RIVER. 1938–39; completed 1943 (cast 1948)
LEAD, 53¼" x 7' 6" x 66" (136.5 x 228.6 x 167.7 CM), ON LEAD BASE DESIGNED
BY THE ARTIST, 9¾ x 67 x 27¾" (24.8 x 170.1 x 70.4 CM)
MRS. SIMON GUGGENHEIM FUND, 1949

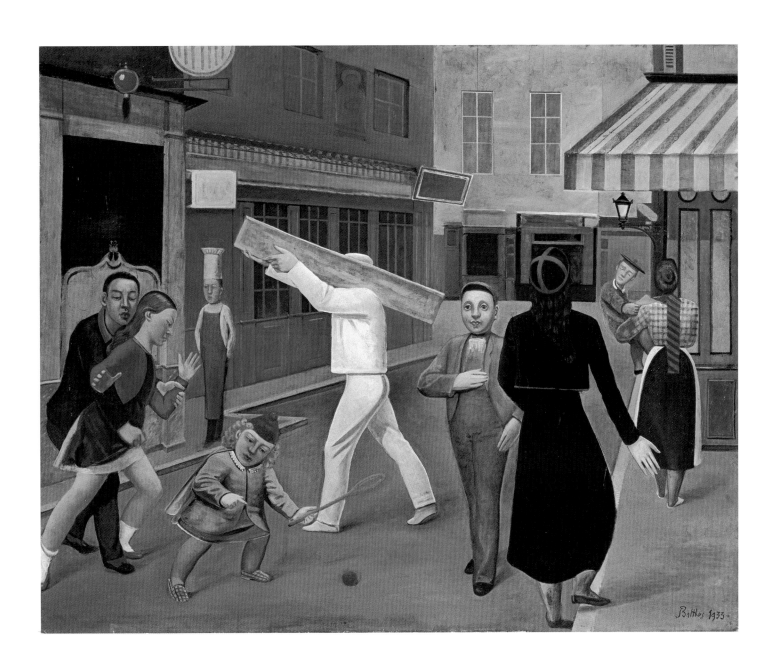

Balthus
(FRENCH, 1908–2001)
THE STREET. 1933
OIL ON CANVAS, 6' 4¾" x 7' 10½" (195 x 240 CM)
JAMES THRALL SOBY BEQUEST, 1979

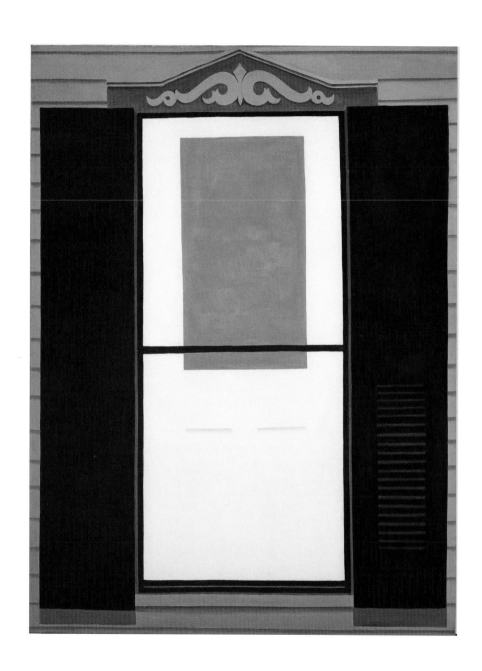

Georgia O'Keeffe | (AMERICAN, 1887–1986)
LAKE GEORGE WINDOW. 1929
OIL ON CANVAS, 40 x 30" (101.6 x 76.2 CM)
ACQUIRED THROUGH THE RICHARD D. BRIXEY BEQUEST, 1945

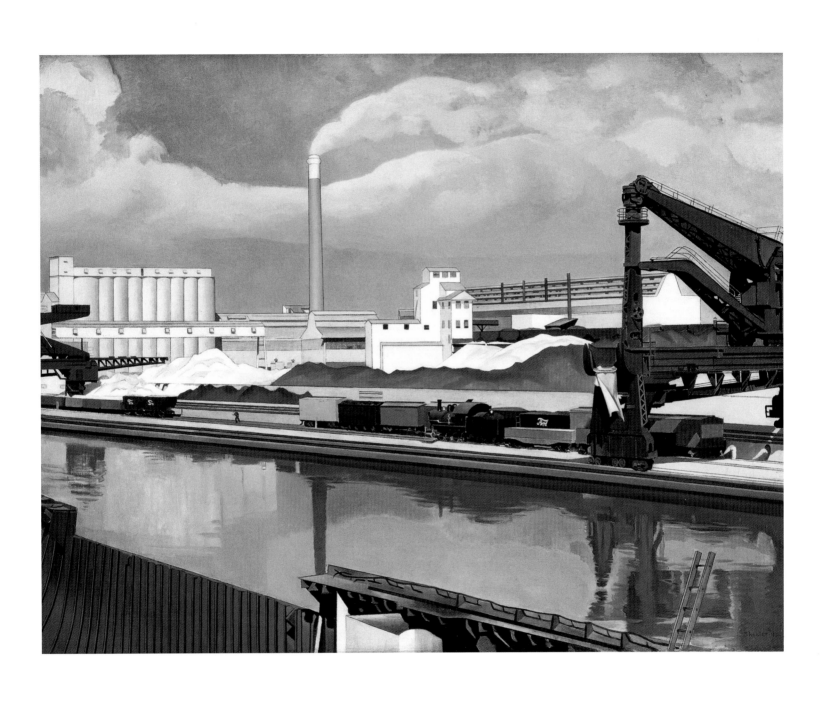

Charles Sheeler | (AMERICAN, 1883–1965)
AMERICAN LANDSCAPE. 1930
OIL ON CANVAS, 24 x 31" (61 x 78.8 CM)
GIFT OF ABBY ALDRICH ROCKEFELLER, 1934

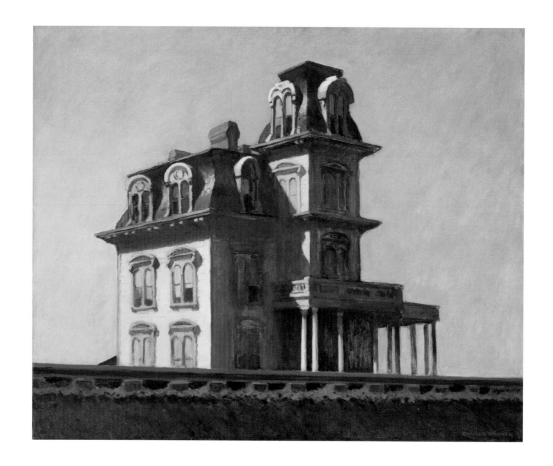

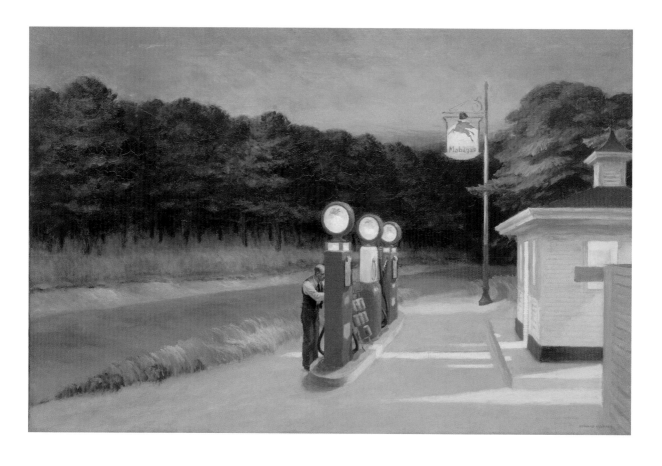

Edward Hopper | (AMERICAN, 1882–1967)
HOUSE BY THE RAILROAD. 1925
OIL ON CANVAS, 24 x 29" (61 x 73.7 CM)
GIVEN ANONYMOUSLY, 1930

Edward Hopper
GAS. 1940
OIL ON CANVAS, 26¼ x 40¼" (66.7 x 102.2 CM)
MRS. SIMON GUGGENHEIM FUND, 1943

Jacob Lawrence | (AMERICAN, 1917–2000)
THE WORLD WAR HAD CAUSED A GREAT SHORTAGE IN
NORTHERN INDUSTRY AND ALSO CITIZENS OF FOREIGN COUN-
TRIES WERE RETURNING HOME, from The Migration Series.
1940–41
TEMPERA ON GESSO ON COMPOSITION BOARD, 12 x 18" (30.5 x 45.7 CM)
GIFT OF MRS. DAVID M. LEVY, 1942

Jacob Lawrence
THE RAILROAD STATIONS IN THE SOUTH WERE CROWDED WITH
PEOPLE LEAVING FOR THE NORTH, from The Migration Series.
1940–41
TEMPERA ON GESSO ON COMPOSITION BOARD, 12 x 18" (30.5 x 45.7 CM)
GIFT OF MRS. DAVID M. LEVY, 1942

Jacob Lawrence
ANOTHER OF THE SOCIAL CAUSES OF THE MIGRANTS' LEAVING WAS
THAT AT TIMES THEY DID NOT FEEL SAFE, OR IT WAS NOT THE BEST
THING TO BE FOUND ON THE STREETS LATE AT NIGHT. THEY WERE
ARRESTED ON THE SLIGHTEST PROVOCATION, from The Migration
Series. 1940–41
TEMPERA ON GESSO ON COMPOSITION BOARD, 12 x 18" (30.5 x 45.7 CM)
GIFT OF MRS. DAVID M. LEVY, 1942

Jacob Lawrence
HOUSING FOR THE NEGROES WAS A VERY DIFFICULT PROBLEM,
from The Migration Series. 1940–41
TEMPERA ON GESSO ON COMPOSITION BOARD, 18 x 12" (45.7 x 30.5 CM)
GIFT OF MRS. DAVID M. LEVY, 1942

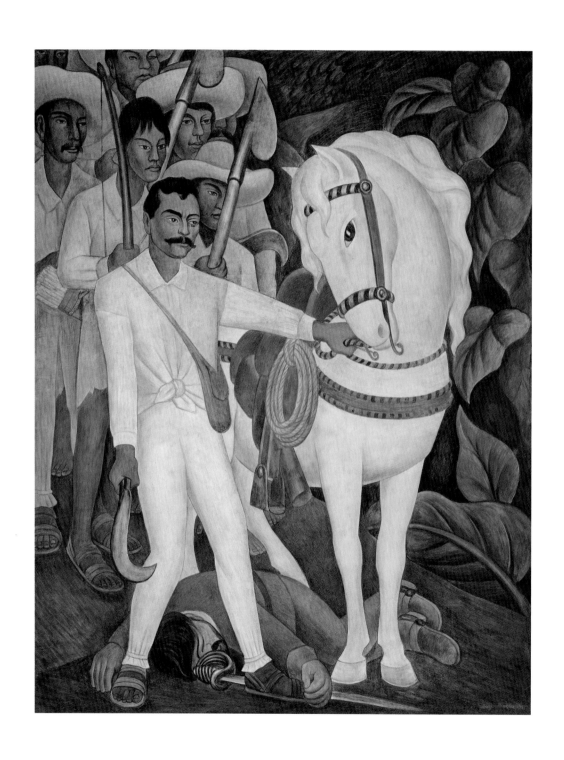

Diego Rivera | (MEXICAN, 1886–1957)
AGRARIAN LEADER ZAPATA 1931
FRESCO, 7' 9¼" x 6' 2" (238.1 x 188 CM)
ABBY ALDRICH ROCKEFELLER FUND, 1940

274

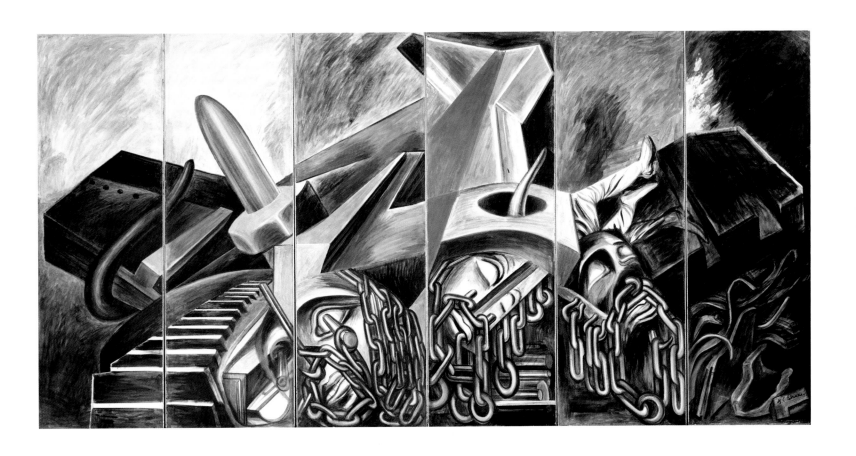

José Clemente Orozco | (MEXICAN, 1883–1949)
DIVE BOMBER AND TANK. 1940
FRESCO, SIX PANELS, EACH 9' x 36" (275 x 91.4 CM), OVERALL 9 x
18' (275 x 550 CM)
COMMISSIONED THROUGH THE ABBY ALDRICH ROCKEFELLER FUND, 1940

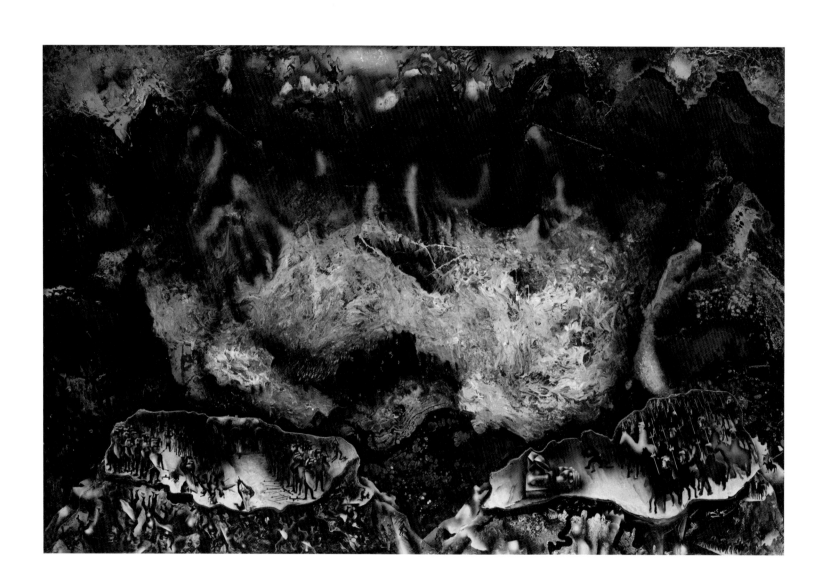

David Alfaro Siqueiros | (MEXICAN, 1896–1974)
COLLECTIVE SUICIDE, 1936
ENAMEL ON WOOD WITH APPLIED SECTIONS, 49" x 6' (124.5 x 182.9 CM)
GIFT OF DR. GREGORY ZILBOORG, 1937

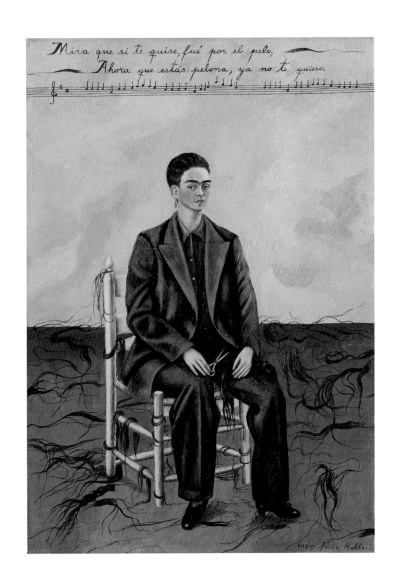

Frida Kahlo | (MEXICAN, 1907–1954)
SELF-PORTRAIT WITH CROPPED HAIR. 1940
OIL ON CANVAS, 15⅞ x 11" (40 x 27.9 CM)
GIFT OF EDGAR KAUFMANN, JR., 1943

Surrealism

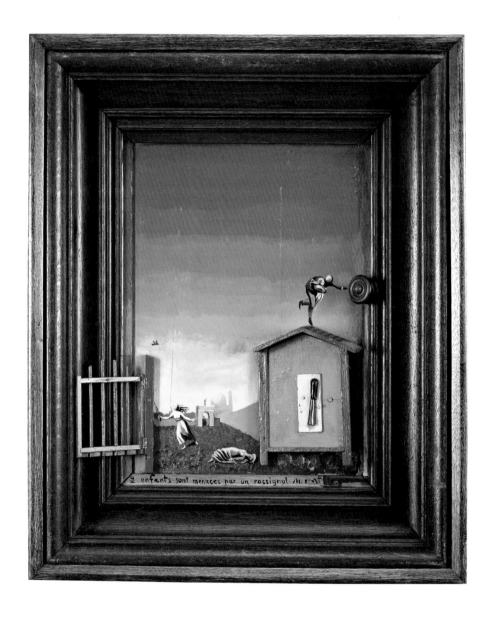

Max Ernst | (FRENCH, BORN
GERMANY. 1891–1976)
TWO CHILDREN ARE THREATENED BY
A NIGHTINGALE. 1924
OIL ON WOOD WITH PAINTED WOOD
ELEMENTS AND FRAME, 27½ x 22½ x 4½"
(69.8 x 57.1 x 11.4 CM)
PURCHASE, 1937

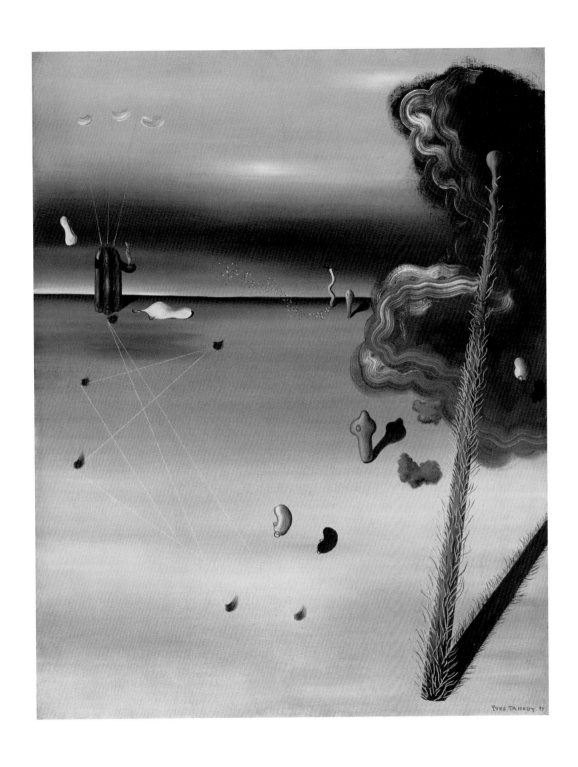

Yves Tanguy | (AMERICAN, BORN FRANCE. 1900–1955)
MAMA, PAPA IS WOUNDED! 1927
OIL ON CANVAS, 36¼ x 28¾" (92.1 x 73 CM)
PURCHASE, 1936

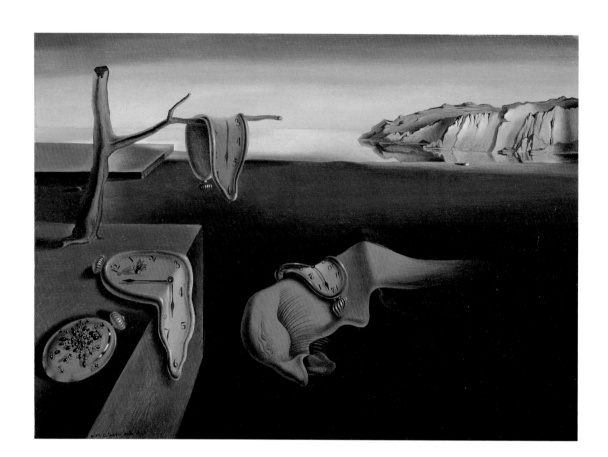

Salvador Dalí | (SPANISH, 1904–1989)
THE PERSISTENCE OF MEMORY. 1931
OIL ON CANVAS, 9½ x 13" (24.1 x 33 CM)
GIVEN ANONYMOUSLY, 1934

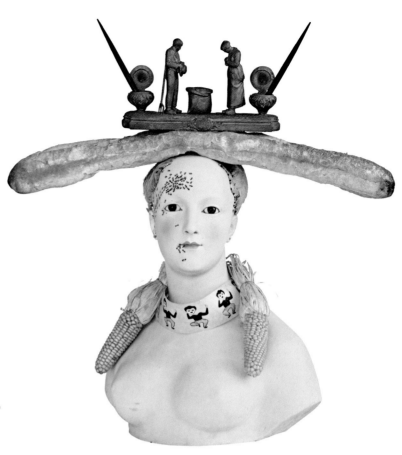

Salvador Dalí
RETROSPECTIVE BUST OF A WOMAN. 1933
(some elements reconstructed 1970)
PAINTED PORCELAIN, BREAD, CORN, FEATHERS, PAINT
ON PAPER, BEADS, INK STAND, SAND, AND TWO PENS,
29 x 27⅞ x 12⅝" (73.9 x 69.2 x 32 CM)
ACQUIRED THROUGH THE LILLIE P. BLISS BEQUEST AND
GIFT OF PHILIP JOHNSON (BOTH BY EXCHANGE), 1992

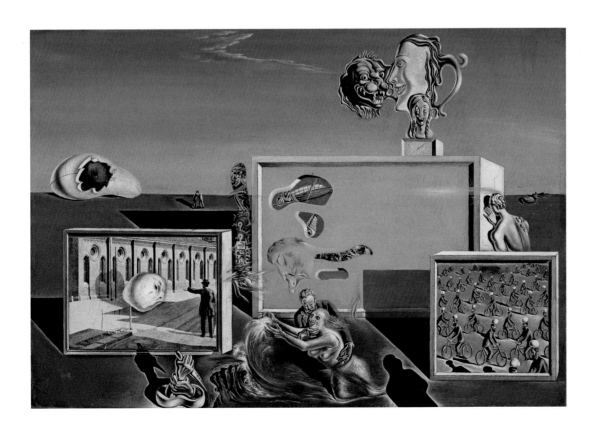

Salvador Dalí
ILLUMINED PLEASURES. 1929
OIL AND COLLAGE ON COMPOSITION BOARD, 9⅜ x 13¾" (23.8 x 34.7 CM)
THE SIDNEY AND HARRIET JANIS COLLECTION, 1967

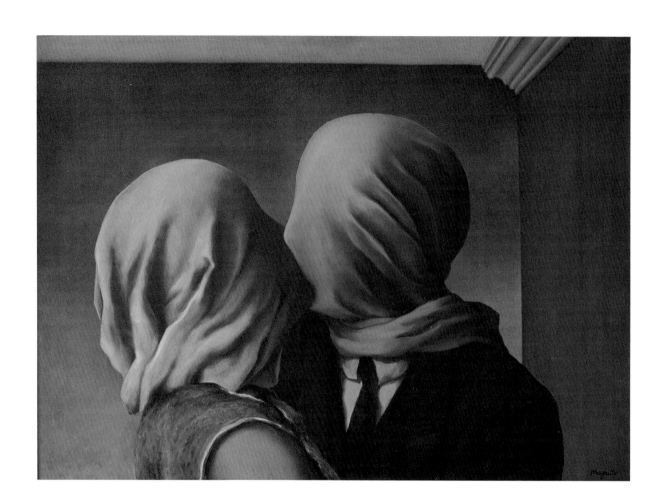

René Magritte | (BELGIAN, 1898–1967)
THE LOVERS. 1928
OIL ON CANVAS, 21⅛ x 28⅞" (54 x 73.4 CM)
FRACTIONAL AND PROMISED GIFT OF RICHARD S. ZEISLER, 1998

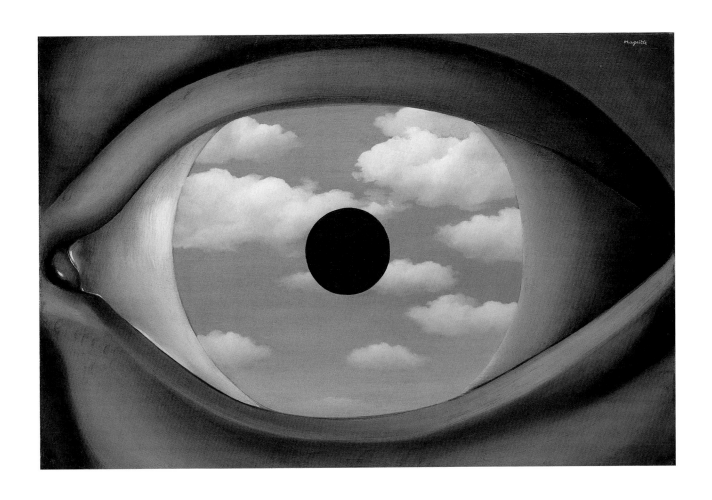

René Magritte
THE FALSE MIRROR. 1928
OIL ON CANVAS, 21¼ x 31⅞" (54 x 80.9 CM)
PURCHASE, 1936

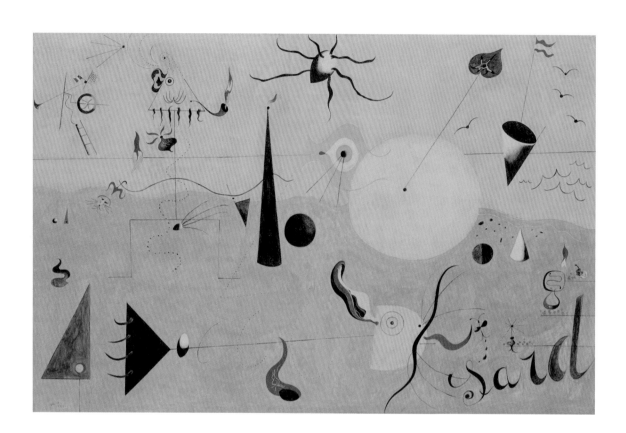

Joan Miró | (SPANISH, 1893–1983)
THE HUNTER (CATALAN LANDSCAPE)
July 1923–winter 1924
OIL ON CANVAS, 25½ x 39½" (64.8 x 100.3 CM)
PURCHASE, 1936

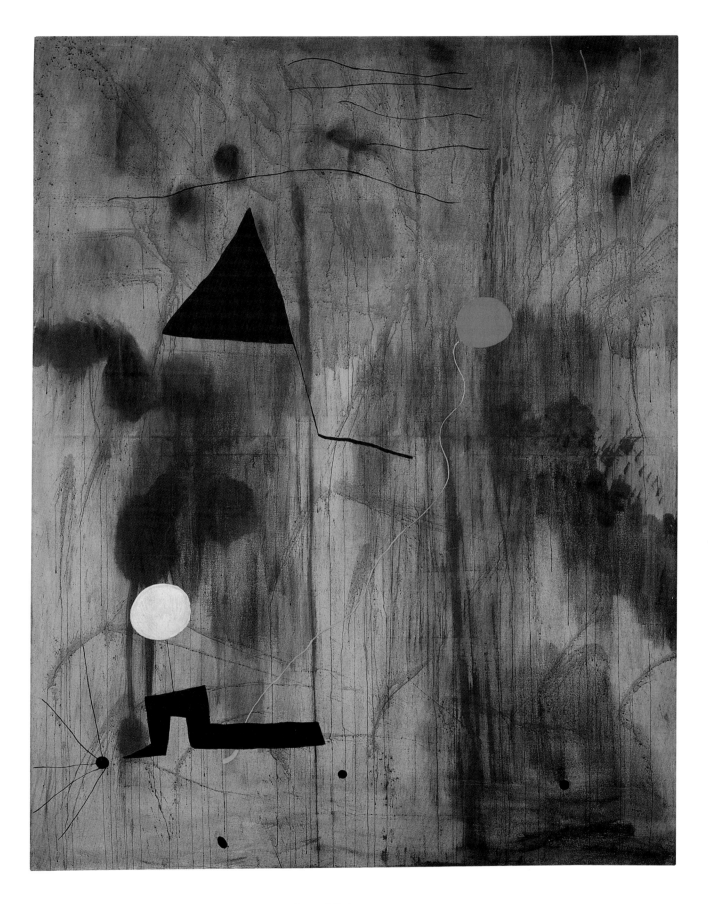

Joan Miró
THE BIRTH OF THE WORLD. Late summer–fall 1925
OIL ON CANVAS, 8' 2¾" x 6' 6⅞" (250.8 x 200 CM)
ACQUIRED THROUGH AN ANONYMOUS FUND, THE MR. AND
MRS. JOSEPH SLIFKA AND ARMAND G. ERPF FUNDS, AND BY
GIFT OF THE ARTIST, 1972

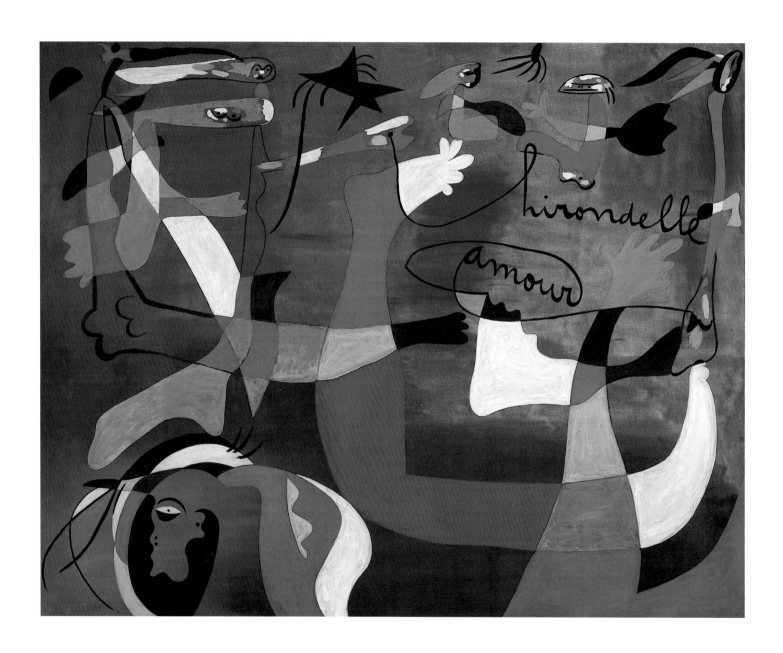

Joan Miró | (SPANISH, 1893-1983)
"HIRONDELLE AMOUR." Late fall 1933–winter 1934
OIL ON CANVAS, 6' 6½" x 8' 1½" (199.3 x 247.6 CM)
GIFT OF NELSON A. ROCKEFELLER, 1976

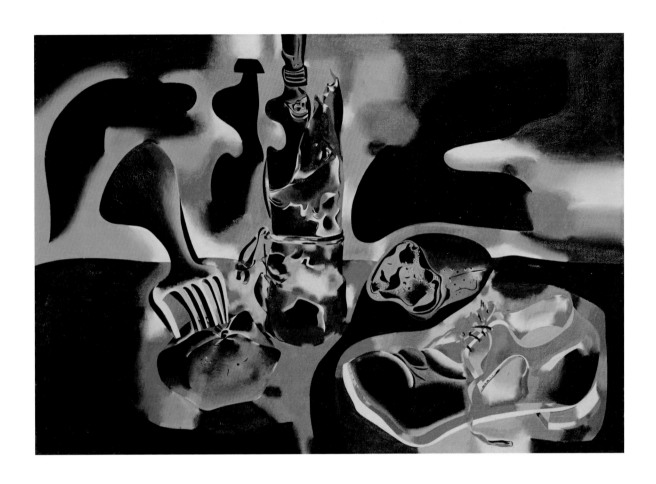

Joan Miró
STILL LIFE WITH OLD SHOE. January 24–May 29, 1937
OIL ON CANVAS, 32 x 46" (81.3 x 116.8 CM)
GIFT OF JAMES THRALL SOBY, 1969

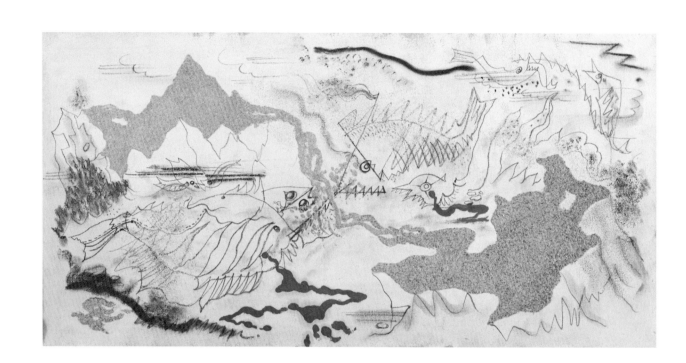

André Masson | (FRENCH, 1896–1987)
BATTLE OF FISHES. 1926
SAND, GESSO, OIL, PENCIL, AND CHARCOAL ON CANVAS,
14¼ x 28¾" (36.2 x 73 CM)
PURCHASE, 1937

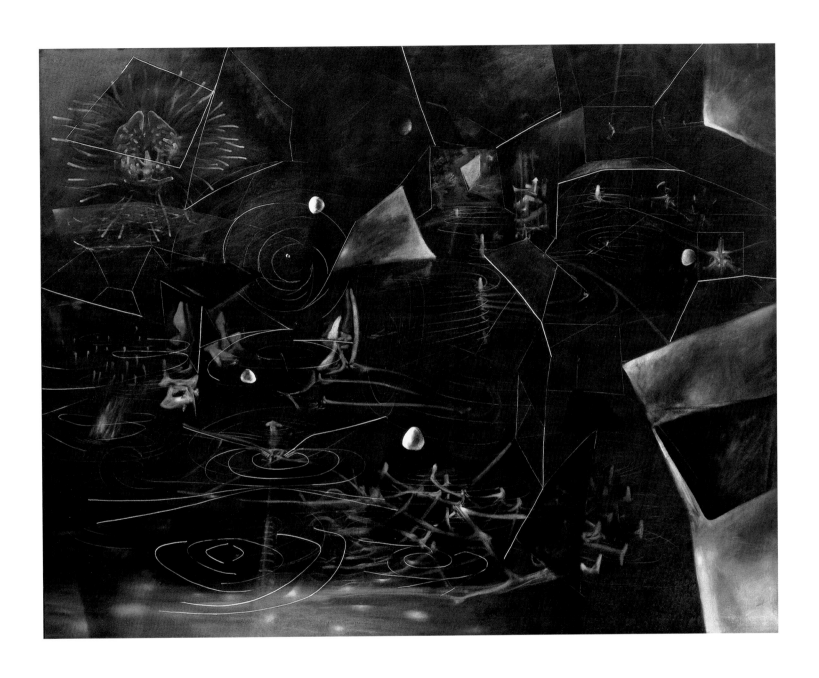

Matta
(CHILEAN, 1911–2002)
THE VERTIGO OF EROS. 1944
OIL ON CANVAS, 6' 5" x 8' 3" (195.6 x 251.5 CM)
GIVEN ANONYMOUSLY, 1944

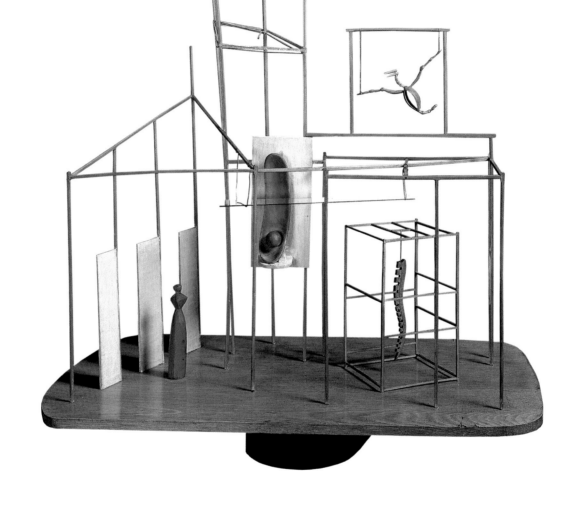

Alberto Giacometti | (SWISS, 1901–1966)
THE PALACE AT 4 A.M. 1932
WOOD, GLASS, WIRE, AND STRING, 25 x 28¼ x 15¾"
(63.5 x 71.8 x 40 CM)
PURCHASE, 1936

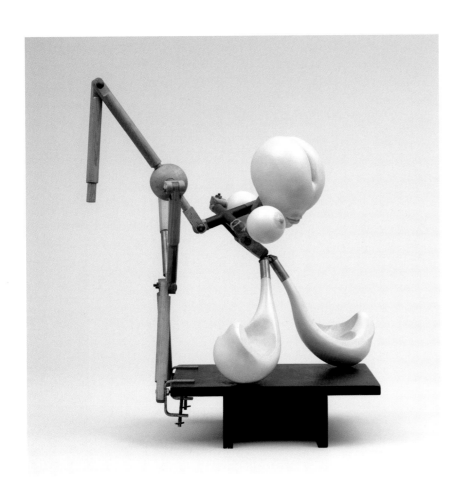

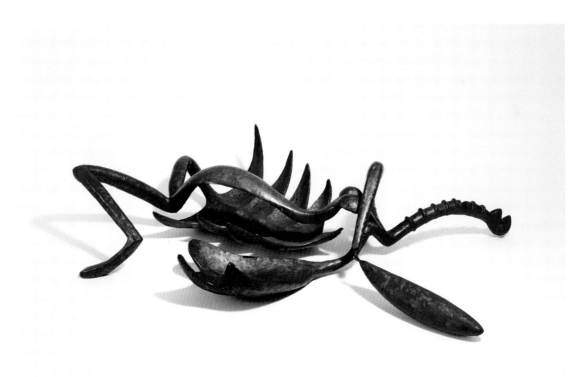

Hans Bellmer | (GERMAN, 1902–1975)
THE MACHINE-GUNNERESS IN A STATE OF GRACE. 1937
CONSTRUCTION OF WOOD AND METAL, 30⅞ x 29¼ x 13⅝" (78.5 x
75.5 x 34.5 CM), ON WOOD BASE 4¼ x 15¾ x 11⅞" (12 x 40 x 29.9 CM)
ADVISORY COMMITTEE FUND, 1968

Alberto Giacometti
WOMAN WITH HER THROAT CUT. 1932 (cast 1949)
BRONZE, 8 x 34½ x 25" (20.3 x 87.6 x 63.5 CM)
PURCHASE, 1949

291

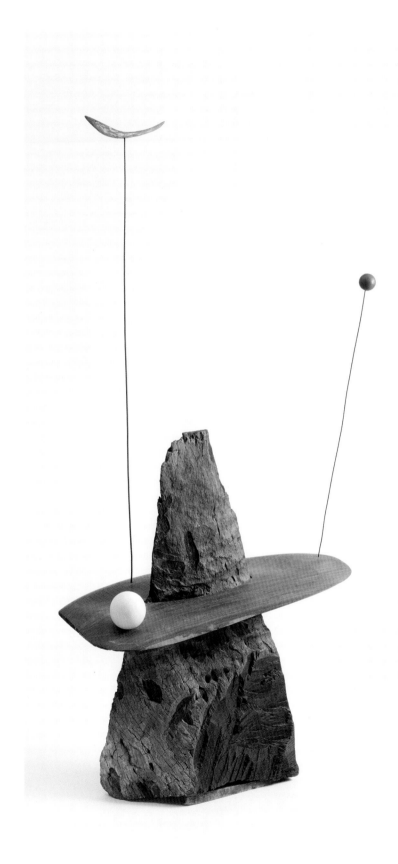

Joan Miró | (SPANISH, 1893–1983)
OBJECT. 1936
STUFFED PARROT ON WOOD PERCH, STUFFED SILK
STOCKING WITH VELVET GARTER AND DOLL'S PAPER
SHOE SUSPENDED IN HOLLOW WOOD FRAME, DERBY HAT,
HANGING CORK BALL, CELLULOID FISH, AND ENGRAVED
MAP, 31⅞ x 11⅞ x 10¼" (81 x 30.1 x 26 CM)
GIFT OF MR. AND MRS. PIERRE MATISSE, 1965

Alexander Calder | (AMERICAN, 1898–1976)
GIBRALTAR. 1936
LIGNUM VITAE, WALNUT, STEEL RODS, AND PAINTED WOOD,
51⅞ x 24¼ x 11⅜" (131.7 x 61.3 x 28.7 CM)
GIFT OF THE ARTIST, 1966

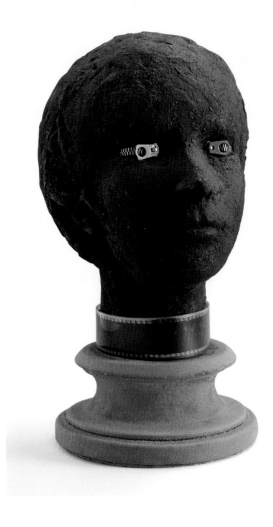

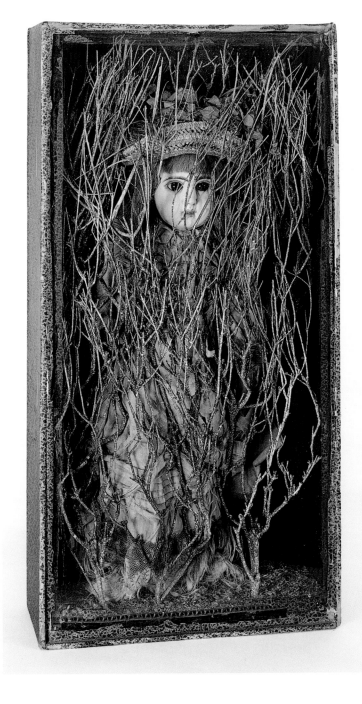

Marcel Jean | (FRENCH, 1900–1993)
SPECTER OF THE GARDENIA. 1936
PLASTER HEAD WITH PAINTED BLACK CLOTH, ZIPPERS, AND STRIP OF
FILM ON VELVET-COVERED WOOD BASE, 13⅞ x 7 x 9⅞" (35 x 17.6 x
25 CM) INCLUDING BASE 3" HIGH x 7" DIAMETER (7.5 x 17.6 CM)
D. AND J. DE MENIL FUND, 1968

Joseph Cornell | (AMERICAN, 1903–1972)
UNTITLED (BÉBÉ MARIE). Early 1940s
PAPERED AND PAINTED WOODEN BOx, WITH PAINTED CORRUGATED
CARDBOARD FLOOR, CONTAINING DOLL IN CLOTH DRESS AND STRAW
HAT WITH CLOTH FLOWERS, DRIED FLOWERS, AND 1WIGS, FLECKED
WITH PAINT, 23½ x 12⅜ x 5¼" (59.7 x 31.5 x 13.3 CM)
ACQUIRED THROUGH THE LILLIE P. BLISS BEQUEST, 1980

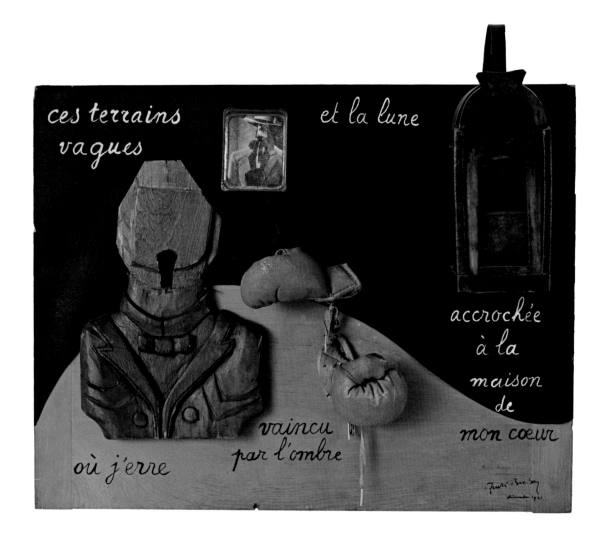

André Breton | (FRENCH, 1896–1966)
POEM-OBJECT. December 1941
ASSEMBLAGE MOUNTED ON DRAWING BOARD. CARVED WOOD
BUST OF MAN, OIL LANTERN, FRAMED PHOTOGRAPH, TOY BOX-
ING GLOVES, AND PAPER, 18 x 21 x 4⅜" (45.8 x 53.2 x 10.9 CM)
KAY SAGE TANGUY BEQUEST, 1963

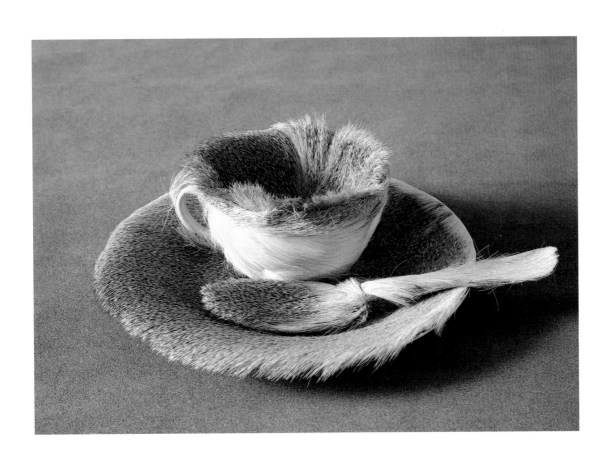

Meret Oppenheim | (SWISS, 1913–1985)
OBJECT. 1936
FUR-COVERED CUP, SAUCER, AND SPOON, CUP 4⅜" (10.9 CM) IN DIAMETER; SAUCER 9¾"
(23.7 CM) IN DIAMETER; SPOON 8" (20.2 CM) LONG, OVERALL HEIGHT 2⅞" (7.3 CM)
PURCHASE, 1946

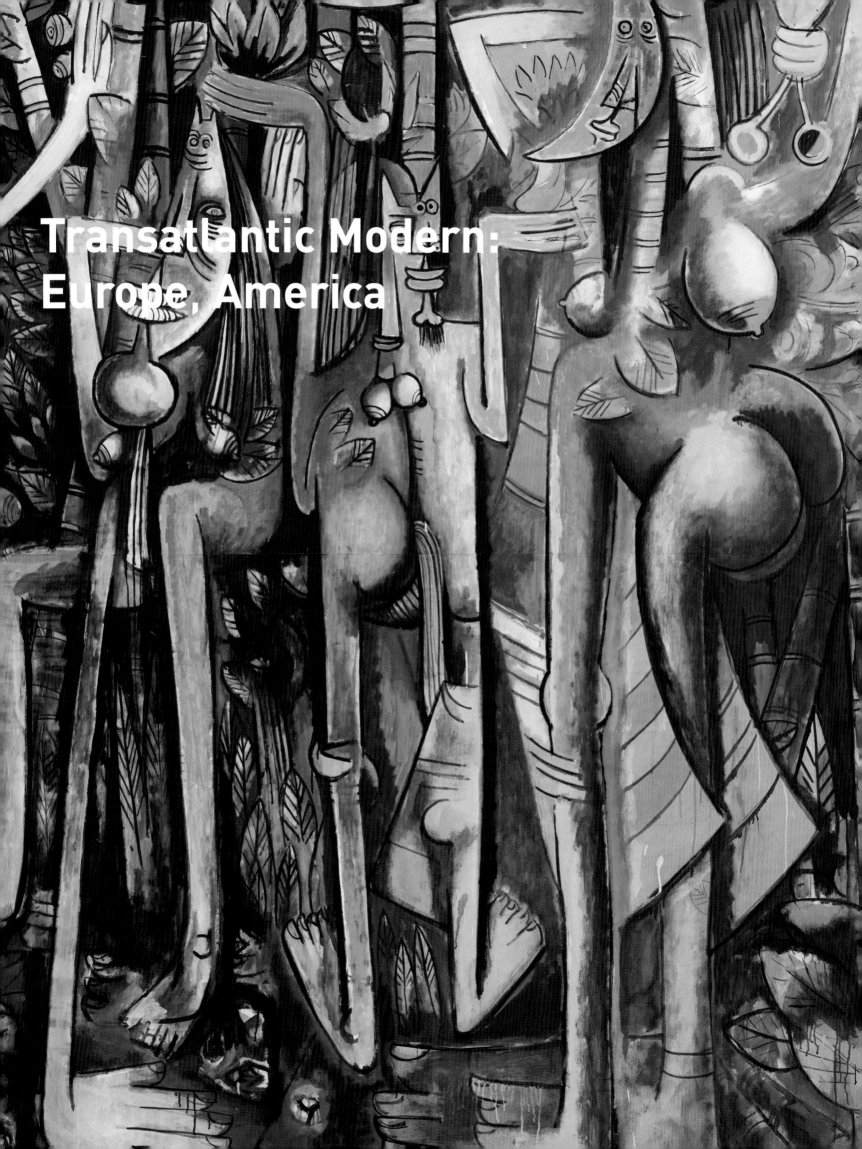

Transatlantic Modern:
Europe, America

For the past twenty years, the two-floor installation of the historical (precontemporary) painting and sculpture collection at the Museum has divided at World War II, the second part opening with the conflux of post-Cubism and late Surrealism in Europe and America before moving on to the mature work of the Abstract Expressionists.

Postwar Europe is represented by work of around 1950 by the founders of Cubism, Pablo Picasso and Georges Braque; by the post-Surrealist style of Alberto Giacometti; and by then young artists, including Jean Dubuffet and Francis Bacon. Now, they are joined by less-expected partners, among them the Cuban late Surrealist Wifredo Lam and the Venezuelan painter of luminous materiality, Armando Reverón. Postwar New York is represented by sometimes slightly earlier and sometimes contemporaneous paintings by Abstract Expressionists to-be, including Mark Rothko and Arshile Gorky, that self-evidently are still learning from Surrealism and by one, Willem de Kooning, who has already moved past it to shape an eventually figurative style that has affinities with those of his European contemporaries.

The Museum's collection of Abstract Expressionism ranges from eighteen paintings by Jackson Pollock to only two by Clyfford Still, with most artists more than well represented. Therefore, the selection here offers only the more important works. But it has always been the Museum's ambition to collect key works, and Pollock's *One: Number 31, 1950*, Barnett Newman's *Vir Heroicus Sublimis*, and Rothko's *No. 5 /No. 22* are as much key works in this period as are *Les Demoiselles d'Avignon*, *The Red Studio*, and *The Birth of the World* in the period of Picasso, Matisse, and Miró. In the galleries, the installations will change periodically, so that a room devoted to Pollock may be subsequently devoted to Newman, or to the sculpture of David Smith and others associated with the painters of the period.

The post-Abstract Expressionist presentation charts two principal directions in the second half of the 1950s and early 1960s. The first comprises artists who built on or tempered the painterly abstraction of their predecessors, artists such as Morris Louis, Helen Frankenthaler, and Anthony Caro, and those who transformed its painterliness by infusing it with image content, most notably Jasper Johns, Robert Rauschenberg, and Cy Twombly. The second direction encompasses a broad group of artists of the same period outside the United States, who, being outsiders, challenged some basic premises for painting and sculpture that hitherto had been left untouched. This direction corresponds to the post-Cubist one that concluded the second section of this book, both revealing crosscurrents that complicate, develop, and seek to escape from a dominant style. Here, the Parisian work of the American Ellsworth Kelly and the Venezuelan Jesús Rafael Soto propose severe, abstract alternatives to painterliness; another Venezuelan, Alejandro Otero, and an Englishwoman, Bridget Riley, find means of perceptual dematerialization in Pollock. The Brazilians Hélio Oiticica and Lygia Clark accentuate the manual and corporeal implications of recent art; a Swiss, Dieter Roth, and a Belgian, Marcel Broodthaers, find contrasted lessons in an art of poetry and autobiography sanctioned by Surrealism. And finally, a Spaniard, Antoni Tàpies, and an Italian and a Frenchman, Lucio Fontana and Yves Klein, reengage the materiality of European art just after World War II, with which this section began.

Abstraction and Figuration

Pablo Picasso
Pregnant Woman. 1950
Illustrated on page 328

Joachim Pissarro, report on purchase, Department of Painting and Sculpture, **2003**

Picasso was sixty-eight years old when his companion, Françoise Gilot, became pregnant with his last child. Paloma was born in 1949—a year before the plaster and the bronze casts of *Pregnant Woman* were executed (1950).

At no point in his life had Picasso begun to show such intense and moving attention to another crucial (in fact, "vital") aspect of his own creation—his personal capacity to (re-)create life. This sudden and intense attention developed through his own late parenthood with Françoise, who gave birth to Claude in 1948, before having Paloma only a year later. The aging Picasso found himself with two babies less than a year apart and tons of makeshift postwar toys. Suddenly, his imagery in all mediums became replete with references to childhood. It is easily arguable that *Pregnant Woman* constitutes the culmination of this reflection on life, and its reproductive cycle in which he was suddenly wholly engaged in his late sixties. But there is more to *Pregnant Woman* than just that.

This interest in life, in his and Françoise's own family, did not dislodge Picasso's previous artistic interests. It was Roland Penrose who perhaps most pithily succeeded in characterizing Picasso's ongoing protean creative force and his power to surprise us over and over when he said that, for Picasso, "reality can never be satisfactorily stated except by paradox." Picasso was acutely, even painfully, aware of the contradictions and the dialectical oppositions that make up the fabric of life. Distilling or refining those very contradictions became for Picasso the way to express a novel and sharper perception of the truth. But at the turn of the 1940s/1950s, there was a big change in the way Picasso articulated these dialectical oppositions into his work. . . .

[I]n the years immediately after the war an unprecedented move took place in his oeuvre. Picasso demonstrated a sudden directness of attention to simple objects . . . except that those simple objects in fact became the sites of dual or multiple meanings themselves. . . .

Pregnant Woman fully belongs to the new trend (begun in the mid-1940s) of depicting wholesome figures or objects. This wholesomeness reveals (or partly conceals) Picasso's continuous obsession with duality and dialectical tensions. Nowhere does Picasso combine this interest in duality embedded into oneness more forcefully, more fully than in *Pregnant Woman.* . . . [T]he very subject matter of this sculpture is precisely about the fact that one can contain two. And this is not just a matter of linguistics or psychoanalysis, but a matter of life.

Alberto Giacometti
Man Pointing. 1947
Illustrated on page 329

John Russell, *The Meanings of Modern Art*, **1981**, pages 370–71, 372

[W]hen Giacometti returned to Paris from his native Switzerland in 1945 he brought with him a new preoccupation, a new kind of physicality in sculpture, and an existential view of "the masterpiece." "Existential" was everyone's favorite adjective in Paris at that time; and it referred not only to the philosophy which was associated primarily with the name of Jean-Paul Sartre but, more colloquially, to the belief that in all human enterprises the odds are stacked against us and that all we can do is to play a losing game as lucidly as possible. This belief related exactly to the conditions of life in German-occupied France; and it found a most vivid outlet in such key works of the time as Sartre's play *No Exit* and Albert Camus's novel *The Stranger.* . . . But it had also a more general implication: that our century has eaten away at beliefs once taken for granted—the unity of human personality, the unity of matter, the unity of space and time—and that it is the role of art to come to terms with that erosion.

This is where Giacometti came in. Ever since he had read [Friedrich] Nietzsche and [Arthur] Schopenhauer at the age of 12, he had been familiar with the tragic sense of human destiny which was fundamental to everyday life in France between 1940 and 1945. Nobody was more inventive than he when it came to finding a metaphor for imminent doom; we remember, here, the

Woman with Her Throat Cut of 1932 [see page 291]. But when that doom became a fact of political history with the coming to power of Hitler in Germany in 1933, Giacometti began to turn to quite another aspect of art.

"I knew that one day," he said later, "I'd have to sit down on a stool in front of a model and copy what I saw." His colleagues among the Surrealists were appalled—"As if everyone didn't know what a head is!" was André Breton's reaction—but to Giacometti it seemed that the most adventurous thing which remained for art to do was to reinvent the idea of likeness. On this one card, as Simone de Beauvoir said in her memoirs, he staked everything. He sat down and tried to say exactly what it was like to be in the presence of another human being. And he tried to do it as if no one had ever done it before: to start from zero. He did it, as he said himself, "with no hope of succeeding." What do we really see? What do we mean by likeness? What are we to do with the formless, blubberlike space which separates us from the person we are looking at? How can we possibly recapture the total experience? What if the sculpture, even if passable in itself, is falsified by its relation to the world around it? These were the problems which Giacometti tried to deal with. . . .

It was as a result of these preoccupations that Giacometti eventually found three-dimensional equivalents for things that sculpture had not previously dealt with: the fugacity of sense-impressions, for instance, the unstable or at any rate unseizable nature of human personality, and the arbitrary deformations which are imposed on the human figure by memory, by its surroundings at any given time, or by the chance involvements of looking. We can see today that the break with the sculpture of the past was not as complete as it once seemed; the *Man Pointing* of 1947 had a look of [Auguste] Rodin, for instance. Nor did Giacometti lose altogether the Gogol-like feeling for the grotesque which had marked some of his Surrealist pieces . . . But in general what Giacometti had to say about the poignancy and the incompleteness of human relations was altogether new—as were, equally, his ways of saying it.

Alberto Giacometti

The Chariot. 1950
Illustrated on page 329

Robert Storr, *Modern Art despite Modernism*, **2000**, pages 75–76

After an academic education that included studying with the sculptor of monuments Antoine Bourdelle and copying from the old masters in Italy, Giacometti developed his own mix of Cubist elements and motifs bor-rowed from African art. By the late 1920s, his work had acquired a fantastic quality that recommended him to the Surrealists . . . In 1935, however, he broke with [André] Breton and rejected poetic reverie for an austere realism anchored in the scrutiny of isolated individuals. Set in the boxy confines of his studio or the desolate streets of Paris, his paintings reconstitute the Renaissance geometries exploded by Cubism in brittle linear structures. The flickering tonal clusters of his brushwork are like a vestigial Impressionism from which color has been drained away. The slender, eroded figurines of Giacometti's sculpture are barely three-dimensional incarnations of his simultaneously tentative and irreducibly iconic paintings.

In both mediums, Giacometti's lonely enterprise was a return to basics and a return to his roots. The test was to represent the world with a willed innocence, which demanded remembering and forgetting, relearning and unlearning in equal parts. Thus, each painterly mark or cancellation and each sculptural addition or subtraction required the artist to repeatedly confirm the truth of what he saw directly before him while resisting the temptation to speed up that painstaking and interminable process or slide back into familiar stylistic solutions. Nevertheless, signs of Giacometti's art-historical self-consciousness are everywhere; only someone who had drawn Etruscan bronzes in Rome could have achieved the marvelous abbreviation of man and vehicle, stasis and implied motion found in *Chariot*. The skeletal race Giacometti created and the ordeal of its making invited critics and the public to read his art as an existentialist narrative, a compound metaphor for alienation and solitary tenacity in the Holocaust-haunted, post-Hiroshima world. Viewed as literature, Giacometti's images do lend themselves to such interpretations, but the new beginning he strove for had less to do with generalizations about mankind than a struggle to render the specifics of sensation—that which is by its very nature fleeting and impermanent—through old-fashioned means. Transfixed by a mirage he could never reach, though it hovered only inches beyond his grasp, Giacometti was an extremist in pursuit of profoundly traditional ends.

Jean Dubuffet

Joë Bousquet in Bed. 1947
Illustrated on page 330

Adam Gopnik, *High & Low: Modern Art and Popular Culture*, **1990**, pages 144–45, 146

If it was still possible to remake tradition through a sculptural marriage of classical form and its parody, by

the end of the 1930s the reimagining of the caricatural likeness had become so common that it had lost all power to disturb. The funny face had become simply the heraldic emblem of modernism. It required some great crisis to make a mixed-up face seem again like something more than syncopated décor, and that was achieved just after World War II by Jean Dubuffet. Dubuffet's aggressive, graffiti-style caricatural portraits of 1946–47 are in part caricature in the simplest sense, a mocking variant on the pantheons of artists that had become sober clichés of even "radical" French art, as in Surrealist group portraits. But Dubuffet's portraits manifest the revolt, and revulsion, of intellectuals: mental energy and will are now all that matter, and the body can (indeed, must, as a Savonarola-style demonstration of adherence to a new anti-faith) go to hell. His writers and intellectuals are pathetic monsters, their features reduced to pop-eyed scrawls, their aplomb prodded into jumping-jack spasms. Yet, since grotesque harshness and imbalanced disturbance are in Dubuffet's view tokens of authenticity, to be portrayed by him with scar-like contours and inept anatomy is, perversely, to be made glamorous. A rich and peculiar underlying conservatism can be found in Dubuffet's portraits, one that is expressed in their choice of subjects. . . . Dubuffet's portraits, far from purposely lying outside the realm of cultural debate, choose up sides and manners from deep within it.

Like Giacometti's gaunt walking figures, these portraits are, of course, self-conscious visual metaphors of Existentialist man. But if for Giacometti that condition was expressed in the play between leaden-footed movement and immense solitude, for Dubuffet the same angst could be captured through the play of the spastic figure within compressed space. His intellectuals are like pinned insects, leaping and writhing as they are pierced and labeled. Yet even these inadequate, absurd, incongruous leaps and claps and bounds have some baseline heroism about them: they are images (in every sense) of survival, even if they show the will reduced to a nervous spasm and the smile of reason reduced to a reflexive grimace. . . .

Dubuffet's portraits obstinately insist that caricatural wit (and the social life it belongs to) is itself a kind of mania. As much as in his transformation of the meaning of graffiti imagery in art, in these portraits Dubuffet was also out to change our sense of the role of wit in art. . . . The Surrealists thought that the consummately unsocial product was the thing to pay attention to, and they were interested in low jokes only in as much as they could be made to look like dreams. Dubuffet reversed this process. The line between constructive, healthily "socialized" outward life and dangerous (if arrestingly rich) mental life—the line that had in the past been the distinction between wit and dreams—was for Dubuffet an illusion. You didn't have to look past the caricature for the craziness; the caricature itself showed you all the craziness you needed to see. Look into the caricature, the Surrealists had suggested, and you may see there a little piece of the intricate psyche of modern man; look into the psyche of postwar man, Dubuffet's portraits insist, and all that remains is a caricature.

Francis Bacon

Painting. 1946
Illustrated on page 331

James Thrall Soby (1962) in *MoMA: The Magazine of The Museum of Modern Art,* **1990**, pages 10, 11

Bacon's subject matter, though never fixed or predictable, began to assume its basic psychological identity in 1946, the year in which he exhibited a group of his studies for the Crucifixion at the Lefevre Gallery in London. His was and remains an iconography primarily concerned with the torments and hysteria of contemporary existence. Its aim has been well stated by the artist himself: "I would like my pictures to look as if a human being had passed between them like a snail, leaving a trail of human presence and memory traces of past events, as the snail leaves its slime."[1] But what gives his art its extraordinary force is that it is expressed in seductive rather than satirical terms. His technical handling is so deft and magic that he seems to caress rather than belabor his monstrous subject matter. . . .

In 1945 and 1946 Bacon created two unforgettable paintings: *Figure in a Landscape* and the major work known simply as *Painting*. It is astonishing to learn from the Tate Gallery's fine catalog of the [1962] Bacon exhibition that the first of these two pictures was painted from a snapshot of the artist's friend Eric Hall dozing in a chair in Hyde Park. . . .

In *Painting* the man has moved indoors to what would seem to be one of the butcher shops which Bacon is said to have visited often in his youth. Behind him hangs a huge carcass, its arms or legs outstrung as if it were crucified. The man's face is now half-hidden by the shadow cast by an umbrella—a symbolic reference to the umbrella of [Neville] Chamberlain, which became an uneasy token of appeasement in Europe? Before him on a circular metal structure are placed other carcasses, flanked by a battery of those microphones which have been the constant instrument of perverse oratory in our time. Behind the figure hang curtains with tassels, and here again as in the case of Bacon's recurrent use of the human scream based on that of the wounded *Potemkin* nurse, a photographic reference is

implicit. We know that Bacon always has been deeply interested in press photography in its more macabre aspects and that a snapshot in his possession shows Hitler exhorting a crowd in his hoarse and lurid rhetoric. Beside the dictator on his balcony hangs a tassled curtain whose idling tranquility adds an ironic note of contrast to public hysteria. In physical terms Bacon's *Painting* is rich and subtle, as though the artist intended to give a beguiling veneer to an image of frightening portent.

Jean Dubuffet
The Magician. 1954
Illustrated on page 332

Jean Dubuffet, in *The Work of Jean Dubuffet*, **1962**, pages 87, 89–90

The first of [my] statues [of precarious life, of March 1954] was *Grouloulou*, made of pieces of newspaper smeared with glue and bunched around an armature. It was above all a glorification of newspaper paper. I had only recently used torn fragments of newspaper in several of my assemblages, notably in the poster for my show at the Cercle Volney. *Grouloulou* was therefore closely related to these works.

The second was *Gigoton* made of steel wool such as housewives use to clean their pots and pans.

The third, *Personage with Paste Eyes*, made use of fragments of burned automobiles that I found in the garage where I kept my car.

Those that followed were made of broken clinkers [slag or brick] put together with cement. First I used clinkers I picked out of the trash cans in the apartment house where I was living, but soon I went out looking for more clinkers, as well as for different kinds of rubbish (old trampled cords, broken glass, big rusty nails) in the railroad yards of Montrouge.

It should be noted that these works borrowed my method of assemblage, and may, therefore, be considered a development of the butterfly-wing collages, of the lithographs made of superposed and glued fragments . . .

After using clinkers for two months, I went on to sponges. A wholesale dealer on rue Monge let me take my pick from a huge pile, all of them grotesque and unsaleable. But what were defects for the trade were added virtues for me. To these assemblages of pieces of sponge I would sometimes add oakum dipped in glue.

Later I made other little statues out of grapevine stocks collected in Burgundy, and out of pieces of charcoal from a coal dealer in Morvan. Finally, beginning in September, for the last of these little statues, I used scoria, pieces of lava, and volcanic stones picked up in Auvergne.

In October 1954 there was an exhibition of about forty-four of these statues at the Galerie Rive Gauche.

Henry Moore
The Bride. 1939–40
Illustrated on page 332

Andrew Carnduff Ritchie, *Sculpture of the Twentieth Century*, **1952**, pp. 24–25

The two sculptors . . . who next to [Constantin] Brancusi have contributed most to the development of organic abstract sculpture are Jean Arp and Henry Moore. While Arp was one of the founders of the dada movement and was closely associated with the surrealists, and Moore likewise was influenced early in his career by similar tendencies, both have their formal origins in Brancusi. . . .

Moore has been influenced by Arp as well as by Brancusi . . . Like Brancusi and [Pablo] Picasso, whose organic abstract painting of the late twenties influenced him also, Moore has a capacious appetite for the art of many periods and places. He has studied such divergent sources as renaissance, medieval, Sumerian, African Negro and pre-Columbian art. Although much of his work in the thirties was extremely abstract (the strung wire and lead construction, *The Bride*, is a still later example), in his major sculpture he has concentrated to a much greater extent, than Arp or Brancusi, on the elementary forms and rhythms of the human body. While he was never strictly speaking a surrealist, he has in common with many contemporary artists derived much from the surrealists' investigations of the world of the unconscious. As the renaissance artist helped medical men to develop a scientific knowledge of anatomy, so Moore by emphasizing certain features of the body and exaggerating or contracting others suggests a sort of foetal connection with other phenomena in nature which the biological and psychological sciences of our day are exploring. Until recently Moore carved directly in wood and stone and, a great respecter of his materials, created images related to trees and stones themselves. Some contemporary sculptors have exploited the accidental shapes of field stone and tree trunks, assisting the stone or wood, as it were, to better represent the form it is striving towards. . . . Moore . . . establishes his own synthesis of body-stone and stone-body by creative means, as independent as possible of the accidents of nature.

Louise Bourgeois

Sleeping Figure. 1950
Illustrated on page 333

Deborah Wye, *Louise Bourgeois*, **1982**, pages 13, 14, 22

Bourgeois is articulate about the underlying psychological motivations for her art. In this regard, she is situated within the Surrealist tradition, which sees the exploration and expression of the unconscious as art's primary aim (she also shares the Surrealists' literary and poetic predilections). The work of art serves a psychological function for Bourgeois, for she believes that making art is the process of giving tangible form to, and thus exorcising, the gripping, subconscious states of being that fill one with anxiety—a belief that places her in line with the Expressionist tradition, as well.

By fulfilling this function, Bourgeois's art achieves emotional intensity. She captures those exorcised feelings in her work and thereby animates it. The result, whether four inches in diameter or forty feet long, is sculpture with an inner force resembling magnetic powers. Her work has the kind of indwelling energy of an amulet with good-luck charms, an object with a hex on it, a chalice having a religious aura, or even a tombstone. Her sculpture radiates a vital spark that thoroughly absorbs the viewer, as if something inside the object were alive. This emanation rivets the viewer. Through a suggestiveness of form or resonance of representation, her sculpture conveys a quite specific experience—whether anxious, frightening, or repellent; poignant, humorous or calming. Bourgeois's achievement of such potent emotional intensity within a wide range of inventive and meaningful images is ultimately the real mystery of her artistic powers. . . .

As Bourgeois pointed out in the fifties: "My work grows from the duel between the isolated individual and the shared awareness of the group. At first I made single figures without any freedom at all. . . . now I see my work as groups of objects relating to each other. . . . But there is still the feeling with which I began—the drama of one among many."[1]

Isamu Noguchi

Apartment. 1952
Illustrated on page 333

Isamu Noguchi, in *Fourteen Americans*, **1946**, page 39

The essence of sculpture is for me the perception of space, the continuum of our existence. All dimensions are but measures of it, as in the relative perspective of our vision lie volume, line, point, giving shape, distance, proportions. Movement, light, and time itself are also qualities of space. Space is otherwise inconceivable. These are the essences of sculpture and as our concepts of them change so must our sculpture change.

Since our experiences of space are, however, limited to momentary segments of time, growth must be the core of existence. We are reborn, and so in art as in nature there is growth, by which I mean change attuned to the living. Thus growth can only be new, for awareness is the everchanging adjustment of the human psyche to chaos. If I say that growth is the constant transfusion of human meaning into the encroaching void, then how great is our need today when our knowledge of the universe has filled space with energy, driving us toward a greater chaos and new equilibriums.

I say it is the sculptor who orders and animates space, gives it meaning.

Armando Reverón

Woman of the River. 1939
Illustrated on page 334

John Elderfield, proposal for an exhibition, **1999**

Armando Reverón was an extraordinary artist who is revered in his native Venezuela but is little known outside Latin America. He is, however, not only one of the most important of modern Latin American artists, but unique in the first half of the century in his conflation of late Post-Impressionist idioms with an extremely tactile surface and almost monochromatic palette. The result was unmistakably original paintings that are both highly mysterious and utterly radical. His achievement deserves to be ranked among that of the important early European modernists. Indeed, it may truly be said of Reverón that he is the last of the great early modern artists to be discovered and shown to international audiences.

Reverón's artistic education was spent in Caracas, punctuated by two short visits to Spain and France. His mature work dates from the 1920s onward, when he settled at Macuto on the Caribbean coast not far from Caracas. His works made in these years are, in the main, figure paintings that reveal the influences of historical Spanish art, especially Francisco Goya, and of Symbolism. Soon, however, this typically bluish, nocturnal style was transposed to, and transformed by, the treatment of landscape subjects. The result was paintings still of a bluish haze but also of a tactile surface, revealing the influence of French Impressionist and Post-Impressionist idioms.

By the mid-1920s, he had transformed himself into a

highly original painter of perceptual appearances. His so-called white paintings, some of which are virtually monochromatic, show landscapes, seascapes, and figures whose appearances dissolve and distort in the intense light of the Caribbean. They are unique in early modernism, and seem to be anticipatory of later monochromatic abstract art.

Reverón's preoccupation with the break-up of form in light led him to make radical changes in his painting technique, stressing the physical materiality of the canvas and the paint, and loosening the means of the application. The result was an even greater disembodiment of the visual scene.

Reverón would be an important early modernist only for these "white" paintings, which may be thought to represent the perceptual experience of landscape dissolving in the intensity of bright, Caribbean light. But they were only the beginning. By the early 1930s, the figure had reappeared in his work, and soon a now "sepia" monochrome, which may be thought to represent the perceptual experience of puzzling-out forms in shadowy interiors. Surprisingly, the subjects of these paintings were, increasingly, not human figures but the lifesize dolls that Reverón and his companion Juanita Ríos constructed, along with a wide variety of imitation practical objects. Similarly, the late landscapes painted around the nearby port of La Guaira make of this bustling environment a place of ghosts and shadows.

Wifredo Lam
The Jungle. 1943
Illustrated on page 335

Rocío Aranda-Alvarado, in *Latin American & Caribbean Art: MoMA at El Museo*, **2004**, pages 103, 106

Arguably the most well-known work of art by a Latin American artist, Wifredo Lam's *The Jungle* (1943) is a paradigm: an emblem of the influence of School of Paris technique and theory in Latin America, the work is also a signifier for the shift in representation developed by the American avant-garde in the period between the wars. . . .

In fragmenting the figure, Lam juxtaposes a variety of signifiers for race: Africanized masks, hyperbolic exaggeration of body parts, and "jungle" vegetation. In turn, this further underscores Lam's original intent, presenting the figures simultaneously as victims of their surroundings and guardians of their culture. Nearly choked on the picture plane by the lush, lascivious jungle growth, Lam's figures face one another confused and enraged. The image is a seismic conflation of environment and beings, of Santería ceremony and labor, spiritual frenzy and colonial history. The chaos of the scene is intended to underscore the plight of the worker in the Cuban landscape, surrounded by the staple crop that signifies both livelihood and enslavement.

This racialized figure was of particular interest to Lam, who said, "I wanted with all my heart to paint the drama of my country, but by thoroughly expressing the negro spirit, the beauty of the plastic art of the blacks. In this way I could act as a Trojan horse that would spew forth hallucinating figures with the power to surprise, to disturb the dreams of the exploiters."[1]

An endless Surrealist landscape, Lam's jungle represents a signifying space, where the discourse of anti-colonialism is visualized through the landscape and the figures that are caged in its forms. *The Jungle*, then, represents Lam's affirmation of *Cubanismo*—the act of embracing emblems of authentic Cuban culture—as well as his dedication to illuminating the harsh realities of life for Afro-Cubans and, certainly, his attempts to place his paintings within the larger framework of avant-garde modernity. Lam's jungle is not only the field of sugarcane, the sole source of income for so many Afro-Cubans, but also the land itself. It is everything that engulfs the island.

Abstract Expressionism

Mark Rothko
Slow Swirl at the Edge of the Sea. 1944
Illustrated on page 336

Kirk Varnedoe, in *"Primitivism" in 20th Century Art: Affinity of the Tribal and the Modern*, **1984**, page 631

Various scholars have found among the shapes of Rothko's works of the mid-1940s suggestions of native-American sand paintings, or of costumes and implements of Primitive ritual.[1] His art seems a prime example, however, of the ways in which Primitivism operated in the art of the 1940s on levels that lay beyond whatever specific stylistic influences appeared,

and in domains of meaning rarely touched on in direct primitivizing rhetoric. Without citing [Carl] Jung directly, Rothko argued for a timeless validity of art derived from the unconscious.[2] Moreover, the aqueous character of pictures such as *Slow Swirl by the Edge of the Sea* and *Figure in Archaic Sea* may be in harmony with Jung's observation that "water is the commonest symbol for the unconscious."[3] The delicate ciliated organisms that hover in these canvases use the fragile yet irresistible stirrings of primal evolution as equivalents for the generative power of the most basic levels of consciousness. They move vertically across banded strata that define breached horizons between rootedness and ascension, potential and blossoming, preconscious thought and higher development. Typically, the cutaway vision of these images emphasizes continuity above and below such divisions, and the organic integrity of a transformation that binds diverse forms to a single driving energy. These shapes were, Rothko said, "organisms with volition and a passion for self-assertion," his modern equivalents for the "monsters and gods" without which "art cannot enact our drama."[4] Suggested here are metaphors for thought, for the primal archetypes Rothko felt should guide his work, emerging from the depths of consciousness with indeterminate potential yet with a preordained, "natural" inner impulse to self-definition.

Arshile Gorky

Summation. 1947
Illustrated on page 337

John Elderfield, *The Modern Drawing: 100 Works on Paper from The Museum of Modern Art*, **1983**, page 184

Drawing was . . . the probity of Gorky's art. He was essentially a draftsman of the wrist and hand, and at his best, line is given priority and the other pictorial components support it. Color is tinted or scumbled around line, and shading offsets and enlarges it. Moreover, he was obsessed by the exactness that line drawing allowed. Adoption of Surrealist automatism in 1944–45 freed Gorky's line, dissociating it from color and shading, and giving to it specifically the kind of mobility and fluency that had been developing in his art as a whole since he passed into maturity two years before. But by the date of [this] drawing, it had recovered its contouring function and was again at the work of exactly identifying forms, albeit forms that defy exact identification. Even in 1944, in fact, Gorky was using his new linear mobility not to enlarge the spontaneity of his art, but rather to recover from within an already

spontaneous art, which had subsumed line in painterliness, a kind of drawing that was at once compositional and episodic and that was precise and ambiguous at the same time.

What I mean by this—and we see it in *Summation*—is the following. Gorky's drawing creates clusters of incident. It creates them precisely, but they are ambiguous. It is the mobility of the line that allows them to form what [André] Breton, the Surrealist leader, called "hybrids"—linear units with multiple metaphoric meanings. This same mobility allows their association. Although this work is episodic, the drawing that creates its separate episodes accumulates them. Gorky's is an additive, constructive art, conceived not as a whole made up of parts, but as individual parts (often the subjects of separate studies) that combine to make up a whole. We see and easily read (if not quite decipher) the separate, distilled motifs; and by recognizing the formal and familial analogies in the treatment of these motifs, and the soft continuity of the shading that surrounds them, we also read them together: as one single and richly detailed image, whose force is strengthened by the variety of incident it contains. The immense size of the drawing meant that Gorky could move out his composition toward the framing edges rather than having to order the work in their terms. This carries him beyond Cubist design. However, the play of soft against hard in the shallow monochrome space almost as completely brings him back. And the sheer grandness of the work returns him yet further, and adds justification to his biographer's characterization. Gorky did indeed make of automatism an art with the monumentality, as well as precision, that we associate with the classical masters of the past.

Arshile Gorky

Agony. 1947
Illustrated on page 337

William C. Seitz, *Arshile Gorky*, **1962**, page 40

The succession of catastrophes that led to Gorky's suicide on July 21, 1948 began with the destruction of his paintings and his studio by fire in January, 1946 and his operation for cancer in February. During that year he underwent crushing blows to his physique, his personal life and his art. The tragic and beautiful canvas in The Museum of Modern Art is an outcome of these pressures. Compared with preparatory drawings, the anguished theme is aesthetically transformed; but the color scheme alone—cold yellow, smoldering and feverish red, black patches in a curdled umber broth—justifies Gorky's title.

Unlike some other pictures of the period, *Agony* was not systematically developed from one master drawing, but was preceded by several bold studies spasmodically drawn with a soft black pencil. Each one, like the final painting, concentrates on the same structure—a fearful hybrid resembling a dentist's chair, an animated machine, a primitive feathered fetish or a human figure hanging on the rack, its rib cage hollow and its groin adorned with petals. The less shocking form it takes in the painting is studied in a few small wash drawings as an altered detail, and connected with an oval spot at the far left. *Agony* is not a landscape, but a furnished interior closed from behind by a partition; the floor line crosses the picture, and horizontal and vertical lines are echoed throughout. Silhouetted against the brightest cloud of red, at right center, a concave-sided plane is hung from a hook incised as sharply as a knife cut, and counterbalanced by a black weight. From the right a droll homunculus, his two huge vertebrae exposed, bows toward the center. It is of interest to note that a smaller version of the painting, done before the revision of the main motif and in a different color scheme, resembles a landscape. It is delicately painted in deft washes on a bare ground, and drawn with an almost lyrical lightness.

Gorky
Agony
Illustrated on page 337

William S. Rubin, *Dada, Surrealism, and Their Heritage*, **1968**, pages 171, 173, 174

Arshile Gorky was the last important artist to be associated with Surrealism. [André] Breton became interested in him in 1943, and two years later devoted the concluding section of the new edition of his *Le Surréalisme et la peinture* to Gorky.[1] By then he was considered a full-fledged member of the movement. Though Gorky explored the possibilities of automatism and wrung from biomorphism a particular pathos, he was more deeply committed by affinity and by training than even [Joan] Miró to the mainstream of European painting, as represented by [Pablo] Picasso and [Henri] Matisse. The Surrealists, by and large, disdained the medium, as their various techniques for bypassing it suggest. Gorky delighted in oil painting and nursed from its possibilities a range of effects that place him second to none as a manipulator of the brush.

The extraordinary painterly sensibility of Gorky's best work was achieved through a long apprenticeship. Years of paraphrasing [Paul] Cézanne, Picasso, and Matisse, and then in the later thirties and early forties,

Miró and Matta, allowed Gorky to select and retain from their styles what was viable for him. But even as he passed into his maturity in the winter of 1942/1943 he was still anxious to learn, and still unwilling to narrow himself to a single tradition, as his assimilations at the time from [Vasily] Kandinsky's works of 1910–1914 testify. By the following year his modesty and openness to the art of other painters, whom he selected with infallible instinct, emerged in pictures that communicated Gorky's personal poetry with an overwhelming orchestral sumptuousness. . . .

During the winter of 1944/1945, Gorky's interest in spontaneity carried him beyond the "Improvisations" of Kandinsky to the technique of automatism. [Some] pictures . . . show him nearer to Surrealism than he had yet been, or was ever to be afterward, and mark precisely the time of his greatest personal closeness to Breton and to Matta. The rapid drawing, the loose brushwork that encouraged the spilling and dripping of the liquid paint, departed from Matta's automatism of 1938–1942 and went beyond it. It was only natural that Breton should have encouraged Gorky in this excursion. Julien Levy, Gorky's dealer at the time, speaks of this as "liberation." For Gorky, "automatism was a redemption." Surrealism, he continues, helped Gorky "both to bring himself to the surface and dig himself deep in his work," so that "his most secret doodling could be very central."[2]

Bradley Walker Tomlin
Number 20. 1949
Illustrated on page 340

Helen M. Franc, *An Invitation to See: 150 Works from The Museum of Modern Art*, **1992**, page 137

Tomlin's monumental, seven-foot-high canvas is filled with a bold calligraphy in which each character stands out clear and distinct. The light-toned bars and ribbons of angular, curving, and hooked signs, punctuated by small black and white squares and circles, seem like hieroglyphs that lack only the appropriate Rosetta Stone for their deciphering. They are deployed against a background of shifting rectangles, derived ultimately from the structural grid of such Cubist paintings as Picasso's *"Ma Jolie"* [see page 151]. The sober color of Tomlin's *Number 20* of 1949, relieved only by a small red accent toward the top center, is also reminiscent of monochromatic Cubist paintings of 1911–1912.

The freely invented forms of his calligraphy, on the other hand, come out of a different tradition. They owe something to Surrealist automatism, one of the major formative influences on the avant-garde artists of the New York School, with whom Tomlin became associated

in the late forties. His *Number 20*, however, cannot strictly be classified as "Abstract Expressionist," for besides its geometric underpinning, the signs, too, show a disciplined control rather than free spontaneity, and they are arranged in a formal design of austere, though decorative, elegance.

Willem de Kooning

Painting. 1948
Illustrated on page 342

John Russell, *The Meanings of Modern Art*, **1981**, pages 308, 309

De Kooning is one of the great draftsmen of this century, with a variety of attack and a range of subject matter which are almost beyond comparison. He can do anything that he wants with line; and the line in question can be as thin as a silk thread or as broad as the nose of an orangutan. And when he crossed over from drawing to painting at the end of the 1940s he used zinc white and a housepainter's black enamel to make forms which were completely flat, like the forms in late Cubism. They were not so much painted as *laid on*; and they related to the signs which had been devised by [Jean] Arp and [Joan] Miró to echo the human body without actually naming it. "Even abstract shapes must have a likeness," de Kooning once said. And in pictures like his *Painting*, 1948, every shape has its likeness: its familiar companion, which stays within hailing distance but does not come forward to be identified.

As [Thomas] Hess has remarked, the black-and-white paintings are "packed to bursting with shapes metamorphosed from drawings of women which have been cut apart, transposed, intermixed until they were abstract, but always with a 'likeness' and a memory of their source and its emotive charge."

Willem de Kooning

Woman, I. 1950–52
Illustrated on page 343

Thomas B. Hess, *Willem de Kooning*, **1968**, page 74

In February 1951, de Kooning was invited by The Museum of Modern Art to write a paper for a symposium titled *What Abstract Art Means to Me* . . . and it has since been frequently quoted and misquoted. But while considered a spokesman for the new American abstract art, de Kooning was engaged in a very different enterprise. Almost as soon as *Excavation* left his studio in 1950, he tacked a seventy-inch-high canvas to his painting wall and began to paint *Woman, I*; it was not finished until two years later, having been abandoned after about eighteen months' work . . .

Most of those who knew de Kooning's work and had followed his heroic struggles with *Woman, I* felt it was a triumph. Many younger artists, already in reaction to the rigorously intellectual climate of Abstract Expressionism, considered it a permission to revive figure painting. But the public was scandalized by de Kooning's hilarious, lacerated goddesses. And the more doctrinaire defenders of abstract art were equally severe.

de Kooning

Woman, I
Illustrated on page 343

John Russell, *The Meanings of Modern Art*, **1981**, pages 310, 311

In *Woman I*, de Kooning gave painting its head with what looks to be a maximum of spontaneity. But in point of fact the picture cost him 18 months' hard work and was then put aside, only to be rescued at the suggestion of the art historian Meyer Schapiro and brought to a triumphal conclusion. The image was "painted out literally hundreds of times," Thomas B. Hess tells us; but it stood for a concept of imperious womanhood that would give the painter no rest until it had been set down in canvas.

In this painting, as in certain others of its date, what Ezra Pound had called a *style* came out of America. Action is what . . . *Woman I* [is] all about, and Action Painting (a phrase first used by Harold Rosenberg in 1952) is as good a generic name as any for the "shower of wonders" which was produced in New York in the late 1940s. It is not an all-inclusive name—how could it be?—but it fits much of the work for much of the time. Both words count. "Action" stands for the particular physical involvement which characterizes the work; and it also stands for a determination to get up and go, rather than to settle for nostalgic imitation. "Painting" stands for the belief that there was still a great future for the act of putting paint on canvas. The way to realize that future was, first, to assimilate the past; second, to open out the act of painting in such a way that it became, in itself and by itself, one of the most capacious forms of human expression.

Jackson Pollock

The She-Wolf. 1943
Gothic. 1944
Illustrated on pages 344, 345

Pollock

The She-Wolf. 1943
Gothic. 1944
Illustrated on pages 344, 345

Jackson Pollock (1944 and 1947), in *The Museum of Modern Art Bulletin,* **1956–57**, page 33

I accept the fact that the important painting of the last hundred years was done in France. American painters have generally missed the point of modern painting from beginning to end. (The only American master who interests me is [Albert Pinkham] Ryder.) Thus the fact that good European moderns are now here is very important, for they bring with them an understanding of the problems of modern painting. I am particularly impressed with their concept of the source of art being the Unconscious. This idea interests me more than these specific painters do, for the two artists I admire most, [Pablo] Picasso and [Joan] Miró, are still abroad. . . .

The idea of an isolated American painting, so popular in this country during the thirties, seems absurd to me just as the idea of creating a purely American mathematics or physics would seem absurd. . . . And in another sense, the problem doesn't exist at all; or, if it did, would solve itself: An American is an American and his painting would naturally be qualified by that fact, whether he wills it or not. But the basic problems of contemporary painting are independent of any country.

My painting does not come from the easel. I hardly ever stretch my canvas before painting. I prefer to tack the unstretched canvas to the hard wall or floor. I need the resistance of a hard surface. On the floor I am more at ease. I feel nearer, more a part of the painting, since this way I can walk around it, work from the four sides and literally be *in* the painting. This is akin to the method of the Indian sand painters of the West.

I continue to get further away from the usual painter's tools such as easel, palette, brushes, etc. I prefer sticks, trowels, knives and dripping fluid paint or a heavy impasto with sand, broken glass and other foreign matter added.

When I am *in* my painting, I'm not aware of what I'm doing. It is only after a sort of "get acquainted" period that I see what I have been about. I have no fears about making changes, destroying the image, etc., because the painting has a life of its own. I try to let it come through. It is only when I lose contact with the painting that the result is a mess. Otherwise there is pure harmony, an easy give and take, and the painting comes out well.

William S. Rubin, *Dada, Surrealism, and Their Heritage,* **1968**, pages 177, 178

Pollock's development offers a paradigm of the relationship of Surrealism to American art of the forties. The myth-oriented iconography of his work of the early forties like that of [Mark] Rothko, [Adolph] Gottlieb, and others, paralleled that of the late phase of Surrealist *peinture-poésie* and his form-language was influenced by [Joan] Miró and [André] Masson (though his Cubist substructure and bravura execution reflected a more profound commitment to [Pablo] Picasso than to anyone else). But what Pollock really took from Surrealism was an idea—automatism—rather than a manner.[1] . . . His desire to liberate himself from the restrictions of traditional facture and the mannerisms they entailed had led him to drip liquid paint and to draw with a stick rather than a brush. Spilling and dripping as such was hardly a novel idea, but Pollock was the first to use it consistently in order to facilitate extended spontaneous drawing.

Pollock used automatism as a means of getting the picture started, and, like the Surrealists, believed that this method would give freer rein to the unconscious. The increasing velocity of his execution from 1943 onward led to an atomization of the picture surface that permitted him to invest it with a continuous rhythm, his characteristic "pneuma." By the winter of 1946/1947 the scale and richness of this rhythm had necessitated the adoption of the drip technique in a consistent manner; the totemic presences of Pollock's earlier work disappeared under the ensuing labyrinthine web. This "classic" style of Pollock constituted a kind of apotheosis of automatism, and of the constructive possibilities of chance and accident. His painting not only went beyond the wildest speculations of Surrealism in the extent of its automatism, but in its move toward pure abstraction, was alien to the Surrealist conception of picture-making. Nevertheless, as Pollock relaxed his drip style in the black-and-white paintings of 1951, fragments of anatomies—some monstrous and deformed, others more literal—surfaced again, as if the fearful presences in his work of the early forties had remained as informing spirits beneath the fabric of the "all-over" pictures.

Jackson Pollock

One: Number 31, 1950. 1950
Illustrated on page 346

Kirk Varnedoe, *Jackson Pollock*, **1998**, pages 47–48, 53

By the summer of 1946 . . . [Pollock] began painting on the floor in a different way, dispensing liquid enamel paint directly from the can or with sticks and stiffened brushes. This changed everything.

Pollock had spent over seven years wrestling with [Pablo] Picasso and a few others, in an effort to charge his paintings with meaningful content and potent symbols. Those struggles would now be left in abeyance. "How?" would take over from "What?" as the prime point of genesis. Changing his self-awareness from a search for buried icons or totems to a reliance on more pragmatic instincts about how it felt best to work, Pollock would unblock the way to a fundamentally personal, original art. And a great deal more.

The concatenation of decisions that flowed from Pollock's new praxis—the abandonment of an image in favor of a dispersed, omnidirectional network of incident, the supplanting of brushwork by an orchestration of "untouched" material—has continued to produce reverberations in and beyond painting ever since. As much as [Marcel] Duchamp did when he mounted a bicycle wheel on a stool [see page 232] or submitted a urinal to an exhibition, but with an altogether different spirit, Pollock in 1947 ruptured the existing definitions of how art could be made, and offered a new model of how one could be an artist. Spontaneity and chance, previously left lurking in either Dada nihilism or the musky netherworlds of the Surrealists, were now brought forward into daylight as tools of concrete engagement with materials and the act of making, and submitted to a dialogue of control from which every trace of didacticism or stock symbolism had been expunged. . . .

One (Number 31, 1950) . . . is . . . entirely poured, without any initial lay-in, and includes no elements of squeezed or brushed paint to provide temporal accent or physical third dimension. The directional energies, accordingly, are all the product of the pouring itself, and—particularly in the recurrent, looping verticality of several black passages that stride across the field—are crucial to its more epic, sinewy pulsings of energy. With a similar but more uniform "reserve" of revealed canvas along the edges, *One* has both a more constant pizzicato of spattering in its open areas and a center more densely concealed, by an amorphous "field" of beige-green—a softer foil that allows the interlace of smoothly viscous and nimble pourings of black and white to become the dominant "figuration," and that

lends the picture its impact of combined explosive riot and nebular filigreed suspension. Rather like [Claude] Monet's series pictures, drip canvases like [this one] do have a strong family resemblance that encourages us to talk of them in terms of an ensemble, or a period. But each also involves a response to a different internal "weather," and develops a precisely varied orchestration appropriate to its scale and ambitions, as the "method"—how much, what kind, when, for how long?—is reinvented at a million different moments along the way.

Pollock

One: Number 31, 1950
Illustrated on page 346

Pepe Karmel, *Jackson Pollock*, **1998**, pages 129, 131, 132

Rather than describing the abstract webs of Pollock's 1947–50 work as veiling the painted figures, it might be more accurate to say that the figures are inserted to give form and rhythm to an abstract web that might otherwise tend toward monotony and homogeneity. . . . What was distinctive in Pollock's allover drip paintings was neither their technique nor their appearance of allover abstraction, both of which could be found in the work of contemporaries like Hans Hofmann, Mark Tobey, Janet Sobel, and Knud Merrild.[1] It was, rather, the rhythmic energy that animated Pollock's work at every level, from the individual line to the overall composition. And this energy seems in large part to have resulted from the interaction between Pollock's figurative imagery and his allover, all-absorbing web. . . .

At the risk of oversimplification, we might say that he [Pollock] has two ways of creating a horizontal image. One is to create a vertical composition—a figure—and to turn it sideways. The other is to do just what [Thomas Hart] Benton says: to arrange a series of figures or figure groups into "distinct rhythmical sets which are joined on their fringes." There are numerous examples of Pollock composing in just this way. . . .

Coming to artistic maturity in the early 1940s, Pollock was drawn to an art of the sign rather than an art of primordial sensation. His early work derives with almost painful obviousness from [Pablo] Picasso and [Joan] Miró, but, astonishingly, within a few years he had discovered a way to go beyond his masters. Pollock's achievement, in his pictures of 1947–50, was to transform graphic flatness into optical flatness—to show that by piling layer upon layer, sign upon sign, you could generate a pictorial sensation equivalent to that of the primordial visual field. The impact of this discovery is evident in Pollock's paintings.

Jackson Pollock

Echo: Number 25, 1951. 1951
Illustrated on page 347

James Coddington, in *Jackson Pollock: New Approaches*, **1999**, pages 110, 111

The black pour paintings of 1951 have been identified as a departure from Pollock's prior work, and this is certainly true in regard to his materials and methods. Aside from the reduced palette, Pollock made some fundamental changes in technique. He introduced a new tool, the turkey baster.[1] He also moved back toward more-consistent direct contact with the canvas, applying some of his initial marks with a brush. *Echo: Number 25, 1951* demonstrates many of his basic techniques in these works: he did indeed brush some passages on, but the bulk of the paint he either poured or more likely worked with the baster, which he used almost like a big fountain pen. For a large, dramatic discharge, he could squeeze the bulb; or he could hold the paint in the device's tube and draw extended lines.

According to Lee Krasner [Pollock's wife], Pollock would start the black pours with a sizing of Rivit glue.[2] It should be clear by now that he was very sensitive to the implications of preparing a canvas or board, in terms both of underlying color and of the way the next layer of paint would be absorbed; choosing whether or not to use a size would have given him a way to control the bleeding of the paint into the canvas. In *Number 22, 1951*, for example, the paint in places bleeds quite readily, blending with the fabric in much the same way it blends with the ground in works on paper from 1948. In *Echo*, on the other hand, although there is variation in the quality of the line from center to edge (hard and glossy in the center, soft toward the edge, as the nap of the fabric reasserts itself), there is nothing that could be called a bleeding of the paint into the canvas. This might suggest a sizing with Rivit glue—yet there is no such coating in *Echo*. Technical analysis suggests that in this case Pollock may have used a more sophisticated technique to control the bleed, and that was the mixing of two different paints, an oil and an alkyd enamel.

Clyfford Still

Painting 1944–N. 1944
Illustrated on page 349

Clyfford Still, in *15 Americans*, **1952**, pages 21, 22

That pigment on canvas has a way of initiating conventional reactions for most people needs no reminder. Behind these reactions is a body of history matured into dogma, authority, tradition. The totalitarian hegemony of this tradition I despise, its presumptions I reject. Its security is an illusion, banal, and without courage. Its substance is but dust and filing cabinets. The homage paid to it is a celebration of death. We all bear the burden of this tradition on our backs but I cannot hold it a privilege to be a pallbearer of my spirit in its name.

From the most ancient times the artist had been expected to perpetuate the values of his contemporaries. The record is mainly one of frustration, sadism, superstition, and the will to power. What greatness of life crept into the story came from sources not yet fully understood, and the temples of art which burden the landscape of nearly every city are a tribute to the attempt to seize this elusive quality and stamp it out.

The anxious men find comfort in the confusion of those artists who would walk beside them. The values involved, however, permit no peace, and mutual resentment is deep when it is discovered that salvation cannot be bought.

We are now committed to an unqualified act, not illustrating outworn myths or contemporary alibis. One must accept total responsibility for what he executes. And the measure of his greatness will be in the depth of his insight and his courage in realizing his own vision.

Demands for communication are both presumptuous and irrelevant. The observer usually will see what his fears and hopes and learning teach him to see. But if he can escape these demands that hold up a mirror to himself, then perhaps some of the implications of the work may be felt. But whatever is seen or felt it should be remembered that for me these paintings had to be something else. It is the price one has to pay for clarity when one's means are honored only as an instrument of seduction or assault.

Still

Painting 1944–N
Illustrated on page 349

Lucy Lippard, in *Three Generations of Twentieth-Century Art*, **1972**, page 126

Although Clyfford Still was one of the major innovators among the Abstract Expressionists, often known as the "New York School," he did not settle in New York until 1950; however, from about 1945 on, he was already widely influential among his fellow artists there, through exhibitions and brief sojourns. He developed his basic style in the latter half of the 'forties on the West Coast, where he taught at the California School of Fine Arts in San Francisco. More programmatically than any other of the Abstract Expressionists, Still consciously sought to

expunge from his painting any traces of modern European movements—especially Cubism—and, by freeing himself from all such influences, to evolve a completely new art appropriate to the New World. . . .

Painting is a particularly powerful example of Still's early mature style. It presents a variegated surface that negates illusionistic space and concentrates attention on itself. The wide expanse of tarry black impasto is enlivened with knife marks and cut across by a jagged red line that rushes horizontally across the upper part of the canvas, to be intersected by two irregular, pointed, vertical shapes descending from above, before it plunges downward to the bottom edge at the right. The elements of this composition, the way in which it fills the entire surface without reference to a surrounding frame or central scaffolding, and the unusually large size for a painting of this period, are all indicative of Still's originality and his masterly command of a new kind of abstraction, free from any decipherable symbols or references to nature. Although many critics have read into Still's works a vision of the broad, romantic Western landscape, he himself has rejected such allusions, believing that the impact of his work could only be diminished by such associations on the part of the viewer.

Barnett Newman

Vir Heroicus Sublimis. 1950–51
Illustrated on page 350

Thomas B. Hess, *Barnett Newman*, **1971**, pages 67, 68–69, 70–71

Vir Heroicus Sublimis [was] Newman's first attempt at a very large painting. The idea of the large picture, like the idea of blackness, was very much in the air in the late 1940s in New York for a number of reasons. . . .

Painting big was a heritage of the Social Realist ambitions of the 1930s. By the 1940s, the application of the 1930s esthetic to large public walls with didactic or other social motives seemed comical. Still, the idea of an important scale remained, and with it, the notion that such a picture would be beyond middle-class, middle-brow values; it could appeal directly to the widest possible audience.

Size makes a difference; quantity changes quality. Artists wanted to make images with direct, powerful impact. They wanted to get rid of artifice and style. And in the large picture, which envelops the viewer, an intimate relationship is established. The edges of the painting extend beyond the perimeters of his vision. He is sucked into the action on the canvas. A red six yards wide is a totally different color from the same red six feet wide, and has a different effect. . . .

Newman always worked from stretched canvases made to specifically designated sizes.[1] He once said he never knew how he was going to paint his next picture . . . and this was because his method forced him to begin with a complete blank, with nothing, chaos. . . . Newman . . . had only a pencil and a piece of paper on which he scribbled columns of figures. Sometimes these numbers would mystify his friends who knew that he was not involved with accounts, nor was he very fast at addition. What he was working on, it seems, was finding the proportions and dimensions of his canvases. Until he arrived at them, he was nowhere. They were . . . intricate constructs despite their simple appearance. . . .

The effect of the painting [*Vir Heroicus Sublimis*] is at the farthest remove from any idea of a diagram or a coldly articulated structure. The color envelops the spectator; the verticals stand as presences in it, like the angel sentinels who guard the Throne of the Lord. One thinks of [Paul] Valéry, who said the lyric poem is an elaboration on the exclamation of an "Ah-h!" And of the poet Serferis who added, "For me the 'Ah-h' is quite enough." Here, color in modern painting breaks through its last constraints, and is proclaimed the essence of visual art; in its liberated surge, the zips do not act as reins, but as spurs, heightening the pressure of the sensation.

Such has been the common interpretation of *Vir Heroicus Sublimis*; it has been analyzed by formalist critics into systems and methodologies that sanction the "Ah-h" by tying it to the picture plane, or to the expression of the framing edges, or to an "advanced" elimination of graphic gesture and surface episode. Nor did Newman ever contradict such interpretations, although he always insisted that he was interested in subject matter and that "formalism is a dirty word." Nor indeed are such readings of the picture wrong; the sense of a strong emotion (or esthetic reaction) emanating from the color and from the calm, clean surfaces of *Vir Heroicus Sublimis* is a fairly accurate metaphor for what happens in the painting. What it misses, however, is the richness and ambiguity of Newman's own metaphor. He had taken his image of Genesis, of the creative act, of the artist as God, and expanded it into an ardent, pulsing glow of color.

Mark Rothko

No. 3/No. 13. 1949
No. 5/No. 22. 1950
Illustrated on pages 352, 353

Peter Selz, *Mark Rothko*, **1961**, pages 9–10, 11

Rothko paints large surfaces which prompt us to contemplate. The actuality of the painted surfaces makes

even the symbolic configurations of his earlier work unnecessary. His rectangular configurations have been compared with the work of the followers of neo-plasticism, but unlike them, Rothko does not paint about optical phenomena or space and color relationships. His work has also at times been classed erroneously with action painting, yet he does not inform us about the violence and passion of his gesture.

Holding tenaciously to humanist values, he paints pictures which are in fact related to man's scale and his measure. But whereas in Renaissance painting man was the measure of space, in Rothko's painting space, i.e. the picture, is the measure of man.

This is perhaps the essential nature of the viewer's response to Rothko's work: he contemplates these large surfaces, but his vision is not obstructed by the *means* of painting; he does not get involved in the by-ways of an intriguing surface; these pictures do not remind us of peeling walls or torn canvases. The artist has abandoned the illusions of three-dimensional recession; there is not even the space between various overlaid brush-strokes. The surface texture is as neutral as possible. Seen close up and in a penumbra, as these paintings are meant to be seen, they absorb, they envelop the viewer. We no longer look *at* a painting as we did in the nineteenth century; we are meant to enter it, to sink into its atmosphere of mist and light or to draw it around us like a coat—or a skin.

But, to repeat, they also measure the spectator, gauge him. These silent paintings with their enormous, beautiful, opaque surfaces are mirrors, reflecting what the viewer brings with him. In this sense, they can even be said to deal directly with human emotions, desires, relationships, for they are mirrors of our fantasy and serve as echoes of our experience. . . .

Color, although not a final aim in itself, is his primary carrier, serving as the vessel which holds the content. The color may be savage, at times burning intensely like sidereal landscapes, at others giving off an enduring after-glow. There are paintings whose reds are oppressive, evoking a mood of foreboding and death; there are reds suggesting light, flame, or blood. There are pictures with veil-like blues and whites, and blues suggesting empty chambers and endless halls. At times the color has been gayer, with greens and yellows reminiscent of spring in its buoyant, almost exultant delight. There is almost no limit to the range and breadth of feeling he permits his color to express.

Ad Reinhardt
Number 107. 1950
Illustrated on pages 354

Ad Reinhardt, in *Americans 1963*, **1963**, page 80

A square (neutral, shapeless) canvas, five feet wide, five feet high, as high as a man, as wide as a man's outstretched arms (not large, not small, sizeless), trisected (no composition), one horizontal form negating one vertical form (formless, no top, no bottom, directionless), three (more or less) dark (lightless) non-contrasting (colorless) colors, brushwork brushed out to remove brushwork, a mat, flat, free-hand painted surface (glossless, textureless, non-linear, no hard edge, no soft edge) which does not reflect its surroundings—a pure abstract, non-objective, timeless, spaceless, changeless, relationless, disinterested painting—an object that is self-conscious (no unconsciousness) ideal, transcendent, aware of no thing but Art (absolutely no anti-art). *1961*

The painting leaves the studio as a purist, abstract, non-objective object of art, returns as a record of everyday (surrealist, expressionist) experience ("chance" spots, defacements, hand-markings, accident—"happenings," scratches), and is repainted, restored into a new painting painted in the same old way (negating the negation of art), again and again, over and over again, until it is just "right" again. *1960*

A clearly defined object, independent and separate from all other objects and circumstances, in which we cannot see whatever we choose or make of it anything we want, whose meaning is not detachable or translatable, where nothing can be added and nothing can be taken away. A free, unmanipulated and unmanipulatable, useless, unmarketable, irreducible, unphotographable, unreproducible, inexplicable icon. A non-entertainment, not for art-commerce or mass-art-publics, non-expressionist, not for oneself. *1955*

Reinhardt
Number 107
Illustrated on pages 354

Yve-Alain Bois, *Ad Reinhardt*, **1991**, pages 25, 26

Reinhardt's first attempt at . . . formal structure (the near-monotone) was infecund, perhaps because it was too early and still unnecessary (the all-over had not been fully explored yet). As a result, it was too assertive to produce the effect of almostness: the white on white was feeble precisely because it was too violently white

on white. The issue of the non-color reappears, in the early fifties, in connection with the all-over brush-strokes (see *Number 107* of 1950). Here, Reinhardt immediately perceived the problem: . . . if the issue was to abolish contrast (without arriving at the plain mono-chrome, objecthood, and the like), then the suppression of colors as a means of dispensing with color-contrast was only a brilliant trick (for textural effects could always be perceived as the sublimation of such contrast). To approach it indirectly, by way of value deflation, was much more promising. Paradoxically, to thematize this abolition of contrast through an attenuation of values, one had to *show* this attenuation and thus reintroduce something abandoned long ago, that is, drawing. Drawing had to be reinstated (and geometry was the surest way to accomplish that), but it had to be simultaneously destroyed. The only means not yet explored for this particular purpose was color.

Two options were available to Reinhardt for undermining drawing through color, for rendering the line evanescent while retaining it: . . . either the high pitch, or the low key. The canvases from late 1950 through 1951 (but some as late as 1953) belong to both categories.

Hans Hofmann

Cathedral. 1959
Illustrated on page 355

William C. Seitz, *Hans Hofmann*, **1963**, pages 30, 32, 39, 43

Many of Hofmann's recent works are built up entirely or in part from large rectangular planes of color aligned parallel to the picture plane. He is acutely concerned with the distance that separates these planes, and whether they touch or overlap. On this score he distinguishes between opposing modes: one in which "the element of overlapping plays a predominant part in the pictorial development," and another, in which "the element of overlapping is entirely removed and replaced by the element of shifting," that results in a more equivocal push and pull . . .

It was through long experience as an artist and teacher that Hofmann learned that depth in nature transforms into an act of formal shifting. "The totality of sensitive controlled shifting actions produces finally the coexistence of a produced depth rhythm and a two-dimensional surface rhythm, and with it a new reality in the form of pictorial space." The result is a continual mediation and tension between alternatives, so that the nouns "space" and "flatness" become all but synony-mous with the verbs "push" and "pull." Plastic depth is thus never static, but, like natural depth, is active. "The movement of a carrier on a flat surface is possible only

through an act of shifting left and right or up and down. To create the phenomenon of push and pull on a flat surface one has to understand that by nature the picture plane reacts automatically in the opposite direction to the stimulus received; thus action continues as long as it receives stimulus in the creative process."

The scale of Hofmann's major canvases is often mon-umental, so the suggested span between their elements can be great, the tensions high and the rhythm slow and sonorous—a profound and elastic expansion of the ten-sion and rhythm of color, plane, brush, and line within the picture and across its surface. "The interplay of this multitude of motion produces a combined two- or three-dimensional rhythm with an ambiguous inter-pretation of its plastic fixations." Unlike Renaissance space, in which each detail is mechanically plotted to rest at a simple fixed position in depth, plastic creation (as one can see easily in certain of [Paul] Cézanne's landscapes) can give an element a dual, or even multi-ple, location in depth, and thereby movement and rhythm as well.

Opposition is as operative in Hofmann's work stream as it is in his individual pictures, so that he has been crit-icized for painting in too great a diversity of manners. Indeed, few painters have tried to embrace such contra-dictory extremes. Yet this variety is anything but ran-dom, and the manners are not without common philosophical ground. The pictures constructed from scrupulously adjusted rectangles of color . . . lie at what could be called the Apollonian pole of Hofmann's art. . . . The ways in which pigment is applied contribute enor-mously to the various moods as well as to the enliven-ment of surfaces, which are never without marks of Hofmann's tools and gestures. Even the compositions of parallel rectangles are varied in their brushing.

David Smith

Australia. 1951
Illustrated on page 356

David Smith, statement at a symposium at The Museum of Modern Art, **1952**

My first steel sculpture was made in the summer of 1933, with borrowed equipment. The same year I started to accumulate equipment and moved into the Terminal Iron Works on the Brooklyn waterfront. My work of 1934, '35, '36 was often referred to as line sculpture, but to me it was as complete a statement about form and color as I could make. The majority of work in my first show at the East River Gallery in 1937 was painted. I do not recognize the limits where paint-ing ends and sculpture begins.

Since the turn of the century painters have led the aesthetic front both in number and concept. Outside of [Constantin] Brancusi, the greatest sculptures were mostly made by painters.

Sculpture is more immediate for visionary action. . . . Natural constants such as gravity, space and hard objects are the physicals of the sculpture process; consequently they flow more freely into the act of vision than the illusion of constants used in painting alone. The fact that these constants or premises need no translation should make sculpture the medium of greatest vision. This I mention as a theoretic potential but the conviction and meditation on a concept that the resistance of material presents are elements which are unique to this art form. A sculpture is a thing, an object. A painting is an illusion—there is the absolute difference of one dimension.

My position for vision in my works aims to be in it, but not of it, and not as an identified physical participant with its subject. I only wish to comment on the travel. It is an adventure viewed. I do not enter its order as lover, brother or associate. I seem to view it as from the traveling height of a plane two miles up, or from my mountain workshop viewing a cloud-like procession. When [I am] in my shop I see the clouds. When I am in the clouds I am there to look at my work. From there importances become pattern—depth, bulk are not so evident.

Robert Motherwell

Elegy to the Spanish Republic, 54. 1957–61
Illustrated on page 358

Robert Motherwell, in *The Museum of Modern Art Bulletin*, **1951**, pages 12, 13

The emergence of abstract art is one sign that there are still men able to assert feeling in the world. Men who know how to respect and follow their inner feelings, no matter how irrational or absurd they may first appear. From their perspective, it is the social world that tends to appear irrational and absurd. It is sometimes forgotten how much wit there is in certain works of abstract art. . . .

I think that abstract art is uniquely modern—not in the sense that word is sometimes used, to mean that our art has "progressed" over the art of the past; though abstract art may indeed represent an emergent level of evolution—but in the sense that abstract art represents the particular acceptances and rejections of men living under the conditions of modern times. If I were asked to generalize about this condition as it has been manifest in poets, painters, and composers during the last century and a half, I should say that it is a fundamentally romantic response to modern life—rebellious, individualistic, unconventional, sensitive, irritable. . . .

One of the most striking aspects of abstract art's appearance is her nakedness, an art stripped bare. How many rejections on the part of her artists! Whole worlds—the world of objects, the world of power and propaganda, the world of anecdotes, the world of fetishes and ancestor worship. One might almost legitimately receive the impression that abstract artists don't like anything but the act of painting . . .

One might truthfully say that abstract art is stripped bare of other things in order to intensify it, its rhythms, spatial intervals, and color structure. Abstraction is a process of emphasis, and emphasis vivifies life . . .

I love painting the way one loves the body of woman, that if painting must have an intellectual and social background, it is only to enhance and make more rich an essentially warm, simple, radiant act, for which everyone has a need.

Franz Kline

Chief. 1950
Illustrated on page 359

MoMA Highlights, **2004**, page 205

True to an alternate name for Abstract Expressionism, "action painting," Kline's pictures often suggest broad, confident, quickly executed gestures reflecting the artist's spontaneous impulses. Yet Kline seldom worked that way. In the late 1940s, chancing to project some of his many drawings on the wall, he found that their lines, when magnified, gained abstraction and sweeping force. This discovery inspired all of his subsequent painting; in fact many canvases reproduce a drawing on a much larger scale, fusing the improvised and the deliberate, the miniature and the monumental.

"Chief" was the name of a locomotive Kline remembered from his childhood, when he had loved the railway. Many viewers see machinery in Kline's images, and there are lines in *Chief* that imply speed and power as they rush off the edge of the canvas, swelling tautly as they go. But Kline claimed to paint "not what I see but the feelings aroused in me by that looking," and *Chief* is abstract, an uneven framework of horizontals and verticals broken by loops and curves. The cipherlike quality of Kline's configurations, and his use of black and white, have provoked comparisons with Japanese calligraphy, but Kline did not see himself as painting black signs on a white ground; "I paint the white as well as the black," he said, "and the white is just as important."

After Abstract Expressionism

Helen Frankenthaler

Jacob's Ladder. 1957
Illustrated on page 361

Anne M. Wagner, in *Jackson Pollock: New Approaches*, **1999**, pages 192, 193, 194

In Frankenthaler's hands painting moves farther toward its redefinition as a practice that is both arbitrary and intended as well as both figurative and abstract, produced of moves and gestures whose effects are decisive as their motives are hard to specify. This is a way of proceeding, moreover, that almost didactically disturbs the already improbable and uneasy peace that [Jackson] Pollock sometimes forged between mark and image, drawing and color, figure and ground, and so on; Frankenthaler disrupted that peace almost every chance she got. This is what [Kenneth] Noland and [Morris] Louis were unable to grasp: what Pollock would sometimes integrate and keep in balance when "at home" in his canvas, Frankenthaler insists on prizing apart.

Look at what happens in two very different paintings, *Europa* and *Jacob's Ladder* (both 1957). Both are floor-made pictures, both aggressive in their approach to the conventions and traditions of figuration and landscape—what is attacked and ironized in *Europa* hovers somewhere between comedy and transcendence in *Jacob's Ladder*—but both works have moments where Frankenthaler makes her mark, leaves a trace. And she again does so as a kind of signature that will not quite be integrated or made part of some whole. . . . Individual marks in *Jacob's Ladder* are less assertive but still figurative, though elusively: when I look at the pours that float in the pale upper third of the picture, I think inevitably of someone making angels in the snow. And these marks are likewise more spatial than those in *Europa*; along with stains and splashes there are four quick circles (they are more mundane than magical) that again seem to delimit sites or moments in the picture's expanse. They also interrupt it. I see such incidents, in their separateness, as having more to do with mark and place than with field or image. Think of these canvases laid horizontal, and their maker pacing and tracing on them as if they were another country, one in which she was prepared to dwell.

Morris Louis

Russet. 1958
Illustrated on page 362

John Elderfield, *Morris Louis*, **1986**, pages 32, 33, 48

Louis was able to combine [Jackson] Pollock's layering and [Helen] Frankenthaler's side-by-side color juxtapositions by pouring waves of thinned-down, transparent paint of different hues down the surface of the canvas "so as to mute their separate intensities into so many neutral and ambiguous shades of a single low-keyed color"[1]—in effect, by working, like Pollock, from repetitively superimposed colors, but, like Frankenthaler, with areas not lines of color laid down side-by-side, overlapped, and then veiled over. The result is pictures wherein automatically generated drawing created a holistic image, as in Pollock, but with a heightened, richly nuanced color made possible by virtue of Frankenthaler's example. Different, however, from either Pollock or Frankenthaler, is Louis's conception of painting as the creation of flooded homogeneous fields of color, identified with the surface and developed across the surface without any underpinning in the form of a tonal armature. The openness of his work is not the ultimately Cubist openness of Pollock or Frankenthaler, where imaginary space is articulated, reticulated even, by a pattern of lights and darks; rather, it is the spreading, surface openness of an ultimately Impressionist conception of painting as an unconstricted, aerated, colored field. . . .

There are plenty of modern precedents for the adaptation of a watercolor technique to oil painting . . . [I]t is relevant to know that Louis was interested in [Paul] Cézanne's watercolors . . . He was even more interested in [Henri] Matisse, who also consistently used thin paint in order to exclude anything that might detract from the sheer visibility of color. And it is tempting to see Louis as part of the distinctly American watercolor tradition that includes artists like Georgia O'Keeffe and John Marin, whose work he could have seen at The Phillips Collection, as well as in relation to [Paul] Klee, whose work certainly affected [Kenneth] Noland's when Louis and Noland first met. It is also worth mentioning at this point that Louis's technique bears comparison with a form of painting conceptually opposite to the intimacy of watercolor, namely, fresco painting. The physical bonding of color to a white surface through tinting has long been a method of accentuating its pu-

rity, and also of achieving the difficult coherence of a large-size muralist art. . . . The soak-stain technique that Louis adapted from Frankenthaler combines these opposite traditions: the first, intimate, tending naturally to lyricism, highly dependent on the artist's individual touch, and having the candor and immediacy of a sketch; the second, public, tending to the epic and the monumental, involving suppression of the artist's touch, and having the distanced aloofness of architectural decoration. One way of distinguishing Louis's 1954 Veils and those he began in 1958 is to say that he shifted from the first toward the second of these traditions. . . .

The triadic bronze Veils were among the first that Louis completed in 1958. It would seem that the earlier of these were the pictures with a simpler and duller surface and a less regularly formed veil shape and the later, the pictures with more complex drawing and color contrasts, a more lively, asserted surface, and a more firmly contoured veil shape. Certainly, the more authoritative pictures are those with the latter attributes. Those where the top of the veil shape is not trued to the horizontal, but dips and then peaks as it meets the two vertical "lines" within it, suffer because the functional relationship, thus illustrated, between the internal drawing and the external shape of the veil image tends to give it the appearance of a loosely flapping construction (something like a canvas windbreak) standing in front of the picture surface. Those where the sides of the image are not roughly symmetrical suggest that it is slipping from its mooring, even that the two sides advance and recede in opposite directions. Louis later found that the source of expressive power in the Veils lay in their outside edges. However, he was not able to tap that power until he established the Veil image itself as a flat, heraldic bilaterally symmetrical unit, firmly rested on the base of the picture and floated just free on the other three sides.

Anthony Caro

Midday. 1960
Illustrated on page 363

William Rubin, *Anthony Caro*, **1975**, pages 111, 116

Midday is Caro's first wholly independent structure. The [David] Smith–like frontality and verticality . . . give way here to a horizontality enforced by the lone large beam of the work, to which all the parts, above and below, are subordinated. That girder was altogether horizontal until Caro was well into the work, when he brought it to life by slightly raising one end and gently curving the support below. Near its center he placed the only oblique unit in the piece, a section of I–beam tilted on one corner as if balanced on its center of gravity—an illusion that counteracts the weight we attribute to it in our recognition that it is steel. This interest in optically negating the actual weight of the piece is furthered by Caro's avoidance of any solid, volumetric forms, and by the bright yellow he painted the steel. By establishing for *Midday* a main axis that virtually parallels the ground rather than rising from it, Caro encouraged the spectator to move around the piece, to see it in three–dimensional space rather than in terms of a picture plane, though subsequent works would affirm the three–dimensional quality in a more dramatic manner. . . . *Midday* is . . . frank and open. Everything is given to the eye. . . . *Midday* is all exterior, even to the prominence of the bolts that hold much of it together. . . .

Midday [shows] a rawness that is characteristic of Caro's first two years as a mature sculptor. [It] attest[s] to a certain emulation of the Abstract Expressionist spirit, the assumption of which was certainly designed to set Caro's work apart from the more finished, "fine art" tradition of sculpture operative in London, where *Midday* . . . [was] executed.[1] Yet for all this manifest transatlantic influence, a work such as *Midday* suggests to this writer a monumentality as much in the spirit of Henry Moore as of David Smith, a monumentality that, in any case, would disappear from Caro's subsequent works.

Jasper Johns

Flag. 1954–55
Target with Four Faces. 1955
Map. 1961
Illustrated on pages 364–66

Kirk Varnedoe, *Jasper Johns: A Retrospective*, **1996**, pages 98, 99

Johns . . . is often regarded as the "father of Pop," but as the artist himself has said, "If you make chewing gum and everybody ends up using it as glue, whoever made it is given the responsibility of making glue."[1] It would be obtuse to deny that he and [Robert] Rauschenberg instigated Pop; where [Marcel] Duchamp had put found things on a pedestal, [Frank] Stella remarked, these two took the incidental and the day-to-day world into their art with a striking immediacy and made it functional, finding new relationships between things and forcing unexpected congruities. . . .

Johns seems at first to have sought in American public life a set of symbols that would be timelessly neutral and unvarying. But he did so precisely in a period when political and especially consumer life in this country

political and especially consumer life in this country sped up: the flag got more stars, labels and logos were redesigned, long-steady brand names died or were re-made. This sense of accelerated inconstancy, which seems to have figured in his decision to shift away from making a private iconography of "common things" by extracting items of public commerce,[2] is in part what occasioned the deep vein of nostalgia in Pop art—the bitterly shrill keening for waning commonplaces like soup cans with fifty-year-old label designs, Coca-Cola bottles in an age of canned Coke, and crude little pulp advertisement in the full-color heyday of Madison Avenue. . . .

Johns's fatherhood to Pop is typically paired with his parenting of Minimalism, dividing those artists who were marked by the image of *Flag* from those who were taken with the way that image was treated. The former saw it as all subject, the latter as all object; for them, pushing the image forward to take up the canvas's entire surface seemed to obliterate normal representation. As Robert Morris wrote in 1969, "Johns took painting further toward a state of non-depiction than anyone else. The Flags were not so much depictions as copies. . . . Johns took the background out of painting and isolated the thing. The background became the wall. What was previously neutral became actual, while what was previously an image became a thing."[3]

Johns

Flag
Target with Four Faces
Map
Illustrated on pages 364–66

Kirk Varnedoe, *Jasper Johns: A Retrospective*, **1996**, pages 15, 16, 18, 31

Through every mode and in all mediums, . . . Johns's art has consistently conveyed a sense of virtuosity, sometimes called erotic in its appeal.[1]

That quality has had little to do with suave figuration in an academic sense, nor with any facile choreography of the medium. In fact it most characteristically involves a willful impersonality in lines and marks,[2] a lack of conventional bravura that speaks instead of other gifts and ambitions. Johns has dealt with the world almost exclusively by treating found images, and as models for drawing he has given pride of place to plans, maps, stencils, and other devices (such as linear tracing) that reduce the world's variety to an apparently objective, flattened form. Representing without describing, these schemas combine a maximum of transformation with a seeming absence of subjective stylization.[3] They are functional, concrete modes of encoding ideas,

and they offer, as Johns's early targets also did most succinctly, nonabstract forms of abstraction. Johns has not wanted to be either an abstract or an illusionist artist, but as a constant literalist he has at times been both, and has often purposefully walked the line. Declared admirer of both John F. Peto and Barnett Newman, he has favored in his own work abstractions that can be read as depictions and depictions schematized to the point of abstraction (the masking-tape rectangles, Cubist nails and wood grain, and cartoon facial features of the past decade or so).

Though Johns has often adopted an intentionally staid, [René] Magritte-like manner of depiction, his more declarative "handwriting" in all mediums has been independent of the normal techniques of pictorial rendering. Since the slow compilations of encaustic strokes in his first paintings, he has cultivated a combination of programmed disciplines (such as filling in stripes or backgrounds or puzzle segments) and unexpected intensities (underscaled or outsized units of touch applied with exhaustive density or seemingly untoward breadth) that wields a dislocated expressive power over the work's nominal subjects. Even at the most basic level of making marks and applying medium to surface, he has wrought his "signature" manner from techniques that work against any familiar code of self-expression. Indeed his most "expressionist" gestural brushstrokes, seen in works of the late 1950s and early 1960s, seem by willful contrariness self-consciously generic and often openly repetitive, and there has been an equal muzzling of the usual indices of spontaneously released energy, whether lyric or angry, in his repertoire of dry, wet, and viscous material effects—scraping, smearing, pressing, melting, puddling, etc. Yet, by personal alchemy, he has orchestrated this vocabulary into a compelling and influential sense of craft. Typically blending, in illogical or uncanny proportion, elements of crisply controlled exactitude, obsessiveness, and partial liberation of a material's inherent physicality, this craft often seems repressed and ironic in its refusals; but it remains unmistakably alive, emotively and psychically as well as tactilely and optically. . . .

Johns has wanted his subjects, like his schematic models for drawing, to come ready made. He has also long favored those that have arrived involuntarily, through chance encounters or uncontrolled circumstances—fleeting glances, unexpected gifts from friends, suggestions made by others, or even, in the case of the first *Flag*, 1954–55, a dream. This is clearly not, however, a belated case of the Surrealist courtship of chance and the unconscious mind, which meant so much to the generation of American artists immediately preceding Johns's. What came to him from his initial dreams and serendipities were not primal icons

everyday images shaped by convention and culture. The prime gift, the dream of painting the American flag, was prime precisely because it provided the most conventional of conventions, a wholly public symbol.

It was in acting on that dream that Johns found his way, and decided that through such seemingly self-evident subjects his art could deal in fundamental issues of seeing. More precisely, he was concerned with relations of thought and sight—"the idea of knowing an image rather than just seeing it out of the corner of your eye." To work in that area he needed subjects that had acquired an "invisibility"[4] by virtue of being too well-known to be truly seen, or conversely by being so often seen that they were not truly thought about. He famously referred to his first choices—the flag, target, and numbers—as "things the mind already knows,"[5] and also (because the mind, knowing them too well, ignores them) as things that were "seen and not looked at, not examined."[6]...

The early subjects were chosen as "depersonalized, factual, exterior elements"[7] in part to answer his felt need for emotional disengagement. We know from several accounts that in 1954, Johns decided to reinvent himself; destroying everything he could of his work to that point, and taking what he saw as more adult responsibility for what he was doing, he drastically ratcheted up his level of artistic ambition.[8] A central component of this drive involved an imperious self-repression, a willed emotive shutdown. . . . In Johns's choice of subjects as in every stroke of his brush, this stance hammered a spike into the heart of the existentialist call for decisive engagement and self-expression that had been associated with a sense of epiphany and catharsis in the dominant art movement of his youth, Abstract Expressionism. The singular, compressed power of his early paintings, the sense of life one gains from them, seems to have been fueled by an intense, self-conscious will channeled through a draconian self-policing. . . .

Prime among Johns's refusals has been a refusal of meaning—or, more precisely, an insistence on distancing himself from the enterprise of interpreting what he has achieved. In his ideal of an artist's action, the energies invested in the making of a work should leave none remaining for its analysis or explication. Aside from the commentary or critique implied in the next work he or she makes, the creator then leaves the meaning of a given creation to emerge from its uses or abuses at the hands of its viewers. If there is one key point of congruity between Johns's interest in the language of painting and his broader interest in linguistics, it is this antiessentialist notion—often associated with Ludwig Wittgenstein—that the meaning of something derives from the way in which it is used.

Jasper Johns
Diver. 1962–63
Illustrated on page 367

Roberta Bernstein, in *Jasper Johns: A Retrospective, 1996*, pages 41, 42, 43

By 1959, . . . with his own identity secured, Johns began to acknowledge the artists whose works inspired his own, and with whom he recognized a shared artistic sensibility. In an important statement of that year, on the occasion of the "Sixteen Americans" exhibition at The Museum of Modern Art, he named Leonardo, [Paul] Cézanne, Cubism, and [Marcel] Duchamp as sources for ideas about perception that remain central to his art. . . .

Johns's engagement with Leonardo, Cézanne, and Duchamp plays an important role in his generation of imagery and serves as a touchstone for his art. When he began to use the human figure during the early 1960s, he did so in ways that can be related to these artists' works. . . . In the four *Study for Skin* drawings of 1962, the *Diver* painting of 1962, the *Diver* drawing of 1963, and the 1963 paintings *Land's End* and *Periscope (Hart Crane)*, he uses imprints of his head, hands, and feet to depict figures that allow various interpretations. The figure in both the *Diver* works—indicated through handprints, footprints, and arrows showing movement—may be viewed as making a swan dive from a diving board, or, more dramatically, as taking a suicidal leap.[1] . . .

Johns's conception of the figure in the *Diver* group brings to mind Leonardo's famous drawing *Human Figure in a Circle, Illustrating Proportions*, c. 1485–90,[2] in the way that the figure, as an active and monumental presence, is shown measuring and defining space. At the same time, the sense of emotional and physical vulnerability in Johns's "divers" recalls the view of human fragility and powerlessness that Leonardo presents in his *Deluge* drawings. The agitated surfaces of this group of Johns's works suggest a turbulent sea, engulfing the figures. . . . After visiting Windsor Castle in 1964 to see Leonardo's *Deluge* drawings, Johns said he admired them "because here was a man depicting the end of the world and his hands were not trembling."[3] The swirling cloud formations found in Leonardo's drawings may have provided a model for a range of expressive imagery in Johns's art of this period. One of his sketchbook notes from the early 1960s reads, "An object that tells of the loss, destruction, disappearance of objects. Does not speak of itself. Tells of others. Will it include them? Deluge."[4] Later, in 1967, a reproduction of one of Leonardo's *Deluge* drawings hung on the wall of Johns's studio. . . .[5]

Cézanne's solitary male bathers provided another model for Johns's figures [see page 94]. . . . Cézanne's bathers . . . seem relatively static and contemplative, but they are linked in their themes and expressive qualities to Johns's more active divers. Awkwardly posed and introspective, Cézanne's figures convey emotional vulnerability rather than heroic monumentality. . . . Johns's interest in Cézanne's bathers in the early 1960s may suggest a need on his part to find a type of figure that could be read as anonymous and at the same time enabled him to introduce his own experiences into his work. . . .

While Leonardo and Cézanne provided Johns with models for figuration, the artist he addressed most directly during the 1960s was Duchamp. His works are full of Duchampian references, some intentional, others the result of the two artists' shared concerns. . . . With Duchamp language has primacy. . . . He presents in literal terms the difficulty of knowing what anything means . . . [T]wo ideas that have been integral to Johns's work since the time of his engagement with Duchamp [are] an expanded emphasis on the conceptual aspects of art, and the importance of recognizing how meanings shift. . . .

More important to Johns than the similarities critics had initially recognized between his paintings and sculptures of familiar objects and Duchamp's readymades was the wide range of interests and values he shared with Duchamp concerning the nature of art and the artist's role. While his contact with Duchamp's ideas was expansive for him, it also crucially affirmed what was distinct about his own work, particularly his commitment to visual sensation, and to exploring the eye's relation to the mind.

Robert Rauschenberg

Bed. 1955
Illustrated on page 368

James Leggio, in *Essays on Assemblage*, Studies in Modern Art 2, **1992**, pages 79, 80, 81, 104, 105

Bed derives the rich, almost disconcerting ambiguity of its aesthetic effect from the way Rauschenberg mixed and played with the many associations its material components had for him. . . . [T]he tale of how Rauschenberg came to paint *Bed* has been recounted many times.[1] He awoke one morning and found himself without materials on which to paint. As he looked about, his eye was drawn to a quilt that had been given to him a while before by a fellow student at Black Mountain College, Dorothea Rockburne. At first he stapled it to a stretcher and applied paint to the patchwork, trying to "turn the quilt pattern into an abstraction,"[2] but that did not seem to work. Then he added at the top a pillow and part of a sheet, which seemed better; instead of just a quilt, it now became a bed, and the white of the sheet and pillow gave him a fresh surface to paint on. Finally, up it went on the wall.

But there is a little more to it than that: the question immediately arises of the distinction between the artist's intention—conscious or unconscious—and the spectator's perception. For what the first viewers of this object *thought* they saw was not just a pillow and bedclothes with some paint on them. It seemed instead the evidence of some horrible crime—an axe murder, perhaps. . . .

Rauschenberg says that the "murder bed" reading is wrong, and he has consistently rejected it. He speaks of the work in a very positive way: "I think of *Bed* as one of the friendliest pictures I've ever painted. My fear has always been that someone would want to crawl into it."[3] . . .

[F]rom a very early point in the work's perceptual history, *Bed* was taken as evidence of, as a sign for, an absent human body. This idea of signaling the existence of a body that is not presented directly does, I believe, play a central role in the mode of perceiving *Bed*, for works that deal with the human body at one remove, in the form of signs, make up a very important and characteristic segment of Rauschenberg's production as a whole. . . .

All assemblages, all collages, depend to some extent on juxtaposing disparate elements in an unexpected way, releasing an unaccountable jolt of new meaning. When each element retains its separate identity, and continues to tug in its own direction, an illuminating sense of "wrongness," of the different components' irreconcilable "otherness," results: a sense that the conflicting elements somehow attract each other even as they are repelled. . . .

In the case of *Bed*, plenty of things could be construed as "wrong." Most obviously, the orientation is "wrong," being vertical rather than a bed's expected horizontal; and, of course, the appearance of the fluid medium on this particular cloth support seemed "wrong" enough seriously to disturb the first viewers. At the same time, we are looking at the "wrong" category of art object: the quilt is a product of folk arts, but it is marked with oils and stretched, thus compounding needlework crafts and easel painting. Moreover, the pillow and the swag–like draping of the covers seem to place *Bed* in a limbo somewhere between painting and found–object sculpture. Finally, the very notion of a bed combines, in one ambiguous place, deep–seated yet contradictory associations attaching to both the beginning and the end of life.

Robert Rauschenberg

First Landing Jump. 1961
Illustrated on page 369

Leslie Jones, in *Pop Art: Selections from The Museum of Modern Art*, **1998**, page 82

Robert Rauschenberg . . . collected mundane objects from everyday life and affixed them to a wood or canvas support. Part painting and part sculpture, part art and part life, Rauschenberg's Combines, begun in the mid-1950s, included everything from the extremely personal, like worn shirts and slept-on pillows, to tires and lumber scavenged from the streets and construction sites of New York City. "I felt very rich being able to pick up Con Edison lumber from the street for combines and stretchers, taking advantage of whatever the day would lay out for me to use in my work."[1] Rauschenberg's preference for the banal as opposed to the sublime of Abstract Expressionism led to his early classification as a neo-Dadaist; later, in the early 1960s commentators were quick to name him, with Johns, a prophet of Pop.

Rauschenberg's openness to chance encounters with the urban environment relates his endeavors to those of the Surrealists and resulted in nonhierarchical allover compositions, described as evidence of his "vernacular glance."[2] In *First Landing Jump*, . . . Rauschenberg's glance seems to be momentarily fixed on the road. Predominant elements include a tire, black-and-white striped street barrier, white-enamel light reflector from the street, and a rusted license plate mounted on composition board covered with black tarpaulin, a white drop cloth, and a paint-stained khaki shirt. The work is lit by a small blue lightbulb inserted in a tin can. According to one reviewer: "The tires in Rauschenberg's shantied cenotaphs have rolled straight off Whitman's open road to come to a great big rubbery stop against [Leo] Castelli's wall. In fact there is a tarry ozone of U.S. traffic here altogether, with its Bogart roadblocks and crushed oilcans like the cuffs of bums' trousers."[3]

Literally stalled not only by the barrier that has punctured and impaled the tire to the floor, but also by the electric cord that ties the Combine to its power source, Rauschenberg's view of highway culture is distinctly curbed in contrast to the expansive interpretations of . . . later Pop artists. . . . Rather than accelerating along the open road, capturing glimpses of bold-colored logos and streamlined gas stations, Rauschenberg confined his explorations to the junkyard of journeys past. The colors of *First Landing Jump* are sober and faded, its objects rusted and battered, and its canvas scarred with suture stitches—traces of their pre-artistic histories. . . .

Visual contemplation (as opposed to immediacy) is characteristic of the collage aesthetic, which juxtaposes multiple and often diverse elements that solicit the viewer to "read" its associative potential. Often compared to works by Pablo Picasso and Kurt Schwitters, Rauschenberg's Combines further expanded the collage vocabulary and literally broke through the boundaries of the two-dimensional picture plane to engage floor and space as sculpture does or, as suggested by the artist, to create an environment.

Cy Twombly

The Italians. 1961
Illustrated on page 370

Kirk Varnedoe, *High & Low: Modern Art and Popular Culture*, **1990**, pages 96, 97

Twombly's . . . images vary from airy tumbleweeds of tracery to monumental rhetoric, and often achieve the kind of enveloping intimacy that has marked a particular strain of modern larger-than-easel painting, from [Claude] Monet's *Water Lilies* decorations to [Jackson] Pollock's large dripped canvases. And the drawing, alternately innocent and expressive, follows a deceptively "untutored" course between the pitfalls of the merely brittle or the merely fluid, in lines that loop, pause, and run on, at paces that are by turns ambling, ruminative, and impulsive, through skeins, knots, and thicket-like clusters. The surfaces and the emotional impact of Twombly's paintings are enriched, too, by a duality: they seem to show both the basic urge to scribble and, simultaneously, the compulsion to deface. He often appears engaged in constant self-vandalism, as if he were editing while he wrote, making marks with one hand and covering them or emending them with the other. Impulse and erasure, or confession and repression, lock together in a work like *The Italians*, as every area of the canvas seems subject to revision, separate cancellation, and reintegration. Yet the end results, while rife with scattershot diversity and moments of frenzy and frustration, often have an ardent lyricism. From a purposefully limited palette and set of formal strategies, Twombly has coaxed an astonishingly broad range of aesthetic reference and emotion, from a dark-alley impassioned urgency to the ethereal, decorative feel of cloud-spotted skies by [Giovanni Battista] Tiepolo.

Cy Twombly

Untitled. 1970
Illustrated on page 371

Kirk Varnedoe, *Cy Twombly: A Retrospective*, **1994**, pages 42, 43

In trying to combine . . . reformed intimacy with . . . redefined grandeur, Twombly's grey–ground series, which continued through 1971, reached a peak moment in two huge paintings [both Untitled] executed in his home on the via di Monserrato [Rome] in 1970. Here, as in the work of other artists as diverse as [Eva] Hesse and Richard Serra, one of the challenges of the late 1960s and early 1970s was the recovery or reinvention of important parts of Abstract Expressionism, and especially [Jackson] Pollock's legacy, that had been suppressed by Pop and Minimalism. . . .

[The] edge–to–edge, top–to–bottom overlapping of layer on layer of open, running strokes [in the present work] creates a constant, all–over inscription of motion; it permits no comparable sense of developing time, and dissolves all ready reference to scale. Here . . . the legacy of Abstract Expressionism is at issue: Twombly ventures into the area of an engulfing abstract sublime that Pollock had defined, and that had seemed off–limits to the art of the 1960s. The prospect of extending and remaking Pollock's legacy by changing everything deemed essential to his art might appear as perverse as the notion of a grand subjective expression built on Minimalist reduction, and yet both are here, remarkably realized. Twombly replaces the colored organicism of Pollock with colorless lines whose steady, progressive rise and fall insists on their attachment to the drier constraints of writing, will, and culture. Instead of the varied, looping choreography of pouring, he offers a labor of marking so furiously repetitive, so unconcealedly relentless and unvarying, as seemingly to preclude all sense of lyricism. The results are, however, transporting. The picture brims over with a nervous, obsessed energy, yet its trance–like monotony also opens out into a sense of serene, oceanic dissolution, in a nebular cloud of great depth and infinite complexity. Here, the fusion of sensual body with sunny landscape in the summer of 1961 finds its counterpart: a no less moving metaphor of oneness joins the shuttling loom of the mind and the fathomless expanse of the night sky.[1]

Crosscurrents

Alejandro Otero

Colorhythm, I. 1955
Illustrated on page 372

Aracy Amaral, in *Latin American Artists of the Twentieth Century*, **1993**, page 93

The young artist Alejandro Otero had left [Caracas] for Paris on a grant in 1945, in a specific quest to make his pictorial language up-to-date and more universal, paying special attention to the work of [Paul] Cézanne and [Pablo] Picasso. In the French capital he produced a series of still lifes called Coffeepots from 1946 to 1949; in the latter year the Coffeepots were shown in Caracas at the Museo de Bellas Artes and at the Taller Libre de Arte. The tentative abstraction of these paintings sparked a widespread public debate in conservative Venezuelan art circles. In 1950 Otero and a group of Venezuelan artists and writers in Paris, having been branded "dissidents" by [French critic Gaston] Diehl, published five issues of a periodical, *Revista los disidentes*, which attacked the cultural and artistic conservatism of their native country.

The true Constructivist revolution, however, began in Venezuela in the 1950s when the young, restive artists began to return from their trips abroad. A catalyst of that revolution was the design by the architect Carlos Raúl Villanueva for the Ciudad Universitaria in Caracas. This project proposed and implemented integration among the arts, and created a unique atmosphere on the South American continent by placing works by recognized masters of contemporary art— such as Fernand Léger, Alexander Calder, Henri Laurens, Victor Vasarely, Antoine Pevsner, Jean (Hans) Arp, and [Wifredo] Lam—beside those of local artists Otero [and others].

During the 1950s the triad of Venezuelan kinetic Constructivists—Otero, Jesús Rafael Soto, and Carlos Cruz-Diez—developed distinctive abstract vocabularies and began to achieve public recognition for their pictorial investigations. For instance, in 1952 Otero was included in the *Primera muestra internacional de arte*

abstracto at the Galería Cuatro Muros in Caracas. . . . In 1958 Otero showed his *Colorritmos* in the annual salon at the Museo de Bellas Artes in Caracas and won the National Prize for painting. . . .

Constructivist kineticism may have become an accepted and acclaimed style in Venezuela because it seemed to fulfill the desire for contemporaneity in art far beyond that offered by more established modernist movements.[1] The vertical black bars and colored forms of Otero's *Colorritmos* may be seen as successors to [Piet] Mondrian's Neo-Plastic grids; they differed in effecting totally dynamic surfaces. As described by critic José Balza, Otero's lines established "an open directional rhythm as regarded both the sides and the extremities of the panels. The colors play between the lines creating dimensional and spatial counterpoint, whose departure is the vibration of the parallels and the colors."[2]

Ellsworth Kelly

Colors for a Large Wall. 1951
Illustrated on page 373

E. C. Goossen, *Ellsworth Kelly*, **1973**, page 45

Kelly had given up painting the human figure and had put his plant and nature drawing into a separate category, and so he began again to pursue his fascination with architecture. His association of the flat facade with the flatness of the canvas, his sketches of walls articulated by chimneys and shadows, and his subtle use of architectural fenestration to devise acceptable rhythms and spacing lie behind much of his abstract work between 1950 and 1953. . . .

It is not surprising then to learn that Kelly took a trip to Marseilles just to see Le Corbusier's apartment house, Habitation, while it was still under construction. He had already studied the architect's Swiss Pavilion at the Cité Universitaire in Paris. . . . Unquestionably Corbu's punctured fenestration and his regular but articulated panels on the end walls had an influence on Kelly. Habitation, which he managed to climb around, offered something more—a use of color in modern building Kelly had not seen before. The walls between the balconies were painted bright pastel shades. Corbu was obviously using color to connect his new building form with local tradition. But for Kelly it was something of a shock. He felt that in some way Corbu's scheme diminished his own painting.

Despite Kelly's debts to Le Corbusier and perhaps owing to his continued shyness and modesty, he never made an effort to meet the master architect. But his friend [Alain] Naudé, who had a slight connection with Corbu, showed him slides of Kelly's paintings along with his own and returned with a message that the master had said: "Young people have it so easy these days." Evidently Le Corbusier was thinking of his own early difficulties and what his legacy had cost him. Le Corbusier also observed: "This kind of painting needs the new architecture to go with it.". . .

This picture [*Colors for a Large Wall*] is one of the largest Kelly made in France. The organization, aside from its square panels joined in a grid, is totally arbitrary; the juxtaposition of colors was a matter only of taste. It began, as was Kelly's custom at this time, with the creation of a collage. Using the exact number of leftover squares of colored paper from which the collages for the series Spectrum Colors Arranged by Chance had been composed, he made the study for *Colors for a Large Wall* and that for *Sanary*. The hues of the colored papers, bought in art stores, were precisely matched in oil paints, and the final, full-sized panels arranged in strict adherence to the paper model.

Ellsworth Kelly

White Plaque: Bridge Arch and Reflection.
1952–55
Illustrated on page 374

E. C. Goossen, *Ellsworth Kelly*, *1973*, page 50

White Plaque: Bridge Arch and Reflection is full of implications, iconographical and formal. The Pont de la Tournelle in Paris spans the Seine from the Quai de la Tournelle to the Île Saint–Louis, not far from where Kelly had his hotel–studio. The original bridge was constructed in the fourteenth century, but it has been rebuilt a number of times. Now there is a broad central arch, but along the quai–side there is a kind of tunnel–span that gave rise to *White Plaque*. In a peculiar light one day Kelly noticed that the latter arch formed a black shape and that its reflection upon the water was also black. He held the vision in his head and upon returning home cut out the total image, shadow plus shadow, from dark paper. In the winter of 1954/55, after his return to New York, he made a full–sized version in wood. This version is pure white, because Kelly liked the way it looked after he had covered it with a coat of gesso.

Actually *White Plaque*'s shape derives from two non–things: the hole under the bridge and the reflection of the hole on the water. If one can legitimately speak of the planes of non–things, it is clear that Kelly took two images whose apparent planes were at right angles to each other and flattened them into a single surface. . . .

In the collage he used a darker piece of paper for the horizontal division between the mirrored halves to provide

321

an optical equivalent of the darker area immediately under the bridge. In the white version he accomplished this effect with a clearly differentiated strip of wood, translating it into an actual shadow—a rather appropriate solution for this problem. . . . It would seem that in *White Plaque* he used considerable license in converting black shadow into white light (or at least its white–paint equivalent), but the decision to paint the entire surface white was made in terms of the work of art as such, and not in terms of its likeness to its subject. Yet, paradoxically, since light and shadow are Siamese twins within the same phenomenon, each exists as the paradigm of the other. On a dark day, or at night, for example, the bridge and the atmosphere could have been drowned in darkness, and the same double image could have appeared as lighted areas of shape. The emphasis was thus placed on shape, as such, without belying its primary source. That source was only a fragment of the environment, a chunk of reality taken out of the usual context in which it is viewed. Without a title and an explanation we would be unable to divine its origin. But the insistence of Kelly's shapes, and the obvious integrity in the drawing and the workmanship, push mere curiosity aside and instill confidence in the work for its own qualities.

White Plaque was a very early forerunner of what later came to be known as the shaped canvas. . . . In *White Plaque* the purity of the field of white and the billowing, symmetrical radiation from the horizontal axis find a perfectly logical and sensuous completion at the perimeter.

Ellsworth Kelly

Sculpture for a Large Wall. 1957
Illustrated on page 375

Robert Storr, Interview with Ellsworth Kelly published in *MoMA: The Magazine of The Museum of Modern Art,* **1999**, pages 3–4, 5, 6, 7

RS: I wonder if you could talk a little bit about *Sculpture for a Large Wall,* how it came into being and how it came to be at the Modern. First of all, what was the situation with the commission?

EK: Well that was in 1956. It came through Richard Kelly, the lighting designer who worked with Philip Johnson and Edison Price, a fabricator of lighting fixtures. . . . [Richard] said, "I have a commission for lighting the new transportation building in Philadelphia, with the architect Vincent Kling." Richard was to do the lighting for the building, and also the restaurant, which was off the lobby at the entrance. And he said, "I want you to do something between the counter and the tables, something which I can light. And I know that you do bent and fragmented pieces." I hadn't done any sculpture then, but he had that idea from seeing my fragmented paintings and panels. I then designed seven brass screens for the restaurant, and when Vincent Kling saw the plans—the models and drawings—he said, "We also need something for the entrance. This is a good chance to do an artwork for the lobby." . . . Richard had said, "I'm going to put lights here above the ceiling." We discussed that I should do a sculpture that should catch the light rather than doing something flat.

The lobby wall above the doorways was twelve feet in height by sixty–seven feet wide, and I wanted to do something that would cover the entire space, even though there were two very large concrete pillars in front of the entrance. I thought, "Well, I know that the pillars are going to break it up, but the multiple panels will take care of that problem." The original drawing of the 104 panels was given to Edison Price, who made a blueprint. On the blueprint I added color to approximately a quarter of the panels. . . .

Edison arranged for the anodizing of the aluminum, a process by which the panels are colored. I had to go to the factory in White Plains where the anodizing took place to look at all of the colors, and I remember that I had an exasperating day. I kept saying, "I don't like this color, I want *that* color." The next week the color I asked for just appeared. Edison would make things happen.

At Edison's shop under the 59th Street Bridge, I drew curves and angles on the aluminum panels. It was great working with the men in the factory, because I would draw and they would cut. Edison designed how the panels and all of the rods fit together. There are a couple of drawings in my journal that show how all of the panels attach to the rods.

RS: I remember when you came to me and asked if the Museum [of Modern Art] would be interested in acquiring the work. . . . I said I really didn't think we could because of the size of the piece and the scarcity of space. We talked because you were very worried about something happening to it, but obviously with the new building on the horizon, the whole picture has changed.

EK: Well, I was trying to keep it from being destroyed. In the early 1960s, the brass screens in the restaurant were destroyed without my knowledge. When I heard that the building was being sold, I was afraid the same thing would happen to the lobby sculpture. I went to Edison for his advice: How was it attached to the wall? How to take it down? How to clean it? And how to put it back together again? That's when Matthew Marks and Peter Freeman and I decided to buy it and exhibit it at Matthew's gallery. When Jo Carole and Ronald Lauder said they would acquire *Sculpture for a Large Wall* for the Museum, I couldn't believe it. . . .

RS: *Sculpture for a Large Wall* is possible for us because we're going to have a building in which we can show it properly. What's your sense of what the next phase of the MoMA evolution ought to bring, could bring? How do you feel as an artist working with this institution with which you have had a connection for almost fifty years?

EK: For me, The Museum of Modern Art represents the highest standard of what a museum can be, and it's a great honor that the Museum now owns many of my works. I never could have imagined, when I came back from France in the 1950s, that my first commissioned sculpture would end up here to be part of the Museum's new building. I'm looking forward to installing it when [Yoshio] Taniguchi's addition opens in the twenty-first century!

Bridget Riley

Current. 1964
Illustrated on page 377

William C. Seitz, *The Responsive Eye*, **1965**, pages 30, 31

Almost everything that can be stated generally about optical painting in color is also true of black and white, and the opposite is also the case. The primary aim from which both result is not beauty of form, tasteful relationships, nor equilibrium in the old sense but the activation of vision. And color is unnecessary for perceptual ambiguity, variability, and movement.

Images rendered in unrelieved black and white can elicit responses at least as startling, if not as numerous, as oppositions of complementary hues, and many works in which color is introduced owe their live effects to essentially black—white or black—white—gray relationships. No stronger evidence of the new level of visual sensibility and the spontaneous international spread of perceptual abstraction could be presented than the recent and quite unprecedented wave of painting without color.

Two revealing criticisms have been leveled at these works: that they are little more than psychologists' diagrams, and that they resemble projects from classes in graphic design. These objections point out that black—and—white optical painting unites two disciplines formerly outside the fine arts: the research of Gestalt and experimental psychologists that began in the nineteenth century, and the design teaching that began in the German Bauhaus in 1919 and has continued until the present in similar schools in Germany and other countries. It is surely true that psychologists' diagrams (especially the so—called "geometrical optical illusions") and the assignments of progressive design teaching are the most noteworthy precursors of style. . . .

If the elements in a periodic structure are extremely small or distant from the eye they merge into a single tone. Although without color this is "optical mixture," the phenomenon on which the pointillist technique of Georges Seurat as well as modern halftone reproduction is sbased. And it is apparent that some of the most stimulating effects of movement and illumination occur when, because of sequential changes in the spacing or size of units or because of adjustments in viewing position, clear separations begin to merge in a common tone, either light or dark. When these effects appear in certain linear and radial figures, the impression of brightness and pulsation can reach a startling intensity. The eyes seem to be bombarded with pure energy, as they are by Bridget Riley's *Current.*

Antoni Tàpies

Gray Relief on Black. 1959
Illustrated on page 378

Frank O'Hara, *New Spanish Painting and Sculpture*, **1960**, page 9

The special qualities which Spanish artists have brought to abstract art are several. Already we are aware that the Spanish have challenged certain assumptions which seemed to be safe ones. From Tàpies on, they have tended to question the principles of compositional correctness, particularly in their moral application, and to assume a corrective rather than co—operative stance. In part, their attitude has consisted of an insistence on the literal significance of the plastic means they have used. . . . Tàpies has moved steadily toward bas—relief. There is no illusion of depth in his recent work, except for the actual depth of gougings and incisions. His insistence on the identity of his material and on the totality of image creates a space into which we do not go: if anything, it advances towards us. We have had much *graffiti* in contemporary painting, but when Tàpies uses them he gives us the wall, too, or a piece of the wall, a relief, a fresco.

Tàpies

Gray Relief on Black
Illustrated on page 378

Deborah Wye, *Antoni Tàpies in Print*, **1991**, pages 10–11

From his involvement with Surrealism Tàpies evolved a deeply Romantic view of art, believing in its transformative nature and thus its importance in the world. He

has said, "The basic questions, the whole new vision of the world which stimulated me, were things that I . . . experienced very intensely during the 1940s and early 1950s, when the desperate situations of the terrible postwar years made us profoundly sensitive to the great themes of existence and social co–existence."[1] The process of Surrealist automatism, in which an artist allows spontaneous gesture to be the carrier for unconscious thoughts and feelings, became fundamental to his creative process. "I have to enter into a sort of trance that will give me the feeling that my work is being guided by a cosmic force,"[2] he has said. "In the end, the work itself takes over, and you don't even know you're working."[3] Tàpies incorporated this intuitive method in the 1950s, when he experimented with novel materials for his paintings. He combined marble dust, sand, pigment, varnish, and latex to create thick, rough, gray surfaces that resembled cement. These works were hanging objects more than painted canvases. They displayed scars suggesting fossils, and cracks and fissures that seemed to be an organic effect of an elemental process. Tàpies's "Matter Paintings," as they were called, seemed impervious and confrontational.[4]

Lee Bontecou

Untitled. 1961
Illustrated on page 379

MoMA Highlights, **2004**, page 254

Painting or sculpture? Organic or industrial? Invitation or threat? A rectangle of canvas, like a painting, but one that pushes its faceted, equivocally machine-like mouth out from the wall, this untitled work lives on ambiguity. What many have seen in Bontecou's works of this kind, with their built-up rims and hollow voids, are the nacelles or casings of jet engines, and she, too, acknowledged their influences: "Airplanes at one time, jets mainly." Interest in the streamlined products of modernity may link Bontecou to Pop art, a movement developing at the time, but her work's dark and restricted palette gives it a sobriety distant from much of Pop, and she describes the world more obliquely. Also, instead of replicating an engine's metallic surfaces, she stitches panels of canvas over a steel skeleton. If this is a machine, it is a soft one—which, again, leads many to think of the body, and its charged interiors and openings.

Mystery is one quality Bontecou is interested in, and also "fear, hope, ugliness, beauty." As for those inky cavities, a consistent theme, she remarks, "I like space that never stops. Black is like that. Holes and boxes mean secrets and shelter."

Lucio Fontana

Spatial Concept: Expectations. 1960
Illustrated on page 383

Renée Sabatello Neu, *Alberto Burri and Lucio Fontana*, **1966**, n.p.

Fontana is a worldly and extroverted man; he has extensively expounded his theories on art in several manifestos, in which, reacting to the scientific and technological revolution of our time, he proposes that "matter, color and sound in motion are the phenomena whose simultaneous development is an integral part of the new art." Experimenting with great imaginative restlessness, he tried to bring the elements of space and time into his works. By puncturing the canvas, putting lights behind it, he added a new dimension to painting.

The same concepts govern his paintings and his clay sculptures. In fact, he himself never defines his works as "paintings" or "sculptures," but uses for all the general term "Spatial Concept.". . .

In an interview [in 1966] Fontana restated his principles: "The slash is the beginning of certain things. It is the point of arrival of the Spatialist Movement. I am obsessed with spatial nothingness: I want to show that space is behind and around the painting. I also want people to understand that traditional easel painting is dead, finished forever, and that one cannot go back."

While dogmatic in his writing, in his artistic work Fontana employs the artist's privilege of expressing himself in the way which best suits him at the moment and switches from a rich playful baroque to the most severe and restricted style. Yet this is never done as a form of mere self–expression, but rather to the end of expressing the objective reality around us.

Some works, particularly the ones with large holes, often have a forbidding quality. As implied in their title, the slashed canvases which he calls *Attese* (Waiting) acquire a particular feeling of suspense. But frequently Fontana's optimism mitigates his formal statements with intense, shocking colors, with precious surfaces— silver, gold, studded with stones or colored glass—and with brightly colored fields that delight the senses.

Yves Klein

Blue Monochrome. 1961
Illustrated on page 383

Lucy Lippard, in *Three Generations of Twentieth-Century Art,* **1972**, page 132

Any group of "identical" paintings from Yves Klein's *époque bleue* is devoid of obvious gestural or textural differences; the paint was often applied with a roller to divest the works of any superficially personal touch. Nevertheless, the great variety of intensities and mutations in these richly sensitive surfaces is apparent when several are hung together. . . .

"Yves le monochrome," as Klein called himself, began making one-color, one-surface paintings in 1949 at the age of twenty-one but abandoned the idea a year later for a period of highly individual education and travel. He resumed monochromes in 1952, the year in which he went to Japan to master judo and complete his program of self-enlightenment. In 1957 he began to concentrate on "International Klein Blue," which became his trademark and his obsession. He called his monochrome painting "color realism," choosing the same term as Kasimir Malevich, whose *Suprematist Composition: White on White*, 1918, is the major historic precedent for recent monochrome [see page 247]. As Klein himself noted, however, Malevich's primary concern had been with the form of the square, rather than with color. . . .

Klein concentrated on a closed but transpersonal aura. . . . The viewer carries away with him "not an image at all but the experience of the 'void' . . . a painting by Klein . . . is something to be *looked into*, and entity of matter, concentrating a sum of energy, sufficient to cause . . . a vast explosion in the mind."[1]

Dieter Roth

Snow. 1963–69
Illustrated on page 385

Dirk Dobke, *Roth Time: A Dieter Roth Retrospective,* **2004**, pages 92, 93

As in his artist's books *Copley Book* and *MUNDUNCULUM*, Roth . . . explored new forms of expression in *SNOW*. He assaulted the postulated validity of established semiotic systems and disputed the existence of an intersubjectively comprehensible visual language. He challenged the supposed clarity of signs with a strictly subjective approach. In addition, Roth refused to make any value judgments. He was much more interested in the ambiguities ("faints"),[1] contradictions, and oppositions that "probably live only in language."[2]

SNOW consists of a sequence of photographed pages. Roth superimposed the texts, books, photographs, photograms, collages, prints, and more, so that the layer underneath was still visible. The table of contents lists the subject matter or titles of pages that are grouped together; the book is therefore divided into short chapters. For example, the chapter "Pictures of an exhibition" shows the exhibition of works on paper that were created for the book, and the chapter, "Processing of a painting" contains photographs of the stages involved in the making of a picture. Larded with interruptions, contradictions, and ambiguities, the book is largely a sensual and associative experience for the reader/viewer.

Abstraction and Figuration

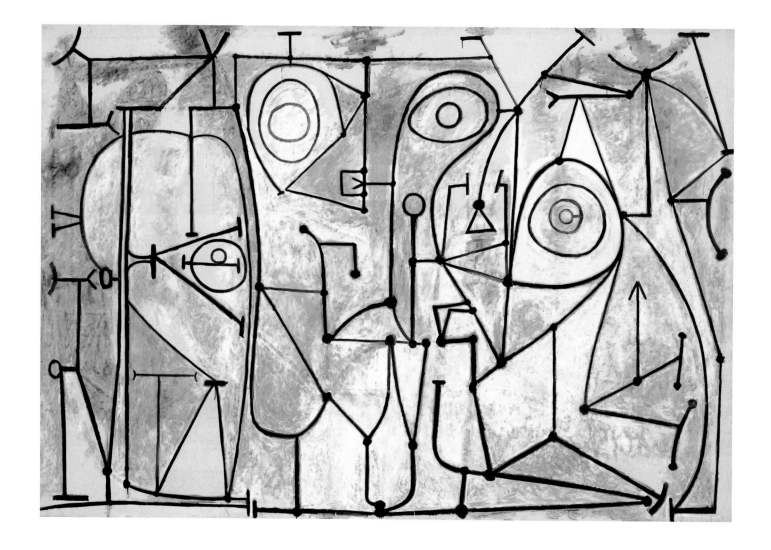

Pablo Picasso | (SPANISH, 1881–1973)
THE KITCHEN. November 1948
OIL ON CANVAS, 69" x 8' 2½" (175.3 x 250 CM)
ACQUIRED THROUGH THE NELSON A. ROCKEFELLER BEQUEST, 1980

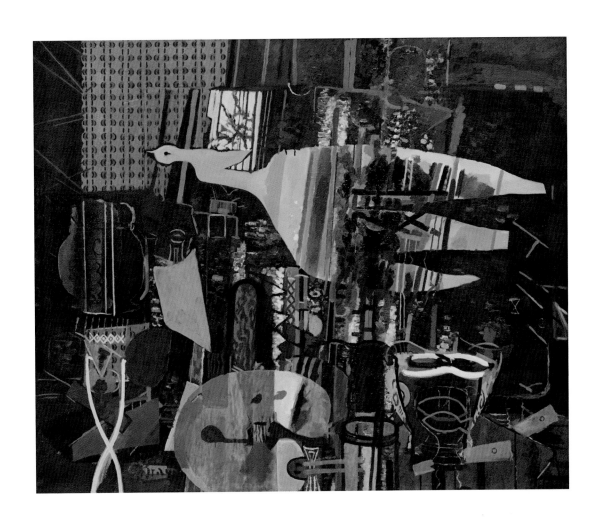

Georges Braque | (FRENCH, 1882–1963)
STUDIO V. 1949–50
OIL ON CANVAS, 57⅞ x 69½" (147 x 176.5 CM)
ACQUIRED THROUGH THE LILLIE P. BLISS BEQUEST, 2000

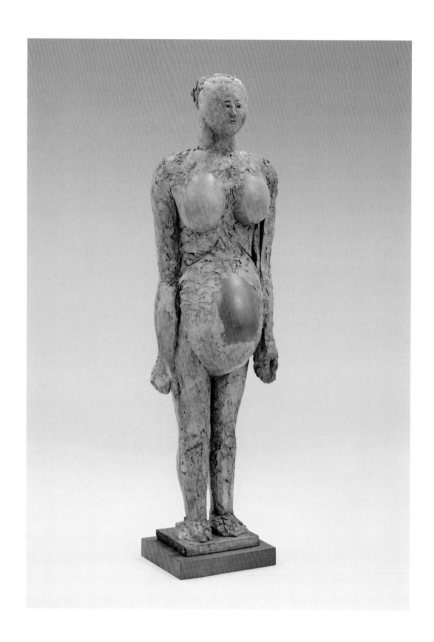

Pablo Picasso | (SPANISH, 1881–1973)
PREGNANT WOMAN. 1950
PLASTER WITH METAL ARMATURE, WOOD, CERAMIC, LARGE VESSEL,
AND TWO POTTERY JARS, 43¼ x 8⅝ x 12½" (110 x 22 x 32 CM)
GIFT OF LOUISE REINHARDT SMITH AND GIFT OF JACQUELINE
PICASSO (BOTH BY EXCHANGE), 2003

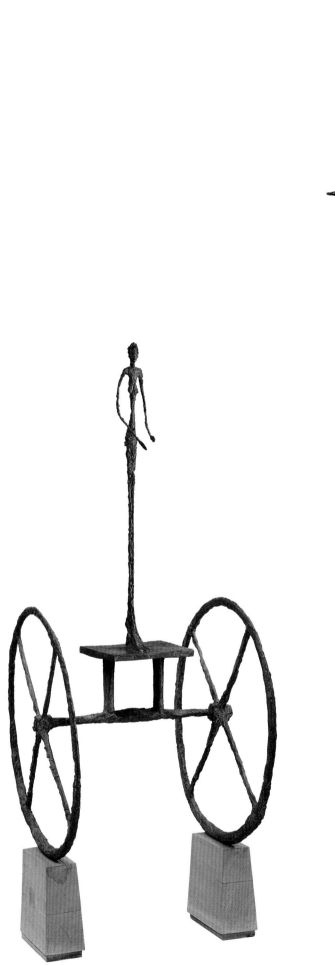

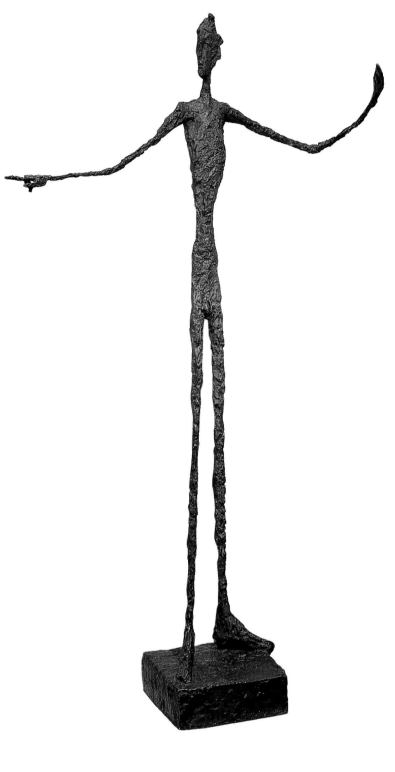

Alberto Giacometti | (SWISS, 1901–1966)
MAN POINTING. 1947
BRONZE, 70½ x 40¼ x 16⅛" (179 x 103.4 x 41.5 CM)
GIFT OF MRS. JOHN D. ROCKEFELLER 3RD, 1954

Alberto Giacometti
THE CHARIOT. 1950
PAINTED BRONZE ON WOODEN BASE, 57 x 26 x 26⅛" (144.8 x
65.8 x 66.2 CM), BASE 9¾ x 4½ x 9¼" (24.8 x 11.5 x 23.5 CM)
PURCHASE, 1951

329

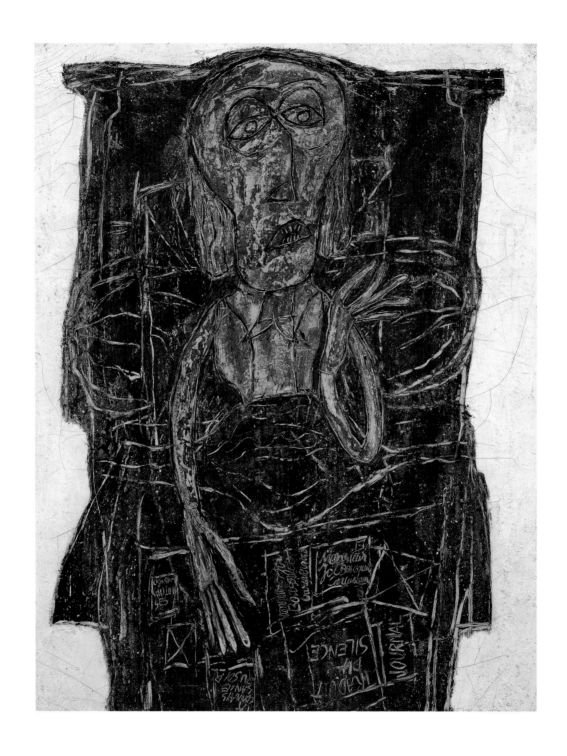

Jean Dubuffet | (FRENCH, 1901–1985)
JOE BOUSQUET IN BED, from the series More Beautiful
than They Think: Portraits [Plus beaux qu'ils croisent
(Portraits)]. January 1947
OIL EMULSION IN WATER ON CANVAS, 57⅝ x 44⅞" (146.3 x 114 CM)
MRS. SIMON GUGGENHEIM FUND, 1961

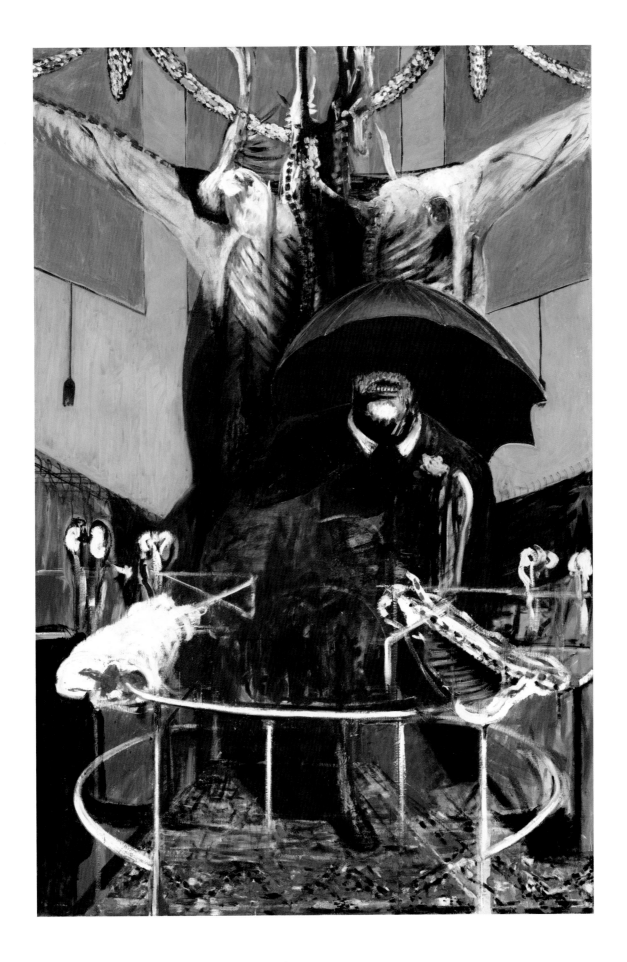

Francis Bacon | (BRITISH, 1909–1992)
PAINTING. 1946
OIL AND PASTEL ON LINEN, 6' 5⅞" x 52" (197.8 x 132.1 CM)
PURCHASE, 1948

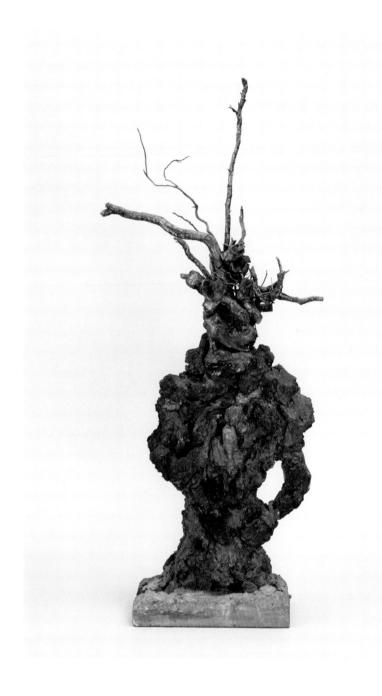

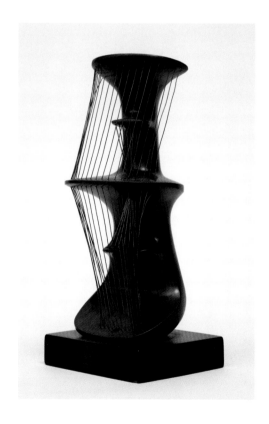

Jean Dubuffet | (FRENCH, 1901–1985)
THE MAGICIAN, from the series Petites Statues de
la vie précaire. September 1954
SLAG AND ROOTS, 43½ x 19 x 8¼" (109.8 x 48.2 x 21 CM)
INCLUDING SLAG BASE
GIFT OF MR. AND MRS. N. RICHARD MILLER AND MR. AND
MRS. ALEX L. HILLMAN AND SAMUEL GIRARD FUNDS, 1968

Henry Moore | (BRITISH, 1898–1986)
THE BRIDE. 1939–40
CAST LEAD AND COPPER WIRE, 9⅜ x 4⅛ x 4" (23.8 x 10.3 x 10 CM)
ACQUIRED THROUGH THE LILLIE P. BLISS BEQUEST, 1947

Isamu Noguchi | (AMERICAN, 1904–1988)
APARTMENT. 1952
UNGLAZED SETO RED STONEWARE, 37½" x 12¼" x 6¾"
(95.2 x 31.3 x 17 CM)
NINA AND GORDON BUNSHAFT BEQUEST, 1994

Louise Bourgeois | (AMERICAN, BORN
FRANCE, 1911)
SLEEPING FIGURE. 1950
PAINTED BALSA WOOD, 6' 2½" x 11⅝" x 11¾"
(189.2 x 29.5 x 29.7 CM)
KATHARINE CORNELL FUND, 1951

333

Armando Reverón | (VENEZUELAN, 1889–1954)
WOMAN OF THE RIVER. 1939
OIL ON CANVAS, 52 x 56⅞" (132.1 x 144.5 CM)
FRACTIONAL AND PROMISED GIFT OF PATRICIA PHELPS
DE CISNEROS IN HONOR OF JOHN ELDERFIELD, 2004

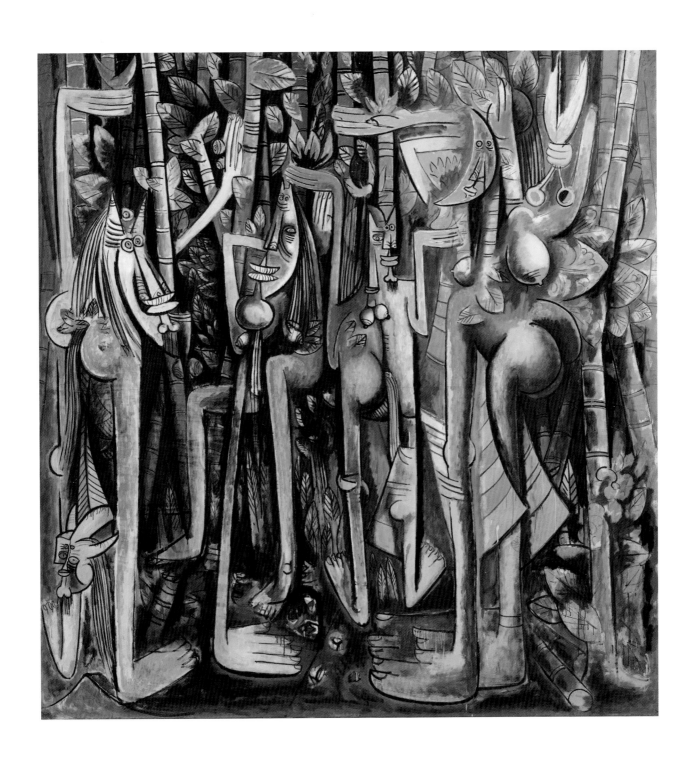

Wifredo Lam | (CUBAN, 1902–1982)
THE JUNGLE. 1943
GOUACHE ON PAPER MOUNTED ON CANVAS, 7'10¼" x 7'6½"
(239.4 x 229.9 CM)
INTER-AMERICAN FUND, 1945

Abstract Expressionism

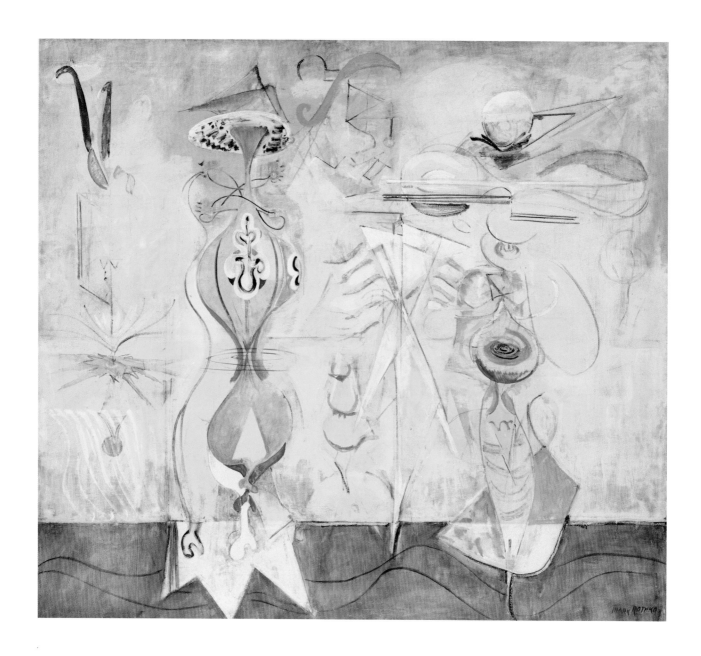

Mark Rothko | (AMERICAN, BORN LATVIA. 1903–1970)
SLOW SWIRL AT THE EDGE OF THE SEA. 1944
OIL ON CANVAS, 6' 3⅛" x 7'1¾" (191.4 x 215.2 CM)
BEQUEST OF MRS. MARK ROTHKO THROUGH THE MARK ROTHKO
FOUNDATION, INC., 1981

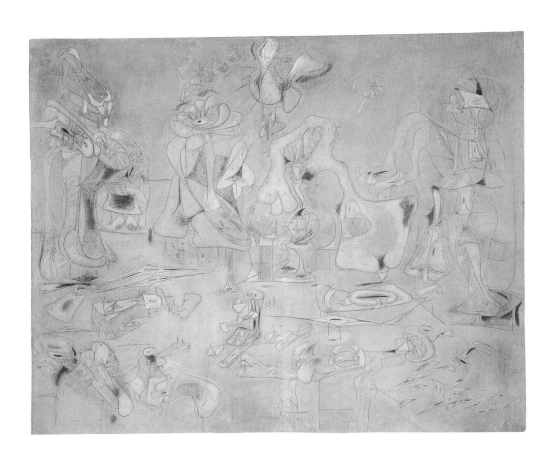

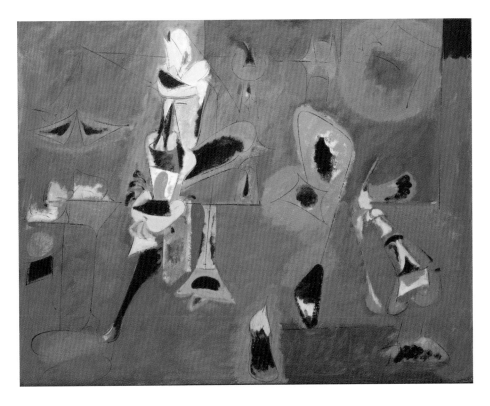

Arshile Gorky | (AMERICAN, BORN ARMENIA. 1904–1948)
SUMMATION. 1947
PENCIL, PASTEL, AND CHARCOAL ON BUFF PAPER MOUNTED ON COMPOSITION
BOARD, 6' 7⅞" x 8' 5¼" (202.1 x 258.2 CM)
NINA AND GORDON BUNSHAFT FUND, 1969

Arshile Gorky
AGONY. 1947
OIL ON CANVAS, 40 x 50½" (101.6 x 128.3 CM)
A. CONGER GOODYEAR FUND, 1950

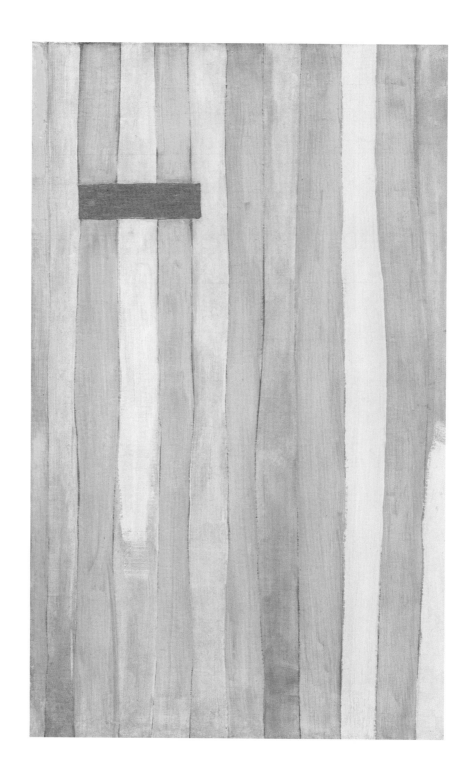

Robert Motherwell | (AMERICAN, 1915–1991)
THE LITTLE SPANISH PRISON. 1941–44
OIL ON CANVAS, 27¼ x 17⅛" (69.2 x 43.5 CM)
GIFT OF RENATE PONSOLD MOTHERWELL, 1985

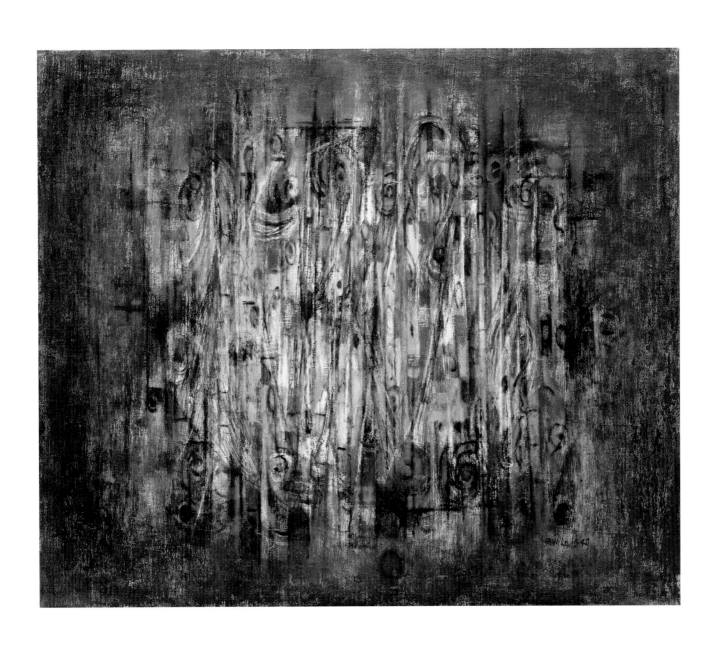

Norman Lewis | (AMERICAN, 1909–1979)
UNTITLED. 1949
OIL ON CANVAS, 26⅞ x 31⅞" (68.3 x 81 CM)
GIFT OF FRIENDS OF EDUCATION, 1998

339

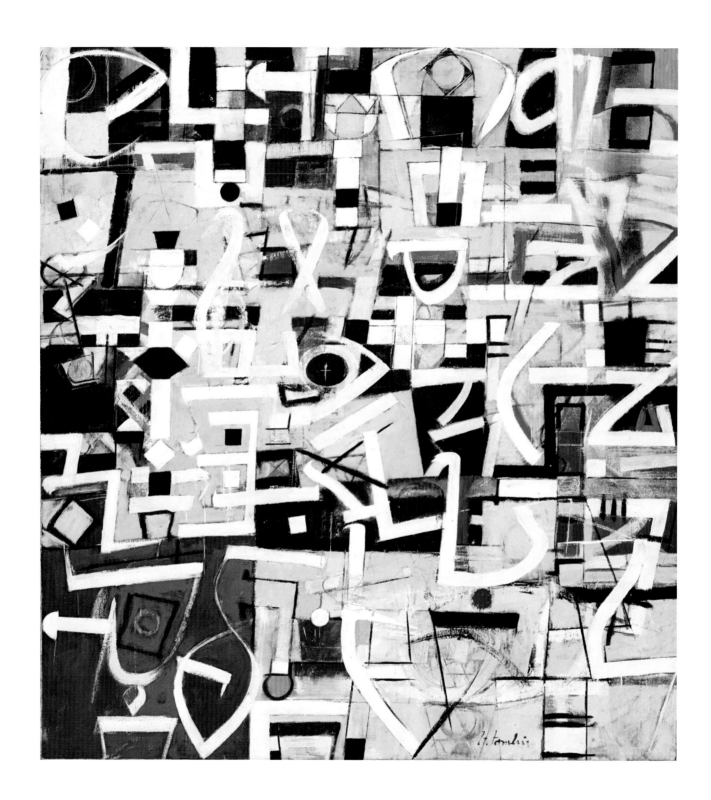

Bradley Walker Tomlin | (AMERICAN, 1899–1953)
NUMBER 20. 1949
OIL ON CANVAS, 7' 2" x 6' 8½" (218.5 x 203.9 CM)
GIFT OF PHILIP JOHNSON, 1952

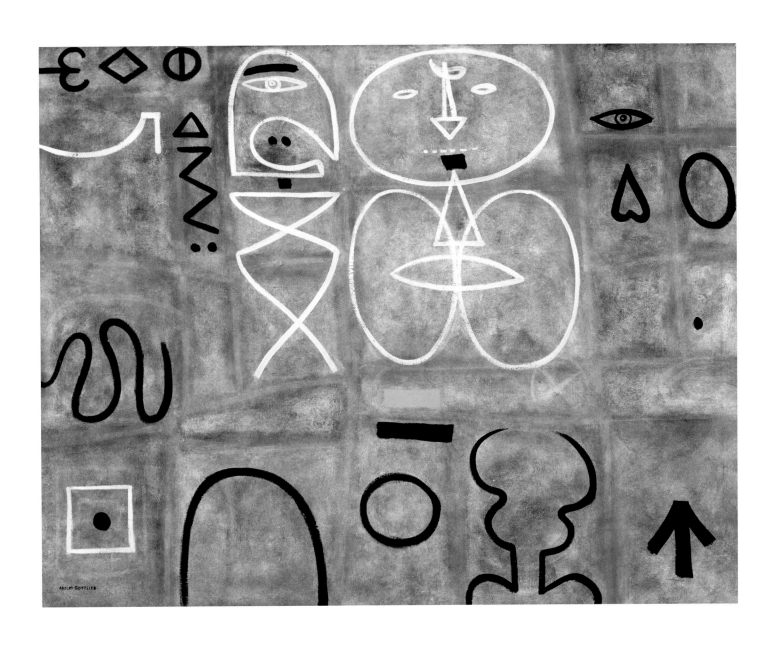

Adolph Gottlieb | (AMERICAN, 1903–1974)
MAN LOOKING AT WOMAN. 1949
OIL ON CANVAS, 42 x 54" (106.6 x 137.1 CM)
GIFT OF THE ARTIST, 1970

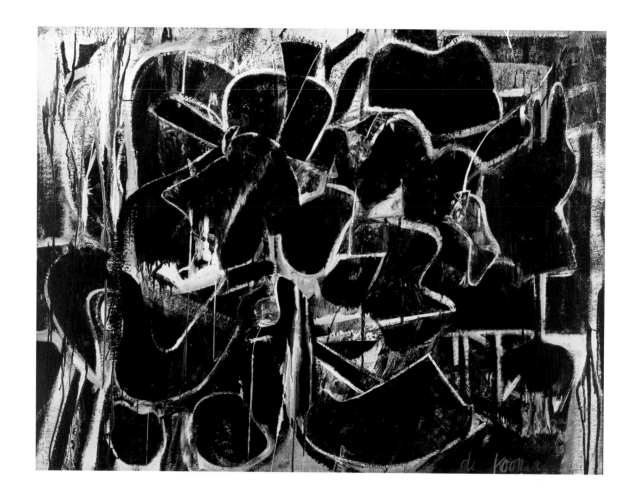

Willem de Kooning | (AMERICAN,
BORN THE NETHERLANDS. 1904–1997)
PAINTING. 1948
ENAMEL AND OIL ON CANVAS, 42⅞ x 56⅛"
(108.3 x 142.5 CM)
PURCHASE, 1948

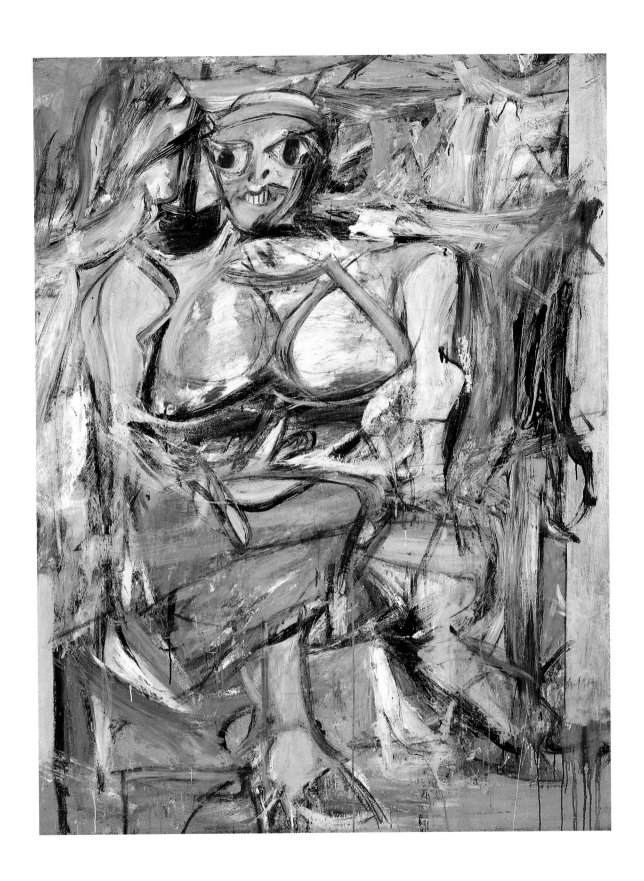

Willem de Kooning
WOMAN, I. 1950–52
OIL ON CANVAS, 6' 3⅞" x 58" (192.7 x 147.3 CM)
PURCHASE, 1953

343

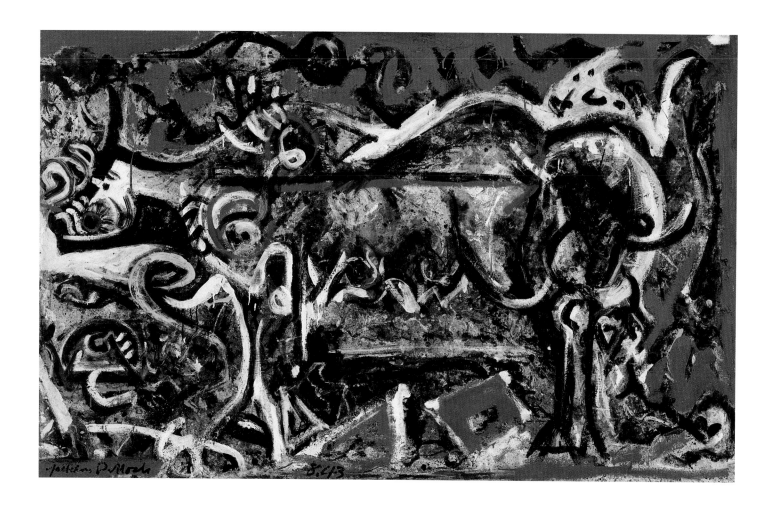

Jackson Pollock | (AMERICAN, 1912–1956)
THE SHE-WOLF. 1943
OIL, GOUACHE, AND PLASTER ON CANVAS,
41⅞ x 67" (106.4 x 170.2 CM)
PURCHASE, 1944

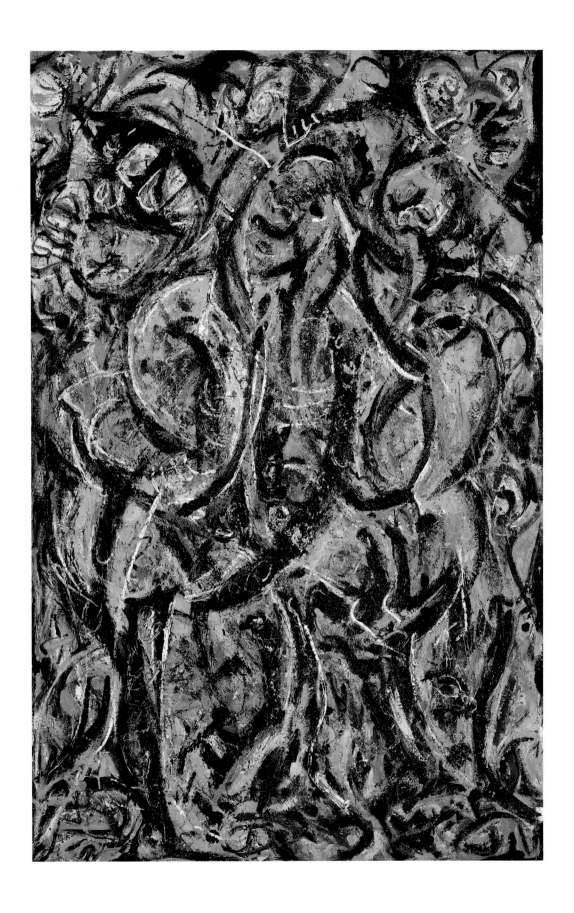

Jackson Pollock
GOTHIC. 1944
OIL ON CANVAS, 7'¼" x 56" (215.5 x 142.1 CM)
BEQUEST OF LEE KRASNER, 1980

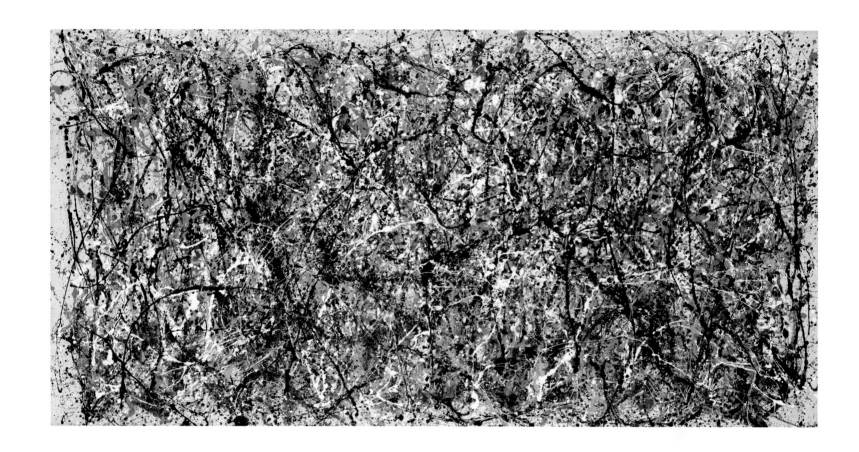

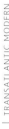

Jackson Pollock | (AMERICAN, 1912–1956)
ONE: NUMBER 31, 1950. 1950
OIL AND ENAMEL ON UNPRIMED CANVAS, 8' 10" x 17' 5¼" (269.5 x 530.8 CM)
SIDNEY AND HARRIET JANIS COLLECTION FUND (BY EXCHANGE), 1968

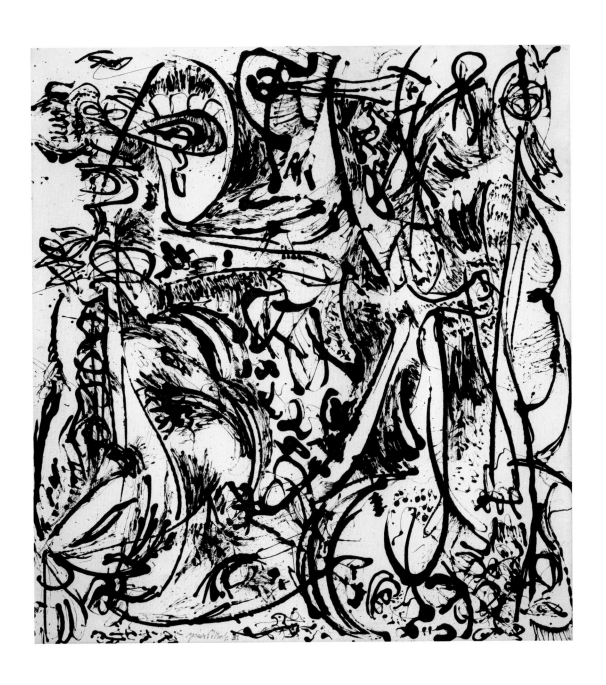

Jackson Pollock
ECHO: NUMBER 25, 1951. 1951
ENAMEL ON UNPRIMED CANVAS, 7' 7⅞" x 7' 2" (233.4 x 218.4 CM)
ACQUIRED THROUGH THE LILLIE P. BLISS BEQUEST AND THE MR. AND
MRS. DAVID ROCKEFELLER FUND, 1969

Jackson Pollock | (AMERICAN, 1912–1956)
EASTER AND THE TOTEM, 1953
OIL ON CANVAS, 6' 10⅛" x 58" (208.6 x 147.3 CM)
GIFT OF LEE KRASNER IN MEMORY OF JACKSON POLLOCK, 1980

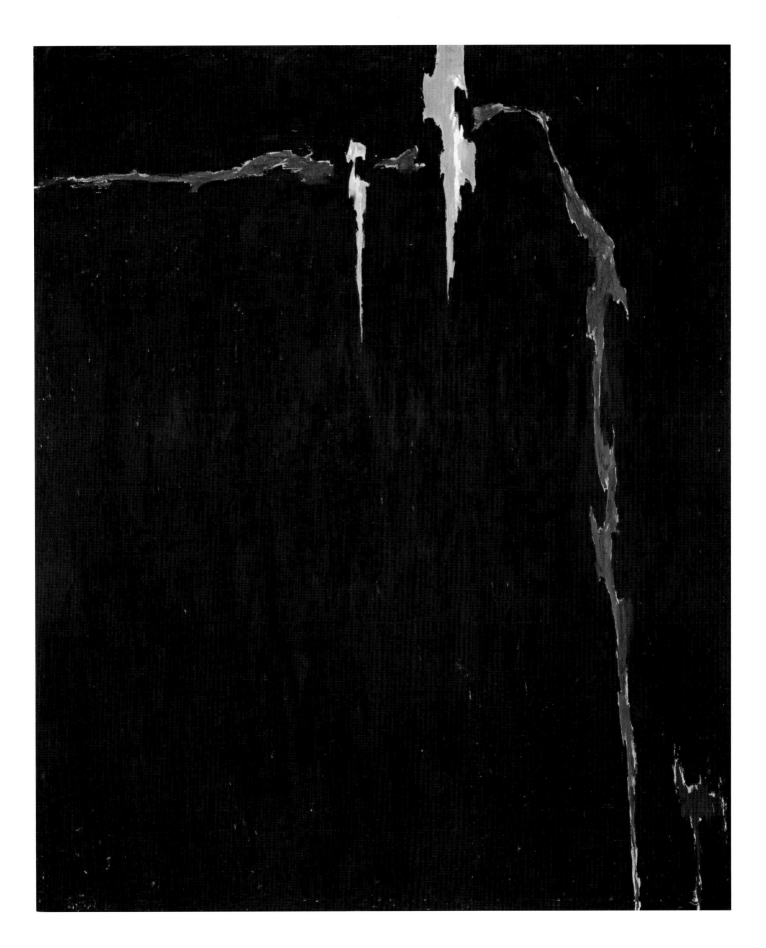

Clyfford Still | (AMERICAN, 1904–1980)
PAINTING 1944-N. 1944
OIL ON UNPRIMED CANVAS, 8' 8¼" x 7' 3¼" (264.5 x 221.4 CM)
THE SIDNEY AND HARRIET JANIS COLLECTION, 1967

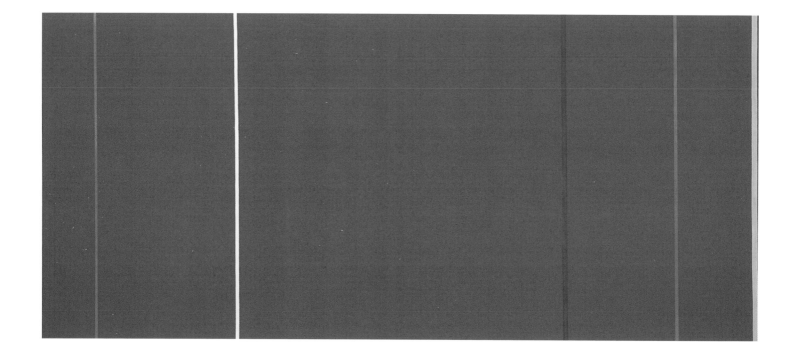

Barnett Newman | (AMERICAN, 1905–1970)
VIR HEROICUS SUBLIMIS: 1950–51
OIL ON CANVAS, 7' 11⅜" x 17' 9¼" (242.2 x 541.7 CM)
GIFT OF MR. AND MRS. BEN HELLER, 1969

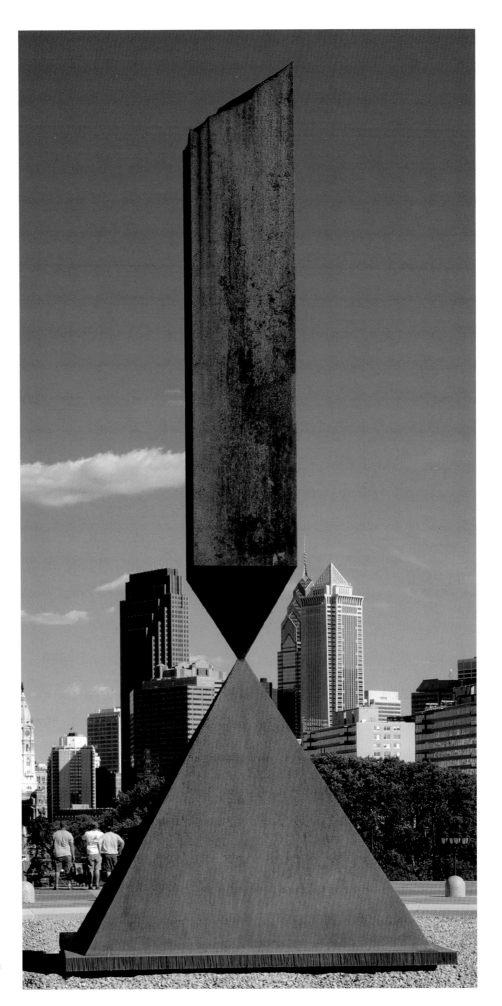

Barnett Newman
BROKEN OBELISK. 1963–69
COR-TEN STEEL, 24' 10" x 10' 11" x
10' 11" (749.9 x 318.8 x 318.8 CM)
GIVEN ANONYMOUSLY, 1971

351

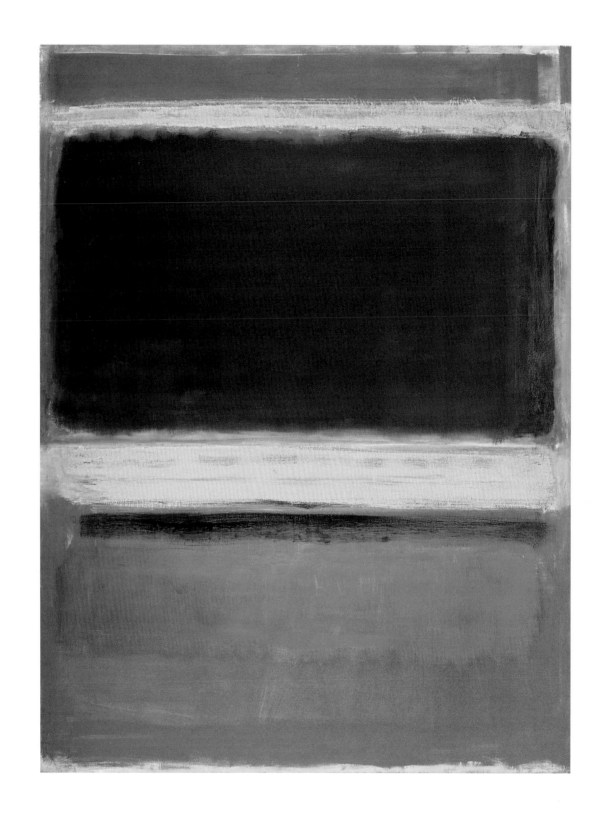

Mark Rothko | (AMERICAN, BORN LATVIA. 1903–1970)
NO. 3/NO. 13. 1949
OIL ON CANVAS, 7' 1⅜" x 65" (216.5 x 164.8 CM)
BEQUEST OF MRS. MARK ROTHKO THROUGH THE MARK ROTHKO
FOUNDATION, INC., 1981

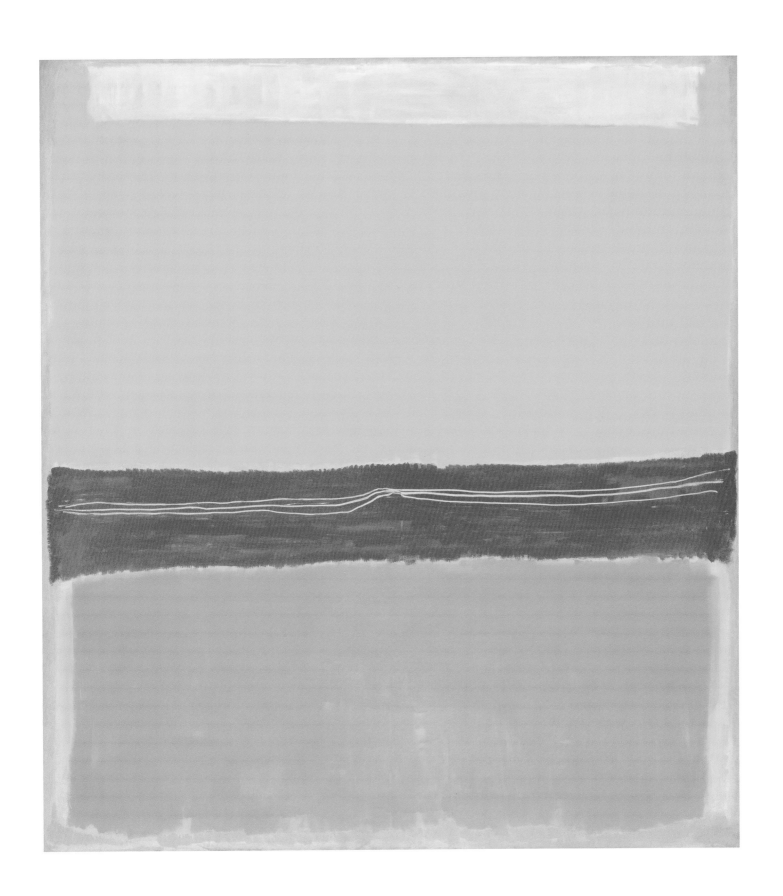

Mark Rothko
NO. 5/NO. 22. 1950 (dated on verso 1949)
OIL ON CANVAS, 9' 9" x 8' 11⅞" (297 x 272 CM)
GIFT OF THE ARTIST, 1969

353

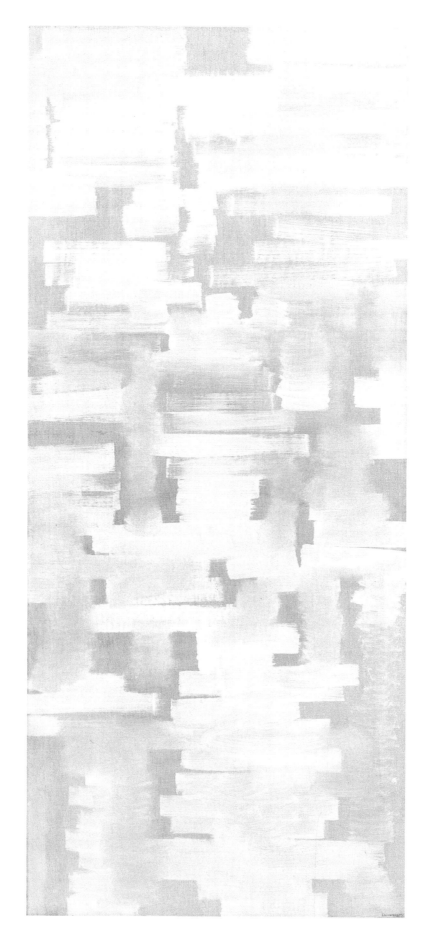

Ad Reinhardt | (AMERICAN, 1913–1967)
NUMBER 107. 1950
OIL ON CANVAS, 6' 8" x 36" (203.2 x 91.4 CM)
GIVEN ANONYMOUSLY, 1980

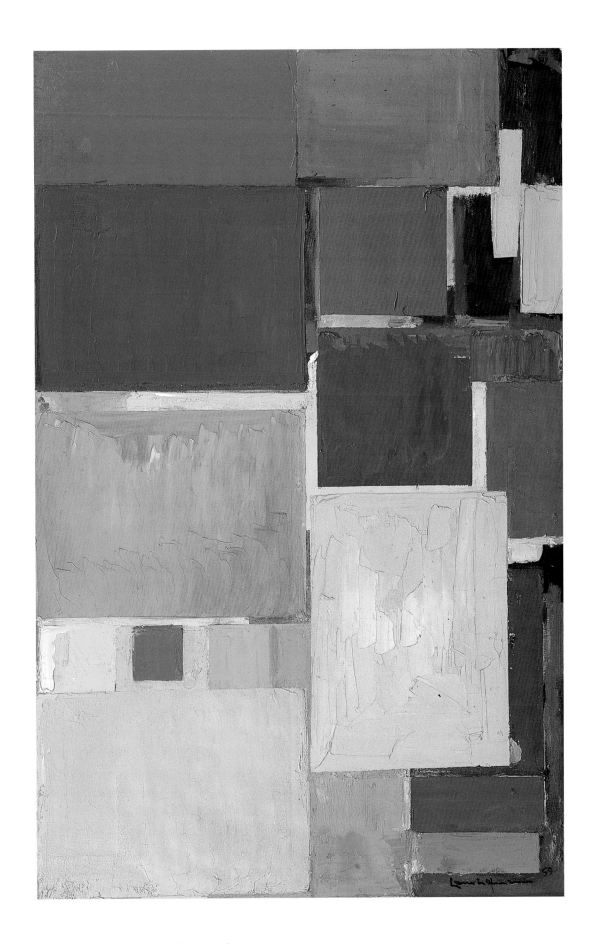

Hans Hofmann | (AMERICAN, BORN GERMANY. 1880–1966)
CATHEDRAL. 1959
OIL ON CANVAS, 6' 2" x 48" (188 x 122 CM)
FRACTIONAL AND PROMISED GIFT OF AGNES GUND IN HONOR OF WILLIAM RUBIN, 1991

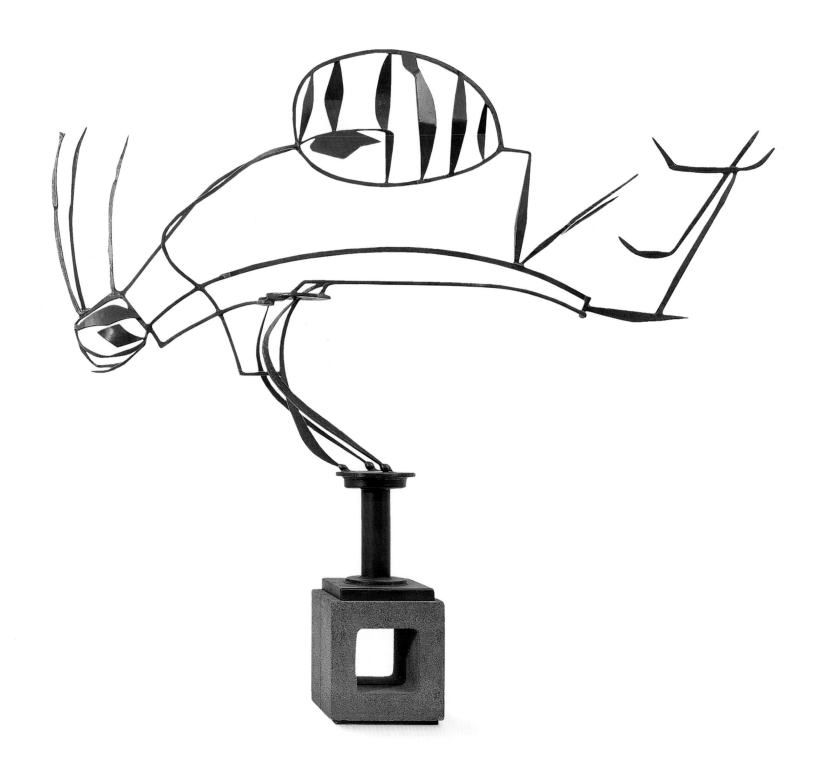

David Smith | (AMERICAN, 1906–1965)
AUSTRALIA. 1951
PAINTED STEEL ON CINDER-BLOCK BASE, 6' 7½" x 8' 11½" x 16½"
(202 x 274 x 41 CM), AT BASE, 14 x 14" (35.6 x 35.6 CM)
GIFT OF WILLIAM RUBIN, 1968

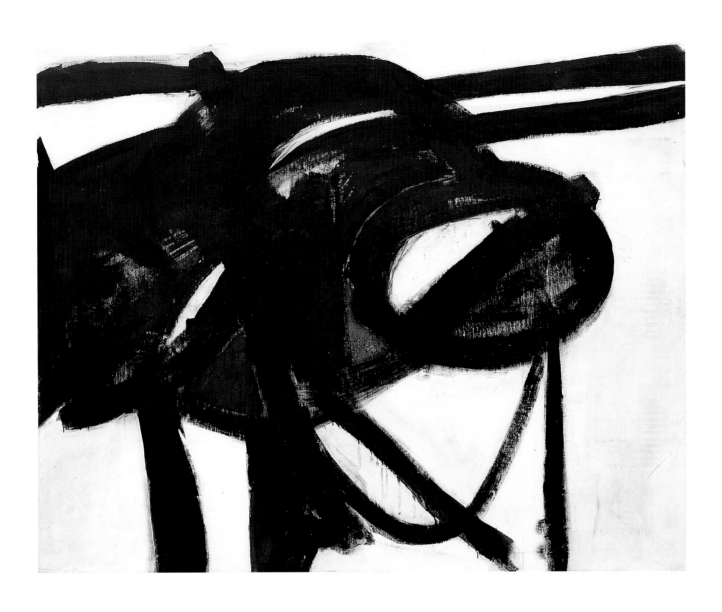

Franz Kline | (AMERICAN, 1910–1962)
CHIEF. 1950
OIL ON CANVAS, 58⅜" x 6' 1½" (148.3 x 186.7 CM)
GIFT OF MR. AND MRS. DAVID M. SOLINGER, 1952

After Abstract Expressionism

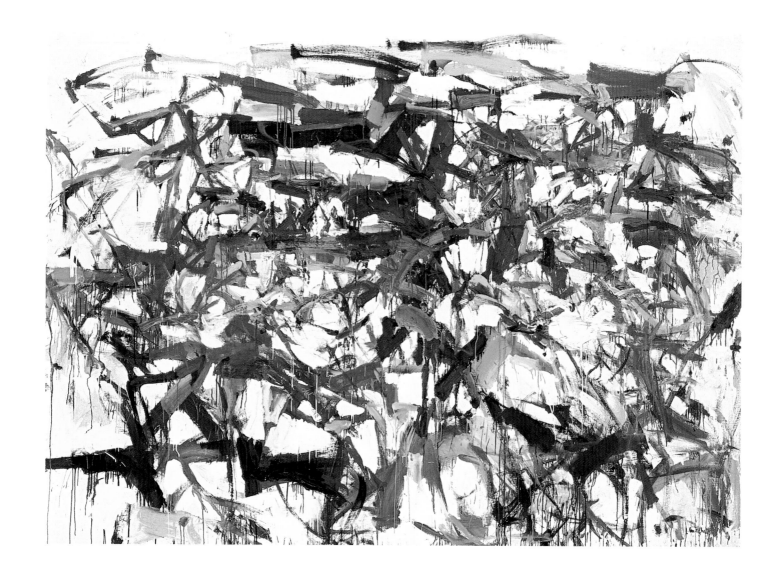

Joan Mitchell | (AMERICAN, 1926–1992)
LADYBUG 1957
OIL ON CANVAS, 6' 5⅞" x 9' (197.9 x 274 CM)
PURCHASE, 1961

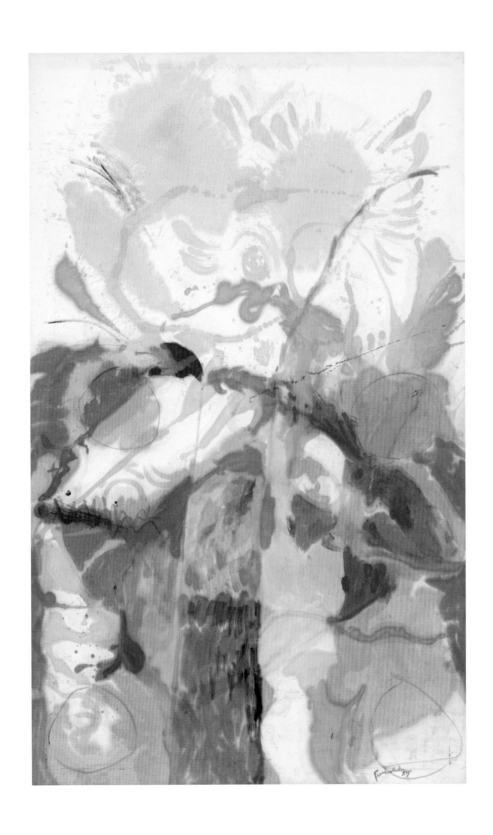

Helen Frankenthaler | (AMERICAN, BORN 1928)
JACOB'S LADDER. 1957
OIL ON UNPRIMED CANVAS, 9' 5½" x 69⅞" (287.9 x 177.5 CM)
GIFT OF HYMAN N. GLICKSTEIN, 1960

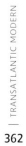
Morris Louis | (AMERICAN, 1912–1962)
RUSSET. 1958
SYNTHETIC POLYMER PAINT ON UNPRIMED CANVAS,
7' 8¼" x 14' 5⅛" (235.6 x 441.1 CM)
GIVEN ANONYMOUSLY, 1977

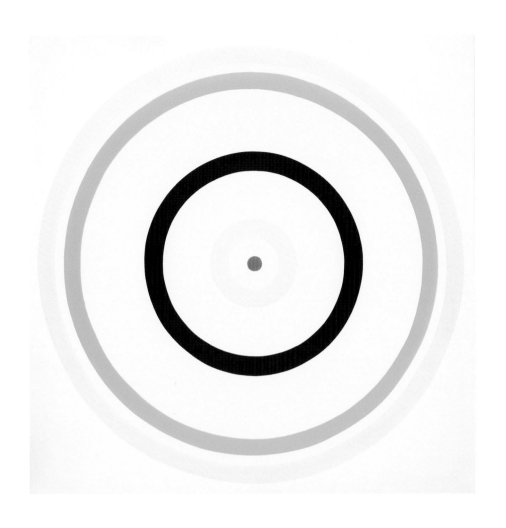

Kenneth Noland
(AMERICAN, BORN 1924)
TURNSOLE. 1961
SYNTHETIC POLYMER PAINT ON
UNPRIMED CANVAS, 7' 10⅛" x 7' 10⅛"
(239 x 239 CM)
BLANCHETTE ROCKEFELLER FUND,
1968

Anthony Caro
(BRITISH, BORN 1924)
MIDDAY. 1960
PAINTED STEEL, 7' 7⅝" x 37⅜" x
12' 1¼" (233.1 x 95 x 370.2 CM)
MR. AND MRS. ARTHUR WIESENBERGER
FUND, 1974

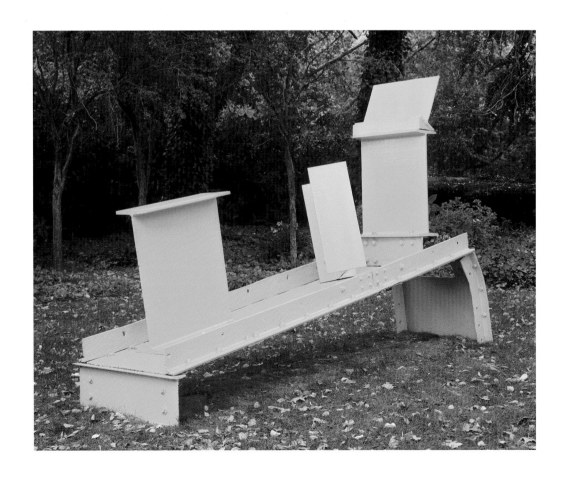

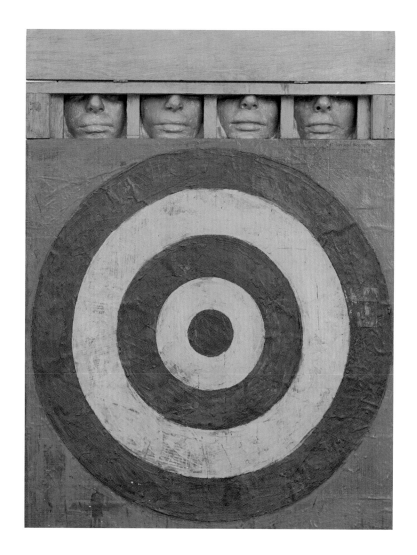

Jasper Johns | (AMERICAN, BORN 1930)
TARGET WITH FOUR FACES. 1955
ENCAUSTIC ON NEWSPAPER AND CLOTH OVER CANVAS SUR-
MOUNTED BY FOUR TINTED-PLASTER FACES IN WOOD BOX
WITH HINGED FRONT, OVERALL, WITH BOX OPEN, 33⅛ x 26 x
3" (85.3 x 66 x 7.6 CM); CANVAS 26 x 26" (66 x 66 CM); BOX
(CLOSED) 3¾ x 26 x 3½" (9.5 x 66 x 8.8 CM)
GIFT OF MR. AND MRS. ROBERT C. SCULL, 1958

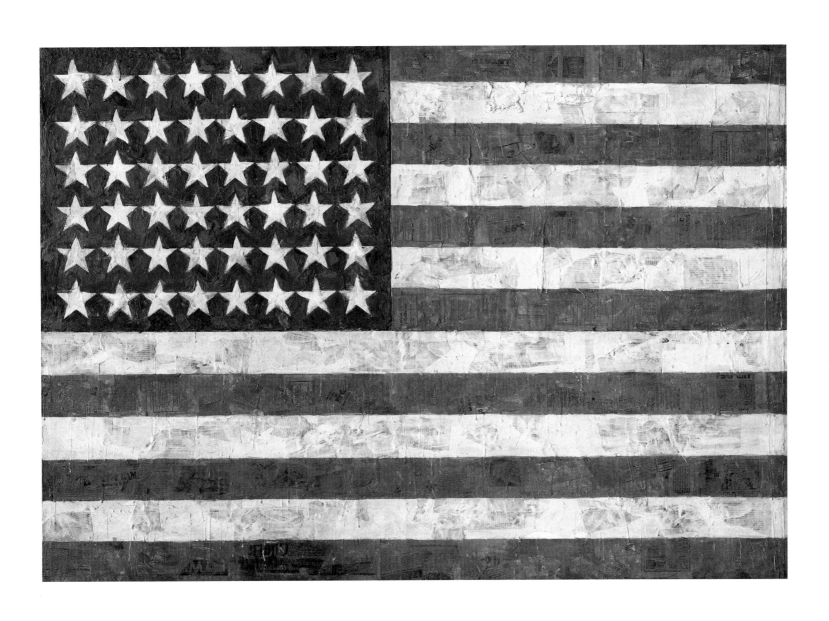

Jasper Johns
FLAG. 1954–55 (dated on reverse 1954)
ENCAUSTIC, OIL, AND COLLAGE ON FABRIC MOUNTED ON PLYWOOD,
THREE PANELS, 42¼ x 60⅝" (107.3 x 153.8 CM)
GIFT OF PHILIP JOHNSON IN HONOR OF ALFRED H. BARR, JR., 1973

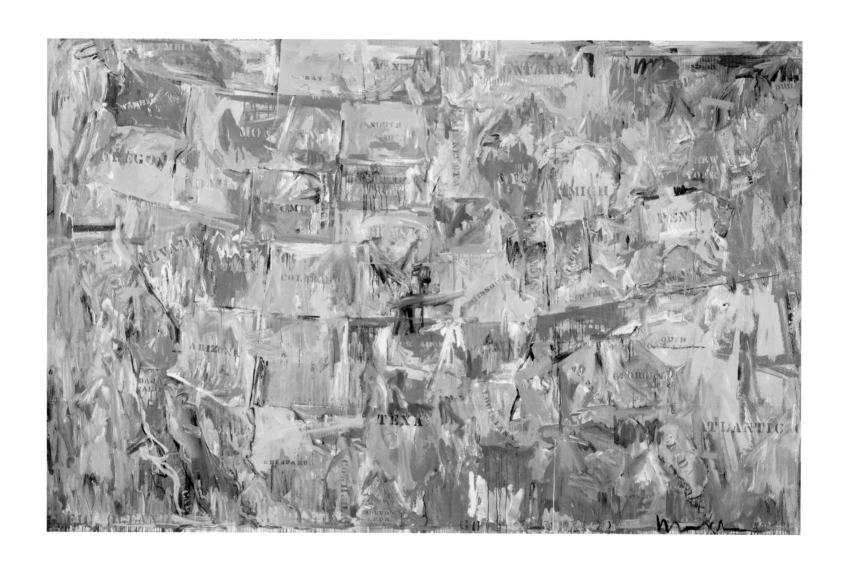

Jasper Johns | (AMERICAN, BORN 1930)
MAP, 1961
OIL ON CANVAS, 6' 6" x 10' 3⅛" (198.2 x 314.7 CM)
GIFT OF MR. AND MRS. ROBERT C. SCULL, 1963

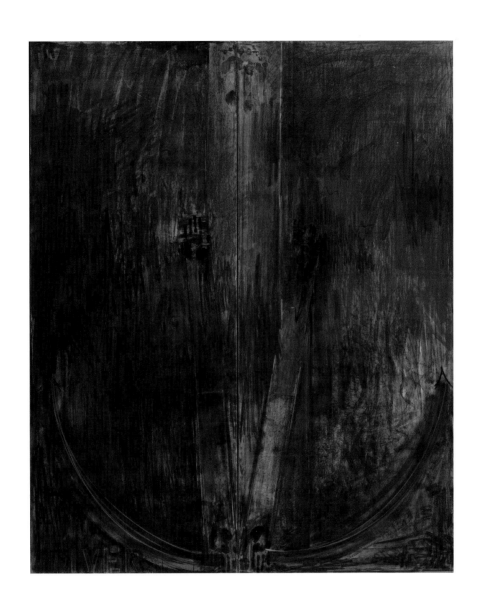

Jasper Johns
DIVER. 1962–63
CHARCOAL, PASTEL, AND WATERCOLOR (?) ON PAPER MOUNTED ON CANVAS,
TWO PANELS, 7' 2½" x 71¼" (219.7 x 182.2 CM)
PARTIAL GIFT OF KATE GANZ AND TONY GANZ IN MEMORY OF THEIR PARENTS,
VICTOR AND SALLY GANZ, AND IN MEMORY OF KIRK VARNEDOE; MRS. JOHN HAY
WHITNEY BEQUEST FUND; GIFT OF EDGAR KAUFMANN, JR. (BY EXCHANGE) AND
PURCHASE. ACQUIRED BY THE TRUSTEES OF THE MUSEUM OF MODERN ART IN
MEMORY OF KIRK VARNEDOE, 2003

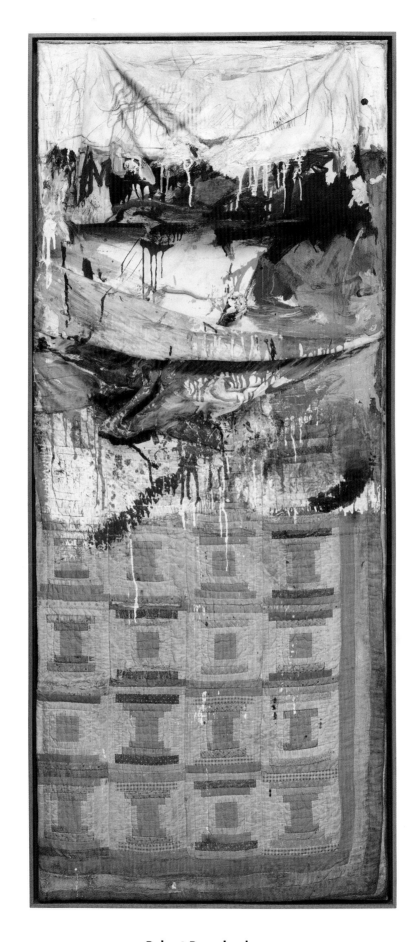

Robert Rauschenberg | (AMERICAN, BORN 1925)
BED. 1955
COMBINE PAINTING: OIL AND PENCIL ON PILLOW, QUILT, AND SHEET ON
WOOD SUPPORTS, 6' 3½" x 31½" x 8" (191.1 x 80 x 20.3 CM)
GIFT OF LEO CASTELLI IN HONOR OF ALFRED H. BARR, JR., 1989

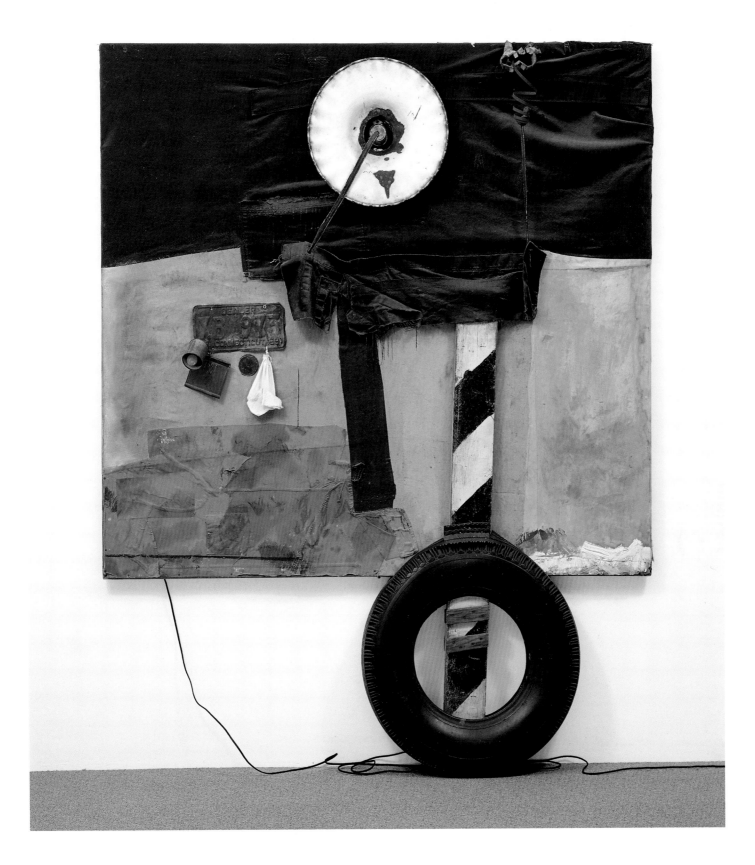

Robert Rauschenberg
FIRST LANDING JUMP. 1961
COMBINE PAINTING: CLOTH, METAL, LEATHER, ELECTRIC FIXTURE,
CABLE, AND OIL PAINT ON COMPOSITION BOARD, WITH AUTOMOBILE
TIRE AND WOODEN PLANK, 7' 5½" x 6' x 8⅞" (226.3 x 182.8 x 22.5 CM)
GIFT OF PHILIP JOHNSON, 1972

369

Cy Twombly | (AMERICAN, BORN 1928)
THE ITALIANS. January 1961
OIL, PENCIL, AND CRAYON ON CANVAS, 6' 6⅛" x 8' 6¼"
(199.5 x 259.6 CM)
BLANCHETTE ROCKEFELLER FUND, 1969

Cy Twombly
UNTITLED. 1970
OIL-BASED HOUSE PAINT AND CRAYON ON CANVAS,
13' 3⅛" x 21'⅛" (405 x 640.3 CM)
ACQUIRED THROUGH THE LILLIE P. BLISS BEQUEST
AND THE SIDNEY AND HARRIET JANIS COLLECTION
(BOTH BY EXCHANGE), 1994

371

Crosscurrents

Alejandro Otero | (VENEZUELAN, 1921–1990)
COLORHYTHM, 1. 1955
ENAMEL ON PLYWOOD, 6' 6⅞" x 19" (200.1 x 48.2 CM)
INTER-AMERICAN FUND, 1956

Ellsworth Kelly | (AMERICAN, BORN 1923)
COLORS FOR A LARGE WALL. 1951
OIL ON CANVAS, MOUNTED ON SIXTY-FOUR WOODEN PANELS,
7' 10½" x 7' 10½" (240 x 240 CM)
GIFT OF THE ARTIST, 1969

Ellsworth Kelly | (AMERICAN, BORN 1923)
WHITE PLAQUE: BRIDGE ARCH AND REFLECTION. 1952–55
OIL ON WOOD, 64⅞ x 47⅞" (164.6 x 121.6 CM)
PROMISED GIFT OF EMILY RAUH PULITZER; VINCENT D'AQUILA AND
HARRY SOVIAK BEQUEST FUND, AND ENID A. HAUPT FUND, 1996

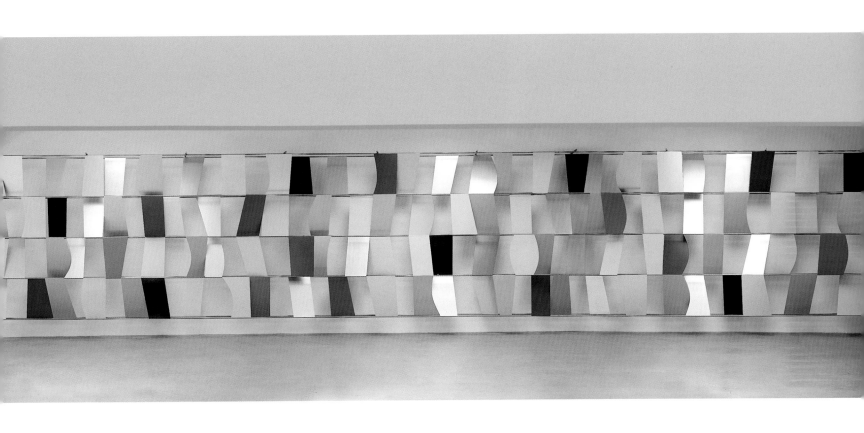

Ellsworth Kelly
SCULPTURE FOR A LARGE WALL. 1957
ANODIZED ALUMINUM, 11' 5" x 65' 5" x 28" (348 x
1994 x 71.1 CM)
GIFT OF JO CAROLE AND RONALD S. LAUDER, 1998

375

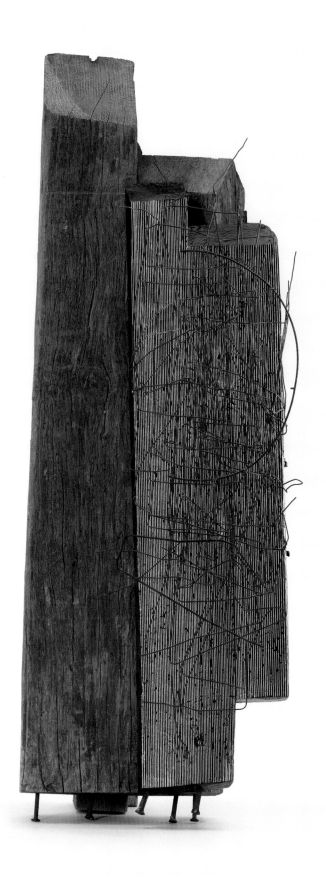

Jesús Rafael Soto
(VENEZUELAN, BORN 1923)
UNTITLED. 1959–60
WOOD, PAINTED WOOD, METAL, AND NAILS,
35⅜ x 11¾ x 13⅜" (89.9 x 29.8 x 34 CM)
PURCHASE, 2003

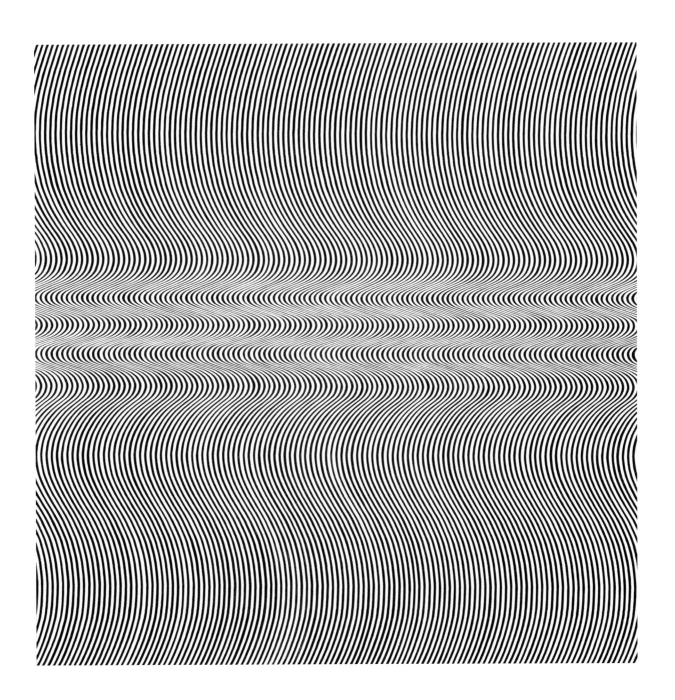

Bridget Riley | (BRITISH, BORN 1931)
CURRENT. 1964
SYNTHETIC POLYMER PAINT ON COMPOSITION BOARD,
58⅞ x 58⅞" (148.1 x 149.3 CM)
PHILIP JOHNSON FUND, 1964

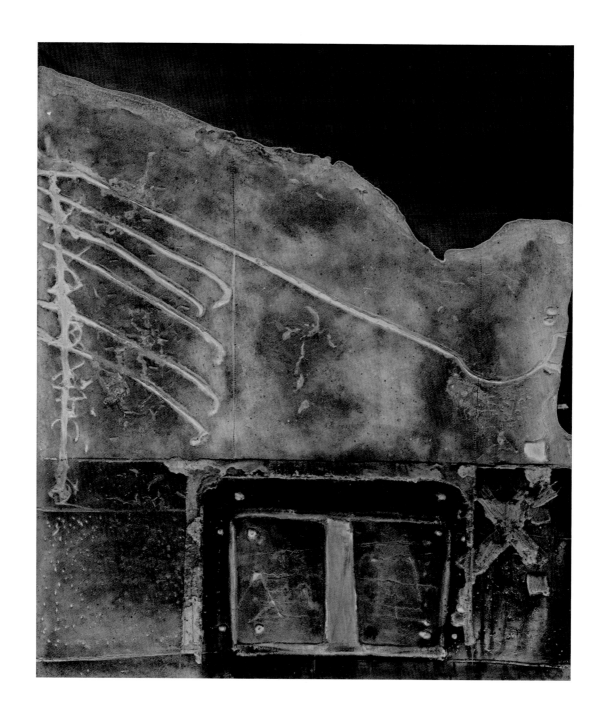

Antoni Tàpies | (SPANISH, BORN 1923)
GRAY RELIEF ON BLACK. 1959
LATEX PAINT WITH MARBLE DUST ON CANVAS,
6' 4⅞" x 67" (194.6 x 170 CM)
GIFT OF G. DAVID THOMPSON, 1961

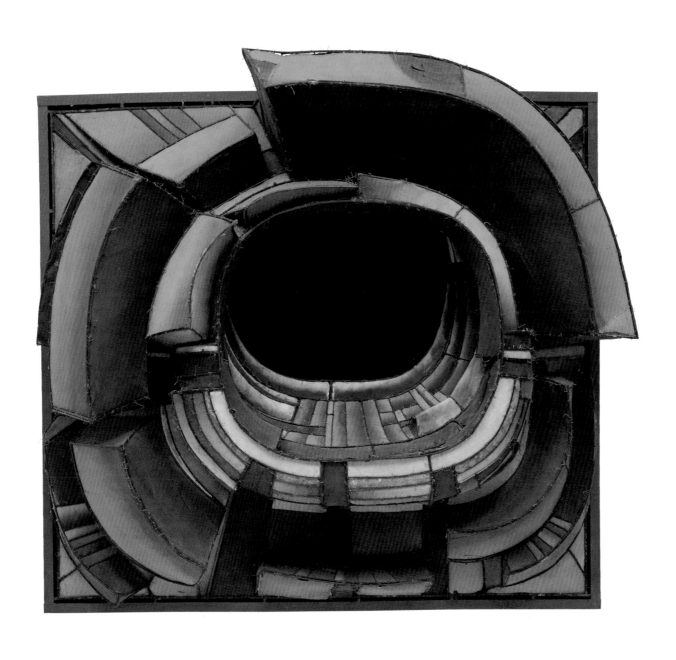

Lee Bontecou | (AMERICAN, BORN 1931)
UNTITLED. 1961
WELDED STEEL, CANVAS, BLACK FABRIC, COPPER WIRE,
AND SOOT, 6' 8⅛" x 7' 5" x 34⅛" (203.6 x 226 x 88 CM)
KAY SAGE TANGUY FUND, 1963

Hélio Oiticica | (BRAZILIAN, 1937–1980)
BOX BOLIDE 12, 'ARCHEOLOGIC'. 1964–65
SYNTHETIC POLYMER PAINT WITH EARTH ON WOODEN
STRUCTURE, NYLON NET, CORRUGATED CARDBOARD,
MIRROR, GLASS, ROCKS, EARTH, AND FLUORESCENT LAMP,
14½ x 51⅝ x 20½" (37 x 131.2 x 52.1 CM)
FRACTIONAL AND PROMISED GIFT OF PATRICIA PHELPS
DE CISNEROS GIVEN IN HONOR OF PAULO HERKENHOFF, 2004

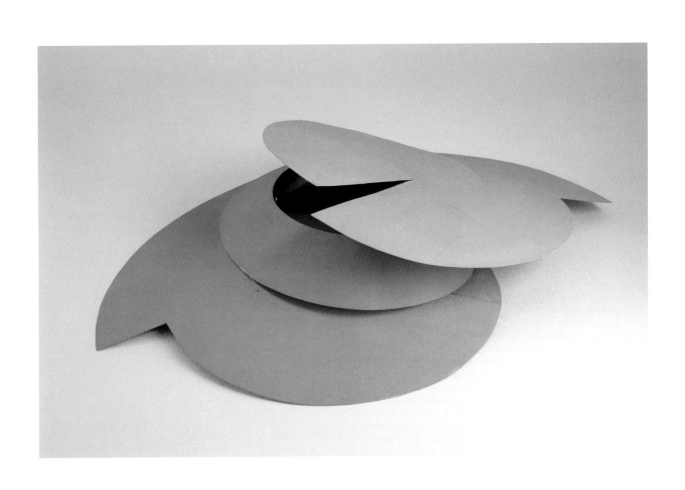

Lygia Clark | (BRAZILIAN, 1920–1988)
POETIC SHELTER. 1960
TIN, 5½ x 24 x 20⅛" (14 x 63 x 51 CM)
FRACTIONAL AND PROMISED GIFT OF PATRICIA PHELPS
DE CISNEROS IN HONOR OF MILAN HUGHSTON, 2004

Yayoi Kusama | (JAPANESE, BORN 1929)
NO. F. 1959
OIL ON CANVAS, 41½ x 52" (105.4 x 132.1 CM)
SID R. BASS FUND, 1997

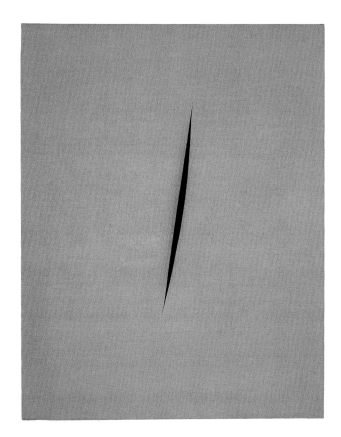

Lucio Fontana | (ITALIAN, 1899–1968)
SPATIAL CONCEPT: EXPECTATIONS. 1960
SLASHED CANVAS AND GAUZE, UNPAINTED,
39½ x 31⅛" (100.3 x 80.3 CM)
GIFT OF PHILIP JOHNSON, 1970

Yves Klein | (FRENCH, 1928–1962)
BLUE MONOCHROME. 1961
DRY PIGMENT IN SYNTHETIC POLYMER MEDIUM ON
COTTON OVER PLYWOOD, 6' 4⅞" x 55¼" (195.1 x 140 CM)
THE SIDNEY AND HARRIET JANIS COLLECTION, 1967

383

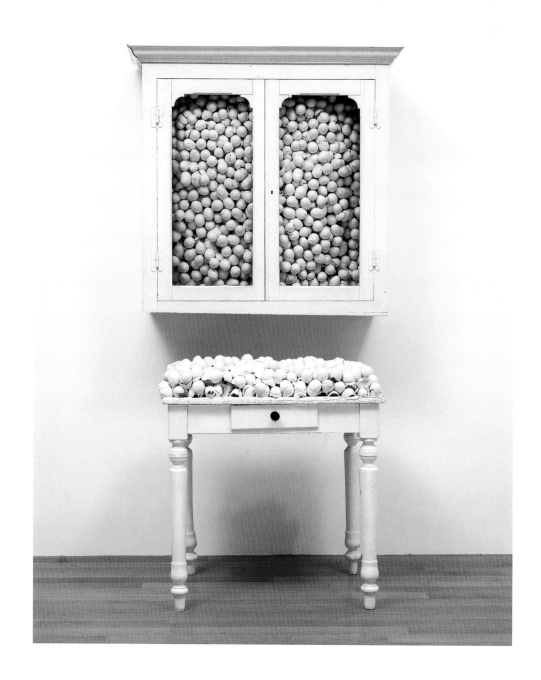

Marcel Broodthaers | (BELGIAN, 1924–1976)
WHITE CABINET AND WHITE TABLE. 1965
PAINTED CABINET, TABLE, AND EGGSHELLS, CABINET 33⅞ x 32¼ x
24½" (86 x 82 x 62 CM); TABLE 41 x 39⅜ x 15¾" (104 x 100 x 40 CM)
FRACTIONAL AND PROMISED GIFT OF RONALD S. LAUDER, 1992

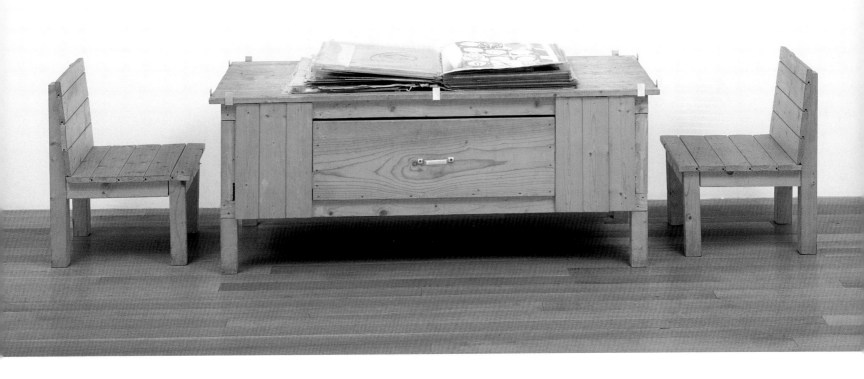

Dieter Roth | (SWISS, 1930–1998)
SNOW. 1963–69
MIXED MEDIUMS ON PAPER IN PLASTIC SLEEVES BOUND AS BOOK WITH METAL SCREWS AND PLASTIC
TUBING, WOOD COMMODE, TWO WOODEN CHAIRS, AND SIX GLUE, INK, AND PAPER COLLAGES ON BOARD,
BOOK (CLOSED) 4 x 18 x 20" (10.2 x 45.7 x 50.8 CM) (IRREGULAR); COLLAGES, EACH 20 x 18" (50.8 x 45.7 CM);
COMMODE 22⅞ x 58¼ x 25⅞" (57 x 149 x 65.8 CM); CHAIRS, EACH 24⅛ x 17¾ x 18½" (61 x 45.1 x 47 CM)
COMMITTEE ON PAINTING AND SCULPTURE FUNDS, 1998

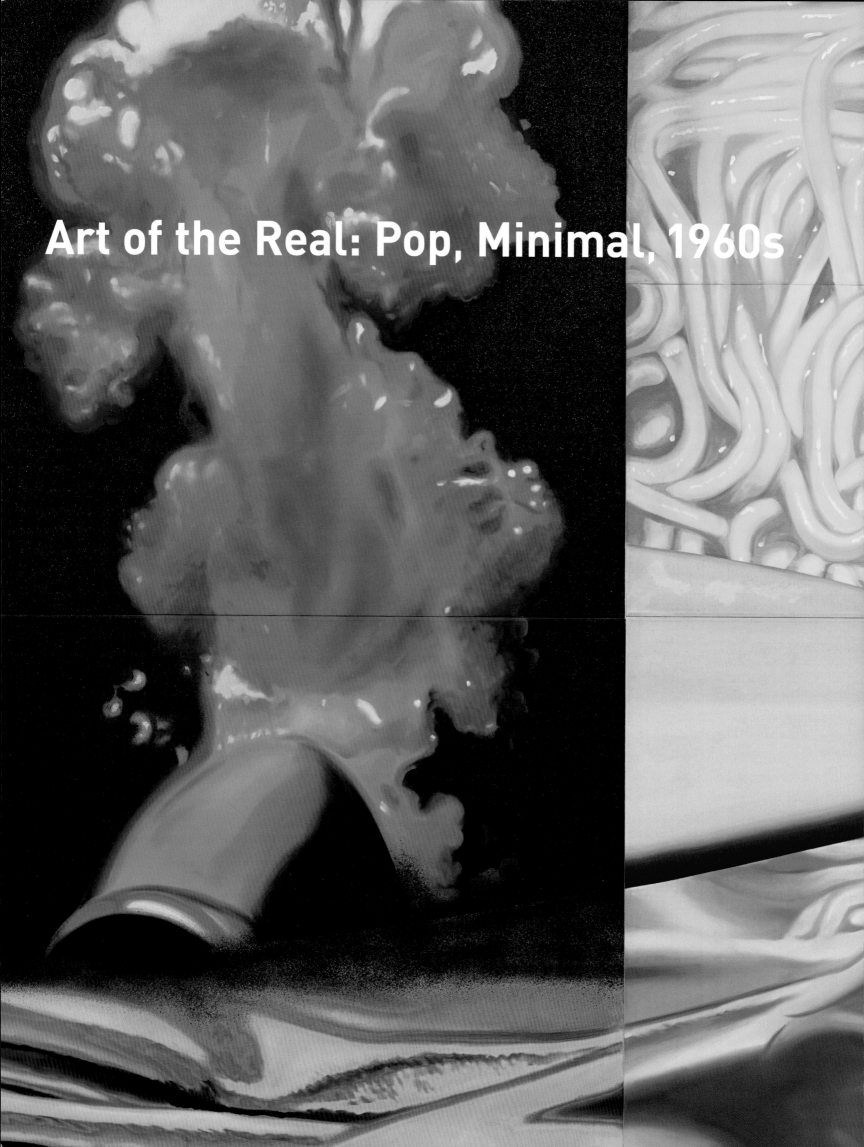

Art of the Real: Pop, Minimal, 1960s

In the case of both Pop art and Minimalism, the Museum's strengths are in works of the early, classic years. Among Pop artists, Andy Warhol is represented by the largest number of works, followed by Roy Lichtenstein, and in both instances the Museum owns their works of the first half of the 1960s. The same is true for the smaller representations of their fellow New Yorkers, Jim Dine, Claes Oldenburg, and James Rosenquist, of the Californian Ed Rusha, and of the representatives of Pop art in Britain, R. B. Kitaj and Richard Hamilton. The Parisian Jacques de la Villeglé, not truly a Pop artist but related in his use of popular imagery, is included here, represented by the latest work of 1968.

Following the work of these Pop or Pop-related artists are works dating from 1959 to 1969 by artists who indubitably are recognized to be Minimalists—the reductive sculptors Carl Andre, Dan Flavin, Donald Judd, Fred Sandback, Sol LeWitt, and Walter de Maria—together with the sculptors, some called post-Minimalists, at times—who associated with them but worked with less purist forms: Eva Hesse, Robert Morris, Bruce Nauman, Richard Serra, Robert Smithson, and Richard Tuttle. Here also are works by a very diverse group of artists—the painters Al Held, Ad Reinhardt, Robert Ryman, Frank Stella, and Agnes Martin, and the sculptors Richard Artschwager, Robert Irwin, and Tony Smith. These artists operated outside the realm of Minimalism, sometimes in opposition to it, but their related formal language positioned their initial reception within the context of its critical debates.

In contrast to Pop art and Minimalism (and painterly abstraction, represented in section four), other currents of the 1960s, most especially those that took place outside the United States, were slow to be embraced by the Museum. However, as a result of acquisitions made mainly over the past decade, the situation has changed. Hence, the *arte povera* movement, based in Italy, is now represented by, among other works, those by Giovanni Anselmo, Jannis Kounellis, Panamarenko, and Gilberto Zorio that are illustrated here. Language-based Conceptual art is represented by John Baldessari, Joseph Kosuth, and others. These are followed by examples of German artists who came to prominence in the 1960s, Joseph Beuys, Anselm Kiefer, Blinky Palermo, and Sigmar Polke.

It now is clear that the interventions of these less-easily-placed artists and movements, few from the United States, were as critical to the ferment of art in the late 1960s as those of their post-Abstract Expressionist counterparts, who appear in the previous section, were in the early 1960s. Together, they have formed relatable, chronological bookends to the contemporaneously opposed, but now self-evidently related movements, Pop art and Minimalism, in shaping the direction of much of contemporary art.

Pop Art

Tom Wesselmann
Still Life #30. 1963
Illustrated on page 402

Leslie Jones, in *Pop Art: Selections from The Museum of Modern Art*, **1998**, page 122

Following his 1961 exhibition of Great American Nudes, Wesselmann initiated his second major series based on a traditional theme—the still life. Like the nudes, the still life featured in *Still Life #30* is set in a contemporary domestic interior; from the bedroom to the kitchen (and eventually the bathroom), Wesselmann's paintings of the early to mid-1960s depict the private spaces of "typical" middle-class homes in postwar America. Displayed within a meticulously clean, orderly, and color-coordinated kitchen, a cornucopia of mass-produced food items spills onto the blue-and-white checkered tablecloth. . . . The contents of *Still Life #30* represent an inventory of mass-produced appliances and food that in the postwar years signified American economic prosperity, while the distant vista of New York City seen through the window locates the home in the suburbs.

The incorporation of three-dimensional objects combined with pasted and painted images presents the viewer with three different layers, literally and figuratively, of representation. For Wesselmann, the hand-painted and machine-made elements "traded off" against one another, heightening the visual tension of the painting surface. By juxtaposing "real" objects, photomechanically reproduced products, and other conventionally painted accoutrements, Wesselmann may also have intended to suggest the disparity between the idealized image of American domesticity portrayed in the media and actual domestic life. Upon close examination, even the three-dimensional elements included in *Still Life #30* are "fake": the 7UP bottles and roses are plastic replicas, the [Pablo] Picasso is a reproduction, and the refrigerator door, a mere facade.

As homemakers, it was, of course, women who were implicated in the maintenance of the American domestic ideal. In addition to the pink color scheme, Wesselmann calls attention to the notion of the kitchen as a "feminine" space by painting two perfectly round or-anges which, in his other paintings, are often matched with female breasts. These same two oranges, however, combine with the skyscraper that appears above them to suggest male genitals, insinuating a "masculine" presence within this private, feminine realm.[1]

In this and other paintings in the Still Life series, Wesselmann decorates his domestic interiors with reproductions by great modern painters. Juxtaposed with 7UP, the Picasso may be perceived as just one more brand name product to be consumed by American society. Or, hung as it is within a middle-class home, it may attest to the democratization of high art brought about by mechanical reproduction. In either case, Picasso has been subsumed by mass culture. Another high-art reference in *Still Life #30* are the yellow, red, and blue panels characteristic of Mondrian's explorations into pure abstraction which, in Wesselmann's painting, function purely as interior design. In the context of the kitchen, Picasso and [Piet] Mondrian become decorator items; in the context of the museum, Wesselmann's kitchen becomes art. The interplay between high and low in *Still Life #30* raises questions concerning both the nature of art and idealized notions of domesticity.

Jim Dine
Five Feet of Colorful Tools. 1962
Illustrated on page 403

Lucy Lippard, in *Three Generations of Twentieth-Century Art*, **1972**, page 150

Jim Dine shares with Jasper Johns a debt to both Marcel Duchamp and the Abstract Expressionists. There has in fact been a certain interplay between the two younger artists, although Johns matured considerably earlier. In Dine's *Five Feet of Colorful Tools*, there are cross references not only to other of his works with palettes and spectrums but also to Johns's paintings that label (or mislabel) colors, as well as to Duchamp's Readymades, especially the snow shovel called *In Advance of the Broken Arm*, 1915. The *Five Feet* is also reminiscent of Duchamp's last painting, *Tu m'*, 1918, which is dominated by the shadows of a bicycle wheel, hat rack, and corkscrew, and includes real safety pins to close a

painted opening. Dine has made his tools—saws, hammers, pliers, screwdrivers, cramps, braces, and nuts—both realities and illusions, three-dimensional and "painted." Despite all this, plus the visual pun made by combining colors and shadows with actual objects, the configuration of this work has less to do with Dada than with Abstract Expressionism—especially those paintings by Clyfford Still in which jagged, irregular forms anchored at the edge cut into the field of the pictures.

The *Five Feet of Colorful Tools* was shown in the "New Realists" exhibition in 1962, which was installed in the Sidney Janis Gallery and a Fifty-seventh Street store one block away. The first group show in New York to juxtapose American Pop art and its European counterparts (including many works that had been seen the previous year in The Museum of Modern Art's exhibition "The Art of Assemblage"), it marked the end of Pop's underground phase and the beginning of its public triumph.

Claes Oldenburg
Pastry Case, I. 1961–62
Illustrated on page 405

Laura Hoptman, in *Pop Art: Selections from The Museum of Modern Art*, **1998**, page 64

The group of nine painted plaster sculptures in *Pastry Case, I* includes cookies, a cake, a tart, ice-cream sundaes, a candied apple, and a piece of blueberry pie. Each object was made by dipping burlap or muslin in plaster and laying the saturated fabric over a wire frame. After the cloth dried, another coat of plaster was applied and Oldenburg then painted the whole with store-bought enamel paint straight from the can. Products though they were, these plaster objects could never be mistaken for mass-manufactured items. Lumpish and messy, their shiny enamel paint was applied almost expressionistically. Their handmade quality was a key element of their humanity, at once establishing their distance from a ready-made reproduction and tying them firmly to the artist who made them. . . .

All the sculptures have the familiar, flyblown look of food too long on display. Not only do these works look old, but they also look artificial, resembling actual sweets less than the wax or plastic replicas often seen in pastry-display cases in diners and coffee shops throughout America.

Pastry Case, I can be seen as part of a long art-historical tradition of the depiction of opulent still lifes painted as allegories of human excess and frailty. Luridly colored and awkwardly shaped, the items in *Pastry Case, I* are both grotesque and seductive, abject and humorous. . . . In *Pastry Case, I*, as in a seventeenth-century Dutch still life, along with temptation and delight there is a sense of the price paid for indulgence. Oldenburg, however, was quick to deflate such grandiose interpretations. "The food," he wrote of the work, "of course, can't really be eaten so that it's an imaginary activity which emphasizes the fact that it is, after all, not real—that it's art, whatever that strange thing is of doing something only for itself rather than for function."[1]

Claes Oldenburg
Giant Soft Fan. 1966–67
Illustrated on page 404

Laura Hoptman, in *Pop Art: Selections from The Museum of Modern Art*, **1998**, page 72

Giant Soft Fan is part of a larger series of sculptures of appliances and domestic objects that Oldenburg created, beginning in 1963, and dubbed The Home. . . . Oldenburg first experimented with soft-fan forms in 1965, and *Giant Soft Fan* is one of two versions of the sculpture of approximately the same dimensions. The other, *Giant Soft Fan—Ghost Version* (1967), in the Museum of Fine Arts in Houston, differs from The Museum of Modern Art's version in that its primary material is white canvas, not black vinyl. Just as Oldenburg reworked the theme of the hamburger in drawings as well as sculptures, he also often altered the aspect of sculptures of the same motif by fabricating them in different materials. A number of works from The Home series come in "soft" and "ghost" versions, a juxtaposition that Oldenburg adopted as much for its metaphorical resonance as for its formal reference to light and shadow. Noting that the black and (ghost) white versions of *Giant Soft Fan* were together "a working of the theme of opposites in the context of superstition," Oldenburg said that they reminded him primarily of "two angels . . . that walk beside you."[1]

Jacques de la Villeglé
122 rue du temple. 1968
Illustrated on page 406

Kirk Varnedoe, *High & Low: Modern Art and Popular Culture*, **1990**, pages 89–90

Shortly after [Jean] Dubuffet's searing imagery of the later 1940s, . . . there emerged at two points in a rebuilding Europe, and in America as well, a much more depersonalized mode of attention to the look of public

389

walls—an art of assemblage or collage, strongly conditioned by aesthetic reactions to postwar abstract painting, and more concerned with the evidences of social commerce than with the romance of isolated alienation. In this work, by the Europeans known as the *affichistes* and by Robert Rauschenberg in New York, the look of the street was conjured by mass-produced ephemera, and graffiti was evoked by the evidences of defacement and painterly overlays. In different ways, each of these approaches to art brought into collaboration two previously separate veins of modernist interest in graffiti: on the one hand, the notion, announced in [Marcel] Duchamp's *L.H.O.O.Q.*, of a vandal art, criticizing the givens of culture; and on the other, the Surrealist idea of a "primitive" art of aggressive gesture and confrontation with chance.

Two Frenchmen, Raymond Hains and Jacques de la Villeglé, and the Italian Mimmo Rotella, began in the late 1940s and early 1950s to base their work on layered and torn paper agglomerations. These collage-style works were found on public walls, and consisted of posters that had been glued one on top of the other and then subjected to decay or vandalism.[1] But, aside from Villeglé's notion that the serendipitous syntax of these stuck-together poster fragments constituted a way to articulate a "collective unconscious" of the society,[2] their aims and motivations seem to have been wholly at odds with the psychological emphases of both the Surrealists and Dubuffet. The *affichistes*, as these three and some later practitioners of a similar method came to be called, were not a self-conscious movement . . . but they shared certain interests, notably in phonetic poetry and linguistic experiment. . . . Their work seems to reflect a shared love/hate relationship with postwar abstract painting: rejecting the trace of a personal touch and the studio's isolation in favor of a more Dada-like stance, they nonetheless followed an aesthetic of full-field gestural energy in the sections of torn-poster groups they appropriated (and sometimes "assisted" by further, selective tearing).

Richard Hamilton

Glorious Techniculture. 1961–64
Illustrated on page 407

John Tancock, in *Marcel Duchamp*, **1973**, pages 166–67

In the context of British art, Richard Hamilton's adoption of Duchampian methods comes as . . . a surprise, since there was almost no awareness of [Marcel] Duchamp in England in the 1950s. From the very beginning, however, Hamilton's response to works of art was primarily intellectual, and with hindsight it seems inevitable that he should have focused consciously on Duchamp. Even his earliest surviving works show a fascination with subjects—movement, perspective—that had preoccupied his predecessor.[1]

Specific references to Duchamp first became apparent in 1956, in the installation of the exhibition "This is Tomorrow," which incorporated several *Rotoreliefs* at the end of an illusionistically treated corridor.[2] In the following year he worked on *Hommage à Chrysler Corp.*, the first of a series of works in which he turned his attention to eroticism. The mechanical and the erotic were ultimately the twin poles of Duchamp's universe, but he had not foreseen the situation, savored by Hamilton, whereby the erotic was used to enhance the salability of machines in a consumer society. In a highly elliptical manner the painting shows a girl in a car showroom caressing an automobile. In one of the studies, the Blossoming from the *Large Glass* hovers over a disembodied mouth, a visual clue (later abandoned) to the nature of Hamilton's preoccupations.[3] In this group of paintings—*Hommage à Chrysler Corp.*, *Hers is a Lush Situation*, *$he*, *Pin-up*, and *Glorious Techniculture*—the mechanomorphic eroticism of [Francis] Picabia that owed so much to Duchamp was reborn but in a considerably more sophisticated form.

Andy Warhol

Campbell's Soup Cans. 1962
Illustrated on page 408

Benjamin H. D. Buchloh, in *Andy Warhol: A Retrospective*, **1989**, pages 54–55

The endless discussions of Warhol's Pop iconography, and, even more, those of his work's subsequent definition in terms of traditional painting,[1] have oversimplified his intricate reflections on the status and substance of the painterly object and have virtually ignored his efforts to incorporate context and display strategies into the works themselves. Features that were aggressively antipictorial in their impulse and evidently among Warhol's primary concerns in the early exhibitions have been obliterated in the process of the acculturation of his art. This is true for his first exhibition at Irving Blum's Ferus Gallery in Los Angeles in 1962 and his second exhibition at that gallery a year later, and also for numerous proposals for some of the subsequent exhibitions, between 1963 and 1966. On the one hand, the installation of the thirty-two paintings at the Ferus Gallery was determined by the number of varieties of Campbell's soup available at that time (Warhol actually used a list of Campbell's products to mark off those fla-

vors that had already been painted). Thus, the number of objects in an exhibition of high art was determined by the external factor of a product line. . . . On the other hand, the paintings' mode of display was as crucial as were the principle of serial repetition and their commercial, ready-made iconography. Standing on small white shelves running along the perimeter of the gallery in the way that display shelves for consumer objects would normally function in a store, the paintings were simultaneously attached to the wall in the way that pictures would be traditionally installed in a gallery.[2] And finally, there is the inevitable dimension of Warhol's own biography explaining why he chose the Campbell's Soup Can image: "I used to drink it. I used to have the same lunch everyday, for twenty years, I guess, the same thing over and over again."[3]

All three factors affect the work itself, and take a reading of it beyond the mere "scandalous" Pop imagery for which it mostly became known. What has been misread as provocative banality is, in fact, the concrete realization of the paintings' reified existence, which denies the traditional expectation of an aesthetic object's legibility. Warhol's work abolishes the claim for aesthetic legibility with the same rigor with which those systems of everyday determination deny the experience of subjectivity.

Andy Warhol
Gold Marilyn Monroe. 1962
Illustrated on page 410

Kynaston McShine, *Andy Warhol: A Retrospective*, **1989**, pages 17–18

[I]t was when the Disasters' theme of death coincided with his fascination with stardom and beauty that Warhol found the subjects of his best-known groups of celebrity portraits: Marilyn Monroe, Elizabeth Taylor, and Jacqueline Kennedy. The ironic implication of doomed beauty produced a number of strong, memorable paintings. Initiated shortly after the actress's suicide in August 1962, the Marilyn series constitutes some of the key images of our time. He created the *Gold Marilyn Monroe* as a gilded Byzantine icon. However, the object of veneration here is not a Blessed Virgin but a slightly lewd seductress, the image of whose face is still suffused with erotic magic. This sensuous radiance transforms the unhappy Marilyn Monroe of real life— the victim of abuse, failed marriages, affairs, and finally suicide. In Warhol's paintings of her, the very human and vulnerable Marilyn becomes a symbolic image of the need for love and to be loved.

Andy Warhol
Orange Car Crash Fourteen Times. 1963
Illustrated on page 409

Leslie Jones, in *Pop Art: Selections from The Museum of Modern Art*, **1998**, page 112

The daily newspaper provided never-ending inspiration for Warhol. In 1962 he began collecting UPI photographs of tragic car accidents to create his own "front-page" sensationalism. In *Orange Car Crash Fourteen Times* the left panel functions as a screen onto which Warhol projected a photograph of a car crash over and over again—fourteen times. Against the orange glow of the right panel, the blackness of the "ink" on the left pulls the viewer in for a closer look at the gruesome details; a pried-open door allows a view of the victim, twisted like the car that is wrapped around a tree.

Orange Car Crash Fourteen Times belongs to a series of paintings by Andy Warhol titled Death and Disasters. . . . Warhol's first treatment of the subject of a car crash actually dates from his years as a commercial artist with the 1955 drawing *Dead Stop.* . . . In the interim, Warhol had abandoned freehand drawing for the practice of silkscreening onto canvas images culled from the mass media. The scenes of car crashes and other disasters focus on the gruesome facts, recalling the sensational journalistic photography featured in print and television tabloids then and now. As a visual document taken "on the scene," the photograph heightens the image's emotional impact but, typically, Warhol presents not a clearly focused picture, but one that has been degraded in the translation from original to silkscreen and finally to canvas. He often, for example, "inked" his screens too heavily or too sparingly making the images difficult to read. This loss of detail emphasizes the retrograde, low-rent nature of Warhol's printing process. His "debt" to the newspaper industry is also suggested by the field of repeated images evocative of the pre-cut sheets that roll off the printing press. Yet Warhol's four registers are not aligned, some of the images run to the edge, others skid to a stop, leaving a mark and an orange gap.

Ed Ruscha
OOF. 1962–63
Illustrated on page 411

Anne Umland, *Pop Art: Selections from The Museum of Modern Art*, **1998**, page 92

Oof! Like a punch line without a joke, or an effect searching for a cause, the bright yellow letters that spell

out the word "oof" are centered and isolated within the boundaries of Ruscha's canvas. They lack even a punctuating exclamation mark. Belonging to that class of words known as interjections, "oof," despite its deadpan presentation, is onomatopoeic, it imitates a sound from the audible world. An "oof" is often prompted by an action like a punch in the stomach or sinking down, exhausted, into a chair. Involving an abrupt, sometimes violent, expulsion of breath, it is typically human. Like other words that appear in Ruscha's paintings of this period . . . it often functions as an interruption, just as, visually speaking, it interrupts the deep blue of the painting's ground.

In its written form, "oof" has definite pop-culture associations, in particular those of comic-strip or cartoon language. Unlike the short phrases or words included in [Roy] Lichtenstein's comic-book paintings, however, it has no graphic sound bubble or any sort of explanatory surround. As a result, it imbues Ruscha's spare, abstract painting with an uncanny, anthropomorphic presence. At the same time, it emphasizes the gap that exists between the noise of human speech and the silence of the written (or painted) word. Emblazoned across the flat opaque surface of Ruscha's canvas, "oof" appears in a state of suspended animation. Noise is presented visually, muted, and severed from literal sound just as the word is severed from clues to its meaning.

Frustrating all but the most rudimentary attempts at reading, *OOF* insists that it is there to be looked at, forcing us to distinguish, as the critic Peter Schjeldahl has noted, between the word as sign and the word as sight. Appearance, sound, and spelling—the "non-discursive aspects of language"[1]—are highlighted and brought, literally, to the foreground. To look at *OOF*, is, first of all, to acknowledge its abstract simplicity, its hard-edged geometric forms, restricted palette, and uninflected ground. At the same time, its two yellow "O"s appear to ogle or gaze at us, doubling as glow-in-the-dark, cartoonlike "eyes." The plain, sans-serif style of *OOF*'s letters contributes to the work's cartoonlike punch and graphic effect.

Roy Lichtenstein

Girl with Ball. 1961
Drowning Girl. 1963
Illustrated on pages 412, 413

Adam Gopnik, *High & Low: Modern Art and Popular Culture*, **1990**, pages 199, 200

Almost without exception, Lichtenstein's comics paintings from the early 1960s (as Lichtenstein, of course, could not have known; all of the romance and war comics were unsigned) were adapted from the work of a small handful of ambitious comic-book artists. The styles of these artists were distinct enough that, thirty years later, their work can still be picked out immediately by the Berensons and Offners of the comics. Lichtenstein's romance images are adapted almost entirely from the works of Tony Abruzzo, John Romita, and Bernard Sachs; his war images almost entirely from the work of Russ Heath—and Irv Novick. High art on the way down to the bottom met, without quite knowing it, low art struggling to find its way back up.

Lichtenstein recast his found images in complicated ways.[1] Ironically, he had to aggressively alter and recompose them to bring them closer to a platonic ideal of simple comic-book style—he had to work hard to make them look more like comics. The effects that make Lichtenstein into Lichtenstein involved not the aestheticizing of a consistent style through mechanical displacements, but the careful, artificial construction of what appears to be a generic, whole, "true-folk" cultural style from a real world of comics that was by then far more "fallen" and fragmented. His early pictures work by making the comic images more like the comics than the comics were themselves.

Lichtenstein was often taken with the Abruzzo-like close-ups of girls caught, lips parted, in states of clichéd emotion: tension, anxiety, misery. But he consistently simplified and isolated these images, translating what was essentially an illustration style into a comic-book style. . . .

Sometimes, Lichtenstein can seem like the perfect Abruzzite. Intuitively recognizing that the girls' faces had a kind of strange intensity that the other elements in the comics lacked, Lichtenstein would pull them out of context, until today the Abruzzo girls have become immortalized, through Lichtenstein, as pop clichés. In *Drowning Girl*, he changes a hero's name from what was, for his purposes, the wrong cliché—the peculiar "Mal"—the right cliché, the nifty "Brad." But the girl's face and the swirling, Beardsley-like, high-contrast liquid patterning of the background are lifted from the original almost entirely intact. . . .

Throughout these transpositions, Lichtenstein emphasizes his constant imposition upon his cartoon figures of Benday dots which, surprising as it may seem to those of us who have learned to see romance comics through Lichtenstein, are hardly visible in the original.

James Rosenquist

F-111. 1964–65
Illustrated on pages 414–15

Anne Umland, *Pop Art: Selections from The Museum of Modern Art*, **1998**, page 22

Measuring ten feet in height and eighty-six in length, *F-111* is an icon of American Pop and of its era, combining political content and domesticated advertising imagery on a vast billboard scale. Completed in 1965, *F-111* marks the moment at which, according to Andy Warhol, "the basic Pop statements had already been made."[1] . . . There is no question that by that point not only the mood of Pop but the political, social, and cultural climate had changed.

Taking the F-111 fighter bomber as his subject, Rosenquist created a modern-day history painting, responding to the link between commerce and militarism made by the Vietnam War. Combining antiwar politics with a form of commodity critique, *F-111* pointed to Pop's sometimes caustic, political side, acknowledging the dominant public issue of the late 1960s, the war in Vietnam. At the same time, it drew attention to the flip side of postwar prosperity and to the darker aspects of American consumer culture that often permeate the brightly colored surfaces of Pop. Enveloping the viewer, *F-111* stands as a major environmental work, as installation art *avant la lettre*, and creates a theater of consumption and display. Weaving together the varied subjects of consumerism, politics, commodification, and audience engagement, *F-111* . . . catches Pop coming and going, tied to its moment and as a result, now history, yet with an immediate, visceral impact that engages viewers of the 1990s no less than those in the past.

Abstract and Minimalist —— Painting and Sculpture

Ad Reinhardt

Abstract Painting. 1960–61
Illustrated on page 416

William C. Seitz, *The Responsive Eye*, **1965**, pages 16, 17

A disinterested, hurried, or inattentive gallery visitor can easily dismiss these "invisible" works as entirely homogeneous, so slight are the differences in tone and color that distinguish their elements and mark the individuality of each artist. "Quietistic" painting, of which Ad Reinhardt was a pioneer, raises a question posed by Leo Steinberg in a commentary on a series of blue pictures by Paul Brach: "How close to all-one can multiplicity come?"

It is wrong, perhaps, to show close-valued painting in crowded exhibitions, for their viability lies at the threshold of invisibility. Each work should be seen in isolation, for a meditative state of mind, proper lighting, and passage of time are absolutely essential to a meaningful response. The eyes must accommodate to the painting as they do to a dimly lit room after having been in sunlight or, conversely, as they accommodate to the transition from darkness to bright light. The eyes and the mind must be prepared gradually to approach the acuity of perception and feeling that was possible in the quiet of the studio, and must slowly follow the experiences of depth or encompassment, appearance or disappearance, unity or multiplicity for which the painter provided the conditions.

It is easy to associate these large paintings with religious and mystical states. The contemplation of nothingness, which they invite while retaining their identity, quickly goes beyond purely visual sensation.

Tony Smith

Die. 1962
Illustrated on page 417

Robert Storr, *Tony Smith: Architect, Painter, Sculptor*, **1998**, page 25

[T]he scale of [*Die*] . . . was strictly, if enigmatically, anthropomorphic. Extrapolating from Leonardo da Vinci's rendering of Vitruvian man spread–eagle within a square, Smith commissioned a six–foot cube. "Why didn't you make it larger so that it would loom over the observer?" Robert Morris asked him. "I was not making a

393

monument," was Smith's reply. "Then why didn't you make it smaller so that the observer could see over the top?" Morris persisted. "I was not making an object," the artist answered.[1] (The distinction asserted by this intermediary "thing" becomes increasingly significant as Smith's interests turned toward the monumental and still further away from conventional gallery formats.)

Agnes Martin
Red Bird. 1964
Illustrated on page 418

Amelia Arenas, *Abstraction, Pure and Impure,*
1995, n.p.

A Zen silence pervades [Martin's] work. Her gentle rhythms are the visual equivalent of a chant, monotonous and constant, lulling the eye into introspection. As Martin says, "the work is all about perfection as we are aware of it in our minds," but "the paintings are very far from being perfect." Looking at them closely, one can follow the delicate variations of the lines that edge the grey bands; one can imagine the pencil sliding tentatively over the field, wavering slightly as it responds to the weave of the canvas.

Some critics have proposed a link between these nuanced paintings and the vast wheat fields of the farm in Vancouver where Martin lived as a child, but she insists that her work is not *about* nature. However, it is hardly about "pure form." If anything, it is an effort to release the tight intellectual grip that form has held on painting. A near contemporary of the Abstract Expressionists, Martin felt at odds with the individualism of her generation. The leanness of her compositions and her self-effacing technique made her seem more akin to some of her younger contemporaries, the Minimalists. But Martin does not seek an exacting scrutiny of sensory phenomena. Her monastic studio method is a way to prevent the interference of the ego with the voice of the spirit, in order to reveal the tacit continuum of life.

Frank Stella
The Marriage of Reason and Squalor, II. 1959
Illustrated on page 420

William Rubin, *Frank Stella,* **1970**, pages 20, 21, 25, 26, 32

Stella began the Black paintings late in 1958. . . . The sketches of the Black pictures, made on drawing paper and yellow pads (graph paper only came later), set out the schemas of their emblematic patterns in a very summary manner.[1] Stella then painted the stripes freehand on the canvas. Sometimes he did not know how many bands the picture would contain. . . .

Stella's absolute bilateral symmetry would produce a sense of *imbalance*, precisely because his configurations are not designed to be read across the picture. Stella's paintings—and those of certain of his contemporaries—force us to look in a different way; the apprehension of their balance demands an instantaneous visual grasp of their oneness.

In order to assure his absolute symmetry, Stella was compelled to force out of the picture the implications of illusionist space that were still present to varying degrees in geometrical painting. . . . His monochromy, his avoidance of modeling, his "negative pattern," and use of deep stretchers helped accomplish this. But as Clement Greenberg has observed, *absolute* flatness is possible only on an empty canvas.[2] A single line drawn on its surface is sufficient to compel some kind of spatial reading. Hence Stella had to confront the fact that though he had mightily pared down the suggestion of space, he could never totally abolish it. His solution was the "regulated pattern" which "forces illusionistic space out of the painting at a constant rate." In the end, it is the "constant rate" that is the key to the spatial equilibrium and thus to the symmetry. We might therefore recast Stella's statement by saying that "such inevitable vestiges of spatial suggestion as remain are kept at even depths by the regular pattern, hence maintaining the possibility of absolute symmetry.". . .

The immediate predecessor of Stella's "non-relational" image is to be found not in the geometrical tradition but in the all-over style of [Jackson] Pollock and the related configurations of [Mark] Rothko and [Barnett] Newman. The synoptic, holistic character of Pollock's poured pictures depended on suppressing traditional hierarchies of size in favor of an approximate all-over evenness in the pictorial fabric. The similar all-over distribution of color, which averaged out into a tonal whole, and the more or less even densities of pigment dosage, assured a web which would be biaxially symmetrical and frontal and situated in a space that—however it might be read[3]—would suggest an approximately even depth throughout. Rothko's characteristic configurations also combined frontality, lateral symmetry, and an elusive but approximately even depth, while in Newman the image was frontal, but the symmetry was usually vertical rather than lateral. . . . Newman's minimizing of "visual incident," his rectilinear format, and his less painterly facture anticipated the manner of Stella, while the all-overness of Pollock foreshadowed Stella's synoptic, biaxially symmetrical configurations. . . .

Stella's Black pictures divide roughly into two groups: those painted during 1958 and through the fall

of 1959, and those dating from the winter of 1959/60. In the earlier group, the black bands are all rectilinear and parallel to the framing edge. . . . *The Marriage of Reason and Squalor* . . . is symmetrical only on its vertical axis, its binary form constituting, in effect, a mirror-image pairing of the configuration. In none of these paintings is the symmetry exact, however, since they were all painted freehand from sketches that were less fully elaborated than were the graph-paper studies for later works.

This is, of course, the way Stella wanted it. Not only did he wish to avoid the mechanical appearance of the truing and fairing of geometrical art, but he wished frankly to reveal the tracking of the brush with whatever awkwardness that might entail. Such an approach constituted for him more than an affirmation of anti-elegance; it revealed an insistence upon the importance of the *conception* of the picture as opposed to the refinements of its *execution*.

Robert Ryman

Twin. 1966
Illustrated on page 421

Robert Storr, *Robert Ryman*, **1993**, pages 24, 25, 26

Starting in 1965 Ryman . . . pursue[d] avenues parallel to those travelled by the minimalists, whose hallmarks are routinized handwork, modular formats and programmatic production. The "Winsor" paintings [of which *Twin* is one] . . . were executed on sized but unprinted linen with the same brand of cool white Winsor & Newton oil pigment that lends its name to the group. . . . The "Winsors," properly speaking, were done with a two-inch brush that could cover about six to ten inches before running out. Dragged over the dry tooth of the fabric, the opaque white paste leaves a crackling or clotted edge, horizontal bristle tracks, and at the point where it overlaps with the next stroke there is often a thick crest. In . . . *Twin*, Ryman . . . employed a specially made twelve-inch-wide brush and thinner, smoother paint, so that the grain would be finer, and the white could be pulled all the way from one side to the other without reloading. The painterly field that results is extraordinarily active. Tripping on the lateral striations in the paint as it would in much magnified fashion off the louvers of a white venetian blind, light vibrates at an intense pitch. Where the paint is thickest, it creates reflective hot-spots and small contrasting shadows; where strokes merge in an upright seam an irregular counter-rhythm to the horizontal segments catches the eye so that the whole painting becomes a sliding grid of still white ribbons laid end to end.

Inevitably, the "Winsors" summon to mind Frank Stella's "Black Paintings" of 1959 [see page 420]. . . . When, in 1965, Ryman adopted a method similar to the one employed in the "Black Paintings," his choice of a different paint and application substantially altered the results. These differences in technical approach define their basic aesthetic differences as well. Stella is a theoretically inclined formalist; Ryman is a lyric pragmatist. . . . For Ryman, the art of painting is a search for particulars and distinctions; accordingly, composition is an experiment in the behavior of the medium and its sensory effects. . . . Stella tries to make things happen to painting; Ryman paints in order to see things happen. . . . In the "Winsors" Ryman sets his course, monitors the distribution of pigment and discovers in the brush tracks the structure of concentration and the fascination of random incident. All the works in the series have the same design; each depends for its identity on minor shifts in painterly emphasis. . . .

Small paintings with the wide, waxing lozenges and large ones . . . are clearly informed by Ryman's study of [Mark] Rothko. Yet, rather than evoke a diffuse and remote "sublime," the white lozenges in Ryman's paintings mate hypnotic luminosity and tactile immediacy. Standing in front of them, the viewer is at once drawn toward and held in place by the surface of these paintings. Their radiance releases the spirit, but the spirit remembers its body and takes satisfaction in the tangible proportions the body registers.

Walter de Maria

Cage II. 1965
Illustrated on page 422

MoMA Highlights, **2004**, page 286

Cage II may seem easy to grasp: a space sealed by bars—a cage. But it would be a thin person indeed who could fit in this narrow room, and in any case, how would anyone get in? There are no doors, no hinges. The metal, too, a pristine stainless steel, is richer than brute prison iron. *Cage II* is surely a paradox: a cage made elegant and abstract.

The paradox only multiplies, for *Cage II* is also a kind of portrait. It remakes a piece from 1961, in wood, but otherwise [is] the same except for the title: *Statue of John Cage*. The John Cage whose name gave de Maria a pun was, of course, the well-known composer and theorizer of modern music. But an aesthetic tradition is also cited here, for Cage had close links to an art-making approach associated with Marcel Duchamp (a long-standing friend of Cage's)—an approach favoring conceptual thought, and, also, a love of puns and wordplay.

The foursquare geometry of *Cage II*, meanwhile, and the purity of the work's medium, point in another direction—toward the Minimal art of the 1960s, an art of system and order. Yet in the work's enigmatic combination of openness and rigor there remains a tribute to the paradoxical artist and musician who inspired it.

Sol LeWitt
Serial Project, I (ABCD). 1966
Illustrated on page 423

Lucy Lippard, *Sol LeWitt*, **1978**, pages 23, 25, 26

Integral to the systems that generate LeWitt's art is the "idea," which, he has implied, can be considered synonymous with intuition.[1] He is far more concerned with what things are and how they come about than with how they look. His art is an objective *activity*, related to play in the most profound sense of fundamental creative discovery. The elusive "idea" that delivers his work from academic stagnation is transformation—the catalytic agent that makes it *art* even when the artist plays down its visual powers. . . .

LeWitt's work is rich in contradictory material, which operates at times as a mental and at times as a visual construct. He confronts concepts of order and disorder, open and closed, inside and outside, two- and three-dimensionality, finity, and infinity, static (modular) and kinetic (serial). For all the overt simplicity of his serial systems, the content of his work is often hermetic. On one level, the concepts themselves may be perfectly accessible, but the viewer needs an overview to understand not only the mechanism of the system, but also the philosophy by which the art was made *from* that system. It has also been part of what artist Terry Atkinson has called LeWitt's "quiet strategy"[2] to actually hide things, most of which are subsequently revealed by the operations of the same systems that have hidden them. This lends a progressive dimension even to modular works, and further transforms the serial works. . . .

In 1966–67, this idea was subjected to the more complex systems of LeWitt's later work with *Serial Project No. 1 (ABCD)*, four nine-part pieces on a gridded base that explored the known and unknown within a finite, self-exhausting framework. Here sensuous or perceptual order was firmly neglected in favor of conceptual order, reflecting LeWitt's notion of a "nonvisual" art that could be made (and appreciated) by a blind person. The project as a whole must be read sequentially and conceptually; in some parts the closed elements are contained by open ones so both are visible, but in other parts, the open elements are contained by the closed or the closed by the closed, leaving the viewer to believe what s/he cannot see. . . .

The hermetic notion also points up the Conceptual aspect of LeWitt's art because it forces the viewer to think, sometimes to guess, and to decide whether what is inferred is in fact true. *Serial Project No. 1* was, therefore, a highly significant development in the Minimal movement in that it indicated LeWitt's dissatisfaction with the "specific object," or the mute Gestalt. The goal of Minimalism (or in fact of most 1960s art, far more than that of the 1970s) was to find a new way of making art, a new vocabulary and even new forms—something "neither geometric nor organic," as Don Judd put it.[3] While Minimal art succeeded in logically extending the Cubist-Constructivist tradition by divesting it of the expressive touch and compositional subjectivity hitherto associated with art and by making clear that even the most obvious forms, executed by assistants or in a factory, could contain or transmit complex esthetic content,[4] form, or the physical vehicle, still presented a major problem in advance. Being stuck with geometry was not entirely satisfying to the more visually oriented of these artists.

LeWitt, however, saw no need to invent new forms and is still not interested in originality.[5] He was content with the "relatively uninteresting, standard and officially recognized" forms of the square and the cube because "released from the necessity of being significant in themselves, they can be better used as grammatical devices from which the work may proceed." By synthesizing the Cubist-Constructivist tradition with the intelligent perversity of the best of the Surrealist tradition, LeWitt could incorporate both order and disorder, and thereby set up a far more complex *modus operandi* than that offered by the basic Minimalist doctrines, with their sources in Josef Albers, Ad Reinhardt and Jasper Johns.

Donald Judd
Untitled (Stack). 1967
Untitled. 1968
Illustrated on pages 424, 425

Ashley Bickerton, in *Contemporary Art in Context*, **1990**, pages 56–57

[Donald Judd's] work was ostensibly about a new way of looking at the world, but I don't think it was a new way at all. I think it was an extreme manifestation of an existing and entrenched form. It was tied into the machinery of the new colonial apparatus, and his works became meaningless banners which he ushered forth, contentless objects to reflect a liberal and intellectual self–image.

This is reading the subtext. Physically, in its pres-

ence, this work is sublime, it's absolute, it's irreducible: you can't kick it or shove it one way or the other because it just is. You can't take it down any further—at least one can say that of Judd at his best. He probably is most successful when he addresses what he terms "the skin of the work." That's how he and other Minimalists would always refer to the paint, as the skin of the object. And it *is* seductive. [These surfaces remind us of the] parade of monster trucks and dune–buggies and surfboards, sailboats, diners, and the lot, not to mention television graphics, that we all grew up with. Those things became inscribed in the basic makeup of our whole way of processing information. Judd touches a nerve, and I don't think he's unaware of that.

The position that Judd and his cohorts took to make this irreducible, sublime statement—what it eventually boils down to in my estimation—is an aesthetic practice like saturation bombing. I'm referring to the serialism of it, the absoluteness, the inundation, the inexorable repetition of it all, the blind faith in technology to overpower all difference, any adversary. I see that blind faith in this work. Judd is in the extreme opposite corner from the holistic healer who would attempt to heal the entire body, or who would take into account the entire agricultural system, the ecosystem, the biosphere. Judd is practicing a form of extreme specialization, breaking something down to its most minute element.

Richard Artschwager

Key Member. 1967
Illustrated on page 427

Robert Storr, *On the Edge: Contemporary Art from the Werner and Elaine Dannheisser Collection*, **1997**, pages 22, 23

Richard Artschwager is a philosophical cabinetmaker. He is also a painter, though his pictures often have the appearance of furniture. His is a strange vocation, but it is not unprecedented in the history of American art. The suburban aesthete Joseph Cornell was the jewel box-maker of this tradition; the ex-marine, ex-carnival acrobat, and obsessive carpenter H. C. Westermann was its master joiner. Both these artists drew on the formal language of classic Surrealism. . . .

Like Westermann, [Artschwager] found himself slowly, working in obscurity at the margins of the art world for years before making his independent vision public; and, like Westermann, he just plain worked—designing and making furniture to keep himself going. This artisanal bent, the manufacturing principles he learned and adapted to his special purposes, and the materials he discovered and added to the repertoire of con-

temporary art practice are at the foundation of Artschwager's idiosyncratic endeavor.

Thus Formica, a slick synthetic replacement for just about any natural substance—wood, marble, metal—entered his vocabulary through his job finishing household interiors with countertops and storage spaces. . . .

Exhibited in 1965, when the Pop art movement was at its peak, Artschwager's sculptures were admired exceptions to the rule of Pop's easily legible graphic style. Perhaps closer in spirit to Jasper Johns' work, they announced that they were not what they looked like, but they looked like that thing all the same. Indeed they were the distilled essence of the broad category of objects to which they referred, and what could be more anomalous next to an ordinary chair than an Ur–chair, or next to an ordinary dresser than an Ur–dresser? Artschwager was rearranging the mind's furniture. . . .

[O]ne can never be absolutely sure of Artschwager's intended meaning. He is a shaper of enigmas, and the precise status of his work is, by rigorously crafted design, always in question. Moreover, despite his on–again–off–again associations with Pop, Minimalism, Photorealism, and other recent tendencies, he remains aesthetically unclassifiable. No longer hovering around the edges of the contemporary scene, yet impossible to pin down, he is a maverick in the middle of the herd.

Robert Irwin

Untitled. 1968
Illustrated on page 428

Rosalind Krauss, in *American Art of the 1960s*, Studies in Modern Art 1, **1991**, pages 129, 131

"To be an artist is not a matter of making paintings at all. What we are really dealing with is our state of consciousness and the shape of our perception." [Robert Irwin]

If Minimalism was characterized through this worry about surface, about the interface formed by materials as they stretched across the frame of either painting or three–dimensional object, aligning the meaning of the work with its physical medium, as that medium "surfaced," contingently, into the world, the California art of the sixties had an abhorrence of the physicality signaled by surface. The real medium of this work, John Coplans was fond of saying, was the viewer's perceptual process.[1] . . .

Irwin . . . abandoned the conventional canvas format—no matter how minimally inflected, first with paired lines, then with dots—and [began] to work with large, slightly convex discs, projected from the wall. Everything about these objects that Irwin showed in

1968 "revealed his preoccupation with a range of coloristic subtlety and spatial suspension, which work to eliminate a consciousness of the paintings' actual physical limits and surfaces."[2] Irwin's disc pictures were white . . . but everything about the imperceptibly close–valued color, the suspension of the convex planes from the wall, the disorientation of their lighting that made them seem to hover above a clover–leafed bed of shadow, conspired to dissolve the concreteness of the picture plane, to diffuse the edges of the pictorial object, to create the sense that an almost invisible veil was floating "somewhere in front of the actual white surface of the canvas."[3]

Dan Flavin

Untitled (To the "innovator" of Wheeling Peachblow). 1968
Illustrated on page 429

Jennifer Licht, *Spaces*, **1969**, n.p.

For Dan Flavin, fluorescent light functions as both material and medium. His original decision to work with this familiar commodity as an adjunct to painted structure did not represent for him the incorporation of technology into the realm of art, but was a token of his everyday environment and had the significance of a found object. The special propensity of fluorescent light to project aura, however, gave it the implication of infinite space; it was then natural and inevitable for Flavin to exploit this quality by deploying fluorescent lamps alone, first to alter our perception of a particular area in discrete works, then to distribute lights systematically in formations that conditioned entire areas through light–color. His medium has been sufficiently flexible to allow a range of spatial effects and psychological responses, some bordering on sensory deprivation. The saturating quality of green, for example, brings about a sensation of atmospheric weight, and the eye's exposure to the color causes a compensatory reddening in one's perception of natural light. The particular qualities and psychological potential of Flavin's medium, together with its authority over space, endow his works with a special sense of place, and the effect is often to imbue an otherwise anonymous area with the power to promote feelings akin to primitive awe at a sacred grove.

Carl Andre

144 Lead Square. 1969
Illustrated on page 432

Robert Storr, *On the Edge: Contemporary Art from the Werner and Elaine Dannheisser Collection,* **1997,** page 20

From the rigid male figures of earliest Greek antiquity to the elegantly simplified heads, birds, and pillars fashioned by Constantin Brancusi in the first half of this century, sculpture, when detached from architecture, has generally stood upright in our midst. It is, in a wisecrack usually ascribed to the abstract artist and wit Ad Reinhardt, "the thing you bump into when you back up to look at a painting."

Thanks in large part to the work of Carl Andre, this generalization no longer holds true. Instead, a sculpture may now be something you walk across, like a carpet; step onto, like a patio platform; or wander through, like purposely scattered stones in a garden. Even if it should still crowd the gallery-goer or claim large segments of his or her territory, it does so as something not apart from but a part of his or her immediate reality.

Despite their obvious differences over the position and, correspondingly, the relative importance of painting and sculpture, Andre has always worked in tacit agreement with Reinhardt regarding the resolute nonreferentiality of modern abstract art. Just as Reinhardt's gridded pictures represent nothing, offering instead a unique experience of an externally bounded and internally ordered visual field, Andre's variously squared-off or irregularly scattered sculptures occupy and articulate physical space in a similarly austere but even more matter-of-fact way. . . .

The essence of Andre's innovation was to establish a strong sculptural presence without recourse to traditional monumentality. Instead of building up, as artists of the past as well as he himself had once done, Andre built out. Instead of confronting the public with static monoliths, he created markers and zones around and through which people would move, thereby becoming active protagonists in the work rather than passive viewers of it.

Although Andre may be credited as one of the first artists of his generation to explore the possibilities of the random distribution of objects in space . . . the vast majority of his sculptures have been based on the sequential and often plainly symmetrical deployment of a given set of standardized components. These elementary but imposing compositions frequently recall the similarly emblematic configurations found in [Frank] Stella's black, aluminum, and copper "stripe" canvases of 1959–61, signaling the extent to which Minimalism depended upon precedents in painting even though its

sculptural manifestations seemed to dominate the tendency as a whole.

Robert Morris

Untitled. 1969
Illustrated on page 433

MoMA Highlights, **2004**, page 287

Although Morris helped to define the principles of Minimal art, writing important articles on the subject, he was also an innovator in tempering the often severe appearance of Minimalism with a new plasticity—a literal softness. In works like this one, he subjected sheets of thick industrial felt to basic formal procedures (a series of parallel cuts, say, followed by hanging, piling, or even dropping in a tangle), then accepted whatever shape they took as the work of art. In this way he left the overall configuration of the work (a configuration he imagined as temporary) to the medium itself. "Random piling, loose stacking, hanging, give passing form to material," Morris wrote. "Chance is accepted and indeterminancy is implied. . . . Disengagement with preconceived enduring forms and orders for things is a positive assertion."

This work emphasizes the process of its making and the qualities of its material. But even if Morris was trying to avoid making form a "prescribed end," as a compositional scheme, the work has both formal elegance and psychological suggestiveness: the order and symmetry of the cut cloth is belied by the graceful sag at the top. In fact, a work produced by rigorous aesthetic theory ends up evoking the human figure. "Felt has anatomical associations," Morris has said, "it relates to the body—it's skinlike."

Eva Hesse

Vinculum, II. 1969
Illustrated on page 435

Lynn Zelevansky, *Sense and Sensibility: Women Artists and Minimalism in the Nineties*, **1994**, pages 8, 9, 10

Eva Hesse's use of repetition with abstract forms that are either erotic or have uncomfortable, even repugnant, associations with the human body, may have emphasized the absurd nature of repetitive activity, but the connection to Minimalism is nonetheless there. . . .

Post-Minimalism enabled women as a group to have an impact on the art world for the first time; this occurred in terms of both the critical dialogue and the marketplace. Eva Hesse was among the first to offer an alternative to orthodox Minimalism. Her mature career spanned only five years,[1] but during that time she created emphatically handmade work that, in its bold exploration of disquieting psychological realms, prefigured certain concerns of the Women's Movement as they would be manifested in the art world. Its preoccupation with the body, and its embrace of absurdity and freedom, opened up new avenues of expression that would speak especially pointedly to artists of the following two and a half decades.[2] . . .

Hesse's work resonates in many directions, and it is clear that part of what she had to overcome in order to make her best pieces was the fear of manifesting "feminine" traits in her art. . . .

It is evident in Hesse's works, from *An Ear in the Pond* of 1965 to *Addendum* of 1967, with their breastlike forms; from *Ingeminate* of 1965 to *Untitled or Not Yet* of 1966, which reference male genitalia, or *Accession II* of 1969, which contends with all possible associations with the word "box," from the vaginal to the Minimalist, that, in overcoming her fear of being uncool or untalented, she also found the courage to confront and accept her sexual identity. Clearly, she did so with the vengeance of those who must have truth at all costs: "I could take risks . . . my attitude toward art is most open. It is totally unconservative—just freedom and the willingness to work. I really walk on the edge."[3]

Richard Serra

Cutting Device: Base Plate Measure. 1969
Illustrated on page 437

Rosalind E. Krauss, *Richard Serra/Sculpture*, **1986**, page 16

[Among] Serra's list of verbs, compiled in 1967–68, suspended in the grammatical midair of the infinitive [are]: "to roll, to crease, to fold, to store, to bend, to shorten, to twist, to twine. . . . " These verbs describe pure transitivity. For each is an action to be performed against the imagined resistance of an object; and yet each infinitive rolls back upon itself without naming its end. The list enumerates forty-four acts before something like a goal of the action is pronounced, and even then the condition of object is elided: "of waves," we read, "of tides," or again, "of time." The image of Serra throwing lead is like this suspension of action within the infinitive: all cause with no perceivable effect.

An action deprived of an object has a rather special relation to time. It must occur in time, but it does not move toward a termination, since there is no terminus, no proper destination so to speak. So, while the list of

active verbs suggests the temporal, it is a temporality that has nothing to do with narrative time, with something having a beginning, a middle, and an end. It is not a time within which something develops, grows, progresses, achieves. It is a time during which the action simply acts, and acts, and acts.

After Minimalism

Panamarenko
Flying Object (Rocket). 1969
Illustrated on page 440

Laura Hoptman and **Michael Carter**, *Making Choices*, exhibition brochure, **2000**, n.p.

[A]fter World War II . . . interest in the absurd as a philosophical, literary, and artistic concept dovetailed with the dawn of the atomic age, the birth of the space program, and many popular cultural manifestations of science fiction to create a critical mass of work that used the language and imagery of science and technology to speculate on the implications of scientific advancement. . . .

With the belief that a combination of science and imagination could overcome the limitations of his materials, the Belgian artist Panamarenko designed rocket ships, bombs, and cars from balsa wood, paper, and rubber that he claimed could really function. . . .

The rapid development of science and technology is one of the defining factors of the past century. Every rational explanation offered and every solution hit upon, however, have brought with them an endless number of counter explanations and questions, all raw material for the critical imagination of the artist/pseudoscientist. As [Jean] Tinguely commented in 1966, "We're living in an age when the wildest fantasies become daily truths. Anything is possible."

Jannis Kounellis
Untitled. 1983
Illustrated on page 441

Bernice Rose, *Allegories of Modernism: Contemporary Drawing*, **1992**, pages 38, 39

Performance and the gallery as theater are at the heart of Kounellis's work, as they have been at the heart of much work since the 1960s, making the exhibition form itself the artwork. An essential aspect of Kounellis's performance is his sense of himself as a traveler, a migrant from his native Greece to Italy. Greece was a fragmented, invaded civilization of ruins, and Kounellis moved from the region of the conquered to that of the possessor. His own life thus takes on an allegorical significance as he moves through space and time; he (and others), like [Joseph] Beuys, regards the artwork itself as a nomadic form and time as nonlinear. Fragments of installations are carried from place to place, their placement and relationship changing each time. (Kounellis's sense of the fragment as a genre originated in his participation in the 1960s in the Arte Povera movement, for whose aesthetic the fragment was the essential component.) . . .

His allegory is based on multiple layers of fragments, created of metaphor and allusion, smoke and substance. Kounellis is an initiator of the present represented as profoundly melancholy, perhaps because he is trapped in a romance with the fragment, "the ruin, which [Walter] Benjamin identified as the allegorical emblem par excellence."

John Baldessari
What Is Painting. 1968
Illustrated on page 442

John Baldessari, in *MoMA: The Magazine of The Museum of Modern Art*, **1994**, n.p.

I think it was [Willem] de Kooning who said that masterpieces are only masterpieces if they inform the present, and I really do concur with that. I think that if works of art in museums don't speak, then they shouldn't be there; they should be there because they speak to us.

One of the joys of going to a museum is that the art can be a talisman or a stand—in for the artist. He or she can't be there alive, but the work can be a reminder, and you can have a conversation with that artist, and that artist can be your teacher. I know exactly what I would say to [Giorgio] de Chirico if I could talk to him, and I have a pretty good idea of what he would say to me; I could have a conversation in my mind. No, they're in

the present. I mean, if they're speaking to me, they're there. A good work of art is timeless. You know, it *doesn't* have any date to it.

There is one thing I wanted to add. My penchant for colliding images really comes out of my fascination with writers. I've always thought I collided images much in the same way that a writer collides words; I'm trying to get a spatial syntax where the relationship among images is not so flabby that it's cliché, nor is it so strained that the relationship snaps and then there is none, but one where there is a certain tautness. Like [Gustave] Flaubert would say about having the right word following the right word—it sounds awfully simple, but trying to get that right is incredibly difficult. And then, with luck, the multiplicity of those images make a gestalt, a whole.

Another thing I try to do is to have my work sort of fence it, teeter on the edge of being a whole, just there on the other side of a collection of parts. I'm really fascinated by when a part is a part and when it becomes a whole.

Joseph Beuys

Eurasia Siberian Symphony 1963. 1966
Illustrated on page 444

Ann Temkin, in *Thinking Is Form: The Drawings of Joseph Beuys*, **1993**, page 15

At the beginning of the 1960s [Beuys] virtually abandoned traditional sculpture in bronze and wood and began to organize the making of sculpture around the performance of actions or the occasion of exhibitions. The two outstanding examples of this new aesthetic were felt and fat, materials that are emblematic of Beuys's work. . . . Each had autobiographical significance, as Beuys explained that these were the insulating materials with which the Tatars had brought him back to life in 1943 [after his plane crashed]. Beyond this anecdotal reference, however, fat had an ambivalent resonance. On the one hand it is a nurturing, life–sustaining substance, essential to survival as nourishment and fuel; at the same time it gestures to human decay and the image of burning bodies in extermination camps. Felt can be a warm, protective insulator, but its composition—compressed fiber or hair—brings similarly ambiguous references to the body.[1]

Just as fat and felt carry negative and positive associations, both have structures that embody the two poles of open and closed form. Each is made of amorphous elements that, when compressed, form a solid mass; fat and felt thus integrate the opposite poles of cold and warm identified in Beuys's theory of sculpture. Thermal change became the operative principle for sculpture in working with fat and felt. For Beuys, the role of the heating process extended the reach of sculpture into both scientific and psychological realms. The reconciliation of opposites sought in Beuys's manipulation of warm and cold addressed a longtime goal of alchemists and their Romantic heirs.[2]

Beuys's use of fat and felt underlies much of the mystification of his work. Generally, critics have interpreted the use of fat and felt as a result of his wartime plane crash, a response encouraged in Beuys's own remarks. But this explains away their significance rather than illuminating their real function in the context of his theory of sculpture, their connection to past and contemporary sculptural practice, and other metaphoric resonances. The mystification of Beuys's work has also worked to obscure the irony inherent in Beuys's choice of felt and fat to make sculpture, as it teased at conventions of form, purpose, and stature. It is an irony very much in the spirit of his time, explicitly expressed in Claes Oldenburg's "soft monuments," and present in much of the art of the 1960s. Fat and felt also took part in the contemporary opposition to formalist criteria of sculptural quality and to the role of art as a luxury commodity. As did similar materials used in contemporary process art in the United States or Arte Povera in Italy, fat and felt affected a conspicuous distance from the affluence of the societies in which they were made.[3]

Pop Art

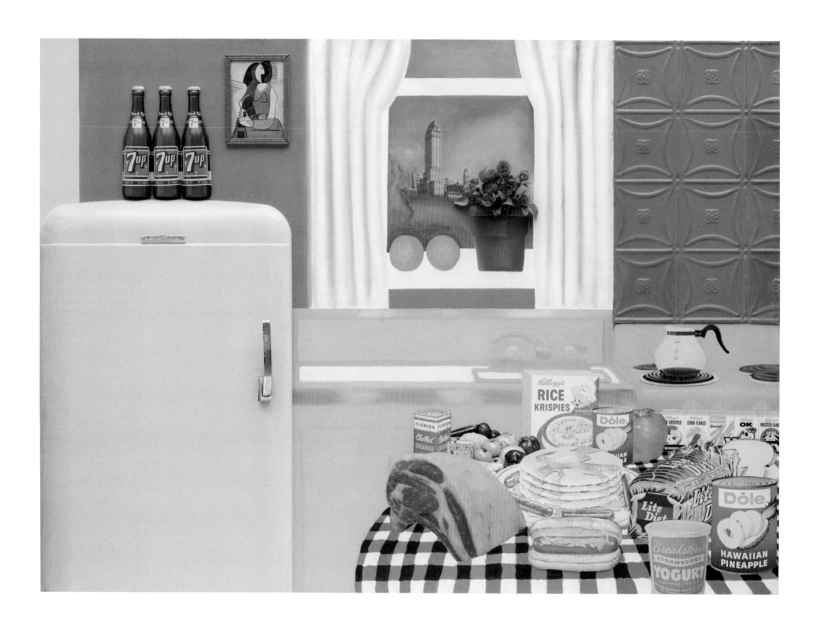

Tom Wesselmann | AMERICAN, BORN 1931
STILL LIFE #30. 1963
ASSEMBLAGE: OIL, ENAMEL, AND SYNTHETIC POLYMER
PAINT ON COMPOSITION BOARD WITH COLLAGE OF
PRINTED ADVERTISEMENTS, PLASTIC ARTIFICIAL FLOWERS,
REFRIGERATOR DOOR, PLASTIC REPLICAS OF "7-UP"
BOTTLES, GLAZED AND FRAMED COLOR REPRODUCTION,
AND STAMPED METAL, 48½ x 66 x 4" (122 x 167.5 x 10 CM)
GIFT OF PHILIP JOHNSON

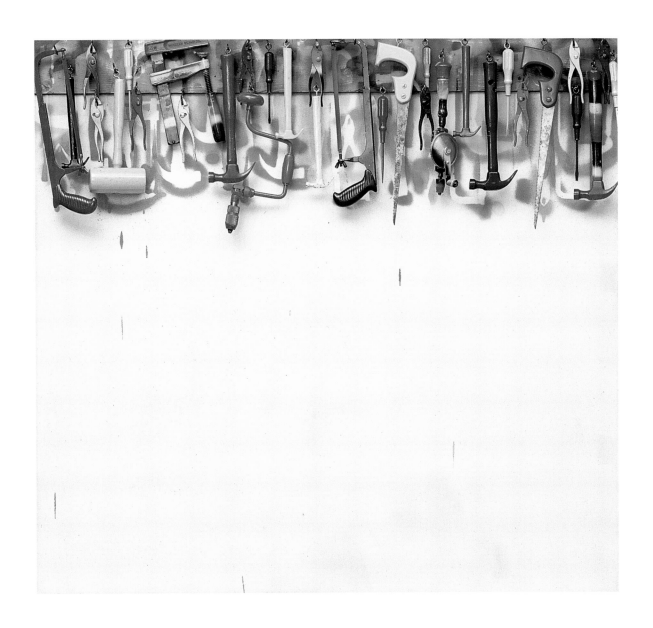

Jim Dine | AMERICAN, BORN 1935
FIVE FEET OF COLORFUL TOOLS. 1962
OIL ON UNPRIMED CANVAS SURMOUNTED BY
A BOARD ON WHICH THIRTY-TWO PAINTED
TOOLS HANG FROM HOOKS; OVERALL, 55¼ x
60¾ x 4⅛" (141.2 x 152.9 x 11 CM)
THE SIDNEY AND HARRIET JANIS COLLECTION

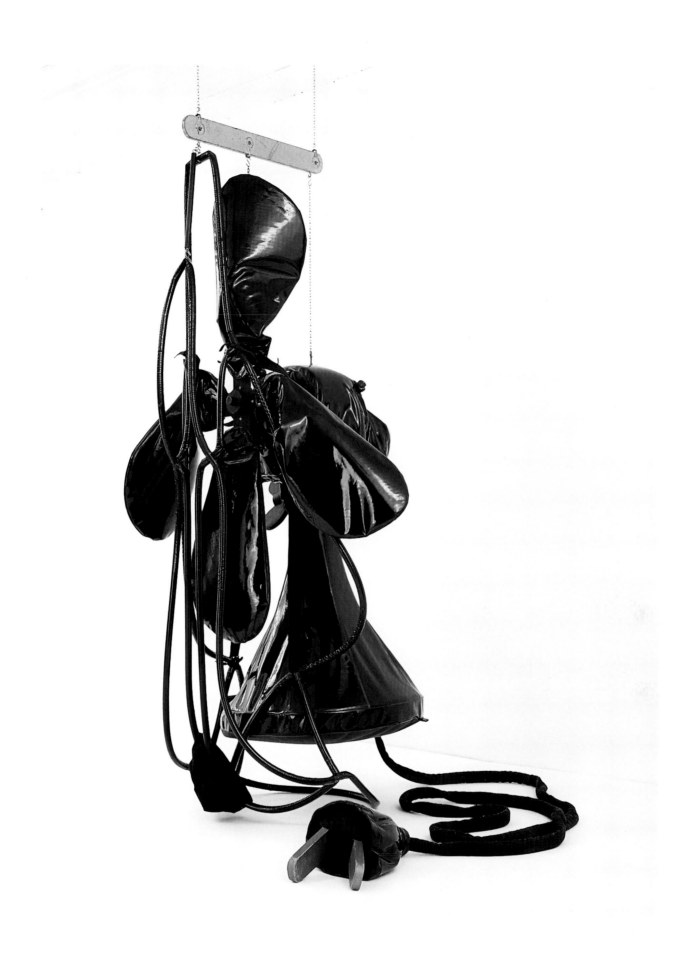

Claes Oldenburg | (AMERICAN, BORN SWEDEN, 1929)
GIANT SOFT FAN. 1966–67
VINYL FILLED WITH FOAM RUBBER, WOOD, METAL, AND PLASTIC TUBING, FAN, APPROXIMATELY
10' x 58⅝" x 61⅞" (305 x 149.5 x 157.1 CM), PLUS CORD AND PLUG 24' 3¼" (739.6 CM) LONG
THE SIDNEY AND HARRIET JANIS COLLECTION, 1967

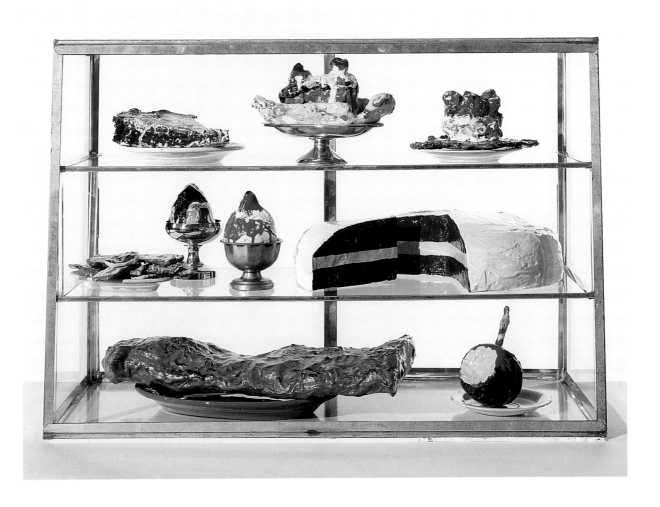

Claes Oldenburg
PASTRY CASE, I. 1961–62
PAINTED PLASTER SCULPTURES ON CERAMIC PLATES,
METAL PLATTER AND CUPS IN GLASS-AND-METAL CASE,
20¼ x 30⅛ x 14¼" (52.7 x 76.5 x 37.3 CM)
THE SIDNEY AND HARRIET JANIS COLLECTION, 1967

405

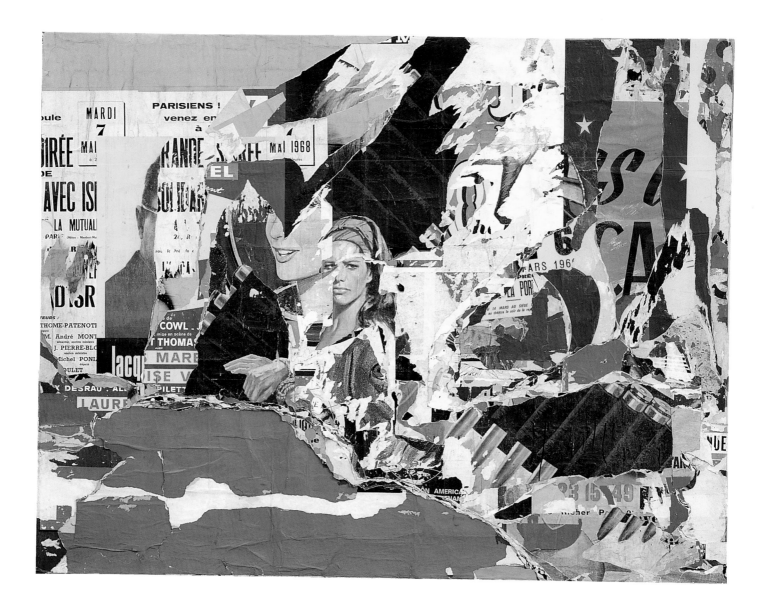

Jacques de la Villeglé | (FRENCH, BORN 1926)
122 RUE DU TEMPLE, 1968
TORN AND COLLAGED PAINTED AND PRINTED PAPER ON LINEN,
62⅝ x 82¼" (159.2 x 210.3 CM)
GIFT OF JOACHIM ABERBACH (BY EXCHANGE), 1988

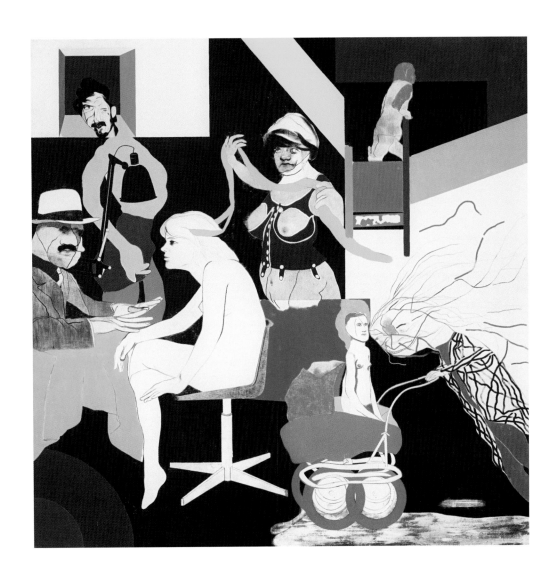

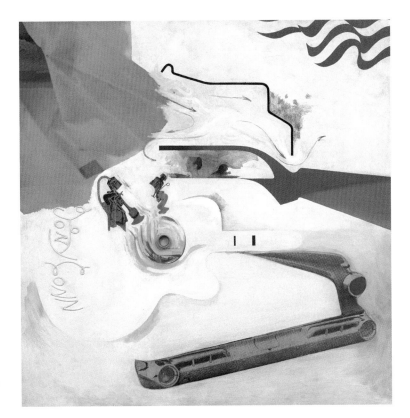

R. B. Kitaj | (AMERICAN, BORN 1932)
THE OHIO GANG. 1964
OIL AND GRAPHITE ON CANVAS, 6'1⅛" x 6'¼"
(183.1 x 183.5 CM)
PHILIP JOHNSON FUND, 1965

Richard Hamilton | (BRITISH, BORN 1922)
GLORIOUS TECHNICULTURE. 1961–64
OIL AND COLLAGE ON PANEL, 48⅜ x 48⅜" (122.9 x 122.9 CM)
ENID A. HAUPT FUND AND THE SIDNEY AND HARRIET JANIS
COLLECTION (BY EXCHANGE), 1999

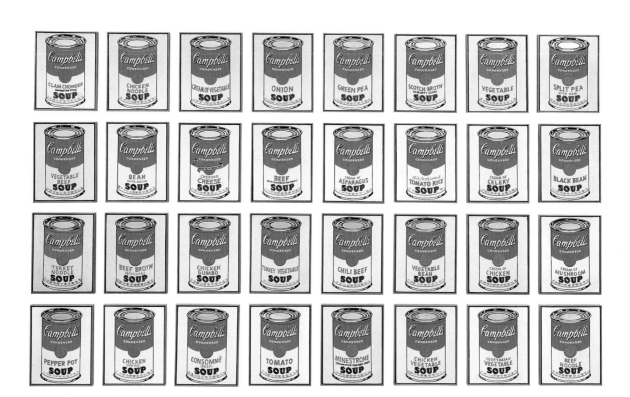

Andy Warhol | (AMERICAN, 1928–1987)
CAMPBELL'S SOUP CANS. 1962
SYNTHETIC POLYMER PAINT ON THIRTY-TWO CANVASES,
EACH CANVAS 20 x 16" (50.8 x 40.6 CM)
GIFT OF IRVING BLUM; NELSON A. ROCKEFELLER BEQUEST,
GIFT OF MR. AND MRS. WILLIAM A. M. BURDEN, ABBY
ALDRICH ROCKEFELLER FUND, GIFT OF NINA AND GORDON
BUNSHAFT IN HONOR OF HENRY MOORE, LILLIE P. BLISS
BEQUEST, PHILIP JOHNSON FUND, FRANCES KEECH BEQUEST,
GIFT OF MRS. BLISS PARKINSON, AND FLORENCE B. WESLEY
BEQUEST (ALL BY EXCHANGE), 1996

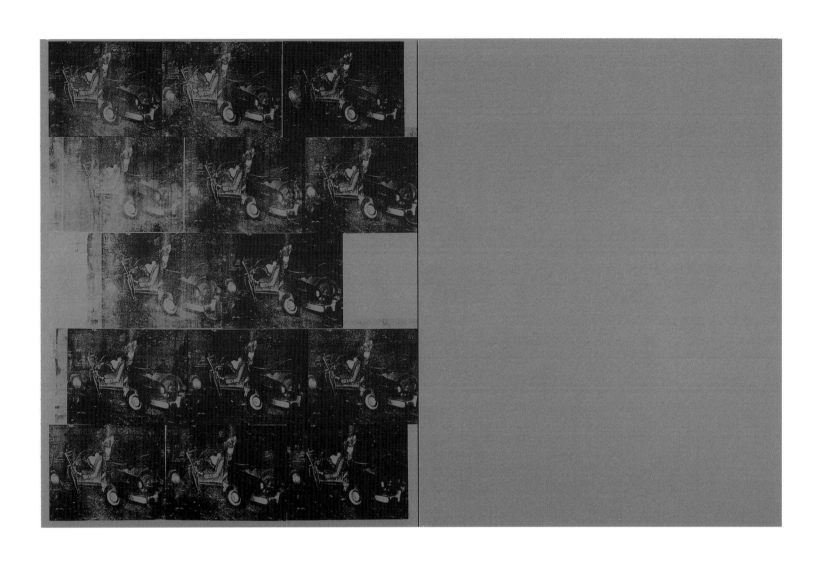

Andy Warhol
ORANGE CAR CRASH FOURTEEN TIMES. 1963
SYNTHETIC POLYMER PAINT AND SILKSCREEN ON CANVAS,
TWO PANELS, 8' 9⅞" x 13' 8⅛" (268.9 x 416.9 CM)
GIFT OF PHILIP JOHNSON, 1991

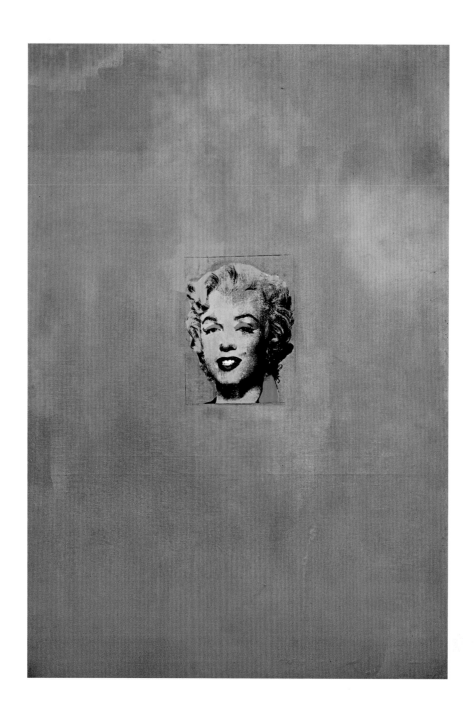

Andy Warhol | (AMERICAN, 1928–1987)
GOLD MARILYN MONROE. 1962
SYNTHETIC POLYMER PAINT, SILKSCREENED, AND
OIL ON CANVAS, 6' 11¼" x 57" (211.4 x 144.7 CM)
GIFT OF PHILIP JOHNSON, 1962

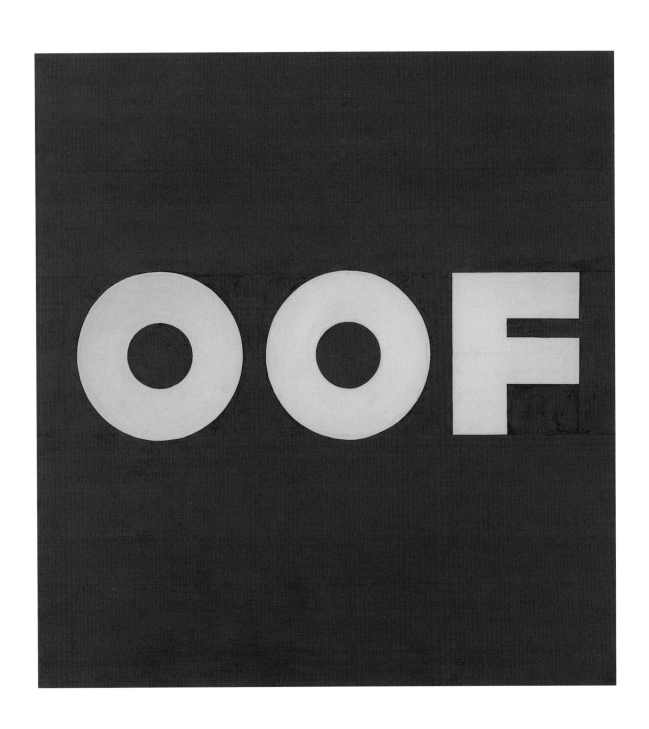

Edward Ruscha | (AMERICAN, BORN 1937)
OOF. 1962 (reworked 1963)
OIL ON CANVAS, 71½ x 67" (181.5 x 170.2 CM)
GIFT OF AGNES GUND, THE LOUIS AND BESSIE ADLER
FOUNDATION, INC., ROBERT AND MERYL MELTZER, JERRY I.
SPEYER, ANNA MARIE AND ROBERT F. SHAPIRO, EMILY AND
JERRY SPIEGEL, AN ANONYMOUS DONOR, AND PURCHASE, 1988

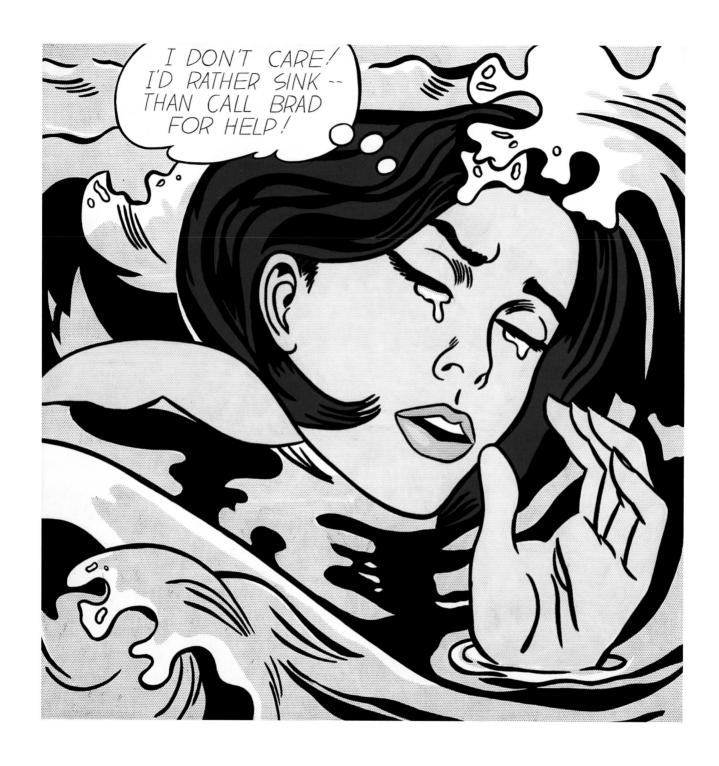

Roy Lichtenstein | (AMERICAN, 1923–1997)
DROWNING GIRL. 1963
OIL AND SYNTHETIC POLYMER PAINT ON CANVAS, 67⅝ x 66¾" (171.6 x 169.5 CM)
PHILIP JOHNSON FUND (BY EXCHANGE) AND GIFT OF MR. AND MRS. BAGLEY WRIGHT, 1971

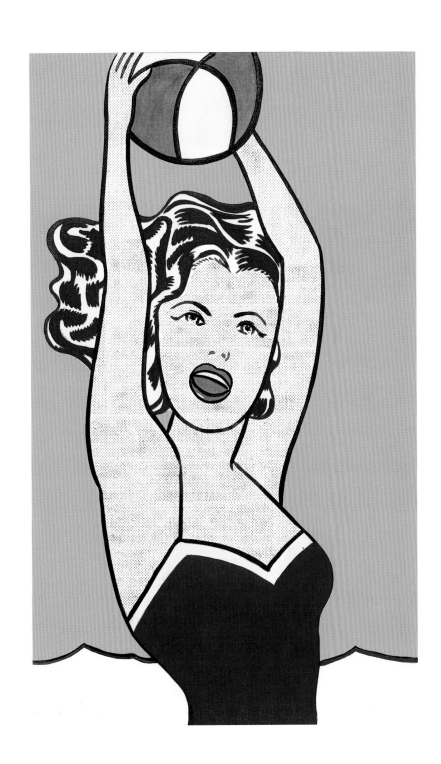

Roy Lichtenstein
GIRL WITH BALL. 1961
OIL AND SYNTHETIC POLYMER PAINT ON CANVAS,
60⅛ x 36⅛" (153 x 91.9 CM)
GIFT OF PHILIP JOHNSON, 1981

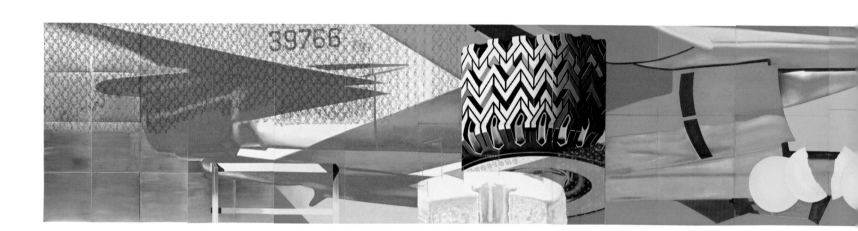

James Rosenquist | (AMERICAN, BORN 1933)
F-111. 1964–65
OIL ON CANVAS WITH ALUMINUM (23 SECTIONS), 10 x 86' (304.8 x 2621.3 CM)
GIFT OF MR. AND MRS. ALEX L. HILLMAN AND LILLIE P. BLISS BEQUEST
(BOTH BY EXCHANGE), 1996

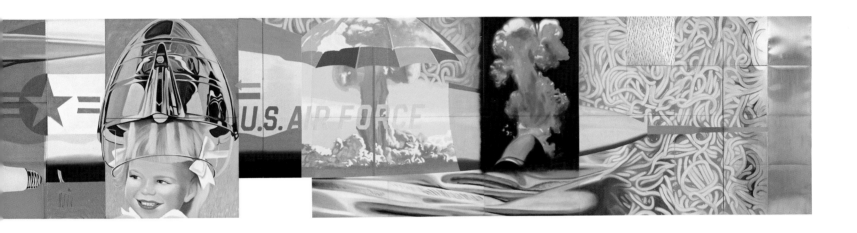

Abstract and Minimalist Painting and Sculpture

Ad Reinhardt | (AMERICAN, 1913–1967)
ABSTRACT PAINTING. 1960–61
OIL ON CANVAS, 60 x 60" (152.4 x 152.4 CM)
PURCHASE (BY EXCHANGE), 1963

Tony Smith | (AMERICAN, 1912–1980)
DIE, 1962 (fabricated 1998)
STEEL, 6 x 6 x 6' (182.9 x 182.9 x 182.9 CM)
GIFT OF JANE SMITH IN HONOR OF AGNES GUND, 1998

Agnes Martin | (AMERICAN, BORN CANADA, 1912)
RED BIRD. 1964
SYNTHETIC POLYMER PAINT AND COLORED PENCIL ON CANVAS,
71⅛ x 71⅛" (180.5 x 180.5 CM)
GIFT OF PHILIP JOHNSON, 197

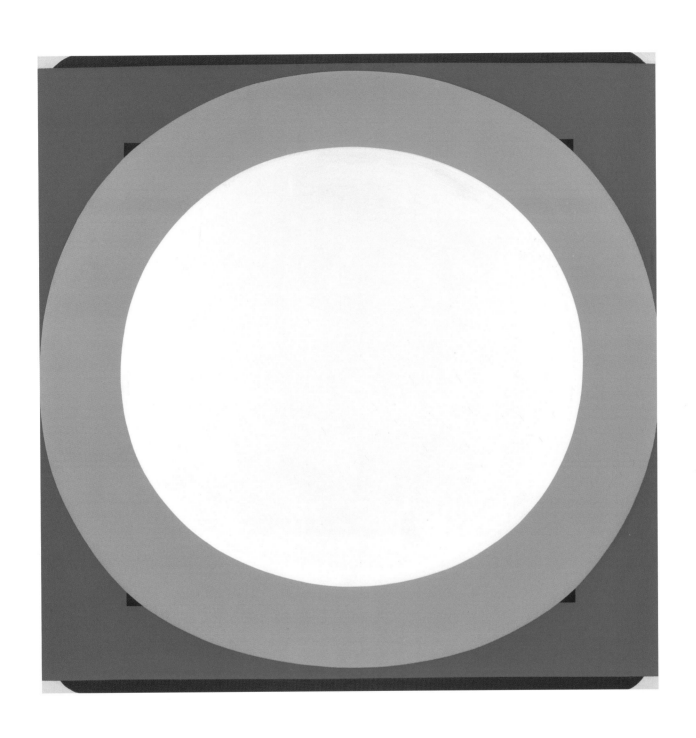

Al Held | (AMERICAN, BORN 1928)
MAO. 1967
SYNTHETIC POLYMER PAINT ON CANVAS, 9' 6" x 9' 6" (289.6 x 289.6 CM)
THE SIDNEY AND HARRIET JANIS COLLECTION (BY EXCHANGE), 1998

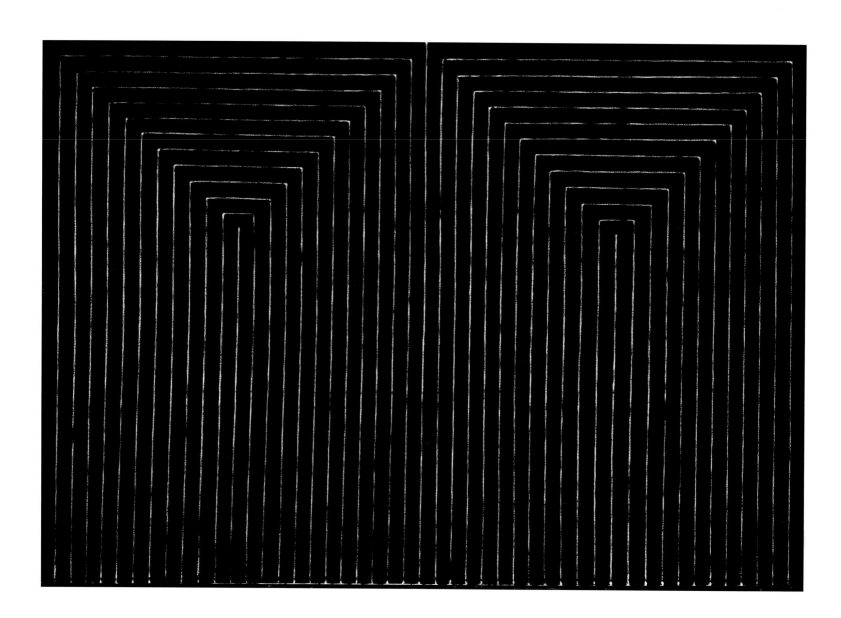

Frank Stella | (AMERICAN, BORN 1936)
THE MARRIAGE OF REASON AND SQUALOR, II. 1959
ENAMEL ON CANVAS, 7' 6¾" x 11'¾" (230.5 x 337.2 CM)
LARRY ALDRICH FOUNDATION FUND, 1959

Robert Ryman | (AMERICAN, BORN 1930)
TWIN. 1966
OIL ON COTTON, 6' 3¼" x 6' 3⅞" (192.4 x 192.6 CM)
CHARLES AND ANITA BLATT FUND AND PURCHASE, 1971

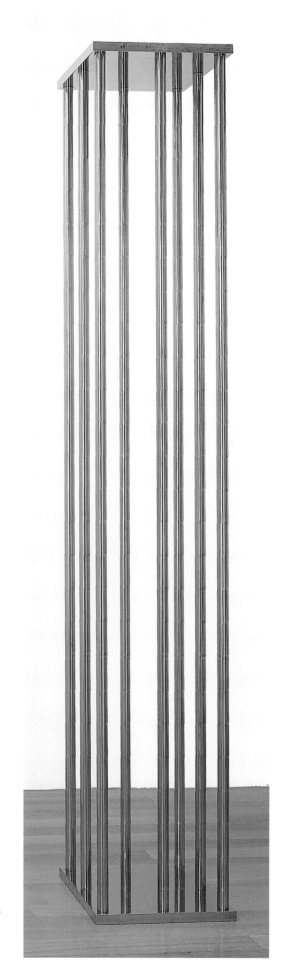

Walter de Maria | (AMERICAN, BORN 1935)
CAGE II. 1965
STAINLESS STEEL, 7' 1¼" x 14⅛" x 14⅛"
(216.5 x 36.2 x 36.2 CM)
GIFT OF AGNES GUND AND LILY AUCHINCLOSS, 1993

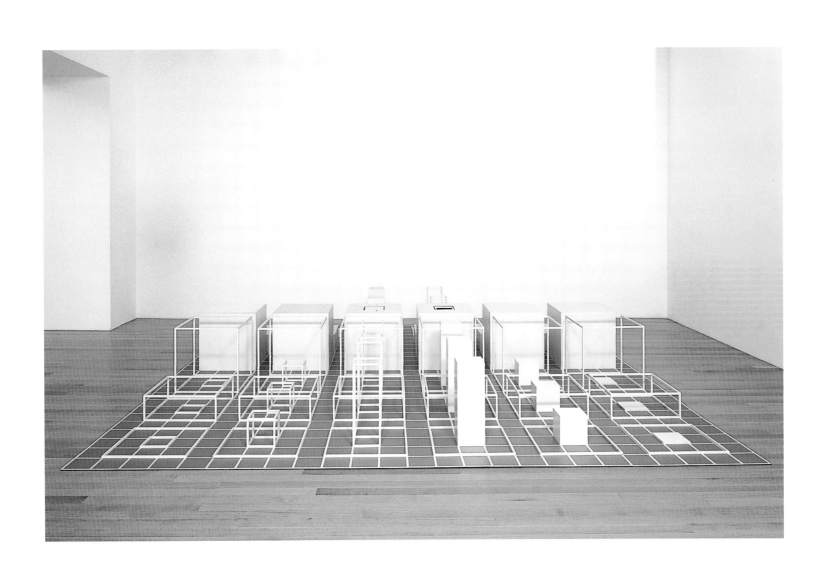

Sol LeWitt | (AMERICAN, BORN 1928)
SERIAL PROJECT, I (ABCD). 1966
BAKED ENAMEL ON STEEL UNITS OVER BAKED ENAMEL ON ALUMINUM,
20" x 13' 7" x 13' 7" (50.8 x 398.9 x 398.9 CM)
GIFT OF AGNES GUND AND PURCHASE (BY EXCHANGE), 1978

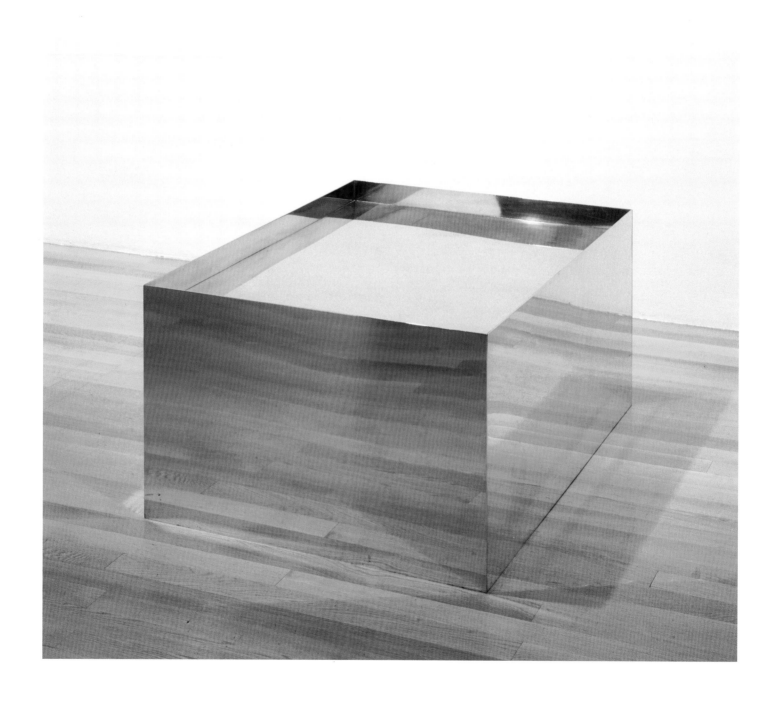

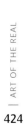

Donald Judd | (AMERICAN, 1928–1994)
UNTITLED. 1968
BRASS, 22 x 48¼ x 36" (55.9 x 122.6 x 91.4 CM)
GIFT OF PHILIP JOHNSON, 1980

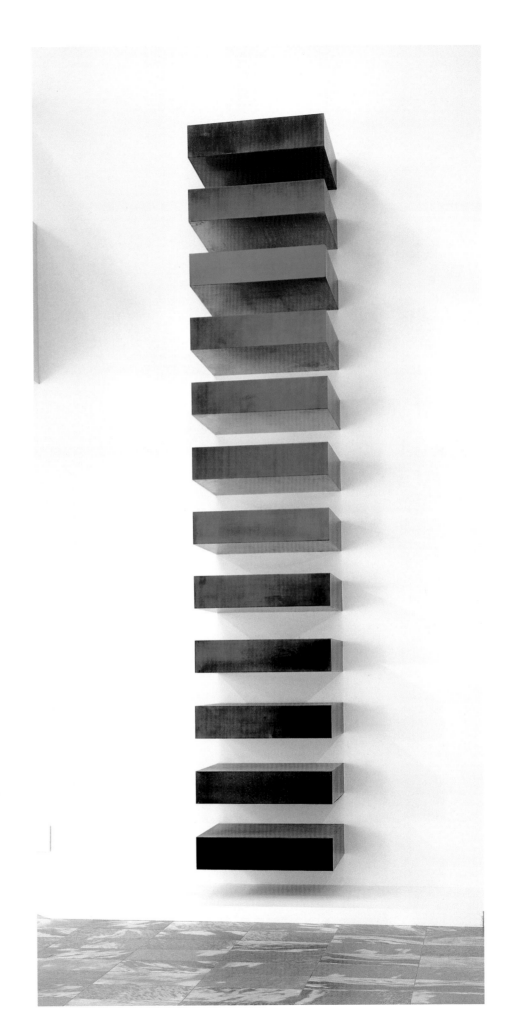

Donald Judd
UNTITLED (STACK). 1967
LACQUER ON GALVANIZED IRON, TWELVE UNITS,
EACH 9 x 40 x 31" (22.8 x 101.6 x 78.7 CM), INSTALLED
VERTICALLY WITH 9" (22.8 CM) INTERVALS
HELEN ACHESON BEQUEST (BY EXCHANGE) AND
GIFT OF JOSEPH HELMAN, 1997

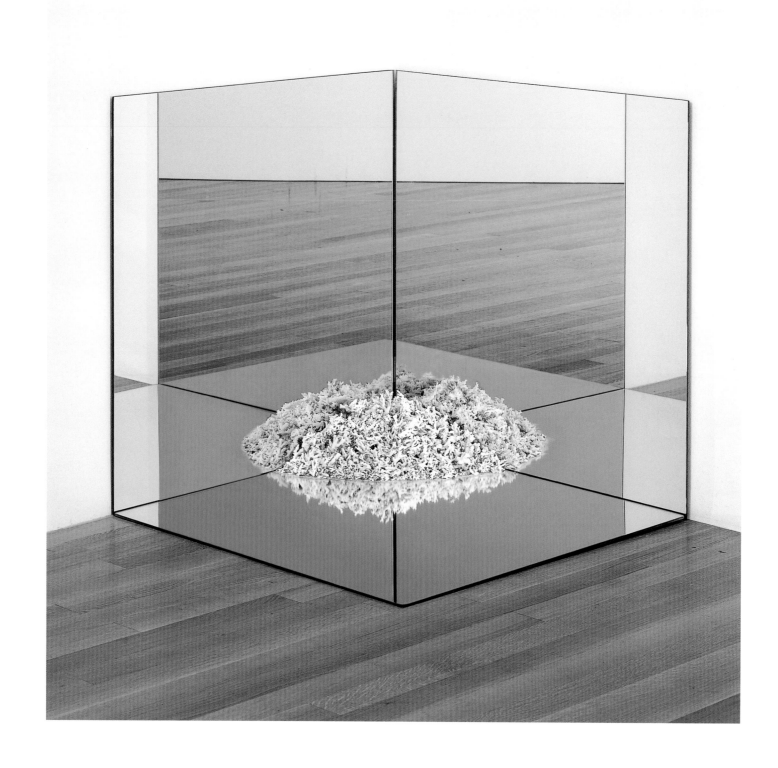

Robert Smithson | (AMERICAN, 1938–1973)
CORNER MIRROR WITH CORAL. 1969
MIRRORS AND CORAL, 36 x 36 x 36" (91.5 x 91.5 x 91.5 CM)
FRACTIONAL GIFT OF AGNES GUND, 1991

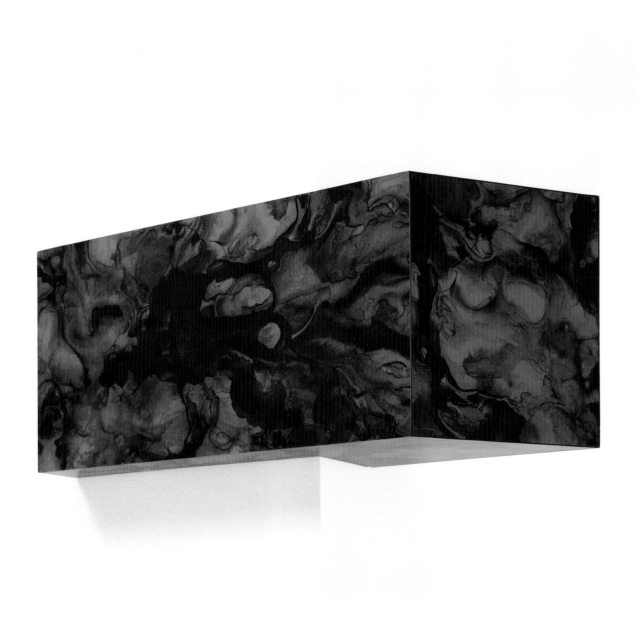

Richard Artschwager | (AMERICAN, BORN 1923)
KEY MEMBER. 1967
FORMICA VENEER AND FELT ON WOOD, 11⅞ x 29⅛ x 8⅝" (30.1 x 74 x 21.9 CM)
GIFT OF PHILIP JOHNSON, 1968

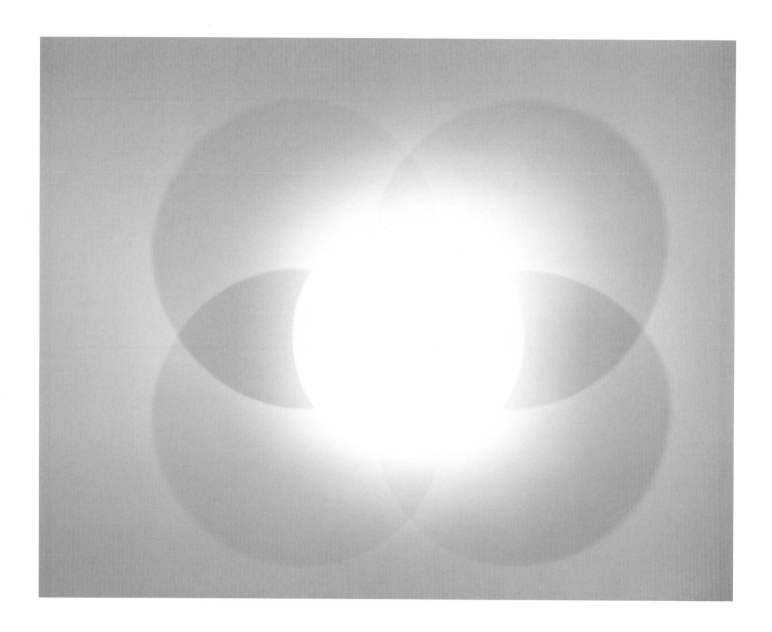

Robert Irwin | (AMERICAN, BORN 1928)
UNTITLED. 1968
SYNTHETIC POLYMER PAINT ON ALUMINUM AND LIGHT,
DISC 60⅜" (153.2 CM) IN DIAMETER
MRS. SAM A. LEWISOHN FUND, 1969

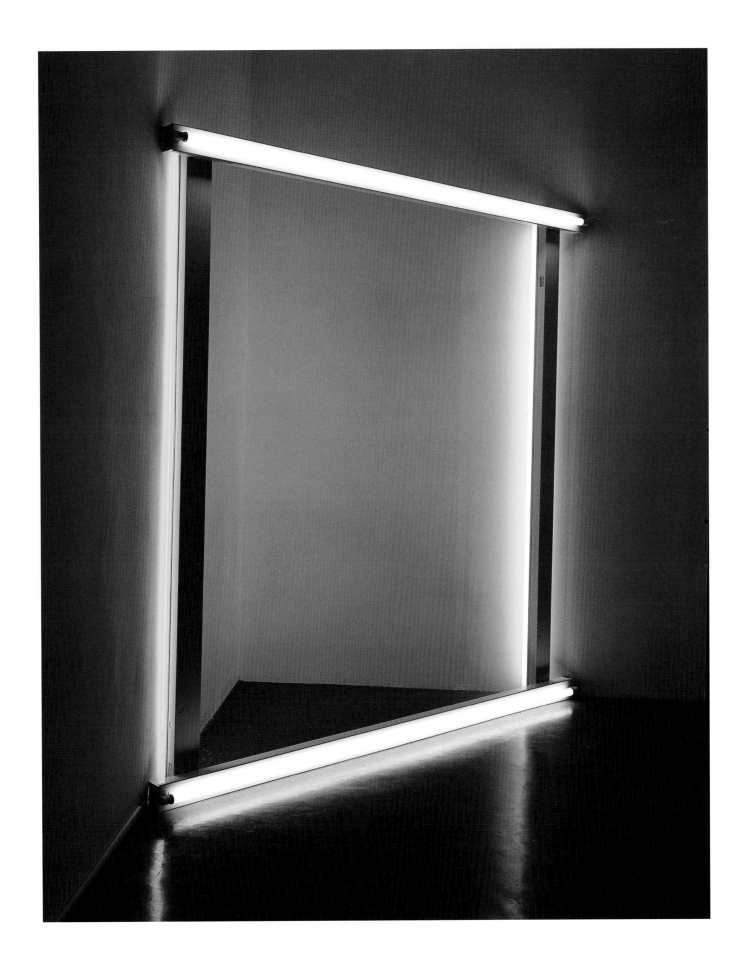

Dan Flavin | (AMERICAN, 1933–1996)
UNTITLED (TO THE "INNOVATOR" OF WHEELING PEACHBLOW). 1968
FLUORESCENT LIGHTS AND METAL FIXTURES, 8' ½" x 8'¼" x 5¼" (245 x 244.3 x 14.5 CM)
HELENA RUBINSTEIN FUND, 1969

429

Fred Sandback | (AMERICAN, 1943–2003)
UNTITLED. 1967
ELASTIC RAYON CORD AND METAL SLEEVE CLAMPS,
69" x 14' x 24" (175.2 x 426.7 x 60.9 CM)
GIFT OF PHILIP JOHNSON, 1971

Richard Tuttle | (AMERICAN, BORN 1941)
CLOTH OCTAGONAL, 2. 1967
DYED AND SEWN CANVAS, 57⅛ x 53¾" (145.2 x 136.5 CM)
MRS. ARMAND P. BARTOS FUND, 1974

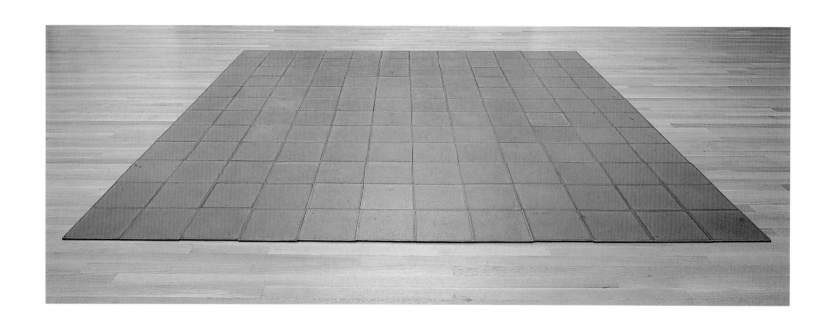

Carl Andre | (AMERICAN, BORN 1935)
144 LEAD SQUARE. 1969
LEAD (144 UNITS), EACH UNIT ⅜ x 12 x 12" (1 x 30.5 x
30.5 CM), OVERALL ⅜" x 12' x 12' (1 x 367.8 x 367.8 CM)
ADVISORY COMMITTEE FUND, 1969

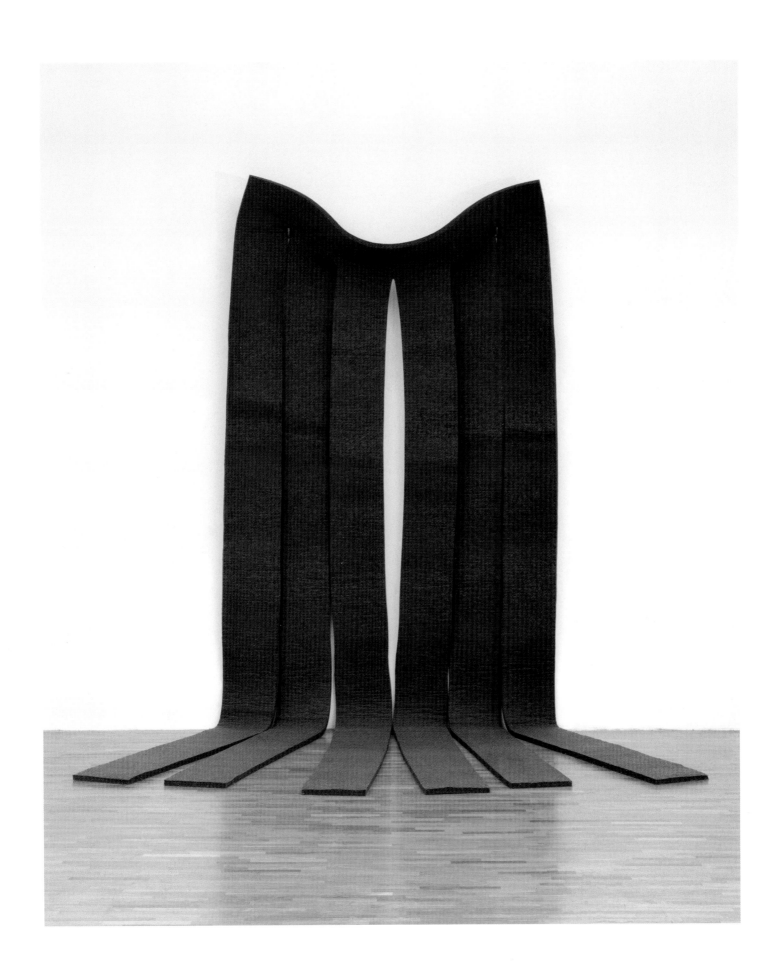

Robert Morris | (AMERICAN, BORN 1931)
UNTITLED. 1969
FELT, 15'1¼" x 6'½" x 1" (459.2 x 184.1 x 2.5 CM)
THE GILMAN FOUNDATION FUND, 1975

433

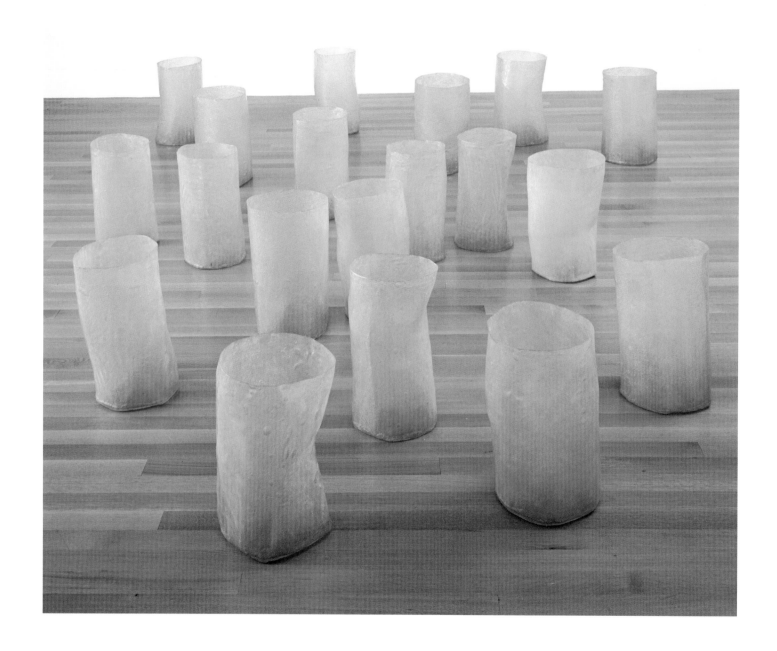

Eva Hesse | (AMERICAN, BORN GERMANY. 1936–1970)
REPETITION NINETEEN III. 1968
FIBERGLASS AND POLYESTER RESIN, 19 UNITS, EACH 19 TO 20¼"
(48 TO 51 CM) HIGH x 11 TO 12¾" (27.8 TO 32.2 CM) IN DIAMETER
GIFT OF CHARLES AND ANITA BLATT, 1969

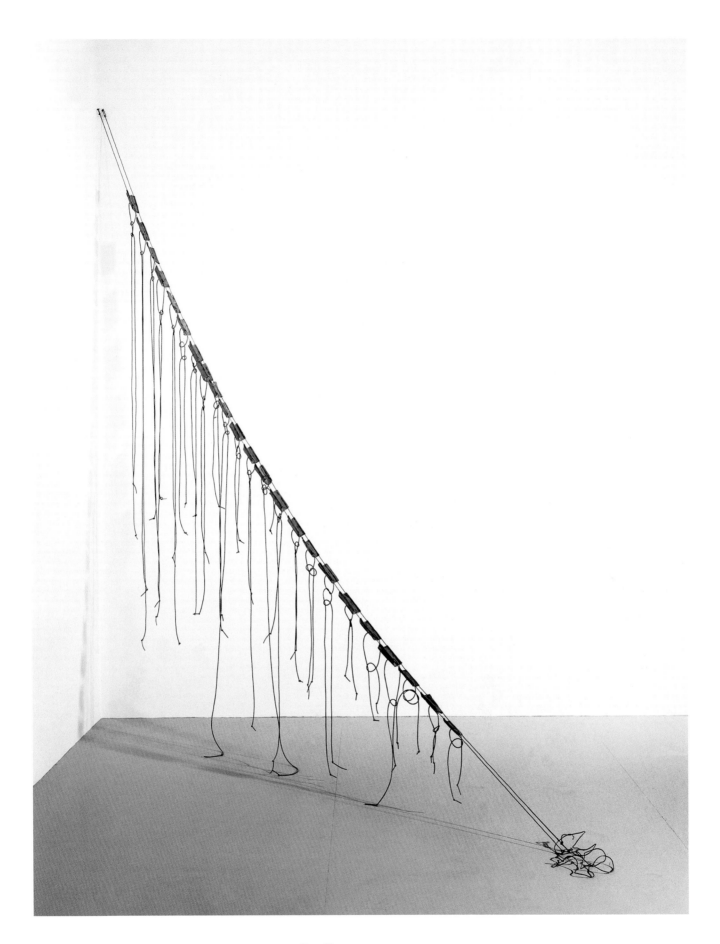

Eva Hesse
VINCULUM, II. 1969
LATEX ON METAL SCREENING STAPLED TO WIRE WITH VINYL
TUBING, OVERALL 9' 9" x 2½" x 9' 7½" (297.2 x 5.8 x 293.5 CM)
THE GILMAN FOUNDATION FUND, 1975

435

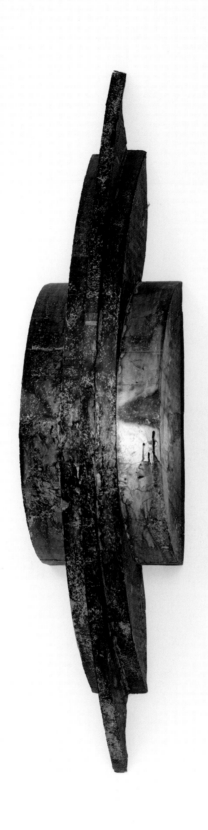

Bruce Nauman | (AMERICAN, BORN 1941)
UNTITLED. 1965
FIBERGLASS, POLYESTER RESIN, AND LIGHT,
8' 4" x 20" x 21" (254 x 50.3 x 53.3 CM)
GIFT OF JOSEPH HELMAN, 1978

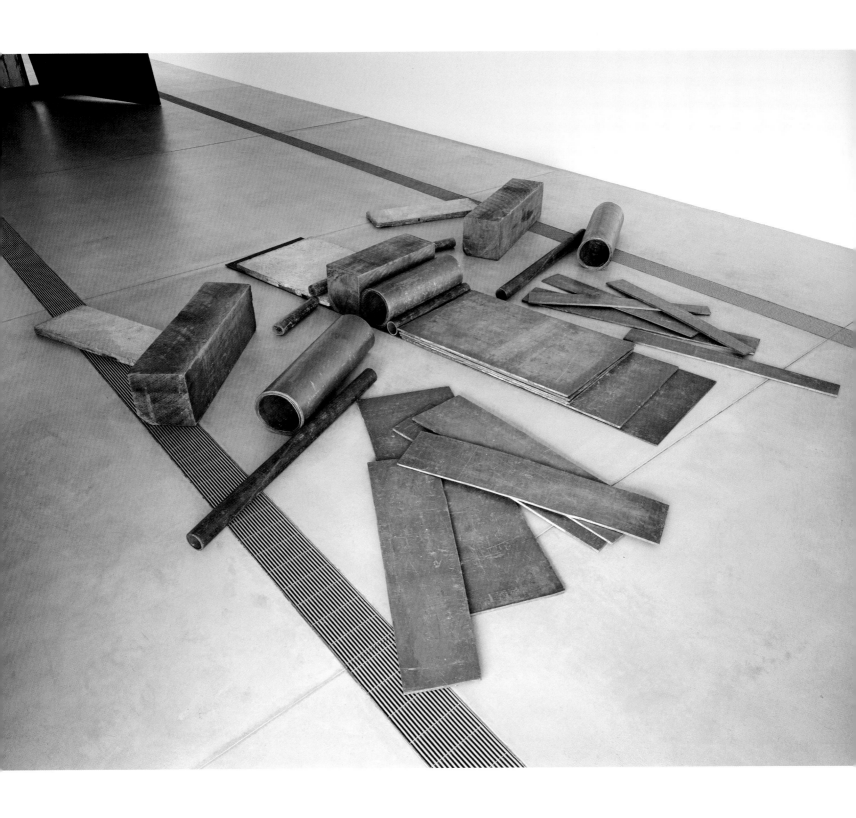

Richard Serra | (AMERICAN, BORN 1939)
CUTTING DEVICE: BASE PLATE MEASURE. 1969
LEAD, WOOD, STONE, AND STEEL, OVERALL 12" x 18' x
15' 7¼" (30.5 x 549 x 498 CM)
GIFT OF PHILIP JOHNSON, 1979

After Minimalism

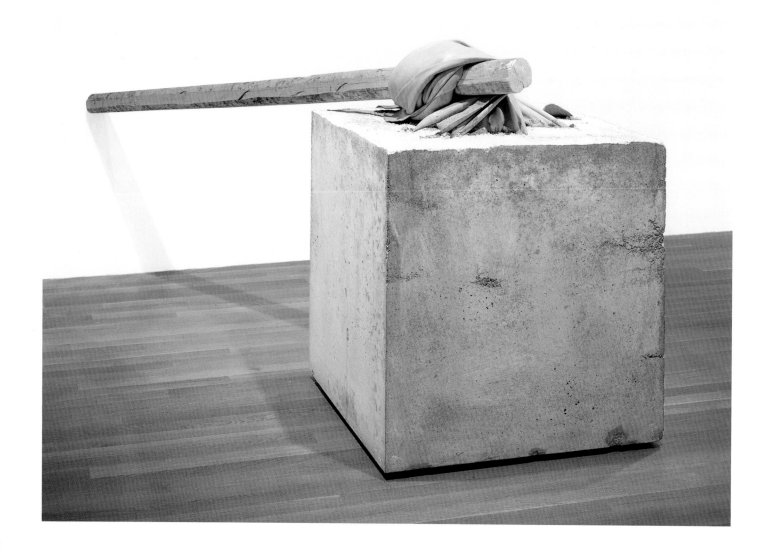

Giovanni Anselmo | (ITALIAN, BORN 1934)
TORSION. 1968
CEMENT, LEATHER, AND WOOD, CUBE 39⅜ x 39⅜ x 39⅜" (100 x 100 x
100 CM); POLE 9' 10" (299.7 CM) LONG x 4½" (11.4 CM) IN DIAMETER
GIFT OF JO CAROLE AND RONALD S. LAUDER, 2000

Gilberto Zorio | (ITALIAN, BORN 1944)
CRYSTAL STAR WITH JAVELINS. 1977
GLASS AND STEEL, 6' 2½" x 6' 2½" x 8' 6½" (189.2 x 189.2 x 260.4 CM)
ANNE AND SID BASS FUND, 1986

439

Panamarenko | (BELGIAN, BORN 1940)
FLYING OBJECT (ROCKET). 1969
BALSA WOOD, CARDBOARD, PLASTIC, FABRIC, ALUMINUM,
STEEL, AND SYNTHETIC POLYMER PAINT, 8' 11" x
11' 4" x 8' 2" (271.7 x 345.5 x 249 CM)
GIFT OF AGNES GUND, 1998

Jannis Kounellis | (GREEK, BORN 1936)
UNTITLED. 1983
STEEL BEAM, STEEL BED FRAME WITH PROPANE GAS
TORCH, FIVE STEEL SHELVES, SMOKE TRACES, AND STEEL
PANEL AND SHELF WITH WOOD, OVERALL APPROXIMATELY
10' 11½" x 17' 7¾" x 16¼" (333.9 x 536.5 x 41.2 CM)
SID R. BASS, BLANCHETTE ROCKEFELLER, THE NORMAN
AND ROSITA WINSTON FOUNDATION, INC. FUNDS, AND
PURCHASE, 1989

441

WHAT IS PAINTING

DO YOU SENSE HOW ALL THE PARTS OF A GOOD
PICTURE ARE INVOLVED WITH EACH OTHER, NOT
JUST PLACED SIDE BY SIDE ? ART IS A CREATION
FOR THE EYE AND CAN ONLY BE HINTED AT WITH
WORDS.

John Baldessari | (AMERICAN, BORN 1931)
WHAT IS PAINTING. 1968
SYNTHETIC POLYMER PAINT ON CANVAS, 67¾ x 56¾" (172.1 x 144.1 CM)
GIFT OF DONALD L. BRYANT, JR., 1998

Joseph Kosuth | (AMERICAN, BORN 1945)
ONE AND THREE CHAIRS. 1965
WOODEN FOLDING CHAIR, PHOTOGRAPHIC COPY OF A
CHAIR, AND PHOTOGRAPHIC ENLARGEMENT OF A DICTION-
ARY DEFINITION OF A CHAIR, CHAIR 32⅜ x 14⅞ x 20⅞"
(82 x 37.8 x 53 CM); PHOTOGRAPHIC PANEL 36 x 24⅛"
(91.5 x 61.1 CM); TEXT PANEL 24 x 24⅛" (61 x 61.3 CM)
LARRY ALDRICH FOUNDATION FUND, 1978

443

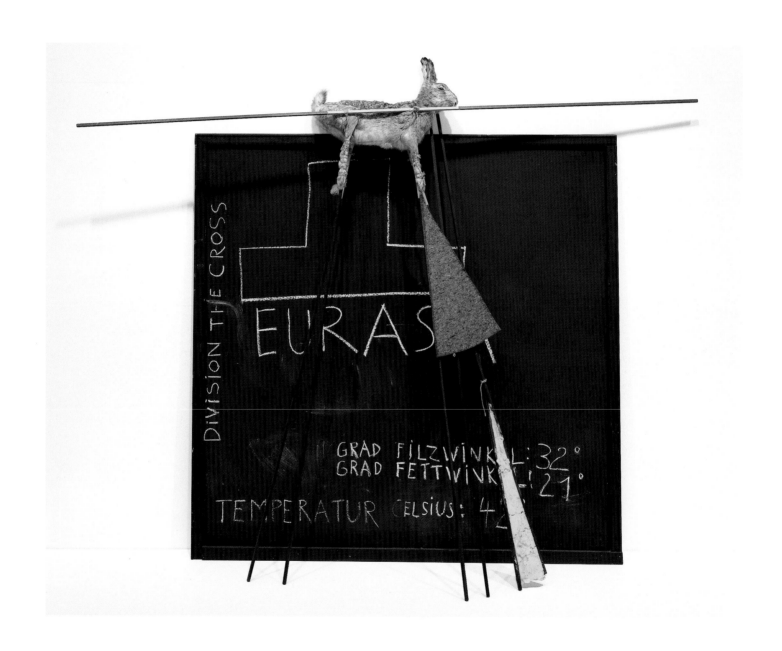

Joseph Beuys | (GERMAN, 1921–1986)
EURASIA SIBERIAN SYMPHONY 1963. 1966
PANEL WITH CHALK DRAWING, FELT AND FAT, HARE, AND
BLUE PAINTED POLES, 6' x 7' 6¾" x 20" (183 x 230 x 50 CM)
GIFT OF FREDERIC CLAY BARTLETT (BY EXCHANGE), 2000

Joseph Beuys
IRON CHEST FROM "VACUUM ←—→ MASS," October 14, 1968
IRON, FAT, AND BICYCLE PUMPS, 22 x 43 x 21½" (55.9 x 109 2 x 54 CM)
PROMISED GIFT OF AGNES GUND, 2002

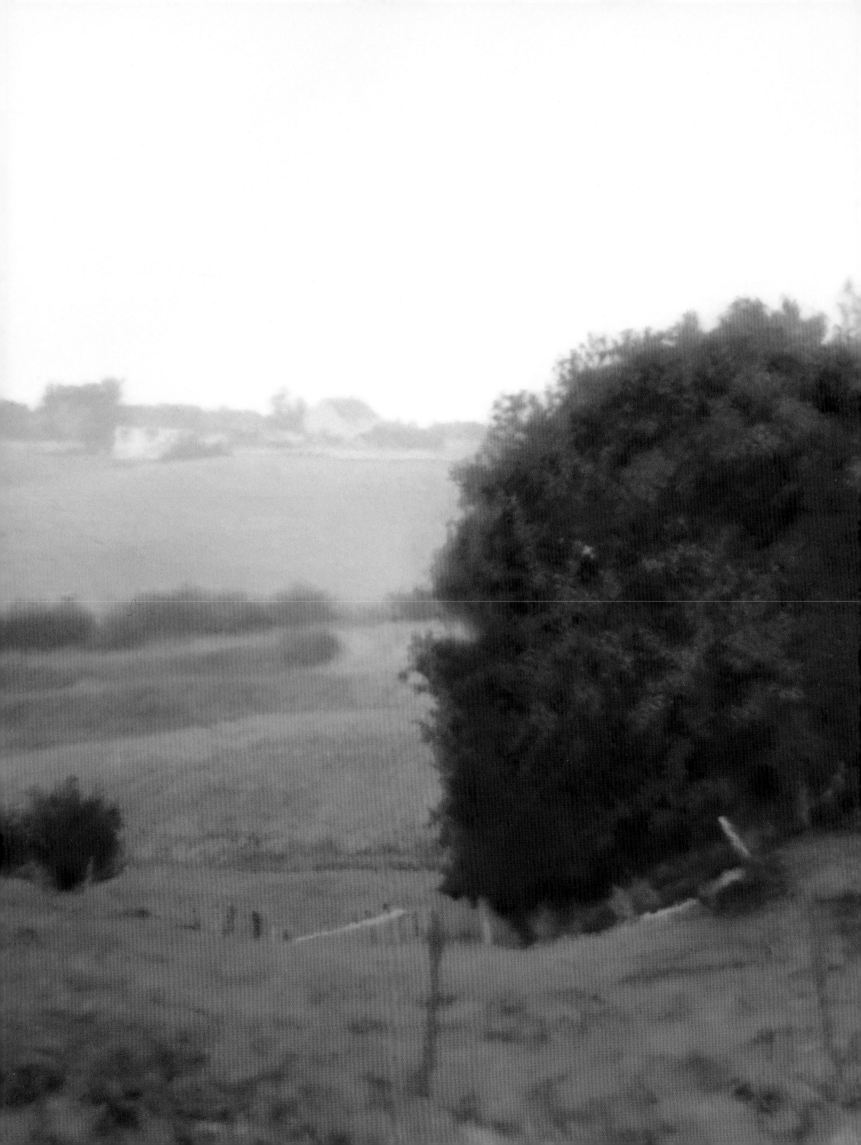

The Museum's exhibited collection on its fifth and fourth floors of painting and sculpture from around 1880 to 1970 comprises a considered synoptic account of the artistic developments of ninety years. It will change from time to time, either from a wish to offer a varying view of these developments, and of the collection, or because of loans of works to temporary exhibitions, but the principles that guide its installation will remain the same: to afford a step-by-step account of the unfolding of modern art in its many, competing, and sympathetic manifestations which this collection alone can provide. The art of the last thirty or so years is too recent to be presented in the form of a synthetic overview; it would be both presumptuous and unrealistic to attempt it with confidence of success. For that reason, its presentation in the Museum's second-floor galleries will comprise successive selections of the art of this period, each one chosen with an eye to coherence and compatibility of some sort, but more with the aim of sampling the period than of defining it absolutely. In the succession of selections, the resulting accumulation of provisional definitions might be sifted, compared, and conclusions drawn.

One sample in the pages of a book cannot replicate that process. Indeed, to have offered, in the pages that follow, a sample that was chosen to be coherent would have provided an unduly narrow view of the art of the period and of the collection. Therefore, this selection is eclectic by design and brings together works that are, in fact, unlikely to be assembled in a single installation. What is more, the second-floor installation, although composed in the main of works in the collection of painting and sculpture, will add to them works from other mediums in order to provide a sense of the varieties of expression in contemporary art. A nominal representation of works of installation and media art, in the painting and sculpture collection, is included here to give but a hint of the hybridized context of contemporary art.

All this said, it would be idle to suggest that no overarching sense can be made of progressive art since 1970. It can, and the desire to sample from its components has shaped the following selection. Popular culture, visual and verbal quotation, illustration, machinelike anonymity, techniques of photomechanical reproduction: these and other engagements of Pop art persist, transformed, well after the vitality of the movement has ebbed. Hence, to choose extremely varied examples, the depictive paintings of Gerhard Richter, the sculpture of Jeff Koons and Charles Ray, and the photomurals of Gilbert & George. As for Minimalism, it has shaped the dominant tendencies of contemporary art, in the continuing example of artists like Richard Serra and Bruce Nauman, in its formal austerity, and, above all, in its emphasis on contexts, on the work of art not only as an object but as the enabler of spatial, temporal experience. This last aspect, more than the others, has offered a versatility of options that can tolerate, for better or worse, the imposition of many kinds of formal strategies and artistic intentions. As such, it informs, to a greater or lesser extent, virtually all later, progressive sculpture and installation art and some painting besides. In more than a few cases, Pop and Minimalist currents coalesce, as in the two obvious, but very different examples of Chris Burden and Chuck Close. And issues relating to materiality, corporeality, and the poetry of unconventional materials, which appeared more frequently outside the United States in the 1960s, continue to work their way through contemporary production.

Untitled (Contemporary)

Sigmar Polke
Watchtower. 1984
Illustrated on page 462

Bernice Rose, *Allegories of Modernism: Contemporary Drawing*, **1992**, page 20

Polke has adopted a new attitude toward subject and style, which renders distinctions between traditional modes irrelevant. His new strategy, based on an old illusionist game, the reflection of light, is nevertheless an experimental attitude toward art–making that sets the terms for much contemporary work. Like a number of other artists, he works on several mediums simultaneously; the artist's career is no longer represented by a smooth development in a single medium or style over the course of time. In Polke's work the mechanical and the handmade interact, producing a virtual catalogue of current practice. As he works simultaneously in several disciplines he creates a new montage–based aesthetic out of a number of disparate, often contradictory modes and historical antecedents, utilizing the interpenetration of different means and techniques of representation: the figurative and the abstract, the mechanical and hand–drawn, the printed and the photographic, the painting and the drawing, the automatic, the deliberate, and the accidental.

On his larger canvases (and on the stitched–together printed cloth that he often uses as a support for large paintings) as well as in his photographic work, Polke's drawing becomes apparent as a major subject of his art. Included in the term "drawing" are his various graphic modes as well as the graphic impulse and conception in which the interplay between eye and mind, hand and "mechanism," light and material all play a part. Polke's drawing practice has been fundamental to the change in the structure of art and to the new attitude toward drawing in relation to current practice. He starts with an outpouring of drawings on paper, which he produces parallel to his paintings both as studies and as autonomous drawings, and finishes in quite another place.

Blinky Palermo
Untitled. 1970
Illustrated on page 464

Robert Storr, *Gerhard Richter*, **2002**, pages 57–58

Like [Gerhard] Richter and [Sigmar] Polke, Palermo was East German in origin. Born Peter Schwarze in Leipzig in 1943, he was almost immediately adopted and given the surname of his new parents, Wilhelm and Erika Heisterkamp. In 1952 he moved with his family to West Germany, and in 1962 he enrolled at the Düsseldorf academy—the same year Richter did. In 1963 he entered the class of Joseph Beuys who treated him as a favorite and in effect became his artistic father. Beuys suggested the pseudonym Blinky Palermo (the moniker of a minor gangster and boxing promoter associated with Sonny Liston), which his protégé assumed in 1964. Gifted with the subtlest of artistic sensibilities, but emotionally volatile and self–destructive—he died at thirty–four while in the Maldives after years of hard drinking and drug abuse—Palermo was something of a romantic figure, but his art was resolutely contemporary, and the lyricism that infused it was the product of a keen sensitivity to materials and a deft, matter-of-fact touch. In addition to working in oil, enamel, and acrylics on canvas, wood, and metal, Palermo drew extensively, made watercolors, wall reliefs, graphic architectural interventions, and so-called *Stoffbilder*, or cloth–paintings, in which fabrics were stretched over wood stretchers with the harmonious juxtaposition of dyed colors recalling the chromatic "zone" compositions of Mark Rothko or Ellsworth Kelly. . . .

Although quiet and not given to debating ideas, he was alert to what was going on around him . . . and [made] it his own. Richter's bond with Palermo was predicated on this combination of refinement, reticence, and openness. And yet, commenting on his affinity with Palermo, Richter explained that it was in part based on the differences in their inclinations and abilities. . . . Richter said: "His constructive pictures have remained in my memory because they particularly appeal to me, because I can't produce such a thing. I always found it very good how he made it and that he made it—this astonished me. There was an aesthetic quality which I loved and which I couldn't produce, but I was

happy that such a thing existed in the world. In comparison, my own things seemed to me somewhat destructive, without this beautiful clarity."[1]

Jackie Winsor

Bound Square. 1972
Illustrated on page 465

Ellen H. Johnson, *Jackie Winsor*, **1979**, page 9

Jackie Winsor's sculptures are like [Paul] Cézanne's apples in their "stubborn existence." The phrase is [Rainer Maria] Rilke's: "With Cézanne, fruit ceases entirely to be edible, becoming such real things, so simple, indestructible in their stubborn existence."[1] When the idea of a kinship between the young American sculptor and the great master of modern painting first occurred to me, I tried to put it aside as just another example of my personal inclination to find Cézanne everywhere. But questioning the notion only strengthened its persistence, and I sought to locate those particular elements that had suggested the analogy.

Cézanne's painted fruits are as indestructible and everlasting as the rock of Mont Sainte-Victoire; and Winsor's sculpture obstinately proclaims mass, weight, and density, properties she combines with space in such a way that mass and air tend to become one solid substance. Winsor's sculpture is as stable and as silent as the pyramids; yet it conveys not the awesome silence of death, but rather a living quietude in which multiple opposing forces are held in equilibrium. Jackie Winsor marshals her strands of rope and metal, her 1 x 1 inch sticks and layers of laths and pounds of nails as laboriously as Cézanne organized his countless *petites sensations*, but she does it like a Yankee pioneer; she struggles through to her own solution to problems in construction by means of a series of diagrams and numerical calculations, which she calls "my little systems." The decidedly handmade character of all Winsor's sculpture lends it an immediacy, a look of being in the process of becoming, that belies the stability of forms. . . . Such oppositions are among the many that enliven her art and account in part for its latent energy, which she herself has signalized: "The pieces have a quietness to them, they have their own energy. You relate to them the way you might relate to a sleeping person, to the potential energy that is manifested in a dormant state."[2]

Brice Marden

Grove Group, I. 1973
Illustrated on page 466

Robert Storr, *On the Edge: Contemporary Art from the Werner and Elaine Dannheisser Collection*, **1997**, pages 84–85

Marden started out in what many thought of as the aftermath of American painting's most glorious episode. Spanning the paradigm-setting improvisations of Willem de Kooning and Jackson Pollock, the sedimented icons of Jasper Johns, the one-, two-, or three-tone abstractions of Ellsworth Kelly, and the nested geometries of Frank Stella, that epoch had left behind a rich but daunting legacy, threatening anyone who drew directly upon it with the taint of "follower."

Instead of shunning this heritage, Marden has gracefully acknowledged it. His willingness to do so may be taken as a sign of "mainstream" American modernism's maturity. For as avant-gardes age and become tradition, those most sincerely committed to the aesthetic principles they represent, and most hopeful that those principles can still engender fresh if not altogether "new" art, have only one alternative: that is, to wholly absorb what is given them with the aim of finding unexploited uses for preexisting models. Marden's stage-by-stage assimilation of the work of his predecessors bears this out. . . .

Marden, like Johns before him, [turned] to the previously neglected medium of encaustic—pigments dissolved in molten wax, which, once congealed, retains a soft sheen, as if the color suspended in the medium emitted heat as well as light. . . .

Embedded in the uniform texture of Marden's paintings and drawings of this time was a palpable gestural force as insistent as that of the Abstract Expressionists. . . .

The combination of respectful ambition and genuine refinement found in Marden's work is the mark of a traditional painter. Unshaken by avant-garde attacks on his medium, the artist has sought to synthesize once divergent approaches to it, and so add to the still unfolding history of abstraction. . . . As with all purposefully traditional enterprises, the goal is not progress toward the unknown but fulfillment of an existing promise. The reward for such effort . . . is art of great stylistic fluency and beauty.

Richard Diebenkorn

Ocean Park 115. 1979
Illustrated on page 467

John Elderfield, *The Drawings of Richard Diebenkorn*, **1988**, pages 20–21, 41, 46, 51

[Diebenkorn] is essentially a pragmatist. Certain works of the Ocean Park series have evoked comparison to [Piet] Mondrian. But Diebenkorn is deeply suspicious of the transcendental. His geometry does not express some hidden, noumenal reality behind the external reality of things as they are. If Diebenkorn's work is, indeed, the product of his imagination engaged in active confrontation with reality, then he simply cannot entertain belief in any hidden reality. Such a "reality" would not be external to the artist but, rather, the projection of his imagination. This would make his work merely narcissistic: the product of his imagination confronting its own projection. Diebenkorn's work is autobiographical in the sense that every work tells of its own history and that many works tell of the artist's whole history up to the moment of their completion. But it is never just private, never bound up with its history; it does not create a secret world. Rather, the world that it shapes is chosen from the public domain. Even at its most abstract, it confronts the same external reality that we know too, a phenomenal, ever-changing reality, and reimagines it. And because reality is like this, the artist's work too must constantly change: not wildly or gratuitously (the point is not to rove about in the world but to imagine its multiple identities); rather, repetitively. "Notice that the classics went on redoing the same painting and always differently," one of Diebenkorn's most admired artists, [Henri] Matisse, once said. . . .

[T]he Ocean Park work is composed additively. In each, he builds networks of relationships. In doing so, however, he cancels relationships that do not seem meant. These do not "stay put" but are effaced and overlaid by new ones to a far greater extent and with greater frankness than obtained earlier. They are submerged, we might say, but not quite drowned by those that do not seem meant. For his works of the Ocean Park series—on paper and canvas alike—discover their definitive meanings not by destroying what seems less than definitive. The process of their creation cannot be halted to do that. Rather, the indefinite gradually concedes to the definite as the artist looks for "errors," as he put it, in what he makes. . . .

From the very beginning of his career, he was an instinctive colorist, and one most striking feature of his development has been the way that his color sense seems to blossom over the years. In the Ocean Park series, the sheer range not merely of color but of feeling evoked by color is extraordinary. But it is tonally controlled color. To look at the works on paper of the Ocean Park series, as well as at the paintings, is to see that he rarely composes purely from color, from the sheer juxtapositions of hues, rarely from juxtaposed, large areas at high density. Color, usually, is totally softened and scumbled. And when high-intensity colors appear, more often than not they cluster together in small, vivid segments at the sides of broad, open areas of unnameable hue, or they flash out from such areas, frequently between such areas. . . .

Diebenkorn's deepest feeling is not simply for space and light: when he lists these as his interests, he places mood between them. Neither is his feeling, finally, for place. It is, rather, for his own sense of place: he does not only look out on the world but examines his place in the world as he does so. The character of his art has always been so intimately related to the character of his environment that he could well say, with [John] Constable: "Still I should paint my own places best"—but only with the corollary, "Painting is with me but another word for feeling."

Romare Bearden

Patchwork Quilt. 1970
Illustrated on page 468

Carroll Greene, *Romare Bearden: The Prevalence of Ritual*, **1971**, page 4

In 1967, Bearden began to add generous amounts of color to his enlarged collages. . . . He often used colored paper and fabrics, or paper which he painted and then glued to the surface of the work. Since then his collages have become increasingly more sophisticated in color and design, less compressed, airier, and more elegant, beautifully exemplified in two works from 1970, *Patchwork Quilt* (The Museum of Modern Art) and *Mississippi Monday* (Shorewood Publishers). Here is an artist who truly enjoys the plasticity of his medium. In his mammoth effort to explore the formal elements of [African-American] life and to express its "innerness" visually, Bearden has not only chosen to deal with "black anguish," an undeniably pervasive element, to be sure, but also with a whole range of emotional shadings. "Art celebrates a victory," says Bearden; "I look for all those elements in which life expresses that victory." In America's technological society, increasing numbers of people feel that man is becoming dehumanized. Bearden holds that the life style of the black in America is "perhaps the richest because it is the one life style that is talking about life and about the continuation of life . . . and through all of the anguish—the joy of life." . . .

There are some persistent elements in Bearden's collage paintings—the train, the window, the moon, the haunting eyes of his people. Although Bearden abjures the idea of symbol in his work, he adds, "These [elements] should not be construed in a literary sense. Each painting envisions a world complete within itself."

Susan Rothenburg

Axes. 1976
Illustrated on page 470

Bernice Rose, *Allegories of Modernism: Contemporary Drawing*, **1992**, page 58

Susan Rothenberg works on the edge between the personal and the objective, using the mark and line quite literally as signs that oscillate between the two. Her multiplication of outline relates her to the tradition of [Paul] Cézanne; she uses outline as he did, to situate an object in space. That said, Rothenberg is not a neo-expressionist although her work is dominated by darting nervous marks and expressive line; her line is too distanced mechanistically from the emotion for which it is a sign to be expressionist. However her drawing is a direct expression through its medium of a personal viewpoint, and is in a sense "innocent" in that its distancing is a matter of necessity rather than of strategy. There is an authenticity and visible effort, a kind of morality of picture-making in Rothenberg's work, as she retains in the multiple outlines of her image the traces of her struggle to make the iconic figure (with its traditional figure-ground relationship) function in a nonhierarchical manner. The multiplication of strokes, of limbs and fractured bodily parts that are evidence of her struggle to make figure and ground equal, results in a seeing of other things on a less conscious level—an opening to the inside. There is a kind of phallic joking around, a kind of frenetic intensity, repressed except at the edges, and a trafficking between the expressed and the repressed that, together with her determination to resurrect painting, admits her work to distinctly contemporary concerns.

Philip Guston

Box and Shadow. 1978
Illustrated on page 471

Robert Storr, *Philip Guston in the Collection of The Museum of Modern Art*, **1992**, page 20

Almost a decade after *City Limits* Guston painted *Box and Shadow*, 1978, the symmetrical stillness of which seems the antithesis of the clamorously eventful [Ku Klux] Klan pictures. Divided into essentially monochromatic bars and bands, its background is expansive and nearly abstract, as if the artist had rendered Mark Rothko's or Barnett Newman's "sublime" in warm red mud. The lush oleaginous brushwork of Guston's late paintings is most evident here, especially in the monochrome areas where the artist was able to cut loose, confident that the uniform color would contain within its pictorial boundaries the tumult stirred by his hand. Closely examined, these areas show the full repertoire of his strokes; slathered zig-zags, suave sweeps, and dragged sticky pastes. Storyteller that he was, Guston understood that the best tales are those that resonate in the senses as well as in the mind, and so he rehearsed his gesture and extended its range like an actor practicing his lines in various vocal registers and at different volumes—from a dry whisper to a resounding laugh or a booming speech.

At the center foreground of *Box and Shadow* a spider is poised atop a nail-studded crate that casts a long evening shadow across a scorched wasteland. The location and contents of the box are unknown, as are the reasons for the spider being there. The choice and arrangement of symbols, recalling the hermetic still lifes of [Giorgio] de Chirico, are enigmas—impenetrable but therefore inexhaustible points of focus for speculation.

Gerhard Richter

Meadowland. 1985
Illustrated on page 475

Robert Storr, *Modern Art despite Modernism*, **2000**, pages 97–98

[Meadowland] is, despite its shimmering lights, not a landscape at all but a sign erected to block our view of other landscapes, a warning against the temptations of romantic vistas such as those painted by Caspar David Friedrich and his many imitators. Moreover, in these terms, Richter's *Self-Portrait* [see page 474] is, despite its haunting directness, not an image of a contingent being but an emblem that says this is not a portrait, this is a representation's cul–de–sac. Yet while it is true that

appearances can deceive—and perfectly reasonable to mistrust naïve versions of the picturesque or to maintain, as Alberto Giacometti did, that no mimetic device can capture the likeness of a sitter—Richter's images are too compelling, too vivid in their specific ambiguities, to be mere exercises in reflex disbelief. . . .

What keeps Richter moving, then, is not the drive to exhaust an attitude or procedure but the residue of unforeseen and indestructible experiences or meanings that remain after the artist's processes of painting and doubting are complete. Thus, as its look of perfect naturalness is smeared by Richter as he drags his brush over the first, sharply focused statement of his image, the almost kitsch postcard scene of *[Meadowland]* reveals an underlying beauty and answers to a genuine craving for such beauty. In a similar fashion, Richter's identity is partially exposed to us in *Self-Portrait* by the incomplete, painterly erasure of his photographic image. Instead of canceling one another out, each of Richter's apparently competing ways of making a picture follows the same rules, and each, at the point of extinguishing faith in the painter's art, revives it.

Gerhard Richter
Self-Portrait. 1996
Illustrated on page 474

Robert Storr, *Gerhard Richter: Forty Years of Painting*, **2002**, page 81

The countenance Richter offers the world in his 1996 *Self-Portrait* has a somewhat haunted aspect, although without the heightened emphasis on the eyes. . . . Indeed, Richter's glance off to the left side of the picture breaks with the tradition of self-portraiture in that he does not stare straight ahead, as into a mirror, and by thus breaking anticipated eye contact with himself and with the viewer, he creates distance, interrupts reflex empathy, and underscores the photographic dimension of the image. . . . Richter positions himself in front of a wall vertically divided into tonal zones that is bisected horizontally by his blue shirt, lending the symmetrical composition a spare formality reminiscent of the Spanish baroque realists Diego Velázquez and Francisco Zurbarán. The painting reminds one as well of the artist's early comments on the genre. "A portrait must not express anything of the sitter's 'soul,' essence, or character," Richter said. "Nor must a painter 'see' a sitter in any specific, personal way; because a portrait can never come closer to the sitter than when it is a very good likeness. For this reason, among others, it is far better to paint a portrait from a photograph, because no one can ever paint a specific person. . . . I never paint to create a likeness of a person or of an event. Even though I paint credibly and correctly, as if the likeness were important, I am really using it only as a pretext for a picture."[1] There is no melodrama in this self-portrait, but in the tension between his deadpan pose and the self-examination to which he submits himself much of the artist's character and something of his anxiety come through. In the tug-of-war in his own mind between the hidden motive for making a particular picture and its visible pretext, Richter's motionless but not quite emotionless face becomes the scene of the contest.

Bruce Nauman
Human/Need/Desire. 1983
Illustrated on page 476

Robert Storr, *On the Edge: Contemporary Art from the Werner and Elaine Dannheiser Collection*, **1997**, page 92

No other artist of his generation has been so insistent in the conceptual and psychological demands they make on the public, or so persistent and inventive in varying the form and tone in which those demands are made. Simply keeping track of the diversity of Nauman's output requires effort, while puzzling through the riddles of some pieces, or enduring the aggression of others, calls for an intellectual rigor and an emotional stamina that set a uniquely high standard for seriousness in contemporary art.

Like Samuel Beckett, an author he greatly admires, or Ludwig Wittengenstein, the philosopher of language whose writings define the basic terms for many aspects of his work, Nauman addresses complex issues with great economy. The essential questions—and Nauman's art consists of leading questions, with no unambiguous answers—are constant insofar as they concern eternal tensions between life and death, love and hatred, verifiable truth and gnawing existential doubt, yet to retain their resonance and urgency they are at the same time constantly in need of concise and exacting restatement. By videotape, by drawing, by sculpture, by installation, by neon, Nauman rephrases these questions in a hybrid contemporary idiom that for all its novel and sometimes daunting elements has been devised precisely in order to connect in as many ways as possible the thought of the artist with the experience of the viewer. Far from playing hard-to-get with his audience, Nauman seeks to involve people with hard-to-grasp ideas and hard-to-face uncertainties or ambivalences, and he is prepared to use any method—formal contradictions, verbal gymnastics, blunt declarations, disturbing images, raw humor—to push aside distractions, break down resistance, and make contact. Correspondingly, the unease

created by Nauman's all-out and all-fronts assault on his own and other people's mental habits expresses itself in many ways: recoil at the sight of an apparently grim object, confusion at the sight of an inexplicably abstract one, surprise at the intensity of sounds or lights, embarrassed laughter at a crude joke or cartoon. Whatever that discomfort's manifestation, however, its importance is the same. For Nauman, thinking is feeling. To do the one is to do, even to be impelled to do, the other.

Gilbert & George

Down to Earth. 1989
Illustrated on page 478

Robert Storr, *On the Edge: Contemporary Art from the Werner and Elaine Dannheisser Collection*, **1997**, page 46

Now known only by their linked first names, the artistic collaboration of Gilbert Proesch and George Passmore is thirty years old and ongoing. Both born into provincial–lower–middle–class families, the two men met for the first time at the St. Martin's School of Art in 1967. It was the heyday of "Swinging London"—of Carnaby Street fashion, British pop culture and rock music, and unprecedented social mixing and mobility in an imperial and tradition–bound nation. . . .

Whimsical reactionaries . . . during most of the past quarter century, Gilbert & George have gone on from these generally modest and often ephemeral early projects to elaborate an increasingly large–scaled genre of retro–Pop, embodied by the hand–tinted photomontages that have occupied them since 1980. Centered on their own dandified personae, these billboard–sized picture grids combine loud graphics, cinematic layouts, scatological sight gags, parodic references to revolutionary struggle and Socialist Realist art, frank but frequently playful homoerotic imagery (theirs is an all–male universe of comely proletarian boys idolized by primly bourgeois elders for whom the artists provide the models), religious kitsch, vestigial romanticism, and genuine longing for a decorous and well–tended England that has all but ceased to exist.

Gilbert & George's arch but ambiguously deadpan mode of address is fully evident in the photo–piece *Down to Earth* (1989). In it the two companions stand off–balance in the middle of a quaint village graveyard. But for the neon chiaroscuro in which it is bathed, this stereotypical setting could suit an English comedy of the 1960s, or an episode of the sort of period drama nowadays recycled by the BBC and *Masterpiece Theater*. Aggressively ordinary in appearance, as usual the "down to earth" everymen, Gilbert & George flank a subliminally phallic headstone. Behind them, enlarged self–portraits comically amplify their horror of ending up "down to earth," or under it. Accented by a stagy composition, garish hue, decorative floral detail, and mock expressionism, this composite image, like the ever expanding corpus to which it belongs, cast contemporary life in an uncanny and ironic light, as if [Andy] Warhol's irradiated silk–screen images had been filtered through the prisms of Gustave Moreau and the Pre-Raphaelites.

Wolfgang Laib

The Passageway. 1988
Illustrated on page 479

Paola Antonelli and **Laura Hoptman**, *Open Ends* exhibition brochure, **2000**

Over the past forty years, both artists and designers have enthusiastically experimented with materials unusual to their discipline, from the relatively conventional—industrial plastics and composite fibers—to the outlandish—foodstuffs like chocolate or rice flour. . . . Wolfgang Laib's *Passageway* (1988) [is] a corridor fashioned entirely from aromatic beeswax. Many art and design landmarks of the past several decades display the artists' and designers' delight in the unexpected creative freedom that new materials and techniques have afforded them. In both art and design, materials are chosen not only for their physical properties, but also for their metaphoric ones. Natural substances like wax, wood, and mud can allude to creation at its most elemental level, while highly artificial or industrial ones like fiberglass and aluminum set a more contemporary and progressive tone. Moreover, materials, old and new, can be tweaked and transformed in order to signify new directions, and reinvigorate old rebellions.

Richard Serra

Intersection, II. 1992
Illustrated on page 481

Robert Storr, *On the Edge: Contemporary Art from the Werner and Elaine Dannheisser Collection*, **1997**, pages 118, 119

Richard Serra, arguably one of the most innovative but also among the most widely commissioned and officially honored sculptors of his day, is a pure product of [the] institutionalization of a formerly insurgent modernism. While a student at Yale in the early 1960s, Serra, then still a painter, worked as [Josef] Albers's assistant,

and helped him to prepare his pedagogical masterwork, *The Interaction of Color*. As Serra's interest shifted toward sculpture, the example of Constantin Brancusi's reductive abstractions offered him an insight the influence of which can be seen in virtually all of his mature works: "What interested me about Brancusi's work," Serra has recalled, "was how he was able to imagine a volume with a line at its edge—in sum, the importance of drawings in sculpture." . . .

While fellow Minimalists such as Carl Andre developed Brancusi's ideas in the direction of standardized unit–by–unit composition, Serra explored the process–oriented manipulation of raw materials as a means of engendering new abstract forms. He enumerated these sculptural operations in "Verb List 1967–68," which begins, "to roll, to crease, to fold, to store, to bend, to shorten, to twist," and continues for another 101 entries. In this respect a systematizer like his mentor Albers, Serra looked still further back in the modernist past to Russian Constructivists of the teens and '20s, and to the interrupted artistic revolution they initiated and for a brief time installed in power under the aegis of the Soviet government. Before the 1960s, the Constructivists were often given short shrift in art history. The work of Serra and others of his generation who identified with their emphasis on industrial facture restored them to the center of discussion and debate. . . .

As a whole, Serra's work may be read as the delayed fulfillment of aesthetic hopes first raised shortly after the beginning of the century in a social and political situation almost diametrically opposed to that of America since the 1960s. From this perspective one may look at Serra's work as a radical reinterpretation of the radical propositions of the past. It is the task of the academy to conserve and transmit tradition; the challenge facing the avant–garde is to alter it fundamentally. Now that modernism has to a large extent become traditional, it is unsurprising that the avant–garde should be not only well served by the academy but in many ways at its service.

Ana Mendieta

Nile Born. 1984
Illustrated on page 484

Charles Merewether, in *Latin American Artists of the Twentieth Century*, **1993**, pages 145, 146

In site-specific works and performances created from the early 1970s until her tragic and untimely death in 1985, the Cuban–American artist Ana Mendieta addressed the violent experience entailed by the social formation of identity through displacement. Drawing on her personal experience of exile from her native Cuba

in 1961 at age thirteen, Mendieta's work also offers a general reflection on the collective identity of the colonial subject. Using the female body (initially her own) to configure woman and land as subjects of conquest, Mendieta shifted the location of meaning and identity from the fixity of an image or place (the body represented, or the land) to the actual process of inscription. Identity was posited as neither coherent nor given, and in such terms, the ephemeral, transient, and therefore unstable character of much of her work is central to understanding its significance.

Mendieta drew on Mexican and Afro–Cuban sources to explore the body as the ritual site of a history that encompasses the memory of the Catholic figure of the martyr, the servitude of the slave, or the state of exile of the runaway slave, or maroon. Her specific references to the Afro–Cuban religion of Santería are not claims to a lost identity, nor are they simply gestures toward her native land. Rather, she invoked Santería as she subjected the body to a process of symbolic healing and transformation, imbuing it with a vitality to embrace death and, ultimately, her ancestors. That process is a ritual of transition from one state to another. . . .

For Mendieta, union with the earth through her art was of paramount importance. She stated in 1981: "Through my earth/body sculptures I become one with the earth. . . . I become an extension of nature and nature becomes an extension of my body. This obsessive act of reasserting my ties with the earth is really the reactivation of primeval beliefs . . . [in] an omnipresent female force, the after–image of being encompassed within the womb."[1]

Alighiero e Boetti

Map of the World. 1989
Illustrated on page 487

Robert Storr, *Mapping*, **1994**, page 15

Geography was at the heart of Italian artist Alighiero e Boetti's personal and aesthetic concerns. Something of a vagabond, Boetti traveled to Afghanistan in 1970 and there made contact with local artisans, whom he commissioned to execute his conceptual designs in embroidered fabrics. Among the works produced in this manner were a series of small, square panels with block–letter images, and a large text-and-textile piece, *Tapestry of the Thousand Longest Rivers of the World* (1971–79, The Museum of Modern Art, New York). On one level, the piece is a straightforward geographic index, or gazetteer, on another it is a spatial fantasia in words. Boetti's maps, which vary in size but are consistent in layout, are also catalogues of a sort. Surrounded

by a uniform oceanic blue background are spread silhouetted continents, each of which is divided into its component countries, represented by flags cropped to fit their boundaries. Graphically, these maps are activated by the stress between the flags' alternately implosive and explosive designs and the breadth or density of the particular territories they stand for. (Conflating the two primary ways of representing the nation–state, its emblem and its contour, Boetti combined the devices separately dealt with by Jasper Johns in his map and flag works.) Resorting to tourist-trade craft, Boetti thus created philosophical souvenirs of global consolidation and countervailing nationalist separatism. Results of that dynamic already date them: the red banner of the Soviet Union no longer extends from Europe to Asia, and not a few small countries have fractured into yet smaller entities. *Mappa del mondo* (1989) is also, in retrospect, a *memento mori*. The last of the series, and unique among them, its background is black instead of blue.

Christopher Wilmarth
Self-Portrait with Sliding Light. 1987
Illustrated on page 485

Laura Rosenstock, *Christopher Wilmarth*, **1989**, page 10

Christopher Wilmarth's art drew above all else on his concern with the mystical and physical possibilities of light—on the ways in which light can evoke reverie and inner longings and generate varied sensations of space and containment. His poems, his prose descriptions of walking through New York City's streets toward its rivers and onto its bridges, indeed his entire artistic sensibility derived from his desire to express his experience of light. It is somewhat paradoxical that Wilmarth should have sought to suggest this immaterial world of light, and shadow, by combining massive industrial materials: plate glass, sheet steel, steel cable. Nonetheless, his sculpture is remarkable in its ability to convey his feelings for subtle modulations of light and shadow, and to intimate poetic, even romantic content through an austerely constructivist, geometric idiom.

Wilmarth transformed his raw materials by treating glass and steel in a manner associated more with a pictorial tradition. In the seventies, especially, he composed with planes of delicate color and light, placing cut–and–bent plates of dark, shadowy steel behind translucent sheets of etched glass imbued with a painterly surface and a luminous, greenish cast. He thought of his structures as "places," and he invested them with a human presence. That presence is implied either through the scale, shape, and vulnerability of the

work, or, with a more visible sense of self–reflexiveness, through the use of a symbolic ovoid form. Distinguished by their fusion of fragility and strength, these pieces transcend their visual beauty and open up a realm of meditation and imagination.

Doris Salcedo
Untitled. 1995
Illustrated on page 491

José Roca, *Latin American & Caribbean Art: MoMA at El Museo*, **2004**, pages 148, 150, 151

Salcedo's work has set out to make intelligible the effects of political violence in her native Colombia. Her sculptures, objects, and installations become memorials . . . by making visible the personal stories of individuals whom history disregards or scorns, bearing witness to "the tears in the fabric of history and the rupture about which history remains silent."[1] Through personal histories narrated by the survivors of tragedy, Salcedo re-creates the violent act by transferring it to the very objects (such as secondhand furniture or clothing) that are her subjects. The sculptural process involves the juxtaposition and effacement of their defining features, and the changes she effects render them dysfunctional, denying them the particular traces of humanity that are the result of their ergonomic characteristics and relationship with the body.[2] Each of these works is a response to a specific event and is dedicated to both victims and survivors. By particularizing the act on which the work is based, Salcedo goes against the grain of one of the most insidious aspects of contemporary violence: the silence to which the survivors are subjected out of fear of reprisal. To name each act is to differentiate it from other acts of violence and reclaim it from statistics, restoring its personal dimension.· . . . In this sense the central premise of Salcedo's work has been to bear witness to a violent act, through the voiceless traces that linger behind, so that the disgrace of forgetting does not compound the tragedy. . . .

An untitled work of 1995 in the MoMA collection is part of a long series Salcedo began at the beginning of the decade that juxtaposes pieces of household furniture to form monolithic sculptures. The bulk and volume of the sculptures are exacerbated by the use of concrete to fill the empty spaces within each piece of furniture, as well as the spaces between them, symbolically burying them and rendering them dysfunctional.[3] Like unfinished narratives of a terrible event, the individual works are organized in groups in an empty, architectonic space where they become silent installations of solemn restraint.[4]

455

Jeff Koons

New Shelton Wet/Dry Doubledecker. 1981
Illustrated on page 492

Robert Storr, *On the Edge: Contemporary Art from the Werner and Elaine Dannheisser Collection*, **1997**, page 76

No artist among the hectically cool "postmodernists" of recent decades has flirted more openly with commercialism than Jeff Koons, nor has anyone struck so steadfastly earnest a post in the endeavor. Unapologetically, indeed some say brazenly appropriating advertising strategies, off-the-shelf merchandise, and kitsch icons from the inventories of mass–marketers and carriage-trade purveyors, Koons—whose artistic preparation included a stint selling memberships at The Museum of Modern Art and another trading commodities on Wall Street—pursues his ambitions with missionary zeal. Self-appointed prophet of a heaven-on-earth of unashamed materialism and sexual bliss, Koons has gone Pop art one or two better, making an art of "the pitch" and "the deal," as well as art objects out of the flotsam and jetsam of consumer culture. . . .

Koons's enthusiasm for absurdly gaudy, expensive, and useless things mirrors the 1980s and 1990s bubble economy, when the middle class, which a generation before had merely been glad about its prosperity, became restlessly convinced that unlimited satisfaction of its overstimulated appetites was within reach. . . . The ultimate irony of Koons's position is that he does not own up to any irony, but instead proselytizes tastelessness with the moral fervor of a social reformer. Like [Andy] Warhol, whose impassive persona was an essential part of his work, Koons, the only real pretender to Warhol's throne and a patient explainer of his own inexplicably ugly but intensely desirable pictures and sculptures, never breaks character.

Producing and packaging his work in series and groups like a high-end retailer launching each year's "line," Koons has followed a simple but perverse strategy. Entitled *The New*, his one-person debut in 1980 presented an assortment of appliance-based works similar to *New Shelton Wet/Dry Double Decker* (1981). . . . It is in Koons's pursuit of technical perfection in re-creating inherently debased prototypes—his expenditure of untold labor on intrinsically worthless albeit mentally indelible forms and images, to which he assigns exorbitant value—that the essential morbidity and despair of his ostensibly "feel-good" art shows through. Banking on the built-in obsolescence of most of what contemporary industry and culture disgorge, Koons harbors the old-fashioned hope that his work, though poetically stillborn, will endure for the ages. "My objects, maybe not in a traditional sense art, last longer than you or myself. Maybe they'll die off as art, but they are equipped to outsurvive us physically."

Gary Hill

Inasmuch As It Is Always Already Taking Place. 1990
Illustrated on page 493

Barbara London, *Video Spaces: Eight Installations*, **1995**, pages 22, 23

The first time Gary Hill arrived to install *Inasmuch As It Is Always Already Taking Place* (1990) at a museum, he brought close–ups of a body recorded on forty different video loops. He selected sixteen to play on individual rasters—monitors stripped of their outer casings. The rasters, ranging in size from the eyepiece of a camera to the dimensions of an adult rib cage, were set on a shelf recessed five feet into the wall, slightly below eye level. Hill ran each loop on a screen that matched the size of the particular section of the body recorded on the tape. As he positioned the monitors, moving them around with the objectivity of a window dresser, it seemed he was actually handling parts of a living body: a soft belly that rose and fell with each bre'th, a quadrant of a face with a peering eye like that of a bird warily watching an interloper.

The components of the body displayed in *Inasmuch*—Hill's own—are without any apparent distinction. Neither Adonis nor troll, neither fresh nor lined with age, suits the endless loops, suggesting that it exists outside of time, without past or future.

The arrangement of the rasters does not follow the organization of a human skeleton. Representations of Hill's ear and arched foot lie side by side; tucked modestly behind them is an image of his groin. Within his unassuming configuration, each raster invites meditation. . . .

Although none of its segments are "still," the installation has the quality of a still life. . . . *Inasmuch* has most in common with a *vanitas*, a category of still life in which the depicted objects are meant to be reminders of the transience of life. In place of the usual skull and extinguished candle, *Inasmuch* depicts an animate being whose vulnerability underscores the mortality of flesh. . . .

Inasmuch recalls an age when art was thought to be an illusion, a trick played on the senses. Here, the images are not illusory, but time itself is hidden from the viewer, in the way that segments of time are made to appear limitless. In folding time back on itself, a seemingly simple concept, Hill has fashioned a creature whose humanness poses an existential challenge.

Rachel Whiteread

Water Tower. 1998
Illustrated on page 494

Rachel Whiteread, Acoustiguide recording for the exhibition *Open Ends*, **2000**

About five years ago, the Public Art Fund in New York asked me if I'd come over to New York and make a site-specific piece on the ground, in a street in New York. So I came over to New York and after giving it probably about two years of thought and an awful lot of wandering around, I decided that I didn't know the city well enough, and I also didn't feel that there was any need to put any more chaos on the ground in New York, and I certainly didn't think it needed a public sculpture by a London artist. . . . [O]ne of my first times in America I noticed the water towers on the rooftops of New York City and I enjoyed these objects; I didn't really know what they were, didn't really know why they were there, but as these weird wooden barrel-like objects that sat on top of many rooftops in very awkward ways. It occurred to me that they were like part of the furniture of the city, sort of street benches or, they're just something that just sat there that no one really took much notice of. I decided, I suppose because you know it's something that I often do is try and give those places and spaces that have never really had a place in the world some authority and some sort of voice.

So I decided that what I wanted to do was to cast one of these water towers in a clear resin. I wanted to make a jewel on the skyline of Manhattan. So it's a single clear plastic casting of a full-sized water tower that sat on the roof on the corner of West Broadway and Grand Street, on a dunnage. I had originally thought of making this piece solid but that's technically impossible. So we had to make it empty, so the whole thing is a skin of about four inches all the way around. And it has the texture of the inside of the water tower, so it's really about solidifying water and trying to make this water look like it's frozen in a moment of time. It's like the actual water tower has been stripped away and there's this solid water left behind. And using a material which was completely in tune with the weather so it could take on its surroundings, so on a white day you could hardly see it; on a blue day, it glowed; it kind of disappears at night time, it just becomes like a sort of smudge. And if the moon is bright, it just caresses the side of it and it just completely takes on its environment and becomes part of the sky, which is what I had always intended.

Cai Guo-Qiang

Borrowing Your Enemy's Arrows. 1998
Illustrated on page 495

Fereshteh Daftari, in *Modern Contemporary: Art at MoMA since 1980*, **2000**, pages 513, 515

In the last two decades, the escalating interconnections throughout the world have made "globalization" a master concept and a key term. An expanding market economy and thickening net of communication have touched, and often altered, an exceptionally broad range of cultures, traditions, and practices. . . .

Contemporary artists often cross cultural boundaries, and have been implicated in and attentive to . . . changes and debates. Their traffic within the networks of globalization is multidirectional. Western artists, . . . by immersing themselves in the cultures of the past, have reaffirmed a familiar linkage between modern art's dominant centers and formerly peripheral cultures. But other artists, of non-Western origin, have also created more complex and unprecedented hybrids in their physical and in their spiritual "residences." Transition has been the order of the day, shuttling between a variety of global terms and an equal mix of local identities. . . .

Cai Guo-Qiang . . . was born in Quanzhou, in the Fujian province of China . . . *Borrowing Your Enemy's Arrows* [is] a sculpture that embodies a metaphor for cross-cultural exchange. The work is built on the skeleton of an old fishing boat, excavated near the port where the artist began his personal journey. Bristling with 3,000 arrows designed by the artist, and fabricated in his native city, the ship flies the flag of contemporary China, but refers to the nation's deeper history. Historical texts recount how General Zhuge Liang, lacking ammunition in the face of a heavily armed enemy, was ordered to procure 100,000 arrows in ten days. The legend recounts that, on a foggy night, the general sent a boat loaded with bales of straw across the river, toward his foes. When the enemy had fired volley after volley of arrows at this decoy, the general pulled it back, full of a captured store of fresh ammunition. One subject of the sculpture, then, is how culture may appropriate and transform foreign intrusions into a defensive strategy. . . .

Hybridization is no absolute novelty, but until now only Western artists . . . have received attention, at the expense of Third World artists grappling with the mainstream. The brand new spotlight currently focused on the many individual "creole" languages of various artists may represent nothing more than a trendy thirst for exoticism. Globalization . . . raises a host of unresolved questions, and a globalized field of art poses similar conundrums. Are the borrowings from and minglings of

references from marginalized cultures only a savvy strategy of "niche marketing," bound eventually to exhaust the freshness of their appeal, or are they the signal of a growing wave of art that will render obsolete many of the frontiers, boundaries, and self-enclosed traditions that have been so determining? Is this a phenomenon of greater tolerance of expanded diversity, or only the cloak for an increasing homogenization? . . . Fluency in the language of Western art has been the requisite for access to the global sphere of exhibitions, museums, galleries, and journals. It may be fair, then, to wonder whether, in the process of featuring and enabling difference, the new art world is ultimately weakening the authority of any zone of resistance, such as those artists who choose not to speak in the current vernacular of the marketplace.

Bill Viola

Stations. 1994
Illustrated on page 496

Barbara London, *Bill Viola: Installations and Videotapes*, **1987**, page 9

For more than sixteen years Bill Viola has consistently used the most contemporary electronic technologies to create deceptively spare, provocative videotapes and video–and–sound installations that pursue an ancient theme: the revelation of the layers of human consciousness. Although based on realistic images, his projects go beyond representation to challenge the viewer's preconditioned expectations and viewing patterns. His work, which derives from a combination of the highly rational and the deeply intuitive, probes many levels of experience. "The real investigation is of life and being itself," Viola has said. "The medium is just the tool in this investigation."[1]

Viola gives painstaking attention to his subjects, both natural and man-made, so that the results invariably have a resplendence, depth of spirit, and intensity that make them indisputably his. He handles his recorded images in a straightforward manner; the primary special effects he employs involve slowing down, reversing, or speeding up time. This directness extends to his editing, which is as concise as it is precise: nothing is extraneous and very little is left to chance. Although his works reflect his extraordinary control, during recording he will accept the serendipitous action occurring in front of the camera, which heightens the energy of the completed piece. Because Viola is exceptionally skillful with and knowledgeable about broadcast–quality video equipment—to the extent that he operates the hardware with what appear to be reflex actions—he is free to be creative during production. He works alone, without needing the assistance of a technical middleman, so each project remains an expression of his personal vision.

Felix Gonzalez-Torres

"Untitled" (Perfect Lovers). 1991
Illustrated on page 497

Deborah Cullen, *Latin American & Caribbean Art: MoMA at El Museo*, **2004**, page 141

Gonzalez-Torres used simple, common materials—often readymades composed of mass–produced items—to create intimate works about memory, loss, love, and sexuality. His work was seen as potently political yet subtle and very personal. Informed by a brand of gentle, humanistic conceptualism, Gonzalez-Torres employed a latterday Minimalist language in the service of a somewhat activist liberal agenda. His work was generous, engaging the viewer in his projects. He became internationally renowned for poignant public billboards, humble images (a hand, a bed, clouds) that evoked social commentary without didacticism; his most revered installations consisted of stacks of offset prints, or piles of foil–wrapped candies to which spectators could help themselves. During a time of raging debates over identity and sexuality, and of fury over the lack of action to fight the devastating AIDS pandemic, Gonzalez-Torres's work was provocative, sincerely emotional, and intelligent. It was poetic yet coolly urbane, and a part of its deeply felt resonance was perhaps due to the human warmth and romantic space for possibility that it offered in angry times. . . .

Gonzalez-Torres's works were economical in means yet profoundly moving. *"Untitled" (Perfect Lovers)* (1987–90, 1991),[1] for example, comprises two identical, abutting, battery–operated, black–and–white Seth Thomas clocks. The neutral units of measure are transformed through their redundancy and composition into a meditation on human connection, mortality, and time's savage inevitability. The work evokes two human heads—perhaps of the same sex—nuzzling together as fleeting minutes tick past. Andrea Miller–Keller has described the work as "a metaphor for two bodies and souls linked by love who understand that at some future date one will 'run down' before the other. . . . The regulation black rim around each clock takes on new meaning when the clocks are understood in this context: the rim becomes a black border signifying that mourning and grief are unavoidable in the natural ebb and flow of life. . . . Not incidentally, their black outlines together combine to form an infinity sign."[2]

"anarchitectural" enterprise to today's audience. The work is the result of Matta-Clark's cutting of the facade of a condemned house in Niagara Falls, New York, a project sponsored by a program called Artpark in nearby Lewiston. First, Matta-Clark gridded the red-shingled facade into nine sections, each five by nine feet in size. He then removed all the sections except the center one, which remained on the house like the central section of a Bingo game card. Minutes after Matta-Clark finished his extraction, the house was razed. The artist decided to save only three of the sections, and arranged them in the present configuration for display at the John Gibson Gallery in Soho in autumn 1974. The triadic compositional structure of *Bingo* reveals Matta-Clark's highly formal artistic sensibility, richly evocative of the work of predecessors such as [Kurt] Schwitters and [Robert] Rauschenberg. Its stateliness belies, and elevates, its humble origin as vernacular architecture. The psychological power of the piece stems in part from its double-sided nature. The shingled front is the public face of a house; the back is the private face, with its traces of stairway, walls, and rooms deeply resonant of the history of lives lived and years passed.

Untitled (Contemporary)

Sigmar Polke | (GERMAN, BORN 1941)
WATCHTOWER. 1984
SYNTHETIC POLYMER PAINTS, DRY PIGMENT AND OILSTICK ON
VARIOUS FABRICS, 9' 10" x 7' 4½" (300 x 224.8 CM)
FRACTIONAL GIFT OF JO CAROLE AND RONALD S. LAUDER, 1991

Anselm Kiefer | (GERMAN, BORN 1945)
WOODEN ROOM. 1972
CHARCOAL AND OIL ON BURLAP, 9' 10" x 7' 2½" (299.7 x 219.7 CM)
FRACTIONAL AND PROMISED GIFT OF THE JERRY AND EMILY SPIEGEL
FAMILY FOUNDATION, INC., 2001

463

Blinky Palermo | (GERMAN, 1943–1977)
UNTITLED. 1970
DYED COTTON MOUNTED ON MUSLIN, 6' 6¼ x 6' 6¼" (200 x 200 CM)
GIFT OF JO CAROLE AND RONALD S. LAUDER, 1997

Jackie Winsor | (AMERICAN, BORN CANADA, 1941)
BOUND SQUARE. 1972
WOOD AND TWINE, 6' 3½" x 6' 4" x 14½" (191.8 x 193 x 36.8 CM)
JOSEPH G. MAYER FOUNDATION, INC., IN HONOR OF JAMES THRALL SOBY
AND GRACE M. MAYER FUND IN HONOR OF ALFRED H. BARR, JR., 1974

465

Brice Marden | (AMERICAN, BORN 1938)
GROVE GROUP, I. 1973
OIL AND WAX ON CANVAS, 6' x 9'1⅛" (182.8 x 274.5 CM)
TREADWELL CORPORATION FUND, 1973

Richard Diebenkorn | (AMERICAN, 1922–1993)
OCEAN PARK 115. 1979
OIL ON CANVAS, 8' 4" x 6' 9" (254 x 205.6 CM)
MRS. CHARLES G. STACHELBERG FUND, 1979

467

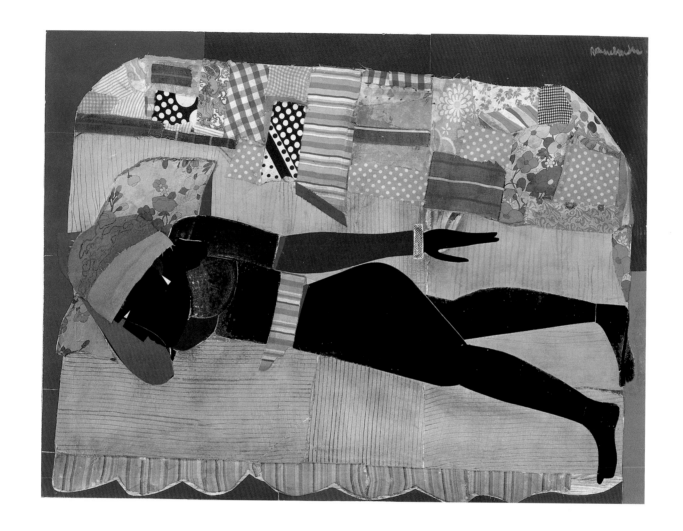

Romare Bearden | (AMERICAN, 1914–1988)
PATCHWORK QUILT. 1970
CUT-AND-PASTED CLOTH AND PAPER WITH SYNTHETIC PAINT
ON COMPOSITION BOARD, 35¼ x 47⅞" (90.9 x 121.6 CM)
BLANCHETTE ROCKEFELLER FUND, 1970

Malcolm Morley | (AMERICAN, BORN
GREAT BRITAIN, 1931)
THE DAY OF THE LOCUST. 1977
OIL ON CANVAS, 7' 10⅛" x 7' 6½" (239.3 x 199.5 CM)
THE BERNHILL FUND, ENID A. HAUPT AND SID R. BASS FUNDS, 1987

469

Susan Rothenberg | (AMERICAN, BORN 1945)
AXES. 1976
SYNTHETIC POLYMER PAINT, GESSO, CHARCOAL, AND PENCIL
ON CANVAS, 64⅛" x 8' 8⅞" (164.2 x 266.4 CM)
PURCHASED WITH THE AID OF FUNDS FROM THE NATIONAL
ENDOWMENT FOR THE ARTS, 1977

Philip Guston | (AMERICAN, BORN CANADA. 1913–1980)
BOX AND SHADOW. 1978
OIL ON CANVAS, 69⅛" x 8' 2⅛" (175.6 x 250.5 CM)
GIFT OF MUSA GUSTON, 1991

471

Howard Hodgkin | (BRITISH, BORN 1932)
RED BERMUDAS. 1978–80
OIL ON WOOD, 27⅛ x 27⅛" (70.5 x 70.5 CM)
GIFT OF MR. AND MRS. GERRIT LANSING, 1981

Elizabeth Murray | (AMERICAN, BORN 1940)
PAINTERS PROGRESS. Spring 1981
OIL ON CANVAS, IN NINETEEN PARTS, OVERALL 9' 8" x 7' 9" (294.5 x 236.2 CM)
ACQUIRED THROUGH THE BERNHILL FUND AND GIFT OF AGNES GUND, 1983

473

Gerhard Richter | (GERMAN, BORN 1932)
SELF-PORTRAIT. 1996
OIL ON LINEN, 20 x 18¼" (51.1 x 46.4 CM)
GIFT OF JO CAROLE AND RONALD S. LAUDER AND COMMITTEE
ON PAINTING AND SCULPTURE FUNDS, 1996

Gerhard Richter
MEADOWLAND. 1985
OIL ON CANVAS, 35⅝ x 37½" (90.5 x 94.9 CM)
BLANCHETTE ROCKEFELLER, BETSY BABCOCK, AND
MRS. ELIZABETH BLISS PARKINSON FUNDS, 1985

475

Bruce Nauman | (AMERICAN, BORN 1941)
HUMAN/NEED/DESIRE, 1983
NEON TUBING, TRANSFORMER, AND WIRES,
7' 10⅛" x 70½" x 25¼" (239.8 x 179 x 65.4 CM)
GIFT OF EMILY AND JERRY SPIEGEL, 1991

Scott Burton | (AMERICAN, 1939–1989)
PAIR OF ROCK CHAIRS. 1980–81
GNEISS, 49⅛ x 43½ x 40" (125.1 x 110.5 x 101.6 CM) AND
44 x 66 x 42½" (111.6 x 167.7 x 108 CM)
ACQUIRED THROUGH THE PHILIP JOHNSON, MR. AND MRS.
JOSEPH PULITZER, JR., AND ROBERT ROSENBLUM FUNDS, 1981

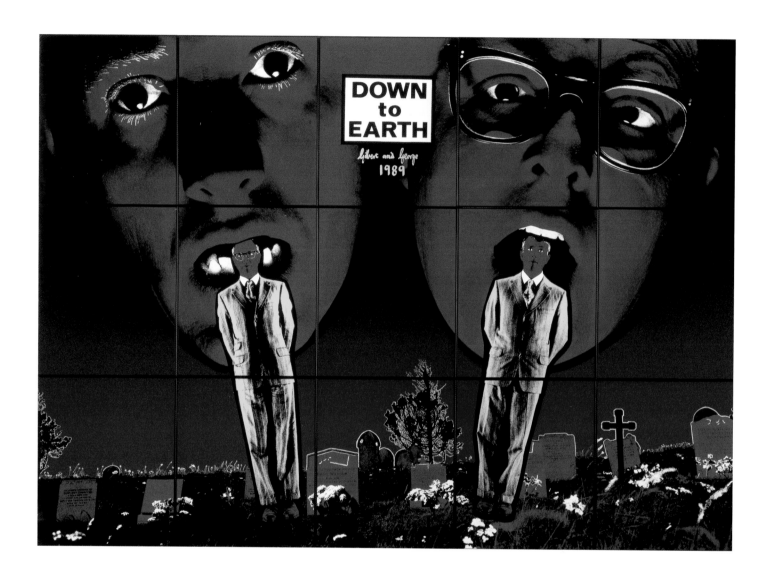

Gilbert & George | (BRITISH)
DOWN TO EARTH. 1989
HAND-COLORED PHOTOGRAPHS WITH INK AND DYES,
MOUNTED AND FRAMED, EACH PHOTOGRAPH 29¾ x 25"
(74.9 x 63 CM), OVERALL 7' 4½" x 10' 5" (224.8 x 317.5 CM)
GIFT OF WERNER AND ELAINE DANNHEISSER, 1996

Wolfgang Laib | (GERMAN, BORN 1950)
THE PASSAGEWAY. 1988
BEESWAX, AND WOOD CONSTRUCTION WITH TWO ELECTRIC LIGHT
BULBS, INTERIOR DIMENSIONS, 10' 11⅜" x 6' 1½" x 18' 9¼"
(333.6 x 86.6 | x 572.1 CM), EXTERIOR DIMENSIONS VARIABLE
COMMITTEE ON PAINTING AND SCULPTURE FUNDS, 1995

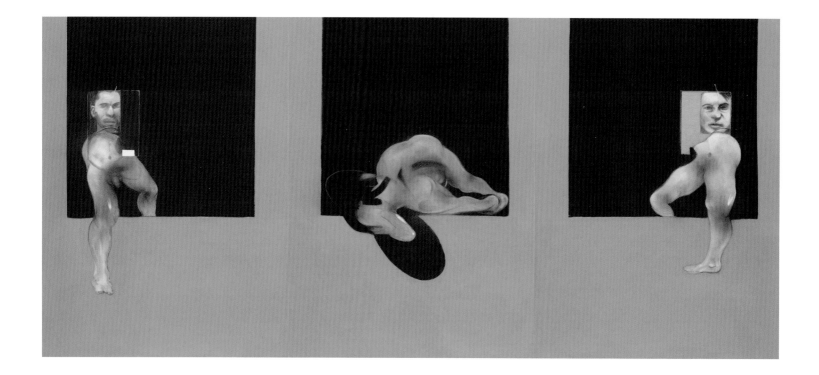

Francis Bacon | (BRITISH, 1909–1992)
TRIPTYCH. 1991
OIL ON LINEN, THREE PANELS, EACH PANEL
6' 6" x 58⅛" (198.1 x 147.6 CM)
WILLIAM A. M. BURDEN FUND AND NELSON A.
ROCKEFELLER BEQUEST FUND (BOTH BY EXCHANGE), 2003

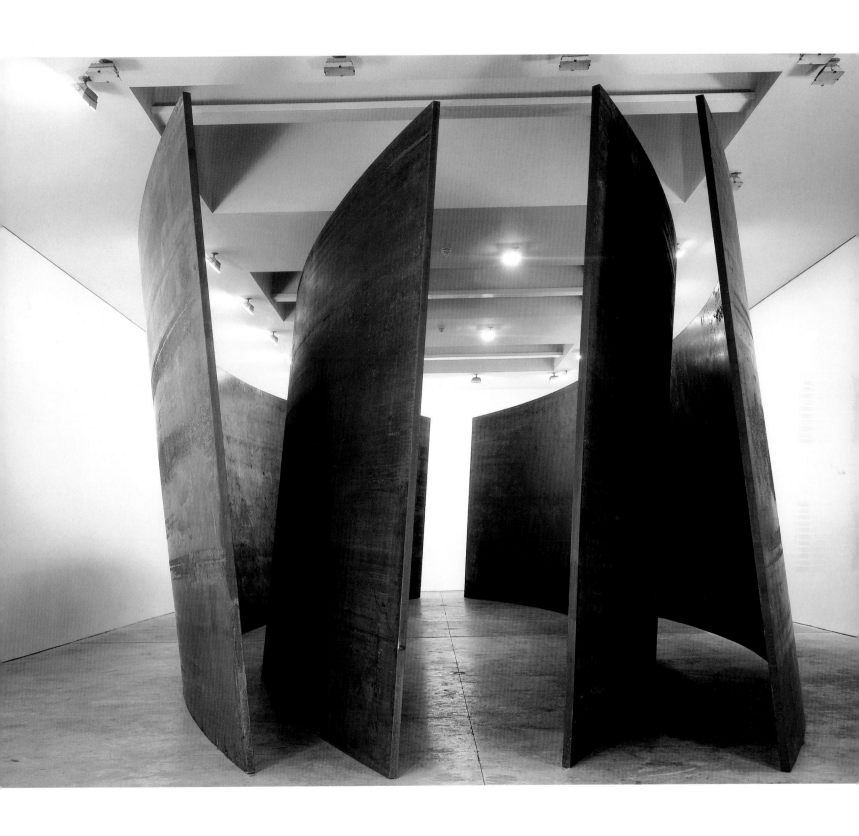

Richard Serra | (AMERICAN, BORN 1939)
INTERSECTION II. 1992
COR-TEN STEEL, FOUR PLATES, EACH 13' 1⅛" x
55' 9¾" x 2" (400 x 1700 x 5 CM)
GIFT OF RONALD S. LAUDER, 1998

Gego (Gertrude Goldschmidt) | (VENEZUELAN, BORN GERMANY. 1912–1994)
DRAWING WITHOUT PAPER. 1988
ENAMEL ON WOOD AND STAINLESS STEEL WIRE, 23⅝ x 34⅝ x 16¼" (60 x 88 x 40 CM)
FRACTIONAL AND PROMISED GIFT OF PATRICIA PHELPS DE CISNEROS IN HONOR OF SUSAN AND GLENN LOWRY, 2004

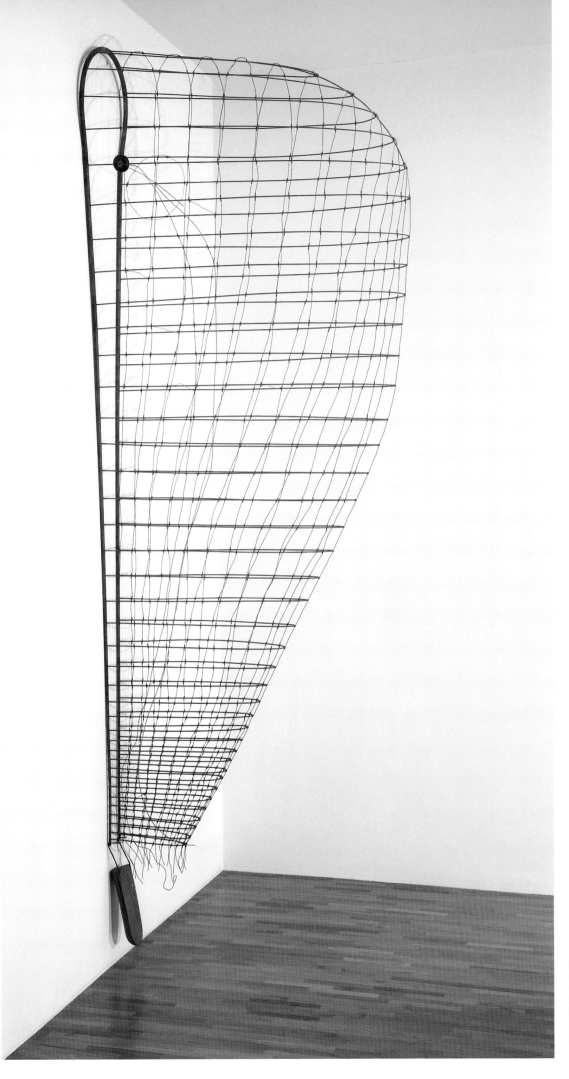

Martin Puryear
(AMERICAN, BORN 1941)
GREED'S TROPHY. 1984
STEEL ROD AND WIRE, WOOD,
RATTAN, AND LEATHER, 12' 9" x
20" x 55" (388.6 x 50.8 x 139.7 CM)
DAVID ROCKEFELLER FUND AND
PURCHASE, 1984

483

Ana Mendieta | (AMERICAN, BORN CUBA. 1948–1985)
NILE BORN. 1984
SAND AND BINDER ON WOOD, 2¾ x 19¼ x 61½" (7 x 48.9 x 156.2 CM)
GIFT OF AGNES GUND, 1992

Sherrie Levine | (AMERICAN, BORN 1947)
BLACK NEWBORN. 1994
CAST AND SANDBLASTED GLASS, 5 x 8" (12.7 x 20.3 CM)
PURCHASE, 2004

Alighiero e Boetti | (ITALIAN, 1940–1994)
MAP OF THE WORLD. 1989
EMBROIDERY ON FABRIC, 46½" x 7' 3½" x 2"
(117.5 x 227.7 x 5.1 CM)
SCOTT BURTON FUND, 1999

Anish Kapoor | (INDIAN, BORN 1954)
A FLOWER, A DRAMA LIKE DEATH. 1986
POLYSTYRENE, PLASTER, CLOTH, GESSO, AND RAW
PIGMENT, THREE PARTS, OVERALL APPROXIMATELY
22" x 11' 8" x 60" (55.8 x 355.6 x 152.4 CM)
SID R. BASS FUND, 1987

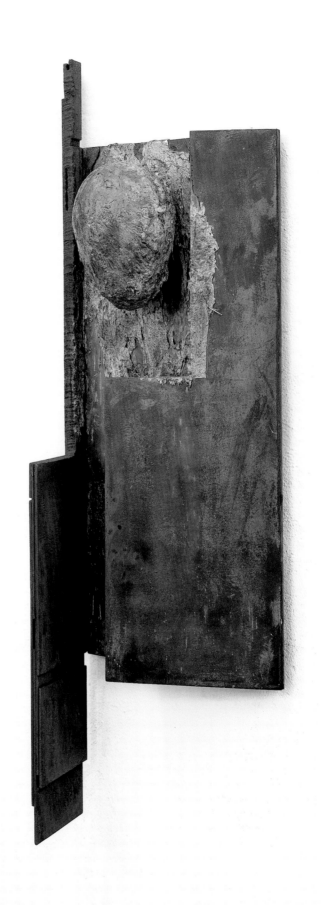

Christopher Wilmarth | (AMERICAN,
1943–1987)
SELF-PORTRAIT WITH SLIDING LIGHT. 1987
STEEL, BRONZE, AND LEAD, 53⅛ x 16⅞ x 7¼"
(136.2 x 42.8 x 18.4 CM)
GIFT OF SUSAN WILMARTH, 1996

Vija Celmins | (AMERICAN, BORN 1939)
NIGHT SKY #5. 1992
OIL ON CANVAS MOUNTED ON WOOD PANEL,
31 x 37½" (78.7 x 95.3 CM)
PARTIAL AND PROMISED GIFT OF UBS, 2002

James Turrell | (AMERICAN, BORN 1943)
A FRONTAL PASSAGE. 1994
FLUORESCENT LIGHT, MUSEUM INSTALLATION,
12' 10" x 22'6" x 34' (391.2 x 685.8 x 1036.3 CM)
DOUGLAS S. CRAMER, DAVID GEFFEN, ROBERT AND
MERYL MELTZER, MICHAEL AND JUDY OVITZ, AND
MR. AND MRS. GIFFORD PHILLIPS FUNDS, 1994

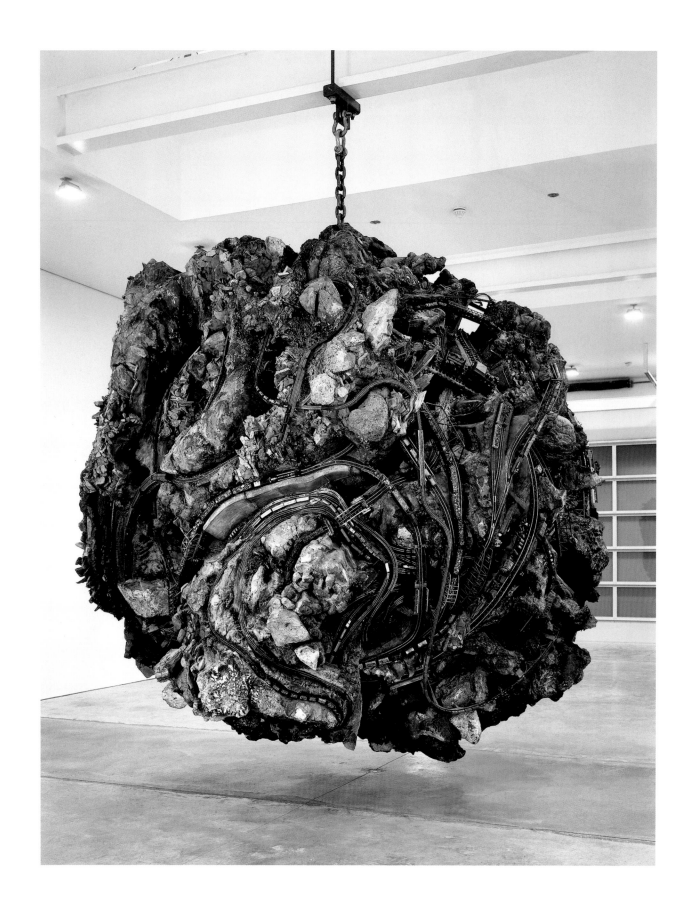

UNTITLED (CONTEMPORARY)

Chris Burden | (AMERICAN, BORN 1946)
MEDUSA'S HEAD. 1989–92
PLYWOOD, STEEL, CEMENT, ROCK, FIVE GAUGES MODEL
RAILROAD TRACK, AND SEVEN SCALE-MODEL TRAINS,
14' (426.7 CM) IN DIAMETER
GIFT OF SID AND MERCEDES BASS, 2000

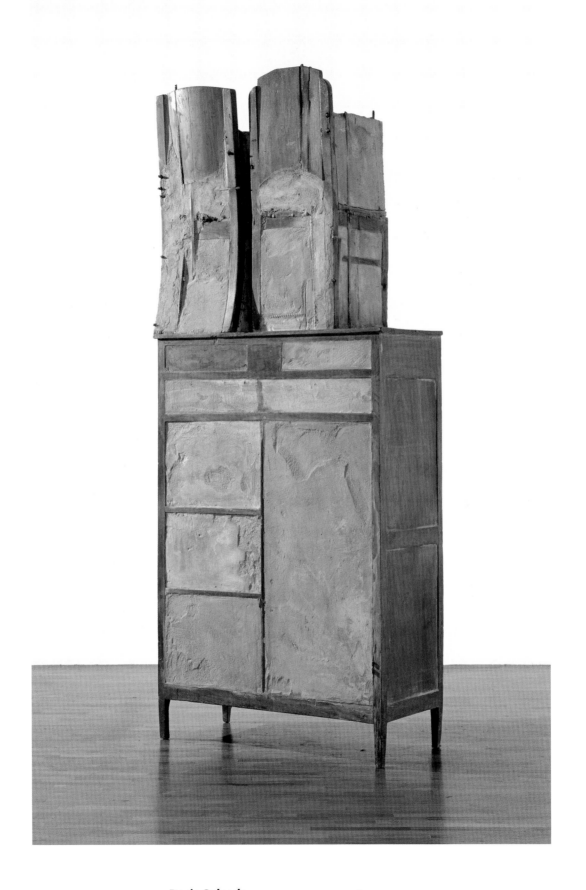

Doris Salcedo | (COLOMBIAN, BORN 1958)
UNTITLED. 1995
WOOD, CEMENT, STEEL, CLOTH, AND LEATHER, 7' 9" x 41" x 19" (236.2 x 104.1 x 48.2 CM)
THE NORMAN AND ROSITA WINSTON FOUNDATION, INC. FUND AND PURCHASE, 1996

491

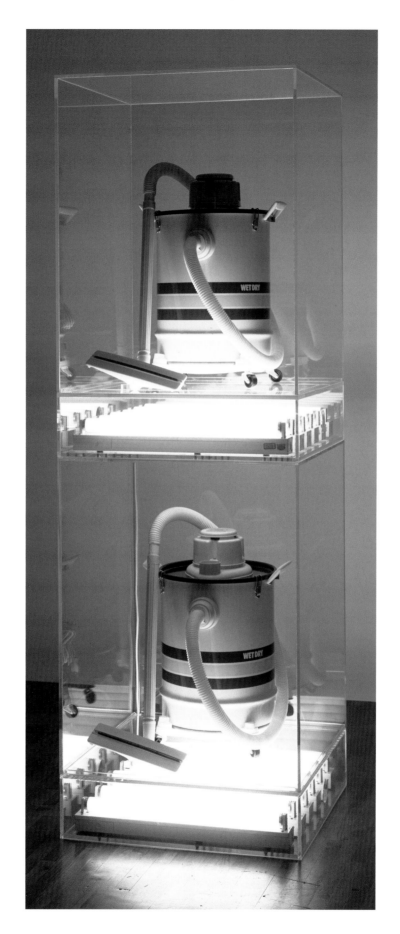

Jeff Koons | (AMERICAN, BORN 1955)
NEW SHELTON WET/DRY DOUBLEDECKER 1981
VACUUM CLEANERS, PLEXIGLASS, AND FLUORESCENT
LIGHTS, 8'⅛" x 28" x 28" (245.4 x 71.1 x 71.1 CM)
GIFT OF WERNER AND ELAINE DANNHEISSER, 1996

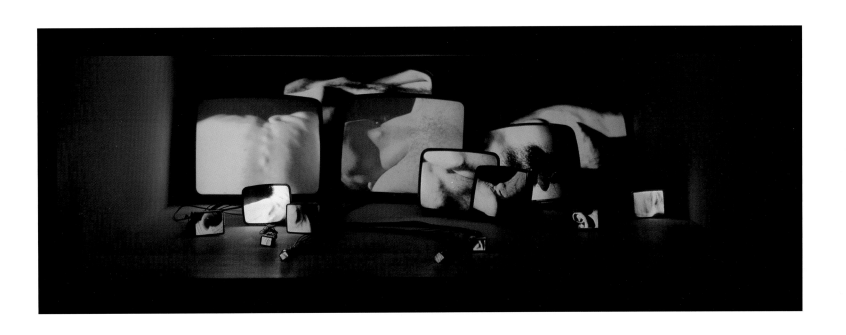

Gary Hill | (AMERICAN, BORN 1951)
INASMUCH AS IT IS ALWAYS ALREADY TAKING PLACE. 1990
SIXTEEN-CHANNEL VIDEO/SOUND INSTALLATION: SIXTEEN MODIFIED
MONITORS RECESSED IN A WALL 42" (106.7 CM) FROM THE FLOOR;
OVERALL 16 x 53⅜ x 68" (40.6 x 136.5 x 172.7 CM).
GIFT OF AGNES GUND, MARCIA RIKLIS, BARBARA WISE AND MARGOT
ERNST, AND PURCHASE (HELD JOINTLY WITH THE DEPARTMENT OF
FILM AND MEDIA), 1997

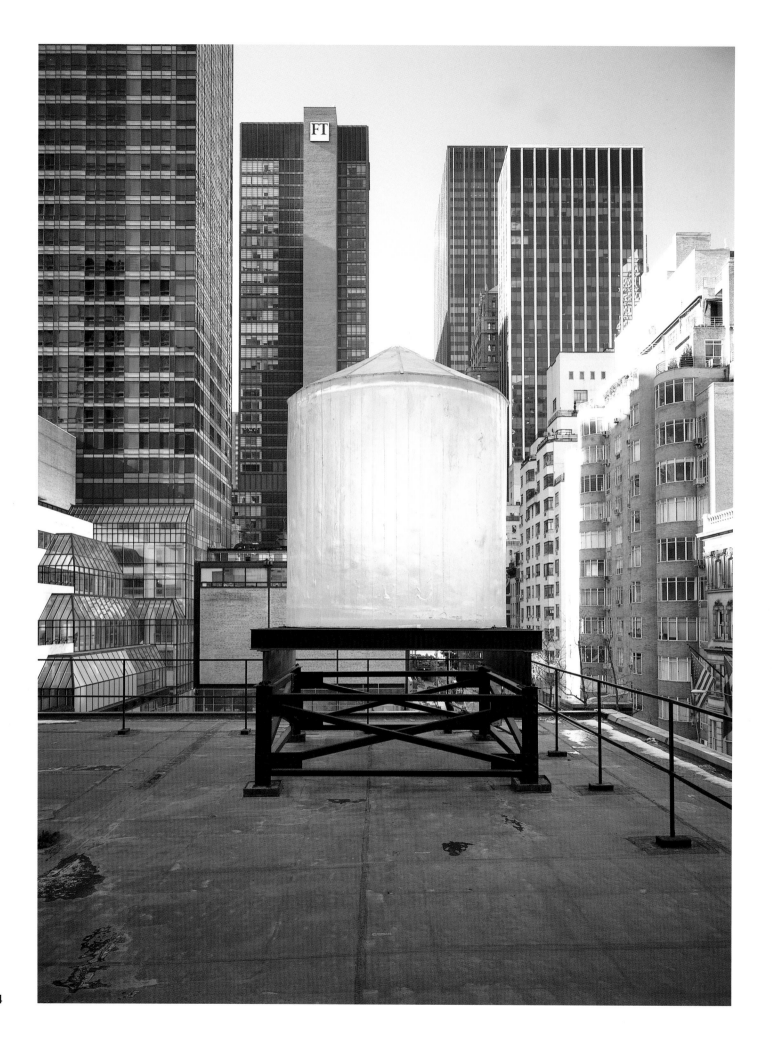

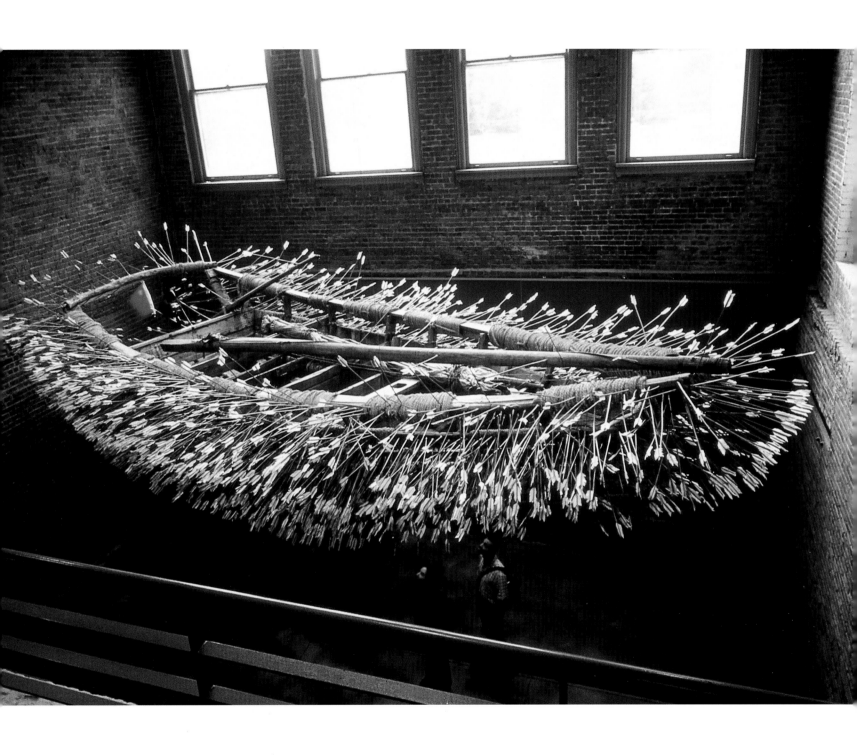

Rachel Whiteread | (BRITISH, BORN 1963)
WATER TOWER. 1998
TRANSLUCENT RESIN AND PAINTED STEEL, 12' 2" (370.8 CM)
HIGH x 9' (274.3 CM) IN DIAMETER
GIFT OF THE FREEDMAN FAMILY IN MEMORY OF DORIS C.
AND ALAN J. FREEDMAN, 1999

Cai Guo-Qiang | (CHINESE, BORN 1957)
BORROWING YOUR ENEMY'S ARROWS. 1998
WOOD BOAT, CANVAS SAIL, ARROWS, METAL, ROPE, CHINESE FLAG, AND
ELECTRIC FAN, BOAT APPROXIMATELY 60" x 23' 7 x 7'6" (152.4 x 720 x
230 CM), ARROWS APPROXIMATELY 24" (62 CM)
GIFT OF PATRICIA PHELPS DE CISNEROS IN HONOR OF GLENN D. LOWRY, 1999

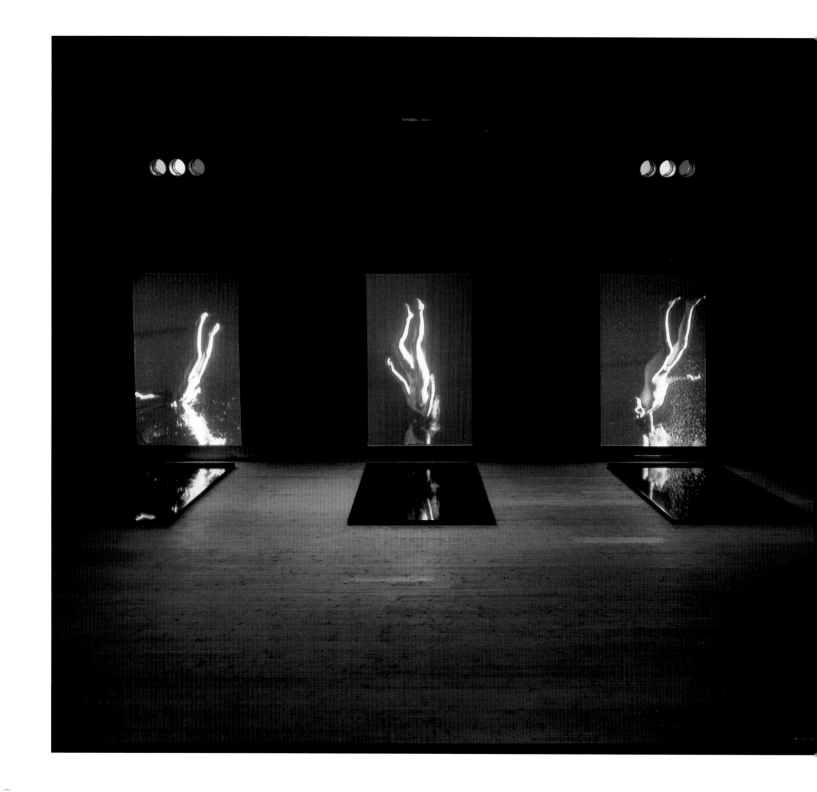

Bill Viola | (AMERICAN, BORN 1951)
STATIONS. 1994
FIVE-CHANNEL VIDEO/SOUND INSTALLATION WITH FIVE
GRANITE SLABS, FIVE PROJECTORS, AND FIVE PROJECTION
SCREENS, EACH SLAB 5' 10" x 9' 3" x ¼" (177.8 x 282 x 6 CM);
EACH SCREEN 5' 10" x 9' 3" (177.8 x 282 CM)
GIFT OF THE BOHEN FOUNDATION IN HONOR OF RICHARD E.
OLDENBURG (HELD JOINTLY WITH THE DEPARTMENT OF FILM
AND MEDIA), 1997

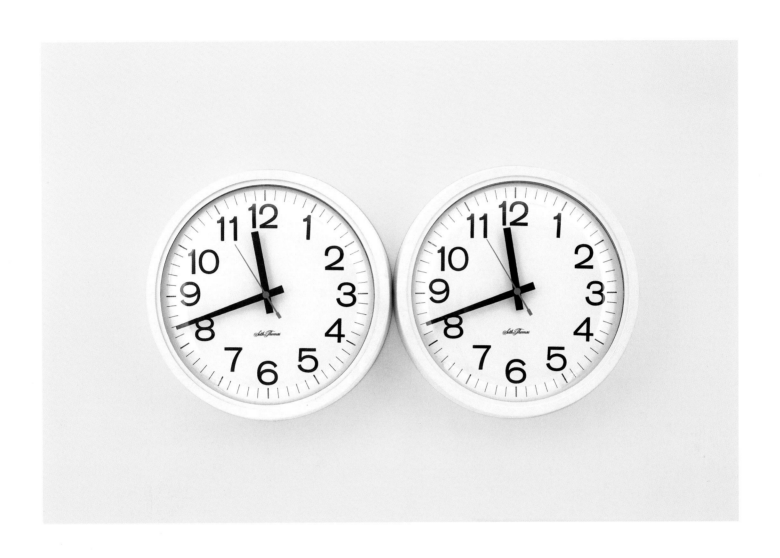

Felix Gonzalez-Torres | (AMERICAN, BORN CUBA. 1957–1996)
"UNTITLED" (PERFECT LOVERS). 1991
CLOCKS, PAINT ON WALL, OVERALL 14 x 28 x 2⅝" (35.6 x 71.2 x 7 CM)
GIFT OF THE DANNHEISSER FOUNDATION, 1996

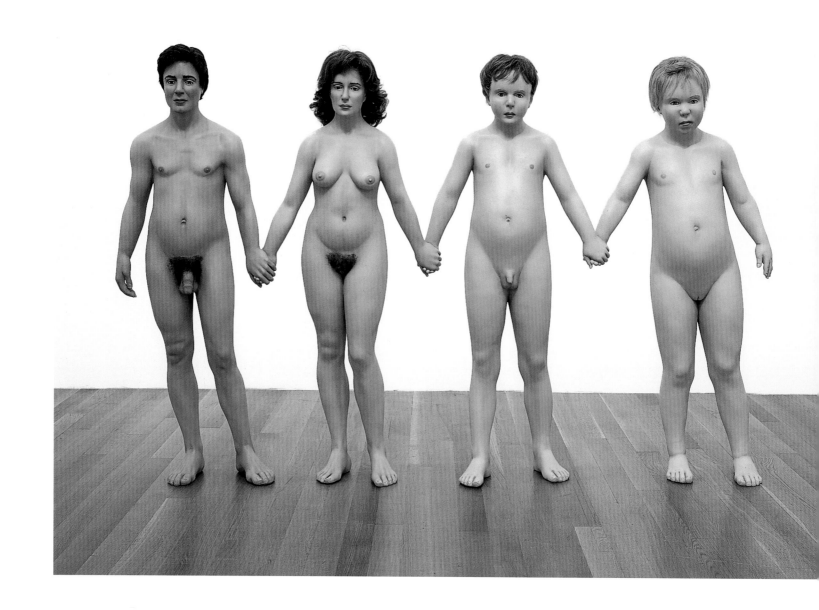

Charles Ray | (AMERICAN, BORN 1953)
FAMILY ROMANCE. 1993
PAINTED FIBERGLASS, 53" x 7' 1" x 11" (134.6 x 215.9 x 27.9 CM)
GIFT OF THE NORTON FAMILY FOUNDATION, 1993

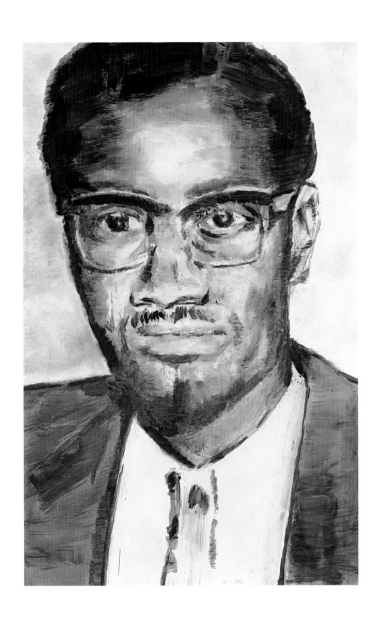

Luc Tuymans | (BELGIAN, BORN 1958)
LUMUMBA. 2000
OIL ON CANVAS, 24½ x 18" (62.2 x 45.7 CM)
FRACTIONAL AND PROMISED GIFT OF DONALD L. BRYANT, JR., 2002

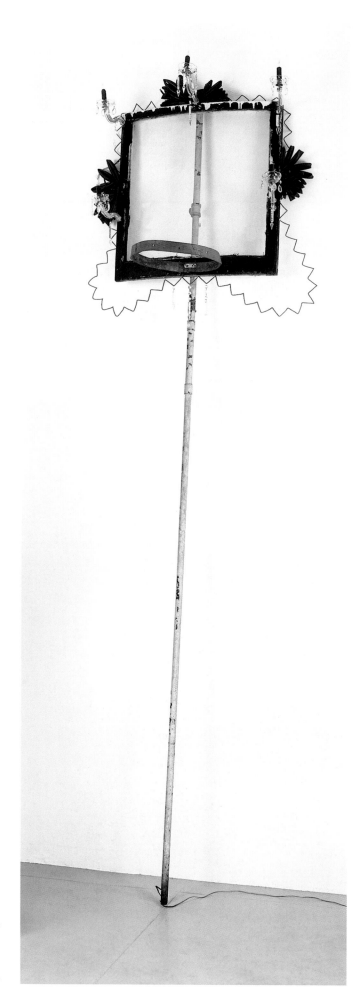

David Hammons | (AMERICAN, BORN 1943)
HIGH FALUTIN', 1990
METAL (SOME PARTS PAINTED WITH OIL), OIL ON WOOD,
GLASS, RUBBER, VELVET, PLASTIC, AND ELECTRIC LIGHT
BULBS, 13' 2" x 48" x 30½" (396 x 122 x 77.5 CM)
ROBERT AND MERYL MELTZER FUND AND PURCHASE, 1990

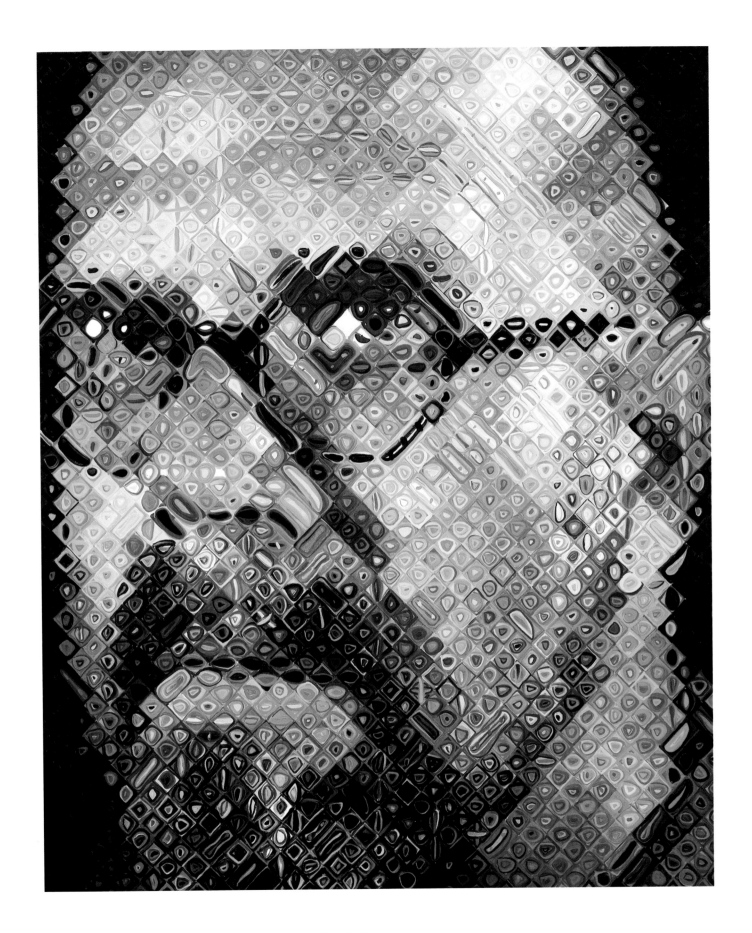

Chuck Close | (AMERICAN, BORN 1940)
SELF-PORTRAIT. 1997
OIL ON CANVAS, 8'6" x 7' (259.1 x 213.4 CM)
GIFT OF AGNES GUND, JO CAROLE AND RONALD S. LAUDER,
DONALD L. BRYANT, JR., LEON BLACK, MICHAEL AND JUDY OVITZ,
ANNA MARIE AND ROBERT F. SHAPIRO, LEILA AND MELVILLE
STRAUS, DORIS AND DONALD FISHER, AND PURCHASE, 2000

501

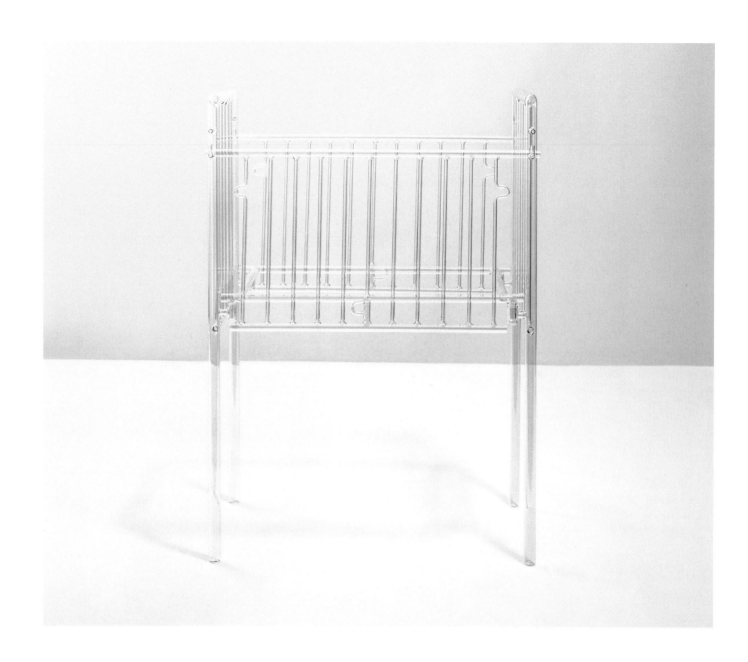

Mona Hatoum | (BRITISH OF PALESTINIAN
ORIGIN, BORN IN BEIRUT, LEBANON, 1952)
SILENCE. 1994
GLASS, 49⅞ x 36⅞ x 23⅛" (126.6 x 93.7 x 58.7 CM)
ROBERT B. AND EMILIE W. BETTS FOUNDATION FUND, 1995

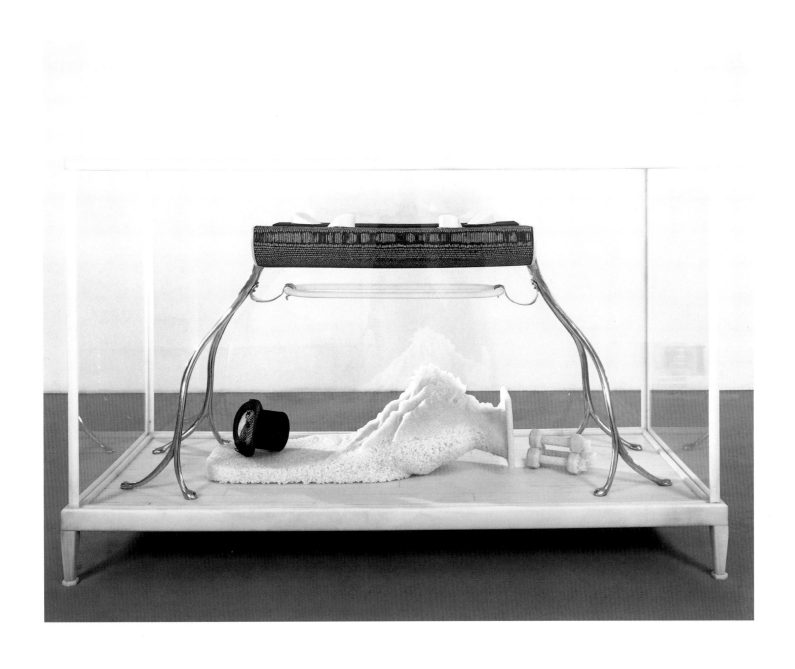

Matthew Barney | (AMERICAN, BORN 1967)
THE CABINET OF BABY FAY LA FOE. 2000
POLYCARBONATE HONEYCOMB, CAST STAINLESS STEEL,
NYLON, SOLAR SALT CAST IN EPOXY RESIN, TOP HAT,
AND BEESWAX IN NYLON AND PLEXIGLASS VITRINE,
59" x 7' 11½" x 38¼" (149.8 x 242.6 x 97.2 CM)
COMMITTEE ON PAINTING AND SCULPTURE FUNDS, 2000

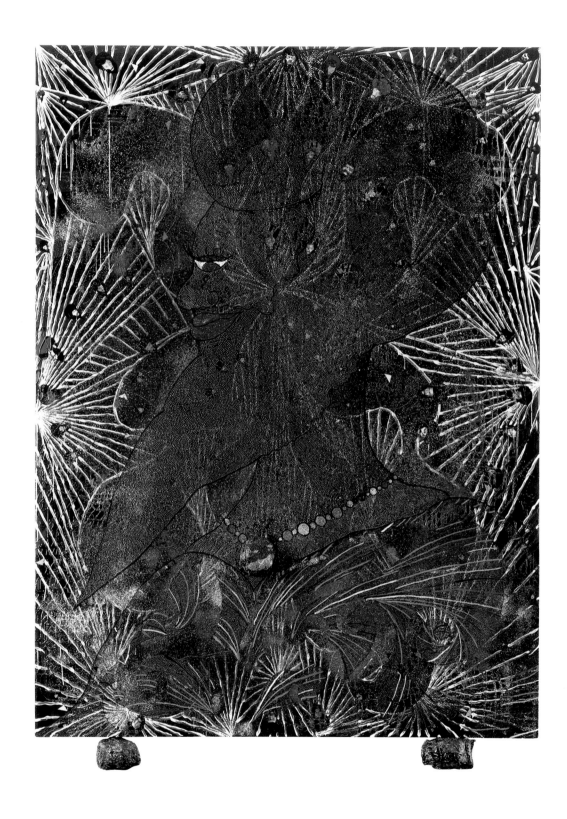

Chris Ofili | (BRITISH, BORN 1968)
PRINCE AMONGST THIEVES. 1999
SYNTHETIC POLYMER PAINT, COLLAGE, GLITTER, RESIN, MAP PINS,
AND ELEPHANT DUNG ON CANVAS, 8 x 6' (243.8 x 182.9 CM)
MIMI AND PETER HAAS FUND, 1999

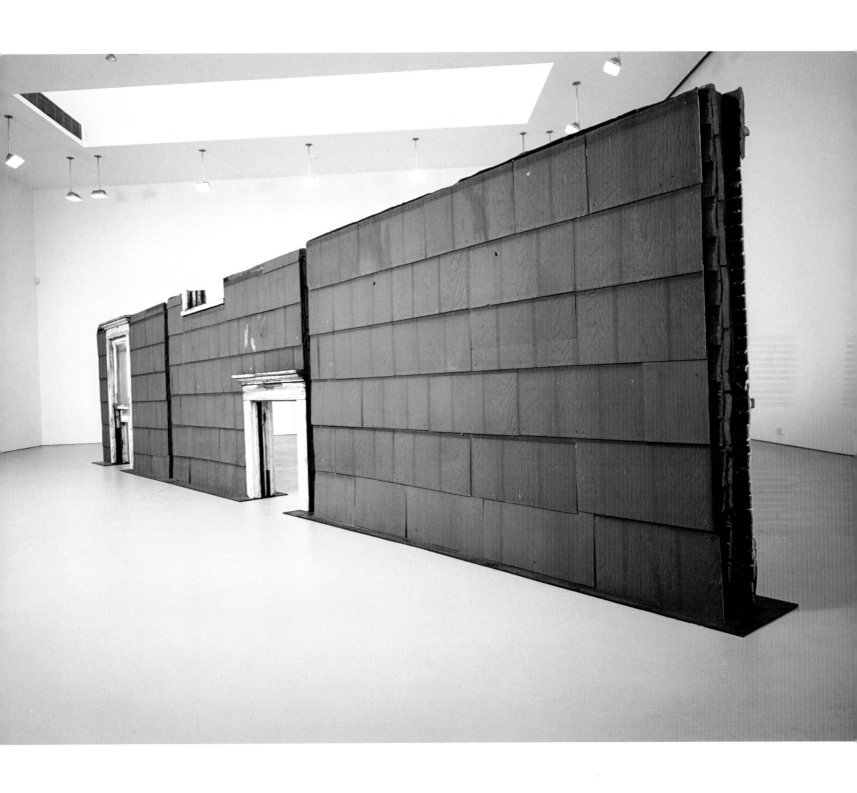

Gordon Matta-Clark | (AMERICAN, 1945–1978)
BINGO, 1974
BUILDING FRAGMENTS (THREE SECTIONS), 69" x 25' 7" x 10"
(175.3 x 779.8 x 25.4 CM)
PURCHASE, 2004

505

Notes to the Texts

The Front Door to Understanding, PP. 8–59

This essay is a work of synthesis, drawing in the main on secondary sources, albeit with due caution as to their relative reliability, and more fallibly on my own institutional history. Therefore it seemed inappropriate to clutter the pages with notes. However, both in the interests of full disclosure and to encourage further and reliable reading on its subjects, this note offers an annotated guide to my principal sources.

The essay itself is a greatly expanded and revised version of my introduction, of the same title, to a similarly conceived catalogue, *Visions of Modern Art: Painting and Sculpture from The Museum of Modern Art,* published by the Museum in 2003 to accompany an exhibition shown at the Museum of Fine Arts, Houston, Texas, and in 2004 at the Neue National-galerie, Berlin, where the German-language version of the catalogue was entitled *Das MoMA in Berlin.* The opening paragraphs and the later discussion of the acquisition of works under Alfred H. Barr, Jr.'s tenure until his retirement are adopted from the text that I wrote as Richard E. Oldenburg's fore-word to Barr's *Painting and Sculpture in The Museum of Modern Art 1929–1967* (New York: The Museum of Modern Art, 1977), pp. ix–xi. I have also borrowed from my essays, "Making Modern-Starts," in John Elderfield et al., *Modernstarts* (New York: The Museum of Modern Art, 1999), pp. 16–30, and "The Adventures of the Optic Nerve," *Proceedings of the British Academy* 122 (2004): 53–85.

My descriptions of the development of the collection draw on accounts of the collection during their tenures written by its three previous chief curators: extensively on Alfred Barr's rich "Chronicle of the Collection of Painting and Sculpture," in his aforementioned 1977 publication, pp. 620–50, where details of the Lillie P. Bliss Bequest, the works sold from and acquired through it, and of the works sold to The Metropolitan Museum of Art, may be found on pp. 651–55; also on William Rubin's "Painting and Sculpture," in *The Museum of Modern Art, New York: The History and the Collection* (New York: Harry N. Abrams, 1984), pp. 42–46 (where Sam Hunter's "Introduction," pp. 9–41, is also worth consulting); and Kirk Varnedoe's "Collection as Instruction: How and Why Masterworks are Displayed at MoMA," manuscript for the introduction published in Japanese in *Masterworks from The Museum of Modern Art, New York (1900–1955),* exh. cat., Ueno Royal Museum, Tokyo, Oct. 6, 2001–Feb. 3, 2002, and his "Introduction," in *Modern Contemporary: Art at MoMA since 1980*

(New York: The Museum of Modern Art, 2000). Additionally, Varnedoe's "The Evolving Torpedo: Changing Ideas of the Collection of Painting and Sculpture of The Museum of Modern Art," in *The Museum of Modern Art at Mid-Century: Continuity and Change,* Studies in Modern Art 5 (1995), pp. 12–73, is indispensable as an historical account of Barr's torpedo model and the intermuseum agreement with The Metropolitan Museum of Art. The history and present status of one aspect of the collection may be judged from Miriam Basilio et al., *Latin American & Caribbean Art: MoMA at El Museo* (New York: El Museo del Barrio and The Museum of Modern Art, 2004).

There are four essential, but problematical external views on the Museum. Russell Lynes, *Good Old Modern: An Intimate Portrait of the Museum of Modern Art* (New York: Atheneum, 1973), is a good, old overview that can be wonderfully acute and is indeed wonderful for the gossip but keeps giving pause as to its reliability. The same is true of Alice Goldfarb Marquis, *Alfred Barr: Missionary for the Modern* (Chicago: Contemporary Books, 1989), which tires with its religious metaphors but, despite its current disfavor, is often illuminating on the development of the collections. Conversely, the far more scholarly book by Sybil Gordon Kantor, *Alfred H. Barr, Jr. and the Intellectual Origins of the Museum of Modern Art* (Cambridge, Mass.: MIT Press, 2002), is illuminating about Barr's formative years, but for present purposes disappoints in allotting only twelve of 472 pages to his building the collection. Finally, Mary Anne Staniszewski, *The Power of Display: A History of Exhibition Installations at the Museum of Modern Art* (Cambridge, Mass.: The MIT Press, 1998), is an enlightening, highly illustrated account. Unfortunately, it too does not much discuss or illustrate the collection.

On the installation of the collection and its architectural implications, I have drawn on the 1996 lecture by Glenn D. Lowry, the Museum's Director, "Building the Future: Some Observations on Art, Architecture, and the Museum of Modern Art," published in *Imagining the Future of The Museum of Modern Art,* Studies in Modern Art 7 (1998), pp. 75–95, and on a number of the other lectures and conversations on the Museum's future that appeared there under my editorship. External views on these subjects are usefully summarized in Christoph Grunenberg, "The Modern Art Museum," in Emma Barker, ed., *Contemporary Cultures of Display* (New Haven and London: Yale University Press in association with The Open University, 1999), pp. 26–49; and in Carol Duncan and Adam Wallach, "The Museum of Modern Art as Late

Capitalist Ritual: An Iconographic Analysis," *Marxist Perspective* 1, no. 4 (winter 1978): 28–51.

In discussing questions of installation, I refer to Richard Woll-heim, *Painting as an Art* (Princeton, N.J.: Princeton University Press, 1987); idem, "Art and the Curator: History or Mystery?," *Modern Painters* (autumn 1999): 94–97; Nicholas Serota, *Experience or Interpretation: The Dilemma of Museums of Modern Art* (London: Thames & Hudson, 1996); and Matthew Armstrong, "On Public Hanging," *Art Press,* no. 201 (April 1995): 41–45. Finally, I refer to three publications on the theory of narrative: Robert Scholes and Robert Kellog, *The Nature of Narrative* (New York: Oxford University Press, 1966); Seymour Chatman, *Story and Discourse: Narrative Structure in Fiction and Film* (Ithaca and London: Cornell University Press, 1978); and Hayden White, "The Value of Narrativity in the Representation of Reality," in W.J.T. Mitchell, ed., *On Narrative* (Chicago: The University of Chicago Press, 1981), pp. 1–23.

There is a large literature on The Museum of Modern Art; of this, the foregoing represents but the most prominent publications. There is a larger literature on modern museums, an enormous one on museums generally, and a vast one on narrative structures; of that, the foregoing represents merely the publications that I have quoted.

Modern Pioneers: From 1880 into the Twentieth Century

Signac. *Opus 217,* P. 66 (Hauptman text)

1. J. U. Halperin, *Félix Fénéon: Aesthete and Anarchist in Fin-de-Siècle Paris* (New Haven: Yale University Press, 1988), pp. 3–5, 267–95.
2. Letter of Mar. 30, 1891, quoted by M.-T. Lemoyne de Forges in *Paul Signac,* exh. cat., Musée du Louvre, Paris, Dec. 1963–Feb. 1964, p. 42.
3. G. Geffroy, article of Apr. 10, 1891 (reprinted in *La Vie artistique,* 1892).
4. E. Verhaeren, *L'Art moderne* (Brussels), April 5, 1891.
5. A. Alexandre, "Le Salon des Indépendants," *Paris* (Mar. 20, 1891); cited in *Paul Signac,* exh. cat., 1963–64, pp. 42–43.

van Gogh. *The Olive Trees; The Starry Night,* P. 67

1. V. van Gogh to his brother, [Saint-Rémy, June 19, 1889]; Verzamelde Brieven van Vincent van Gogh, Amsterdam, 1952–54, vol. 3, no. 595, p. 432.
2. V. van Gogh to his brother, [Saint-Rémy, middle of June, 1889]; Verzamelde Brieven, vol. 3, no. 607, p. 464.

Gauguin. *The Seed of the Areoi,* P. 69

1. Most commentators do not attempt to identify the seed in Tehura's hand, although Bengt Danielsson (*Gauguin in the South Seas* [Garden City, N.Y.: Doubleday, 1966, p. 109) declares it to be that of a coconut. The seed's size makes this unlikely, however, and Edward Dodd (*Polynesia's Sacred Isle* [New York: Dodd, Mead, 1976], p. 117) states, correctly I believe, that "she is holding the sprouting seed of the hutu reva, the sacred marae tree" (which is a form of mango).
2. The Aeroi were, in effect, a religious secret society that was founded—at least a century before the Western discovery of Polynesia—on the island of Raiatea, whence it fanned out to the other islands. Although Oro, the deity to whom it was devoted, was primarily a war god, the activities of the society's itinerant members took the form of religious dancing and music-making. Within that context, they also carried on ritual copulation, independent of marital ties among the members. As a result of the "licentious" character of these activities, the clan was suppressed early on by Christian missionaries. For eighteenth- and nineteenth-century accounts, see Dodd, *Polynesia's Sacred Isle,* pp. 116–27.
3. "Tehura spoke with a kind of religious dread of the sect or secret society of the Areoi, which ruled over the islands during the feudal epoch. Out of the confused discourse of the child I disentangle memories of a terrible and singular institution"; Paul Gauguin, *Noa-Noa,* trans. O. F. Theis (New York: Nicholas L. Brown, 1920), p. 114. In fact, Gauguin's account was lifted virtually verbatim from Moerenhout, *Voyages aux îles du Grand Océan.*
4. According to Danielsson (*Gauguin in the South Seas,* p. 108), there still were a few people alive in Tahiti of Gauguin's time who knew a good deal about its ancient lore. The most learned of these was the seventy-year-old mother of Queen Marau, Arü Taimai, who had married an Englishman named Salmon. She had earlier received both Robert Louis Stevenson and Henry Adams, to whom she recounted much of what she knew. For a variety of reasons, a poor Frenchman such as Gauguin would not have been received by her, and he was probably not even aware of her existence, not to speak of her special knowledge.
5. *Self-Portrait in Front of the "Yellow Christ"* (1889), reproduced in Michel Hoog, *Paul Gauguin: Life and Work* (New York: Rizzoli, 1987), pl. 52.
6. Cited in John Rewald, *Post-Impressionism: From van Gogh to Gauguin* (New York: The Museum of Modern Art, 1956), p. 492.

Rousseau. *The Sleeping Gypsy,* P. 70

1. Excerpts from the text of

Roché's letter to Quinn, dated February 1, 1924, are interesting for the intensity of feeling provoked in Roché by *The Sleeping Gypsy*. See letter in the files of The Museum of Modern Art, New York. Alfred Barr, who secured the painting for The Museum of Modern Art in 1939, seems to have admired the painting as much as Roché had before him. In 1955 he responded to Paul Sachs's query as to which acquisition over the years had afforded him the greatest gratification, as follows: "I look back upon with the keenest satisfaction *The Sleeping Gypsy* by Henri Rousseau; indeed, I believe it to be one of the most remarkable canvases of the 19th century" (files of The Museum of Modern Art, New York).
2. See the letter from Roché to Marcel Duchamp, undated, and a letter from Alfred H. Barr, Jr., to Paul Sachs dated May 3, 1955, Archives of The Museum of Modern Art, New York.

Monet. *Reflections of Clouds on the Water-Lily Pond,* PP. 71–72
1. Claude Roger-Marx, "Les Nymphéas de M. Claude Monet," *Gazette des Beaux-Arts*, series 4, vol. 1 (June 1909): 529.
2. René Gimpel, [Unpublished journal], Paris.
3. The 42-foot composition acquired by The Museum of Modern Art in 1959 is plainly a variant of that opposite the entrance door in the first of the two oval rooms in the Orangerie, and it is also made up of three panels approximately 14 feet in width.
4. Georges Clemenceau, *Claude Monet: The Water Lilies*, trans. George Boaz (Garden City: Doubleday, 1930), pp. 154–55.

Redon. *Green Death,* PP. 73–74
1. A. Masson, "Mystic with a Method," *Art News* (Jan. 1957). This excellent article by one of the master's of our time offers a penetrating analysis of Redon's contribution, which is so often misunderstood when he is linked with the Surrealists.

Ensor. *Masks Confronting Death,* P. 74
1. "Countries differ in aspect, in climate, in atmosphere, in temperature, and always one senses a secret accord between a man and his surroundings. In the eyes of a painter, the role is very far from the equator. Fast travel multiplies, and soon men will cross nations without seeing them. But always it will be necessary for men to build their houses, fish their fishes, cultivate their gardens, plant their cabbages, and for that they must see with all their eyes. And to see is to paint, and to paint is to love—nature and woman and children and the solid earth." Ensor letter reproduced in *Ecrits . . . de 1921 à 1926* (Ostend-Bruges: Editions de "La Flandre littéraire," 1926), p. 3.

Vuillard. *Interior, Mother and Sister of the Artist,* PP. 75–76
1. Thadée Natanson, *Peints à leur tour* (Paris: Albin Michel, 1948), p. 377.

Cézanne. *L'Estaque,* P. 76
1. Paul Cézanne, letter to Émile Zola, May 24, 1883, in John Rewald, ed., *Paul Cézanne: Correspondance* (Paris: Bernard Grasset, 1937), p. 194.
2. Paul Cézanne, as recorded in Émile Bernard, *Souvenirs sur Paul Cézanne et lettres* (Paris: Le Rénovation Esthétique, 1921); cited in Richard Kendall, ed., *Cézanne by Himself: Drawings, Paintings, Writings* (London: Macdonald & Co., 1988), p. 229.
3. See Lawrence Gowing, "The Logic of Organized Sensations," in William Rubin, ed., *Cézanne: The Late Work* (New York: The Museum of Modern Art, 1977), p. 62. We see this selecting out of sensations that contribute to structure marvelously at work in this landscape when we consider those parts of nature Renoir and Monet would have included and which Cézanne has omitted in the interest of his pictorial "logic."

Cézanne. *Boy in a Red Vest,* PP. 76–77 (Hauptman text)
1. A. Vollard, *Cézanne* (Paris: Ambroise Vollard Editeur, 1914), p. 19.

Cézanne. *Still Life with Apples,* P. 77
1. By this I am not implying that Braque failed to appreciate those Cézannes in which the surface is not completely covered. On the contrary, later in his life he acquired a very beautiful still life which shows a great deal of unpainted canvas. While it may be that the purchase of this modest unfinished work best suited his financial possibilities at the time, it is certain that Braque would never have acquired such a picture had he not been convinced of its quality.
2. The influence of the unpainted white canvas in many of Cézanne's works is certainly discoverable, prior to Cubism, in a number of Fauvist paintings by [Henri] Matisse and [André] Derain done in 1905–06. Matisse's decision to leave substantial areas of the primed canvas unpainted in such pictures as the *Girl Reading* and to employ interstitial bits of unpainted "breathing spaces" in many others certainly received sanction from the experience of Cézanne. In Picasso, the admission of unpainted white areas is more extreme, as *Carafe and Candlestick* of 1909 illustrates. Moreover, Picasso picked up from Cézanne the idea of mixing in a finished work passages that are left in coarse underpainting with others that are "finished" with careful modeling. This more radical non-finito has no counterpart in Fauvist painting.

3. An unpainted area of canvas in an Impressionist picture would immediately detach itself from the surface of the image by its failure to reflect light in a manner continuous with the painted surface. We presume the articulation of the entire surface in this respect in an Impressionist picture in a manner in which we do not in Cézanne, even in those oils of his in which the surface is entirely covered.

Rodin. *Monument to Balzac,* P. 79
1. L. Scholl, article in *Echo de Paris*, August 28, 1896.
2. Judith Cladel, *Auguste Rodin* (Brussels: Van Oest, 1908), p. 145 and the entire chapter on the *Monument to Balzac.*
3. Cécile Goldscheider, *Balzac et Rodin* (Paris: Musée Rodin, 1950). Leo Steinberg has stated that on a visit to the Meudon studio in the summer of 1962, he found among the terra cottas in one of the glass cases what he believes to be a small study for the *Balzac.* This study, of which no photographs exist in the albums of the Musée Rodin, does not appear in Goldscheider's writings on the subject.
4. Cladel, *op cit,* p. 131, gives the whole letter.
5. Many writers commented upon Rodin's extreme illness and prolonged fatigue during the year 1894–95.

Matisse, Picasso, Modernism: Art in Europe through World War I

Fauvism, P. 103
1. Georges Duthuit, *The Fauvist Painters* (New York: Wittenborn, Schultz, 1950), p. 35.
2. E. Tériade, "Constance du fauvism," *Minotaure* (Paris) (October 15, 1936): 3; Jack D. Flam, *Matisse on Art* (London: Phaidon, 1973), p. 74.
3. Although it is possible to speak of the Fauve artists as having had certain "Expressionist" ambitions— as evidenced by Matisse's published concern with "expression"— we must await later more precise study of the concept and usage of the term before too readily describing Fauvism as an Expressionist movement. A proper distinction certainly should be made between French and German art in this respect: Fauvism is often treated as a parallel movement to the Brücke group. Donald E. Gordon in "Kirchner in Dresden," *The Art Bulletin* (New York) (Sept.–Dec. 1966): 335–61, argues convincingly that this concept should be considered.
4. Gaston Diehl's *The Fauves* (New York: Abrams, 1975) valuably illustrates the idea of Fauvism as a broad European form of color painting derived from French sources.
5. The term is Meyer Schapiro's.

Derain. *Charing Cross Bridge,* P. 104 (Hauptman text)
1. A. Vollard, *Recollections of a Picture Dealer* (Boston: Little, Brown, 1936), p. 201.
2. Letter of May 15, 1953, to the president of the Royal Academy, London, quoted by R. Alley in *Tate Gallery Catalogues: The Foreign Paintings, Drawings and Sculpture* (London: Published by order of the Trustees, 1959), pp. 64–65.
3. J. Herbert, *Fauve Painting: The Making of Cultural Politics* (New Haven: Yale University Press, 1992), p. 15.

Braque. *Landscape at La Ciotat,* PP. 104–05
1. John Golding, *Cubism: A History and Analysis, 1907–14,* 2nd rev. ed. (London: Faber and Faber, 1968), p. 63. The full quote is, "Hitherto, as a minor Fauve, Braque had not been a painter of any great historical importance."
2. Hilton Kramer, "Those Glorious 'Wild Beasts,'" *New York Times*, Sunday, April 4, 1976.
3. See Douglas Cooper, *G. Braque*, exh. cat., Royal Scottish Academy, Edinburgh, and The Tate Gallery, London, 1956, pp. 26–27.

Matisse. *Interior with a Young Girl (Girl Reading),* P. 105
1. Raymond Escholier, *Matisse ce vivant* (Paris: Fayard, 1956), p. 36.

Klimt. *Hope, II,* PP. 106–07
1. Makart was the dictator of style in the Vienna of the 1860s and 1870s. For accounts of his career, see the list of references in Varnedoe, *Vienna 1900*, "Painting & Drawing," p. 149, note 1. Klimt's major ceiling commissions were for the Burgtheater (1886–88) and the Kunsthistorisches Museum (1890–92); see Carl E. Schorske's consideration of these in relation to Klimt's biography in *Fin-de-Siècle Vienna: Politics and Culture* (New York: Knopf, 1980), pp. 209–12.
2. The Siebener and another club, the Hagenbund, were artists' coffee-house clubs in the nineties, each of which became the core of later exhibition societies. The Siebener members were pioneers in the Secession and then in the Wiener Werkstätte. The Hagenbund members later defected from the Secession to form their own, independent organization, including the architect Josef Urban and the graphic artist Heinrich Lefler; their emphasis on folk-style and fairy-tale illustration appears before 1900 and prefigures much of the design that became more dominant in Vienna around 1907–08. On these clubs see the references in Varnedoe, *Vienna 1900*, "Painting & Drawing," p. 149, note 2.
3. Klimt's father died in 1892, a fact that was likely to have affected his outlook. In this context, see Schorske's discussion of the attitudes toward the generation of the "fathers" in "Gustav Klimt: Painting and the Crisis of the Lib-

eral Ego," in Schorske, *Fin-de-Siècle Vienna*.

4. The poet Peter Altenberg praised Klimt in these terms: ". . . as a painter of vision you are also a modern philosopher, a totally modern poet! In the act of painting you transform yourself, in an instant, as in a fairy-tale, into the 'most modern of men': something which in the reality of every day you may not be at all!" Quoted in Fritz Novotny and Johannes Dobai, *Gustav Klimt* (New York and Washington, D.C.: Praeger, 1968), p. 64, and in Schorske, *Fin-de-Siècle Vienna*, p. 225. On the accuracy of Altenberg's assessment, see the defense of Klimt as thinker by Yves Kobry, "Klimt derrière le décor," in *Vienne: Fin-de-siècle et modernité*, special issue of *Cahiers du Musée national d'art moderne* (Paris), 14 (1984): 56 ff.

5. See Werner Hofmann's discussion of Klimt's use of figure-ground ambiguity, in relation to contemporary work on decoration in *Gustav Klimt and Vienna at the Turn of the Century*, trans. Inge Goodwin (Greenwich, Conn.: New York Graphic Society, 1971), pp. 34 ff.

6. On the erotic symbolism of these forms, see Hofmann, *Gustav Klimt and Vienna at the Turn of the Century*, pp. 35 ff. Alessandra Comini has discussed this kind of device in relation to Adolf Loos's premise that all art is at base erotic; see her *Gustav Klimt* (New York: Braziller, 1975), p. 6.

Nolde. *Christ and the Children*, PP. 107–08

1. E. Nolde, *Jahre der Kämpfe* (Berlin: Rembrandt Verlag, 1934), p. 104.

Picasso. *Boy Leading a Horse*, P. 111

1. The various sketches which came to be summarized in the study for *The Watering Place* extend from the last months of 1905 to early summer 1906. One cannot be sure where *Boy Leading a Horse* fits into this order. Alfred H. Barr, Jr., *Picasso: Fifty Years of His Art* (New York: The Museum of Modern Art, 1946, p. 42) accepted Zervos' dating of 1905 (Zervos, I, 118). I have adopted that of Pierre Daix and Georges Boudaille (*Picasso: The Blue and Rose Periods* [Greenwich, Conn.: New York Graphic Society, 1967], p. 286).

2. *Boy Leading a Horse* had particular affinities with Cézanne's *Bather*, c. 1885; while this picture was probably not in the Salon d'Automne of 1904 and certainly not in that of 1905, it was in [Ambroise] Vollard's possession in 1901 when Picasso exhibited with him, and the artist very probably saw it at the time.

3. Meyer Schapiro, lectures at Columbia University.

4. A. Blunt and P. Pool, *Picasso: The Formative Years* (Greenwich, Conn.: New York Graphic Society, 1962), pp. 26–27.

5. "Rosewater Hellenism" is a term employed in the literary criticism in the late nineteenth century; Meyer Schapiro was the first to apply it to the painting of Puvis.

Cubism, PP. 111–12

1. That Picasso was well aware of Leonardo's definition of painting as *cosa mentale* is indicated by his remark to Françoise Gilot: "Leonardo came nearer the truth by saying that painting is something that takes place in your mind . . ." (cited in Françoise Gilot and Carlton Lake, *Life with Picasso* [New York: McGraw-Hill, 1964], p. 284). Picasso goes on to say that Leonardo's definition is incomplete and, invoking Cézanne, who had characterized his own pictures of the 1860s as couillard, adds that a painter has also to paint with [his] balls."

2. Picasso's remark is cited in Daniel-Henry Kahnweiler, *Juan Gris: His Life and Work*, trans. Douglas Cooper (New York: Abrams, 1969), p. 168.

3. Dora Vallier, "Braque, la peinture et nous," *Cahier d'art* 29, no. 1 (October 1954): 16. John Golding (*Cubism: A History and an Analysis, 1907–1914* [1959; London: Faber & Faber, 1968], pp. 84–85) was the first to underline this distinction.

4. Edward Fry in his probing comparison of Braque's and Picasso's Cubism ("Braque, Cubism and the French Tradition," in *Braque: The Papiers Collés*, ed. Isabelle Monod-Fontaine with E. A. Carmean, Jr. [Washington, D.C.: National Gallery of Art, 1982], pp. 45–51) goes so far as to summarize "the interaction of Braque and Picasso" as "nothing less than the confrontation of the principles of reduction and invention." As comparative terms, I would myself prefer to pair the word "reduction" with "imagination" or "fantasy" rather than "invention," inasmuch as reductiveness, when exercised in the manner of Braque—or Mondrian or Newman—involved considerable invention. Nevertheless, Fry has emphasized here, I think, an essential difference between the two artists. The solution to the "dilemma of post-classical signification," which Fry sees as the real triumph of high Cubism, "lies in the combination of the two modes." Neither "the purely reductive nor the purely inventive approach" alone would have been capable, Fry insists, of producing this Cubist solution.

Picasso, *Les Demoiselles d'Avignon*, PP. 113–14

1. By the time Picasso began painting the *Demoiselles*, he was familiar not only with Fauve works of the two preceding years, but also with Matisse's *Le Bonheur de vivre* (autumn–winter 1905–06) and *Blue Nude: Memory of Biskra* (Jan.–Feb. 1907). The latter was shown in the Salon des Indépendants in March 1907, while Picasso was at work on his picture, but Picasso probably saw it in one of his visits to Matisse's Paris studio between the time when *Blue Nude* was brought back from Collioure to Paris (February 27 or 28, 1907) and when it went on view at the Indépendants on March 20. Picasso had also visited the studio of Derain where, among other things, he doubtless saw the *Bathers*, which, in any case, was also exhibited in

the 1907 Indépendants.

2. The censure of the *Demoiselles* by Picasso's friends was recapitulated by Roland Penrose in his biography of the artist (*Picasso: His Life and Work* [London: Victor Gollancz, 1958], pp. 125–26): "Among the surprised visitors [Picasso] could hear Leo Stein and Matisse discussing [the *Demoiselles*] together. The only explanation they could find amid their guffaws was that he was trying to create a fourth dimension. In reality, Matisse was angry. His immediate reaction was that the picture was an outrage, an attempt to ridicule the modern movement. He vowed he would find some means to 'sink' Picasso and make him sorry for his audacious hoax. Even Georges Braque . . . was no more appreciative"; Russian collector Sergei Shchukin exclaimed in sorrow, "What a loss to French art!"; [Guillaume] Apollinaire "watched the revolution that was going on not only in the great painting but also in Picasso himself, with consternation." Derain . . . remarked to his new friend Kahnweiler, "One fine morning we shall find Picasso has hanged himself behind his great canvas.". . .

3. We cannot precisely date any of the phases of Picasso's work on the *Demoiselles*, and the meager chronological documentation that exists is often contradictory. Even when not, it is open to conflicting interpretations. . . . I have opted for a chronology essentially similar to that proposed by Pierre Daix in the French edition of the *Demoiselles* catalogue (Pierre Daix, "L'Historique des *Demoiselles d'Avignon* révisé à l'aide des carnets de Picasso," in Hélène Seckel, ed., *Les Demoiselles d'Avignon* [Paris: Réunion des Musées Nationaux, 1988]). . . .

4. While this sentence makes clear, to my mind, that the *Demoiselles* involves an implicit critique of "the nature and conventions of life" and, more centrally, a critique of a more purely autobiographical nature, I have specifically avoided any suggestion that Picasso painted the picture as an act of focused social criticism. This has, nevertheless, been the burden of some recent interpretation. . . . Patricia Leighten's "The White Peril and L'Art Nègre: Picasso, Primitivism, and Anticolonialism" (*The Art Bulletin* [New York] 72, no. 4 [Dec. 1990]: 609–30) . . . argues that, for Picasso, the absorption and use of so-called primitive art in the *Demoiselles* was "as much an act of social criticism as a search for a new art." . . . Hal Foster ("The 'Primitive' Unconscious of Modern Art," *October*, no. 34 [autumn 1985]: 45–70) . . . "wonders if [the] aesthetic breakthrough [of the *Demoiselles*] is not also a breakdown, psychologically regressive, politically reactionary." . . .

5. Fauvism, the last vanguard movement previous to Picasso's undertaking of the *Demoiselles*, appears to me to have represented essentially a consolidation and elaboration of late nineteenth-century conceptions of picture-making—Neo-Impressionism and Syn-

thetism particularly. Aside from Picasso's radical departures of 1907–09 (and with them, Braque's contributions to the language of Cubism), only Matisse's post-Fauve painting, which began in 1907, was to provide a major alternative solution to the impasse of the century's opening decade.

6. It is not possible to specify the precise number of studies Picasso made for the *Demoiselles*, due to the way in which his various projects grow into and out of one another. . . . One can say with certainty, nevertheless, that there are at least some four to five hundred studies in all mediums *associated* in one way or another with the genesis and execution of the *Demoiselles*.

7. Picasso referred to *Guernica* by that name in a document concerning the picture's disposition; a few titles for other paintings, such as *The Charnel House*, crystallized in the course of the artist's studio conversations with friends, but such instances are relatively rare. . . . Picasso's 1933 (?) recollection (cited in D.-H. Kahnweiler's notes from a conversation with Picasso at 29 bis, rue d'Astorg, December 2, 1933, published in "Huit Entretiens avec Picasso," *Le Point* [Souillac and Mullhouse] 42, no. 7 [Oct. 1952]: 24) that the *Demoiselles* was called "Le Bordel d'Avignon" at the beginning ("au début") contradicts [André] Salmon's 1912 and 1922 references to "Le B [. . .] philosophique," which he characterized as "the work's first title." As both Picasso and Salmon contradict themselves more than once on this and other subjects, it is impossible to clarify this matter fully on the basis of documentation now available. That Picasso may also have referred to his picture as "Les Filles d'Avignon" is suggested by the accounts of both [Argendo] Soffici and [Axel] Salto.

8. Gelett Burgess, "The Wild Men of Paris," *The Architectural Record* (New York) 27, no. 5 (May 1910): 400–14; the "Study by Picasso" was reproduced on p. 408. There are no "ultramarine" figures in Picasso's paintings of the period, but the most "contorted" of Picasso's demoiselles is next to a blue curtain and her saturated orange face and black hair contain ultramarine linear accents and shadows, hence, probably, the "ultramarine ogresses" of Burgess's text. It cannot be ruled out that he may have been using "ultramarine" in its secondary meaning of "beyond the sea," hence "exotic."

9. This exhibition, and the fact that the *Demoiselles* was first publicly shown in it, was for many years overlooked. When citing it for the first time, in 1966, Edward Fry (in *Cubism* [London: Thames & Hudson, 1966; New York: Oxford University Press, 1978], p. 185s) listed "Cubist Exhibitions . . . 1916 Paris. Salon d'Antin . . . (no catalogue)," and evidently had no knowledge of the catalogue's existence. It was, nevertheless, he who later discovered the catalogue as well, in the summer of 1973, while rummaging through archives and

libraries in Paris. The first published reference to Fry's discovery appeared in Pierre Daix's *Aragon: Une Vie à changer* (Paris: Seuil, 1975), p. 56, note 2: "It has recently been established, thanks to Edward Fry's researches, that *Les Demoiselles d'Avignon* was exhibited for the first time in July 1916 in the Salon d'Antin, organized by André Salmon." The realization of the exhibition depended upon the patronage of the couturier Paul Poiret. It was held at the Galerie Barbazanges. . . . The *Demoiselles* was no. 129 of a catalogue printed in the form of a folded leaflet.

While this catalogue does not indicate the dates of the exhibition itself . . . the invitation card sent by the journal *Sic* to its subscribers gives them as July 16 to 31, 1916.

10. The possibility of scandal resulting from showing a picture of a bordello scene, clearly designated as such by the use of the word *filles* in the title, would have existed under any conditions. However, the situation in wartime Paris . . . involved a new wave of conservative and traditional French rightist sentiment. Modern art, and especially modern art made by foreign painters, found a less congenial reception than had been the case in the immediate prewar years, and the prevalence of these forces no doubt played a role in Salmon's desire to finesse the title. There is some irony in the fact that Picasso's challenging and unnerving style in this picture was pushed so far that the public and press could not—and evidently *did not*—recognize the picture's real subject, in the absence of a descriptive title.

11. The reference by Salto is in "Pablo Picasso," *Klingen* (Copenhagen), no. 2 (November 1917), n.p.; first published in English translation in Marilyn McCully, ed., *A Picasso Anthology: Documents, Criticism, Reminiscences* (London: Arts Council of Great Britain, 1981), pp. 125–26. Salto describes the picture as a canvas the size of a wall, somewhat higher than broad, and showing four [sic] figures. In the translation of Salto's text published by McCully, the picture is referred to throughout as the *Demoiselles d'Avignon*, but Salto in fact used a Danish equivalent of "Filles d'Avignon" that can denote prostitutes.

12. Kahnweiler, notes from a conversation with Picasso, "Huit Entretiens avec Picasso."

13. Ibid.

14. From an unpublished letter by Kahnweiler to Alfred Barr dated December 7, 1959, in the Alfred H. Barr, Jr. Papers of the Archives of The Museum of Modern Art, New York, and first brought to my attention by Edward Burns. My thanks to Rona Roob, Museum Archivist at The Museum of Modern Art, for her help in this and other aspects of my Picasso research. For me, the mystery of this 1959 communication is that in it Kahnweiler seems totally to have forgotten the conversation with Picasso he later published as having taken place in 1933 ("Huit Entretiens avec Picasso"), a conversation

about which Kahnweiler tells us he made detailed notes at the time (even though these were not published until 1952). In view of the difficulty that everyone had in getting Picasso to speak about his own work, it seems nothing short of amazing to me that Kahnweiler would have made notes on Picasso's fascinating remarks regarding the *Demoiselles* in 1933 only to have entirely overlooked their existence and content when writing to Barr just six years later. Among the things Picasso tells Kahnweiler (purportedly in 1933) is that Salmon gave the picture its present name: "It was Salmon who invented it." Yet in his 1959 letter to Barr, Kahnweiler suggests that the author of the title *Les Demoiselles d'Avignon* might have been [Louis] Aragon (whom Picasso did not even know in 1916).

15. Picasso's testiness on this score is evident in the curt reply attributed to him—"Connais pas" ("Don't know," or "Never heard of it")—in a journalistic inquiry by Florent Fels into modern artists' "Opinions sur l'art nègre" that appeared in *Action* (Paris) 3 (April 1920): 25. . . .

The collective testimony of friends who knew Picasso during the execution of the *Demoiselles*, combined with his own later remarks linking the painting to "art nègre," suggests that the annoyed artist improvised a strategy aimed at countering the prevailing idea. The context of this rethinking is suggested by Picasso's statement to Fels ("Chronique artistique: Propos d'artistes—Picasso," *Les Nouvelles littéraires* [Paris] 2, no. 42 [Aug. 4, 1923]: 2): "We now know that art is not *truth*. Art is a lie that enables us to approach truth, at least the truth we can see. The artist must catch the way to convince the public of the full truthfulness of his lies." The particular relationship, he said, between "art nègre" and his own painting was summarized in his declaration to Fels: "It is that 'l'art nègre' had become too familiar to me. The African sculptures that hang around almost everywhere in my studio are more witnesses [of my work] than models [for it]" ("Propos d'artistes," p. 2).

16. André Malraux, *Picasso's Mask*, trans. June Guicharnaud and Jacques Guicharnaud (New York: Holt, Rinehart & Winston, 1976), p. 11.

Picasso. "Ma Jolie," P. 115

1. This type of brushwork originated in [Paul] Signac's basketweave variation on [Georges-Pierre] Seurat's points. But unlike Picasso, the Neo-Impressionists had used it in the form of a consistent, molecular screen. Matisse, too, frequently used such neo-impressionist brushwork with varying degrees of consistency until about 1905.

The choice of rectangular strokes that echo the framing edge and almost resemble a kind of brickwork is consistent with the architectural nature of Cubist pictures. The texture of the strokes varies with the solidity of the planes they articulate. Compare, for example, those

in the center of *"Ma Jolie"* with those in its upper corners.

2. With the exception of *Guernica* and perhaps a few other pictures, Picasso has never titled his works. Daniel-Henry Kahnweiler (*The Rise of Cubism* [New York: Wittenborn, Schultz, 1949], p. 13) stresses the importance of providing Cubist pictures with descriptive titles so as to "facilitate" the viewer's "assimilation" of the image. This was, in any case, his common practice. Zervos accepted the tradition, cataloguing the picture the Museum has called *"Ma Jolie"* as *Woman with a Guitar* (II, part I, 244). An early inscription on the stretcher—though not in Picasso's handwriting—identifies the picture as *Woman with a Zither*. Picasso told the author he is no longer sure what instrument was intended; he thinks it was a guitar.

3. Braque described the letters as "forms which could not be distorted because, being themselves flat, the letters were not in space, and thus by contrast their presence in the picture made it possible to distinguish between objects situated in space and those that were not." "La Peinture et nous, Propos de l'artiste, recueillis par Dora Vallier," *Cahiers d'art* (Paris) 29, no. 1 (Oct. 1954): 16.

4. Statement by Picasso, 1923, as reprinted in Alfred H. Barr, Jr., *Picasso: Fifty Years of His Art* (New York: The Museum of Modern Art, 1946), pp. 270–71.

5. The refrain of *Dernière Chanson* begins "*O Manon, ma jolie, mon coeur te dit bonjour.*" Maurice Jardot, *Picasso, Peintures 1900–1955* (Paris: Musée des Arts Décoratifs, 1955), no. 28, identifies it as a well-known song of 1911 composed by Fragson and based upon a motif from a dance by Herman Frink.

6. Letter to Kahnweiler dated June 12, 1912, cited in Jardot, *Picasso*, no. 30. In some paintings of 1912 Picasso went beyond the allusion involved in the inscription "Ma Jolie," writing *j'aime Eva* on the surface.

7. See Robert Rosenblum, "Picasso and the Typography of Cubism," in *Picasso/An Evaluation: 1900 to the Present* (London: Paul Elek, 1972).

8. Picasso told the author that this picture was painted from the imagination and that while it was in no way a portrait, he had Eva "in mind" when he painted it.

Picasso. Guitar, PP. 115–16
(Rubin text)

1. There is no firm external evidence for the dating of *Guitar*, which [Christian] Zervos (II, part 2, 773) and [Roland] Penrose (*The Sculpture of Picasso* [New York: The Museum of Modern Art, 1967], p. 58) place in 1912. The *terminus ante quem* for its cardboard maquette is summer 1913, since it figures in a photograph of the studio on the boulevard Raspail that Picasso occupied for about a year, ending with his return from Céret where he vacationed during the summer of 1913. Sometime in the course of 1913, Picasso added a new bottom element to the maquette so as to incorporate it better into a *Still Life*

of cut paper; the whole ensemble was pinned for some months to the wall of his studio, where [Daniel-Henry] Kahnweiler had it photographed. That additional bottom element still exists, along with the other (diassembled) parts of the original cardboard maquette, though the ancillary paper forms which were added to make up the *Still Life* of 1913 have been lost.

Picasso has told the author that, while he cannot remember the year in which *Guitar* was executed, he recalls that this first of his construction-sculptures antedated his first collage, *Still Life with Chair Caning*, "by many months." The date of that collage is itself the subject of some controversy. In 1945, Picasso indicated to Alfred Barr that it may date from 1911 (*Picasso: Fifty Years of His Art* [New York: The Museum of Modern Art, 1946], p. 79). As a result of what Douglas Cooper described as a three-way discussion between himself, Picasso, and Kahnweiler ("The Making of Cubism," a symposium at the Metropolitan Museum of Art, New York, Apr. 17–19, 1971), he proposed in 1959 (*Picasso*, exh. cat., Musée Cantini, Marseille, May 11–July 31, 1959, no. 19) the date of spring 1912 (later refined to May 1912) for the collage—a date in keeping with the painted parts of the image. As this first collage, in which oilcloth was glued to the surface, antedated both Braque's and Picasso's first *papiers collés*, the date of November 9, 1912, given for it by David Duncan (*Picasso's Picassos* [New York: Harper and Brothers, 1961], p. 207) and repeated elsewhere cannot be correct. Picasso had already begun to make *papiers collés* in late September 1912, taking his lead from Braque, who made the first *papier collé* early in that month during Picasso's short absence from Sorgues, where the two had been vacationing together.

Cooper's dating for *Still Life with Chair Caning* is entirely logical; accepting it means dating *Guitar* near the beginning of 1912 or late in 1911—assuming that Picasso's recollection of the order of the two works is correct. On that score, it should be noted that the order of pivotal works is far easier for an artist to remember years afterward than is their particular dating.

2. Douglas Cooper (*The Cubist Epoch* [London: Phaidon Press, 1970], p. 58) states that in the summer of 1912 Braque made paper and cardboard models (since lost) of objects, and that Picasso "followed his example." These 1912 models were "primarily investigations of form and volume, objects existing in paintings transposed for study in three dimensions" (p. 234). Cooper thus sees them as utilitarian objects which "became important forerunners of *papiers collés*." Braque may indeed have thought of them that way—which would explain why he failed to preserve them or translate them into more durable materials. That Picasso, on the other hand, thought of them as a new form of sculpture is evident from the way he treated them—and from what he

subsequently developed out of them. (Cooper, in minimizing these works, would seem unaware of their immense impact on twentieth-century sculpture.)

As to whether Cooper is right in his contention that Picasso followed Braque in this matter, one can only choose between his and Picasso's version of events. Picasso had all along shown himself a more sculpturesque painter than Braque and would later confirm himself as a great sculptor, whereas Braque was a very timid and mediocre one. If, indeed, Braque made his cardboard models earlier, it was Picasso who saw their possibilities as sculpture.

Braque. *Still Life with Tenora,*
P. 117 (Rosenblum text)
1. Without knowing the real identity of this enigmatic instrument, I suggested as far back as 1960 (*Cubism and Twentieth-Century Art* [New York: Harry N. Abrams, 1960], p. 94) that the clarinet in a Braque papier collé of 1913 more closely resembled an oboe with a projecting reed.
2. I rapidly surveyed the question of musical references in *Cubism,* both popular and classical, in my "Picasso and the Typography of Cubism," in *Picasso/An Evaluation: 1900 to the Present* (London: Paul Elek, 1972), p. 57.

Modigliani. *Head,* P. 118
1. Sidney Geist, *Brancusi/The Kiss* (New York: Harper and Row, 1978), p. 9.
2. Alfred Werner, *Modigliani the Sculptor* (New York: Golden Griffin, 1962), p. xxiii.
3. Ibid.

Epstein. *The Rock Drill,* P. 119
1. J. Epstein, *Jacob Epstein: An Autobiography* (New York, Dutton & Co., 1955), p. 56.
2. R. Buckle, *Jacob Epstein, Sculptor* (Cleveland and New York: World Publishing Company, 1963), p. 98.

Leger. *Contrast of Forms,*
PP. 119–20.
1. Fernand Léger, "The Origins of Painting and Its Representational Value," 1913, in Edward F. Fry, ed., *Functions of Painting,* trans. Alexandra Anderson with a preface by George L. K. Morris (New York: The Viking Press, 1973), p. 5. See also his "Contemporary Achievements in Painting," 1914, in ibid., pp. 11–19.
2. Léger, "Contemporary Achievements in Painting," p. 14.
3. Léger, "The Origins of Painting," p. 7.
4. Ibid., p. 8.
5. Léger, "Contemporary Achievements in Painting," p. 11.
6. Léger, "The Origins of Painting," p. 8.
7. Ibid.
8. Ibid., p. 4.

Delaunay. *Simultaneous Contrasts: Sun and Moon,* P. 121
1. *Du Cubisme à l'art abstrait,* edited by Pierre Francastel, with an oeuvre catalog by Guy Habasque (Paris: S.E.V.P.E.N.,

1957), p. 129.
2. See John Elderfield, *The "Wild Beasts": Fauvism and Its Affinities* (New York: The Museum of Modern Art, 1976), pp. 35, 40.
3. Habasque, p. 155.
4. For a discussion of Delaunay's color theories in relation to Chevreul's see Gustav Vriesen and Max Imdahl, *Robert Delaunay: Light and Color* (New York: Abrams, 1957), pp. 44–46, 79 ff.

Futurism, PP. 122–23
1. An exception was the Florentine periodical, *La Voce,* founded in 1908, which was an important force in encouraging rebellion against tradition and fostering the discussion of new ideas concerning society and the arts. Certainly the Futurists owed much to its renovating spirit.
2. *Le Temps* (Paris), March 14, 1911 (*Archivi del Futurismo* [Rome: De Luca, 1958], p. 473).

Boccioni. *States of Mind I, II, III,* PP. 123–24
1. Quoted in Joshua C. Taylor, *Futurism* (New York: The Museum of Modern Art, 1961), pp. 46–48.
2. Quoted in ibid., p. 129.

Boccioni. *Unique Forms of Continuity in Space,* PP. 124–25
1. Umberto Boccioni, "Technical Manifesto of Futurist Painting," in Charles Harrison and Paul Wood, eds., *Art in Theory, 1900–1990: An Anthology of Changing Ideas* (Oxford: Blackwell, 1992), p. 124.
2. Henri Bergson, *An Introduction to Metaphysics,* trans. T. H. Hume (London: Macmillan, 1913), pp. 1–2.

Severini. *Dynamic Hieroglyphic of the Bal Tabarin,* P. 125
1. Introduction to the catalogue of Severini's exhibition at the Marlborough Gallery, London, April 1913.

Severini. *Visual Synthesis of the Idea: "War,"* P. 125
1. "Symbolisme plastique et symbolisme littéraire," *Mercure de France* (Paris), February 1, 1916; reprinted in *Archivi del Futurismo* (Rome: De Luca, 1962), vol. I, pp. 204–10.

Matisse. *The Red Studio,*
PP. 126–27
1. Clara T. MacChesney, "A Talk with Matisse," 1912, Jack D. Flam, ed., *Matisse on Art* (London: Phaidon, 1973), p. 50. This interview was published in the *New York Times Magazine* on March 9, 1913. MacChesney says in it that she talked with Matisse "on a hot June day."
2. I am indebted to Pierre Matisse, on whose memories the plan of the studio (now destroyed) is based. Although an exterior photograph shows a window to the left of the studio door, Pierre Matisse is sure that there was no window in the sections of the walls shown in the *Red Studio.* Presumably the window seen in the photograph served to admit light to the storage area, unless the storage area remembered by Pierre Matisse was added after 1911, in which case what we

see to the left of the *Red Studio* is in fact a curtained window.
3. This dimension is extrapolated from the actual dimensions of the paintings shown in the *Red Studio.*
4. Dominique Fourcade, "Autres Propos de Henri Matisse," *Macula,* no. 1 (1976): 92.
5. Louis Aragon, *Henri Matisse: A Novel* (London: Collins, 1972), vol. II, p. 251.
6. Clement Greenberg, *Henri Matisse* (New York: Abrams, 1953), n.p. (pl. 19).
7. Henri Bergson, *Creative Evolution,* trans. Arthur Mitchell (London: Macmillan, 1911), p. 2.

Matisse. *Goldfish and Sculpture,*
P. 127
1. Some time around 1912 Matisse bought a Hokusai print of a carp. See R. Reif, "Matisse and Torii Kiyonaga," *Arts,* no. 55 (Feb. 1981): 164–67.
2. Pierre Schneider, *Matisse,* trans. Michael Taylor and Bridget Strevens Romer (New York: Rizzoli, 1984), p. 422.
3. Ibid.
4. Matisse, letter to Louis Aragon, September 1, 1942, in Aragon, *Henri Matisse: Roman* (Paris: Gallimard, 1971), vol. 2, p. 208.

Matisse. *The Blue Window,*
PP. 127–28
1. Lawrence Gowing has suggested the possible influence of willow-pattern plate decoration to Matisse's stylization of trees in this period (conversation with the author, Mar. 1978).
2. The view is from the northwest corner of the house looking north, with the large north-light windows of the studio therefore on the far side of the roof. Matisse has confirmed that the building visible was his studio (Questionnaire I from Alfred Barr, 1945, Archives of The Museum of Modern Art).
3. Matisse said that the window was set over a chimney piece (Questionnaire I).
4. It is impossible to identify this sculpture from its depiction in the painting. However, it resembles an Iberian head of a veiled woman acquired by the Louvre in 1907. See *Société des Artistes Indépendants: 89e Exposition* (Paris, 1978), pp. 31–32, recording a Cubist section in this exhibition, where the work was shown.
5. It resembles the lamp to be seen in *Interior with a Top Hat,* 1896.
6. Matisse sees a yellow pincushion with black hatpins in front of the vase. However, these shapes probably denote the base and decorations of the vase itself (*Matisse: His Art and His Public* [New York: The Museum of Modern Art, 1951], p. 166).
7. Barr, p. 166.
8. Ibid.
9. "Matisse's Radio Interviews, 1942," in Barr, *Matisse: His Art and His Public,* p. 562.
10. See Lawrence Gowing, *Henri Matisse: 64 Paintings* (New York: The Museum of Modern Art, 1966), p. 18.
11. Barr, *Matisse,* 1951, p. 166, says it was first made for the couturier Paul Poiret. This, however, must have been a transcription error, for

Matisse told Barr it was made for Doucet (Questionnaire I, 1945). Mme Duthuit told John Neff that Doucet was the original client (Neff, "Matisse and Decoration, 1906–1914: Studies of the Ceramics and the Commissions for Paintings and Stained Glass," Ph.D. dissertation, Harvard University, 1974, p. 198).
12. Jacques Lassaigne says that it was definitely intended as such (*Matisse* [Geneva: Skira, 1959], p. 77); John Jacobus suggests it as a possibility (*Henri Matisse* [New York: Abrams, 1972], pp. 31–32).
13. Matisse, Questionnaire I from Alfred Barr, 1945, Archives of The Museum of Modern Art. When Barr questioned Mme Matisse, she was unsure of the date of this work, first suggesting 1912, after Matisse's first Moroccan visit (Questionnaire VII, July 1951), then 1911, before that visit (Barr, *Matisse,* 1951, p. 540, no. 8 to p. 514).

Matisse. *View of Notre Dame,*
PP. 128–29
1. Matisse, who had a studio in 1891 at 19 quai Saint-Michel in the gables and without a view, moved to the fifth floor between 1895 and 1908, then went to the fourth floor in 1913.
2. "Notes of a Painter," in Jack Flam, ed., *Matisse on Art* (Berkeley and Los Angeles: University of California Press, 1995), p. 37.
3. Pablo Picasso quoted in Christian Zervos, "Conversations avec Picasso," *Cahiers d'art,* special issue, 1935.
4. Stéphane Mallarmé, "The Impressionists and Edouard Manet," *Art Monthly Review* (Sept. 30, 1876), retranslated from the French.
5. To use an expression coined by Pierre Schneider in chapter 13 of his *Matisse* (Paris, 1984).
6. Pablo Picasso, quoted by Hélène Parmelin, *Picasso dit . . .* (Paris, 1966), p. 127.
7. Likewise, in his 1900–1901 paintings entitled *Le Pont Saint-Michel* which face in the opposite direction, Matisse uses for these landscape paintings two formats which are half the size of standard French windows: 64 x 80.6 cm. and 59 x 72 cm.
8. This essential moment in Matissian research will reach an outermost limit in *Porte-fenêtre à Collioure,* painted several months later. See Isabelle Monod-Fontaine with Anne Baldassari and Claude Laugier, *Matisse: Collections du musée national d'art moderne* (Paris, 1989), pp. 41–45, no. 10.
9. The color is evocative of a Matisse painting dated 1902, *Notre Dame, fin d'après-midi,* altogether Cézannian in inspiration, and sharing the same twilight purplish blue atmosphere.
10. As Picasso writes: "Nature is one thing, painting another . . . the image we have of nature we owe to painters. . . . In fact, there are only signs involved in that image." *Arts,* no. 22 (June 29, 1945).

Matisse. *Memory of Oceania,*
P. 130
1. Henri Matisse, *Jazz* (Paris: Edi-

tions Verve, 1947).

2. Raymond Escholier, *Matisse, ce vivant* (Paris: Fayard, 1956); Eng. trans., *Matisse from the Life* (London: Faber & Faber, 1960).

Brancusi. *Endless Column,*
PP. 132–33 (Naumann text)

1. G. P. Adrian, "Constantin Brancusi," *Goya* 16 (Jan.–Feb. 1957): 258.

2. "Propos by Brancusi," in *Brancusi* (New York: Brummer Gallery, 1926), n. p.

3. Siegfried Giedion, *Mechanization Takes Command* (New York: Oxford News, 1948), p. 395.

4. M. M., "Constantin Brancusi: A Summary of Many Conversations," *The Arts* 4, no. 1 (July 1923): 16–17.

5. Date from Brancusi (1926), catalogue to the exhibition organized by Brancusi.

Brancusi. *Endless Column,* P. 133
(Soby text)

1. Constantin Brancusi. *La Colonne sans fin [The Endless Column].* 1937. Gilt steel, 97' 6" (30 m) high. Brancusi began producing his "endless columns" in 1918; the Tîrgu Jiu column was commissioned in 1935 to commemorate the fallen heroes of World War I.

2. Quoted in "Constantin Brancusi," *Saturday Review* 38, no. 49 (Dec. 3, 1955): 50.

de Chirico. *The Song of Love,*
P. 134

1. *L'Art magique* (Paris, 1957), p. 42.

Bruce. *Painting,* P. 137

1. See Henri-Pierre Roché, *Collection of the Société Anonyme* (New Haven: Yale University Press, 1950), statement, p. 223.

Murphy. *Wasp and Pear,* P. 137

1. Calvin Tomkins, *Living Well Is the Best Revenge* (New York: The Viking Press, 1971), p. 144.

2. Douglas MacAgy, "Gerald Murphy: 'New Realist' of the Twenties," *Art in America* (New York) 51, no. 2 (April 1963): 54.

3. John C. Palester, Research Associate, Entymology, at the American Museum of Natural History, New York, kindly verified the accuracy of this detail and pointed out the absence of the wasp's rear wings.

Age of "isms": Modernisms between the two World Wars

Duchamp. *The Passage from Virgin to Bride,* P. 192

1. See Marcel Duchamp, "The Creative Act," in Robert Lebel, *Marcel Duchamp* (New York: Grove Press, 1959), p. 77.

2. Elizabeth Sewell, *The Field of Nonsense* (London: Chatto & Windus, 1952).

3. The notion of "short-circuit" is derived from Duchamp's notes for the *Large Glass* and the "blossoming of the bride."

4. For these images, see Lebel, *Marcel Duchamp,* pp. 10–15; Arturo Schwarz, *Complete Works of Marcel Duchamp* (New York:

Abrams, 1969), pp. 103–20; and Lawrence D. Steefel, "The Position of *"La Mariée mise à nu par ses célibataires même* (1915–1923)" in *Stylistic and Iconographic Development of the Art of Marcel Duchamp* (Ann Arbor: University Microfilms, 1960), pp. 133–50.

5. See Michel Foucault, "7 Propos sur le 7e ange," in Jean-Pierre Brisset, *La Grammaire logique* (Paris: Tchou, 1970), pp. vii–xix, and Brisset's own text.

6. The most compelling frame of reference for *l'état brut* of Duchamp's obsessional matrix is Georges Bataille's *Death and Sensuality: A Study of Eroticism and the Taboo* (New York: Ballantine, 1969), pp. 5–19 and passim.

Duchamp. *Bicycle Wheel,* P. 193

1. Probably the 1925 *Rotary Demisphere (Precision Optics)* (The Museum of Modern Art, Gift of Mrs. William Sisler and Purchase, 1970), a motorized construction on a metal stand. When operated, black eccentric circles painted on the rotating demisphere appear to undulate, producing an illusion of space and depth.

Man Ray. *The Rope Dancer Accompanies Herself with Her Shadows,* PP. 194–95

1. Walter Pach, *Queer Thing, Painting: Forty Years in the World of Art* (New York: Harper and Brothers, 1938), p. 162.

2. Man Ray, *Self Portrait* (Boston: Little, Brown, 1963), p. 82.

3. Before beginning the painting, Man Ray worked on a collage version of the same subject in which the scraps of paper left over from the operation of cutting out the dancer in her various positions were used as the shadows. Following Duchamp, Man Ray evolved a constructive technique that departed from all previous artistic conventions. From collage he turned to airbrush painting, photography, and the rayograph.

With the aerographs and the rayographs he discovered additional ways of eliminating the personal touch. Using a spraygun and stencils of various shapes, he showed in Untitled, 1919, that a Cubist painting could be created using entirely mechanical means, the end product lacking nothing in sensitivity when compared to a carefully handcrafted painting. "It was thrilling," he said, "to paint a picture hardly touching the surface—a purely cerebral act, as it were" (*Self-Portrait,* pp. 72–73).

Taeuber-Arp. *Dada Head,* P. 195

1. Hugo Weber, in Georg Schmidt, ed., *Sophie Taeuber-Arp* (Basel: Holbein Verlag, 1948), p. 125.

Schwitters. *Revolving,* P. 197

1. See John Elderfield, *Kurt Schwitters* (London: Thames & Hudson, 1985), p. 53.

Schwitters. *Merz Picture 32A (The Cherry Picture),* PP. 197–98

1.See, for example, the two lost assemblages, *Papierfetzenbild* and *Merzbild Lackleder* (Werner Schmalenbach, *Kurt Schwitters* [London and New York, 1967],

figs. 22, 23); also the curious 1921 painted collage *Dein Treufrischer* (see *Selections from the Joseph Randall Shapiro Collection* [Chicago: Museum of Contemporary Art, 1969], cat. 60) and the even odder *Das Geistreich* of 1922, named after the Berlin museum run by Rudolf Bauer (see *Solomon R. Guggenheim. Collection of Non-Objective Paintings* [Charleston, 1936], cat. 398; now no longer in that collection). The latter two works reveal Schwitters' uncertainty in his 1921–22 assemblages as he began to move beyond the earlier Futuro-Expressionist compositions.

Klee. *Actor's Mask,* PP. 198–99
(Lippard text)

1. *Klee (1879–1940),* with an introduction and notes by Andrew Forge (London: Faber and Faber, 1954), vol. 2, p. 12.

Malevich. *Reservist of the First Division,* P. 200

1. *From Cubism and Futurism to Suprematism: The New Realism in Painting* was first published as a brochure on the occasion of "The Last Futurist Exhibition of Paintings: 0.10," Petrograd, 1915; it was dated June 1915. Two further editions followed in 1916. An English translation of the third edition is in Troels Andersen, ed., *K.S. Malevich, Essays on Art* (Copenhagen: Borgen, 1968), vol. I, pp. 19–41 (the sentence quoted here appears on p. 19).

2. *Essays on Art,* vol. I, p. 19.

3. Ibid., p. 21.

4. Ibid., p. 38.

Rodchenko. *Non-Objective Painting no. 80 (Black on Black),* PP. 202–03

1. V. A. Rodchenko, E. Iu. Dutlova, and Aleksandr Lavrent'ev, eds., *A. M. Rodchenko, Star'i* (Moscow: Sovetskii Khudozhnik, 1982), p. 62.

2. Ibid.

3. See Aleksandr Lavrent'ev, "On Priorities and Patents," in Magdalena Dabrowski, Leah Dickerman, and Peter Galassi, *Aleksandr Rodchenko* (New York: The Museum of Modern Art, 1998).

4. Malevich's presentation of *Black Square* and thirty-eight other non-objective Suprematist paintings in December 1915 in Petrograd was accompanied by a pamphlet, *From Cubism and Futurism to Suprematism. The New Realism in Painting*—an apologia for his newly evolved style and for the philosophy of Suprematism. Here Malevich delineates the fundamental premises of Suprematism. The pamphlet, distributed at the exhibition, was illustrated with two Suprematist paintings, *Black Square* and *Black Circle.* Published in English in Troels Andersen, ed., *K.S. Malevich: Essays on Art 1915–1928* (Copenhagen: Borgen, 1968), vol. 1, pp. 19–41.

Rodchenko. *Spatial Construction no. 12,* PP. 203–04

1. For information on Zhivskul'ptarkh, its activities, and Rodchenko's involvement in it, see Selim Khan-Magomedov, *Rodchenko: The Complete Work,* trans.

Huw Evans (Cambridge, Mass.: The MIT Press, 1987), pp. 45–54, and Christina Lodder, *Russian Constructivism* (New Haven: Yale University Press, 1983), p. 60.

Mondrian. *Broadway Boogie-Woogie,* P. 208 (Kernan text)

1. Letter, in French, to Harry Holtzman, September 7, 1938; reproduced in Michel Seuphor, *Piet Mondrian: Life and Work* (New York: Harry N. Abrams, 1956), p. 175.

2. Quoted in Harry Holtzman, "Piet Mondrian: The Man and His Work," in *The New Art—The New Life: The Collected Writings of Piet Mondrian* (Boston: G. K. Hall, 1986), p. 2.

Torres-García. *Construction in White and Black,* P. 209

1. Juan Torres-García, *Universalismo constructivo.* 2 vols. (Buenos Aires: Editorial Poseidon, 1944), p. 98.

2. Ibid., p. 79.

3. Ibid., pp. 101, 178.

4. Juan Torres-García, *Estructura* (Montevideo: Biblioteca Alfar, 1935), p. 45.

5. Torres-García, *Universalismo,* p. 99.

6. Juan Fló, *Torres-García en (y desde) Montevideo* (Montevideo: Arca, 1991), pp. 15–17.

7. Stephen Bann, "Introduction: Constructivism and Constructive Art in the Twentieth Century," in Stephen Bann, ed., *The Tradition of Constructivism* (New York: Viking Press, 1974), p. XXV.

8. Naum Gabo and Antoine Pevsner, "Realistic Manifesto" (1920), in Bann, *Tradition of Constructivism,* pp. 3–11.

Schlemmer. *Bauhaus Stairway,* P. 210

1. Alfred Barr, "'Returning Sanity' in German Art" (1933), *Magazine of Art* (October 1945): 216.

2. Alfred Barr, letter to Walter Gropius, May 28, 1968. The Museum of Modern Art, Department of Painting and Sculpture, Schlemmer M.C. File.

3. Barr, letter to Wulf Herzogenrath, July 26, 1967. Ibid.

4. Barr, letter to Walter Gropius, September 16, 1943. Ibid.

Beckmann. *Departure,* P. 211

1. According to Beckmann's carefully kept records, the central and right panels were completed in November 1933, and the left panel in December 1933. (Heretofore it was believed that Beckmann worked on *Departure* until 1935.)

2. Bernard S. Myers, *The German Expressionists* (New York, Frederick A. Praeger, 1957), p. 304.

3. Unpublished letter dated June 1, 1955.

4. T. S. Eliot, "The Waste Land," 1922, in *Collected Poems 1909–1935* (New York, Harcourt, Brace & World, 1963).

5. Charles S. Kessler, "Max Beckmann's Departure," *Journal of Aesthetics & Art Criticism* 14, no. 2 (Dec. 1955): 215.

6. Günter Busch, *Max Beckmann* (Munich: R. Piper Verlag, 1960), p. 76. But how could Charon convey his passengers into such a

bright world?

7. Lothar-Günther Buchheim, *Max Beckmann* (Feldafing: Buchheim Verlag, 1959), p. 159.

Picasso. *Girl Before a Mirror,* PP. 212–13

1. Reinhold Hohl, "C. J. Jung on Picasso (and Joyce)," *Source: Notes in the History of Art* (New York), 3, no. 1 (fall 1983): 15–16.
2. For more on these sexual puns, see my "Picasso and the Anatomy of Eroticism," in Theodore Bowie and Cornelia V. Christenson, eds., *Studies in Erotic Art* (New York: Basic Books, 1970); and László Glózer, *Picasso und der Surrealismus* (Cologne: M. DuMont Schauberg, 1974), pp. 56–69.

Pierre Bonnard. *The Bathroom,* P. 213

1. "Esthétique du mouvement et des gestes. Il faut qu'il ait un arrêt, un appui." [Bonnard] Diary entry, December 4, 1935.
2. Ibid.

Balthus. *The Street,* PP. 213–14

1. The exhibition was held at the Galerie Beaux-Arts, Paris, in March 1956. Soby's letter to Balthus of October 28, 1955, indicates that it was Soby who offered the painting for the Paris show: "Pierre [Matisse] tells me that you are having a retrospective exhibition in Paris this winter. If you would like to have *La Rue* in the exhibition, by all means do so" (MoMA Archives: Soby Papers, IV.C.1).
2. Concerned that the French Customs officials would not permit the reentry of *La Rue* into France, Soby asked the conservators Sheldon and Caroline Keck to advise him as to methods of camouflage. They overpainted the offending area with watercolor, so that it could be easily and safely removed by Balthus when the painting reached France. Pierre Matisse acted as intermediary between Soby and the artist, arranging for the painting to be sent from Paris "to Chassy where Balthus plans to operate on the offending parts! T[o] tell you the truth he does not quite know how he is going to do it and it will probably require quite a bit of thought" (letter, Pierre Matisse to Soby, June 21, 1956; MoMA Archives, Soby Papers, I.7.2). On June 20, 1956, Balthus wrote to Soby, "It was a strange feeling, after so many years, to see this picture again which I painted when I was little over twenty. I succeeded only in the last few days to change the objectionable gesture of the boy—a rather difficult affair, the whole picture having been built up mathematically. As I told P.M. [Pierre Matisse] I accepted to reconsider the matter as I do not think—and never thought—that the real interest, if any, was residing there. It was rather done in a mood of youthful desire to provoke, at a time one still believed in scandal. Today scandal is just worn out as an old shoe." Soby was thoroughly pleased with the changes made, writing to Balthus on August 20, 1956, "I am everlastingly grateful

for your repairs on *La Rue*. I know it must have been a struggle and I greatly appreciate it" (MoMA Archives: Soby Papers, I.7.2).

Kahlo. *Self-Portrait with Cropped Hair,* P. 218

1. André Breton, *Le Surréalisme et la peinture, suivi de genèse et perspective artistiques du surréalisme et de fragments inédits* (New York: Brentano's, 1945), p. 143.

Surrealism, PP. 218–19

1. According to [André] Breton, the first appearance in print of the word "surrealism" was as the subtitle ("a surrealist drama") of Apollinaire's *Les Mamelles de Tirésias (The Breasts of Tiresias),* which had its première on June 24, 1917, under the sponsorship of Pierre Albert-Birot and his review *Sic.* Actually, as William S. Lieberman has pointed out ("Picasso and the Ballet," *Dance Index* [New York], Nov.–Dec. 1946, p. 265), the word had appeared in print a month earlier, in a short text written by Apollinaire for the program of Diaghilev's production of the Satie-Massine-Picasso ballet *Parade.*
2. "Entrée des médiums," reprinted in André Breton, *Les Pas perdus* (Paris, 1924), p. 149.
3. *Manifeste du Surréalisme* (Paris, 1924), p. 42.
4. Though "abstract" is a handy word to distinguish the surrealism of Miró and Masson from the illusionism of Magritte and Dali, the process it normally describes—and the etymology of the word itself—are, in fact, alien to all Surrealist art. For this reason I have placed the word in quotation marks.

Magritte. *The Lovers,* P. 221

1. The only exception to Magritte's stylistic continuity is a series of loosely painted Impressionistic versions of his typical subject matter painted during the first years of World War II.
2. The rare instances of Magritte's use of biomorphism—such pictures as *The Acrobat's Ideas* (1928) and *Surprises and the Ocean* (c. 1929–30)—all date from his earliest years as a Surrealist.

Miró. *The Hunter (Catalan Landscape),* PP. 221–22

1. Shown for the first time in a one-man exhibition at the Galerie Pierre, Paris, June 12–27, 1925, as "Le Chasseur," this painting is inscribed on the reverse "Paysage catalan" (no longer visible because of lining) and has often been exhibited and referred to as "Catalan Landscape." At Miró's request the painting is now titled as it was in its initial showing, with the inscribed title following in parentheses.
2. For discussion see Rosalind Krauss and Margit Rowell, *Magnetic Fields* (New York: Solomon R. Guggenheim Foundation, 1972), pp. 77–78.
3. Ibid., p. 77.
4. Gerta Moray, "Miró, Bosch and Fantasy Painting," *The Burlington Magazine* (London) 113, no. 820 (July 1971): 387, proposes paintings by Bosch as the source of this and

other motifs in Miró's painting of 1923–25.
5. For example, *The Eye Like a Strange Balloon Mounts toward Infinity.* Masson was a great admirer of Redon and frequently brought his work to Miró's attention.
6. See Krauss and Rowell, p. 77, who single out in particular a collage from Ernst's *Repetitions* (1922) showing a string pulled through the eye parallel to the lower edge of the picture thus suggesting Miró's horizon line.
7. Jacques Dupin interprets the following quotation from a Miró letter to Rafols as referring only to *The Hunter:* "Hard at work and full of enthusiasm. Monstrous animals and angelic animals. *Tree with ears and eyes and a peasant in a Catalan cap,* holding a shotgun and smoking a pipe" (italics mine). In fact, as Miró has told the author, he was referring to two pictures, *The Tilled Field,* which does depict a tree with both an ear and an eye, and *The Hunter,* in which the peasant is presented as described.

Miró. *The Birth of the World,* P. 222

1. Gaffé in *A la verticale: Réflexions d'un collectionneur* (Brussels: André de Rache, 1963), p. 108, claims to have bought this picture "as soon as it was finished," but Miró has told the author that the painting was in his studio for "at least a year" after he had finished it. In the same passage as the quote above Gaffé mentions his astonishment at and admiration for the pictures hanging on Miró's studio walls at 22 Rue Tourlaque; the address given suggests that it may even have been 1927 when Gaffé bought *The Birth of the World.*
2. As recounted to the author in November 1967.
3. *Joan Miró,* exh. cat., Palais des Beaux Arts, Brussels, Jan. 6–Feb. 7, 1956, no. 15.
4. In an interview with the author, June 1959. Breton actually erred slightly in the title of the painting, but there is no question that he was referring to *The Birth of the World.*
5. *Le Surréalisme et la peinture* (New York and Paris: Brentano's, 1945, 2nd ed.; originally published 1928 by Gallimard), p. 68.
6. Interview with the author, June 1959.

Miró. *"Hirondelle Amour,"* P. 223

1. The four paintings were commissioned by Mme Marie Cuttoli, a well-known collector and an early patron of many of the major painters of the [twentieth] century. It is largely to her efforts that the French tapestry industry owes its revival after a decline of nearly two hundred years. Among other artists from whom she has commissioned tapestry cartoons are Matisse, Braque, and Picasso.
2. Among example of Miró's picture-poems of the twenties are: *Photo: Ceci est la couleur de mes rêves,* 1925; *Etoiles en des sexes d'escargot,* 1925; *Un Oiseau poursuit une abeille et la baisse,* 1927; *Musique, Seine, Michel, Bataille et moi,* 1927. In these paintings, as

in *Hirondelle/Amour,* the writing serves an essential plastic function within the pictorial structure while at the same time verbally reinforcing the emotional and connotative impact of the image. For an indepth discussion of Miró's picture-poems see Rosalind Krauss and Margit Rowell, *Magnetic Fields* (New York: Solomon R. Guggenheim Foundation, 1972), pp. 11–35, pp. 39–64 passim.
3. Pierre Schneider, "Miró," *Horizon* (New York) 1, no. 4 (March 1959): 72.

Miró. *Still Life with Old Shoe,* PP. 223–24

1. This object has been identified by Miró himself as an apple, not a potato or squash.

Masson. *Battle of Fishes,* P. 224

1. *Manifeste du surréalisme, poisson soluble* (Paris: Editions du Sagittaire, Kra, 1924), pp. 100–102.
2. Masson's sand paintings of the twenties have always been dated 1927 by the artist himself and all who have written on his work. His first use of this technique, however, most have occurred earlier—in late 1926—as is made evident by a letter from Masson to [Daniel Henry] Kahnweiler uncovered in 1975 in the files of the Galerie Louise Leiris by Frances Beatty. In his letter, dated January 8, 1927, Masson tells Kahnweiler that he has just finished twelve sand paintings. The previous misdating is in part the result of the fact that Kahnweiler's Galerie Simon records assigned the date of recently completed work according to the year in which it was received by the gallery.

Placing the sand series earlier than heretofore necessitates a dating change for the group of works that just preceded it, of which *Hunted Castle* was one of the earliest. Masson remembers paintings such as *Chevauché, Children of the Isles,* and *Horses Attacked by Fish* as preceding the sand series and, while his memory was faulty about the exact date of the sand paintings, it is most unlikely that he would not accurately remember the sequence which led up to realization of the sand paintings. This new dating explains what had previously seemed the curious barrenness of 1926 as compared with the highly prolific years which preceded and followed. As for the order within the series of sand paintings, we know that *Battle of Fishes* was the first and that the more schematic, such as *Villagers,* tend to have been executed toward the last.

Giacometti. *The Palace at 4 A.M.,* PP. 225–26

1. *Minotaure,* nos. 3–4 (Dec. 1933): 46; Michel Leiris and Jacques Dupin, eds., *Écrits/Alberto Giacometti* (Paris: Hermann, 1990), p. 17f.
2. R. Hohl, *Alberto Giacometti* (Stuttgart: Hatje, 1971): 84; in addition, Hohl refers to pictures by André Lurçat (illus. p. 294) which draw inspiration from the same source: Böcklin, particularly for his *Isle of the Dead,* which was

one of the most important reference points for the Surrealists; see *Arnold Böcklin–Giorgio de Chirico–Max Ernst: Eine Reise ins Ungewisse* (Zürich: Kunsthaus, 1998).
3. *Labyrinthe*, nos. 22–23 (1946): 12 f.; *Écrits* (1990): 27–35.

Miró. Object, PP. 226–27
1. Although the original map is owned by the Museum, it is badly deteriorated and has been replaced with a map, approved and signed by Miró, that is as close to the original in appearance as possible.

Calder. Gibraltar, P. 228
1. J. J. Sweeney, *Alexander Calder*, 2nd ed. (New York: The Museum of Modern Art, 1951).

Transatlantic Modern: Europe, America

Bacon. Painting, PP. 300–301
1. Francis Bacon, statement in *The New Decade: 22 European Painters and Sculptors* (New York: The Museum of Modern Art, 1955), p. 63.

Bourgeois. Sleeping Figure, P. 302
1. Louise Bourgeois, statement in Belle Krasne, "10 Artists in the Margin," *Design Quarterly* (Minneapolis), no. 30 (1954): 18.

Lam. The Jungle, P. 303
1. Wifredo Lam, quoted in Max-Pol Fouchet, *Wifredo Lam* (New York: Harry N. Abrams, 1976), p. 199.

Rothko. Slow Swirl at the Edge of the Sea, PP. 303–04
1. Robert Rosenblum, "Notes on Rothko's Surrealist Years," in *Mark Rothko* (New York: Pace Gallery, 1981), p. 8, compares *Slow Swirl at the Edge of the Sea* with a Navaho sand painting from The Museum of Modern Art's 1941 exhibition of "Indian Art of the United States." Irving Sandler, in *The Triumph of American Painting* (New York: Harper and Row, 1971), p. 179, holds that "Although the hybrids in Rothko's myth-inspired pictures are abstract, they do allude to observable phenomena—underwater organisms or the paraphernalia used in primitive rituals." Sandler, in a note appended to this comment, refers to the similar association of Rothko's images with "shields, arrows, and other objects associated with primitive rites," made by William Seitz in his Princeton Ph.D. dissertation of 1955, "Abstract Expressionist Painting in America."
2. In the joint interview "The Portrait and the Modern Artist," typescript of a broadcast on "Art in New York," WNYC, October 13, 1943, Rothko argued that the myths of antiquity were "the symbols of man's primitive fears and motivations, no matter in which land or what time, changing only in detail but never in substance, be they Greek, Aztec, Icelandic or Egyptian. And our modern psychology finds them persisting still in our dreams, our vernacular and

our art, for all the changes in the outward conditions of life" (cited in Sandler, *Triumph*, p. 63).
3. See the discussion of water as symbol in mythology, in C.G. Jung, "Archetypes of the Collective Unconscious," 1934, in *The Collected Works of C.G. Jung*, vol. 9, part I, pp. 17–22.
4. In "The Romantics Were Prompted…" (*Possibilities* 1, no. 1 [winter 1947-48]: 84), Rothko included a broader reference to the connotations of his forms: On shapes: They are unique elements in a unique situation. They are organisms with volition and a passion for self-assertion. They move with internal freedom, and without need to conform with or violate what is probable in the familiar world. They have no direct association with any particular visible experience, but in them one recognizes the principle and passion of organisms.

Gorky. Agony, P. 305 (Rubin text)
1. *Le Surréalisme et la peinture*, 2nd ed. (New York, 1945), pp. 196–99.
2. Foreword, in William C. Seitz, *Arshile Gorky: Paintings, Drawings, Studies* (New York, 1961), p. 8.

Pollock. The She-Wolf; Gothic, P. 307 (Rubin text)
1. Pollock's relationship to Surrealist methods has been discussed many times; see interview between Robert Motherwell and Sidney Simon in *Art International* (Zurich) (summer 1967): 21–23, and the author's "Jackson Pollock and the Modern Tradition, VI: An Aspect of Automatism," *Artforum* (Los Angeles) (May 1967): 28–33. Pollock's experimentation with automatic poetry has been specifically noted by Francis V. O'Connor, *Jackson Pollock* (New York, 1967), p. 26.

Pollock. One: Number 31, 1950, P. 308 (Karmel text)
1. For a discussion of the work of Mark Tobey and Janet Sobel in relation to Pollock, see William Rubin, "Jackson Pollock and the Modern Tradition, Part III," *Artforum* (New York) 5, no. 8 (April 1967): 27–30.

Pollock. Echo: Number 25, 1951, P. 309
1. See Krasner, quoted in B. H. Friedman, "An Interview with Lee Krasner Pollock," in Hans Namuth et al., *Pollock Painting* (New York: Agrinde Publications, 1980), n.p.
2. Ibid. Rivit was manufactured by Behlen's, a company that has since been absorbed into larger corporations. The current company, Mohawk Industries, after cursory search, found no record of the glue's formula in the early 1950s, but the evidence points to it being a (poly)vinyl acetate emulsion, a white glue similar to Elmer's.

Newman. Vir Heroicus Sublimis, P. 310
1. When Newman moved in 1968 into his last and largest studio, he devised a painting wall on which to affix unstretched canvases. The

wall itself, however, was divided by a checkerboard pattern into nine-inch squares. He executed his two nine-by-twenty-foot paintings on it: *Anna's Light*, 1968, and *Who's Afraid of Red, Yellow and Blue IV*, finished in 1970. In both cases, he calculated beforehand precisely what the dimensions of his image, and of its subdivisions, would be. With these two exceptions, he worked on stretched canvases; he liked to paint on a surface that gives a little.

Louis. Russet, PP. 314–15
1. Clement Greenberg in *Three New American Painters: Louis, Noland, Olitski*, exh. cat., Norman Mackenzie Art Gallery, Regina, Saskatchewan, 1963, p. 174.

Caro. Midday, P. 315
1. In this regard Hilton Kramer has written: "Mr. Caro's first sculptures in the new mode were exceedingly 'tough.' He seemed intent on placing the greatest possible distance between his new work and the genteel styles which were then prevalent even among the most advanced artists in London." "A Promise of Greatness," *New York Times*, May 17, 1970.

Johns. Flag; Target with Four Faces; Map, PP. 315–16
1. Johns, quoted in G. R. Swensen, "What is Pop Art? Part II," *Artnews* 62, no. 10 (Feb. 1964): 66.
2. See Johns interview with David Sylvester published in *Jasper Johns Drawings* (London: Arts Council of Great Britain, 1974), pp. 7–8.
3. Robert Morris, "Notes on Sculpture, Part 4, Beyond Objects," *Artforum* 7, no. 8 (Apr. 1969): 50.

Johns. Flag; Target with Four Faces; Map, PP. 316–17
1. Characteristic responses to this quality in John's work include [Barbara] Rose's remark "Jasper Johns seems to me in love with his paintings. . . . Only a lover could lavish the kind of care and consideration Johns gives the surfaces of his paintings"; see her "Pop Art at the Guggenheim," *Art International* 5, no. 7 (May 25, 1963): 22.
2. [Barbara] Rose writes, "Johns often displaces elements from one context to another. Depriving color of its conventionally expressive role as well as disregarding the associative possibilities of objects, he displaces a great deal of the expressive burden of his work to technique. . . . His expressiveness arises . . . out of an ability to create analogs of emotional experience in the tempo, regularity and irregularity of stroke, firmness or openness of contour and sensitive bleeding or dripping wash passages." Rose, "The Graphic Work of Jasper Johns: Part II," *Artforum* 9, no. 1 (Sept. 1970): 69–70.
3. In a 1990 interview, Johns discussed his lack of training as a draftsman, his techniques, and his predilection for "found" schemas. He allowed that "perhaps I'm more confident working with images of a schematic nature or images that lend themselves to schematization than with things that have to be established imagi-

natively." Johns, quoted in Ruth E. Fine and Nan Rosenthal, *The Drawings of Jasper Johns*, exh. cat., National Gallery of Art, Washington, D.C., 1990, p. 70.
4. Johns, quoted in Grace Glueck, "No Business like No Business," *New York Times*, January 16, 1966, Section II, p. 26x.
5. Johns, quoted in "His Heart Belongs to Dada," *Time* 73 (May 4, 1959): 58.
6. Johns, quoted in Walter Hopps, "An Interview with Jasper Johns," *Artforum* 3, no. 6 (March 1965): 34.
7. Johns in David Sylvester, "Interview with Jasper Johns," in *Jasper Johns Drawings*, exh. cat., Arts Council of Great Britain, London, 1974, p. 7.
8. Johns has said, "After the army, I wondered when I was going to stop 'going to be' an artist and start being one. I wondered what was the difference between these two states, and I decided that it was one of responsibility. . . . I could not excuse the quality of what I did with the idea that I was going somewhere or that I was 'going to be something.' What I did would have to represent itself. I would be responsible to it now, in the present tense, and though everything would keep changing, I was as I was and the work was as it was at any moment. This became more important to me than any idea about 'where things were going.'" Johns, quoted in Sylvia L. McKenzie, "Jasper Johns Art Hailed Worldwide," *Charleston (S.C.) News and Courier*, October 10, 1965, p. 13-B.

Johns. Diver, PP. 317–18
1. See Roberta Bernstein, *Jasper Johns' Paintings and Sculptures 1954–1974: "The Changing Focus of the Eye"* (Ann Arbor: UMI Research Press, 1985), pp. 103–12.
2. See Nan Rosenthal, "Drawing as Rereading," in Nan Rosenthal and Ruth E. Fine, with Marla Prather and Amy Mizrahi Zorn, *The Drawings of Jasper Johns*, exh. cat., National Gallery of Art, Washington, D.C., 1990, p. 30.
3. Johns, quoted in Max Kozloff, *Jasper Johns* (New York: Harry N. Abrams, 1969), p. 38
4. Johns, quoted in John Cage, "Jasper Johns: Stories and Ideas," in Alan R. Solomon, *Jasper Johns: Paintings, Drawings, and Sculptures 1954–1964*, exh. cat., The Jewish Museum, New York, 1964, p. 22.
5. Bernstein, *Jasper Johns' Paintings and Sculptures*, p. 60.

Rauschenberg. Bed, P. 318
1. Various versions by Rauschenberg appear in interviews by Calvin Tomkins, *The Bride and the Bachelors: Five Masters of the Avant-Garde* (New York: Viking, 1965), p. 215; Tomkins, *Off the Wall: Robert Rauschenberg and the Art World of Our Time* (New York: Penguin, 1981), pp. 136–37; Mary Lynn Kotz, *Rauschenberg: Art and Life* (New York: Abrams, 1990), p. 85; Barbara Rose, "An Interview with Robert Rauschenberg," in *Rauschenberg*, Vintage Contemporary Artists series (New York:

Random House, 1987), pp. 50, 58, 62; and numerous others.
2. Rose, "An Interview with Robert Rauschenberg," p. 62.
3. Quoted in Tomkins, *Off the Wall*, p. 137

Rauschenberg. *First Landing Jump*, P. 319
1. Robert Rauschenberg, quoted by Dorothy Gees Seckler, "The Artist Speaks: Robert Rauschenberg," *Art in America* 54, no. 3 (May–June 1966): 76.
2. Brian O'Doherty, "Rauschenberg and the Vernacular Glance," *Art in America* 61, no. 4 (Sept.–Oct. 1973): 84.
3. J[ack]. K[roll]., "Robert Rauschenberg," *Art News* 60 (Dec. 1961): 12.

Twombly. *Untitled*, P. 320
1. The problem of scale presented by this huge canvas and the other one made at the same time was solved in an ingeniously low-tech fashion. Twombly wanted to be able to work continuously across the width of the works, at every level including those well above his reach. A motorized lift of rolling ladder could conceivably have solved the problem, but Twombly worked in a much simpler fashion. The upper areas of both canvases were executed with the artist sitting on the shoulders of a friend, Nicola del Roscio, who shuttled back and forth across the canvas so that Twombly could work on the moving surface as if he were a typewriter striking its moving platen (conversation with Nicola del Roscio, September 1993).

Otero. *Colorythm, I*, PP. 320–21
1. The idea is Roberto Guevara's. See Guevara, "Artes visuales en Venezuela," in Damián Bayón, ed., *Arte Moderno en América Latina* (Madrid: Taurus, 1985), p. 211.
2. José Balza, *Alejandro Otero* (Milan: Olivetti, 1977), p. 66.

Tàpies. *Gray Relief on Black*, PP. 323–24 (Wye text)
1. Giancarlo Politi, "Domande per Antoni Tàpies," *Flash Art* (Milan), no. 82–83 (May–June 1978): 47.
2. Ibid., p. 46.
3. Michael Peppiat, "Antoni Tàpies: Fields of Energy," *Art International* (Paris), no. 3 (summer 1988): 42.
4. For information on Matter Painting generally, see *Matter Painting* (London: Institute of Contemporary Art, 1960).

Klein. *Blue Monochrome*, P. 325
1. "Yves Klein," *Art International* (Zurich) 11 (Oct. 20, 1967): 23.

Roth. *Snow*, P. 325
1. Dieter Rot(h), *Gesammelte Werke, Bd. 20: Bücher und Grafik (1. Teil). Aus den Jahren 1947 bis 1971* (Stuttgart, London, and Reykjavik: edition hansjörg mayer, 1972), appendix, n.p.
2. Dieter Roth, *MUNDUNCLUM. Band 1: Das Rot'sche Videum* (Cologne: M. Dumont Schauberg, 1967), p. 33.

Art of the Real: Pop, Minimal, 1960s

Wesselmann. *Still Life #30*, P. 388
1. See Cécile Whiting, "Wesselmann and Pop at Home," in Whiting, *A Taste for Pop: Pop Art, Gender, and Consumer Culture* (Cambridge: Cambridge University Press, 1997), pp. 50–99.

Oldenburg. *Pastry Case, I*, P. 389
1. Claes Oldenburg, quoted in Jeanne Siegal, "How to Keep Sculpture Alive In and Out of a Museum: An Interview with Claes Oldenburg on His Retrospective Exhibition at The Museum of Modern Art," *Arts Magazine* 44 (Sept.–Oct. 1969): 26.

Oldenburg. *Giant Soft Fan*, P. 389
1. Oldenburg, quoted in *Three Generations of Twentieth-Century Art: The Sidney and Harriet Janis Collection of The Museum of Modern Art* (New York: The Museum of Modern Art, 1972), p. 158.

de la Villeglé. *122 rue du temple*, PP. 389–90
1. For a general introduction to the *nouveau réalisme* movement and for sections on individual artists, see Pierre Restany, *Les Nouveaux réalistes*, preface by Michel Ragon (Paris: Planète, 1968); and *1960: Les Nouveaux réalistes*, exh. cat., Musée d'Art Moderne de la Ville de Paris, Paris, 1986. On Raymond Hains, see *Hains*, exh. cat., Musée National d'Art Moderne, Centre Georges Pompidou, for the Centre National d'Art Contemporain, Paris, 1976. On Jacques de la Villeglé, see *Villeglé: Défense d'afficher*, exh. cat., Galerie Beaubourg, Paris, 1974; *Villeglé: Lacéré anonyme*, exh. cat., Musée National d'Art Moderne, Centre Georges Pompidou, Paris, 1977; and Christopher Phillips, "When Poetry Devours the Walls," *Art in America* 78 (Feb. 1990): 158–45. For the artists' writings, see *Urbi & Orbi* (Paris: Éditions W. Macon, 1986). On Mimmo Rotella, see *Rotella: Décollages, 1954–1964*, introduction by Sam Hunter (Milan: Electa, 1986); and Tommaso Trini, *Rotella*, preface by Pierre Restany (Milan: G. Prearo, 1974).
2. Cited in *Villeglé: Lacéré anonyme*, p. 21.

Hamilton. *Glorious Techniculture*, P. 390
1. "Anything that I respect in art is for its idea rather than its handling or any other quality; . . . this is an obsession I've had ever since I was a student." Interview conducted by Andrew Forge for the British Broadcasting Corporation on November 3, 1964, as quoted in Richard Morphet, *Richard Hamilton* (London: The Tate Gallery, 1970), p. 8.
 Movement was one of the first themes that Hamilton explored systematically. *Still-life?* and *re Nude*, both 1954, explored spectator movement in relation to a static object, while in the series of four *Trainsitions* he turned his attention to the relationship between the moving spectator (in a train) and the moving subject (the view through the train window). There is no stylistic relationship between Duchamp's *Sad Young Man on a Train* and Hamilton's train paintings, but the similarity of interests is striking. The same holds true for *d'Orientation*, 1952, and *Sketch for Super-Ex-Position*, 1953, both highly sophisticated examinations of problems of perspective, likewise a topic on which Duchamp lavished considerable attention in his studies for the *Large Glass*.
2. For a reproduction of the collage study, see Morphet, *Richard Hamilton*, p. 29, no. 22.
3. Reproduced in Morphet, *Richard Hamilton*, p. 32, no. 24.

Warhol. *Campbell's Soup Cans*, PP. 390–91
1. The first step in this direction was, as usual, to convince Warhol that each work had to be signed individually by him (no longer by his mother, for example, as in the days of being a commercial artist), in spite of the fact that he had originally considered it to be crucial to *abstain* from signing his work: "People just won't buy things that are unsigned. . . . It's so silly. I really don't believe in signing my work. Anyone could do the things I am doing and I don't feel they should be signed" (Roger Vaughan, "Superpop, or a Night at the Factory," *New York Herald Tribune*, August 8, 1965, p. 7).
2. As early as 1961–62 Claes Oldenburg created a programmatic fiction of a store (*The Store*) as a framing institution for the production and reception of his work.
3. G. R. Swenson, "What Is Pop Art? Answers from 8 Painters, Part I," *Artnews* 62 (Nov. 1963): 2.

Ruscha. *OOF*, PP. 391–92
1. Dave Hickey, quoted in Michael Dooley, "Ed Words: Ruscha in Print," *Print* 48, no. 5 (Sept.–Oct. 1994): 36.

Lichtenstein. *Girl with Ball; Drowning Girl*, P. 392
1. See John Coplans, "Interview. Roy Lichtenstein" (1970), in Coplans, ed., *Roy Lichtenstein* (New York: Praeger, 1972).

Rosenquist. *F-111*, P. 393
1. Andy Warhol and Pat Hackett, *POPism: The Warhol '60s* (New York and London: Harcourt Brace Jovanovich, 1980), p. 115.

Smith. *Die*, PP. 393–94
1. Robert Morris, "Notes on Sculpture, Part 2," *Artforum* 5 (Oct. 1966): 20.

Stella. *The Marriage of Reason and Squalor, II*, PP. 394–95
1. Graph-paper drawings of the configurations of some of the Black pictures do exist but, like many such drawings of the early pictures, they were executed some years after the paintings.
2. See, for example, Clement Greenberg, "Modernist Painting," *Art and Literature* (Lausanne) (spring 1965): 198.

3. There are two alternative spatial readings for the classic configuration of Pollock. Since none of the conventional visual cues for what we call illusionistic space are present, we are required to see only the very shallow space created by the actual displacement of the overlapping skeins, whose unique antisculptural line implies no space in itself. See the author's "Jackson Pollock and the Modern Tradition, II: The All-Over Compositions and the Drip Technique," *Artforum* (Los Angeles) (Feb. 1967): 20–21.

LeWitt. *Serial Project, I (ABCD)*, P. 396
1. In taped conversations with the author, 1971–72.
2. Terry Atkinson of Art & Language in *Sol LeWitt*, Haags Gemeentemuseum, 1970. LeWitt had been in touch with Atkinson and Michael Baldwin since the winter of 1965 or so; he admired their use of maps and linguistic philosophy to generate a unique kind of content.
3. Bruce Glaser interview, "Questions to Stella and Judd," broadcast on WBAI, New York, February 1964; subsequently edited by Lucy R. Lippard and published in *Art News* (New York) (Sept. 1966).
4. There were of course precedents in the twentieth century for this attitude, especially [Lázló] Moholy-Nagy's famous Telephone Pictures series. As Lawrence Alloway has put it, "What the Americans did was to standardize the unit," *Artforum* (New York) (Apr. 1975): 42.
5. This disinterest in "originality" became something of a cause célèbre in 1973, when the Italian artpaper *Flash Art* published an advertisement accusing LeWitt of copying European artists, an accusation LeWitt answered easily. In the process he noted that "there are many works of artists that superficially resemble the works of other artists" but that the only valid comparison is between the total works of any artist.

Irwin. *Untitled*, PP. 397–98
1. John Coplans, *Los Angeles 6*, exh. cat., The Vancouver Art Gallery, Vancouver, B.C., 1968, p. 9.
2. Emily Wasserman, "Robert Irwin, Gene Davis, Richard Smith," *Artforum* 6 (May 1968): 47.
3. Ibid.

Hesse. *Vinculum, II*, P. 399
1. Hesse died of a brain tumor at the age of thirty-four on May 19, 1970. Jewish, born in Hamburg, Germany, in 1936; at two she was separated from her parents for some months, when she was evacuated to Holland. At three the family, reunited, emigrated to the United States. When she was nine her parents divorced and when she was ten, her mother committed suicide. An unhappy marriage ended shortly before the death of her father in 1966.
2. Lucas Samaras is one of a number of artists who shared Hesse's interests.
3. Quoted in Lucy R. Lippard, "Eva Hesse: The Circle," in *From*

the Center: Feminist Essays on Women's Art (New York: E. P. Dutton, 1976), p. 161.

Beuys. *Eurasia Siberian Symphony 1963*, P. 401
1. One of the objects in Beuys's *Auschwitz* vitrine in the Hessisches Landesmuseum Darmstadt positions two mounds of fat atop two electric hotplate burners. See Eva Beuys, Wenzel Beuys, and Jessyka Beuys, *Joseph Beuys: Block Beuys* (Munich, 1990), pp. 182–87.
2. See C. G. Jung, *Psychology and Alchemy,* 2nd ed., trans. R. F C. Hull (Princeton, 1968).
3. See Donald B. Kuspit, "Beuys: Fat, Felt, and Alchemy," *Art in America* 68 (May 1980): 78–89. On related work, see, for example, Robert Morris, "Anti-Form" (1968), reprinted in *The New Sculpture, 1965–75* (New York, 1990), pp. 100–101. See also Germano Celant, *Arte Povera* (New York and Washington, D.C., 1969), which groups Beuys with Italian, British, Dutch, and American artists working in a similar vein.

Untitled (Contemporary): Modern Art since 1970

Palermo. *Untitled*, PP. 448–49
1. Gerhard Richter, "About Watercolor and Related Things: Gerhard Richter in Conversation with Dieter Schwarz. Cologne, June 26, 1999," in Dieter Schwarz, ed., *Gerhard Richter: Aquarelle/Watercolors, 1964–1999* (Winterthur: Kunstmuseum; Düsseldorf: Richter Verlag, 1999), p. 21.

Winsor. *Bound Square*, P. 449
1. "Bei Cézanne hört ihre Essbarkeit überhaupt auf, so sehr dinghaft wirklich werden sie, so einfach unvertilgbar in ihrer eigensinnigen Vorhandenheit." From letter to Clara Rilke, Paris, Oct. 8, 1907, in Rainer Maria Rilke, *Briefe* (Wiesbaden: Insel Verlag, 1950), vol. 1, p. 187.
2. "A Conversation between Two Sculptors, Jackie Winsor and Ellen Phelan," *Jackie Winsor/Sculpture* (Cincinnati: Contemporary Arts Center, 1976), p. 8.

Richter. *Self-Portrait*, P. 452
1. Gerhard Richter, "Interview with Dieter Hülsmanns and Fridolin Reske," in Hans-Ulrich Obrist, ed., *Gerhard Richter: The Daily Practice of Painting: Writings and Interviews, 1962–1993* (Cambridge, Mass.: MIT Press, 1995), pp. 57–58.

Mendieta. *Nile Born*, P. 454
1. Cited in John Perreault, "Earth and Fire: Mendieta's Body of Work," in Petra Barreras del Rio and John Perreault, *Ana Mendieta: A Retrospective* (New York: New Museum of Contemporary Art, 1987), p. 10.

Salcedo. *Untitled*, P. 455
1. Charles Merewether, "To Bear Witness," in *Unland—Doris Salcedo* (New York: New Museum of Contemporary Art, 1998), p. 17.
2. "Salcedo's enlistment of these utilitarian objects in the service of active memory is simultaneous with their functional death: the several kinds of physical quarantine to which they are submitted include being shielded behind translucent skin and immobilized by concrete." Nancy Princenthal, "Silence Seen," in Princenthal, Carlos Basualdo, Andreas Huyssen, et al., *Doris Salcedo* (London: Phaidon, 2000), p. 43.
3. Salcedo notes, "Used materials are profoundly human. They all bespeak the presence of a human being. Therefore metaphor becomes unnecessary." Quoted in an interview with Carlos Basualdo, in ibid., p. 21.
4. The work in the collection of The Museum of Modern Art was featured in the 1995 Carnegie International Exhibition in Pittsburgh as part of a large-scale installation.

Viola. *Stations*, P. 458
1. Raymond Bellour, "An Interview with Bill Viola," *October* 34 (fall 1985): 101.

Gonzalez-Torres. *"Untitled" (Perfect Lovers)*, P. 458
1. There are two versions of *Perfect Lovers*. The first (1987–90), which is rimmed in black, is in an edition of three, with one Artist's Proof. The second (1991) is in the collection of The Museum of Modern Art. This too is in an edition of three, but has white edges.
2. Andrea Miller–Keller, "Pleasures of the Unexpected: Modern-Day Alchemy." *Radcliffe Quarterly* (spring 1998): 26.

Hammons. *High Falutin'*, P. 459
1. Kellie Jones, "David Hammons," *Real Life Magazine* (autumn 1986): 4.

Selected Bibliography

The publications and documents listed below are those cited in the anthology texts.

Abbott 1930
Abbott, Jere. *Wilhelm Lehmbruck and Aristide Maillol: Sculpture.* New York: The Museum of Modern Art, 1930.

Agee 1979
Agee, William C. *Patrick Henry Bruce, American Modernist: A Catalogue Raisonné.* New York: The Museum of Modern Art, 1979.

Amaral 1993
Amaral, Aracy. "Abstract Constructivist Trends in Argentina, Brazil, Venezuela, and Colombia." In *Latin American Artists of the Twentieth Century,* edited by Waldo Rasmussen, pp. 86–99. New York: The Museum of Modern Art, 1993.

Antonelli 2000
Antonelli, Paola, and Laura Hoptman. *Open Ends.* Exhibition brochure. New York: The Museum of Modern Art, 2000.

Aranda-Alvarado 2004
Aranda-Alvarado, Rocio. "Wifredo Lam's *The Jungle* and Matta's '"Inscapes.'" In *Latin American & Caribbean Art: MoMA at El Museo,* edited by Miriam Basilio, Fatima Bercht, Deborah Cullen, Gary Garrels, and Luis Enrique Pérez-Oramas, pp. 103–07. New York: The Museum of Modern Art, 2004.

Arenas 1995
Arenas, Amelia. *Abstraction, Pure and Impure.* New York: The Museum of Modern Art, 1995.

Aycock 1990
Aycock, Alice. "Alice Aycock on Constructivism: A Schema on Her Back." In *Contemporary Art in Context,* edited by Christopher Lyon, pp. 53–54. New York: The Museum of Modern Art, 1990.

Baldassari 2002
Cowling, Elizabeth; Anne Baldassari; John Elderfield; John Golding; Isabella Monod-Fontaine; and Kirk Varnedoe. *Matisse Picasso.* New York: The Museum of Modern Art, 2002.

Baldessari 1994
Varnedoe, Kirk. "An Interview with John Baldessari." *MoMA: The Magazine of The Museum of Modern Art,* no. 16 (winter/spring 1994): 10–13.

Barr 1929
Barr, Alfred H., Jr. *The Museum of Modern Art: First Loan Exhibition, New York, November 1929: Cézanne, Gauguin, Seurat, van Gogh.* New York: The Museum of Modern Art, 1929.

Barr 1931
Barr, Alfred H., Jr. *Modern German Painting and Sculpture.* New York: The Museum of Modern Art, 1931.

Barr 1936
Barr, Alfred H., Jr. *Cubism and Abstract Art.* New York: The Museum of Modern Art, 1936.

Barr 1941
Barr, Alfred H., Jr. *Paul Klee.* New York: The Museum of Modern Art, 1941.

Barr 1943
Barr, Alfred H., Jr. *What is Modern Painting?* New York: The Museum of Modern Art, 1943.

Barr 1951
Barr, Alfred H., Jr. *Matisse: His Art and His Public.* New York: The Museum of Modern Art, 1951.

Barr 1954
Barr, Alfred H., Jr., ed. *Masters of Modern Art.* New York: The Museum of Modern Art, 1954.

Bernstein 1996
Bernstein, Roberta. "Seeing a Thing Can Sometimes Trigger the Mind to Make Another Thing." In *Jasper Johns, A Retrospective,* by Kirk Varnedoe, pp. 39–77. New York: The Museum of Modern Art, 1996.

Bickerton 1990
Bickerton, Ashley. "Ashley Bickerton on Donald Judd: Monoculture and Polyculture." In *Contemporary Art in Context,* edited by Christopher Lyon, pp. 56–57. New York: The Museum of Modern Art, 1990.

Bois 1991
Bois, Yve-Alain. *Ad Reinhardt.* New York: The Museum of Modern Art, 1991.

Buchloh 1989
Buchloh, Benjamin H. D. "Andy Warhol's One-Dimensional Art: 1956–1966." In *Andy Warhol: A Retrospective,* edited by Kynaston McShine, pp. 39–61. New York: The Museum of Modern Art, 1989.

Burchfield 1933
Burchfield, Charles. "Edward Hopper—Classicist." In *Edward Hopper: Retrospective Exhibition,* p. 16. New York: The Museum of Modern Art, 1933.

Burton 1989
Burton, Scott. *Artist's Choice: Burton on Brancusi.* New York: The Museum of Modern Art, 1989.

Barr 1931 *(sic)*

Calder 1951
Calder, Alexander. "What Abstract Art Means to Me," statement presented at a symposium at The Museum of Modern Art, February 1951, and subsequently published in *The Museum of Modern Art Bulletin* 18, no. 3 (1951): 8–9.

Carter 2000
Carter, Michael. *Making Choices.* Exhibition brochure. New York: The Museum of Modern Art, 2000.

Chagall 1946
Chagall, Marc. "Eleven Europeans in America." *The Museum of Modern Art Bulletin* 13, nos. 4–5 (1946): 32–34, 37.

Coddington 1999
Coddington, James. "No Chaos Damn It." In *Jackson Pollock: New Approaches,* edited by Kirk Varnedoe and Pepe Karmel, pp. 101–15. New York: The Museum of Modern Art, 1999.

Cullen 2004
Cullen, Deborah. "José Clemente Orozco's New York Works." In *Latin American & Caribbean Art: MoMA at El Museo,* edited by Miriam Basilio, Fatima Bercht, Deborah Cullen, Gary Garrels, and Luis Enrique Pérez-Oramas, pp. 87–92. New York: The Museum of Modern Art, 2004.

Dabrowski 1992
Dabrowski, Magdalena. "Kazimir Malevich's Collages and His Idea of Pictorial Space." In *Essays on Assemblage.* Studies in Modern Art 2, pp. 13–29. New York: The Museum of Modern Art, 1992.

Dabrowski 1995
Dabrowski, Magdalena. In *Masterworks from The Louise Reinhardt Smith Collection,* edited by Kirk Varnedoe. New York: The Museum of Modern Art, 1995.

Dabrowski 1998
Dabrowski, Magdalena; Leah Dickerman; and Peter Galassi. *Aleksandr Rodchenko.* New York: The Museum of Modern Art, 1998.

Dabrowski 1999
Dabrowski, Magdalena. "Vasily Kandinsky: The Campbell Commission." *MoMA: The Magazine of The Museum of Modern Art,* no. 9 (Nov. 1999): 2–5.

Daftari 2000
Daftari, Fereshteh. "Home and Away." In *Modern Contemporary: Art at MoMA since 1980,* edited by Kirk Varnedoe, Paola Antonelli, and Joshua Siegel, pp. 513–15. New York: The Museum of Modern Art, 2000.

Dobke 2004
Dobke, Dirk. "Snow." In *Roth Time: A Dieter Roth Retrospective*, edited by Theodora Vischer and Bernadette Walter, pp. 92–93. New York: The Museum of Modern Art, 2004.

Dubuffet 1962
Dubuffet, Jean. "Petites Statues de la Vie Precaire (Little Statues of Precarious Life)." In *The Work of Jean Dubuffet*, by Peter Selz, pp. 87–90. New York: The Museum of Modern Art, 1962.

Duchamp 1946
Duchamp, Marcel. "Eleven Europeans in America." *The Museum of Modern Art Bulletin* 13, nos. 4–5 (1946): 19–21, 37.

Eggum 1979
Elderfield, John, and Arne Eggum. *The Masterworks of Edvard Munch.* New York: The Museum of Modern Art, 1979.

Elderfield 1976
Elderfield, John. *The "Wild Beasts": Fauvism and Its Affinities.* New York: The Museum of Modern Art, 1976.

Elderfield 1976
Elderfield, John. *European Master Paintings from Swiss Collections: Post-Impressionism to World War II.* New York: The Museum of Modern Art, 1976.

Elderfield 1978
Elderfield, John. *Matisse in the Collection of The Museum of Modern Art.* New York: The Museum of Modern Art, 1978.

Elderfield 1979
Elderfield, John, and Arne Eggum. *The Masterworks of Edvard Munch.* New York: The Museum of Modern Art, 1979.

Elderfield 1983
Elderfield, John. *The Modern Drawing: 100 Works on Paper from The Museum of Modern Art.* New York: The Museum of Modern Art, 1983.

Elderfield 1985
Elderfield, John. *Kurt Schwitters.* New York: The Museum of Modern Art, 1985.

Elderfield 1986
Elderfield, John. *Morris Louis.* New York: The Museum of Modern Art, 1986.

Elderfield 1988
Elderfield, John. *The Drawings of Richard Diebenkorn.* New York: The Museum of Modern Art, 1988.

Elderfield 1996
Elderfield, John. *Henri Matisse: Masterworks from The Museum of Modern Art.* New York: The Museum of Modern Art, 1996.

Elsen 1963
Elsen, Albert E. *Rodin.* New York: The Museum of Modern Art, 1963.

Franc 1992
Franc, Helen M. *An Invitation to See: 150 Works from The Museum of Modern Art.* New York: The Museum of Modern Art, 1992.

Ganz 1999
Alexander, M. Darsie; Mary Chan; Starr Figura; Sarah Ganz; and Maria del Carmen González. *Body Language.* New York: The Museum of Modern Art, 1999.

Golding 2002
Cowling, Elizabeth; Anne Baldassari; John Elderfield; John Golding; Isabelle Monod-Fontaine; and Kirk Varnedoe. *Matisse Picasso.* New York: The Museum of Modern Art, 2002.

Goldwater 1969
Goldwater, Robert. *What Is Modern Sculpture?* New York: The Museum of Modern Art, 1969.

Goossen 1973
Goossen, E. C. *Ellsworth Kelly.* New York: The Museum of Modern Art, 1973.

Gopnik 1990
Varnedoe, Kirk, and Adam Gopnik. *High & Low: Modern Art and Popular Culture.* New York: The Museum of Modern Art, 1990.

Gowing 1966
Gowing, Lawrence. *Henri Matisse: 64 Paintings.* New York: The Museum of Modern Art, 1966.

Greene 1971
Greene, Carroll. *Romare Bearden: The Prevalence of Ritual.* New York: The Museum of Modern Art, 1971.

Haftmann 1957
Haftmann, Werner. *German Art of the Twentieth Century.* New York: The Museum of Modern Art, 1957.

Handler 1998
Handler, Beth. In *Fernand Léger*, by Carolyn Lanchner, pp. 152–55. New York: The Museum of Modern Art, 1998

Hauptman 1994
Hauptman, Jodi. In *Masterpieces from the David and Peggy Rockefeller Collection: Manet to Picasso*, by Kirk Varnedoe. New York: The Museum of Modern Art, 1994.

Hauptman 1996
Hauptman, Jodi. "Philip Johnson: MoMA's Form Giver." *MoMA: The Magazine of The Museum of Modern Art*, no. 22 (summer 1996): 20–24.

Hess 1968
Hess, Thomas B. *Willem de Kooning.* New York: The Museum of Modern Art, 1968.

Hess 1971
Hess, Thomas B. *Barnett Newman.* New York: The Museum of Modern Art, 1971.

Holzer 1990
Holzer, Jenny. "Jenny Holzer on Meret Oppenheim's Object: A Cup of Words." In *Contemporary Art in Context*, edited by Christopher Lyon, pp. 55–56. New York: The Museum of Modern Art, 1990.

Hoog 1985
Shattuck, Roger; Henri Béhar; Michel Hoog; Carolyn Lanchner; and William Rubin. *Henri Rousseau.* New York: The Museum of Modern Art, 1985.

Hope 1949
Hope, Henry R. *Georges Braque.* New York: The Museum of Modern Art, 1949.

Hope 1954
Hope, Henry R. *The Sculpture of Jacques Lipchitz.* New York: The Museum of Modern Art, 1954.

Hoptman 1998
Hoptman, Laura. In *Pop Art: Selections from the Museum of Modern Art*, by Anne Umland. New York: The Museum of Modern Art, 1998.

Hoptman 2000
Hoptman, Laura. *Making Choices.* Exhibition brochure. New York: The Museum of Modern Art, 2000.

Hoptman 2000
Antonelli, Paolo, and Laura Hoptman. *Open Ends.* Exhibition brochure. New York: The Museum of Modern Art, 2000.

Hultén 1968
Hultén, Karl Gunnar Pontus. *The Machine as Seen at the End of the Mechanical Age.* New York: The Museum of Modern Art, 1968.

Johnson 1979
Johnson, Ellen H. *Jackie Winsor.* New York: The Museum of Modern Art, 1979.

Jones 1998
Jones, Leslie. In *Pop Art: Selections from The Museum of Modern Art*, by Anne Umland. New York: The Museum of Modern Art, 1998.

Karmel 1998
Karmel, Pepe. "Pollock at Work: The Films and Photographs of Hans Namuth." In *Jackson Pollock*, by Kirk Varnedoe with Pepe Karmel, pp. 87–139. New York: The Museum of Modern Art, 1998.

Kelly 1990
Kelly, Ellsworth. *Artist's Choice: Fragmentation and the Single Form.* New York: The Museum of Modern Art, 1990.

Kernan 1995
Kernan, Beatrice. "Mondrian's New York Years." *MoMA: The Magazine of The Museum of Modern Art*, no. 20 (fall 1995): 7–13.

Klemm 2001
Klemm, Christian. *Alberto Giacometti.* New York: The Museum of Modern Art, 2001.

Kokoschka 1953
Kokoschka, Oskar. Letter to Dorothy Miller, October 4, 1953. Archives of The Museum of Modern Art, New York.

Kosuth 1990
Kosuth, Joseph. "Joseph Kosuth on Marcel Duchamp: 'Please Do Not Touch the Sculpture.'" In *Contemporary Art in Context*, edited by Christopher Lyon, pp. 46–47. New York: The Museum of Modern Art, 1990.

Krauss 1986
Krauss, Rosalind E. *Richard Serra/ Sculpture*. New York: The Museum of Modern Art, 1986.

Krauss 1991
Krauss, Rosalind. "Overcoming the Limits of Matter: On Revising Minimalism." In *America Art of the 1960s*. Studies in Modern Art 1, pp. 123–41. New York: The Museum of Modern Art, 1991.

Lange 2001
Lange, Angela C. In *Masterworks from The Museum of Modern Art, New York, 1900–1955*, edited by Kirk Varnedoe. New York: The Museum of Modern Art, 2001 [text in Japanese only].

Lawrence 1992
Lawrence, Jacob. *The Great Migration*. New York: The Museum of Modern Art, 1992.

Leggio 1992
Leggio, James. "Robert Rauschenberg's *Bed* and the Symbolism of the Body." In *Essays on Assemblage*. Studies in Modern Art 2, pp. 79–117. New York: The Museum of Modern Art, 1992.

Licht 1969
Licht, Jennifer. *Spaces*. New York: The Museum of Modern Art, 1969.

Lieberman 1969
Lieberman, William S. *Twentieth-Century Art from the Nelson Aldrich Rockefeller Collection*. New York: The Museum of Modern Art, 1969.

Lieberman 1975
Lieberman, William, ed. *Modern Masters: Manet to Matisse*. New York: The Museum of Modern Art, 1975.

Lippard 1972
Three Generations of Twentieth-Century Art: The Sidney and Harriet Janis Collection of The Museum of Modern Art. Foreword by Alfred H. Barr, Jr. Introduction by William Rubin. Text on works by Lucy Lippard. New York: The Museum of Modern Art, 1972.

Lippard 1978
Lippard, Lucy. *Sol LeWitt*. New York: The Museum of Modern Art, 1978.

London 1987
London, Barbara. *Bill Viola: Installations and Videotapes*. New York: The Museum of Modern Art, 1987.

London 1995
London, Barbara. *Video Spaces: Eight Installations*. New York: The Museum of Modern Art, 1995.

McShine 1961
McShine, Kynaston. "Joseph Cornell." In *The Art of Assemblage*, by William C. Seitz, pp. 68–71. New York: The Museum of Modern Art, 1961.

McShine 1989
McShine, Kynaston, ed. *Andy Warhol: A Retrospective*. New York: The Museum of Modern Art, 1989.

Makholm 1997
Makholm, Kristin. "Strange Beauty: Hannah Hoch and the Photomontage." *MoMA: The Magazine of The Museum of Modern Art*, no. 24 (winter/spring 1997): 19–23.

Merewether 1993
Merewether, Charles. "Displacement and the Reinvention of Identity." In *Latin American Artists of the Twentieth Century*. edited by Waldo Rasmussen, pp. 144–55. New York: The Museum of Modern Art, 1993.

MoMA Highlights 2004
MoMA Highlights: 350 Works from The Museum of Modern Art, New York. New York: The Museum of Modern Art, 2004.

Mondrian 1946
Mondrian, Piet. "Eleven Europeans in America." *The Museum of Modern Art Bulletin* 13, nos. 4–5 (1946): 35–36.

Morris 1935
Morris, George L. K. "Fernand Léger versus Cubism." *The Museum of Modern Art Bulletin: Fernand Léger Exhibition* 1, no 3 (Oct. 1935): 2–7.

Motherwell 1951
Motherwell, Robert. "What Abstract Art Means to Me," statement presented at a symposium at The Museum of Modern Art, February 1951, and subsequently published in *The Museum of Modern Art Bulletin* 18, no. 3 (1951): 12–13.

Naumann 1984
Naumann, Francis M. *The Mary and William Sisler Collection*. New York: The Museum of Modern Art, 1984.

Nelson 1993
Nelson, Florencia Bazzano. "Joaquin Torres-García and the Tradition of Constructive Art." In *Latin American Artists of the Twentieth Century*, edited by Waldo Rasmussen, pp. 72–85. New York: The Museum of Modern Art, 1993.

Neu 1966
Neu, Renée Sabatello. *Alberto Burri and Lucio Fontana*. New York: The Museum of Modern Art, 1966.

Noguchi 1946
Noguchi, Isamu. In *Fourteen Americans*, edited by Dorothy C. Miller, p. 39. New York: The Museum of Modern Art, 1946.

O'Hara 1960
O'Hara, Frank. *New Spanish Painting and Sculpture*. New York: The Museum of Modern Art, 1960.

Pollock 1956–57
Pollock, Jackson. "Statements by Pollock" (dated 1944 and 1947). *The Museum of Modern Art Bulletin* 24, no. 2 (1956–57): 33.

Rasmussen 1993
Rasmussen, Waldo, ed. *Latin American Artists of the Twentieth Century: A Selection from the Exhibition*. New York: The Museum of Modern Art, 1993.

Reed 1999
Reed, Peter. "Objects, Walls, Screens." In *Modernstarts*, edited by John Elderfield, Peter Reed, Mary Chan, and Maria del Carmen González, pp. 333–39. New York: The Museum of Modern Art, 1999.

Reinhardt 1963
Reinhardt, Ad. In *Americans 1963*, edited by Dorothy C. Miller. New York: The Museum of Modern Art, 1963.

Rewald 1962
Rewald, John; Harold Joachim; and Dore Ashton. *Odilon Redon. Gustave Moreau. Rodolphe Bresdin*. New York: The Museum of Modern Art, 1962.

Rewald 1978
Rewald, John. *Post-Impressionism: From van Gogh to Gauguin*. New York: The Museum of Modern Art, 1978.

Rich 1942
Rich, Daniel Catton. *Henri Rousseau*. New York: The Museum of Modern Art, 1942.

Rich 1958
Rich, Daniel Catton, ed. *Seurat: Paintings and Drawings*. New York: The Museum of Modern Art, 1958.

Ritchie 1952
Ritchie, Andrew Carnduff. *Sculpture of the Twentieth Century*. New York: The Museum of Modern Art, 1952.

Ritchie 1954
Ritchie, Andrew Carnduff. *Édouard Vuillard*. New York: The Museum of Modern Art, 1954.

Roca 2004
Roca, José. "Ana Mendieta's *Nile Born*, José Leonilson's *34 with Scars* and Doris Salcedo's *Untitled*." In *Latin American & Caribbean Art: MoMA at El Museo*, edited by Miriam Basilio, Fatima Bercht, Deborah Cullen, Gary Garrels, and Luis Enrique Pérez-Oramas, pp. 148–54. New York: The Museum of Modern Art, 2004.

Rose 1992
Rose, Bernice. *Allegories of Modernism: Contemporary Drawing*. New York: The Museum of Modern Art, 1992.

Rosenblum 1990
Rosenblum, Robert. "Cubism as Pop Art." In *Modern Art and Popular Culture: Readings in High and Low*, edited by Kirk Varnedoe and Adam Gopnik, pp. 116–32. New York: The Museum of Modern Art, 1990.

Rosenblum 1996
Rosenblum, Robert. "Picasso's Blond Muse: The Reign of Marie-Thérèse Walter." In *Picasso and Portraiture: Representation and Transformation*, edited by William Rubin, pp. 337–83. New York: The Museum of Modern Art, 1996.

Rosenblum 1996
Rosenblum, Robert. "Rapturous Masterpieces: Picasso's Portraits of Marie-Thérèse." *MoMA: The Magazine of The Museum of Modern Art*, no. 22 (summer 1996): 3–8.

Rosenstock 1989
Rosenstock, Laura. *Christopher Wilmarth*. New York: The Museum of Modern Art, 1989.

Rubin 1957
Rubin, William. *Matta*. New York: The Museum of Modern Art, 1957.

Rubin 1968
Rubin, William S. *Dada, Surrealism, and Their Heritage*. New York: The Museum of Modern Art, 1968.

Rubin 1970
Rubin, William. *Frank Stella*. New York: The Museum of Modern Art, 1970.

Rubin 1972
Rubin, William. *Picasso in the Collection of The Museum of Modern Art*. New York: The Museum of Modern Art, 1972.

Rubin 1973
Rubin, William. *Miró in the Collection of The Museum of Modern Art*. New York: The Museum of Modern Art, 1973.

Rubin 1974
Rubin, William. *The Paintings of Gerald Murphy*. New York: The Museum of Modern Art, 1974.

Rubin 1975
Rubin, William. *Anthony Caro*. New York: The Museum of Modern Art, 1975.

Rubin 1976
Rubin, William, and Carolyn Lanchner. *André Masson*. New York: The Museum of Modern Art, 1976.

Rubin 1977
Rubin, William, ed. *Cézanne: The Late Work*. New York: The Museum of Modern Art, 1977.

Rubin 1989
Rubin, William. *Picasso and Braque: Pioneering Cubism*. New York: The Museum of Modern Art, 1989.

Rubin 1992
Rubin, William, and Matthew Armstrong. *The William S. Paley Collection*. New York: The Museum of Modern Art, 1992.

Rubin 1994
Rubin, William, et al. *Les Demoiselles d'Avignon*. Studies in Modern Art 3. New York: The Museum of Modern Art, 1994.

Russell 1981
Russell, John. *The Meanings of Modern Art*. New York: The Museum of Modern Art, 1981.

Seitz 1960
Seitz, William C. *Claude Monet: Seasons and Moments*. New York: The Museum of Modern Art, 1960.

Seitz 1962
Seitz, William C. *Arshile Gorky: Paintings, Drawings, Studies*. New York: The Museum of Modern Art, 1962.

Seitz 1963
Seitz, William C. *Hans Hofmann*. New York: The Museum of Modern Art, 1963.

Seitz 1965
Seitz, William C. *The Responsive Eye*. New York: The Museum of Modern Art, 1965.

Selz 1961
Selz, Peter. *Mark Rothko*. New York: The Museum of Modern Art, 1961.

Selz 1963
Selz, Peter. *Emil Nolde*. New York: The Museum of Modern Art, 1963.

Selz 1964
Selz, Peter. *Max Beckmann*. New York: The Museum of Modern Art, 1964.

Selz 1965
Selz, Peter. *Alberto Giacometti*. New York: The Museum of Modern Art, 1965.

Smith 1952
Smith, David. Statement presented at a symposium on "The New Sculpture" at The Museum of Modern Art, New York, February 12, 1952.

Soby 1948
Soby, James Thrall. *Contemporary Painters*. New York: The Museum of Modern Art, 1948.

Soby 1955
Soby, James Thrall. *Giorgio de Chirico*. Rev. ed. New York: The Museum of Modern Art, 1955.

Soby 1959
Soby, James Thrall. *Joan Miró*. New York: The Museum of Modern Art, 1959.

Soby 1990
Soby, James Thrall. "A Trail of Human Presence: On Some Early Paintings by Francis Bacon." *MoMA: The Magazine of The Museum of Modern Art*, no. 4 (spring 1990): 8–12.

Soby 1995
Soby, James Thrall. "The Changing Stream." Personal reminiscences written between 1962 and 1971 and published, in part, in *The Museum of Modern Art at Mid-Century: Continuity and Change*. Studies in Modern Art 5, pp. 183–229. New York: The Museum of Modern Art, 1995.

Spate 1975
Spate, Virginia. In *Modern Masters: Manet to Matisse*, edited by William Lieberman. New York: The Museum of Modern Art, 1975.

Steefel 1973
Steefel, Lawrence D., Jr. "Marcel Duchamp and the Machine." In *Marcel Duchamp*, edited by Anne d'Harnoncourt and Kynaston McShine, pp. 69–81. New York: The Museum of Modern Art, 1973.

Still 1952
Still, Clyfford. In *15 Americans*, edited by Dorothy C. Miller. New York: The Museum of Modern Art, 1952.

Storr 1991
Storr, Robert. *Dislocations*. New York: The Museum of Modern Art, 1991.

Storr 1992
Storr, Robert. *Philip Guston in the Collection of The Museum of Modern Art*. New York: The Museum of Modern Art, 1992.

Storr 1993
Storr, Robert. *Robert Ryman*. New York: The Museum of Modern Art, 1993.

Storr 1994
Storr, Robert. *Mapping*. New York: The Museum of Modern Art, 1994.

Storr 1997
Storr, Robert. *On the Edge: Contemporary Art from the Werner and Elaine Dannheisser Collection*. New York: The Museum of Modern Art, 1997.

Storr 1998
Storr, Robert. *Tony Smith: Architect, Painter, Sculptor*. New York: The Museum of Modern Art, 1998.

Storr 1998
Storr, Robert. *Chuck Close*. New York: The Museum of Modern Art, 1998.

Storr 1999
Storr, Robert. "Interview with Ellsworth Kelly." *MoMA: The Magazine of The Museum of Modern Art*, no. 5 (June 1999): 2–7.

Storr 2000
Storr, Robert. *Modern Art despite Modernism*. New York: The Museum of Modern Art, 2000.

Storr 2002
Storr, Robert. *Gerhard Richter: Forty Years of Painting*. New York: The Museum of Modern Art, 2002.

Sweeney 1946
Sweeney, James Johnson. *Marc Chagall*. New York: The Museum of Modern Art, 1946.

Sweeney 1948
Sweeney, James Johnson. *Mondrian*. New York: The Museum of Modern Art, 1948.

Tancock 1973
Tancock, John. "The Influence of Marcel Duchamp." In *Marcel Duchamp*, edited by Anne d'Harnoncourt and Kynaston McShine, pp. 159–78. New York: The Museum of Modern Art, 1973.

Tannenbaum 1951
Tannenbaum, Libby. *James Ensor*. New York: The Museum of Modern Art, 1951.

Taylor 1961
Taylor, Joshua C. *Futurism*. New York: The Museum of Modern Art, 1961.

Temkin 1993
Temkin, Ann. "Joseph Beuys: An Introduction to His Life and Work." In *Thinking Is Form: The Drawings of Joseph Beuys*, by Ann Temkin and Bernice Rose, pp. 11–25. New York: The Museum of Modern Art, 1993.

Umland 1998
Umland, Anne. *Pop Art: Selections from The Museum of Modern Art*. New York: The Museum of Modern Art, 1998.

Varnedoe 1984
Varnedoe, Kirk. "Abstract Expressionism." In *"Primitivism" in 20th Century Art: Affinity of the Tribal and the Modern*, edited by William Rubin, vol. 2, pp. 614–59. New York: The Museum of Modern Art, 1984.

Varnedoe 1986
Varnedoe, Kirk. *Vienna 1900: Art, Architecture & Design*. New York: The Museum of Modern Art, 1986.

Varnedoe 1990
Varnedoe, Kirk, and Adam Gopnik. *High & Low: Modern Art and Popular Culture*. New York: The Museum of Modern Art, 1990.

Varnedoe 1994
Varnedoe, Kirk. *Cy Twombly: A Retrospective*. New York: The Museum of Modern Art, 1994.

Varnedoe 1994
Varnedoe, Kirk. *Masterpieces from the David and Peggy Rockefeller Collection: Manet to Picasso*. New York: The Museum of Modern Art, 1994.

Varnedoe 1996
Varnedoe, Kirk. *Jasper Johns, A Retrospective*. New York: The Museum of Modern Art, 1996.

Varnedoe 1997
Varnedoe, Kirk, and Pepe Karmel. *Picasso: Masterworks from The Museum of Modern Art*. New York: The Museum of Modern Art, 1997.

Varnedoe 1998
Varnedoe, Kirk. *Jackson Pollock: A Retrospective*. New York: The Museum of Modern Art, 1998.

Varnedoe 2000
Modern Contemporary: Art at MoMA since 1980, edited by Kirk Varnedoe, Paola Antonelli, and Joshua Siegel. New York: The Museum of Modern Art, 2000.

Varnedoe 2001
Varnedoe, Kirk. *Van Gogh's Postman: The Portraits of Joseph Roulin*. New York: The Museum of Modern Art, 2001.

Varnedoe 2001
Varnedoe, Kirk, ed. *Masterworks from The Museum of Modern Art, New York, 1900–1955*. New York: The Museum of Modern Art, 2001 [text in Japanese only].

Wagner 1999
Wagner, Anne M. "Pollock's Nature, Frankenthaler's Culture." In *Jackson Pollock: New Approaches*, edited by Kirk Varnedoe and Pepe Karmel, pp. 181–99. New York: The Museum of Modern Art, 1999.

Whiteread 2000
Whiteread, Rachel. Acoustiguide recording for the exhibition *Open Ends*. New York: The Museum of Modern Art, 2000.

Whitfield 1998
Whitfield, Sarah. "Fragments of an Identical World." In *Bonnard*, by Sarah Whitfield and John Elderfield, pp. 9–31. New York: The Museum of Modern Art, 1998.

Wilk 1999
Wilk, Deborah. "Nine Guitars." In *Modernstarts*, edited by John Elderfield, Peter Reed, Mary Chan, and Maria del Carmen González, pp. 308–11. New York: The Museum of Modern Art, 1999.

Wilkinson 1984
Wilkinson, Alan G. "Paris and London: Modigliani, Lipchitz, Epstein and Gaudier-Brzeska." In *"Primitivism" in 20th Century Art: Affinity of the Tribal and the Modern*, edited by Willliam Rubin, vol. 2, pp. 417–51. New York: The Museum of Modern Art, 1984.

Williams 1939
Williams, William Carlos. "Introduction." In *Charles Sheeler: Paintings, Drawings, Photographs*, pp. 6–9. New York: The Museum of Modern Art, 1939.

Wye 1982
Wye, Deborah. *Louise Bourgeois*. New York: The Museum of Modern Art, 1982.

Wye 1991
Wye, Deborah. *Antoni Tàpies in Print*. New York: The Museum of Modern Art, 1991.

Zelevansky 1994
Zelevansky, Lynn. *Sense and Sensibility: Women Artists and Minimalism in the Nineties*. New York: The Museum of Modern Art, 1994.

Chronology

The following chronology serves as a brief introduction to the history of The Museum of Modern Art, its exhibitions and acquisitions history with a primary focus on painting and sculpture. The building history module chronicles the various spaces in which the Museum has been housed. The exhibitions module recognizes selected major painting and sculpture exhibitions, exhibitions from whose catalogues anthology excerpts have been extracted, as well as selected circulating exhibitions organized by The Museum of Modern Art. The acquisitions column contains works exclusive to this volume.

	Building History	Major Exhibitions of Painting and Sculpture	Acquisitions
1929	The Museum of Modern Art opens November 8 in space rented in Heckscher Building, 730 Fifth Avenue	• *Cézanne, Gauguin, Seurat, van Gogh* • *Paintings by Nineteen Living Artists*	
1930		• *Weber, Klee, Lehmbruck, Maillol* • *46 Painters and Sculptors under 35 Years of Age* • *Homer, Ryder, and Eakins* • *Corot and Daumier* • *Painting and Sculpture by Living Americans*	• Edward Hopper, *House by the Railroad* (1925)
1931		• *Toulouse-Lautrec, Redon* • *Modern German Painting and Sculpture* • *Memorial Exhibition: The Collection of the Late Lillie P. Bliss* • *Henri Matisse* • *Diego Rivera*	
1932	Move to 11 West Fifty-third Street	• *Murals by American Painters and Photographers* • *A Brief Survey of Modern Painting* • *American Painting and Sculpture 1862–1932* • *American Folk Art: The Art of the Common Man in America, 1750–1900*	• Otto Dix, *Dr. Mayer-Hermann* (1926)
1933		• *Sculptor's Drawings* • *American Sources of Modern Art (Aztec, Mayan, Incan)* • *Lehmbruck* • *Edward Hopper: Retrospective* • *Painting and Sculpture from 16 American Cities*	
1934		• *Machine Art* • *The Lillie P. Bliss Collection, 1934* • *Whistler: Portrait of the Artist's Mother* • *Modern Works of Art: Fifth Anniversary Exhibition*	• Constantin Brancusi, *Bird in Space* (1928) • Paul Cézanne, *The Bather* (c. 1885) and *Still Life with Apples* (1895–98) • Salvador Dali, *The Persistence of Memory* (1931) • Georges–Pierre Seurat, *Port-en-Bessin, Entrance to the Harbor* (1888) • Charles Sheeler, *American Landscape* (1930) • Édouard Vuillard, *Interior, Mother and Sister of the Artist* (1893)

	Building History	Major Exhibitions of Painting and Sculpture	Acquisitions
1935		• *Gaston Lachaise: Retrospective* • *George Caleb Bingham, The Missouri Artist, 1811–1879* • *African Negro Art* • *Fernand Léger: Drawings and Paintings* • *The Recent Work of Le Corbusier* • *Vincent van Gogh*	• Max Ernst, *The Hat Makes the Man* (1920) • Kazimir Malevich, *Woman with Pails: Dynamic Arrangement* (1912–13), *Reservist of the First Division* (1914), *Suprematist Composition: Airplane Flying* (1915), and *Suprematist Composition: White on White* (1918) • Pablo Picasso, *The Studio* (1927–28)
1936		• *New Acquisitions: The Collection of Mrs. John D. Rockefeller, Jr.* • *Cubism and Abstract Art* • *New Horizons in American Art* • *John Marin Retrospective* • *Fantastic Art, Dada, Surrealism*	• Giorgio de Chirico, *The Evil Genius of a King* (1914–15) • Alberto Giacometti, *The Palace at 4 A.M.* (1932) • Joan Miró, *The Hunter (Catalan Landscape)* (1923–24) • Aleksandr Rodchenko, *Non-Objective Painting no. 80 (Black on Black)* (1918) • Yves Tanguy, *Mama, Papa is Wounded!* (1927) • René Magritte, *The False Mirror* (1928)
1937	Exhibitions held at Time-Life Building, temporary quarters for the Museum	• *Vincent van Gogh* • *Prehistoric Rock Pictures in Europe and Africa* • *Paintings by Paul Cézanne* • *The War: Etchings by Otto Dix and a Painting by Gino Severini* • *Paintings for Paris* • *Transitions and Contrasts in Painting and Sculpture*	• Max Ernst, *Two Children Are Threatened by a Nightingale* (1924) • Henri Laurens, *Head of a Woman* (1915) • Le Corbusier, *Still Life* (1920) • André Masson, *Battle of Fishes* (1926) • Piet Mondrian, *Composition in White, Black, and Red* (1936) • David Alfaro Siqueiros, *Collective Suicide* (1936)
1938		• *American Folk Art* • *Subway Art* • *Machine Art* • *Masters of Popular Painting: Modern Primitives of Europe and America* • *Three Centuries of Art in the United States* • *Bauhaus: 1919–1928*	• Naum Gabo, *Head of a Woman* (c. 1917–20) • Wilhelm Lehmbruck, *Kneeling Woman* (1911) • Pablo Picasso, *Girl Before a Mirror* (1932)
1939	New building on West Fifty-third Street opens, designed by Edward D. Stone and Philip L. Goodwin	• *Art in Our Time: Tenth Anniversary Exhibition* • *Charles Sheeler* • *Picasso: 40 Years of His Art*	• Paul Klee, *Around the Fish* (1926) • Oskar Kokoschka, *Hans Tietze and Erica Tietze-Conrat* (1909) • Henri Matisse, *The Blue Window* (1913) • Amedeo Modigliani, *Head* (1915?) • Pablo Picasso, *Les Demoiselles d'Avignon* (1907) • Henri Rousseau, *The Sleeping Gypsy* (1897)
1940		• *Italian Masters* • *Twenty Centuries of Mexican Art* • *Portinari of Brazil*	• José Clemente Orozco, *Dive Bomber and Tank* (1940) • Diego Rivera, *Agrarian Leader Zapata* (1931)
1941		• *Paintings, Drawings, Prints by George Grosz* • *Indian Art of the United States* • *New Acquisitions: American Painting and Sculpture* • *Paul Klee* • *Abstract Painting: Shapes of Things* • *Masterpieces of Picasso* • *Ancestral Sources of Modern Painting* • *Britain at War* • *Joan Miró* • *Salvador Dali*	• Vincent van Gogh, *The Starry Night* (1889)

	Building History	Major Exhibitions of Painting and Sculpture	Acquisitions
1942	Sculpture Garden opens	• *Americans 1942: 18 Artists from 9 States* • *Henri Rousseau* • *Understanding Modern Art* • *How Modern Artists Paint People* • *The Museum and the War*	• Max Beckmann, *Departure* (1932, 33–35) • Jacob Lawrence, The Migration series (1940–41) • Fernand Léger, *Three Women* (1921) • Oskar Schlemmer, *Bauhaus Stairway* (1932)
1943		• *Americans 1943: Realists and Magic Realists* • *The Latin American Collection of The Museum of Modern Art* • *Religious Folk Art of the Southwest* • *Understanding Modern Art* • *Guernica* (on extended loan from Pablo Picasso, until 1981) • *Alexander Calder* • *Romantic Painting in America*	• Edward Hopper, *Gas* (1940) • Frida Kahlo, *Self-Portrait with Cropped Hair* (1940) • Piet Mondrian, *Broadway Boogie Woogie* (1942–43)
1944		• *Modern Cuban Painters* • *American Battle Painting 1776–1918* • *Art in Progress: Fifteenth Anniversary Exhibition* • *Paintings by Jacob Lawrence* • *Marsden Hartley* • *Lyonel Feininger*	• Matta, *The Vertigo of Eros* (1944) • Jackson Pollock, *The She-Wolf* (1943)
1945		• *Piet Mondrian* • *Georges Rouault* • *Fourteen Paintings by Vincent van Gogh* • *Stuart Davis*	• Georges Braque, *Man with a Guitar* (1911–12) • Marc Chagall, *I and the Village* (1911) • Marcel Duchamp, *The Passage from Virgin to Bride* (1912) • Wifredo Lam, *The Jungle* (1943) • Georgia O'Keeffe, *Lake George Window* (1929) • Pablo Picasso, *"Ma Jolie"* (1911–12)
1946		• *Marc Chagall* • *Georgia O'Keeffe* • *Fourteen Americans* • *Florine Stettheimer* • *Henry Moore*	• Henri Matisse, *Piano Lesson* (1916) • Theo van Doesburg, *Rhythm of a Russian Dance* (1918) • Meret Oppenheim, *Object* (1936)
1947		• *Ben Shahn*	• Roger de La Fresnaye, *The Conquest of the Air* (1913) • Henry Moore, *The Bride* (1939–40)
1948		• *Portraits of Gertrude Stein by Picasso* • *Gabo—Pevsner* • *Pierre Bonnard* • *Bonnard—Picasso* • *Elie Nadelman* • *Timeless Aspects of Modern Art*	• Francis Bacon, *Painting* (1946) • Umberto Boccioni, *Development of a Bottle in* Space (1912) and *Unique Forms of Continuity in Space* (1913) • Carlo Carrà, *Funeral of the Anarchist Galli* (1910–11) • Willem de Kooning, *Painting* (1948) • Piet Mondrian, *Composition C* (1920)
1949		• *Georges Braque* • *Twentieth-Century Italian Art* • *Oskar Kokoschka* • *Paul Klee*	• Giacomo Balla, *Swifts: Paths of Movement+Dynamic Sequences* (1913) • Constantin Brancusi, *Fish* (1930) • Alberto Giacometti, *Woman with Her Throat Cut* (1932) • Aristide Maillol, *The River* (1943) • Henri Matisse, *The Red Studio* (1911) • Pablo Picasso, *Three Musicians* (1921) • Gino Severini, *Dynamic Hieroglyphic of the Bal Tabarin* (1912)

	Building History	Major Exhibitions of Painting and Sculpture	Acquisitions
1950		• Picasso: The Sculptor's Studio • Charles Demuth • Edvard Munch • Chaim Soutine	• Arshile Gorky, Agony (1947) • Piet Mondrian, Composition in Oval with Color Planes 1 (1914)
1951		• Abstract Painting and Sculpture in America • Amedeo Modigliani • Le Corbusier: Architecture, Painting, Design • James Ensor • Henri Matisse: Retrospective CIRCULATING EXHIBITION: • U.S. Representation: I Bienal do Museu de Arte Moderna, São Paulo: works by 58 artists	• Louise Bourgeois, Sleeping Figure (1950) • Stuart Davis, Lucky Strike (1921) • James Ensor, Masks Confronting Death (1888) • Alberto Giacometti, The Chariot (1950) • Ernst Ludwig Kirchner, Street, Dresden (1908) • Jacques Lipchitz, Man with a Guitar (1915) • George Grosz, "The Convict": Monteur John Heartfield after Franz Jung's Attempt to Get Him Up on His Feet (1920) • Franz Kline, Chief (1950)
1952		• Masterworks acquired through the Mrs. Simon Guggenheim Fund • 15 Americans • Les Fauves • De Stijl	• Henri Matisse, The Back (I) (1908–09), (III) (1916), and (IV) (c. 1931) • Bradley Walker Tomlin, Number 20 (1949)
1953		• Georges Rouault • Sculpture of the XXth Century • Katherine S. Dreier Bequest • Fernand Léger CIRCULATING EXHIBITION: • U.S. Representation: II Bienal do Museu de Arte Moderna, São Paulo: Sculptures by Alexander Calder; paintings and drawings by fifteen artists	• Constantin Brancusi, Maiastra [Magic Bird] (1910–12) and Mlle Pogany (1913) • Marcel Duchamp, To Be Looked At (from the Other Side of the Glass) with One Eye, Close To, for Almost an Hour (1918) • Willem de Kooning, Woman, I (1950–52) • Fernand Léger, Propellers (1918) • El Lissitzky, Proun 19D (1922?) • Aristide Maillol, The Mediterranean (1902–05) • Piet Mondrian, Tableau I: Lozenge with Four Lines and Gray (1926) • Georges Vantongerloo, Construction of Volume Relations (1921)
1954		• Ancient Arts of the Andes • Vuillard • The Sculpture of Jacques Lipchitz • Sculpture of Constantin Brancusi • Twenty-fifth Anniversary Exhibitions CIRCULATING EXHIBITION: • U.S. Representation: XXVII Biennale di Venezia: principally Willem de Kooning and Ben Shahn	• Robert Delaunay, Simultaneous Contrasts: Sun and Moon (1913) • Alberto Giacometti, Man Pointing (1947) • Vasily Kandinsky, Panels for Edwin R. Campbell Nos. 1 and 3 (1914) • Man Ray, The Rope Dancer Accompanies Herself with Her Shadows (1916) • Francis Picabia, I See Again in Memory My Dear Udnie (1914) • Henri Rousseau, The Dream (1910) • Kurt Schwitters, Merz Picture 32A (The Cherry Picture) (1921)
1955		• Fifteen Paintings by French Masters of the 19th Century from the Louvre and the Museums of Albi and Lyon • Picasso: 12 Masterworks • The New Decade: 22 European Painters and Sculptures • Giorgio de Chirico • Yves Tanguy CIRCULATING EXHIBITIONS: • U.S. Representation: III Bienal do Museu de Arte Moderna, São Paulo: Pacific Coast Art • The Family of Man	• Paul Cézanne, Boy in a Red Vest (1888–90) • Paul Klee, Vocal Fabric of the Singer Rosa Silber (1922) • Henri Matisse, Goldfish and Sculpture (1912) and The Moroccans (1915–16) • Emil Nolde, Christ and the Children (1910) • Auguste Rodin, Monument to Balzac (1898) and St. John the Baptist Preaching (1878–80)

	Building History	Major Exhibitions of Painting and Sculpture	Acquisitions
1956		• *Toulouse-Lautrec* • *Kandinsky Murals* • *Twelve Americans* • *Renoir's Reclining Nude* • *Masters of British Painting 1800–1950* • *Balthus* • *Jackson Pollock*	• František Kupka, *Mme Kupka among Verticals* (1910–11) • Henri Matisse, *The Back (II)* (1913) • Alejandro Otero, *Colorhythm, I* (1955)
1957		• *Picasso 75th Anniversary* • *Matta* • *David Smith* • *German Art of the Twentieth Century* • *Marc Chagall* • *Antonio Gaudi* CIRCULATING EXHIBITIONS: • *U.S. Representation: III International Contemporary Art Exhibition, India: Nine American artists* • *U.S. Representation: IV Bienal do Museu de Arte Moderna, São Paolo: Jackson Pollock and eight additional artists* • *Jackson Pollock, 1912–1956* (based on retrospective exhibition shown as part of *U.S. Representation at IV Bienal do Museu de Arte Moderna, São Paolo*	• Hilaire-Germain-Edgar Degas, *At the Milliner's* (c. 1882) • Georges–Pierre Seurat, *Evening, Honfleur* (1886) • Karl Schmidt-Rottluff, *Houses at Night* (1912)
1958		• *Seurat: Paintings and Drawings* • *Juan Gris* • *Jean Arp: A Retrospective* • *Philip L. Goodwin Collection* CIRCULATING EXHIBITION: • *The New American Painting*	• Paul Gauguin, *Portrait of Jacob Meyer de Haan* (1889) • Jasper Johns, *Target with Four Faces* (1955) • Fernand Léger, *Contrast of Forms* (1913) • Lyubov Popova, *Painterly Architectonic* (1917)
1959		• *Joan Miró* • *Recent Sculpture USA* • *New Images of Man* • *Sixteen Americans* CIRCULATING EXHIBITION: • *U.S. Representation: Dokumenta II, Kassel: works by 44 artists, plus a retrospective of works by Pollock*	• Paul Cézanne, *L'Estaque* (1879–83) • Vasily Kandinsky, *Picture with an Archer* (1909) • Claude Monet, *Reflections of Clouds on the Water-Lily Pond* (c. 1920) • Medardo Rosso, *The Bookmaker* (1894) • Frank Stella, *The Marriage of Reason and Squalor, II* (1959)
1960		• *Claude Monet: Seasons and Moments* • *New Spanish Painting and Sculpture* • *Fernand Léger in the Museum Collection* CIRCULATING EXHIBITION: • *Art in Embassies*	• Helen Frankenthaler, *Jacob's Ladder* (1957)
1961		• *Mark Rothko* • *Painting and Sculpture from the James Thrall Soby Collection* • *Max Ernst* • *Futurism* • *The Art of Assemblage* • *The Last Works of Matisse: Large Cut Gouaches* • *Chagall—The Jerusalem Windows* • *Redon, Moreau, Bresdin*	• Jean Dubuffet, *Joë Bousquet in Bed* (1947) • Joan Mitchell, *Ladybug* (1957) • Robert Motherwell, *Elegy to the Spanish Republic, 54* (1957–61) • Antoni Tàpies, *Gray Relief on Black* (1959)

	Building History	Major Exhibitions of Painting and Sculpture	Acquisitions
1962		• *Jean Dubuffet* • *Picasso in The Museum of Modern Art* • *Recent Painting U.S.A.: The Figure* • *Mark Tobey* • *Arshile Gorky: 1904–1948* CIRCULATING EXHIBITION: • *Two Decades of American Painting*	• Jacob Epstein, *The Rock Drill* (1913–14) • Andy Warhol, *Gold Marilyn Monroe* (1962)
1963		• *The Intimate World of Lyonel Feininger* • *Emil Nolde: 1867–1956* • *Auguste Rodin* • *Americans 1963* • *André Derain in the Museum Collection* • *Hans Hofmann* • *Medardo Rosso*	• Lee Bontecou, Untitled (1961) • André Breton, *Poem-Object* (1941) • Jasper Johns, *Map* (1961) • Henri Matisse, *Dance (I)* (1909) • Ad Reinhardt, *Abstract Painting* (1960–61)
1964	Major renovation, designed by Philip Johnson	• *Art in a Changing World: 1884–1964* • *Eduardo Paolozzi* • *Bonnard and His Environment* • *Max Beckmann*	• Hannah Höch, *Indian Dancer: From an Ethnographic Museum* (1930) • Gerald Murphy, *Wasp and Pear* (1927) • Pablo Picasso, *Boy Leading a Horse* (1905–06) • Bridget Riley, *Current* (1964)
1965		• *The Responsive Eye* • *American Collages* • *Alberto Giacometti* • *The Kay Sage Tanguy Bequest* • *Robert Motherwell* • *The School of Paris: Paintings from the Florene May Schoenborn and Samuel A. Marx Collection* • *René Magritte* • *Chasubles Designed by Henri Matisse*	• R. B. Kitaj, *The Ohio Gang* (1964) • Joan Miró, *Object* (1936)
1966		• *Turner: Imagination and Reality* • *Henri Matisse: 64 Paintings* • *The Taste of a Connoisseur: The Paul J. Sachs Collection*	• Alexander Calder, *Gibraltar* (1936) • Man Ray, *Indestructible Object* (1964)
1967		• *Latin American Art 1931–1966* • *Jackson Pollock* • *Guernica: Studies and Postscripts* • *The 1960s: Painting and Sculpture from the Museum Collection* • *Lyonel Feininger: The Ruin by the Sea* • *The Sculpture of Picasso*	• Salvador Dali, *Illumined Pleasures* (1929) • Jim Dine, *Five Feet of Colorful Tools* (1962) • Marcel Duchamp, *Bicycle Wheel* (1951) • Paul Klee, *Actor's Mask* (1924) • Claes Oldenburg, *Giant Soft Fan* (1966–67) and *Pastry Case, I* (1961–62) • Clyfford Still, *Painting 1944-N* (1944)
1968		• *The Sidney and Harriet Janis Collection* • *Dada, Surrealism, and Their Heritage* • *Cézanne to Miró* • *Christo Wraps the Museum* • *The Art of the Real* • *John Graham* • *Tribute to Marcel Duchamp* • *Robert Rauschenberg: Soundings* • *The Machine as Seen at the End of the Mechanical Age*	• Richard Artschwager, *Key Member* (1967) • Hans Bellmer, *The Machine-Gunneress in a State of Grace* (1937) • Jean Dubuffet, *The Magician* (1954) • Marcel Jean, *Specter of the Gardenia* (1936) • Henri Matisse, *Memory of Oceania* (1952–53) • Kenneth Noland, *Turnsole* (1961) • Francis Picabia, *Take Me There* (1919–20) • Jackson Pollock, *One: Number 31, 1950* (1950) • Kurt Schwitters, *Revolving* (1919) • David Smith, *Cubi X* (1963)

	Building History	Major Exhibitions of Painting and Sculpture	Acquisitions
1969		• *Willem de Kooning* • *Twentieth-Century Art from the Nelson Aldrich Rockefeller Collection* • *New American Painting and Sculpture: The First Generation* • *Robert Motherwell: Lyric Suite* • *Claes Oldenburg* • *Matisse: Memory of Oceania* • *A Salute to Alexander Calder*	• Carl Andre, *144 Lead Square* (1969) • Giorgio de Chirico, *Gare Montparnasse* (1914) • Arshile Gorky, *Summation* (1947) • Eva Hesse, *Repetition Nineteen III* (1968) • Robert Irwin, Untitled (1968) • Ellsworth Kelly, *Colors for a Large Wall* (1951) • Barnett Newman, *Vir Heroicus Sublimis* (1950–51) • Jackson Pollock, *Echo: Number 25, 1951* (1951) • Mark Rothko, *No. 5/No. 22* (1950) • Cy Twombly, *The Italians* (1961) • Yves Klein, *Blue Monochrome* (1961) • Dan Flavin, *Untitled (To the "innovator" of Wheeling Peachblow)* (1968)
1970		• *Mrs. Simon Guggenheim Memorial 1877–1970* • *Frank Stella: Paintings* • *Mark Rothko: 1903–1970* • *Information* • *Archipenko: The Parisian Years* • *Robert Irwin* • *Four Americans in Paris: The Collection of Gertrude Stein and Her Family*	• Romare Bearden, *Patchwork Quilt* (1970) • Marcel Duchamp, *Network of Stoppages* (1914) • Lucio Fontana, *Spatial Concept: Expectations* (1960) • Paul Klee, *Fire in the Evening* (1929) • Tom Wesselmann, *Still Life #30* (1963) • Joan Miro, *Still Life with Old Shoe* (1937) • David Smith, *Australia* (1951) • Adolph Gottlieb, *Man Looking at Woman* (1949) • Agnes Martin, *Red Bird* (1964)
1971		• *Romare Bearden: The Prevalence of Ritual* • *The Sculpture of Richard Hunt* • *Younger Abstract Expressionists of the Fifties* • *Projects* • *The Artist as Adversary* • *Barnett Newman: 1905–1970* • *Tony Smith/81 More* • *Seven by de Kooning*	• Roy Lichtenstein, *Drowning Girl* (1963) • Barnett Newman, *Broken Obelisk* (1963–69) • Robert Ryman, *Twin* (1966) • Pablo Picasso, *Guitar* (1912–13) • Fred Sandback, Untitled (1967)
1972		• *Picasso in the Collection of The Museum of Modern Art* • *The Sculpture of Matisse* • *Symbolism, Synthesists and the Fin-de-Siècle* • *Kurt Schwitters* • *African Textiles and Decorative Arts* • *Dubuffet: Persons and Places*	• Vladimir Baranoff-Rossiné, *Symphony Number 1* (1913) • Joan Miró, *The Birth of the World* (1925) • Robert Rauschenberg, *First Landing Jump* (1961)
1973		• *Agnes Martin: On a Clear Day* • *Ellsworth Kelly* • *Miró in the Collection of The Museum of Modern Art* • *Marcel Duchamp*	• Jasper Johns, *Flag* (1954–55) • Brice Marden, *Grove Group, I* (1973)
1974		• *The Painting of Gerald Murphy* • *Contemporary Soviet Art* • *Eight Contemporary Artists* • *Chasubles Designed by Henri Matisse*	• Anthony Caro, *Midday* (1960) • Edvard Munch, *The Storm* (1893) • Richard Tuttle, *Cloth Octagonal, 2* (1967) • Jackie Winsor, *Bound Square* (1972)

	Building History	Major Exhibitions of Painting and Sculpture	Acquisitions
1975		• *Lucas Samaras* • *Anthony Caro* • *Jacques Villon: 1875–1975* • *Modern Masters: Manet to Matisse*	• Georges Braque, *Landscape at La Ciotat* (1907) • Eva Hesse, *Vinculum, II* (1969) • Henri Matisse, *View of Notre Dame* (1914) • Robert Morris, Untitled (1969)
1976		• *Constructivism in Poland: 1923–1935* • *Cubism and Its Affinities* • *The "Wild Beasts": Fauvism and Its Affinities* • *André Masson* • *Rodin and Balzac* • *The Natural Paradise: American Painting 1800–1950* • *Alexander Calder: 1898–1976* • *Man Ray: 1890–1976*	• Joan Miró, *"Hirondelle Amour"* (1933–34)
1977		• *Matisse: The Swimming Pool* • *Robert Rauschenberg* • *Impresario: Ambroise Vollard* • *Extraordinary Women* • *Cézanne: The Late Work*	• Morris Louis, *Russet* (1958) • Susan Rothenberg, *Axes* (1976)
1978		• *Sol LeWitt* • *Mexican Art* • *Nine Windows by Chagall* • *Russia: The Avant-Garde* • *Matisse in the Collection of The Museum of Modern Art*	• Patrick Henry Bruce, *Painting* (c. 1929–30) • Gustav Klimt, *Hope, II* (1907–08) • Sol LeWitt, *Serial Project, I (ABCD)* (1966) • Bruce Nauman, Untitled (1965) • Joseph Kosuth, *One and Three Chairs* (1965)
1979		• *Jackie Winsor* • *The Masterworks of Edvard Munch* • *Bequest of James Thrall Soby* • *Larry Rivers and Terry Southern: The Donkey and The Darling* • *Patrick Henry Bruce* • *Art of the Twenties*	• Jean Arp, *Enak's Tears (Terrestrial Forms)* (1917) • Balthus, *The Street* (1933) • Umberto Boccioni, *States of Mind I: The Farewells; States of Mind II: Those Who Go; States of Mind III: Those Who Stay* (all 1911) • Georges Braque, *Still Life with Tenora* (1913) • Giorgio de Chirico, *The Song of Love* (1914) • Richard Diebenkorn, *Ocean Park 115* (1979) • Juan Gris, *Guitar and Glasses* (1914) and *The Sideboard* (1917) • Gustav Klucis, Maquette for *"Radio-Announcer"* (1922) • Pablo Picasso, *Girl with a Mandolin (Fanny Tellier)* (1910) and *Guitar* (1913) • Richard Serra, *Cutting Device: Base Plate Measure* (1969)
1980		• *Pablo Picasso: A Retrospective* • *Joseph Cornell*	• Joseph Cornell, *Untitled (Bébé Marie)* (early 1940s) • Donald Judd, Untitled (1968) • Pablo Picasso, *Bather with Beach Ball* (1932) and *The Kitchen* (1948) • Jackson Pollock, *Gothic* (1944) and *Easter and the Totem* (1953) • Ad Reinhardt, *Number 107* (1950)
1981		• *Sophie Taeuber-Arp* • *Balthus: Works from the Collection*	• Scott Burton, *Pair of Rock Chairs* (1980–81) • Howard Hodgkin, *Red Bermudas* (1978–80) • Roy Lichtenstein, *Girl with Ball* (1961) • Mark Rothko, *Slow Swirl at the Edge of the Sea* (1944) and *No. 3/No. 13* (1949)

	Building History	Major Exhibitions of Painting and Sculpture	Acquisitions
1982	Temporary West Wing, 20 West Fifty-fourth Street (used during construction of Pelli building)	• *Giorgio de Chirico* • *Louise Bourgeois*	• Egon Schiele, *Portrait of Gerti Schiele* (1909)
1983		• *Mondrian: New York Studio Compositions*	• Constantin Brancusi, *Endless Column* (1918) • Vassily Kandinsky, *Panels for Edwin R. Campbell Nos. 2 and 4* (1914) • Elizabeth Murray, *Painters Progress* (1981)
1984	Opening of new West Wing, designed by Cesar Pelli & Associates, and renovated Museum facilities	• *An International Survey of Recent Painting and Sculpture* • *"Primitivism" in 20th Century Art: Affinity of the Tribal and the Modern* • *Lee Krasner: A Retrospective*	• Martin Puryear, *Greed's Trophy* (1984)
1985		• *Henri Rousseau* • *Kurt Schwitters* • *Contrasts of Form: Geometric Abstract Art 1910–1980* • *Henri de Toulouse-Lautrec*	• Ivan Puni, *Suprematist Relief-Sculpture* (1920s) • Robert Motherwell, *The Little Spanish Prison* (1941–44) • Gerhard Richter, *Meadowland* (1985) • Lázló Moholy-Nagy, *Q 1 Suprematistic* (1923)
1986		• *Richard Serra* • *Vienna 1900: Art, Architecture & Design* • *Morris Louis*	• Aleksandr Rodchenko, *Spatial Construction no. 12* (c. 1920) • Gilberto Zorio, *Crystal Star with Javelins* (1977)
1987		• *Paul Klee* • *Berlinart 1961–1987* • *Frank Stella: Works from 1970–1987* • *Bill Viola*	• Anish Kapoor, *A Flower, A Drama Like Death* (1986) • Malcolm Morley, *The Day of the Locust* (1977)
1988		• *Vito Acconci: Public Places* • *Contemporary Art in Context* • *Anselm Kiefer*	• Ed Ruscha, *OOF* (1962–63) • Jacques de la Villeglé, *122 rue du temple* (1968)
1989		• *Andy Warhol: A Retrospective* • *Christopher Wilmarth* • *Helen Frankenthaler: A Paintings Retrospective* • *Picasso and Braque: Pioneering Cubism* • *Artist's Choice*	• Vincent van Gogh, *Portrait of Joseph Roulin* (1889) • Jannis Kounellis, Untitled (1983) • Robert Rauschenberg, *Bed* (1955)
1990		• *Robert Moskowitz* • *Francis Bacon* • *Matisse in Morocco: The Paintings and Drawings, 1912–1913* • *High & Low: Popular Art and Modern Culture* CIRCULATING EXHIBITION: • *Picasso Exchange Exhibition*	• Paul Gauguin, *The Seed of the Areoi* (1892) • David Hammons, *High Falutin'* (1990)

529

	Building History	Major Exhibitions of Painting and Sculpture	Acquisitions
1991		• *Liubov Popova* • *Ad Reinhardt* • *Dislocations*	• Philip Guston, *Box and Shadow* (1978) • Hans Hofmann, *Cathedral* (1959) • Henri Matisse, *Interior with a Young Girl (Girl Reading)* (1905–06) • Bruce Nauman, *Human/Need/Desire* (1983) • Sigmar Polke, *Watchtower* (1984) • Paul Signac, *Opus 217. Against the Enamel of a Background Rhythmic with Beats and Angles, Tones, and Tints. Portrait of M. F. Fénéon in 1890* (1890) • Robert Smithson, *Corner Mirror with Coral* (1969) • Andy Warhol, *Orange Car Crash Fourteen Times* (1963)
1992		• *The William S. Paley Collection* • *Philip Guston in the Collection of The Museum of Modern Art* • *Henri Matisse: A Retrospective* CIRCULATING EXHIBITIONS: • *MoMA, New York from Cézanne to Pollock* • *Masterworks from the Museum of Modern Art*	• Marcel Broodthaers, *White Cabinet and White Table* (1965) • Salvador Dali, *Retrospective Bust of a Woman* (1933) • André Derain, *Charing Cross Bridge* (1905–06) • Ana Mendieta, *Nile Born* (1984)
1993		• *Max Ernst, Dada and the Dawn of Surrealism* • *John Heartfield: Photomontages* • *Latin American Artists of the Twentieth Century* • *Robert Ryman* • *Joan Miró*	• Walter de Maria, *Cage II* (1965) • Charles Ray, *Family Romance* (1993)
1994		• *Masterpieces from the David and Peggy Rockefeller Collection: From Manet to Picasso* • *Sense and Sensibility: Women Artists and Minimalism in the Nineties* • *Cy Twombly: A Retrospective* • *Mapping*	• Isamu Noguchi, *Apartment* (1952) • James Turrell, *A Frontal Passage* (1994) • Cy Twombly, Untitled (1970)
1995		• *Jacob Lawrence: The Migration Series* • *Kandinsky: Compositions* • *Bruce Nauman* • *Masterworks from the Louise Reinhardt Smith Collection* • *Selections from the Bequest of Nina and Gordon Bunshaft* • *Piet Mondrian: 1872–1944* • *Annette Messager* • *From The Collection: Abstraction, Pure & Impure*	• Mona Hatoum, *Silence* (1994) • Wolfgang Laib, *The Passageway* (1988) • Odilon Redon, *Green Death* (c. 1905)
1996		• *Brancusi: Selected Masterworks from the Musée de l'Art Moderne, Paris, and from The Museum of Modern Art, New York* • *Deformations: Aspects of the Modern Grotesque* • *Picasso and Portraiture: Representation and Transformation* • *From Bauhaus to Pop: Masterworks Given by Philip Johnson*	• Pierre Bonnard, *The Bathroom* (1932) • Gilbert & George, *Down to Earth* (1989) • Felix Gonzalez-Torres, *"Untitled" (Perfect Lovers)* (1991) • Ellsworth Kelly, *White Plaque: Bridge Arch and Reflection* (1952–55) • Jeff Koons, *New Shelton Wet/Dry Doubledecker* (1981) • Gerhard Richter, *Self-Portrait* (1996) • James Rosenquist, *F-III* (1964–65)

	Building History	Major Exhibitions of Painting and Sculpture	Acquisitions
1996		• *Jasper Johns: A Retrospective* • *Simple Gifts: A Selection of Gifts to the Collection from Lily Auchincloss* CIRCULATING EXHIBITIONS: • *The William S. Paley Collection* • *Henri Matisse: Masterworks from The Museum of Modern Art*	• Doris Salcedo, Untitled (1995) • Andy Warhol, *Campbell's Soup Cans* (1962) • Christopher Wilmarth, *Self-Portrait with Sliding Light* (1987)
1997		• *Willem de Kooning: The Late Paintings, the 1980s* • *Masterworks from the Florene May Schoenborn Bequest* • *The Photomontages of Hannah Höch* • *Objects of Desire: The Modern Still Life* • *On the Edge: Contemporary Art from the Werner and Elaine Dannheisser Collection* • *Egon Schiele: The Leopold Collection, Vienna* CIRCULATING EXHIBITION: • *Picasso: Masterworks from The Museum of Modern Art*	• Gary Hill, *Inasmuch As It Is Always Already Taking Place* (1990) • Donald Judd, *Untitled (Stack)* (1967) • Yayoi Kusama, *No. F* (1959) • Henri Matisse, *The Yellow Curtain* (1915) • Bill Viola, *Stations* (1994) • Blinky Palermo, Untitled (1970)
1998		• *Fernand Léger* • *Chuck Close* • *Pierre Bonnard* • *Aleksandr Rodchenko* • *Tony Smith: Architect, Painter, Sculptor* • *Love Forever: Yayoi Kusama, 1958–1968* • *Jackson Pollock* CIRCULATING EXHIBITION: • *Pop Art: Selections from The Museum of Modern Art*	• John Baldessari, *What is Painting* (1968) • Paul Cézanne, *Turning Road at Montgeroult* (1898) • Vincent van Gogh, *The Olive Trees* (1889) • Al Held, *Mao* (1967) • Ellsworth Kelly, *Sculpture for a Large Wall* (1957) • Norman Lewis, Untitled (1949) • René Magritte, *The Lovers* (1928) • Panamarenko, *Flying Object (Rocket)* (1969) • Dieter Roth, *Snow* (1963–69) • Richard Serra, *Intersection II* (1992) • Tony Smith, *Die* (1962)
1999		• *The Museum as Muse: Artists Reflect* • *Ellsworth Kelly: Sculpture for a Large Wall and other Recent Acquisitions* • *ModernStarts: People, Places, Things,*	• Alighiero e Boetti, *Map of the World* (1989) • Cai Guo–Qiang, *Borrowing Your Enemy's Arrows* (1998) • Richard Hamilton, *Glorious Techniculture* (1961–64) • Rachel Whiteread, *Water Tower* (1998) • Chris Ofili, *Prince amongst Thieves* (1999)
2000		• *Making Choices* • *Open Ends*	• Giovanni Anselmo, *Torsion* (1968) • Matthew Barney, *The Cabinet of Baby Fay La Foe* (2000) • Joseph Beuys, *Eurasia Siberian Symphony 1963* (1966) • Georges Braque, *Studio V* (1949–50) • Chris Burden, *Medusa's Head* (1989–92) • Chuck Close, *Self-Portrait* (1997)
2001		• *Van Gogh's Postman: The Portraits of Joseph Roulin* • *Alberto Giacometti* CIRCULATING EXHIBITION: • *Masterworks from The Museum of Modern Art, New York (1900–1955)*	• Anselm Kiefer, *Wooden Room* (1972)

	Building History	Major Exhibitions of Painting and Sculpture	Acquisitions
2002	The Museum opens MoMA QNS, its temporary new home in Long Island City, designed by Cooper, Robertson & Partners; lobby and roofscape designed in collaboration with Michael Maltzan Architecture	• *Gerhard Richter: Forty Years of Painting* • *Tempo* • *To Be Looked At: Painting and Sculpture from the Permanent Collection*	• Joseph Beuys, *Iron Chest from "Vacuum↔Mass"* (1968) • Vija Celmins, *Night Sky #5* (1992) • Luc Tuymans, *Lumumba* (2000)
2003		• *Matisse Picasso* • *Max Beckmann* CIRCULATING EXHIBITION: • *Visions of Modern Art: Painting and Sculpture from The Museum of Modern Art, New York*	• Francis Bacon, *Triptych* (1991) • Jasper Johns, *Diver* (1962–63) • Pablo Picasso, *Pregnant Woman* (1950) • Jesús Rafael Soto, Untitled (1959–60) • Sophie Taeuber-Arp, *Dada Head* (1920)
2004	75th anniversary of The Museum of Modern Art; newly expanded Museum, designed by Yoshio Taniguchi, opens in November	• *Dieter Roth* • *Lee Bontecou* CIRCULATING EXHIBITION: • *Das MoMA in Berlin*	• Sherrie Levine, *Black Newborn* (1994) • Gino Severini, *Visual Synthesis of the Idea: "War"* (1914) • Lygia Clark, *Poetic Shelter* (1960) • Gego (Gertrude Goldschmidt), *Drawing without Paper* (1988) • Hélio Oiticica, *Box bolide 12, 'archeologic'* (1964–65) • Armando Reverón, *Woman of the River* (1939) • Joaquín Torres–García, *Construction in White and Black* (1938) • Gordon Matta-Clark, *Bingo* (1974) • Donald Judd, Untitled (1989)

Index

This index references the texts to the illustrations. Numbers in *italics* refer to the plates.

Photograph Credits

In reproducing the images contained in this publication, the Museum obtained the permission of the rights holders whenever possible. In those instances where the Museum could not locate the rights holders, notwithstanding good-faith efforts, it requests that any contact information concerning such rights holders be forwarded, so that they may be contacted for future editions.

The following credits appear at the request of the artists or the artists' representatives and/or the owners of the works:

536